THE
METROPOLITAN MUSEUM
OF ART
GUIDE

THE METROPOLITAN MUSEUM OF ART GUIDE

WORKS OF ART SELECTED BY
PHILIPPE DE MONTEBELLO, DIRECTOR

EDITED BY
KATHLEEN HOWARD

DESCRIPTIVE TEXTS WRITTEN BY
THE CURATORIAL STAFF OF THE MUSEUM

SECOND EDITION

THE METROPOLITAN MUSEUM OF ART, NEW YORK
YALE UNIVERSITY PRESS, NEW HAVEN AND LONDON

Second Edition, 1994
Seventh printing, 2006

Published by The Metropolitan Museum of Art

John P. O'Neill, Editor in Chief
R. Michael Shroyer, Designer, based on the original design
 by Irwin Glusker and Kristen Reilly

Printed and bound by Arnoldo Mondadori Editore, S.p.A.,
 Verona, Italy

LIBRARY OF CONGRESS CATALOGING-IN-PUBLICATION DATA

Metropolitan Museum of Art (New York, N.Y.)
 The Metropolitan Museum of Art guide / works of art selected by
Philippe de Montebello; descriptive texts written by the curatorial
staff of the Museum.—Rev. ed.
 p. cm.
 Includes index
 ISBN 0-87099-710-6.—ISBN 0-87099-711-4 (pbk.).—ISBN
0-300-08558-3 (Yale University Press)
 1. Art—New York (N.Y.)—Catalogs. 2. Metropolitan Museum of Art
(New York, N.Y.)—Catalogs. I. De Montebello, Philippe. II. Title.
N610.A6743 1994
708.147'1—dc20
 94-9094
 CIP

CONTENTS

INTRODUCTION

The Metropolitan Museum is a living encyclopedia of world art. Every culture from every part of the world—from Florence to Thebes to Papua New Guinea—from the earliest times to the present and in every medium is represented, frequently at the highest levels of quality and invention. The Metropolitan's two million square feet houses what is in fact a collection of collections; several of its departments could and would be major independent museums almost anywhere else. But here musical instruments adjoin arms and armor, and thirty-six thousand Egyptian objects are displayed on the floor directly above a collection of forty-five thousand costumes.

A guide to the Museum's immense holdings—more than three million works of art, of which several hundred thousand are on public view—can be only the briefest of anthologies. Through a selection of some of the finest works in every department we have attempted to give a balanced picture of the collection. Inevitably many legitimate candidates had to be excluded, and it is no empty boast to say that the guide could have been twice as long with scarcely a loss of quality or éclat in the works presented. For example, out of more than thirty paintings by Monet we show four, and only fifty-one examples of Greek and Roman art must stand for the thousands of objects in that department's galleries. And how many museums could omit two works by so rare and supreme a painter as Vermeer while still including three?

The difficulty we faced in these choices makes it clear that the works of art reproduced here are only signposts to direct and introduce the visitor to the various parts of the Metropolitan. I hope those who come to the Museum often will use this book to plan their visits, creating itineraries to suit a time or a mood (they may find, as I have, that a short, focused visit is perhaps the most rewarding way to experience the Museum). This guide can, of course, be used as a basis for a tour of

highlights, serving as an articulate companion to eluci-
date the visit as well as direct the visitor's steps. I should
add that the random stroll, the unexpected discovery
often bring as much pleasure as the satisfaction of locat-
ing a specific object.

Selecting the works of art for this guide helped to
remind us that some degree of humility is called for, as
there remain many gaps in the Metropolitan's collec-
tions—where is Donatello? Where are the poetic church
interiors of Saenredam? And where, in our superlative
holdings of Impressionism, is Caillebotte?* Still, this
guide could not fail to fill us with pride; it underscores the
crucial role played by donors in the Museum's growth,
and to all of them we extend our profound gratitude and
admiration.

Philippe de Montebello
Director

*In an earlier edition of this book the name Bazille appeared
where Caillebotte now stands. It is gratifying to report that
since that time this major gap in our collection has been
filled.

GENERAL INFORMATION

In Paris in 1866 a group of Americans gathered to celebrate the Fourth of July at a restaurant in the Bois de Boulogne. John Jay, the grandson of the eminent jurist and himself a distinguished public man, delivered the after-dinner speech, proposing that he and his compatriots create a "National Institution and Gallery of Art." This suggestion was enthusiastically received, and during the next years the Union League Club in New York, under Jay's presidency, rallied civic leaders, art collectors, and philanthropists to the cause. The project moved ahead swiftly, and The Metropolitan Museum of Art was incorporated on April 13, 1870. During the 1870s the Museum was located first in the Dodworth Building at 681 Fifth Avenue and then in the Douglas Mansion at 128 West Fourteenth Street; finally, on March 30, 1880, it moved to Central Park at Eighty-Second Street and Fifth Avenue. Its first building, a Ruskinian Gothic structure, was designed by Calvert Vaux and Jacob Wrey Mould; its west facade is still visible in the Lehman Wing. The Museum's Neoclassical facade on Fifth Avenue was erected during the early years of the twentieth century. The central pavilion (1902) was designed by Richard Morris Hunt; after his death in 1895 work continued under his son, Richard Howland Hunt. The north and south wings (1911 and 1913) were the work of McKim, Mead and White. The Robert Lehman Wing (1975), The Sackler Wing (1978), The American Wing (1980), The Michael C. Rockefeller Wing (1982), the Lila Acheson Wallace Wing (1987), and the Henry R. Kravis Wing (1991) were designed by Kevin Roche John Dinkeloo and Associates.

NOTABLE ACQUISITIONS

The following section (pp. 9–15) presents a group of extraordinary acquisitions made by the Museum in the years from 1990 to 2005. Philippe de Montebello, Director of the Metropolitan, has chosen these works to demonstrate the Museum's ongoing commitment to enriching its collection with objects of the highest aesthetic quality and historical importance. The head of each curatorial department has also selected a notable acquisition which appears on the page opposite the departmental introduction.

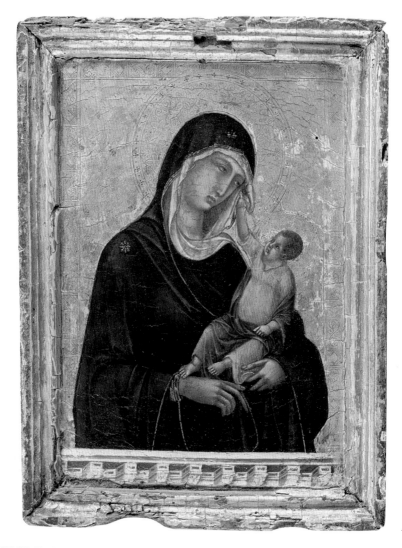

DUCCIO DI BUONINSEGNA, Sienese, active by 1278, died 1318
Madonna and Child
Tempera and gold on wood, with original engaged frame; 11 x 8 1/8 in. (28 x 20.8 cm)

Painted about 1295–1300, this exquisite *Madonna and Child* by the great Sienese painter Duccio di Buoninsegna is among the most important single acquisitions made by the Museum in the last two decades. Although well known in the literature, the painting has been inaccessible, even to scholars, for more than half a century. Nonetheless, its innovative qualities and intrinsic beauty have been much discussed: the use of an illusionistic parapet behind which the Madonna and child appear; the tender gesture of the child, who reaches upward to push aside his mother's veil; the Virgin's distant, melancholy, yet deeply moving expression; the use of the folds of the drapery to describe the underlying forms of the body; and the refined sense of color. This picture marks the opening page of the most glorious chapter of Duccio's

art, culminating in his great Maestà altarpiece in the Museo dell'Opera del Duomo in Siena, a milestone of Western art, comparable only to Giotto's frescoes in the Scrovegni Chapel in Padua. Duccio unquestionably knew Giotto's work and the illusionistic parapet is adapted from Giotto's experiments in his frescoes at Assisi. Both artists rejected the flat, codified schemas of medieval and Byzantine tradition, attempting to evoke the events of sacred history by reference to the complex and varied world of human experience. *Purchase, Rogers Fund, Walter and Leonore Annenberg and The Annenberg Foundation Gift, Lila Acheson Wallace Gift, Annette de la Renta Gift, Harris Brisbane Dick, Fletcher, Louis V. Bell, and Dodge Funds, Joseph Pulitzer Bequest, several members of The Chairman's Council Gifts, Elaine L. Rosenberg and Stephenson Family Foundation Gifts, 2003 Benefit Fund, and other gifts and funds from various donors, 2004, 2004.442*

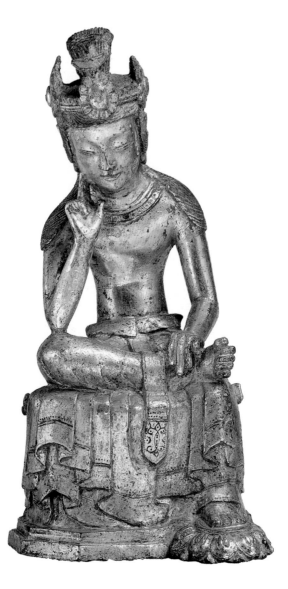

Pensive Bodhisattva
Korean, Three Kingdoms period (57 B.C.–A.D. 668), mid-7th century
Gilt bronze; h. 8⅞ in. (22.5 cm)

Images of the pensive bodhisattva—many representing Maitreya, bodhisattva of the future—were produced throughout Asia from India to Japan. In Korea the type emerged as an impor-tant Buddhist icon during the sixth and seventh centuries. While the iconographic and stylistic origins can be firmly traced to India and China, the pensive bodhisattva is one of the most distinctively Korean of Buddhist sculptures. This piece is among the best preserved and most spectacular of the extant Korean pensive images.
Purchase, Walter and Leonore Annenberg and The Annenberg Foundation Gift, 2003, 2003.222

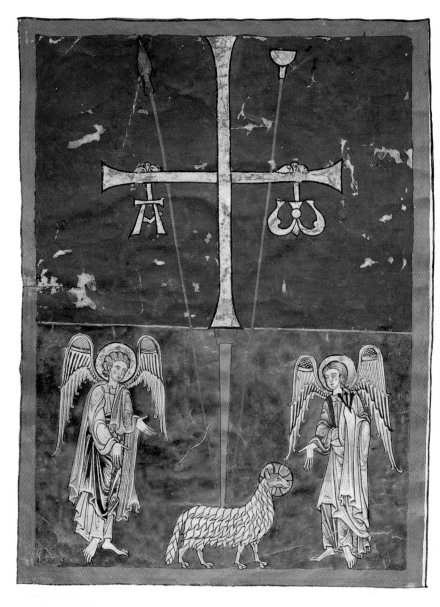

Frontispiece from a Beatus Manuscript: The Lamb of God before the Cross Flanked by Two Angels
Spanish (Benedictine Monastery of San Pedro de Cardeña), late 12th century
Tempera, gold, and ink on parchment; h. 17⅝ in. (44.8 cm)

About 776 the Asturian monk Beatus of Liébana compiled passages from the Apocalypse with his allegorical interpretations. Through the Romanesque period illustrated Beatus manuscripts were as important in Spain as Gospels

and Bibles were elsewhere in Europe. This leaf and thirteen others now in the Metropolitan came from a manuscript broken up in the 1870s and divided between museums in Madrid and Gerona. The pictorial style, notable for vibrant, dramatic color contrasts and refined linear treatment of figures and draperies, is characteristic of the European Transitional style of the late twelfth century. *Purchase, The Cloisters Collection, Rogers and Harris Brisbane Dick Funds, and Joseph Pulitzer Bequest, 1991, 1991.232.1v*

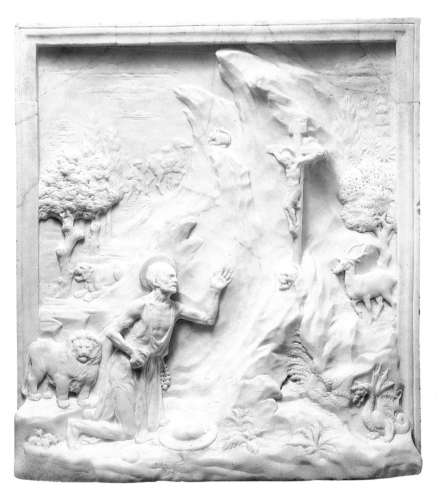

BENEDETTO DA MAIANO, Florentine,
1442–1497
Saint Jerome in the Wilderness
Marble; 16³⁄₄ x 15 in. (42.6 x 38 cm)

The hermit-scholar Saint Jerome was particu-
larly venerated in humanist Florence. In this
work (ca. 1470) he kneels before a crucifix, his
cardinal's hat at his feet. A stream, the water of
life, flows from beneath the crucifix in a land-
scape inhabited by various symbolic creatures.
The stag signifies the thirst for salvation (Psalms
42). The squirrel stands for endurance or the
search for divinity. The lion, whose paw Jerome
healed, is followed by a lioness; they may sym-
bolize constancy as well as the dangers the
saint faced (as does the wyvern, a dragonlike
monster, at bottom right). The drover and his
camel alludes to Jerome's infrequent glimpses
of the everyday world.

The naive but felicitous plants and animals,
the drill work, and the atmospheric staging are
characteristic of the artist, as is his abandon-
ment of the linear perspective that preoccupied
his peers for an airier continuum. The fore-
ground spills over the bottom edge, an effect
that derives from the reliefs on Lorenzo
Ghiberti's Gates of Paradise for the Florence
Baptistery (1452). *Purchase, Rogers Fund and
Lila Acheson Wallace Gift, 2001, 2001.593*

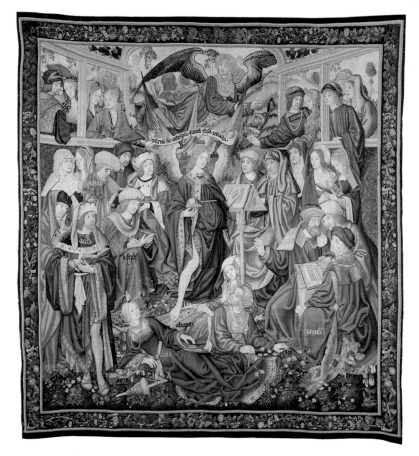

The Triumph of Fame from a set of
The Triumphs of Petrarch
Flemish (probably Brussels), ca. 1502–4
Wool and silk tapestry; 11 ft. 7 in. x 11 ft. (3.5 x 3.4 m)

One of the finest early Renaissance tapestries to have appeared on the market in the twentieth century, this piece is extraordinary for its condition, color, and harmonious composition. Fame stands reading at a lectern, an orb crowned with a cross in one hand, surrounded by writers who have immortalized the deeds of the ancients. His triumph over death is represented by the three Fates beneath his feet. Over his head Atropos, the Fate who cuts the thread of life, appears again, flying toward the mouth of Hell. Below, a

rich carpet of flowers, some in fruit, some in seed, echoes the themes of mortality and redemption. Originally, this tapestry was one of six in a sequence representing the triumphs of Love, Chastity, Death, Fame, Time, and Religion. Based in part on Petrarch's poem, *I Trionfi,* this allegorical cycle enjoyed tremendous popularity in the late medieval era, blending superstition with humanistic erudition and providing a resonant mix of entertainment and moral admonition. Documented in a Spanish ducal collection in the late nineteenth century, it corresponds exactly with a tapestry purchased in 1504 by Isabel, queen of Castile and Aragon. *Purchase, The Annenberg Foundation Gift, 1998, 1998.205*

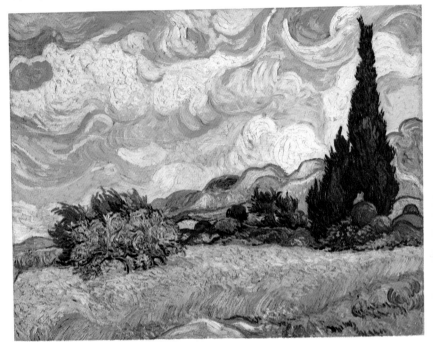

VINCENT VAN GOGH, Dutch, 1853–1890
Wheat Field with Cypresses
Oil on canvas; 28¾ x 36¾ in. (73 x 93.4 cm)

This exceptionally beautiful landscape (June 1889) is one of the most important works Van Gogh executed during his year-long internment at the asylum of Saint-Rémy (May 1889–May 1890). The thickly impastoed and vigorously brushed canvas is among his most successful and evocative compositions. The trees were at once an emblem of death, which haunted him during his breakdown in the winter of 1888–89, and one of salvation, for it was only after he was well enough to take walks outside the asylum that he perceived the cypresses' beauty.

Van Gogh launched an ambitious series of paintings devoted to cypresses, which he hoped would rival his still lifes of sunflowers. He mentioned this work in a letter of early July: "I have a canvas of cypresses with some ears of wheat, some poppies, a blue sky like a piece of Scotch plaid; the former painted with a thick impasto like the Monticellis, and the wheat field in the sun, which represents the extreme heat, very thick, too." *Purchase, The Annenberg Foundation Gift, 1993, 1993.132*

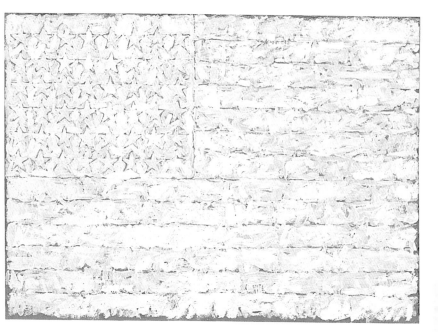

JASPER JOHNS, American, b. 1930
White Flag
Encaustic, oil, newsprint, and charcoal on canvas; 78³/₈ x 120³/₄ in. (198.9 x 306.7 cm)

During the 1950s and 1960s Johns often appropriated well-known images (such as targets, flags, and beer cans), elevating them to cultural icons. *White Flag* (1955) is the largest of his flag paintings and the first in which the flag is presented in monochrome. By draining most of the color from the flag but leaving subtle gradations in tone, the artist shifts our attention from the familiarity of the image to the way in which it is made. *White Flag* is painted on three separately stretched canvases: the stars, the seven upper stripes to the right of the stars, and the longer stripes below. The fast-setting medium of encaustic enabled Johns to make each brush-stroke distinct, while the forty-eight star flag design, contiguous to the perimeters of the canvas, provided a structure for the richly varied surface, which ranges from translucent to opaque.

Purchase, Lila Acheson Wallace, Reba and Dave Williams, Stephen and Nan Swid, Roy R. and Marie S. Neuberger, Louis and Bessie Adler Foundation Inc., Paula Cussi, Maria-Gaetana Matisse, The Barnett Newman Foundation, Jane and Robert Carroll, Eliot and Wilson Nolen, Mr. and Mrs. Derald H. Ruttenberg, Ruth and Seymour Klein Foundation Inc., Andrew N. Schiff, The Cowles Charitable Trust, The Merrill G. and Emita E. Hastings Foundation, John J. Roche, Molly and Walter Bareiss, Linda and Morton Janklow, Aaron I. Fleischman, and Linford L. Lougheed Gifts, and gifts from friends of the Museum; Kathryn E. Hurd, Denise and Andrew Saul, George A. Hearn, Arthur Hoppock Hearn, Joseph H. Hazen Foundation Purchase, and Cynthia Hazen Polsky and Leon B. Polsky Funds; Mayer Fund; Florene M. Schoenborn Bequest; Gifts of Professor and Mrs. Zevi Scharfstein and Himan Brown, and other gifts, bequests, and funds from various donors, by exchange, 1998, 1998.329

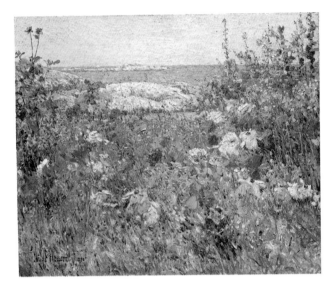

CHILDE HASSAM, American, 1859–1935
Celia Thaxter's Garden, Isles of Shoals, Maine
Oil on canvas; 17¾ x 21½ in. (45.1 x 54.6 cm)

Like other leading American Impressionists, Hassam pursued academic training in Paris. He was attracted as well to the French Impressionists' commitment to painting outdoors and to creating series dedicated to a single site. Hassam became the most prolific recorder of New York scenes in an Impressionist mode. He is also known for his rural views, and this picture is among the finest of the many that he made during summers in New England. *Anonymous Gift, 1994, 1994.567*

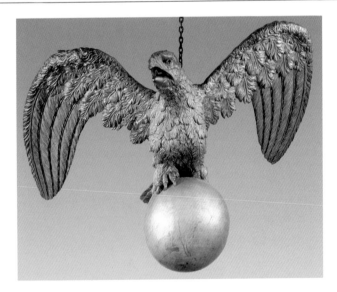

WILLIAM RUSH, American, 1756–1833
Eagle
Carved wood, gessoed and gilded, and painted cast iron; w. 68 in. (172.7 cm)

Rush is recognized today as one of this country's first portrait sculptors as well as a leading wood-carver and gilder in the vibrant artisan community of early-nineteenth-century Philadelphia. This monumental gilded eagle (1809–11), hung in Saint John's Evangelical Church in Philadelphia until 1847. It was then installed in the Assembly Room of Independence Hall, near the Liberty Bell and above Rush's wood statue of George Washington, where it remained until 1914. *Purchase, Sansbury-Mills Fund, and Anthony W. and Lulu C. Wang, Mr. and Mrs. Robert G. Goelet, Annette de la Renta, and Vira Hladun-Goldmann Gifts, 2002, 2002.21*

THE AMERICAN WING

Since its establishment in 1870, the Museum has acquired important examples of American art. The collection, one of the finest and most comprehensive in existence, is housed in The American Wing and is supervised by the departments of American Paintings and Sculpture, established in 1948, and American Decorative Arts, organized in 1924. Comprehensive in scope and extraordinary in quality, the collection of paintings illustrates almost all phases of the history of American art from the late eighteenth to the early twentieth century. The collection of sculpture is equally distinguished and is especially strong in Neoclassical and Beaux-Arts works. (Paintings and sculpture by artists born after 1876, as well as decorative arts created after World War I, are exhibited by the Department of Modern Art.)

The collection of decorative arts extends from the late seventeenth to the early twentieth century and includes furniture, silver, glass, ceramics, and textiles. Of special interest are the period rooms; twenty-five rooms with original woodwork and furnishings offer an unequaled view of American art history and domestic life.

The Henry R. Luce Center for the Study of American Art displays American fine art and decorative art objects that are not currently on view in the permanent galleries and period rooms.

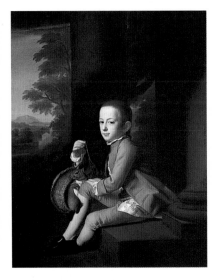

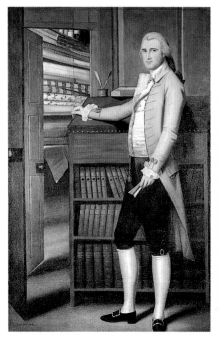

1 JOHN SINGLETON COPLEY, 1738–1815
Daniel Crommelin Verplanck
Oil on canvas; 49½ × 40 in. (125.7 × 101.6 cm)

Copley was America's foremost painter of the
eighteenth century. This portrait of Daniel
Verplanck, painted in 1771 when the subject
was nine years old, represents Copley at the
height of his power. Daniel holds a pet squirrel
on a gold leash, a motif that the artist used
several times in other portraits. The picturesque
landscape has traditionally been called a view
from the Verplanck country estate at Fishkill,
New York, looking toward Mount Gulian. *Gift of
Bayard Verplanck, 1949, 49.12*

2 RALPH EARL, 1751–1801
Elijah Boardman
Oil on canvas; 83 × 51 in. (210.9 × 129.5 cm)

Boardman is pictured in a room of the dry-
goods store he operated with his brother in
Connecticut. A door open to an adjoining room
reveals shelves holding bolts of plain and printed
stuffs. The young merchant stands in front of an
unusual piece of furniture, which probably
served as a stand-up desk. This portrait, painted
in 1789 during the years which are generally
regarded as the finest period of Earl's work,
blends truth with grace, and it embodies the
whole spirit of the age and place in which it
was painted. *Bequest of Susan W. Tyler, 1979,
1979.395*

3 RUFUS HATHAWAY, 1770–1822
Lady with Her Pets (Molly Wales Fobes)
Oil on canvas; 34¼ × 32 in. (87 × 81.3 cm)

This work, executed in 1790 by Rufus Hathaway,
an itinerant Massachusetts artist, is one of the
finest American primitive paintings. It exhibits
the curious dichotomy characteristic of works
of the self-taught: a naive, all-inclusive narrative
element combined with an almost abstract use
of line, color, and pattern in a sophisticated
composition. The reduction of drapery folds to
linear, rhythmical designs reaffirms the work's
two-dimensional, decorative quality. The paint-
ing shows an allover crackle, or alligatoring,
the result of an improper combination of
materials. *Gift of Edgar William and Bernice
Chrysler Garbisch, 1963, 63.201.1*

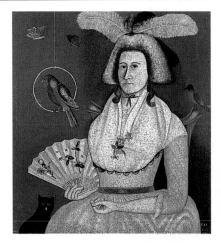

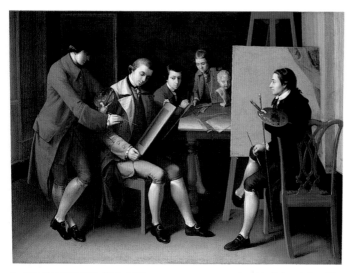

4 MATTHEW PRATT, 1734–1805
The American School
Oil on canvas; 36 × 50¼ in. (91.4 × 127.6 cm)

One of the great documents of colonial painting, *The American School* was done by Pratt in 1765, when he was in London studying with his countryman Benjamin West. Subdued in color, hard in finish, painstakingly drawn, and somewhat awkwardly composed, it is a rare attempt by an American at the informal group portrait, or "conversation piece," a staple of eighteenth-century English painting. The painting represents a group of young American artists working in West's studio under the direct supervision of the master, who stands, palette in hand, criticizing work by a young man who may be Pratt. The picture speaks eloquently of the youthful eagerness of Pratt and his companions as they listen to West, who taught virtually every major artist of the fledgling United States until his death in 1820. *Gift of Samuel P. Avery, 1897, 97.29.3*

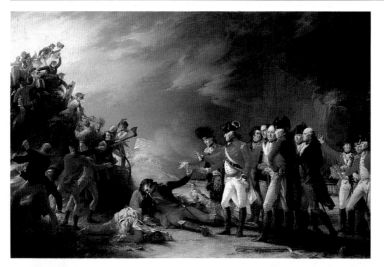

5 JOHN TRUMBULL, 1756–1843
The Sortie Made by the Garrison of Gibraltar
Oil on canvas; 70½ × 106 in.
(179.1 × 269.2 cm)

Trumbull wanted to excel at history painting in the grand manner, to create pictures large in scale and heroic in import. Possibly his most successful work in this manner is *The Sortie Made by the Garrison of Gibraltar,* painted in 1789 when he was in London. It depicts an episode during the three-year siege of the English fortress by French and Spanish forces. In 1781 the British under General Eliott destroyed an entire line of the enemy's counterworks in a nighttime foray. Trumbull chose to dramatize the moment when a gallant Spaniard, Don José de Barboza, although mortally wounded, refused British help because that would have meant complete surrender to the enemy. *Purchase, Pauline V. Fullerton Bequest, Mr. and Mrs. James Walter Carter Gift, Mr. and Mrs. Raymond J. Horowitz Gift, Erving Wolf Foundation Gift, Vain and Harry Fish Foundation Inc. Gift, Gift of Hanson K. Corning, by exchange, and Maria DeWitt Jesup and Morris K. Jesup Funds, 1976, 1976.332*

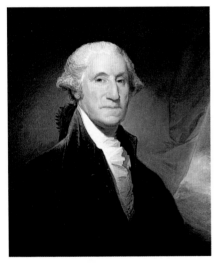

6 GILBERT STUART, 1755–1828
George Washington
Oil on canvas; 30¼ × 25¼ in. (76.8 × 64.1 cm)

In Philadelphia in 1795, two years after return-ing to the United States from Great Britain, Stuart painted his first portrait of George Wash-ington from life. The picture, which established Stuart as the leading American portrait painter of his time, is one of the best-known images in American art. Thirty-two replicas were commis-sioned, but few of them have the vitality and immediate quality of this version, which sug-gests that it must have been painted at least in part from life. The rich, vibrant flesh tones, set off by the green drapery, and the freely expres-sive brushwork contrast effectively with the simple composition and austere dignity of the subject. Stuart's work had a strong influence on many American portrait painters of the early nineteenth century. *Rogers Fund, 1907, 07.160*

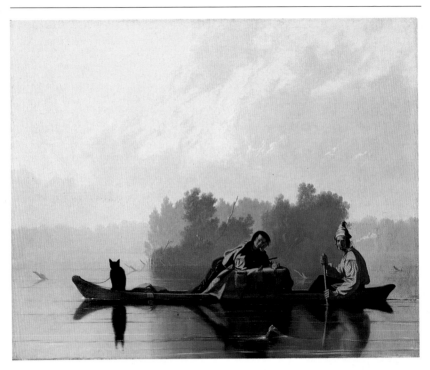

7 GEORGE CALEB BINGHAM, 1811–1879
Fur Traders Descending the Missouri
Oil on canvas; 29 × 36½ in. (73.7 × 92.7 cm)

A unique document of river life in the Midwest, this work is one of the masterpieces of Ameri-can genre painting. Bingham has raised anec-dote to the level of poetic drama by setting up a tension between the suspicious stare of the old trader, the unconcerned reverie of his sprawling son, and the compact, enigmatic silhouette of their pet fox. Parallel planes receding into deep space suggest the artist's familiarity with en-gravings from classical European paintings, yet the strict formality is softened by the exquisitely luminous atmosphere. Painted about 1845, this work is an early example of Luminism, a metic-ulous realism concerned with light and atmo-sphere. *Morris K. Jesup Fund, 1933, 33.61*

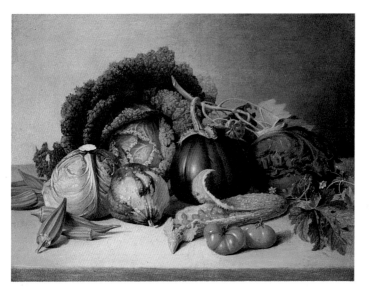

8 JAMES PEALE, 1749–1831
Still Life: Balsam Apple and Vegetables
Oil on canvas; 20¼ × 26½ in. (51.4 × 67.3 cm)

This remarkable still life, probably dating from the 1820s, is a surprising departure from James Peale's usual work in this genre. Instead of the more familiar formal composition of tightly drawn pieces of fruit falling out of a Chinese export porcelain basket, we have here a freely painted, casually arranged assortment of vegetables— okra, blue-green cabbage, crinkly Savoy cabbage, hubbard squash, eggplant, purple-red cabbage, and tomatoes—and a balsam apple. In place of the somber coloring characteristic of most of his still lifes, Peale has adjusted his palette and handling of paint to reproduce the rich colors and textures of the vegetables. *Maria DeWitt Jesup Fund, 1939, 39.52*

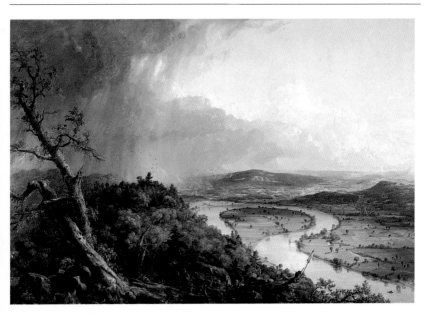

9 THOMAS COLE, 1801–1848
View from Mount Holyoke, Northampton, Massachusetts, after a Thunderstorm (The Oxbow)
Oil on canvas; 51½ × 76 in. (130.8 × 193 cm)

"I would not live where tempests never come, for they bring beauty in their train." So wrote Cole in his diary in 1835, the year before he painted this magnificent panorama of the Connecticut River valley. It is thus not surprising to find that he selected the moment following a cloudburst, when all nature seems freshened, and foliage, still wet, glitters in the crisp light. There is a marvelous wealth of detail—especially in the rocks and vegetation along the foreground promontory. Cole is often called the father of the Hudson River School of landscape painters. *Gift of Mrs. Russell Sage, 1908, 08.228*

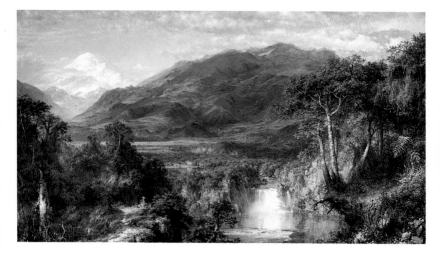

10 FREDERIC EDWIN CHURCH, 1826–1900
The Heart of the Andes
Oil on canvas; 66¹/₈ × 119¹/₄ in.
(168.3 × 302.9 cm)

Church, Thomas Cole's major pupil, headed the second generation of the Hudson River School. He gained fame for his large views of near and distant places. Church's panorama of the Ecuadorian Andes was a sensation when it was exhibited in the artist's studio in New York in 1859. This huge canvas is a dazzling compen-dium of minutely rendered wildlife, vegetation, and terrain. To heighten the sense of reality, *The Heart of the Andes* was exhibited in a darkened gallery, placed in a windowlike frame illuminated by gas jets. To experience the total grandeur of the painting, the visitor was advised to use opera glasses to explore, bit by bit, the marvelously rendered details. *Bequest of Margaret E. Dows, 1909, 09.95*

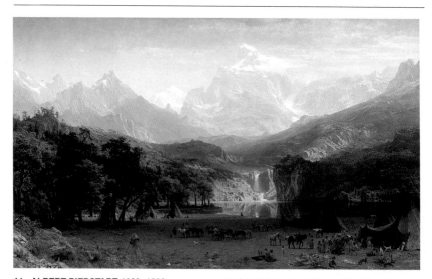

11 ALBERT BIERSTADT, 1830–1902
The Rocky Mountains, Lander's Peak
Oil on canvas; 73¹/₄ × 120³/₄ in.
(186.1 × 306.7 cm)

Bierstadt specialized in panoramic depictions of the American West, typified by *The Rocky Mountains,* painted in 1863. The peaceful encampment of Shoshone Indians, bathed in soft morning light, is an Edenic image of the unset-tled American West. Bierstadt's vision of soaring snowcapped mountains and broad fertile valleys reflects the prevailing belief in manifest destiny—the assumption that divine will paralleled national interest in the country's westward expansion. Bierstadt used sketches and photographs made during trips west to paint finished pictures in his studio. *Rogers Fund, 1907, 07.123*

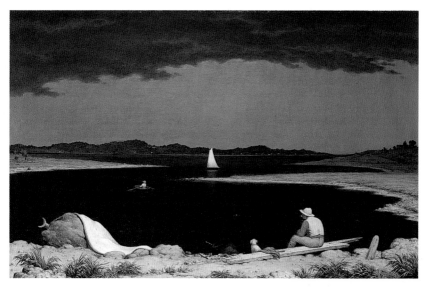

12 MARTIN JOHNSON HEADE, 1819–1904
The Coming Storm
Oil on canvas; 28 × 44 in. (71.1 × 111.8 cm)

A preoccupation with the effects of light and atmosphere earned a group of painters the name of Luminists, among them John Frederick Kensett, Fitz Hugh Lane, and Martin Johnson Heade. In *The Coming Storm* (1859) Heade reveals his intense love of nature and light.

Land and sea are hushed before the ominous approaching storm. Isolated figures and a single white sail under the threatening cloud produce an almost surrealistic impression, which is typical of his work. Heade's eerie pictures of sky and water achieve their compelling moody spells with an exciting contrast of gloom and light. *Gift of Erving Wolf Foundation and Mr. and Mrs. Erving Wolf, 1975, 1975.160*

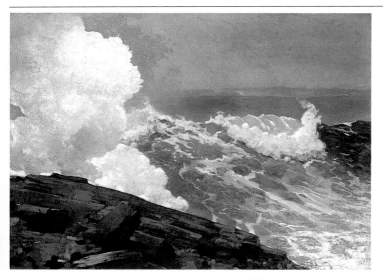

13 WINSLOW HOMER, 1836–1910
Northeaster
Oil on canvas; 34⅜ × 50¼ in. (87.3 × 127.6 cm)

Northeaster, painted in 1895, is an outstanding example of the late work of Homer, one of America's indisputable masters. In this painting the thrust of the storm is concentrated in a single heaving wave, and the composition has been simplified to one sweeping diagonal. Two areas of sharp contrast between light and dark heighten the drama, as does the fear generated by the ominous pull of undertow toward the

lower right corner. These effects are made possible by Homer's great breadth and freedom of brushstroke.

Homer produced a series of distinctive images of the sea unparalleled in American art. His commitment to the evidence of his own observations, his development of a direct technique largely unencumbered by the constraints of extensive academic training, and his unconventional, inventive imagery contribute to the originality that distinguishes his work. (See also no. 23.) *Gift of George A. Hearn, 1910, 10.64.5*

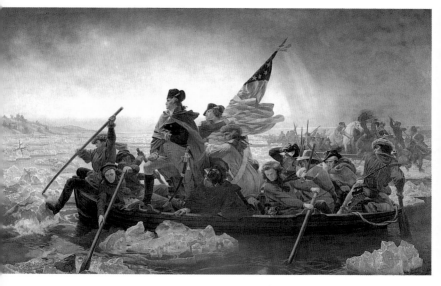

14 EMANUEL GOTTLIEB LEUTZE, 1816–1868
Washington Crossing the Delaware
Oil on canvas; 149×255 in. (378.5×647.7 cm)·

Many nineteenth-century painters, sculptors, and novelists created sentimentalized reconstructions of American colonial history. Inaccurate in many historical details, this painting is a conspicuous example of such Romantic imagery. The style is highly representative of a school of Romantic painting that flourished in Düsseldorf, where Leutze was living when he painted this picture in 1851. Worthington Whittredge, one of the American artists present while Leutze was working in Germany, posed for the figures of both Washington and the steersman. *Gift of John S. Kennedy, 1897, 97.34*

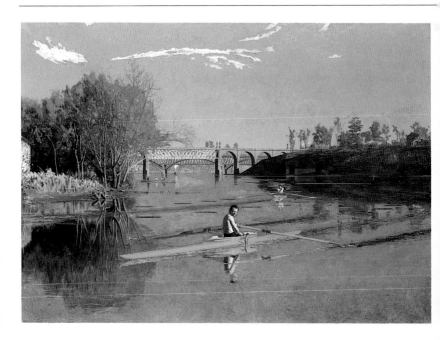

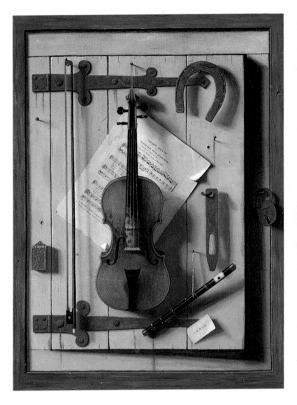

16 WILLIAM MICHAEL HARNETT, 1848–1892
Still Life—Violin and Music
Oil on canvas; 40 × 30 in. (101.6 × 76.2 cm)

In this work of 1888 Harnett pushes trompe-l'oeil painting to its limits, presenting objects in a daring range of spatial planes: the sheet music and calling card are shown with edges bent, not flat; the partly open door suggests depth behind it; heavy items are suspended on strings or balanced precariously on nails. Harnett delights in the textures and subdued colors of the old violin and its gleaming strings; in the silver, ivory, and granadilla piccolo; in the metal hinges, horseshoe, hasp, and lock. His technical brilliance and popular subject matter made him the most emulated American still-life painter of his generation. *Catharine Lorillard Wolfe Collection, Wolfe Fund, 1963, 63.85*

◀ **15 THOMAS EAKINS,** 1844–1916
Max Schmitt in a Single Scull, or
The Champion Single Sculls
Oil on canvas; 32½ × 46¼ in. (82.6 × 117.5 cm)

In this haunting work, painted in 1871, the artist's passion for sports is suffused with a lyrical response to subtle qualities of light and to the rhythmic placement of forms in deep space. In a serene and spacious setting, provided by the Schuylkill River flowing through Philadelphia's Fairmount Park, Eakins's friend Max Schmitt turns toward us; just beyond, the artist himself pulls away in a shell. Accents in the distance are created by other oarsmen, a train approaching the near bridge, and a steamboat. Most of the details are crystal clear, yet here and there passages are more freely painted, such as the stone house and leafy shore at the left. *Purchase, The Alfred N. Punnett Endowment Fund and George D. Pratt Gift, 1934, 34.92*

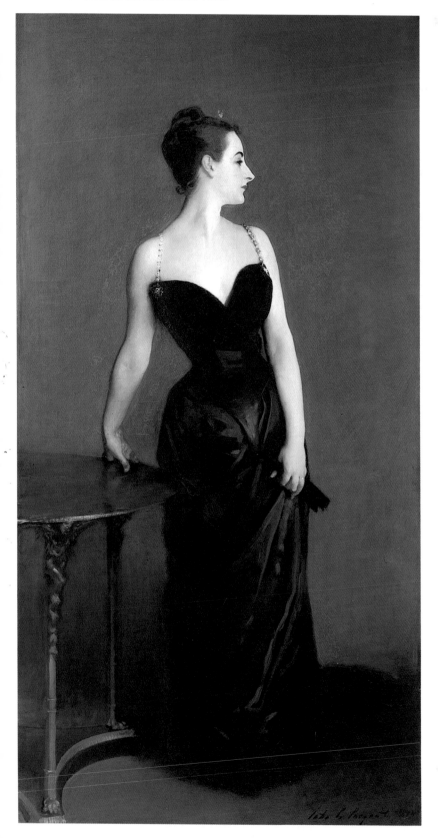

17 JOHN SINGER SARGENT, 1856–1925
Madame X (Madame Pierre Gautreau)
Oil on canvas; 82⅛ × 43¼ in. (208.6 × 109.9 cm)

Mme Gautreau, born Virginie Avegno in New
Orleans, married a French banker and became
one of Paris's notorious beauties during the
1880s. Sargent probably met her in 1881, and
impressed by her charm and theatrical use of
makeup, he determined to paint her. Work
began the following year but was attended by
delays and numerous reworkings of the canvas.
The picture was shown at the 1884 Paris Salon
with the title *Portrait de Mme. . . .* It was given a
scathing reception by reviewers critical of the
character of Mme Gautreau, the lavender color-
ing of her skin, and the impropriety of her
dress, with its revealing décolletage and slipped
strap that bared her right shoulder (this strap
was later painted over).

The portrait lacks the bravura brushwork of
many of Sargent's major paintings, partly be-
cause of the many reworkings, but the elegant
pose and outline of the figure, recalling his debt
to Velázquez, make it one of his most striking
canvases. When he sold it to the Museum in
1916, Sargent wrote, "I suppose it is the best
thing I have done." *Arthur Hoppock Hearn Fund,
1916, 16.53*

18 MARY CASSATT, 1844–1926
Lady at the Tea Table
Oil on canvas; 29 × 24 in. (73.7 × 61 cm)

Cassatt was the only American artist who be-
came an established member of the Impression-
ist group in Paris. In this painting of 1885 she
places the imposing figure in an ambiguous
setting where foreground and background—
virtually the same color—nearly merge. This
departure from traditional spatial relationships
shows Cassatt's debt to Degas and Manet and
her growing awareness of Japanese prints in
the early 1880s. The picture is enlivened by the
blue-and-gold Canton tea set and the fluid
brushwork of the delicate lace near the sen-
sitively portrayed face. In Cassatt's well-
constructed design, the sitter is framed in a se-
ries of rectangles, which increase in intensity as
they diminish in size. *Gift of Mary Cassatt, 1923,
23.101*

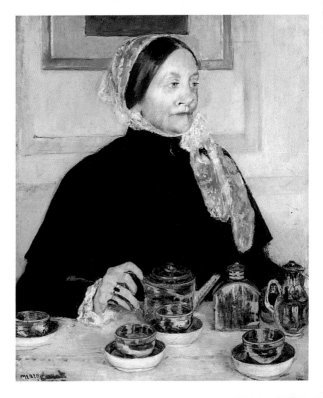

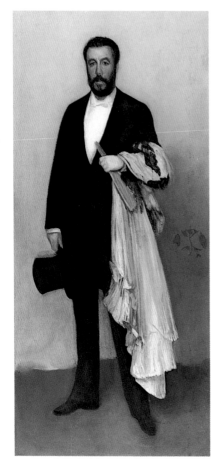

19 JAMES MCNEILL WHISTLER, 1834–1903
Arrangement in Flesh Colour and Black: Portrait of Théodore Duret
Oil on canvas; 76⅛ × 35¾ in. (193.4 × 90.8 cm)

This painting, of about 1883, demonstrates Whistler's use of portraiture as a vehicle for the investigation of formal problems of design and color. It also reflects his preoccupation with subtle color effects. Into a palette of white, gray, and black he introduced color only in the flesh, pink domino, and stylized butterfly (his signature). The dark, full-length figure on a neutral ground has precedents in the works of Velázquez and Manet. The reduction of content to the most essential and expressive forms, the subtle asymmetrical placement of the figure, the strong silhouette, and the monogram itself show Whistler's interest in Japanese art. These characteristics of his style made Whistler one of the most avant-garde and controversial painters of the nineteenth century. *Catharine Lorillard Wolfe Collection, Wolfe Fund, 1913, 13.20*

20 JOHN H. TWACHTMAN, 1853–1902
Arques-la-Bataille
Oil on canvas; 60 × 78⅞ in. (152.4 × 200.3 cm)

Twachtman was an influential member of the American Impressionist group known as "The Ten." This work, painted in Paris in 1885, pictures a river scene near Dieppe on the Normandy coast in a subtle orchestration of subdued colors. Its restricted palette (delicate grays, greens, and blues), thinly and broadly applied paint, subtle tonal transitions, and strong calligraphic motifs reflect the influences of French Impressionism, Japanese art, and Whistler's tonal studies. This work stands today as one of the masterpieces of nineteenth-century American painting. *Morris K. Jesup Fund, 1968, 68.52*

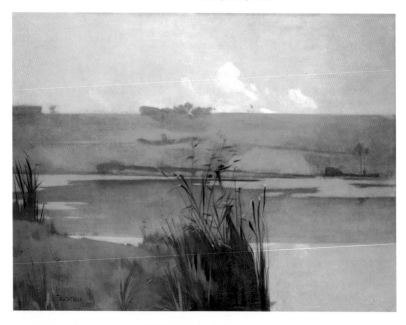

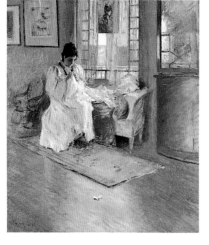

21 WILLIAM MERRITT CHASE, 1849–1916
For the Little One
Oil on canvas; 40 × 35¼ in. (101.6 × 89.5 cm)

This peaceful scene (ca. 1895) shows Chase's wife sewing in their Long Island home. Sunlight through the window caresses the folds of her white dress and pink blouse and enlivens wood surfaces. Ignoring detail, Chase revels in the fluidity of his pigments, in texture and contour. His composition, arranged on a diagonal, relegates the figure and furniture to the middle ground, leaving the foreground bare except for a white scrap. An American Impressionist, Chase executed many superb oils but few equal this one in intimacy, glowing light, and fresh composition. *Amelia B. Lazarus Fund, by exchange, 1917, 13.90*

WATERCOLORS

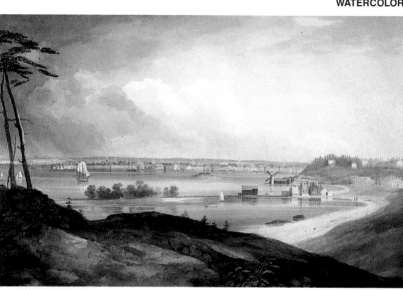

22 WILLIAM GUY WALL, 1792–after 1864
New York from Heights near Brooklyn
Watercolor with white on paper; 16 × 25½ in. (40.6 × 64.8 cm)

A native of Dublin, Wall arrived in the United States in 1818. During the 1820s the publication of a series of aquatints from twenty of his watercolors in the *Hudson River Portfolio* established his reputation and satisfied a growing demand for representations of American scenery. This work was published as an aquatint in 1823. It shows an old windmill once used by a distillery with Brooklyn Heights on the right and Manhattan in the distance. An eloquent example of Wall's skill as a water-colorist, this rare early-nineteenth-century view of the city demonstrates his keen sense of light, color, and descriptive detail. *The Edward W. C. Arnold Collection of New York Prints, Maps and Pictures. Bequest of Edward W. C. Arnold, 1954, 54.90.301*

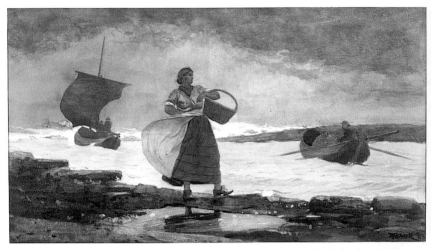

23 WINSLOW HOMER, 1836–1910
Inside the Bar

*Watercolor and pencil on paper; 15 3/8 × 28 1/2 in.
(39.1 × 72.4 cm)*

In 1881 and 1882 Homer spent several months in the English fishing village of Cullercoats rethinking his approach to watercolor. Already a leader in the American watercolor movement, he returned to surprise his New York contemporaries with a technique and content transformed by his exposure to modern British watercolor. Where previously he had studied novel American subjects in a personal and restrained manner, his English work showed a more conventional notion of the picturesque, delivered in a monumental and deliberate style. *Inside the Bar* (1883), one of the most powerful of his Cullercoats works, demonstrates the disciplined complexity of Homer's new technique and its heroic concept of the struggle between humans and their environment. *Gift of Louise Ryals Arkell, in memory of her husband, Bartlett Arkell, 1954, 54.183*

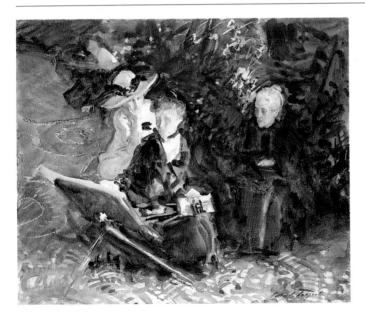

24 JOHN SINGER SARGENT, 1856–1925
In the Generalife

*Pencil and watercolor on paper; 14 3/4 × 17 7/8 in.
(37.5 × 45.4 cm)*

This scene (ca. 1912) depicts Sargent's sister, at the easel, and two companions in the gardens of the Generalife, the former residence of the sultans in Granada, Spain. Sargent vividly demonstrates the versatility of his medium in a technique ranging from transparent washes, with little articulation of form, to well-worked, heavily saturated areas in which vigorous brushstrokes create deep, rich shadows. He achieves brilliant highlights by exposing the white paper and enlivens fluid surfaces with chalky calligraphic lines. Sargent placed his figures in an oblique, close-up view, which seems to draw the spectator into the cool mysterious shadows. *Purchase, Joseph Pulitzer Bequest, 1915, 15.142.8*

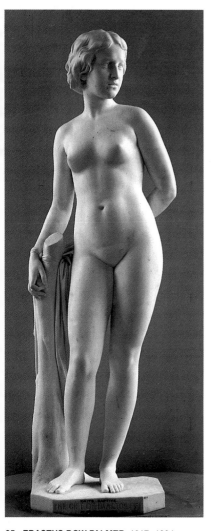

25 ERASTUS DOW PALMER, 1817–1904
The White Captive
Marble; h. 66 in. (167.6 cm)

The Neoclassical style dominated American
sculpture during the second quarter of the nine-
teenth century, and works in white marble were
especially popular because of the medium's as-
sociations with purity. Although the Neoclas-
sical spirit is evident in this graceful life-size
nude, this figure was probably inspired by tales
of the Indians' captives along the colonial fron-
tier. An upstate New Yorker, Palmer was self-
taught and, unlike most of his contemporaries,
did not go abroad to study. He worked directly
from live models; his model for *The White Cap-
tive* was a local girl "less than eighteen years
old." Completed in 1859, this work is Palmer's
first attempt at an undraped figure and one of
the finest nudes produced in the United States
during the nineteenth century. *Bequest of
Hamilton Fish, 1894, 94.9.3*

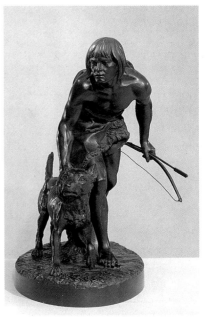

26 JOHN QUINCY ADAMS WARD, 1830–1910
The Indian Hunter
Bronze; h. 16 in. (40.6 cm)

Ward, one of the leading American sculptors of
the late nineteenth century, adopted a naturalis-
tic approach toward his subject matter. *The
Indian Hunter,* dated 1860, is a paradigm of this
realistic style. The sculptor has paid close atten-
tion to physiognomic accuracy of the man and
dog and to the textural detail of the bronze sur-
face. Encouraged by the statuette's success, a
few years later Ward made an enlarged version
of *The Indian Hunter,* the first sculpture to be in-
stalled in New York City's Central Park. *Morris K.
Jesup Fund, 1973, 1973.257*

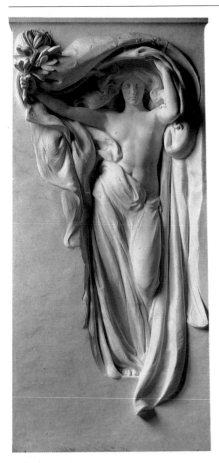

27 AUGUSTUS SAINT-GAUDENS, 1848–1907
Victory
Gilded bronze; h. 41¾ in. (106 cm)

One of the foremost nineteenth-century American sculptors, Saint-Gaudens was among the first generation of artists from the United States to study in Paris at the École des Beaux-Arts, the official French academy. This figure derives from his bronze equestrian statue of General William Tecumseh Sherman, which was placed at the southeast corner of Central Park in New York in 1903. With her right arm outstretched, she leads the mounted general forward. In her left hand she holds a laurel branch, the symbol of honor. This reduced Victory is a brilliant reminder of the Sherman monument, which is also gilded. *Rogers Fund, 1917, 17.90.1*

28 DANIEL CHESTER FRENCH, 1850–1931
The Melvin Memorial
Marble; h. 146 in. (345.4 cm)

French's finest funerary monument, *The Melvin Memorial* commemorates three brothers who died while serving in the Union army during the Civil War. The original marble of 1908 is located in Sleepy Hollow Cemetery, Concord, Massachusetts; the Museum's replica was made in 1915. French enjoyed a long and illustrious career. In 1874 he had executed the bronze *Minute Man,* also in Concord, which won him immediate fame; forty-eight years later he created the statue of Abraham Lincoln for that president's memorial in Washington, D.C.

The Melvin Memorial, also known as *Mourning Victory,* projects the duality of melancholy (the downcast eyes and somber expression) and triumph (the laurel held high). In this moving work French has captured the sense of calm after the storm of battle. *Gift of James C. Melvin, 1912, 15.75*

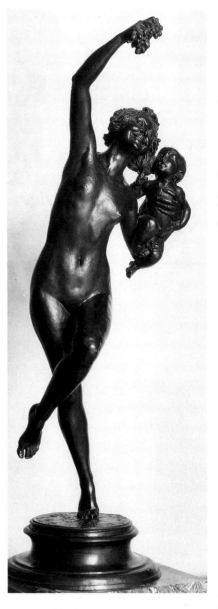

29 FREDERIC REMINGTON, 1861–1909
The Mountain Man
Bronze; h. 28 in. (71.1 cm)

The Mountain Man is one of four statuettes
purchased directly by the Museum from
Remington in 1907. It was described by the
artist as "one of these old Iriquois [*sic*] Trappers
who followed the Fur Companies in the Rocky
Mountains in the '30 and '40ties." Encumbered
with all his equipment—bear traps, ax, bedroll,
and rifle—the mountain man guides his horse
down a precariously steep path. Remington has
masterfully captured the breathless moment of
descent. *Rogers Fund, 1907, 07.79*

30 FREDERICK WILLIAM MACMONNIES,
1863–1937
Bacchante and Infant Faun
Bronze; h. 83 in. (210.8 cm)

The *Bacchante* of MacMonnies epitomizes the
jubilance of the Beaux-Arts style of sculpture.
Her spiraling form, joyous mouth, and richly tex-
tured surfaces create a most gleeful image.
MacMonnies gave the statue to the architect
Charles McKim, who placed it in the courtyard
of the Boston Public Library, designed by his
firm. After protests against the figure's "drunken
indecency," the sculpture was removed. McKim
then presented it to the Museum. *Gift of Charles
Follen McKim, 1897, 97.19*

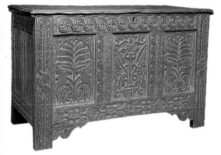

1 Chest
Ipswich, Massachusetts, 1660–80
*Red and white oak; 29 ¾ × 49 ⅛ × 21 ⅜ in.
(75.6 × 124.8 × 72.1 cm)*

The richest and most vigorous early colonial carving is that associated with the work of William Searle (1634–1667) and Thomas Dennis (d. 1706) of Ipswich. Paired leaves, with a naturalistic, three-dimensional quality rare in American furniture of the period, dominate the panels of this chest; the panels are carved in the popular seventeenth-century design of a stalk of flowers and leaves emerging from an urn, of which only the opening is indicated here. Varied geometric and plant forms appear on the stiles and rails. Searle and Dennis came from Devonshire, England, where a tradition of florid carving, using many of the motifs seen on this chest, flourished in the early seventeenth century. *Gift of Mrs. Russell Sage, 1909, 10.125.685*

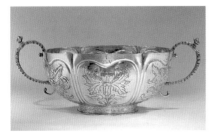

2 CORNELIUS KIERSTEDE, New York, 1675–1757
Two-Handled Bowl, ca. 1700–1710
Silver; h. 5 ⅜ in. (13.7 cm), diam. 10 in. (25.4 cm)

A uniquely New York form, this lavishly decorated six-lobed bowl attests to the skill of the city's early silversmiths and the luxurious taste of its prosperous burghers. It was made by Cornelius Kierstede, an outstanding early New York craftsman of Dutch descent. Following Dutch custom, the bowl was most likely filled with a drink of brandy and raisins and passed to guests, who helped themselves with silver spoons. It combines the horizontal shape, caryatid handles, stamped baseband, and naturalistic flowers of the late seventeenth century with the strong, repetitive Baroque rhythms and extravagant ornament of the William and Mary style. *Samuel D. Lee Fund, 1938, 38.63*

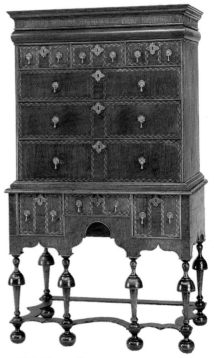

3 High Chest of Drawers
Probably New York, 1700–1730
*Walnut veneer, maple and cedar banding, maple, walnut; 65 × 37 ½ × 22 in.
(165.1 × 95.3 × 55.9 cm)*

The William and Mary style, introduced into the colonies in the 1690s, remained the ruling fashion until the 1730s. Among the new forms that became popular during this period was the high chest, which replaced the cupboard as the most important piece of case furniture in the household. The early-eighteenth-century high chest, raised up on six boldly turned legs, featured trim lines and large smooth surfaces decorated with figured veneers. Chests of known New York origin have a pulvinated drawer under the cornice and three drawers in the top tier, as seen in this example, rather than two. Also characteristic of New York workmanship is the prominent banding that visually divides each drawer into smaller units. *Gift of Mrs. J. Insley Blair, 1950, 50.228.2*

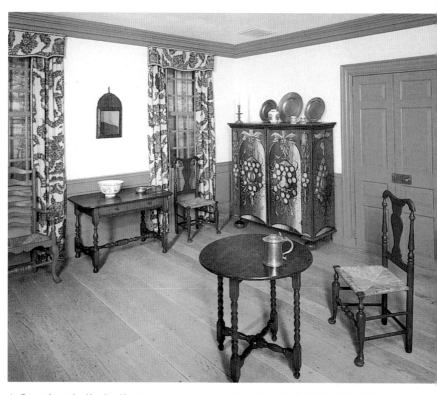

4 Room from the Hewlett House
Woodbury, New York, 1740–60
H. 9 ft. (2.78 m), l. 17½ ft. (5.33 m), w. 14 ft. (4.27 m)

The woodwork of this room, painted a bright blue based on traces of the original color, came from a Long Island farmhouse. The wall opposite the door is fully paneled and contains the fireplace and a shell-carved cupboard. In the mid-Atlantic colonies, where the furniture shown in this room was made, English styles mingled with those from other European countries during the seventeenth and early eighteenth centuries. The painted cupboard, or *kast,* in the corner, which was made about 1690–1720, came from the Hewlett family for whom the house was built. Cupboards of this form and with this distinctive grisaille decoration of heavy fruit and foliage are found exclusively in the areas of New York and New Jersey settled by the Dutch, who carried on a tradition of painting designs on furniture to simulate carving. *Gift of Mrs. Robert W. de Forest, 1910, 10.83*

5 Armchair
Philadelphia, 1740–50
Walnut; 41 × 32 × 18½ in. (135.1 × 81.3 × 47 cm)

The Queen Anne style, characterized by continuous flowing curves, became popular in the colonies during the second quarter of the eighteenth century. Boston, Newport, New York, and Philadelphia developed distinctive interpretations of this style, but its purest and most elegant renditions are in the seating furniture of Philadelphia. This stately Queen Anne armchair, made inviting by the broad, ample seat and the outsplayed arms with crisply scrolled armrests, is a symphony of curves. It perfectly exemplifies William Hogarth's famous description of the serpentine curve as the "line of beauty." *Rogers Fund, 1925, 25.115.36*

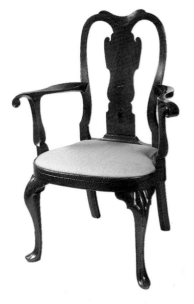

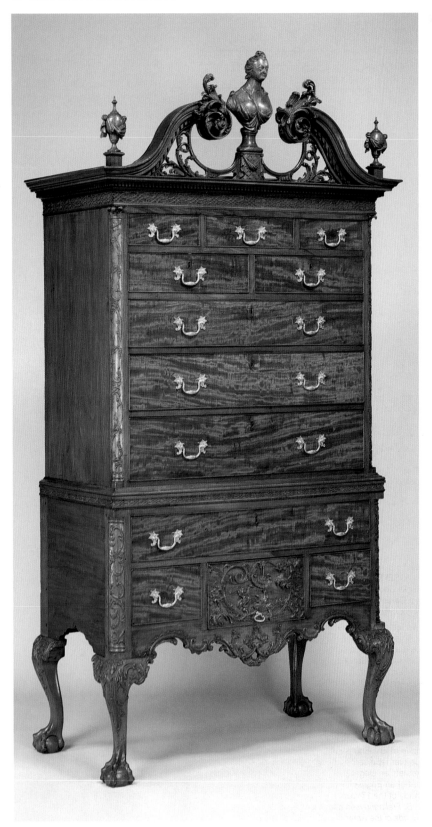

6 High Chest of Drawers
Philadelphia, 1762–90
Mahogany and mahogany veneer; 91¹/₂ × 46³/₄ ×
24¹/₄ in. (232.4 × 118.7 × 62.2 cm)

This high chest, an unsurpassed example of
the Philadelphia Chippendale style, is popularly
known as the "Pompadour," owing to the
fanciful idea that the finial bust represents Louis
XV's mistress Mme de Pompadour. Although the
basic form of double chest on high cabriole
legs is a distinctively American innovation, the
pediment and carving are drawn from English
pattern books. The representation on the large
bottom drawer of two swans and a serpent
spewing water is taken directly from Thomas
Johnson's *New Book of Ornament* (1762). The
entire top of the piece—the continuous cornice
with scroll pediment above—is adapted from a
secretary desk in Thomas Chippendale's
Gentleman and Cabinet Maker's Director (1782);
the urn finials flanking the pediment are
reduced versions of one on a bookcase also in
the *Director*. This chest of drawers is unequaled
among American pieces in its perfect
proportions and masterful execution. *John
Stewart Kennedy Fund, 1918, 18.110.4*

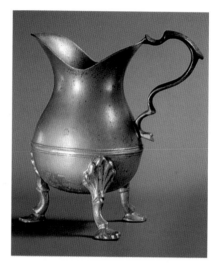

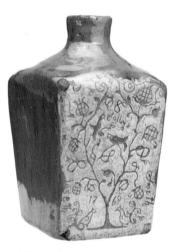

7 JOSEPH SMITH POTTERY, Wrightstown,
Bucks County, Pennsylvania
Tea Canister, ca. 1769
Earthenware; h. 7¹/₂ in. (19 cm)

This tea canister, one of the earliest examples
of American pottery known, is a departure from
the decorative red earthenware typical of
Pennsylvania-Germans. Although decorated in
the German sgrafitto manner, whereby a design
was scratched through the cream-colored slip,
or outer coating, to expose the red body
beneath, it reflects Joseph Smith's English
heritage in both its function and decorative
motifs. The tea canister, or caddy, was part of
the fashionable tea equipage, which was usually
made of fine English pottery or porcelain. This
canister represents an attempt by the potter to
emulate an elegant, high-style form, specifically
that of an English salt-glazed stoneware tea
caddy of the 1740s and 1750s. *Purchase, Peter
H. B. Frelinghuysen and Anonymous Gifts, and
Friends of the American Wing Fund, 1981,
1981.46*

8 PETER YOUNG, New York City or Albany,
New York, act. 1775–95
Creamer
Pewter; h. 4¹/₂ in. (11.4 cm)

This diminutive pewter pitcher, or creamer, has
a robustness of form and an elegance and
assurance of line that were seldom equaled in
larger vessels. It is stamped PY in a serrated
rectangle, the mark of Peter Young, one of the
most gifted of American pewterers.

Pewter, which was widely used for eating and
drinking utensils in colonial America, is about
90 percent tin with copper or bismuth added for
hardness. It was cast in brass molds and then
scraped by hand or skimmed on a lathe. Since
the molds were very costly, pewterers continued
to use them long after their shapes went out of
fashion. Thus it is not surprising that, in the last
quarter of the eighteenth century, Young was
producing these masterful creamers (half a
dozen are known) whose baluster shape and
cabriole legs with shell feet stylistically match
silver creamers made in the Baroque style in
the 1750s. *Purchase, Anonymous Gift, 1981,
1981.117*

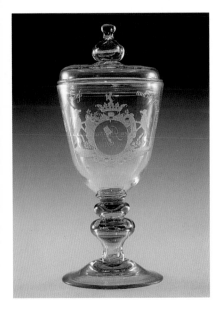

9 NEW BREMEN GLASS MANUFACTORY,
Frederick County, Maryland, 1784–95
Covered Goblet, 1788
Glass; h. with cover 11¼ in. (28.6 cm)

This goblet, or pokal, is dated 1788 and is engraved with the arms of Bremen, Germany. It was very likely presented by John Frederick Amelung (fl. 1784–95) to merchants in his native Germany who had invested in his glassworks at New Bremen, Maryland. Typical of Amelung's glass is the superb engraving, the inverted baluster stem, and the domed foot with plain rim. In style, the goblet looks back to the Baroque and Rococo rather than to the newly popular Neoclassical taste. *Rogers Fund, 1928, 28.52*

10 Room from the Williams House
Richmond, Virginia, 1810
H. 13 ft. (3.96 m), l. 19 ft. 10 in. (6.05 m), w. 19 ft. 6 in. (5.94 m)

This parlor is from the William C. Williams house in Richmond. The influence of the French Empire style is evident in the massive proportions of the doorways, the palmettes decorating their friezes, the simple but heavy moldings, and the inclusion of a paneled dado. Highly unusual, but in tune with this aesthetic, is the use of somber mahogany woodwork and of King of Prussia marble for the baseboard.

The woodwork is signed "Theo. Nash, Executor," presumably the joiner. The walls are covered with facsimiles of a colorful French scenic wallpaper—a popular embellishment of Federal American homes from New England to Virginia. Published in 1814 by the Dufour firm of Paris, this paper celebrates the monuments of Paris. The room displays furniture by the two most prominent New York cabinetmakers of the period, Duncan Phyfe (1768–1854) and Charles Honoré Lannuier (1779–1819). *Gift of Joe Kindig Jr., 1968, 68.137*

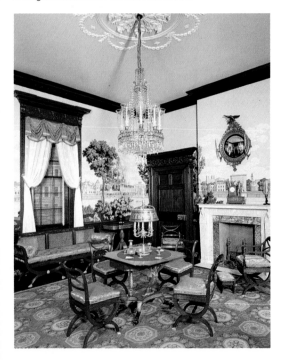

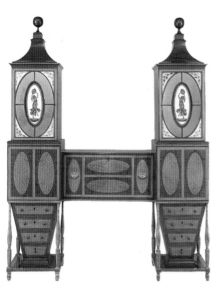

11 Desk and Bookcase
Baltimore, ca. 1811
Mahogany, satinwood, églomisé; *91 × 72 × 19⅛ in. (231.1 × 162.9 × 48.6 cm)*

The design of this large, elaborate, and colorful combination desk and bookcase was taken from a plate in Thomas Sheraton's *Cabinet Dictionary* (1803), where it is termed the "Sister's Cylinder Bookcase," but it has been artfully and originally reworked. The inlaid satinwood ovals and banding and, more conspicuously, the two flanking panels of glass with Neoclassical painted decorations are devices associated with Baltimore Federal furniture. A pencil inscription on the bottom of one drawer reads "M Oliver Married the 5 of October 1811 Baltimore." *Gift of Mrs. Russell Sage and various other donors, by exchange, 1969, 69.203*

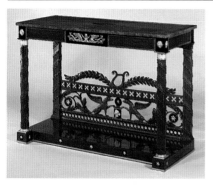

12 JOSEPH B. BARRY (act. 1794–d. 1838) AND SON, Philadelphia
Pier Table, 1810–15
Mahogany, satinwood, amboyna, gilt brass; 38⅝ × 54 × 23¾ in. (98.1 × 137.2 × 60.3 cm)

The pier table was made for the Philadelphia merchant Louis Clapier by one of Philadelphia's greatest Federal period cabinetmakers, Joseph B. Barry and Son. The total design of this extraordinarily rich table is a unique American interpretation of classical taste that demonstrates the cabinetmaker's training in the English Neoclassical mode and the distinct influence of the French Empire style. The carved and pierced griffin panel is based on Thomas Sheraton's "Ornament for a Frieze or Tablet," from his *Drawing-Book* (1793). *Purchase, Friends of the American Wing Fund, Anonymous Gift, George M. Kaufman Gift, Sansbury-Mills Fund; Gifts of the Members of the Committee of the Bertha King Benkard Memorial Fund, Mrs. Russell Sage, Mrs. Frederick Wildman, F. Ethel Wickham, Edgar William and Bernice Chrysler Garbisch and Mrs. F. M. Townsend, by exchange; and John Stewart Kennedy Fund and Bequests of Martha S. Tiedeman and W. Gedney Beatty, by exchange, 1976*

13 FLETCHER & GARDINER, Philadelphia, 1808–ca. 1827
Presentation Vase, 1824
Silver; 23½ × 20½ in. (59.7 × 52.1 cm)

Thomas Fletcher and Sidney Gardiner, who produced this magnificent vase, were the foremost designers and makers of the large presentation pieces that became an important form in late Federal silver. This vase is one of a pair presented in 1825 to DeWitt Clinton, the governor of New York, by a group of New York City merchants for his role in the building of the Erie Canal. The shape of the vessel and the vine handles which continue into a grape border are based directly on a classical model; the decoration combines American motifs such as the eagle finial with ornament derived from antique sources. On the front, Mercury (commerce) and Ceres (agriculture) flank a view of the canal at Albany; another canal scene appears on the back of the vase. *Purchase, Louis V. Bell and Rogers Funds; Anonymous and Robert G. Goelet Gifts; and Gifts of Fenton L. B. Brown and of the grandchildren of Mrs. Ranson Spaford Hooker, in her memory, by exchange, 1982, 1982.4*

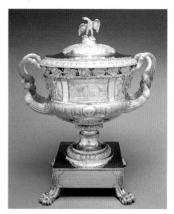

14 THE AMERICAN CHAIR COMPANY, Troy,
New York, 1829–58
Centripetal Spring Chair, ca. 1849
*Cast iron, wood, upholstery; 31⅛ × 17¾ in.
(79.1 × 45.1 cm)*

Innovations in design, materials, and function,
all characteristics of nineteenth-century furni-
ture, are nowhere better illustrated than in this
cast-iron and upholstered centripetal spring
chair. The prototype of twentieth-century desk
chairs that revolve and tilt to facilitate movement
and give maximum comfort, it was manu-
factured after the designs of Thomas Warren,
who first patented its central spring in 1849.
Gift of Elinor Merrell, 1977, 1977.255

15 Tête-à-tête
New York, 1850s
*Rosewood; 44½ × 52 × 43 in.
(101.3 × 132.1 × 109.2 cm)*

The Victorian love of innovation resulted in a
number of new furniture forms, among them
the tête-à-tête, or love seat. This Rococo Revival
example in laminated rosewood was made in
New York, possibly in the factory of John Henry
Belter (1804–1863). Bold S- and C-scrolls
outline the backs and form the seat rail and
cabriole legs; the decoration is carved flowers,
leaves, vines, acorns, and grapes. The sinuous
shape illustrates the importance of lamination
and bending. This piece has eight layers; the
wood was pressed in steam molds to achieve its
curves. *Gift of Mrs. Charles Reginald Leonard, in
memory of Edgar Welch Leonard, Robert Jarvis
Leonard, and Charles Reginald Leonard, 1957,
57.130.7*

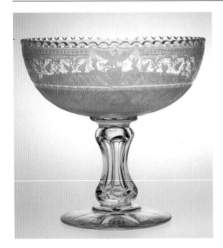

16 GREENPOINT FLINT GLASS WORKS,
Brooklyn, New York, 1852–63
Compote, ca. 1861
Glass; h. 7½ in. (19.1 cm)

This elegantly designed compote shows the
restraint and predilection for engraving and
shallow cutting typical of fine glassware of the
1860s. It bears the United States coat of arms
in the center of an engraved border of leaves,
scrolls, and flowers. The compote was part of
the state service ordered by President and Mrs.
Lincoln for the White House from Christian
Dorflinger (1828–1915), the French émigré who
established his first Brooklyn glass factory in
1852. *Gift of Kathryn Hait Dorflinger Manchee,
1972, 1972.232.1*

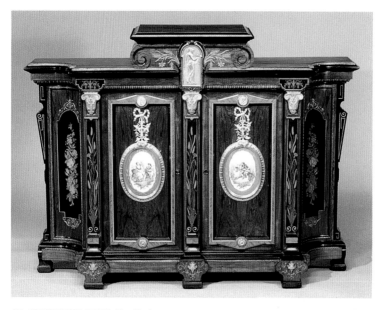

17 ALEXANDER ROUX, New York,
ca. 1813–1886
Cabinet, ca. 1866
*Rosewood, tulipwood, ebonized cherry, poplar,
porcelain, gilt bronze; 53 ³/₈ × 73 ³/₈ × 18 ³/₈ in.
(135.6 × 186.4 × 46.7 cm)*

The Renaissance Revival of the mid-1860s was
often characterized by the eclectic combination
of historical styles. In this cabinet, labeled by
the maker, Louis XVI ornament has been joined
to a form derived from the Italian Renaissance

credenza. In the Louis XVI manner are the or-
molu moldings and mounts, metal plaque with
a classical figure, painted porcelain plaques
on the doors, and marquetry. The form is typi-
cal of New York cabinetmakers in the 1860s,
as are the use of contrasting woods for color-
istic effect and incised and gilded decoration.
*Purchase, The Edgar J. Kaufmann Foundation
Gift, 1968, 68.100.1*

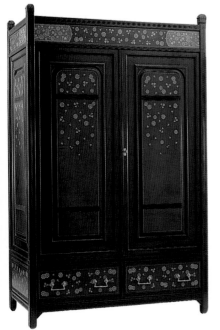

18 HERTER BROTHERS, New York
Wardrobe, ca. 1880
*Cherry, ebonized with marquetry veneers;
78¹/₂ × 49¹/₂ × 26 in. (199.4 × 125.7 × 66 cm)*

Herter Brothers was one of the most influential
New York interior decorators and furniture-
makers in the second half of the nineteenth
century. Although trained on the Continent,
Christian Herter was influenced by English re-
formers such as E. W. Godwin, who rebelled
against exuberant historical-revival styles and
advocated designs that featured rectilinear
shapes and flat surface decoration. This ward-
robe is deceptively simple in its straight lines
and sparse ornament but is actually a studied
composition. The seemingly asymmetrical,
Japanesque marquetry pattern animates the
static form. The thoughtful relating of ornament
to structure, with emphasis on blank space,
shows the new vision of reform—or "art"—
furniture, of which this is one of the finest ex-
amples in the Anglo-Japanese taste. *Gift of
Kenneth O. Smith, 1969, 69.140*

19 GORHAM MANUFACTURING COMPANY,
Providence, Rhode Island, 1865–1961
Ewer with Plateau, 1900–1904
*Silver; h. with plateau 21½ in. (54.6 cm),
diam. of plateau 17⅛ in. (43.5 cm)*

Martelé was a term applied to a line of art silver
introduced by Gorham and considered the
finest expression of the Art Nouveau style in
the United States. This ewer is a particularly
successful example of Martelé silver, hand-
hammered into undulating forms and decorated
with swirling repoussé waves, plants, and
female figures. *Gift of Mr. and Mrs. Hugh J.
Grant, 1974, 1974.214.26a,b*

20 LOUIS COMFORT TIFFANY, New York,
1848–1933
Favrile Glass Bottle and Vases, 1893–1910
*Blown glass; h. (left to right) 2⅞ in. (7.3 cm),
15½ in. (39.4 cm), 18¾ in. (47.6 cm), 4⅛ in.
(10.5 cm)*

Louis Comfort Tiffany, America's leading de-
signer in the Art Nouveau style, gained interna-
tional renown for his work in glass. The son of
Charles L. Tiffany, founder of the well-known
New York silver store, he studied landscape
painting and then pursued a career in the dec-
orative arts. In 1893, after working with stained
glass for almost fifteen years, Tiffany began to
experiment with free-blown glass at his Corona,
New York, furnaces. Rejecting mechanical pro-
duction in favor of quality handcrafting, he
named his pieces "Favrile," a variant of the Old
English *fabrile* (of the craftsman). Natural forms
predominate in Favrile glass—willowy flower-
form vases, leafy designs embedded in glass,
peacock feathers captured in gleaming color.
Also noteworthy is the iridescent surface, which
imitates that found on long-buried ancient
glass. *Gift of H. O. Havemeyer, 1896, 96.17.46;
Gift of Louis Comfort Tiffany Foundation, 1951,
51.121.17; Anonymous Gift, 1955, 55.213.11,27*

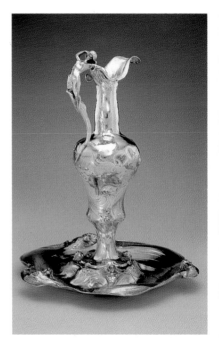

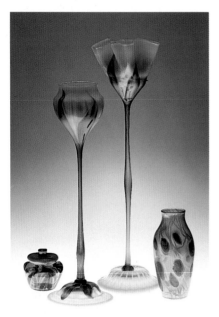

21 GRUEBY FAIENCE COMPANY, Boston, ▶
1894–1911
Vase, 1899–1910
*Earthenware; h. 11 in. (27.9 cm), diam. 6 in.
(15.2 cm)*

Art pottery (a term that loosely refers to ceram-
ics made with aesthetic intent and respect for
the handcrafted object) was produced from
about 1875 to the 1920s by commercial enter-
prises throughout the United States. Much of
the Grueby Company's art pottery seems to
have been influenced by Egyptian forms, and
this yellow vase, with its small scrolls and flat
leaves, is typical in that respect. Typical too is
the matte glaze, which William Grueby (1867–
1925) developed in the late 1890s. *Purchase,
The Edgar J. Kaufmann Foundation Gift, 1969,
69.91.2*

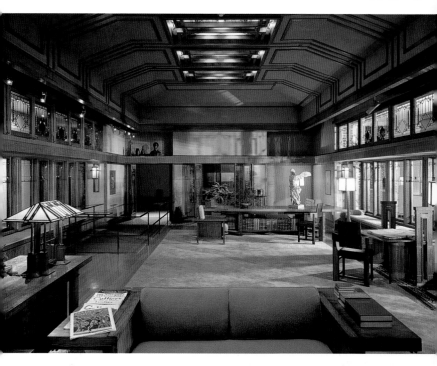

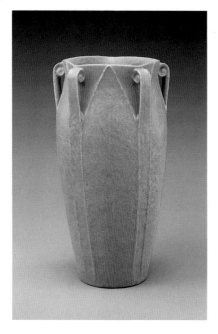

22 FRANK LLOYD WRIGHT, 1867–1959
Living Room from the Little House, Wayzata, Minnesota, 1912–14
H. 13 ft. 8 in. (4.17 m), l. 46 ft. (14 m), w. 28 ft. (8.53 m)

The living room of the Little house is an extension of Wright's earlier Prairie Style houses, where he first developed his concept of total design for his interiors. Characteristically, the room has a strong architectural quality in its finishes and furnishings. Harmony is achieved in the combination of the ocher plaster walls, the natural oak flooring and trim, the reddish-brown bricks of the fireplace (a repetition of the exterior brickwork), and the electroplated copper finish of the leaded windows. The bold forms of the oak furniture were conceived as an integral part of the composition, and the arrangement of the furniture reflects Wright's architectural ideals. The center of the room is empty with furniture at the perimeter, essentially an "open plan." Many of the accessories are original to the room, and others recall objects that appear in period photographs. The use of Japanese prints and natural flower arrangements are characteristic Wright touches. *Purchase, Emily Crane Chadbourne Bequest, 1972, 1972.60.1*

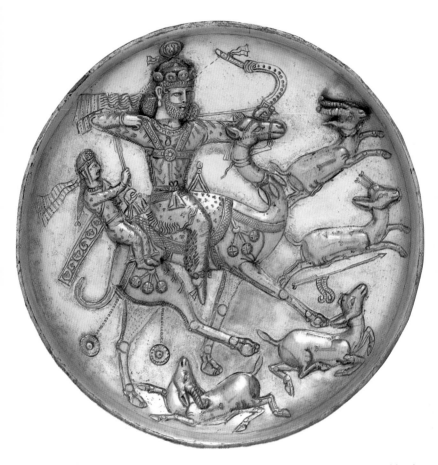

Plate with a Hunting Scene
Allegedly from Iran (Sasanian period), 5th or 6th
century A.D.
Silver-gilt; diam. 7⅞ in. (20.1 cm)

The great Iranian epic, the Shāhnāma, or Book
of Kings, as recorded by Firdausī in the late
tenth to early eleventh century, includes a tale
about the Sasanian king Bahram V (r. 420–38).
It is said that when he was crown prince, Bahram
"Gur" (Wild Ass) went hunting accompanied by
his favorite lyre player, a woman named Azada.
Challenged by the woman, he shot an arrow that
removed the horns of a male gazelle, transform-
ing it in appearance into a female, and shot two
arrows into the head of a female gazelle, giving
it the appearance of a male.

Beautifully executed in a complex but char-
acteristic Sasanian technique, the silver plate is
a unique illustration of a theme from epic litera-
ture. *Purchase, Lila Acheson Wallace Gift, 1994,
1994.402*

ANCIENT NEAR EASTERN ART

This department, formed in 1956, covers both a lengthy chronological span and a vast geographical area. The works of art in the collection range in date from the sixth millennium B.C. to the time of the Arab conquest in A.D. 626, almost seven thousand years later. They were created in ancient Mesopotamia, Iran, Syria, Anatolia, and other lands in the region that extends from the Caucasus in the north to the Gulf of Aden in the south and from the westernmost borders of Turkey to the Indus River in central Pakistan.

The department's collection has been acquired by gift, notably the 228 cylinder and stamp seals recently given by Nanette Kelekian; by participation in excavations in the Near East; and by an innovative program of long-term loans. Its strengths include Sumerian stone sculptures, Anatolian ivories, Iranian bronzes, and Achaemenian and Sasanian works in silver and in gold. An extraordinary group of Assyrian reliefs and statues from the palace of Ashurnasirpal II (r. 883–859 B.C.) at Nimrud can be seen in the Raymond and Beverly Sackler Gallery for Assyrian Art. A new installation in 1999 opened a skylight above the Sackler Gallery, allowing the reliefs to be seen in natural light.

IRAN, INDUS, BACTRIA

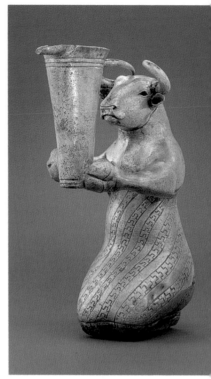

1 Jar
Iranian, ca. 3500 B.C.
Terracotta; h. 20⅞ in. (53 cm), diam. 19⅛ in. (48.6 cm)
This ovoid vessel is a masterpiece of the art of early pottery. On the upper two-thirds of the vessel three ibexes, painted dark brown, appear against a buff background. Each ibex is placed in the center of a large panel and is shown in silhouette facing right. The panels are bordered at the top and bottom by several thin bands and at the sides by zones of neatly drawn vertical zigzags framed within thick vertical bands.
Purchase, Joseph Pulitzer Bequest, 1959, 59.52

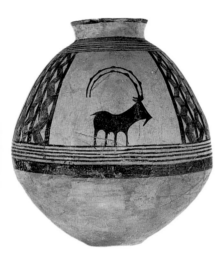

2 Bull Holding a Vase
Proto-Elamite, ca. 2900 B.C.
Silver; h. 6⅜ in. (16.2 cm)
This figurine of a kneeling bull is magnificently sculpted in silver. It is clothed as a human, in a textile decorated with a stepped pattern, and holds a tall, spouted vessel in its outstretched hooves in the posture of a supplicant. We know nothing of the religious rituals of Iran from the beginning of the third millennium B.C. Contemporary Proto-Elamite cylinder seals do, however, show animals in human posture that may be engaged in some kind of ritual activity.
Purchase, Joseph Pulitzer Bequest, 1966, 66.173

3 Recumbent Mouflon
Mature Harappan(?), second half of 3rd millennium B.C.
Marble; l. 11 in. (28 cm)
This powerful sculpture represents a mouflon, a wild sheep native to the highland regions of the Near East. The entire body is contained within a single unbroken outline. The horns, ears and tail, and muscles were clearly modeled in relief, although time and secondary use have somewhat softened the contours. Incised lines define the eye and brow and mark the horizontal striations on the horns. This combination of a closed outline with broadly modeled masses and a minimum of incised detail is characteristic of animal sculptures from Harappan-period levels at the site of Mohenjo Daro in the lower reaches of the Indus River. The function of animal sculptures such as this is unknown, but findspots of excavated examples suggest that

they were primarily religious objects. It is likely that such images were deposited in sacred places as offerings to ensure an abundance of wild game. *Purchase, Anonymous Gift and Rogers Fund, 1978, 1978.58*

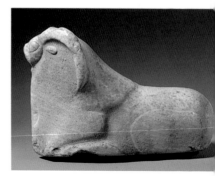

4 Head of a Dignitary
Iranian(?), ca. 2000 B.C.
Arsenical copper; h. 13½ in. (34.3 cm)

This magnificent copper head is reminiscent of the head of an Akkadian ruler found at Nineveh in northern Mesopotamia. Hollow cast, a dowel on the plate at the base of the neck presumably served to join the head to the body. The heavy-lidded eyes, the prominent but unexaggerated nose, the full lips, and enlarged ears all suggest that this is a naturalistic portrait of a real person, a rare phenomenon in the art of the ancient Near East. Its costly material and impressive workmanship, size, and appearance are all indications that this is a representation of a ruler whose identity remains unknown. The head is one of the great works of art preserved from the ancient Near East. *Rogers Fund, 1947, 47.100.80*

5 Cup with Four Gazelles
Iranian, ca. 1000 B.C.
Gold; h. 2½ in. (6.4 cm)

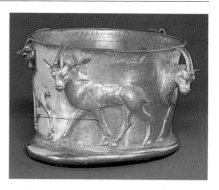

The tradition of making vessels decorated with animals whose heads project in relief has a long history in the Near East, and a number of cups similar to this one have been excavated in Iran at Marlik in the north and Susa in the southwest. On this cup, which is probably from the southwest Caspian region, four gazelles framed by guilloche bands walk to the left. Their bodies are in repoussé with finely chased details; the heads are in the round and were added separately by skillful working of the metal. The horns and ears were added to the heads. The base of the cup is decorated with a chased pattern of seven overlapping six-petaled rosettes against a dotted background. *Rogers Fund, 1962, 62.84*

6 Plaque with Fantastic Creatures

Iranian, ca. 700 B.C.
Gold; 8⅜ × 10⅜ in. (21.3 × 27 cm)

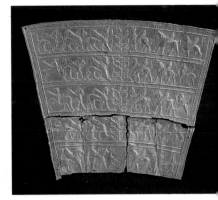

This gold plaque was part of a treasure alleg-
edly found in 1947 at Ziwiyeh, in northwestern
Iran, the site of a first-millennium hill-fortress. At
the time of its discovery, this plaque was cut
into three parts. It is thin metal and now con-
sists of five registers (the lowest, sixth register is
missing) decorated in repoussé and chasing
with fantastic winged beasts—griffins, lions with
horns and scorpion tails, human-headed bulls—
striding from left and right toward a sacred tree
in the center. Between each register and around
the plaque's edges are beautifully executed
guilloche patterns. This plaque was perhaps
sewn on the garment of a wealthy lord.
Although it was undoubtedly made in Iran, its
style shows the influence of both the Assyrians
and the Urarteans, who vied for the domination
of northern Iran during the first part of the first
millennium B.C. *Rogers Fund, 1962, 62.78.1*

7 Vessel Ending in the Forepart of a Lion

Achaemenian, ca. 6th–5th c. B.C.
*Gold; h. 7 in. (17.8 cm), diam. of rim 5⅜ in.
(13.7 cm)*

Horn-shaped vessels or cups, terminating in an
animal's head, have a long history in Iran and
the Near East as well as in Greece and Italy. In
the early first millennium B.C., this type of vessel
occurs at Hasanlu in northwestern Iran. These
early Iranian examples are straight, having the
cup and animal head made in the same plane.
Later, in the Achaemenian period, the head or
animal protome was often placed at a right
angle to the cup, as on this example. The vessel
illustrated here was made of a number of
pieces; the cup and the lion's body and its legs
were made separately and then joined. The
animal's tongue, some of its teeth, and the roof
of its mouth, which is finely ribbed, were
decorative additions. *Fletcher Fund, 1954, 54.3.3*

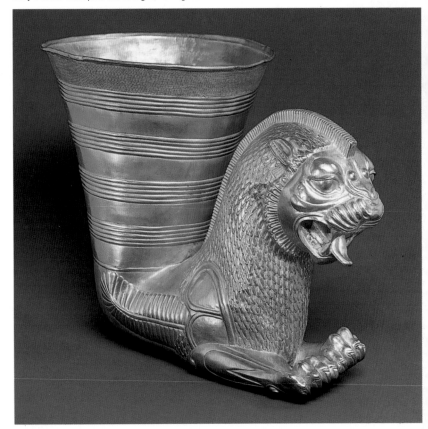

8 Head of a Horned Animal

Achaemenian, 6th–5th c. B.C.

Bronze; h. 13⅜ in. (34 cm), w. at horns about 9 in. (23 cm)

The stylization of all forms, human, plant, and animal, is a striking characteristic of the art of the ancient Near East, typified by this head. The patterns for the eyes, brows, horns, beard, and curls are those used again and again by artists of the Achaemenian period. The massive size and weight of this head suggest that it was used to decorate a throne or some part of a royal building. The head was cast in a number of parts, which were joined by fusion welding. This piece is an eloquent example of Iranian art of the Achaemenian period, still untouched by the influence of classical Greece. *Fletcher Fund, 1956, 56.45*

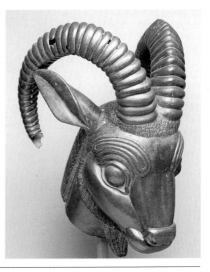

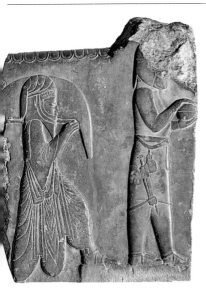

9 Servants Bearing a Wineskin and a Covered Bowl

Achaemenian, Persepolis, 4th c. B.C.

Limestone; 34 × 25½ in. (86.4 × 64.8 cm)

Achaemenian art and architecture are best exemplified by the vast ruins of Persepolis, the ceremonial capital of the empire under Darius I and his successors. (These ruins lie thirty miles from Shiraz in southwest Iran.) Column capitals were decorated with the foreparts of bulls, lions, and griffins carved in the round. The most characteristic Achaemenian sculptures, however, are stone reliefs such as this fragment from a staircase at Persepolis. The sculptures are essentially symbolic; while detail is exquisitely rendered, the forms and composition tend to be formal and abstract. *Harris Brisbane Dick Fund, 1934, 34.158*

10 Plate with a King Hunting Antelopes

Sasanian, ca. 5th c. A.D.

Silver, niello, mercury gilding; h. 1⅝ in. (4.1 cm), diam. 8⅝ in. (21.9 cm)

On this silver plate, alleged to have come from Qazvin in northwestern Iran, a king mounted on horseback is depicted as an archer. The animals are shown in two pairs: one pair alive and running before the king; the other pair dead beneath the horse's hooves. Similar hunting scenes appear on a large number of Sasanian silver vessels. The raised design, which is covered with mercury gilding, consists of a number of separate pieces fitted into lips which have been cut up from the background of the plate. It is impossible to identify the king precisely, but judging from comparisons with the coins of the period, he is either Peroz or Kavad I, both of whom ruled Iran in the second half of the fifth century A.D. This plate is superior in style—notably in the naturalism of the forms and in the delicate modeling of the bodies—to most Sasanian silver objects. *Fletcher Fund, 1934, 34.33*

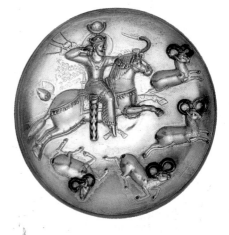

11 Head of a King
Sasanian, late 4th c. A.D.
Silver; h. 15⅛ in. (38.4 cm)

The prestige of the Sasanian dynasty, which ruled over northwestern Iran from the third to the mid-seventh century, was so great that its art was widely imitated in the East and the West. Silver-gilt plates and vases decorated with hunting, ritual, and banquet scenes are among the best-known Sasanian works of art (nos. 10 and 13). Magnificent weapons also exist, with handles and scabbards of gold and silver and blades of iron (no. 12).

This powerful head, which may depict the Sasanian king Shapur II (310–379), is raised from a single piece of silver with details chased and in repoussé. A true sculpture in silver, it demonstrates the technical proficiency and aesthetic eloquence of Sasanian metalworkers. *Fletcher Fund, 1965, 65.126*

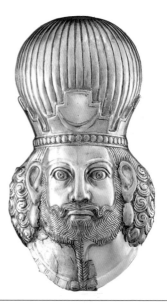

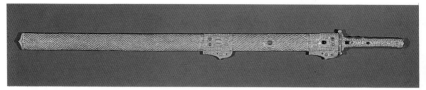

12 Sword
Iranian, 6th–7th c. A.D.
Iron and gold; l. 39½ in. (100.3 cm)

This splendid iron sword with gold-covered scabbard and hilt, dating from the sixth or seventh century A.D., is an excellent example of the swords used by the Hunnish nomads who roamed Europe and Asia at that time. It is a type adopted by the Sasanians from these nomads shortly before the beginning of the Islamic era. The sword has a long pommelless grip with two finger rests and a very short quillon bar; its scabbard has a pair of large cufflike mounts with irregularly P-shaped flanges, which are fixtures for the two straps—a short one and a long one—that held the sword suspended from the waist belt. The different lengths of the straps caused the sword to hang at a convenient "quick draw" angle. This way of carrying a sword was particularly practical for a horseman. The gold on the scabbard replaced leather, which was normally used for the sheath. Several other swords of this type are known—some mounted in gold, some in silver. Stylistically and technically, they are all very similar, although the Museum's sword is by far the most elaborate of the group. *Rogers Fund, 1965, 65.28*

13 Ewer
Sasanian, ca. 6th c. A.D.
Silver and mercury gilding; h. 13⅜ in. (34.1 cm)

Late Sasanian silver vessels, particularly bottles and ewers, were often decorated with female figures. Although they suggest the Dionysiac representations of the Roman West, these scenes may relate to the cult of an Iranian deity, perhaps the goddess Anahita, or to Iranian festivals. Sasanian artists frequently used Greco-Roman designs as models for the works of art they created. Here birds peck at fruit and a small panther drinks from a ewer; framed by arcades, the female figures, like maenads, are in a dancing pose and hold branches and flowers. Few ewer lids have survived; this one is decorated with a female figure holding a branch and a bird. The handle terminates at both ends in onager heads. Made in separate parts, this vessel is close in shape to late Roman and Byzantine ewers. *Purchase, Mr. and Mrs. Douglas Dillon Gift and Rogers Fund, 1967, 67.10ab*

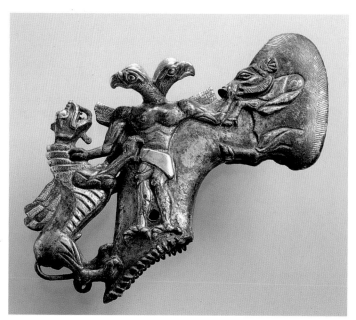

14 Ax with Winged Demon, Double Bird-Headed Figure, and Boar
Northern Afghanistan, late 3rd–early 2nd millennium B.C.
Silver with gold foil; l. 6 in. (15 cm)

This silver-gilt ax is a masterpiece of three-dimensional and relief sculpture. Expertly cast in silver and gilded with gold foil, it shows a lively struggle between a superhuman hero (the double bird-headed creature at center) and infernal forces represented by a winged demon at left and a boar at right. At the far right is the ax's splayed blade, and at the bottom is a shaft hole for a wooden handle or staff. Its shape, as well as the stylistic and iconographic elements of the figures, identifies the ax as a product of the Bronze Age culture of ancient Bactria (northern Afghanistan and southern Turkmenistan). During the late third and early second millennia B.C., a prosperous urban culture flourished in this region and engaged in a lively trade of luxury and utilitarian goods with the civilizations of Iran, Mesopotamia, and Asia Minor.
Purchase, Harris Brisbane Dick Fund, James N. Spear and Schimmel Foundation, Inc. Gifts, 1982, 1982.5

MESOPOTAMIA

15 Standing Male Figure
Sumerian, Tell Asmar, ca. 2750–2600 B.C.
White gypsum; h. 11⅜ in. (28.9 cm)

This male figure, which is from the Square Temple at Tell Asmar, illustrates the abstract geometric style of some Sumerian sculpture of the Early Dynastic period. The large head has a dominant triangular nose and prominent eyes made of shell set in bitumen; the one pupil that is preserved is cut from black limestone. Traces of the bitumen that once heavily colored the long hair, mustache, and beard are still to be seen, recalling that the Sumerians referred to themselves as the "black-headed people." In characteristic Sumerian style, the bare-chested male figure is clad in a long skirt. For all its abstraction, or perhaps even because of it, the statuette seems to exude life and power.
Fletcher Fund, 1940, 40.156

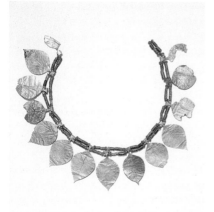

17 Ibex on Stand

Sumerian, ca. 2600 B.C.
Arsenical copper; h. 15⅝ in. (39.7 cm)

During the Early Dynastic period (2900–2370 B.C.), the Sumerian civilization developed in southern Mesopotamia. Government was based on the city-state unit. Each city had a patron deity, although many other gods were also worshiped; the life of the city was organized around the temple of the patron deity and the palace of the king.

The upper part of this stand, with its four rings, may have been used to support offering bowls. The lower stand, to which the ibex is fastened by tenons, is similar in form to others found in excavations in the region of the Diyala River. *Rogers Fund, 1974, 1974.190*

16 Chaplet of Gold Leaves

Sumerian, ca. 2600–2500 B.C.
Gold, lapis lazuli, carnelian; l. 15⅛ in. (38.4 cm)

This chaplet is part of an important collection of Sumerian jewelry found in the royal tombs of the Early Dynastic period at the site of Ur, excavated in 1927–28. It came from one of the graves of Queen Pu-abi's handmaidens, who were interred at the same time as the queen. This wreath of gold beech leaves, suspended from strings of little lapis and carnelian beads, encircled the crown of the head. *Dodge Fund, 1933, 33.35.3*

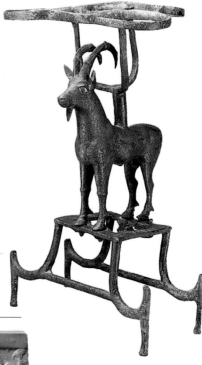

seal

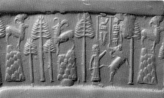

impression

18 Cylinder Seal

Mesopotamian, late Akkadian period, 2250–2154 B.C.
Green serpentine; h. 1⅛ in. (2.8 cm), diam. ¾ in. (1.8 cm)

The scene engraved around the edge of this seal shows a spear-bearing hunter grasping a rampant mountain goat by the horn. This lively hunt scene is set in a mountain landscape in which two similar goats are shown, each perched on a towering peak surrounded by high-topped conifers. Above the scene of capture is a two-line Akkadian inscription in cuneiform, which identifies the owner of this seal as "Balu-ilu, cup bearer."

During the Akkadian period (2334–2154 B.C.) the iconographic repertory of the seal engraver expanded to include a variety of mythological and narrative scenes that were unknown in earlier periods. The artist also rendered images in a realistic style that occasionally includes specific details of landscape, a rare feature in the Near East. *Bequest of W. Gedney Beatty, 1941, 41.160.192*

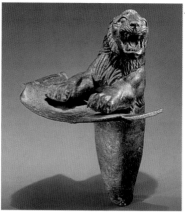

19 Foundation Figure
Northern Mesopotamian, reportedly Urkish,
ca. 2200 B.C.
Bronze; h. 4⅝ in. (11.7 cm)

From the northern reaches of the Akkadian
empire comes this bronze foundation figure in
the form of a snarling lion; its forelegs are
outstretched to hold an inscribed tablet (now
missing). Although attributed to the Hurrians, a
people whose role in third-millennium Mesopo-
tamia is still obscure, this piece parallels the art
of Akkad in its stirring realism. *Purchase,
Joseph Pulitzer Bequest, 1948, 48.180*

20 Seated Gudea
Neo-Sumerian, ca. 2100 B.C.
Diorite; h. 17⅜ in. (44.1 cm)

In the late third millennium B.C., under the leader-
ship of the kings of Lagash and the rulers of the
Third Dynasty of Ur, Sumerian culture experi-
enced a renaissance that matched
a revival of Sumerian political power.
During this period, while Gudea and
his son Ur-Ningirsu (no. 21) were
governors of the city-state of Lagash,
many fine works of art were pro-
duced, among them this statue of
Gudea.

This is the only complete statue
of Gudea in the United States, and
it is almost identical to another
now in the Louvre. The Museum's
figure is broken; the perfect join
between the head and body, how-
ever, leaves no doubt that they be-
long together. Gudea sits on a low
chair in a formal attitude of con-
scious piety, conveyed by the steady
forward gaze of the eyes, the tightly
clasped hands with their very long
fingers, the precisely rendered feet,
and the neatly draped garment. Like
most Gudea statues, it has a cunei-
form inscription that names the statue:
"It is of Gudea, the man who built
the temple: may it make his life long."
*Harris Brisbane Dick Fund, 1959,
59.2*

21 Ur-Ningirsu, Son of Gudea

Neo-Sumerian, ca. 2100 B.C.
Chlorite; h. of head 4½ in. (11.4 cm), h. of body 18½ in. (46 cm)

This statue of Ur-Ningirsu, son of Gudea (no. 20), shows the competence of the Neo-Sumerian sculptor. Although this is not a monumental work, it has a sense of great dignity. The scene on the base shows tribute being borne to the ruler by figures wearing distinctive plumed headdresses. The head of Ur-Ningirsu belongs to the Metropolitan Museum, and the body belongs to the Musée du Louvre. In 1974 they were joined as a result of an unprecedented agreement between the two institutions, and the entire statue is now exhibited at each institution for alternating three-year periods. Head of Ur-Ningirsu: *Rogers Fund, 1947, 47.100.86;* body and base: *lent by Musée du Louvre, Département des Antiquités Orientales (Inv. A. O. 9504)*

22 Winged Bird-Headed Divinity ▶

Neo-Assyrian, Nimrud, 883–859 B.C.
Limestone, 94 × 66 in. (238.8 × 167.6 cm)

The kings of the Neo-Assyrian empire ruled over a vast area from the ninth to the seventh century B.C. The heart of the kingdom lay in northern Iraq where the capital cities were located. The first great Assyrian king in this era was Ashurnasirpal II (r. 883–859 B.C.). His capital was at Nimrud (ancient Kalhu), near modern Mosul, and he undertook a vast building program at that site. The palace rooms were decorated in a new fashion with immense stone reliefs and gate figures. While the door guardians (no. 24) are cut partially in high relief and partially in the round, wall reliefs such as this one, which were originally painted in different colors, are always low and flat. This bird-headed divinity resembles the *apkallu* of Babylonian ritual texts, which carries in its right hand a purifier and in its left hand a ritual cup; the creature protected the house from evil spirits. This relief originally decorated a doorjamb of the palace at Nimrud. *Gift of John D. Rockefeller Jr., 1932, 32.143.7*

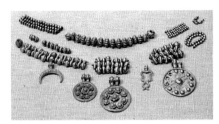

23 Hoard of Jewelry

Mesopotamian, ca. 18th–16th c. B.C.
Gold

This hoard of necklace pendants and beads, cylinder seals, and seal caps allegedly comes from Dilbat in the region of Babylon. Some of the pendants are in the shape of divine symbols: the lightning fork of Adad (the storm god), the crescent moon of Sin (the moon god), a medallion with rays, perhaps signifying the sun god, Shamash. Two others are figures of the suppliant goddess, identified as Lama, who acted as a mediator between humans and the gods. These figures, although minute in size, are carefully delineated. Their flounced robes, divine horned crowns, and heavy necklaces with counterweights are all depicted in fine detail. Both in form and in the use of elaborate granulation, the various beads and pendants are closely related to jewelry elements of the nineteenth–eighteenth century B.C. found in a house at the site of Larsa, as well as to jewelry of the middle of the second millennium B.C. The cylinder seals found in the Metropolitan Museum hoard have been dated stylistically to the late Old Babylonian–early Kassite period (eighteenth–sixteenth century B.C.). *Fletcher Fund, 1947, 47.1a–n*

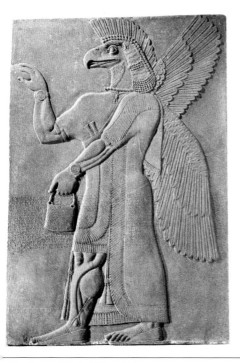

24 Human-Headed Winged Lion
Neo-Assyrian, Nimrud, 883–859 B.C.
Limestone; h. 10 ft. 2½ in. (3.11 m)

In the palace of Ashurnasirpal II (no. 24), pairs of human-headed winged lions and bulls decorated the gateways and supported the arches above them. This lion creature wears the horned cap of divinity and a belt signifying his superhuman power. The Neo-Assyrian sculptor gave these guardian figures five legs. Viewed from the front, the animal stands firmly in place; from the side he appears to stride forward. *Gift of John D. Rockefeller Jr., 1932, 32.143.2*

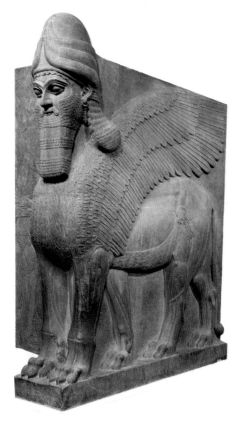

25 Nubian Tribute Bearer
Neo-Assyrian, Nimrud, 8th c. B.C.
Ivory; h. 5⅜ in. (13.7 cm)

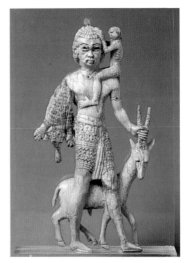

In contrast to the massive stone reliefs and winged animals (nos. 23 and 24), the Museum's other important group of objects from Nimrud consists of carved ivories, delicate in material, size, and execution. This statuette is one of four that may have ornamented a piece of royal furniture. Many of the ivories found at Nimrud were brought there as booty or tribute from vassal states to the west of Assyria, where elephants were native and ivory carving was a long-established craft. This masterpiece may have been sent from Phoenicia as tribute, or it may have been carved in Nimrud by Phoenician craftsmen. The Phoenician ivory carvers were strongly influenced by Egyptian art, and the Egyptianizing style of this piece has caused it to be associated with Phoenicia. *Rogers Fund, 1960, 60.145.11*

26 Walking Lion
Babylonian, 6th c. B.C.
Glazed brick; 89½ × 38¼ in. (227.3 × 97.2 cm)

The Assyrian dynasty fell before the combined onslaughts of the Babylonians, Scythians, and Medes in 612 B.C. In the dying days of the empire, Nabopolassar, who had been in Assyrian service, became king in Babylon, and in the reign of his son Nebuchadnezzar the Neo-Babylonian empire reached its peak. During this period an amazing amount of building activity took place in southern Mesopotamia. Babylon became a city of brilliant color through the use of molded glazed bricks—white, blue, red, and yellow—which decorated the gates and buildings of the city. This relief comes from the Processional Way, which passed through the city to the Festival House; the walls of this street between the Ishtar Gate and the Festival House were decorated with these striding lions. *Fletcher Fund, 1931, 31.13.1*

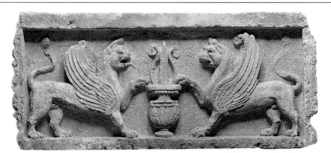

27 Door Lintel
Northern Iraq, Hatra, ca. 2nd c. A.D.
Stone; l. 67¾ in. (172.2 cm)

Originally part of a decorated doorway in the north hall of the so-called Palace Building at Hatra, this lintel stone was positioned so that the carved surface faced the floor. The two fantastic creatures have feline bodies, long ears, and bird's wings and crest feathers, a combination of animal and bird elements typical of Near Eastern lion-griffins. Between the two figures is a vase containing a stylized lotus leaf and two curling tendrils. The naturalistic modeling of the creatures' bodies and the form of the central vase reflect Roman influence. However, the rigid symmetry of the composition, the pronounced simplification of the plant forms, and the lion-griffin motif are all characteristic Near Eastern features. *Purchase, Joseph Pulitzer Bequest, 1932, 32.145*

28 Median Bringing Horses to King Sargon

Neo-Assyrian, Khorsabad, 8th c. B.C.
Limestone; 20 × 32 in. (50.8 × 81.3 cm)

Divine and fantastic creatures (nos. 23 and 24) were not the only subjects that engaged Assyrian sculptors; they were also concerned with depicting the victories of their monarchs in war and in the chase. Full of vitality and extraordinarily detailed, these scenes expressing regal power and triumph are among the masterworks of Assyrian art. This fragment is from the palace at Khorsabad of Sargon II (r. 722–705 B.C.); it shows a mountaineer of Media bringing two gaily caparisoned horses as tribute to the king. *Gift of John D. Rockefeller Jr., 1933, 33.16.1*

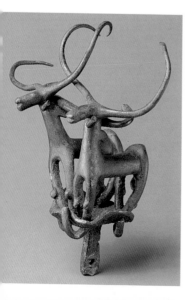

ANATOLIA

29 Standard with Two Long-horned Bulls

Anatolian, reportedly from Horoztepe,
ca. 2300–2000 B.C.
Arsenical copper; h. 6¼ in. (15.9 cm)

This pair of long-horned bulls probably served as a symbolic finial for a religious or ceremonial standard. The bulls were cast separately and are held together by extensions of their front and back legs, bent around the plinth. A pierced tang at the base suggests that the pair were connected to another object. The bulls' elaborate, curving horns are one and one-half times as long as their bodies, and, though impossible in nature, this illustrates an effective stylistic convention. The tendency to emphasize important features in the representation of animals is frequently repeated in ancient Near Eastern art. *Purchase, Joseph Pulitzer Bequest, 1955, 55.137.5*

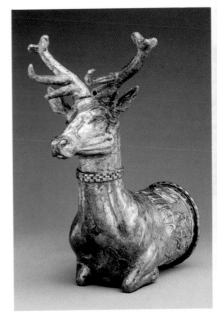

30 Female Sphinx

Anatolian, ca. 18th c. B.C.
Ivory; h. 5⅜ in. (13.7 cm)

This is one of three ivory female sphinxes from central Anatolia in the Museum's collection. In all probability these ivories came from Acem-höyük, a huge mound near the Turkish town of Aksaray on the Konya plain. Recent excavation has revealed a burned building on the highest part of the mound; this structure contained ivories related to those in the Museum's collection. The heat of the fire that destroyed the building is reflected in the vitrification, warping, and discoloration of the Museum's ivories. The sphinxes were undoubtedly set into some object of furniture. Deep sockets are carved in the head and sometimes the base to anchor them in place. Traces of gold leaf remain on the heads and hair of some of the sphinxes. The spiral locks of the sculptures ultimately derive from the female hair fashion of the Middle Kingdom in Egypt, and the heads are precursors of those of the fourteenth-century gate sculptures at Boghazkeui, the capital of the Hittite empire. *Gift of George D. Pratt, 1932, 32.161.46*

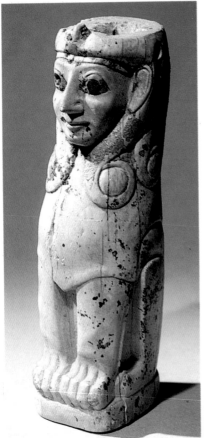

31 Vessel in the Form of a Stag

Anatolian, Hittite Empire Period,
ca. 15th–14th c. B.C.
Silver with gold inlay; h. 7⅛ in. (18.1 cm)

Anatolia is rich in metal ore, and the consummate skill of Hittite metalworkers is amply demonstrated by this fine silver rhyton, which is thought to be a rare example of art produced by court workshops. Of particular interest is the frieze depicting a religious ceremony that decorates the rim of the cup section. Although the precise meaning of the frieze remains a matter of conjecture, it is possible that the vessel was intended as a dedication to or the personal property of the stag god. *Gift of Norbert Schimmel Trust, 1989, 1989.281.10*

SYRIA

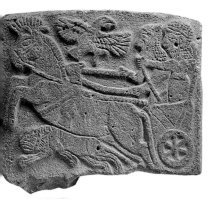

32 Hunting Scene
Neo-Hittite, Tell Halaf, 9th c. B.C.
Basalt; 22 × 27 in. (55.9 × 68.6 cm)

During the Neo-Assyrian period (883–612 B.C.), much was happening in the peripheral areas around Assyria. The two regions of greatest power and importance lay directly to the west in North Syria and to the southeast in Elam. In the west a number of small Aramean city-states, which acted as a barrier between Assyria and the Mediterranean coast, were gradually brought under Assyrian domination. Although in the beginning the art of this western region was independent of that of Assyria, it soon came to reflect the cultural influence of this powerful neighbor. Stone reliefs decorated the walls of the Neo-Hittite palaces and temples; these sculptures are often extremely crude, but the influence of Assyrian prototypes can be detected in the choice of scene and in such details as the types of chariots and horse trappings (see nos. 23–26). *Rogers Fund, 1943, 43.135.2*

33 Sphinx
North Syrian, 9th–8th c. B.C.
Bronze; h. 5¼ in. (13.3 cm)

This plaque, one of a pair in the Museum, was hammered from a thick sheet of bronze. Parallels for the stance and facial features of this fantastic creature can be found in similar North Syrian works in bronze and ivory from the same period. The flamelike pattern on the hind legs was common at this time and appears on ivories from Hama, Nimrud, and Ziwiyeh. The Museum's plaques may have been used as inlays in an object of furniture, or they may have been set into a wall or door. Whatever their use, the plaques are fine examples of North Syrian metalwork. *Rogers Fund, 1953, 53.120.2*

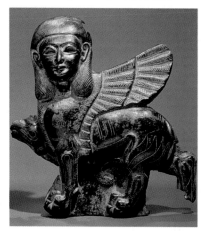

THRACE

34 Beaker
Danubian region, ca. 4th c. B.C.
Silver; h. 11 in. (27.9 cm)

This beaker, raised from a single piece of silver, has a repoussé, stamped, and chased design of stags and goats, birds and fishes. Small scales, surmounted by a running spiral, are represented beneath the feet of the animals. The fantastic decorative fashion in which the animals are represented, the addition of bird's heads to the animal horns, and the pendent position of the hooves are all characteristics of the art of the nomadic peoples who spread across the steppes of southern Russia into Europe in the first millennium B.C.

The area from which the Museum's beaker comes, ancient Thrace, was occupied by various tribes in the fourth century B.C. Objects related in form and style to this vessel have been found in graves at sites in Romania and Bulgaria and can be associated with the Getae and Triballi tribes who ruled in northern Thrace. *Rogers Fund, 1947, 47.100.88*

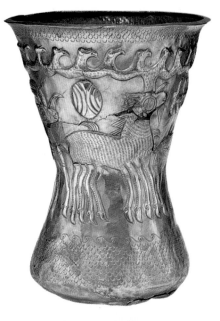

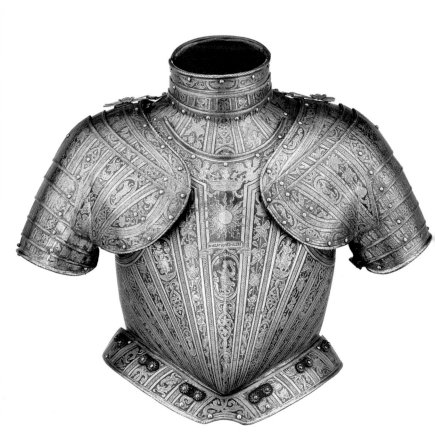

POMPEO DELLA CESA, Milanese,
ca. 1537–1610
**Fragmentary Armor for Vincenzo Luigi di
Capua, Prince of Riccia**
Steel, gold, leather, and brass; h. 19 in. (48 cm)

Italian armor making in the last quarter of the
sixteenth century was dominated by Pompeo
della Cesa, armorer to the Spanish court in
Milan. His richly decorated harnesses were com-
missioned by Philip II of Spain, the ruling dukes
of Savoy, Parma, and Mantua, and the scions of
the leading Spanish and Italian families. Pom-
peo was one of the few armorers who regularly

signed his pieces, a reflection of his pride of
workmanship and his elevated status in the
world of military high fashion.

This fragmentary armor, made about 1595,
is an example of Pompeo's best work. Its sur-
faces are covered with closely set vertical bands
etched and gilt with grotesques, trophies of
arms, and religious and allegorical figures. The
owner's emblem, or impresa, appears at the top
of the breastplate: a radiant sun with a crown
above and a motto below, NVLLA QVIES ALIBI (No
repose but here); the armorer's name, POMPEO,
is etched beneath. *Purchase, Arthur Ochs
Sulzberger Gift, 2001, 2001.72*

ARMS AND ARMOR

The Department of Arms and Armor includes approximately fourteen thousand items, ranging in date from the fifth through the nineteenth century. Elaborate armor and martial accoutrements were essential trappings for high-ranking warriors and rulers. Armor and weapons, often embellished with precious metals and jewels, proclaimed the wearer's social status, wealth, and taste. The finest examples reflect the artistic culture of their time.

Western Europe and Japan are the areas most strongly represented, but the collection also contains significant material from North America, the Islamic countries of the Middle East, and Asia. (Arms and armor from Egypt, classical Greece and Rome, and the ancient Near East are exhibited by their respective curatorial departments.) Arms and armor have been permanently displayed in the Museum since 1904. The collection became an independent curatorial department in 1912, with the goal of presenting armor, edged weapons, and firearms of the highest quality as works of art.

The department's European armor includes extensive holdings of late medieval pieces, as well as elaborately embossed or etched Renaissance parade armors. Among the Islamic holdings are decorated armors from fifteenth-century Iran and Anatolia and jewel-studded weapons from the Ottoman and Mughal courts. The Japanese collection, numbering more than five thousand objects, is the finest outside Japan.

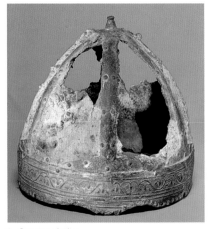

1 Spangenhelm

Germanic, early 6th c.
Steel, bronze, gilt; h. 8⅝ in. (21.7 cm), wt. 2 lb. (.9 kg)

During the Migration period and early Middle Ages the spangenhelm was the helmet type characteristic of the barbarian warriors who brought about the Fall of Rome. Its structural features—triangular steel segments mounted into a framework of bronze browband and straps (*Spangen* in German)—are a translation into metal of the felt cap worn by Eastern steppe nomads. The invasion of Europe by the Huns (375–453) probably brought the spangenhelm to the West. The twenty-odd spangenhelms known, most of which were found in graves of Germanic chieftains, are so closely linked in style and workmanship that it is safe to assume that they all came from a common workshop. Most likely they were made at the court armory of the Ostrogothic kings, who ruled Italy from Ravenna (ca. 500–550). These helmets were apparently prized regalia, which were presented to allied princes and chieftains as diplomatic gifts.

Originally this helmet would have had two shield-shaped cheekpieces and a mail curtain as a neckguard hanging from its browband; a horsehair plume would have been attached to the apical spike. This helmet is the only spangenhelm in the Western Hemisphere.
Gift of Stephen V. Grancsay, 1942, 42.50.1

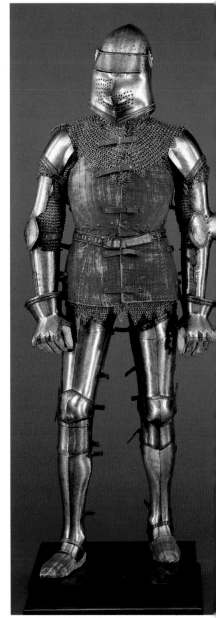

2 Composite Armor

Italian, ca. 1400
Steel, brass, velvet; wt. 41 lb. (18.7 kg)

The appearance of "the knight in shining armor" was actually a gradual process. It began in the thirteenth century when stiffened leather or metal plates were added to the knight's armor of mail (a fabric of interlinked iron rings) at such vulnerable points as the elbows, knees, and shins. This process culminated around 1400, when the knight was encased cap-a-pie in articulated steel plates held together and made flexible by rivets and leather straps. The armor shown here represents this last stage. However, the cuirass is not formed of the usual solid breastplate and back. Instead, the torso is covered by a "brigandine," a tight-fitting sleeveless jacket lined with small steel plates riveted to the fabric, with the decorative rivet heads visible on the outside. With the exception of the helmet, this armor is composed of plates found in the ruins of the Venetian fortress of Chalcis, on the Greek island of Euboea, which was overrun by the Turks in 1470. *Bashford Dean Memorial Collection, Gift of Helen Fahnestock Hubbard, in memory of her father, Harris C. Fahnestock, 1929, 29.154.3*

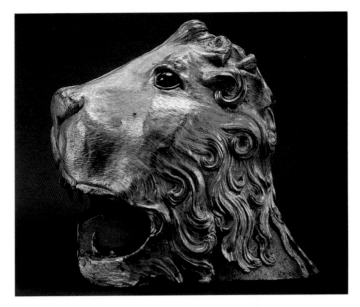

3 Parade Sallet
Italian, ca. 1460
Steel, copper, gilded and partly silvered,
semiprecious stones; h. 11⅛ in. (28.3 cm),
wt. 8 lb. 4 oz. (3.7 kg)

Under the splendid covering of gilt copper, embossed in the form of a lion's head, is a plain steel helmet painted red around the face opening to simulate the appearance of a lion's gaping jaws. The teeth are silvered and the eyes inset with semiprecious stones, apparently carnelian. This parade helmet—imitating the headdress of Hercules, who wore the skin of the Nemean lion—is a striking example of the impact of the rediscovered classical world on the unfolding Renaissance. A practically identical helmet is found on one of the figures accompanying King Alfonso on his triumphal arch at the Castel Nuovo in Naples. *Harris Brisbane Dick Fund, 1923, 23.141*

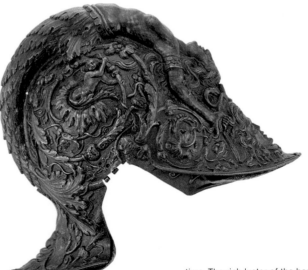

4 Parade Helmet
Milanese, 1543
Steel and gold, h. 9½ in. (24.1 cm)

This superb example of Italian Renaissance art in steel was made by Filippo Negroli (ca. 1500–1561), one of the greatest artist-armorers of all time. The rich luster of the hammered helmet bowl makes it look as if it had been cast in black bronze; the browband is damascened in gold and the embossed decoration repeats classical motifs discovered recently in Nero's Golden House in Rome. A reclining mermaid, which forms the crest of the helmet, holds the head of Medusa, which stares out at the oncoming enemy. *Gift of J. Pierpont Morgan, 1917, 17.190.1720*

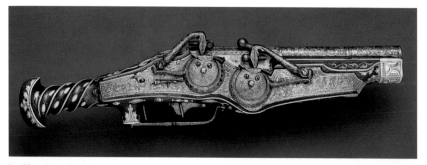

5 Wheellock Pistol
German, Munich, ca. 1540
Steel, gold, walnut, bone; l. 19⅜ in. (49.2 cm)

Portable firearms are recorded in Europe in the fourteenth century, first as hand-cannon, later as match-fired guns. It was not until the early sixteenth century that the first automatic ignition system, the wheellock, was invented. The wheellock mechanism allowed a gun to be loaded and primed in advance, ready for instant use, and thus was ideally suited for troops on horseback. The shorter version, the pistol, did not appear until the 1530s. Made about 1540, this pistol is the masterpiece of the Munich watchmaker and gunsmith Peter Peck (ca. 1500/1510–1596); it combines mechanical ingenuity with sophisticated design and decoration. The etched and gilded barrels and locks are decorated with the coat of arms and devices (the Pillars of Hercules and the motto "Plus Ultra") of the Holy Roman Emperor Charles V (r. 1519–56), one of the first and most lavish patrons of the gunmaker's art. *Gift of William H. Riggs, 1913, 14.25.1425*

6 Armor for Man and Horse
German, Nuremberg, both dated 1548
Etched steel, leather; wt. of man's armor 56 lb. (25.4 kg), wt. of horse's armor 92 lb. (41.7 kg)

Kunz Lochner (1510–1567) was one of the few Nuremberg armorers of the mid-sixteenth century to achieve an international reputation. His patrons included the Holy Roman Emperor, the dukes of Saxony, and the king of Poland. The man's armor illustrated here bears Lochner's personal mark (a rampant lion) and the date 1548. The associated horse armor, also of Nuremberg make and dated 1548, can be attributed to Lochner on stylistic grounds. Its decoration includes the arms and initials of its original owner, Duke Johann Ernst of Saxony. Man's armor: *Bashford Dean Memorial Collection, Gift of Mrs. Bashford Dean, 1929, 29.151.2;* horse armor: *Rogers Fund, 1932, 32.69*

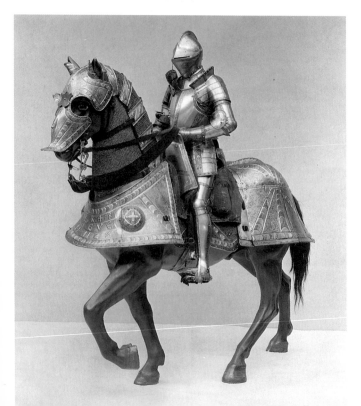

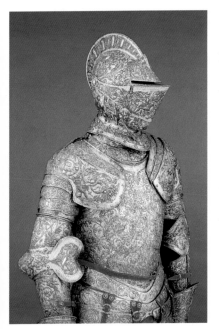

7 Parade Armor
French, ca. 1555
Steel, embossed, blued, silvered, and gilded, leather, red velvet; h. 5 ft. 9 in. (175 cm)

This sumptuous parade armor was made, probably in the Louvre Atelier of Royal Armorers, for Henry II (r. 1547–59) and was meant to adorn him in state processions amid much pomp and pageantry. Requirements of defense are completely subordinated here to purposes of display. The decoration, designed by Étienne Delaune (1518/19–1583), shows the influence of such Italians as Primaticcio and Benvenuto Cellini. The elaborate surface is decorated with a variety of techniques; the embossing alone required the attention of three goldsmiths. The design, contained in arabesques of acanthus, illustrates the theme of Triumph and Fame and is intended to reflect the king's military achievements. *Harris Brisbane Dick Fund, 1939, 39.121*

8 Parade Rapier
German, Dresden, 1606
Steel, gilt bronze, various jewels and seed pearls, traces of enamel; l. 48 in. (121.9 cm)

Israel Schuech (act. ca. 1590–1610), swordcutler and hiltmaker to the electoral court of Saxony, fashioned the magnificently cast and chiseled bronze hilt of this rapier for Christian II, duke of Saxony and elector of the Holy Roman Empire. Lavishly covered with decorative detail of elaborate strapwork and exquisite allegorical figurines and sparkling with jewels and pearls, the hilt expresses the pomp of the early Baroque. However, under this pageantry lurked the religious and dynastic conflicts that led to the Thirty Years War (1618–48), and in these troubled times a rich and powerful man might have to use a sword to defend his life. Therefore attached to the splendidly overdecorated hilt is a blade by Juan Martinez (act. late sixteenth century), bladesmith to the king of Spain and the most renowned of the celebrated swordsmiths of Toledo. *Rogers Fund, 1970, 1970.77*

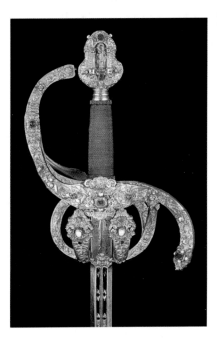

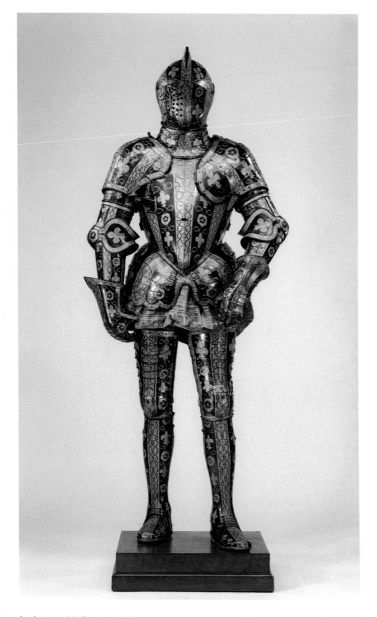

9 Armor with Exchange Pieces
English, Greenwich, ca. 1580–85
Steel, blued, etched, and gilded; brass, leather, velvet; h. as mounted 69½ in. (176.5 cm), wt. as mounted about 60 lb. (27 kg)

This armor, a "garniture" comprising extra pieces of exchange and reinforcement for field and tournament use, was made for Sir George Clifford (1558–1605), the third earl of Cumberland. Clifford was the prototype of the Elizabethan gentleman, combining the qualities of courtier, soldier, scholar, and pirate. He studied at Cambridge and Oxford; he fitted out ten expeditions against the Spaniards, personally leading four of them; and in 1590 he became the queen's champion, presiding over the Ascension Day tournaments on November 17.

This armor was made under the direction of Jakob Halder (act. 1555–1607), master of the royal armor workshop at Greenwich, which was established by Henry VIII for the fabrication of his personal armors. For a knight to have his armor made in this workshop was a special privilege granted by the sovereign. The earl of Cumberland's armor is the best preserved and most complete Greenwich garniture in existence.

The main motifs of the decoration are Tudor roses and fleurs-de-lis tied together by double knots and, repeated on the ornamental gilded bands filled with strapwork, a cipher of two addorsed *E*'s (for Elizabeth) interlaced with annulets (a Clifford badge). *Rogers Fund, 1932, 32.130.6a–y*

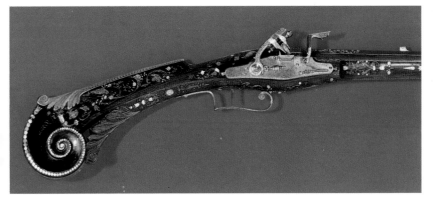

10 Flintlock Fowling Piece
French, Lisieux, ca. 1615
*Steel, gilt bronze, silver, wood, mother-of-pearl;
l. 55 in. (139.7 cm)*

One of the earliest known flintlocks, this fowling piece bears the mark of Pierre Le Bourgeoys, who worked with his brothers Marin and Jean in a family shop which is credited with the invention of this ignition system. It also bears the crowned cipher of Louis XIII (1601–1643), who was an avid gun collector and an amateur gunsmith and the inventory number 134 of his *cabinet d'armes. Rogers and Harris Brisbane Dick Funds, 1972, 1972.223*

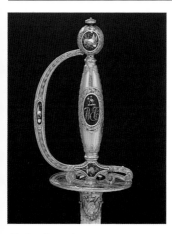

11 Smallsword
English, London, 1798
Steel, gold, enamel; l. 38½ in. (97.8 cm)

The smallsword was an indispensable costume accessory for the eighteenth-century gentleman. This light thrusting sword could be a deadly weapon, well suited for self-defense. On the other hand, many of these swords are mounted with hilts of gold or silver embellished with porcelain, tortoiseshell, even rhinestones. Such precious and delicate materials indicate that the swords had a purely ornamental purpose as masculine jewelry and as status symbols. A distinctive series of richly decorated smallswords was produced in England around 1800 as gifts to honor distinguished naval and military commanders. This one, made by the goldsmith James Morisset (recorded 1767–1815), was presented to Captain W. E. Cracraft of the H.M.S. *Severn* in 1798. It has a hilt of gold set with plaques of translucent enamels painted with maritime scenes, trophies, and the recipient's coat of arms and monogram. *Gift of Stephen V. Grancsay, 1942, 42.50.35*

12 Flintlock Fowling Piece
French, Versailles, ca. 1820
Steel, walnut, gold; l. 47⅜ in. (120.3 cm)

The author of this hunting gun was Nicolas Noël Boutet (1761–1833), the most renowned gunmaker in Napoleonic France. From 1793 until 1818 Boutet was *directeur-artiste* of the National Arms Factory at Versailles, which produced not only regulation arms for the French army but also lavishly decorated arms for presentation by the government to national heroes, foreign diplomats, and esteemed members of the emperor's court. This fowling piece, one of Boutet's last works, ranks as one of his masterpieces. The decoration includes subject matter appropriate to the hunt—dogs and wolves appear on the blued and gilt steel barrels and locks; hares, squirrels, and birds are shown on the gold inlaid stocks. No owner for this splendid weapon is indicated on the blank escutcheon, but a trophy of oriental arms on one of the gold mounts suggests it may have been made for an eastern European or Near Eastern prince. *Gift of Stephen V. Grancsay, 1942, 42.50.7*

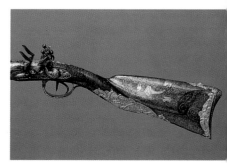

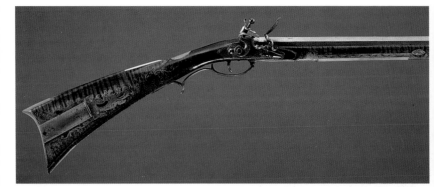

13 "Kentucky" Rifle
Pennsylvania, ca. 1810–20
Steel, maple, brass, silver, bone, horn; l. 59¼ in. (150.5 cm)

This uniquely American form of flintlock rifle was developed during the eighteenth century in Pennsylvania by Swiss and German gunsmiths skilled at rifling barrels (from the German *riffeln*, "to make small grooves"). Rifling gave the bullet spin and thus greater accuracy. The "Kentucky" rifle, with its long, small-caliber barrel, was an adaptation of a German prototype to the American wilderness. The small caliber allowed the hunter to carry more bullets without extra weight; the long barrel ensured a straighter trajectory and gave a boost to the inferior slow-burning gunpowder available in the colonies. The stocks and patch boxes of these utilitarian guns were often skillfully decorated. A Rococo scroll ornament, which survived into the nineteenth century in German and Pennsylvania-German folk art, is seen on this rifle by Jacob Kuntz (1780–1876). *Rogers Fund, 1942, 42.22*

14 Presentation Sword
New York, ca. 1815–17
Steel, gold, silver; l. 37¼ in. (94.6 cm)

Following the War of 1812, New York State presented swords to twelve officers who had commanded troops within its borders. This example, made by the goldsmith John Targee (recorded 1797–1841), was awarded posthumously to Brigadier General Daniel Davis (1777–1813) of the New York Militia, who died in the Battle of Erie on September 10, 1813. The sword's design reflects the classical tenor of the Federal period. The hilt, with its downturned shell, is based on French Empire models. Hercules, strangling the Nemean lion, is emblematic of strength and courage; the scene is probably taken from an English engraving after a classical gem or cameo. The eagle-head pommel is, however, typically American, as is the style of engraving on the scabbard, illustrating the Battle of Erie. *Gift of Francis P. Garvan, 1922, 22.19*

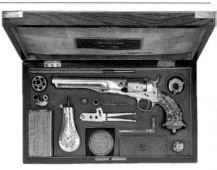

15 Cased Colt Model 1862 Police Revolver
American, 1862
Pistol: steel; accessories: steel, brass, wood; case: wood, brass, velvet; l. of barrel 6½ in. (16.5 cm)

This revolver, with its five-shot cylinder, was manufactured by Colt's firearm factory in Hartford, Connecticut, whose founder, Samuel Colt (1814–1862), achieved fame as an industrialist and as the inventor of the modern revolver (a multishot, rapid-fire pistol with a cylindric magazine rotated by hammer action). The Model 1862 Police Revolver, produced until 1872, was one of the most popular firearms during the Civil War. This specimen is a rare presentation firearm richly decorated with engraved scrollwork in the manner of Gustav Young, who headed Colt's arms-decorating workshop. An uncommon feature is the set of accessories that allowed the revolver to be used with self-contained metallic cartridges; this conversion was an important innovation developed by F. Alexander Thuer, an engineer at Colt's factory. *Gift of Mr. and Mrs. Jerry D. Berger, 1985, 1985.264a–r*

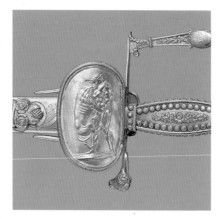

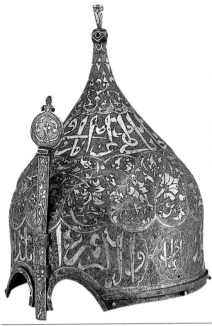

16 Turban Helmet

Iranian, Ak-Koyunlu/Shirvan period, late 15th century
Steel, engraved and damascened with silver; h. 13⅜ in. (34 cm)

This helmet's large bulbous form and fluting imitate a turban's shape. A Koranic inscription in silver encircles the helmet and was intended to protect the wearer and proclaim his piety. The Ak-Koyunlu (White Sheep Turkomans) controlled much of Anatolia in the fifteenth century before being conquered by the Ottoman Turks. *Rogers Fund, 1950, 50.87*

17 Dagger

Indian, Mughal period, ca. 1620
Watered steel, gold, emeralds, rubies, glass; l. 14 in. (35.6 cm)

The Mughal emperors stood at the apex of a powerful military aristocracy. Men who were members of the ruling classes always wore some kind of weapon or military accoutrement in public, and jeweled swords and daggers were especially favored as marks of rank. This dagger with its bifurcated pommel and rounded quillon tips descends from a Central Asian type, popular in Mughal India in the seventeenth century. The hilt is made of heavy sections of gold over an iron core, and the scabbard mounts are gold. The intricately engraved gold surfaces are set with gems and colored glass finely cut with floral forms. The designs have parallels in Mughal paintings of the early seventeenth century, and daggers similar to this one are often seen in miniatures of the period. *Purchase, Harris Brisbane Dick Fund and The Vincent Astor Foundation Gift, 1984, 1984.332*

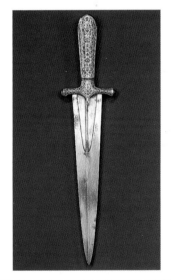

18 Sword *(Jatagan)*

Turkish, Istanbul, ca. 1525–30
Steel, walrus ivory, gold, silver, rubies, turquoise, pearl; l. 23⅜ in. (59.4 cm)

This sword, one of the earliest known *jatagans* — a Turkish short-sword with a distinctive double-curved blade — is a stellar example of Ottoman goldsmiths' work at the court of Süleyman the Magnificent (r. 1520–66). The talents of the bladesmith, ivory carver,

goldsmith, and jeweler are displayed in a rich variety of precious materials. Both sides of the blade are thickly encrusted in gold with scenes of combat between a dragon and a phoenix. The relief is minutely detailed; the eyes of the phoenix are set with rubies and the dragon's teeth are of silver. *Purchase, Lila Acheson Wallace Gift, 1993, 1993.14*

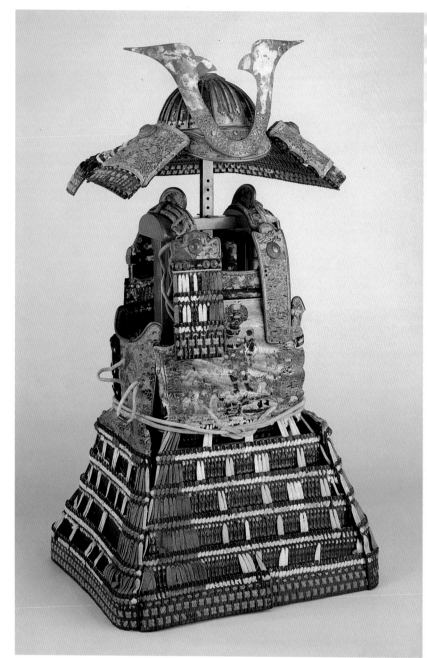

19 Armor (*yoroi*)
Japanese, late Kamakura period, early 14th c.
*Lacquered iron and leather, silk, stenciled
leather, gilt copper; h. as mounted 37½ in.
(95.3 cm), w. 38 lb. 3 oz. (17.3 kg)*

This is a rare example of a medieval *yoroi*. This
type of armor has a cuirass that wraps around
the body and is closed by a separate panel
(*waidate*) on the right side and by a deep four-
sided skirt. In use from around the tenth to the

fourteenth century *yoroi* were generally worn
by warriors on horseback. The breastplate
bears the image of the powerful Buddhist
deity Fudō Myō-ō, whose fierce mien and
attributes of calmness and inner strength
were highly prized by the samurai (see Asian
Art, no. 5). The helmet, long associated with
this armor, dates from the middle of the
fourteenth century. *Gift of Bashford Dean,
1914, 14.100.121*

20 *Wakizashi* (Short Sword)
Japanese, Edo period, dated 1829
Steel; l. 20 in. (50.8 cm)

This is an example of one of the pair of blades
that a samurai wore. The other was the three-
foot-long *katana,* and as a set they were called
daishō. A Japanese sword was made of easily
assembled parts held together by a single dowel
that passed through the handle and the tang of
the blade. A samurai's sword had an almost
religious significance. In fact, the present blade
carries the image of Fudō Myō-ō, the Buddhist
guardian figure (see Asian Art, no. 5). The
laborious process of forging such a blade in-
volved crucial steps that were the jealously
guarded secrets of master craftsmen. This
wakizashi bears the name of the smith Naotane
(1778–1857). *Gift of Brayton Ives and W. T.
Walters, 1891, 91.2.84*

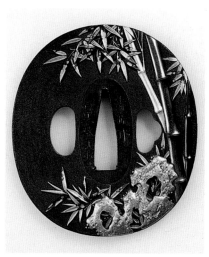

21 *Tsuba* (Sword Guard)
Japanese, Edo period, 19th c.
*Copper alloys (shakudō, shibuichi), copper,
gold; 2⁷⁄₈ × 2⁵⁄₈ in. (7.3 × 6.7 cm)*

The *tsuba* (guard) was part of the hilt of a
Japanese sword. This element and other pieces
of sword furniture were the jewelry of Japanese
gentlemen. This rather somber guard is, in fact,
a work of great luxury. *Shakudō* is an alloy of
gold and copper, acid-treated to turn a deep
blue-black; it was developed to circumvent
sumptuary laws prohibiting ostentatious use
of gold. The decorative schemes of sword
furniture included a wide variety of subjects,
among them military emblems, Zen symbols,
and motifs from nature. Here bamboo is shown
amid rocks. This guard was signed by Ishiguro
Masayoshi (1772–after 1851). *The Howard
Mansfield Collection, Gift of Howard Mansfield,
1936, 36.120.79*

Page from an Illuminated Gospel
Ethiopia (Lake Tana region), early 15th century
*Wood, vellum, and pigment; page 16½ x 11¼ in.
(41.9 x 28.6 cm)*

The Ascension is one of the twenty-four full-page paintings that depict events from the New Testament in this illuminated Gospel. This work documents the convergence of indigenous African forms with those of the Byzantine and Arab worlds, typified here by the mannered stylization in the portrayal of the protagonists. At the summit Christ appears framed in a red circle surrounded by four beasts representing the Evangelists, while below, Mary and the Apostles gesture upward. Such elaborately ornamented manuscripts were frequently presented to churches by distinguished patrons. Texts of the Gospels are considered the most holy writing of the Ethiopian Orthodox Church, and the series of illuminations was intended to be viewed during liturgical processions. The text and accompanying imagery draw upon Greek prototypes that were translated to Geez, or Classical Ethiopic, beginning in the sixth century. *Rogers Fund, 1998, 1998.66*

ARTS OF AFRICA, OCEANIA, AND THE AMERICAS

THE MICHAEL C. ROCKEFELLER WING

The Department of the Arts of Africa, Oceania, and the Americas exhibits works of art that span 3,500 years, three continents, and countless islands. The works express the great diversity of many cultural traditions and range from ritual sculptures to gold and silver ornaments, costumes and textiles, impressive ceremonial figures, and monuments of wood or stone. Highlights include pieces from the Court of Benin in Nigeria, sculpture from West and Central Africa, wood carvings from New Guinea and the island groups of Melanesia and Polynesia, and gold, ceramic, and stone objects from the Precolumbian cultures of Mexico and Central and South America.

The Metropolitan made its first acquisitions in these areas — a group of Peruvian antiquities — as early as 1882, but significant commitment came only one hundred years later with the opening of The Michael C. Rockefeller Wing in 1982. Named for the son of the major donor Nelson A. Rockefeller, the wing then chiefly included the Rockefeller gift of 3,300 works of art, a specialized library, and a photographic archive. Since that time the department has grown substantially. It now houses almost 12,000 works of art, the Robert Goldwater Library, and the Photograph Study Collection which collects images that explore the cultural contexts of the department's works. The wing includes a special exhibition gallery in which temporary shows are mounted.

AFRICA

1 Seated Figure
Mali, Inland Niger Delta, 13th c.
Terracotta; h. 10 in. (25.4 cm)

Terracotta figures like this one from the Inland Niger Delta are among the oldest known art objects of West Africa. Characterized by bulging eyes, broad noses, large ears, and projecting, open mouths, these sculptures are fluid and graceful in form, a style that reflects the malleable properties of clay. Such figures encompass a variety of poses. Here arms and legs entwine, the back curves, the head turns to rest upon an upraised knee. The figure is unclothed, its only embellishment consisting of a series of raised and recessed marks running down the length of the back, possibly depicting scarification marks. The figure's pensive expression suggests an attitude of mourning, which is strengthened by its apparently shaved head, which reflects a common mourning practice throughout much of West Africa. Secreted under the foundations or in the walls of buildings, Inland Niger Delta sculptures may have had protective or ancestral meanings. Today, pottery in the Delta is the prerogative of women, and it is likely that these figures too were produced by women. *Purchase, Buckeye Trust and Mr. and Mrs. Milton R. Rosenthal Gifts, Joseph Pulitzer Bequest, and Harris Brisbane Dick and Rogers Funds, 1981, 1981.218*

2 Seated Couple
Mali, Dogon, 16th–20th c.
Wood, metal; h. 29 in. (73.7 cm)

The characteristics and gestures of this seated couple illustrate Dogon beliefs about the nature of men and women and their mutual dependency. The figures are portrayed seated side by side, their balanced, frontal poses emphasizing virtually identical forms. Their elongated bodies have similar abdominal scarification and attenuated limbs, and their faces bear identical arrow-shaped noses. The figures are adorned with similar coiffures and jewelry, the man's beard offset by the woman's cylindrical lip plug. The man's right arm wraps around the woman's shoulder, linking the two figures, while other gestures underscore their differences. The man's right hand rests on the woman's breast, while his left hand points toward his own genitals. Similarly, the man carries a quiver on his back while the woman carries an infant on hers. These details stress the ideal male role in Dogon society as progenitor, protector, and provider and the ideal female role as childbearer and nurturer. Although these figures are frequently described as primordial couples, their specific identity remains uncertain. *Gift of Lester Wunderman, 1977, 1977.394.15.*

3 Pair of Male and Female Figures
Côte d'Ivoire, Baule, 19th–20th c.
*Wood, paint, beads; h. 21¾ (male), 20⅝ (female)
in. (55.3, 52.4 cm)*

The Baule produce figural sculpture to honor
and appease aggressive or troublesome spirits.
Personal mishap, financial distress, infertility,
restlessness, and illness may all be caused by a
spirit who desires a special relationship with a
human being. When properly acknowledged,
the spirit may instead bring good luck and grant
extraordinary abilities. These figures were
probably made for a *komien,* or diviner, whose
powers stem from possession by nature spirits.
The figures reflect Baule ideals of physical
beauty, a flattering contrast to descriptions of
nature spirits as hideous. Their facial expres-
sions are serene, their hands rest on slightly
extended abdomens, and their legs are bent to
emphasize muscular calves. Scarification marks,
carefully rendered coiffures, and beads adorn
the figures. White pigment around the eyes is
medicinal, fostering the figures' ability to act as
a medium and protecting them in times of
increased vulnerability. Such sculptures require
frequent care, including offerings of food and
drink, which can leave incrustations like those
around the feet and mouths of these figures.
*The Michael C. Rockefeller Memorial Collection,
Gift of Nelson A. Rockefeller, 1969, 1978.412.390,
1978.412.391*

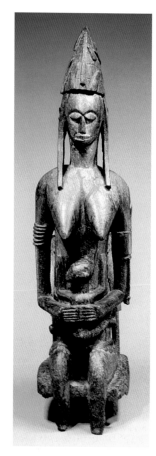

4 Mother and Child
Mali, Bougouni-Dioïla area, Bamana people,
15th–20th c.
Wood; h. 48⅝ in. (123.5 cm)

This figure of a mother and child is one of a
corpus of sculptures that differ in their rounded
and relatively naturalistic forms from other more
angular examples of Bamana sculpture. Dis-
played at the annual ceremonies of Jo, an
association of initiated men and women, and
the rituals of Gwan, a related society concerned
with fertility and childbirth, figures like this one
would be part of a group consisting of a seated
mother and child and a seated male surrounded
by companions, including musicians, warriors,
and bearers of ritual objects or pots of water.
This figure portrays a woman of extraordinary
abilities and idealized character. Her proud
posture is tempered by a peaceful countenance
and downward gaze. Her amulet-laden hat and
the knife strapped to her left arm, items more
often associated with powerful and knowledge-
able male hunters and warriors, attest to her
wisdom and bravery. At the same time, her full
breasts and the baby in her lap give equal
importance to her role in nurturing and
instructing future generations. *The Michael C.
Rockefeller Memorial Collection, Bequest of
Nelson A. Rockefeller, 1979, 1979.206.121*

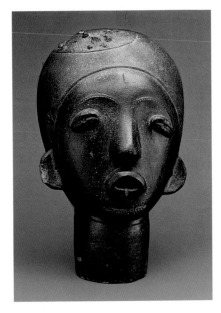

5 Commemorative Head
Ghana, Adansi Kingdom, Akan, 17th c.(?)
Terracotta; h. 12 in. (30.5 cm)

The production of terracotta memorial heads in
southern Ghana and Côte d'Ivoire dates to at
least the seventeenth century, and in some
areas continues to flourish to this day. Most
commonly made by women, who also make
terracotta vessels and containers, these heads
are portraits of deceased members of powerful,
often royal, families. The style of terracotta
commemorative sculpture varies regionally,
ranging from flattened and stylized heads to
more naturalistic examples, like those from the
former Adansi Kingdom. This head, with its
gently curving, rounded face, down-turned,
protruding eyes, softly modeled nose, and open,
full-lipped mouth, is relatively naturalistic in
style; however, it is the details, such as the
distinctive, partially shaved coiffure with
textured patches and the thin beard, rather than
a realistic rendering of facial features, that
distinguish the individual portrayed. Such heads
are placed near the grave of the person they
represent and may be displayed at funeral
ceremonies that follow the burial of the
deceased by several months or more. *The
Michael C. Rockefeller Memorial Collection, Gift
of Nelson A. Rockefeller, 1964, 1978.412.352*

6 Pendant Mask
Nigeria, Edo, Court of Benin, early 16th c.
Ivory, iron, copper; h. 9⅜ in. (23.8 cm)

Objects from the Benin Kingdom reflect its
hierarchical organization and unique history.
This finely carved ivory pendant with metal inlay
is believed to portray the mother of the Oba, or
king, and to have been worn by the Oba in
ceremonies commemorating her role as adviser
and leader. The queen mother's idealized face is
softly modeled. She wears a necklace of coral
beads and has scarification marks above each
eyebrow. Projecting flanges above her head and
below her chin depict mudfish, admired for
their ability to survive both on land and in water,
and the stylized heads of bearded Portuguese
traders, associated with the sea and the
accumulation of riches. Like mudfish, the sea-
going Portuguese were beings of both land and
water. As traders they brought wealth to the
kingdom, becoming symbols of the power of
the Oba and of Olokun, the sea god, who was a
source of wealth and fertility. The ivory from
which the pendant is made is also part of this
symbolic network. It is associated with the white
chalk used in rituals for Olokun and was one of
the valuable items that attracted the Portuguese
to Benin. *The Michael C. Rockefeller Memorial
Collection, Gift of Nelson A. Rockefeller, 1972,
1978.412.323*

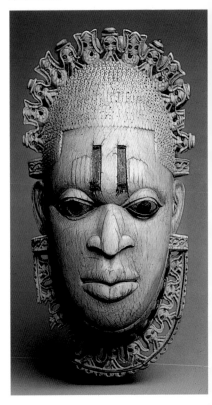

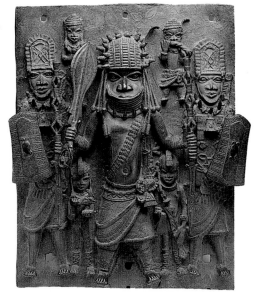

7 Plaque: Warrior Chief, Warriors, and Attendants
Nigeria, Edo, Court of Benin, 16th–17th c.
Brass; h. 18¾ in. (47.1 cm)

This plaque, part of a series of idealized but richly detailed scenes of court life, once decorated the palace of the Oba, or king, of Benin, the powerful African kingdom that flourished from the thirteenth to the late nineteenth century. A warrior chief and his retinue are shown as if ceremonially greeting the Oba. The hieratic organization of the court is reflected in the figures' size, depth of relief, and placement. The central figure wears the leopard's-tooth necklace of a warrior and the beaded coral collar and cap, lavish wrapper, and brass hip ornament of a chief. He honors and swears loyalty to the Oba by raising a ceremonial sword with his right hand. Flanking him are two smaller warrior figures also wearing leopard's-tooth necklaces. They carry shields, and one holds a spear matching that held by the warrior chief. The smallest figures are attendants, each performing a service: fanning the chief, heralding his arrival on a side-blown trumpet, holding an antelope-head box for the kola nuts that were given by the Oba, and carrying a sheathed sword. *Gift of Mr. and Mrs. Klaus Perls, 1990, 1990.332*

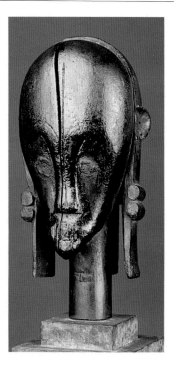

8 Reliquary Guardian Head
Gabon, Fang, 19th–20th c.
Wood, metal; h. 18¼ in. (46.4 cm)

The Fang—inhabitants of Gabon, Equatorial Guinea, and southern Cameroon—placed carved heads and figures on top of wooden reliquaries housing the bones of deceased ancestors. Because these containers were imbued with spiritual power that continued to accumulate over time, those most vulnerable to such forces, usually children and women of childbearing age, were not allowed in their vicinity. Adult men cared for the reliquaries, frequently applying palm oil, which resulted in an oozy, glistening, black surface. This sensitively rendered head, with its formal symmetry and studied composition, is expressive of the Fang belief that human vitality or life force is rooted in harmony between opposites. The eyes, arching incised eyebrows, ears, and coiffure are carefully balanced, while the elegant S-curve traced by the swelling forehead, the receding bridge of the nose, and the pointed chin creates a contrast between convex and concave forms. A sense of balance is further achieved through the interplay of straight lines and sinuous curves and the contrast of vertical and horizontal elements. *The Michael C. Rockefeller Memorial Collection, Bequest of Nelson A. Rockefeller, 1979, 1979.206.229*

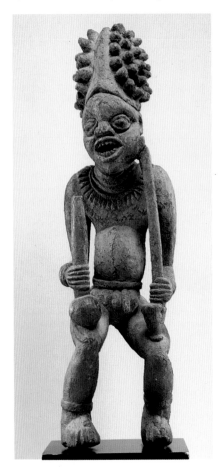

10 Power Figure

Zaire, Kongo (Yombe), 19th c.
Wood, iron, glass, pottery, shells, cloth, fiber, pigments, seeds, glass beads; h. 28½ in. (72.4 cm)

Kongo power figures are receptacles for spirit forces that are all-encompassing in their range of influence. The forces can heal and harm, empower and punish, settle disputes, and safeguard peace. Because power figures are incapable of action without the application of spiritually charged ingredients, their production requires the combined efforts of a sculptor, who carves the underlying form, and a ritual specialist, who collects and applies the organic and inorganic materials that animate it. Medicinal ingredients are contained in the box attached to the figure's stomach and in the upturned clay pot on its head. The metal blades were inserted into the body by a specialist each time the figure's powers were directed. This power figure's form is expressive of its highly charged nature: it stands straight-legged, its chin jutting slightly forward. Its open mouth, with the tongue lying on the lower lip as if panting from exertion, evokes the Kikongo word *venda,* meaning "to lick in order to activate medicines," and suggests that the figure's power is constantly available. *The MURIEL KALLIS STEINBERG NEWMAN Collection, Gift of Muriel Kallis Newman, in honor of Douglas Newton, 1990, 1990.334*

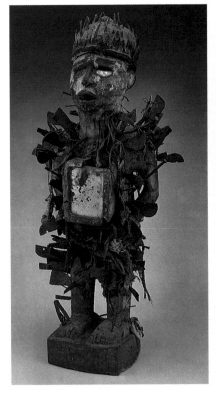

9 Figure of a King

Cameroon, Bangwa,19th–20th c.
Wood; h. 40¼ in. (102.2 cm)

The high plateaus and fertile valleys of the Cameroon Grasslands are home to many autonomous kingdoms that share a history of mutual contact, including cultural and economic exchange. Hierarchical in structure, these kingdoms support a wide range of prestige arts associated with royalty and rank. This lively figure, a memorial for a royal ancestor, was displayed during royal funerals, public appearances by the Fon, or ruler, and annual festivals. The figure is adorned with a rich display of regalia. A knotted cap sits on the ancestor's head, a belt encircles his waist, and a yokelike necklace is draped around his neck. On the right wrist is a bracelet, and anklets reminiscent of those worn by the Fon are placed around each leg. In the left hand the ancestor holds a long-stemmed pipe; in the right hand is a calabash, which was a container for palm wine. The figure's twisting, braced, and bent-legged stance and its wide eyes and open-mouthed expression are suggestive of movement. Such vitality is characteristic of art from the Cameroon Grasslands. *The Michael C. Rockefeller Memorial Collection, Purchase, Nelson A. Rockefeller Gift, 1968, 1978.412.576*

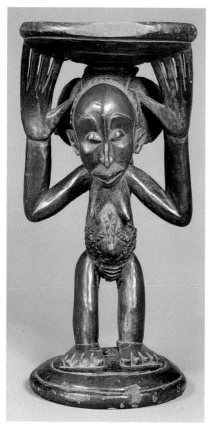

12 Male Figure (probably the god Rogo)
Gambier Islands, Mangareva Island, 19th c.
Wood; h. 38¾ in. (98.4 cm)

It is not known which of the numerous deities worshiped in the Gambier Islands is represented by this figure, but the god most often the subject of wood figures was Rogo, sixth son of Tagaroa and Haumea, the mythological first inhabitants of Mangareva. Rogo was the god of peace, agriculture, and hospitality in all of Polynesia, and he revealed himself in the form of a rainbow and as fog. On Mangareva Island he was invoked especially in rites connected with the cultivation of turmeric tubers. Most of the sculpture of Mangareva, where this object originated, was destroyed in April 1836 at the instigation of missionaries. Only eight figures have survived, six of them naturalistic and two of them highly stylized. *The Michael C. Rockefeller Memorial Collection, Bequest of Nelson A. Rockefeller, 1979, 1979.206.1466*

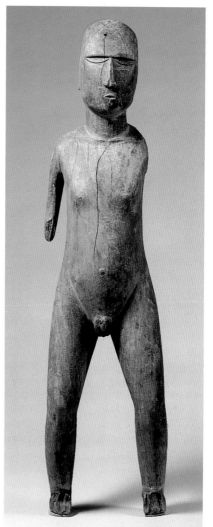

11 Stool with Female Figure
Zaire, Luba–Hemba, The Buli Master,
late 19th c.
Wood; h. 24 in. (61 cm)

This stool is one of only about twenty objects attributed to the Luba artist known today as the Buli Master, who is named after a village in eastern Zaire where a number of his sculptures were collected. The Buli Master's individualistic style is evident in the figure's elongated hands and feet and in the expressive face with its sharply articulated features and prominent cheekbones, traits that are a marked departure from other Luba sculpture. A stool supported by a female figure is a significant part of a Luba chief's treasury, although it is used only on rare occasions. Among these is the investiture ceremony in which the right to rule is officially granted to a member of a chiefly family. The Luba are matrilineal, and because Luba chieftaincy rights are based partially on ancestry, female relatives are fundamental to a chief's power. The noble character of the female figure effortlessly supporting this stool is accentuated by a four-lobed coiffure and scarification marks on torso and buttocks, both symbols of status. *Purchase, Buckeye Trust and Charles B. Benenson Gifts, Rogers Fund, and funds from various donors, 1979, 1979.290*

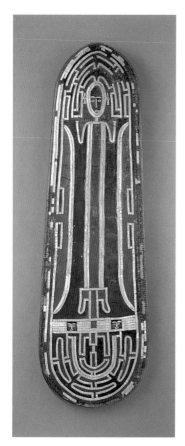

14 Funerary Carving (*malanggan*)
New Ireland, 19th–20th c.
Wood, paint, opercula; h. 8 ft. 4½ in. (2.6 m)

In New Ireland *malanggan* is the collective name for a series of ceremonies and the masks and carvings associated with them. The rituals, seldom practiced today, were held primarily in memory of the dead and were combined with initiation ceremonies in which young men symbolically replaced in society those who had died. The carvings, the most complex of all Oceanic works of art, were commissioned from recognized experts and embody images from clan mythology. They were displayed in special enclosures, sometimes in considerable numbers, during feasts honoring both the dead and the donors of the carvings, after which they were abandoned or destroyed. *The Michael C. Rockefeller Memorial Collection, Gift of Nelson A. Rockefeller, 1972, 1978.412.712*

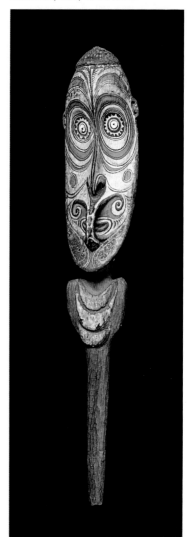

13 Shield
Solomon Islands, probably Santa Isabel Island, 19th c.
Basketry, mother-of-pearl, paint; h. 33¼ in. (84.5 cm)

The Solomon Islands form a double chain of seven large and many small islands. In the western Solomons the standard war shield was elliptical in shape and made of wicker woven over cane strips. A small number of them are painted completely and are encrusted with hundreds of tiny squares of luminous nautilus shell. The central image on these shields represents a figure with several appended but disembodied faces. All of the decorated examples seem to have been made in the 1840s to 1850s. Because of their fragility, it is unlikely that the shields were ever used in combat. *The Michael C. Rockefeller Memorial Collection, Gift of Nelson A. Rockefeller, 1972, 1978.412.730*

15 Male Figure
Papua New Guinea, Madang Province, Lower
Sepik-Ramu River area(?), 19th c.
Wood, paint; h. 18½ in. (47 cm)

Sculpture from the Sepik River region of New
Guinea became known in the West in the 1890s,
when this figure was first collected. Thought to
represent a deified ancestor, the figure was one
of the many carved wooden images, suspension
hooks, and flute stoppers that entered Euro-
pean collections at the time. The specific village
in which the figure was collected is not
recorded, and because of the diversity of Sepik
River art styles, it is difficult today to determine
its point of origin. The figure's proportions and
the rendering of the head and face suggest a
north coastal provenance, probably in the
estuaries of the lower Sepik and Ramu rivers.
Indigenous stone-tool marks are evident on the
surface. *Gift of Judith Small Nash, in honor of
Douglas Newton, 1992, 1992.93*

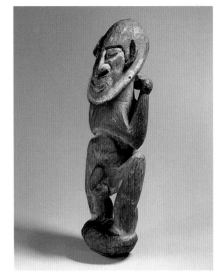

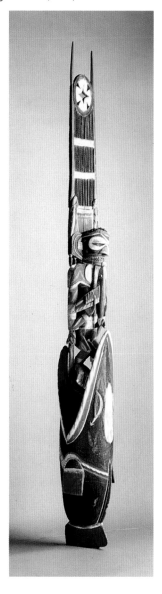

16 Ceremonial Fence Element
Papua New Guinea, East Sepik Province, Iatmul
people, 19th–20th c.
Wood, paint, shell; h. 60½ in. (153.7 cm)

The middle reaches of the Sepik River in
northeast Papua New Guinea are inhabited by
the Iatmul, a group of about nine thousand
people, whose culture was once the most
elaborate of the large island. The Iatmul were
vigorous artists and builders, and their most
impressive architectural achievements were the
great ceremonial houses that were the center of
men's lives. These were impressive, gabled
structures, splendidly decorated with carvings
and paint. Every village had two or three such
houses, and at either end of each house was an
artificial mound planted with totemic trees and
shrubs. Bodies of enemy headhunting victims
were laid out on these mounds, which were
sometimes enclosed by fences that could
include large carved and painted heads of
ancestral spirits as elements. *The Michael C.
Rockefeller Memorial Collection, Gift of Nelson
A. Rockefeller, 1969, 1978.412.716*

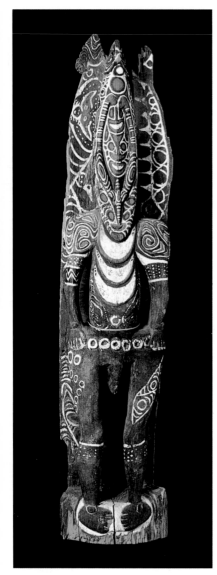

17 Post Figure
Papua New Guinea, East Sepik Province, Keram River, Kambot people, 20th c.
Wood, paint; h. 96 in. (243.8 cm)

The Kambot people live on the Keram River, a tributary that feeds the lower Sepik River and the swamps around it. The Kambot are primarily painters, rather than sculptors, and this figure is the largest carved work known from the area. Undoubtedly not an independent sculpture but part of a huge post for one of the Kambot ceremonial houses, the figure represents either Mobul or Goyen, mythical brothers who created plants and animals. The brothers' spirits lived, from time to time, in such posts. This figure's head is remarkable as a double image in which the eyes extend to form the hands of a figure painted on the forehead; the hands grasp a flute, which is also the main figure's nose. *The Michael C. Rockefeller Memorial Collection, Gift of Nelson A. Rockefeller, 1969, 1978.412.823*

18 Skull Rack (Agibe)
Papua New Guinea, Gulf Province, Omati River, Kerewa people, 19th c.
Wood, paint; h. 55 ⅞ in. (142 cm)

The Gulf of Papua, a very large bay on the south coast of New Guinea, is inhabited by a number of groups with closely related art styles, marked by an interest in two-dimensional patterning. The most important works were open-work wood carvings of stylized ancestor figures (*agibe*), which were used as racks for skulls in the men's ceremonial houses. In earlier times the acquisition and decoration of human skulls were important responsibilities of the Papua men. Headhunting trophies and ancestral skulls were hung on the upright prongs of the *agibe* by cane loops. The present *agibe*, from the village of Paia'a, is one of the largest skull racks known. *The Michael C. Rockefeller Memorial Collection, Gift of Nelson A. Rockefeller, 1969, 1978.412.796*

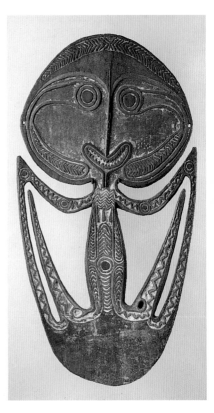

19 Shield

Irian Jaya (New Guinea), Lorentz River, Asmat people, 20th c.
Wood, paint; h. 51 ⅝ in. (131 cm)

Among the Asmat people of New Guinea shields were semisacred because of their association with weapons, warfare, and religious belief. Shields, spears, and bows and arrows acquired special status through use in headhunting which was integral to Asmat sacred thought. The shields, carved from the planklike roots of mangrove trees and painted with powdered lime, ocher, and charcoal, were reserved for the best warriors and had to be inaugurated by special feasts. The feasts were given in the name of ancestors, and the imagery on the shields relates to the ancestors as well. *The Michael C. Rockefeller Memorial Collection, Bequest of Nelson A. Rockefeller, 1979, 1979.206.1597*

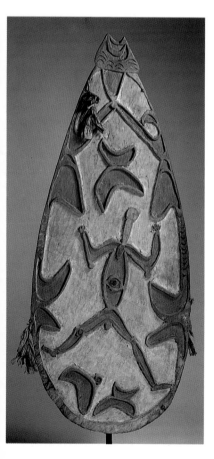

20 *Mbis* Pole

Irian Jaya (New Guinea), between the Asewetsj and Siretsj rivers, Asmat people, 20th c.
Wood, paint; h. 19 ft. (57.9 m)

In southern Irian Jaya, approximately 10,500 square miles of flat, swampy terrain blanketed in jungle is the home of the Asmat, who number about 30,000 people. In Asmat belief, death was never natural; it was always caused by an enemy, and it created an imbalance in society that the living were called upon to correct by imposing death on the enemy. When a village suffered a number of deaths, it would hold the *mbis* ceremony. Carvings made specially for these events include *mbis* poles, the basic form of which is a canoe with an exaggerated prow that incorporates both ancestral figures and a phallic symbol in the shape of a winglike openwork projection. For each *mbis* ceremony several poles were displayed in front of the men's ceremonial house; they were kept until a successful headhunt had been carried out. The victims' heads were then placed in the hollow ends of the poles, and after a final feast the hunters abandoned the carvings in the jungle. This pole comes from Per village. *The Michael C. Rockefeller Memorial Collection, Gift of Nelson A. Rockefeller and Mary C. Rockefeller, 1965, 1978.412.1251*

21 Mask
Papua New Guinea, Torres Strait, Mabuiag
Island, 18th c.
*Turtle shell, clamshell, wood, feathers, sennit,
resin, seeds, paint, fiber; h. 17 ½ in. (44.5 cm)*

The islanders of the Torres Strait, between New
Guinea and Australia, used turtle shell to con-
struct masks, a practice found nowhere else in
the Pacific area. Some are in human form or
represent fish or reptiles, while others are a
combination of attributes from all three. Turtle-
shell effigies in these islands were first recorded
in 1606 by the Spanish explorer Diego de Prado.
Only two masks of the type shown here are
extant; nothing is known of their use. *The
Michael C. Rockefeller Memorial Collection,
Purchase, Nelson A. Rockefeller Gift, 1967,
1978.412.1510*

THE AMERICAS

22 "Baby" Figure
Mexico, Olmec, 12th–9th c. B.C.
Ceramic; h. 13⅜ in. (34 cm)

The Olmecs, who lived in the coastal swamps
along the Gulf of Mexico about 1000 B.C.,
appear to have formalized many of the concepts
that made possible the significant achievements
of the ancient New World. Monumental basalt
works, small jade objects, and carefully crafted
ceramic figures and vessels are their chief
sculptural legacy. The Gulf Coast near San
Lorenzo and La Venta is so wet that only stone
sculptures survive intact. Ceramic vessels in
good condition come from drier areas, such as
the central highland sites of Tlatilco and Las
Bocas, where Olmec influence prevailed from
about the twelfth to the ninth century B.C. The
most notable sculptural ceramics depict pudgy,
nearly lifesize human baby figures. White-
surfaced and hollow, these figures may
represent an early form of a Mexican deity. *The
Michael C. Rockefeller Memorial Collection,
Bequest of Nelson A. Rockefeller, 1979,
1979.206.1134*

23 Standard Bearer
Mexico, Aztec, second half of 15th–early 16th c.
Laminated sandstone; h. 25 in. (63.5 cm)

The Aztecs were the last great civilization to
flourish in Mexico before the Spanish conquest
of the sixteenth century. They dominated much
of Mexico, and Tenochtitlán, their capital in the
Valley of Mexico, was a true imperial city with
many temples, palaces, houses, marketplaces,
canals, and bridges. Aztec temple sanctuaries,
built atop large pyramidal platforms, had pairs
of stone standard bearers flanking the struc-
tures and heading the wide stairways that led
from the plazas below to the temples above.
These sculptures held banner poles in their hol-
low fists. This seated figure, wearing only a loin-
cloth and sandals, is thought to have been a
standard bearer because of the position of his
right hand, now damaged, resting on his knee.
The figure comes from Castillo de Teayo, an
Aztec enclave in northern Veracruz, and is
carved from local sandstone in a provincial ver-
sion of the metropolitan Aztec style of
Tenochtitlán. *Harris Brisbane Dick Fund, 1962,
62.47*

24 Seated Figure
Mexico or Guatemala, Maya, 6th c.
Wood; h. 14 in. (35.6 cm)

Although in close proximity to one another and
sharing many cultural traits, the Mexican and
the Maya peoples were sufficiently different to
represent distinct ancient cultures. Maya
territory encompassed the Mexican states of
Chiapas and Tabasco, those on the Yucatán
Peninsula, the adjacent countries of Guatemala,
Belize, and parts of El Salvador and Honduras.
This figure is reported to have come from the
lowlands of the Mexico–Guatemala border,
where wood objects do not survive well. It is a
rare testament to wood sculptures otherwise
lost to time and tropical rains. The mustachioed,
elegantly dressed figure is seated in a
ceremonial pose, the significance of which is
not clear. Among the ancient Maya, gesture and
posture had specific meanings, many of which
are yet to be determined. *The Michael C.
Rockefeller Memorial Collection, Bequest of
Nelson A. Rockefeller, 1979, 1979.206.1063*

25 Deity Figure (Zemi)
Dominican Republic, Taino, 13th–15th c.
Wood, shell; h. 27 in. (68.5 cm)

The first European settlements in the New World were established on the Caribbean island of Hispaniola, where the indigenous people have come to be known as Taino. Of particular importance to the Taino were the zemis, or idols, which could be named and personally owned and which were dressed and offered foods on special occasions. Crouching, emaciated figures, with a platelike surface on the top of the head, like the present example, are thought to have been used in ceremonies that included the taking of hallucinogenic snuff, or cohoba. The snuff was placed on top of the zemi and inhaled through small tubes held to the nostrils. The altered states of consciousness induced by the snuff were important to divination and curing rituals. *The Michael C. Rockefeller Memorial Collection, Bequest of Nelson A. Rockefeller, 1979, 1979.206.380*

26 Eagle Pendant *(Aguila)*
Costa Rica, Chiriqui, 11th–16th c.
Gold; h. 4⅜ in. (11.1 cm)

The best-known ancient American gold objects are eagle pendants. Made in such generalized forms that identification of species is only tentative, eagle pendants were common in the Panama–Costa Rica area. Early Spanish accounts mention such ornaments and, in fact, gave the pendants the name, *aguilas* (eagles), by which they have come to be known. This eagle has rattles in its bulbous eyes and holds a small animal and a double-ended snake in its large curved beak. *Bequest of Alice K. Bache, 1977, 1977.187.22*

27 Lime Container *(PopORO)*
Colombia, Quimbaya, 5th–10th c.
Gold; h. 9 in. (23 cm)

The ritual use of coca is an ancient tradition in South America, where from earliest times quids of coca leaves were placed in the mouth together with small amounts of powdered lime. Made from calcined seashells, the lime helped release the hallucinogens in the leaves. Standard coca paraphernalia included a small bag for the leaves and a container and dipper for the lime. Made in a variety of materials, the paraphernalia could be quite elaborate and valuable. In the Quimbaya region of Colombia particularly impressive lime bottles were cast by the lost-wax method. These flasks are ornamented on the wide sides with nude human figures. On this example the figures wear multiple rings in the ears and double-strand bands across the forehead and at the neck, wrists, knees, and ankles. The bottle still contains powdered lime. *Jan Mitchell and Sons Collection, Gift of Jan Mitchell, 1991, 1991.419.22*

28 Figure
Ecuador, Tolita, 1st–5th c.
Ceramic; h. 25 in. (63.5 cm)

The most expressive ceramic sculptures of Precolumbian South America are those from the Columbia-Ecuador border area on the Pacific coast. The sculptures range from very small to almost lifesize; the bent and wrinkled figure here is a particularly large example and is a forceful rendition of a known type. Lines of schematized wrinkles mark the long chin, prominent cheekbones, and eyes. The hair may be closely cropped, or there may be a cap on the elongated head. Ornaments are depicted on the wrists and neck, but the nose and ear ornaments are missing. These were presumably made of other materials, perhaps gold, and separately inserted through the holes in the septum and along the rims of the ears. The reconstruction of the lower third of the figure is tentative. *Gift of Gertrud A. Mellon, 1982, 1982.231*

29 Feline-Head Bottle
Peru, Jequetepeque-Cupisnique,
15th–9th c. B.C.
Ceramic, post-fired paint; h. 12⅜ in. (31.4 cm)

A number of large building compounds were erected in the river valleys of the north-central Peruvian coast during the second millennium B.C. The multiroom structures served important ceremonial and administrative functions, and these massive complexes are today grouped under the name of Cupisnique, a word first applied to ceramic vessels found in burials in the Quebrada de Cupisnique, a small ravine located between the Chicama and Jequetepe-que valleys. The iconography on the Cupisnique ceramics is extremely complex, focusing on felines, serpents, and predatory birds. Cupisnique-style vessels have also been found in the Jequetepeque Valley proper, where ancient cemeteries have been located near the town of Tembladera. This impressive bottle is said to have come from that area. It has an incised upended feline head in profile with a toothed snout and protruding curled tongue on the front. A smaller feline profile and scaled body projects from the other side of the vessel.
The Michael C. Rockefeller Memorial Collection, Purchase, Nelson A. Rockefeller Gift, 1967, 1978.412.203

30 Figure Vessel
Peru, coastal Wari, 6th–9th c.
Polychrome ceramic; h. 15 in. (38.1 cm)

In the first millennium A.D. the powerful city states Wari and Tiwanaku dominated the Andean highlands. Their political and cultural influence extended over much of southern Peru and Bolivia and particularly in the valleys of the Pacific coast. This Wari effigy vessel is thought to have originated in the Nasca Valley. It combines the Nasca traits — rich colors and well-burnished surface — with the Wari design elements of straight lines and geometric motifs.

The bottle's neck is modeled in the shape of a man's head. The painted face has almond-shaped eyes, a mustache and beard, and a nose ornament. The head is covered by a cap that has a central spout. The bottle's chamber, which forms the body, is painted with vertical bands reminiscent of banded decoration on fine tapestry tunics. *Purchase, Mary R. Morgan Gift, 1987, 1987.2*

31 Deer Vessel
Peru, Chimu, 12th–15th c.
Silver; h. 5 in. (12.7 cm)

The Chimu kingdom ruled the north of Peru from its capital in the Moche Valley for many centuries. The Chimu monarchs amassed great wealth and constructed enormous walled compounds in which to protect it. This deer-shaped silver vessel is said to be from the Chicama Valley north of Moche and was part of a find of silver objects that included stirrup-spout and double vessels as well as tall beakers. Although three-dimensional animal-form vessels had been common on the north coast of Peru for about two thousand years prior to the making of this deer, the use of silver in their construction was rare. *The Michael C. Rockefeller Memorial Collection, Gift of Nelson A. Rockefeller, 1969, 1978.412.160*

**Trinity with a Preaching Buddha Flanked
by the Bodhisattvas Avalokiteshvara and
Vajrapani**
Indonesia, Java, Early Eastern Javanese period,
second half of the 10th century
Bronze; 11 7/8 in. x 8 5/8 in. (30.2 x 22 cm)

This extraordinary trinity is remarkable for its
great beauty, size, and nearly pristine condition
(all seven of its separately cast pieces are pres-
ent). The central figure is either Shakyamuni, the
historic Buddha, or Vairochana, his transcendent
manifestation. His hand gesture signifies the
preaching of the dharma, and he is seated with

pendent legs in the so-called European posture.
A lion, a reference to the Buddha's clan, emerges
from the center of the base. To the left is a four-
armed Avalokiteshvara seated before his bull
vehicle, and to the right Vajrapani sits in front of his
mount, a makara (fantastic crocodile-elephant).
The group can be dated to the early Eastern
Javanese period (ca. 930–1527) by the some-
what baroque elaborations of jewelry and
throne backs. It is one of the finest works in the
Museum's extraordinary collection of Javanese
bronzes. *Purchase, Rogers Fund and Gift of
Dr. Mortimer D. Sackler, Teresa Sackler and
Family, 2004, 2004.259*

ASIAN ART

The arts of China, Japan, Korea, and South and South-east Asia are the responsibility of the Department of Asian Art, which was established in 1915. The collections range from the third millennium B.C. into the twentieth century A.D. and include paintings, sculpture, ceramics, bronzes, jades, decorative arts, and textiles. The collection of Chinese painting and calligraphy ranks among the finest outside China. The department also has notable holdings of monumental Chinese Buddhist sculpture and Japanese screens, lacquerware, and prints. Its collection of South and Southeast Asian art is one of the most comprehensive in the world.

In recent years the department has embarked on a new installation of its collections. The Astor Court and Douglas Dillon Galleries for Chinese painting opened to the public in 1981. The arts of Japan are on view in The Sackler Galleries for Asian Art, which opened in 1987. The arts of ancient China are in the Charlotte C. and John C. Weber Galleries. Exhibition areas are planned for Korean and later Chinese art. South and Southeast Asian art is displayed in the new Florence and Herbert Irving Galleries.

JAPAN

1 Jar
Middle Jōmon period, ca. 3000–2000 B.C.
Clay with applied, incised, and cord-marked decoration; h. 27½ in. (69.8 cm)

Cord-marked pottery is the characteristic ware of the earliest inhabitants of Japan. These Neolithic people, known as the Jōmon (cord marking) culture, existed on the abundant fishing and hunting of the Japanese islands from at least the fifth millennium B.C., surviving in some areas until the third century A.D. During this period handmade utilitarian wares were treated with inventive, often extravagant artistry, and regional separations between groups resulted in a wide range of types and styles. This earthenware food vessel, which came from the Aomori prefecture in northeastern Japan, is remarkable for the fine quality of its clay and for its sophisticated decoration. The cord-marked herringbone pattern was produced by cords knotted together and twisted in opposite directions. *The Harry G. C. Packard Collection of Asian Art, Gift of Harry G. C. Packard, and Purchase, Fletcher, Rogers, Harris Brisbane Dick, and Louis V. Bell Funds, Joseph Pulitzer Bequest, and The Annenberg Fund Inc. Gift, 1975, 1975.268.182*

2 Talisman ▶
Prehistoric, 4th–5th c.
Steatite; 2½ × ½ in. (6.5 × 1.2 cm)

This irregular disk with smooth radial fluting is a fine example of a type of carved stone object found in the keyhole-shaped burial mounds of central Japan of the fourth and fifth centuries. Works in this shape are called *sharinseki* (carriage-wheel stones), and they are sometimes identified as stone bracelets. They seem, however, to be talismans with magical or religious significance. They do not appear in burials of the later Kofun period; perhaps their special meaning faded with the influx of Chinese and subsequently Buddhist culture that began in the sixth century. *The Harry G. C. Packard Collection of Asian Art, Gift of Harry G. C. Packard, and Purchase, Fletcher, Rogers, Harris Brisbane Dick, and Louis V. Bell Funds, Joseph Pulitzer Bequest, and The Annenberg Fund Inc. Gift, 1975, 1975.268.338*

便輪法門一切眾中自在顯現无量无邊告
法界塵數身雲法門行諸佛主
无功德法門菩薩地顧行法門普門示現
佛主調伏眾生法門諸佛所謂出生一切佛
佛入如來无量功德海所謂此生究竟淨法
是時普賢菩薩成就不可思議方便法門
普眼一切諸法界
光明普照如雲興
如來安坐淨道場

一切眾現前見
眾妙莊嚴光圓滿
示現諸佛深妙法

3 Segment of the *Kegon-kyō*

Nara period, ca. 744
Segment of handscroll (calligraphy) mounted as hanging scroll; silver ink on indigo paper; 9¾ × 20⅛ in. (24.8 × 53.7 cm)

This manuscript is a fragment of a Buddhist text, the *Kegon-kyō*, or *Avatamsaka-sutra*, the story of a young boy's travels through India in search of supreme truth. Written in India, the text was translated into Chinese (the language used in this scroll) in the fifth century. This scripture is one of the longest in the Buddhist canon, comprising sixty scrolls. The set to which this segment belongs came from the Nigatsu-dō, a hall within the Tōdai-ji compound, a vast temple complex that dominated the capital city of Nara in the eighth century. The quality of the writing on this scroll—the finest of its day—is impressive, as is the combination of silver against vibrant blue. The silver is an alloy and has not tarnished—the Buddhist Law was meant to last forever. *Purchase, Mrs. Jackson Burke Gift, 1981, 1981.75*

4 Zaō Gongen

Late Heian period, 11th c.
Bronze; h. 14¾ in. (37.5 cm)

This is a rare example of Zaō Gongen, a uniquely Japanese deity, who is represented here in the strong, active pose conventional for a Buddhist guardian figure. A local Shinto *kami*, Zaō Gongen is the tutelary deity of Mount Kimpu in the Yoshino Mountains south of Nara. During the eleventh century, when this image was cast, he became the object of an important cult that incorporated Shinto and Buddhist beliefs. Zaō was identified as a local manifestation of the Buddha, and Mount Kimpu came to be revered as a sacred mountain associated with the Pure Land of Buddhist salvation. Venerated by Heian aristocrats, Zaō was also regarded as a patron by adherents of Shugendo, an ascetic sect. While expressing an intense spirituality, this image is a fine example of the elegance of the aristocratic Heian style. *The Harry G. C. Packard Collection of Asian Art, Gift of Harry G. C. Packard, and Purchase, Fletcher, Rogers, Harris Brisbane Dick, and Louis V. Bell Funds, Joseph Pulitzer Bequest, and The Annenberg Fund Inc. Gift, 1975, 1975.268.155*

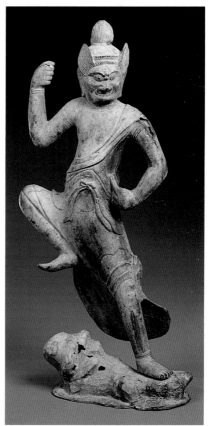

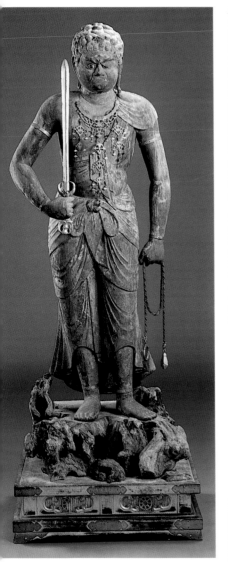

5 Fudō Myō-ō
Late Heian period, 12th c.
*Wood with color and gold leaf; 80 × 30 in.
(203.2 × 76.2 cm)*

Fudō, whose name means "immovable," is a staunch guardian of the faith, warding off enemies of the Buddha with his sword of wisdom and binding evil forces with his lasso. Here his youthful, chubby body and his skirt and scarf are modeled with the restrained gentle curves typical of late Heian sculpture. Fudō's halo of red flames has been lost, and his rock pedestal is a nineteenth-century replacement. Enough pigment remains to show that his hair was once painted red and his flesh dark blue-green. His clothing was covered with delicate patterns of cut gold leaf.

The statue was the central icon of the Kuhonji Gomadō in Funasaka, some twenty miles northwest of Kyoto. A gomadō is a small auxiliary hall attached to temples of the Shingon, or Esoteric, sect of Buddhism and intended specifically for the ritual worship of Fudō with fire-burning ceremonies. *The Harry G. C. Packard Collection of Asian Art, Gift of Harry G. C. Packard, and Purchase, Fletcher, Rogers, Harris Brisbane Dick, and Louis V. Bell Funds, Joseph Pulitzer Bequest, and The Annenberg Fund Inc. Gift, 1975, 1975.268.163*

6 Miracles of Kannon (Avalokiteshvara)
Kamakura period, 1257
*Handscroll; color and gold on paper;
9½ in. × 32 ft. (24.1 cm × 9.76 m)*

In this handscroll (*emaki*) from the middle of the Kamakura period both the sacred text (sutra) and the illustrations are modeled after a Chinese printed scroll said to have been made in the Sung dynasty. The sutra text was transcribed by Sugawara Mitsushige, a thirteenth-century calligrapher, who signed and dated it 1257. We do not, however, know the name of the painter who illustrated with superb color and gold each section of the thirty-three texts describing the many miracles performed by Kannon in saving people from fire, flood, and other calamities.

The bodhisattva Kannon is the God of Mercy who delayed his own attainment of Buddhahood in order to bring salvation to humankind. Known in China as Kuan Yin and in India as Avalokiteshvara, he is one of the most popular deities in the Buddhist pantheon. Here, in the lower right, traders are being waylaid by bandits; they will, however, be rescued because they have invoked the name of Kannon (who appears in the upper left). (See also nos. 8 and 32.) *Purchase, Louisa Eldridge McBurney Gift, 1953, 53.7.3*

7 Tenjin Engi
Kamakura period, late 13th c.
Handscroll; ink and color on paper;
w. 12¼ in. (31.1 cm)

This illustration is from a set of three scrolls
(now remounted as five) that present the leg-
endary origins of the Shinto cult of the deified
Sugawara no Michizane (845–903), a distin-
guished poet, statesman, and scholar. These
scrolls, which contain thirty-seven lively and
evocative illustrations, were painted in the late
thirteenth century for didactic use in one of the
many Tenjin shrines dedicated to this patron of
agriculture and learning. In its combination of
landscape, narrative, and fantastic vision, this
work is a prime example of the classic *yamato-e*
style of painting. The Museum's version of the
Tenjin Engi is unique in its elaboration of the
priest Nichizō's journey through hell. Here
Nichizō is depicted entering the caves of hell.
Fletcher Fund, 1925, 25.224d

8 Eleven-Headed Avalokiteshvara
(Jūichimen Kannon) atop Mount Potalaka
Late Kamakura period, ca. 1300
Hanging scroll; ink, color, gold pigment, gold
leaf on silk; 42¾ × 16¼ in. (108.6 × 41.2 cm)

This strikingly lyrical painting shows an eleven-
headed Kannon on his mountain-island para-
dise, Potalaka, where glorious palaces and lakes
lie amid fragrant trees and flowers. A bodhisatt-
va renowned for his infinite compassion and
mercy, Kannon here sits on a lotus throne, his
right hand making the gift-giving gesture
(*varadamudra*) and his left holding a vase out of
which lotus flowers emerge. (See also nos. 6
and 32.) *The Harry G. C. Packard Collection of*
Asian Art, Gift of Harry G. C. Packard, and Pur-
chase, Fletcher, Rogers, Harris Brisbane Dick,
and Louis V. Bell Funds, Joseph Pulitzer Bequest,
and The Annenberg Fund Inc. Gift, 1975,
1975.268.20

11 OGATA KŌRIN, Edo period, 1658–1716 ▶
Waves

Two-fold screen; ink, color, and gold leaf on pa-per; 57⅞ × 65⅛ in. (147 × 165.4 cm)

Ogata Kōrin was born into a wealthy merchant-class family in Kyoto. After squandering his in-heritance, he turned to painting as a serious vocation. This screen was painted at a period when Japan was enjoying peace and prosperity. Having assimilated foreign influences, Japan was ready to pursue its own artistic progress. The Japanese feeling for nature is obvious here, as is Kōrin's ability to transpose it into a rhyth-mic, bold stylization. The design is really the abstract essence of a wave, and Kōrin expresses this imaginative design with supremely con-trolled brushwork. The subtle gradations of color, with gold and blue predominating, en-hance the extraordinary ink strokes; the result is a remarkable fusion of decorative and realistic elements. (See also no. 12.) *Fletcher Fund, 1926, 26.117*

9 Battles of the Hogen and Heiji Eras
Momoyama period, ca. 1600
Pair of six-fold screens; ink, color, and gold leaf on paper; each 60⅞ × 140⅛ in. (154.6 × 355.6 cm)

The Momoyama period saw the reestablishment of warrior control of Japan. Although these men were not interested in the refinements of court life, they did decorate their large dark castles with warm color. This is the period when the Japanese screen came into its own. Strong thick colors against a ground of gold leaf were the fashion.

In these screens the drama of the two insurrec-tions is set before us, scene by scene. The lo-cale for most of the action is Kyoto, but the artist did not hesitate to switch to Mount Fuji. Nor are the scenes placed chronologically; rather, the artist distributed his incidents as suited him best. The viewer gets a bird's-eye view of the action because of the Japanese technique of looking from above at an oblique angle. Sliding doors and roofs are pulled back so that we see the scene inside the palace as well as outside. The painting is meticulous in detail, making use of strong greens, reds, and blues against the gold. *Rogers Fund, 1957, 57.156.4,5*

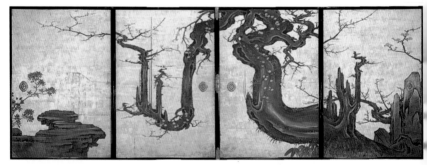

10 The Old Plum
Early Edo period, ca. 1650
Ink, color, and gold leaf on paper; 68 × 191½ in. (172.7 × 486.4 cm)

Even the oldest plum puts out green shoots in spring, and thus the tree is a symbol of fortitude and rejuvenation. *The Old Plum* was probably painted for one of the reception rooms of the abbot's residence in the Tenshō-in, built in 1647, which adjoined the Tenkyū-in, a small temple in Kyoto. It formed part of a continuous painting that probably featured one dramatically en-larged tree on each of the four sides of the room. The artist is thought to be Kanō San-setsu (1590–1651), whose late works are characterized by abstraction and a stylized man-nerism. *The Harry G. C. Packard Collec-tion of Asian Art, Gift of Harry G. C. Packard, and Purchase, Fletcher, Rogers, Harris Bris-bane Dick, and Louis V. Bell Funds, Joseph Pulitzer Bequest, and The Annenberg Fund Inc. Gift, 1975, 1975.268.48*

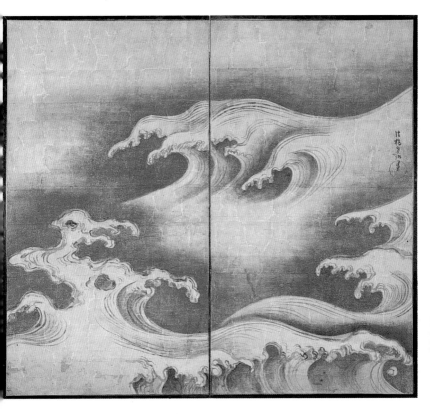

12 OGATA KŌRIN, Edo period, 1658–1716
Yatsuhashi
*Six-fold screen; ink, color, and gold leaf on
paper; 70½ × 146¼ in. (179.1 × 371.5 cm)*

Ogata Kōrin (no. 11) was fascinated by irises,
which he painted often in many media. Here,
however, the bridge is the clue to the painting's
subject, one immediately familiar to a Japanese
viewer. It alludes to a passage from the tenth-
century *Tales of Ise,* a collection of poetic epi-
sodes about the courtier Narihira. Banished
from Kyoto to the eastern provinces after an
indiscretion with a high-ranking lady of the court,
Narihira stopped en route at Yatsuhashi (Eight-
Plank Bridge). There the sight of the irises
blooming brought him nostalgic regret for
friends left behind in the capital. Kōrin may
have seen in this story a parallel to his own
condition. In search of clients, he was forced
to leave Kyoto in 1704 and travel east to Edo.
There, restless and unhappy, he longed for the
refined life of the capital.

This screen is one of a pair; the left screen,
which is also in the Museum's collection, is
identical in size and completes the representa-
tion of Yatsuhashi. *Purchase, Louisa Eldridge
McBurney Gift, 1953, 53.7.2*

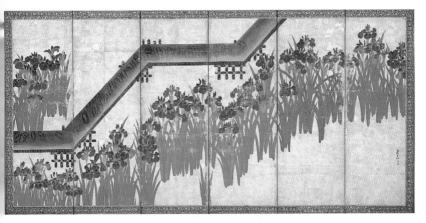

13 Wine Container
Momoyama period, ca. 1596–1600
Lacquered wood; h. 9⅞ in. (25 cm),
diam. 7 in. (17.8 cm)

This sake container (*chōshi*) may have been used by the Momoyama general Toyotomi Hideyoshi (1536–1598), the flamboyant ruler who unified Japan in the 1590s. His mausoleum, the Kōdaiji in Kyoto, was furnished with the finest-quality lacquer prepared by the Kōami family. Works in this style, called Kōdaiji lacquers, are characterized by close-ups of autumn plants painted in simple gold designs. Hideyoshi's chrysanthemum and paulownia-leaf crests are also prominent motifs. The diagonally bisected pattern, half against a sprinkled gold ground and half on a black ground, is typical of Kōdaiji lacquers. The stunning contrast of the two areas was a design invention called *katami-gawari* (alternating sides), which was favored about 1600 by artists working not only in lacquer but also in ceramics and textiles. *Purchase, Gift of Mrs. Russell Sage, by exchange, 1980, 1980.6*

14 Bowl with Lid
Early Edo period, late 17th c.
Arita ware, Kakiemon type; porcelain painted in underglaze blue and overglaze enamels; h. 13¾ in. (35 cm), diam. 12⅜ in. (31.4 cm)

At least eight of these deep bowls, some missing their lids, are known at present. Like this one, most have been found in Europe. They were no doubt produced for the export market toward the end of the seventeenth century under the influence of K'ang-hsi famille verte (no. 58), and all probably originated from the same kiln. The symmetrical design painted on the lid and bowl, although slightly varied on each piece, is coordinated to show a pair of birds with chrysanthemums on one side and a pair of birds with peonies on the other. *The Harry G. C. Packard Collection of Asian Art, Gift of Harry G. C. Packard, and Purchase, Fletcher, Rogers, Harris Brisbane Dick, and Louis V. Bell Funds, Joseph Pulitzer Bequest, and The Annenberg Fund Inc. Gift, 1975, 1975.268.526*

15 Nō Costume
Edo period, early 18th c.
Silk and gold brocade; l. 59⅜ in. (150.9 cm)

The rich color and subtle design of this extraordinarily beautiful costume would have been heightened by the austere setting of the small wooden Nō stage. The silk ground is woven in a pattern of alternate bands of pale orange and cream by binding off the warp threads to reserve them for the dye. Loose binding allowed some of the dye to seep into adjacent areas, creating a softly shaded effect in the woven cloth. A felicitous design of pine and bamboo is woven in glossed green silk on the cream-colored bands of unglossed silk. The technique, known as *karaori* (Chinese weaving), is distinguished from embroidery by the uniform direction of all the weft floats, which lie in long "stitches" across the surface. *Karaori* is unique to Nō costumes and is used for the outer robe worn by female characters. *Purchase, Gift of Mrs. Russell Sage, by exchange, 1979, 1979.408*

16 HISHIKAWA MORONOBU, Edo period, 1625–1694
Lovers in the Garden
Ink printed on paper; 10¾ × 15½ in. (27.3 × 39.4 cm.)

Considered to be the originator of the Japanese single-sheet print, Hishikawa Moronobu was also an extraordinary book illustrator and painter. This print is thought to be the first page of a series of twelve *shunga,* or erotic prints, which date from 1676 to 1683.

Here a young couple embrace ecstatically in a garden corner. In the left foreground autumn plants in full bloom are drawn so large that they almost envelop the lovers. In contrast to the fine lines of the plants, however, the lovers' hair and garments are drawn in large masses, thus focusing the viewer's attention on the couple. The

flowing lines of the lovers' garments are repeated in the rock and the water, uniting the figures both physically and spiritually with the natural setting. *Harris Brisbane Dick and Rogers Funds 1949, JP 3069*

INDIA AND PAKISTAN

17 Pair of Royal Earrings
Indian, perhaps Andhra Pradesh, ca. 1st c. B.C.
Gold; left l. 3 in. (7.7 cm), right l. 3⅛ in. (7.9 cm)

Body adornment in ancient India was not merely self-embellishment but had very real social and religious significance. Jewelry, aside from its intrinsic value, was considered a major art form. These earrings are designed as organic, conceptualized, vegetative motifs. Each is composed of two rectangular, budlike forms growing outward from a central doublestemmed tendril. A winged lion and an elephant, both royal animals, occur on each earring. The animals are of repoussé gold, completely covered in granulation and then consummately detailed, using granules, snippets of wire and sheet, and individually forged and hammered pieces of gold. These earrings are the most superb examples of Indian jewelry known. Their size, weight, craftsmanship, and use of royal emblems leave little doubt that they were royal commissions. *Gift of The Kronos Collections, 1981, 1981.398.3,4*

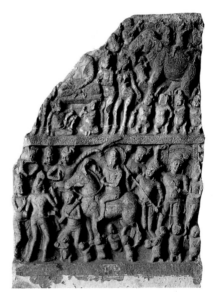

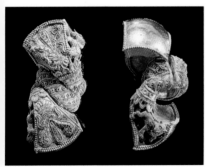

18 Stele with Scenes from the Life of the Buddha
Indian, Andhra Pradesh, Nagarjunakonda, first half of 4th c.
Limestone; h. 56¾ in. (144.1 cm)

This stele shows the Great Departure—Prince Siddhartha (later to become the Buddha) leaving his family and the palace at Kapilavastu in the dark of night. Renouncing his noble life, he embarks on his search for enlightenment. This event became a standard part of the Buddhist pictorial repertory with little variation in the dramatis personae. Siddhartha's horse and groom are usually present, as well as the gods who rejoice at Siddhartha's decision. Dwarflike figures often support the horse to muffle the sound of its hooves and thus prevent the palace occupants from being awakened. In this depiction, the great Vedic god Indra holds a parasol, the symbol of royalty, over the departing Siddhartha. The second scene on the stele depicts Siddhartha at Bodhgaya, where he attained enlightenment and became the Buddha. *Fletcher Fund, 1928, 28.105*

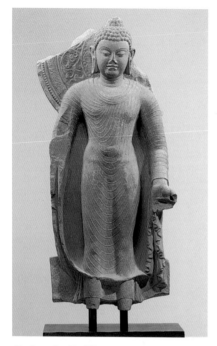

19 Standing Buddha
Indian, Mathura, Gupta period, ca. 5th c.
Mottled red sandstone; h. 33⅝ in. (85.4 cm)

The Gupta period (the early fourth through the early seventh century) was India's Golden Age, when the arts and the sciences flourished under lavish imperial patronage. In sculpture a new naturalism emerged; a highly refined system of aesthetics produced softer, gentler curves and smoothly flowing forms. As practiced at its two greatest centers, the holy cities of Mathura and Sarnath, the Gupta style had an immense and wide-ranging influence.

This well-modeled and elegantly proportioned Buddha is of the type most often represented in South Asian art: standing, with the right hand (now missing) raised in the fear-allaying or protective gesture (*abhaya mudra*) and the lowered left hand holding a portion of the garment. The immutable composure and the calm magnificence of this statue are characteristic of the finest early South Asian sculpture. *Purchase, Enid A. Haupt Gift, 1979, 1979.6*

20 Standing Buddha
Pakistani, Gandharan style, ca. 6th c.
Bronze; h. 13¼ in. (33.6 cm)

The sculptural styles of the ancient Gandhara region of northwest India and northern Pakistan are well preserved by rich remains of stone and stucco. A few rare small bronzes, almost always representations of the standing Buddha, have also survived. Since the Gandharan-style Buddha was of seminal importance, serving as one of the prototypes for early Buddhist images and iconography throughout the Far East and South Asia, the importance of these small, portable bronze images cannot be overestimated.

Standing on a stepped pedestal, the Buddha raises his right hand in the fear-allaying gesture (*abhaya mudra*). His lowered left hand holds a portion of his garment. The mandorla is a complete body halo whose perimeter represents stylized flames. Representing the Gandharan style in its most mature form, this standing Buddha is one of the most important bronze sculptures of the ancient Buddhist world. *Purchase, Rogers, Fletcher, Pfeiffer, and Harris Brisbane Dick Funds, and Joseph Pulitzer Bequest, 1981, 1981.188*

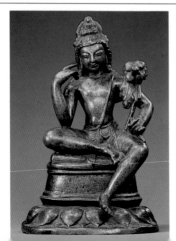

21 Padmapani Lokeshvara Seated in Meditation
Pakistani, Swat Valley region (or Kashmir), first half of 7th c.
Gilded bronze, inlaid with silver and copper; h. 8¾ in. (22.2 cm)

This superb sculpture, one of the finest and earliest Swat Valley bronzes known, closely reflects the inspiration of the Gupta idiom of northern India during the sixth century. It occupies a pivotal position in Indian art, illustrating the transition between the sixth-century Gupta style and the great sculptural tradition of the eighth century in Kashmir and the Swat Valley region. *Harris Brisbane Dick and Fletcher Funds, 1974, 1974.273*

23 Standing Vishnu

Indian, Tamil Nadu, Chola dynasty, 10th c.
Bronze with greenish-blue patination;
h. 33¾ in. (85.7 cm)

This four-armed Vishnu stands on a double-lotus base supported by a plinth. His upper right hand holds a flaming disk, the upper left hand a conch shell. His lower right hand is in the fear-allaying gesture (*abhaya mudra*), while the lower left hand, with extended fingers, points diagonally downward. The figure wears a cylindrical tapering crown and is heavily adorned with earrings, necklaces, bracelets, anklets, and rings on fingers and toes. The sacred cord consists of three threads, said to represent the three letters of the mystic syllable "om." Poles could have been inserted through the rings at the four corners of the base, allowing the image to be carried in ceremonial processions.

The monumental style and superb casting of this piece exemplify the high achievement of early Chola art. *Purchase, John D. Rockefeller 3d Gift, 1962, 62.265*

22 Standing Parvati

Indian, Tamil Nadu, Chola dynasty, 10th c.
Bronze; h. 27⅜ in. (69.5 cm)

Parvati, the consort of Shiva, stands in the *tribhanga* (thrice-bent) pose. Her lithe left arm rests at her side, and her right hand is partly raised (at one time it may have held a lotus). Her hair is piled high into a conical crown decorated with elaborate ornaments. Curls fall across the back of her shoulders in a loose fan shape. She wears more than the usual amount of jewelry; a rich girdle with two long tassels holds the form-revealing dhoti, beautifully stylized in a symphony of ridged folds. The lyrical and rhythmic carriage of her body, especially the hips and lower limbs, is characteristic of the masterly achievement of the great South Indian bronzes of the early tenth century when the Chola dynasty began to gain power. This beautiful image was cast by the lost-wax process. *Bequest of Cora Timken Burnett, 1956, 57.51.3*

24 Standing Hanuman
Indian, Tamil Nadu, Chola dynasty, 11th c.
Bronze; h. 25⅜ in. (64.5 cm)

Hanuman, the leader of the great monkey clan, was an ally of Rama (an avatar of Vishnu). His story is one of the most charming in all Hindu mythology; it is also of great didactic and moral value—in *The Ramayana,* the bravery, courage, and loyalty of Hanuman serve as a supreme example to all. In Chola bronze sculpture Hanuman is almost always depicted standing slightly bent over as if in obeisance before Rama; he is usually part of a larger group that includes Rama and Rama's brother (Lakshmana) and wife (Sita). Except for his thick tail and simian face Hanuman is represented as human. Here he leans forward slightly, appearing to be engrossed in conversation. Chola representations of Hanuman are rare, and this example is probably the finest known. *Purchase, 1982, 1982.220.9*

25 Yashoda and Krishna ▶
Indian, Karnataka, Vijayanagar period, ca. 14th c.
Copper; h. 13⅛ in. (33.3 cm)

The Krishna legend is recounted in books ten and eleven of *The Bhagavata Purana,* a great Hindu epic. As an infant, Krishna was exchanged for a daughter born to a cowherding couple to prevent his being killed by the wicked king Kamsa. The stories of Krishna's heroic exploits are well known and revered by the Indian peoples, but the legends concerning his infancy and youth are especially beloved. The subject of the cowherd Yashoda holding her foster son, Krishna, is very rare in Indian art, particularly in sculpture. Here she is nursing the infant god; with her left hand she cradles the head of Krishna, and with her right she holds him below his waist. This depiction is surely one of the most intimate and tender portrayals in the history of Indian art. *Purchase, Lita Annenberg Hazen Charitable Trust Gift, in honor of Cynthia Hazen and Leon Bernard Polsky, 1982, 1982.220.8*

AFGHANISTAN

26 Linga with One Face (*Ekamukhalinga*)
Afghani, Shahi period, 9th c.
White marble; h. 22½ in. (57.2 cm)

In Hindu theology worship of the linga (phallic emblem) is understood to be worship of the great generative principle of the universe conceptualized as one aspect of the Lord Shiva. The linga is usually the most sacrosanct icon of a Shaivite temple, housed in the main sanctum.

The phallic symbol can be plain or have carved on it one to five faces. The lower shaft of the linga was set into a stone pedestal, the *pitha* or *pindika,* which theoretically corresponded to the female genitalia, though not in actual form. This sculpture shows the orthodox representation of a linga with a single face of Shiva, an *ekamukhalinga.* In traditional fashion Shiva wears the crescent moon in his double-bun hairdo; he also wears earrings and a necklace, his usual adornments. The vertical third eye appears on his forehead. This work is a masterpiece of the Shahi school, which worked almost exclusively in white marble. *Rogers Fund, 1980, 1980.415*

27 Standing Bodhisattva
Nepalese, 8th–9th c.
Gilded bronze; h. 12 in. (30.4 cm)

This majestic sculpture is one of the finest ex-
tant early Nepalese bronzes. Skillfully modeled,
the bare-chested bodhisattva stands in a subtle
contrapuntal posture, the right leg slightly re-
laxed, with the weight of the body resting on the
rigid left leg. He holds a fly whisk in his raised
right hand and the stem of a lotus, the upper
portion of which has not survived, in his left
hand. The deity is dressed in the orthodox
fashion of the period, wearing the usual com-
plement of jewelry; the sacred thread goes from
the left shoulder to the right knee, and a sash,
slung diagonally across the abdomen, termi-
nates in full drapery folds with pointed ends.
The complex arrangement of the garments bal-
ances the elaborate lower portion of the lotus
stem. The elegant proportions of this tall figure
are emphasized by the high chignon and tripar-
tite tiara. *Gift of Margery and Harry Kahn, 1981,
1981.59*

28 Standing Maitreya
Nepalese, 9th–10th c.
Gilt copper with polychrome; h. 26 in. (66 cm)

Ninth-century Nepalese art clearly exhibits the
influences of the art of India. In this sculpture
the elegance of the Pala style at Nalanda is
combined with a wholly Nepalese aesthetic.
This large image of Maitreya, the messianic
bodhisattva, stands in a pronounced *tribhanga*
(thrice-bent) posture. The sensual exaggeration
of the pose is most unusual for Nepalese art of
this early period. This is an extraordinarily radi-
ant and sensuous sculpture. Not only is it one of
the largest of the early Nepalese bronzes in the
West, it is also the only example of such refined
elegance combined with an almost austere
economy of surface decoration. A master sculp-
tor has produced an image combining a deep
spiritual presence with a most beautifully ar-
ranged system of volumes. *Rogers Fund, 1982,
1982.220.12*

29 Hari-Hara
Cambodian, Pre-Angkor period, ca. late 7th–
early 8th c.
Calcareous sandstone; h. 35½ in. (90.1 cm)

Among the rarest and most beautiful South
Asian sculptures, Pre-Angkor statues are char-
acterized by a rather naturalistic treatment of
the body and, often, a polished surface. The
stylistic allegiance is to the aesthetic systems of
the Gupta period in India (no. 19), and the ico-
nography is usually Hindu. Hari-Hara is a
syncretic Hindu deity in whom the aspects and
powers of Shiva and Vishnu are combined. This
iconography was popular in Southeast Asia dur-
ing the sixth through the ninth century, and the
Museum's standing four-armed Hari-Hara fol-
lows orthodox traditions. His hairdo is split
down the center, one side displaying Shiva's
piled-up locks and the other Vishnu's high, un-
decorated miter. Half of Shiva's vertical third eye
is incised on the forehead. The raised left hand
probably held a conch, and the lowered left
hand probably rested on a mace—both attri-
butes of Vishnu. The raised right hand would
have held Shiva's trident, and the lowered right
may have been extended toward the worshiper.
*Purchase, Laurance S. Rockefeller Gift and
Anonymous Gift, 1977, 1977.241*

30 Standing Ganesha
Cambodian, Pre-Angkor period, second half of
7th c.
Calcareous sandstone; h. 17¼ in. (43.8 cm)

Ganesha, the elephant-headed Hindu god of
auspiciousness, is popularly accepted as being
the first son of Shiva and Parvati. He is the deity
who controls obstacles—inventing them or re-
moving them—and he is worshiped before
beginning any serious undertaking. Like the
Museum's Hari-Hara (no. 29), this sculpture is
from the Pre-Angkor period (sixth to early ninth
century). This charming small Ganesha is well
modeled, with an emphasis on the full volumes
of the body and head. The sculptural quality is
so outstanding, and the spirit of this delightful
god so well captured, that it ranks very high
among the few extant Pre-Angkor stone
Ganeshas. *Louis V. Bell and Fletcher Funds,
1982, 1982.220.7*

31 Presentation Bowl

Malaysian(?), ca. 7th–8th c.
Bronze; h. 8¼ in. (20.9 cm)

The top section of this extraordinary bronze vessel is cast with a continuous frieze depicting two scenes: a procession leaving a walled city and a palace courtyard with musicians and a dancer performing for a nobleman and his consort, who are seated on a raised platform with attendants and spectators. The vessel is clearly the product of an advanced and very accomplished workshop with a strongly developed narrative style, but the function or purpose of the bowl is not known. With its elaborate narrative frieze it seems inappropriate for use as either a relic casket or a foundation casket for a religious edifice; perhaps it was intended as an important presentation piece. The scenes represented have not been identified. *Rogers Fund, 1975, 1975.419*

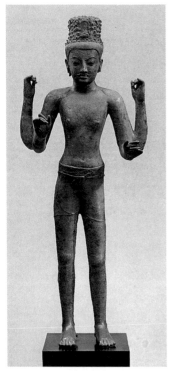

33 Brahma

Cambodian, Angkor period, Bakheng style, late 9th–early 10th c.
Limestone; h. 47½ in. (120.7 cm)

This four-headed, four-armed figure of the Hindu deity Brahma is reportedly from Prasat Prei. That temple, however, belongs to the reign of Jayavarman II (first half of the ninth century), whereas this sculpture is executed in a pure Bakheng style. Therefore, if the information that it comes from Prasat Prei is correct, it must belong to a later phase of this building.

Brahma wears a *sampot;* the manner in which this garment is arranged is typical of the Bakheng style. Also characteristic of this period is a certain rigidity and stiffness in the figure. *Fletcher Fund, 1935, 36.96.3*

32 Four-Armed Avalokiteshvara

Thai, Prakhon Chai, ca. second quarter of 8th c.
Bronze, inlaid with silver and black glass or obsidian; h. 56 in. (142.2 cm)

In 1964 a group of Buddhist bronzes was discovered at Prakhon Chai, Buriram province, Thailand. Reflecting Cambodian, Indian, and Mon influences in an unequal admixture, they are the mature products of important workshops with obvious connections to Si Tep and Lopburi, major centers for sculpture in central Thailand. This piece, the largest and one of the finest of the trove, depicts Avalokiteshvara, the bodhisattva of infinite compassion. (See also nos. 6 and 8.) *Rogers Fund, 1967, 67.234*

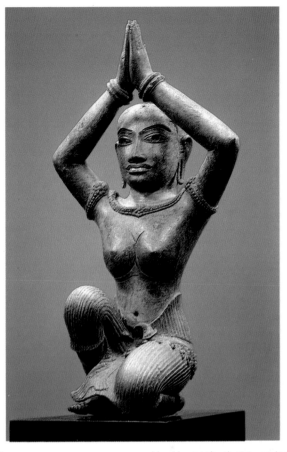

34 Kneeling Queen

Cambodian, Angkor period, Baphuon style,
ca. mid-11th c.
*Bronze with traces of gold, inlaid with
silver; h. 17 in. (43.2 cm)*

This is one of the most beautiful Khmer bronzes
outside Cambodia. In this magnificently poised
and balanced figure, the forms and volumes
blend harmoniously at every viewing angle. It
was once part of what must have been a spec-
tacular bronze group, produced by imperial
workshops and perhaps housed in one of the
temples at the great Angkor complex. *Purchase,
Bequest of Joseph H. Durkee, by exchange,
1972, 1972.147*

INDIAN PAINTING

35 Manuscript Cover

Indian, 9th–10th c.
*Ink and colors on wood, metal insets; h. 2¼ in.
(5.7 cm)*

The format and iconography of this manuscript
cover relate it to eleventh-century Pala-Nepalese
manuscript paintings, but the style of painting is
not only considerably earlier but is allied to the
western cave-painting tradition at Ajanta, Bagh,
and Ellora. This cover is the only work known
that links these traditions. The scenes depicted
on the inside of the cover, except that of the
central panel, are from the life of the Buddha.
The central panel (a detail of which is shown
here) depicts the seated Prajnaparamita, the
Buddhist goddess of Transcendent Wisdom,
flanked by bodhisattvas. This almost certainly
indicates that the palm-leaf manuscript pro-
tected by this cover was the *Ashtasahasrika
Prajnaparamita* (The Perfection of Wisdom in
Eight Thousand Verses), one of the most im-
portant Buddhist texts of the period. *Gift of The
Kronos Collections and Mr. and Mrs. Peter
Findlay, 1979, 1979.511*

CHINA

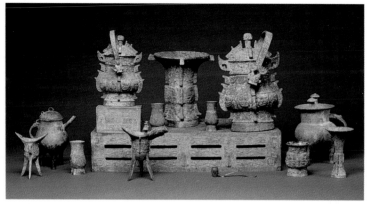

36 Altar Set
Shang and Early Chou dynasties, mid-2nd–early
1st millennium B.C.
Altar table, bronze; 7⅓ × 35⅜ × 18¼ in.
(18.7 × 89.9 × 46.4 cm)

This ritual bronze altar set, comprising fourteen
objects, is extraordinary for its completeness as
well as for the quality and vitality of the individ-
ual pieces. Tuan Fang, viceroy of Shensi
province, purchased the set when it first came
to light in 1901. The Museum acquired it from
his heirs in 1924. The excavation of these
bronzes is undocumented, but they are believed
to have come from an early Chou tomb at Tou-
chi T'ai in Shensi. The vessels themselves prob-
ably date from the Shang and Early Chou
periods. Cast with superb control of the bronze
technique, they are clearly the product of a cul-
ture at its peak. These vessels are related to
ancestor worship, but the exact nature of their
sacrificial and ritual functions is not entirely
clear. The wealth of motifs (particularly the t'ao-
t'ieh masks, dragons, and birds) shows a com-
plete mastery of the art of decorating bronze
forms. *Munsey Fund, 1924, 24.72.1–14*

37 Standing Buddha ▶
Northern Wei dynasty, 386–585
Gilt bronze; 55¼ × 19½ in. (140.3 × 49.5 cm)

This figure is the largest and most important
Northern Wei gilt-bronze statue yet discovered.
The Buddha, standing with outstretched arms
on a lotus pedestal, seems to be welcoming
worshipers. His monastic robe clings in the "wet
drapery" manner, its folds swirling around the
chest and shoulders and falling in ever-
widening ripples. The cranial protuberance
(*usnisha*), the elongated arms, and the large
webbed hands are supernatural attributes of the
Buddha. An inscription around the base dates
the piece to 477 and identifies it as Maitreya, the
Buddha of the Future, but some doubt has been
expressed about the authenticity of this inscrip-
tion. This great image, however, is certainly of
the fourth century. *John Stewart Kennedy Fund,
1926, 26.123*

38 Altar Shrine with Maitreya
Northern Wei dynasty, 524
Gilt bronze; h. 30¼ in. (76.8 cm)

This elaborate and nearly complete Buddhist
shrine of the early sixth century is said to have
been excavated in 1924 in a small village near
Cheng-ting fu in Hopei province. It is a master-
ful grouping of many separate elements in a
shimmering Buddhist pantheon. The central fig-
ure, the Future Buddha, Maitreya, stands in
front of a leaf-shaped mandorla whose open-
work surface gives the effect of flickering flame.
Apsarases, their draperies fluttering upward,
alight on rosettes that decorate the edge of the
mandorla; each plays a musical instrument. The
Buddha is flanked by two standing bodhisatt-
vas. At his feet sit two others; on either side of
these seated figures are a pair of donors. At the
center front, a genie supports an incense
burner protected by lions and guardians. The
inscription on the back of the stand gives the
date of the altarpiece, which corresponds to
524, and reveals that the image was made at the
order of a father to commemorate his dead son.
Rogers Fund, 1938, 38.158.1a–n

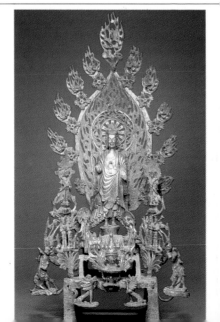

39 Seated Buddha

T'ang dynasty, 7th c.
Dry lacquer; h. 38 in. (96.5 cm)

Few early Chinese dry-lacquer figures have been preserved. In this technique numerous layers of lacquer-soaked cloth are molded over a wooden armature to the desired thickness and form; the figure is then painted in gesso, polychrome, and gilt.

This Buddha is said to be from Hopei province. The simplicity of the cranial protuberance, the squared-off hairline, and the sharply defined facial features all indicate a seventh-century date. Remnants of orange and gold still brighten the gray surface of the figure. *Rogers Fund, 1919, 19.186*

40 HAN KAN, T'ang dynasty, act. ca. 742–56
Night-Shining White
Handscroll; ink on paper; 12⅛ × 13⅜ in.
(30.8 × 34 cm)

Han Kan's portrait of Night-Shining White, one of the favorite horses of the T'ang emperor Ming-huang (r. 712–56), may be the best-known horse painting in Chinese art. Recorded by eminent critics almost continuously from the ninth century on, the short handscroll also has a formidable pedigree in the form of seals and colophons. The animal, with its wild eye, flaring nostrils, and prancing hooves, epitomizes Chinese myths about "celestial steeds" that were dragons in disguise. Although the horse is tethered to a sturdy post, *Night-Shining White* radiates supernatural energy. At the same time it presents an accurate portrayal of a strong, restless animal. The sensitive contour lines are reinforced by pale ink-wash modeling in a style known as *pai-hua*, or "white painting." *Purchase, The Dillon Fund Gift, 1977, 1977.78*

41 Summer Mountains
Northern Sung dynasty, 11th c.
Handscroll; ink and light color on silk;
17¾ × 45¼ in. (45.1 × 114.9 cm)

The monumental landscape style, in the ascendant since the first half of the tenth century, reached its apogee around the middle of the eleventh century. In landscape painting the subject was creation itself. Mountains and trees contrast with and complement each other according to yin and yang concepts in various relationships of high and low, hard and soft, light and dark—to create infinite change, variety, and interest in a timeless landscape. *Summer Mountains*, attributed to Ch'ü Ting (act. ca. 1023–56), depicts the vastness and multiplicity of the natural world. The best way to appreciate such a painting is to look closely and identify oneself with a human figure or a man-made object in the scene. The vastness of the view surrounding the tiny travelers is as convincing as it is staggering. Strife and concern seem far away from a world of such visual splendor. *Gift of The Dillon Fund, 1973, 1973.120.1*

42 KUO HSI, Northern Sung dynasty,
ca. 1000–ca. 1090
Trees Against a Flat Vista
Handscroll; ink and pale color on silk;
13¾ × 41¼ in. (34.9 × 104.8 cm)

During the late eleventh century, landscape
painters began to turn away from minutely de-
scriptive portrayals of nature to explore
evocations of a specific mood, a past style, or
temporal phenomena—the changing seasons,
the hours of the day, or the varied effects of
weather. In this painting the bare branches of
the trees and the dense mist suggest an autum-
nal evening; the travelers emphasize the transi-
tory quality of the moment. The panorama is
depicted in blurred ink washes and freely
brushed outline strokes that impart the illusion
of moisture-laden atmosphere and contribute to
the introspective mood of the scene. The "bil-
lowing cloud" rocks and "crab claw" branches
of the trees add to the painting's dreamlike
quality and are hallmarks of Kuo Hsi, the pre-
eminent late-eleventh-century landscapist. *Gift
of John M. Crawford Jr., in honor of Douglas
Dillon, 1981, 1981.276*

43 EMPEROR HUI-TSUNG, Sung dynasty,
1082–1135
Finches and Bamboo
*Handscroll; ink and colors on silk; 11 × 18 in.
(27.9 × 45.7 cm)*

"What good fortune for these insignificant birds
to have been painted by this sage," mused the
famous connoisseur Chao Meng-fu (1254–1322)
in a colophon attached to this gemlike painting.
The sage he refers to is Hui-tsung, the eighth
emperor of the Sung dynasty and the most ar-
tistically accomplished of his imperial line.
During his reign (1101–25) he spent vast sums
in the pursuit of fine calligraphy, of great
paintings, and of spectacular rocks for his
garden-parks.

Finches and Bamboo illustrates the supra-
realistic style of bird and flower painting
practiced at Hui-tsung's Painting Academy.
The painting is signed at the right with the
emperor's cipher over a seal that reads "impe-
rial writing." Over one hundred other seals of
subsequent owners and connoisseurs dot the
scroll. The scroll is also valued for the superb
calligraphy in the form of appreciative com-
ments that follow the painting. *John M.
Crawford Jr. Collection, Purchase, Douglas
Dillon Gift, 1981, 1981.278*

44 Emperor Ming-huang's Flight to Shu
Southern Sung dynasty, 12th c.
Hanging scroll; ink and colors on silk;
32 ⁵⁄₈ × 44 ¾ in. (82.9 × 113.7 cm)

In 745, after thirty-three years of able rule, the T'ang emperor Ming-huang (r. 712–56) fell in love with the concubine Yang Kuei-fei. As he grew indifferent to his duties, court intrigues flourished, and in 755 Yang Kuei-fei came under attack. Fleeing from the capital at Sian to the safety of Shu (Szechuan province), the emperor was confronted by mutinous troops who forced him to assent to the execution of Yang Kuei-fei. Ming-huang looked on with horror and shame and soon after abdicated. This painting depicts the imperial entourage moving through a somber landscape after the execution. Yang Kuei-fei's richly caparisoned white horse is followed by a palace guard who grins at the absence of the rider. The disconsolate emperor, dressed in a red robe, follows at the right. (This painting was called *The Tribute Horse* in earlier Museum publications.)
Rogers Fund, 1941, 41.138

45 CH'IEN HSUAN, late Southern Sung–early Yüan dynasty, ca. 1235–after 1301
Wang Hsi-chih Watching Geese
Handscroll; ink, color, and gold on paper;
9¹⁄₈ × 36½ in. (23.2 × 92.7 cm)

Ch'ien Hsuan's life was half over when the Mongols completed their conquest of China, and after 1279 he chose to live as an *i-min*, a "forgotten citizen" of the Sung dynasty. His "blue-and-green" style is a consciously "primitive" manner. The "blue-and-green" idiom originated in the T'ang period (618–907), and its characteristic features are the "iron-wire" outline technique and the use of flat mineral green and blue colors. In *Watching Geese* we see this archaic idiom used as the perfect nonrealistic mode for depicting a classic art-historical story. Wang Hsi-chih (321–379), the calligraphic master of legendary fame, derived inspiration from natural forms; he was said to have solved difficult technical problems of writing by observing the graceful movements of geese. *Gift of The Dillon Fund, 1973, 1973.120.6*

46 CHAO MENG-FU, Yüan dynasty, 1254–1322
Twin Pines Against a Flat Vista
*Handscroll; ink on paper; 10½ × 42 in.
(26.7 × 106.7 cm)*

A minor member of the Sung imperial clan,
Chao Meng-fu was a young man when the
Southern Sung fell to the Mongols. He went
north in 1286 to serve at the Mongol court;
there he came in contact with the Northern
Sung tradition of landscape painting. In South-
ern Sung painting a brushstroke's primary
function is to represent form, either as an out-
line or as a modeling stroke. Chao, however,
advised that calligraphic techniques be used in
painting, stating that "calligraphy and painting
have always been the same." Rocks and pines, a
subject made popular by Northern Sung mas-
ters (no. 42), here act as the vehicle for the
expressive brushwork of a master calligrapher.
Chao's approach influenced succeeding paint-
ers, allowing them to "write out" their feelings
in pictorial form. *Gift of The Dillon Fund, 1973,
1973.120.5*

47 NI TSAN, late Yüan–early Ming
dynasty, 1301–1374
Woods and Valleys of Yü-shan
*Hanging scroll; ink on paper; 37½ × 14⅛ in.
(95.3 × 35.9 cm)*

The late Yüan period—the years from 1333 to
1368 that saw the overthrow of the Mongols—
was among the most chaotic in China's history.
One of the Four Great Masters of this era, Ni
Tsan developed only one basic landscape com-
position: sparse trees, sometimes with an empty
pavilion, standing on a riverbank, with distant
mountains on the opposite shore. In this hang-
ing scroll, dated 1372, the trees, like lonely
friends, huddle together against an otherwise
bleak background. The stillness of the trees and
rocks becomes even more alluring when they
are seen as symbols of deep and melancholy
thoughts. *Gift of The Dillon Fund, 1973,
1973.120.8*

49 T'ANG YIN, Ming dynasty, 1470–1524
The Moon Goddess Ch'ang O
Hanging scroll; ink and colors on paper;
53½ × 23 in. (135.3 × 58.4 cm)

A supremely gifted scholar and painter, T'ang
Yin forfeited all chances of an official career af-
ter being involved in an examination scandal in
1499. Turning to painting and poetry for his sub-
sistence, he led the life of a dissolute scholar
and died in poverty. This brilliantly executed
painting (ca. 1510) is a poignant reminder of
T'ang Yin's dashed dreams for success in the
official examinations—symbolized by the cassia
branch in the goddess's left hand. (The word
"cassia" [*kuei*] is a pun on the word "nobility,"
which has the same pronunciation.) T'ang Yin's
poem, in bold calligraphy, reads in part:
"Ch'ang O, in love with the gifted scholar,/
Presents him with the topmost branch of the
cassia tree." The flat, oval face and elegant flut-
tering drapery of the moon goddess reflect the
Ming emphasis on beautiful calligraphic line
rather than three-dimensional form. *Gift of
Douglas Dillon, 1981, 1981.4.2*

48 The Assembly of the Buddha Shakyamuni
Shansi province, ca. second quarter of 14th c.
*Water-base pigments over clay mixed with
mud-and-straw foundation; 24 ft. 8 in. ×
49 ft. 7 in. (7.52 × 15.12 m)*

The northern province of Shansi is a region rich
in monuments of Buddhist art. A distinctive
school of wall painting, containing both Bud-
dhist and Taoist examples, flourished in Shansi
along the lower reaches of the Fen River in the
thirteenth and fourteenth centuries. This monu-
mental mural epitomizes the mannered, elegant
approach of the Fen River artists. Buddhist as-
semblies are arranged symmetrically about a
large central image of the Buddha in one of his
aspects or manifestations. Here Shakyamuni
(the historical Buddha) is flanked by two major
bodhisattvas, and the triad is in turn surrounded
by a host of divine, mythological, or symbolic
figures. Murals such as this one were intended
to provide illiterate believers with a visual ex-
pression of Mahayana Buddhist metaphysics.
They were not, in this period, the principal ob-
jects of devotion but were designed as a
background for sculpture. *Gift of Arthur M.
Sackler, in honor of his parents, Isaac and Sophie
Sackler, 1965, 65.29.2*

50 HUNG-JEN, late Ming–early Ch'ing
dynasty, 1610–1664
Dragon Pine on Mount Huang
*Hanging scroll; ink and slight color on paper;
75⅞ × 31¼ in. (192.7 × 79.4 cm)*

Hung-jen was the central figure of the Anhwei
school of painters, whose common bond was a
fascination with Huang-shan (Yellow Mountain)
in Anhwei province. This monumental work is
one of the monk-painter's many "portraits" of
the eccentric pines that cling to the sheer gran-
ite peaks of the mountain. While Hung-jen's
paintings seem dominated by an aloof moral in-
telligence, intense emotion often lurks just
below the surface. Here the tenacity of the tor-
tuously bent pine reflects the artist's convictions
as a Ming loyalist. Like the pine, he has a pre-
carious existence (Hung-jen chose to become a
Buddhist monk, rejecting the comfort and
safety of an official position under the Ch'ing
dynasty). *Gift of Douglas Dillon, 1976, 1976.1.2*

51 WANG HUI, Ch'ing dynasty, 1632–1717
The K'ang-hsi Emperor's Second Tour of the South
Scroll no. 3; ink and colors on silk; 2 ft. 2⅝ in. × 45 ft. 8½ in. (.68 × 13.93 m)

In 1689 the K'ang-hsi emperor (r. 1662–1722) made a grand tour of southern China to inspect his domains. Wang Hui was commissioned to record the momentous journey in painting, and a series of twelve sumptuous handscrolls was produced by Wang and his assistants between 1691 and 1698. Wang Hui designed the series; he also painted many of the landscape passages, leaving figures, architectural drawings, and the more routine work to his assistants. This scroll—*From Chi-nan to T'ai-an and Ascent of Mount T'ai*—is the third in the set. It shows the emperor's journey through Shantung province and culminates with a view of Mount T'ai, the famous "cosmic peak of the East," where he conducted a ceremony of worshiping heaven. The landscape background, painted in ink and cool colors with blue and green predominating, is typical of the style of Wang Hui's later years. *Purchase, The Dillon Fund Gift, 1979, 1979.5*

52 The Astor Court

The Astor Court is modeled on a scholar's court in the Garden of the Master of the Fishing Nets in Soochow, a city renowned for its garden architecture. Chinese gardens were meant to be lived in as well as viewed. The formula for domestic architecture, repeated over thousands of years, was to build rooms around a central courtyard that provided light, air, and a view of the outdoors to each room. The scholar's garden began with domestic architectural forms and added to them the wildness of nature. By enlarging courtyards and buildings, by increasing the plantings, by adding rocks and water,

the scholar created a microcosm of the natural world. In the scholar's garden, as in the Astor Court, complexity of space is achieved through an orderly use of yin and yang opposites: darkness and light, hardness and softness.

This garden court represents the first permanent cultural exchange between the United States and the People's Republic of China. The materials needed for construction were gathered and manufactured in China, and the court was built almost entirely by Chinese craftsmen. The Vincent Astor Foundation provided the funds for the Astor Court, which includes the Ming Hall at its north end.

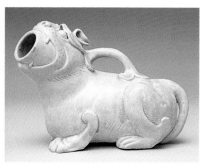

53 Vessel
Six Dynasties, late Northern Dynasties
ca. second half of 6th c.
*Stoneware with celadon glaze; l. 11⅞ in.
(30.2 cm)*

This magnificently sculpted crouching animal
epitomizes the great affection and charm with
which the Chinese have always represented ani-
mals. The pale olive glaze is an interesting
example of a major category of high-fired green
glazes generally called "celadons" in the West.

An extremely important group of celadon-
glazed stonewares was produced in numerous
kilns in northern Chekiang and southern
Kiangsu provinces from as early as the Han dy-
nasty into the Sung era; these ceramics are
frequently called proto-Yüeh and Yüeh wares,
probably after an administrative capital once
known as Yüeh Chou.

Recent tomb and kiln-site finds suggest that
another tradition of green-glazed stonewares
was established in northern China during the
Six Dynasties, probably by the mid-sixth cen-
tury. Analysis of the composition of this vessel
indicates that it may be assigned to this lesser-
known group of northern wares. *Harris Brisbane
Dick Fund, 1960, 60.75.2*

54 Flask
T'ang dynasty, ca. 9th c., probably from Huang-
tao kilns, Honan province
*Stoneware with suffused glaze; h. 11½ in.
(29.2 cm)*

Among the most dramatic T'ang stonewares are
those with fairly thick, opaque dark-brown or
black glazes, which seem to add extra power to
already energetic shapes. Sometimes, as on this
stunning flask, the dark glazes are suffused with
bold splashes of contrasting color, including
shades of cream, gray, blue, and lavender. These
patches of color generally appear to have been
applied at random and to have been permitted
to run at will over the glaze. The unusual shape
of this exceptionally fine flask was probably
based on a leather prototype. As on the leather
original, a cord can be passed up the sides and
through two loops; the back is flat, allowing the
flask to lie securely when carried. *Gift of Mr. and
Mrs. John R. Menke, 1972, 1972.274*

55 Bowl
Five Dynasties, 10th c., Yüeh ware, probably
from a kiln in the vicinity of Shang-lin Hu,
Chekiang province
*Stoneware with celadon glaze; diam. 10⅝ in.
(27 cm)*

The celadon-glazed wares that had been the
pride of the Yüeh kilns for centuries reached
their high point during the Five Dynasties pe-
riod (907–60), when Yüeh potters produced
some of the finest ceramics in the history of the
region. An important part of their output, known
as *mi-se yao*, "secret-color ware," was reserved
for the princes of Wu-Yüeh, who controlled the
area. This special ware is probably represented
by one of the great treasures of the collection—
this bowl with a splendidly carved design of
three high-spirited dragons under a lustrous,
translucent soft-green glaze. The agile grace
displayed by these dragons as they race across
a background of waves is a tribute to the peer-
less technique of the carver, who, by pressing a
stylus against damp clay, has virtually created
perpetual motion. (One dragon's tail is tucked
under its hind leg, a Yüeh trademark.) *Rogers
Fund, 1917, 18.56.36*

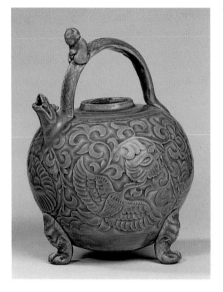

56 Ewer

Northern Sung dynasty, 11th–12th c., probably from Huang-pao Chen (Yao Chou) kilns, Shensi province
Stoneware with celadon glaze; h. 8¼ in. (21 cm)

This magnificent ewer demonstrates the special talent of Sung potters for stressing shape and glaze, relegating ornament—no matter how complex—to the lesser role of complementing rather than dominating the object. The body is brilliantly carved with two phoenixes flying amid a ground of scrolls with conventionalized flowers and sickle-shaped leaves. The bold design is emphasized by the translucent olive-green glaze, which accumulates in the recessed areas, intensifying in tone and accenting the pattern. Standing on three scowling-mask legs that terminate in paws, the ewer is topped by a high arched handle in the form of a serpentlike dragon, whose head forms the spout; a small figure crouches on its back. This ewer exemplifies the group of wares, generically known as Northern celadons, produced at several kiln complexes in northern China during the Northern Sung, Chin, and Yüan periods. *Gift of Mrs. Samuel T. Peters, 1926, 26.292.73*

57 Jar

Ming dynasty, Hsüan-te mark and period, 1426–35, from kilns at Ching-te Chen, Kiangsi province
Porcelain painted in underglaze blue; h. 19 in. (48.3 cm)

The porcelains of the Ming dynasty have attained such recognition in the West that "Ming" has almost become the generic name for anything ceramic fabricated in China before the twentieth century. While, unhappily, many of the pieces called "Ming" have no claim to that attribution, the porcelains that were produced during the period are among the most beautiful and exciting to emerge from China's kilns. In many respects the blue-and-white porcelains of the early fifteenth century illustrate these wares at their apogee. They combine the freedom and energy of a newly ripened art form with the sophistication of concept and mastery of execution that come with maturity. The highest traditions of early Ming-dynasty brushwork are represented in the bristling dragon on this marvelous jar. Flying amid cloud forms, he moves around the jar with total power and consummate grace. Flanked by the heads of fearsome monsters is an inscription with the reign title of the incumbent emperor, Hsüan-te (1426–35). *Gift of Robert E. Tod, 1937, 37.191.1*

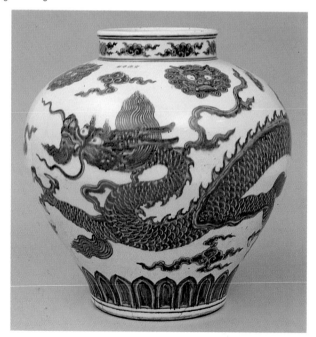

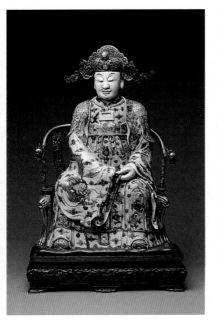

58 The God of Wealth in Civil Aspect
Ch'ing dynasty, probably K'ang-hsi period, late 17th–early 18th c., from kilns at Ching-te Chen, Kiangsi province
Porcelain painted in polychrome enamels on the biscuit; h. 23⁷⁄₈ in. (60.6 cm)

Seated on a gilded silver throne, his filigreed hat set with pearls, jade, and kingfisher feathers, this figure is truly gorgeous. One of a pair, he is possibly the God of Wealth in Civil Aspect (the other may be the God of Wealth in Military Aspect); he wears elaborately fashioned robes, sumptuously embroidered with a panoply of flowers and auspicious symbols. The figure is decorated in the famille verte palette of enamels, but rather than using them over a glaze—which would tend to fill in and blunt the sharp modeling of the features and contours of the garments—the painter has applied them directly onto the unglazed, prefired (or biscuited) porcelain body. *Bequest of John D. Rockefeller Jr., 1961, 61.200.11*

TEXTILES

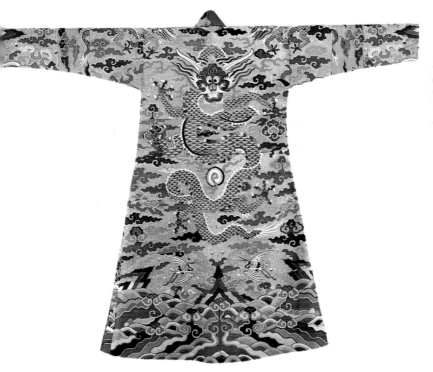

59 Lay Aristocrat's Robe (*Chuba*)
Tibetan, 18th–19th c.
Silk yarns and silk yarns wrapped with gold (k'o-ssu); 62 × 75 in. (157.5 × 190.5 cm)

The Tibetans established a special relationship with the Chinese court from the Mongol period onward. Many Tibetan monasteries and priests were recipients of fine Chinese textiles from the Chinese court in the fourteenth and fifteenth centuries. Some of these Chinese robes were later modified to make Tibetan costumes. This is a fine example of an early Ch'ing dragon robe refurbished into a *chuba*. *Rogers Fund, 1962, 62.206*

60 *Yogi* Coverlet
Japanese, 19th c.
Cotton with cone-painted resist, hand-painted
pigments; h. 63½ in. (161.3 cm), greatest
w. 58½ in. (148.5 cm)

A *yogi* coverlet is ceremonial bedding in the
form of a robe. On this one, the New Year is
symbolized by striking ornaments—the straw
rope with its prescribed strips of seaweed at in-
tervals and traditional auspicious objects (the
lobster, the fern and *yuzuriha* leaves, and the
mandarin orange). These decorative elements
are resist-dyed and, except for the rope, which
is left white, are painted with bright-colored
pigments. The large family crest at the top is
composed of three cloves in a fine clear-dyed
blue. *Seymour Fund, 1966, 66.239.3*

61 Ship Cloth
Sumatran, southern Lampong region, late
19th c.
Woven textile; 27 × 113½ in. (68.5 × 288.3 cm)

Among the most remarkable textiles of the Indo-
nesian archipelago are the so-called ship cloths,
which were woven on the south coast of
Sumatra. One group was decorated with a long
ship or a pair of ships in profile, usually carrying
animals and riders, trees, birds, buildings, and
human figures. The Museum's fine example
(a detail of which is illustrated) belongs, in the
designation of the Sumatrans, to the long ship
cloths (*palepai*). These cloths were hung as
backdrops in ceremonies of transition, such
as weddings and the presentation of the first
grandchild to its maternal grandparents. They
have not been made for at least seventy-five
years, and their origins and the reasons for
their decline are still only conjectural. *Gift of*
Alice Lewisohn Crowley, 1939, 1979.173

62 Woman's Robe (kosode)

Japanese, Edo period, late 17th c.
Satin, tie-dyed, stitch-resisted, embroidered with
silks, couched with silk yarns wrapped in gold;
53½ in. (135.9 cm), w. at sleeves 53 in.
134.6 cm)

This kosode reflects the taste of the Genroku
era (1680–1700), when the wealthy merchant
class was beginning to dominate society and
artists such as Ogata Kōrin (nos. 11 and 12)
were active. The bold design and soft, sump-
uous colors are typical, as is the use of a variety
of techniques to create a single garment. A
branch with enormous cherry blossoms in tie-
dye and stitch-resist hangs in the center of the
robe's back. Below this branch cherry blos-
soms float in front of zigzags suggesting the
cypress slats of a garden fence. A section of a
waterwheel appears on one sleeve, cherry
blossoms on the other. The combination of
cherry blossoms with the waterwheel and the
garden fence undoubtedly has poetic or liter-
ary overtones. Purchase, Mary Livingston
Griggs and Mary Griggs Burke Foundation Gift,
1980, 1980.222

63 Welcoming the New Year

Chinese, Yüan dynasty, late 13th or early 14th c.
Panel; silk embroidery and plant fiber (some orig-
nally gold wrapped) on silk gauze; 85 × 25¼ in.
(215.7 × 64.1 cm)

During the Sung and Yüan dynasties, the art of
embroidery reached a peak of refinement and
complexity, with decorative compositions fre-
quently imitating paintings both in format and in
subject matter. Embroidered hangings were dis-
played in palace halls or residences to mark the
changing seasons or to celebrate a birthday or
the New Year. This large embroidered panel
combines a number of auspicious symbols ap-
propriate to the New Year's celebration. Young
male children, here in Mongol costume, prom-
ise new life and the continuation of the family
line; sheep and goats are emblems of good for-
tune. Since the word for sheep and goats (yang)
also suggests that aspect of the yin–yang
dichotomy associated with growth, warmth, and
light, the embroidery may be read as a visual
pun conveying a wish for a sunny and pros-
perous New Year. Technically, the panel is
extraordinary for its unusual and painstaking
workmanship. Purchase, The Dillon Fund Gift,
1981, 1981.410

JOHN GALLIANO (designer), British, b. 1960
CHRISTIAN DIOR (couturier), French (Paris),
est. 1947
Evening Gown
Silk taffeta; l. (center back) 57 in. (144.8 cm)

In this gown from John Galliano's controversial
"Hobo" collection for Dior (spring/summer 2000),
extravagant silk taffeta is whipped into a spiral-
ing vortex. The stiffness of taffeta and the virtu-
osity of the Dior atelier contribute to this illusion
of fabric come to life. From neckline to train, four
parallel panels are angled into a body-conforming
bias. The gown recalls both the aerodynamic
sleekness of the 1930s, in its second-skin fit, and
the 1950s illustrations by René Gruau of fabric
snaking around bodies and spinning into space.

Here, as in many of Galliano's creations,
cross-pollination of sources has resulted in a
new hybrid. He consistently assimilates the
styles and sensibilities of the past into contem-
porary glamour. While his creations are gener-
ally apolitical, an implicit social critique may be
read into this haute couture confection inspired
by the ragged clothing of Parisian tramps. *Gift of
Anne E. de la Renta, 2001, 2001.397*

COSTUME INSTITUTE

Founded in 1937, the Costume Institute collects, preserves, and exhibits clothing from the late sixteenth century to the present. The exceptionally comprehensive collection includes both fashionable dress and regional costumes from Europe, Asia, Africa, and the Americas; its archives include accessories and photographs, and there is an extensive costume library.

The Costume Institute is a research center where designers from the theater and the clothing industry, as well as students, scholars, and other professionals in the field of design, can study costumes and related materials. The library and storage facilities are available by appointment for consultation by scholars and professionals.

1 Man's Doublet
Spanish, late 16th c.
Silk velvet with patterned silver-gilt bands;
l. at center back 23 in. (58.4 cm)

Paintings, which are the primary visual source for research of costume before the eighteenth century, cannot furnish the kind of information that actual garments provide. For example, from a careful look at the front panels of this doublet we learn that it is the use of the grain of the fabric, cut on the bias, that helps it to fit smoothly and gives it its fashionably elongated protruding center front, called a peacod belly.

For several centuries the doublet was an indispensable article of gentlemen's apparel. It evolved from the protective padded shirts worn under armor during the Middle Ages. To fit comfortably, particularly under plate armor, it had to be shaped closely to the body. For this reason doublets are probably the earliest examples of "tailor-made" clothing. In the latter part of the seventeenth century they grew longer and became waistcoats. Today's men's vests are descendants of the doublet. *Purchase, Catharine Breyer Van Bomel Foundation Gift, 1978, 1978.128*

2 Chopines
Venetian, ca. 1600
Leather decorated with stamped and pierced designs and silk-floss pom-poms; l. 8¾ in. (22.2 cm)

Chopines—a fashionable version of shoes or sandals on platforms or stilts—arrived in Venice from the Far East in the late fifteenth century. Women found them so appealing that their popularity, which was to last for almost two centuries, spread rapidly from Italy to France and from there to other countries throughout Europe. The height of the platforms varied from three to eighteen inches. High chopines made walking so precarious that to keep from toppling, ladies had to be supported by servants or escorts. Thus wearing chopines was looked on as a status symbol, a privilege of rich upper classes who could afford such dependence. Chopines are an interesting example of the vagaries of fashion. Since earliest times, shoes on raised soles have been worn in many places as a protection against muddy roads and fields. When fashion translated this form of footwear into chopines, a practical article of wearing apparel evolved into an essentially impractical accessory serving primarily to enhance the wearer's worth in the eyes of society. *Purchase, Irene Lewisohn Bequest, 1973, 1973.114.4ab*

3 É. PINGAT & CIE, Paris, ca. 1855–ca. 1893
Ball Gowns
(Left) *Satin, various other materials; l. at center back: bodice 11½ in. (29.2 cm), skirt 70 in. (177.8 cm)*
(Right) *Silk faille, various other materials; l. at center back: bodice 13 in. (33 cm), skirt 62¾ in. (159.4 cm)*

These two ball gowns are beautiful examples of the elegant designs of Émile Pingat, one of the first couturiers. They date from about 1866 and were worn by Margaretta Willoughby Pierrepont (1827–1902), the wife of Edwards Pierrepont (1817–1892) whose distinguished career included service as attorney general of the United States and foreign minister to Great Britain.

Little is known of the designer except his name and the address of his shop. The labels on these two dresses read: É. Pingat & Cie, no. 30 rue Louis le Grand, Paris. Both of these gowns show his work at its most sophisticated; especially notable is the embellishment of the wide expanse of the skirts. The dress on the left is of white satin trimmed with ruched tulle, white velvet ribbon, loops of white satin studded with tiny gold beads, and white satin bows. The dress on the right is of white silk faille trimmed with bands of black lace dotted in gilt, black velvet ribbon, white satin appliqués, and black chenille fringe. *Gift of Mary Pierrepont Beckwith, 1969, CI 69.33.1ab* (left), *CI 69.33.12ab* (right)

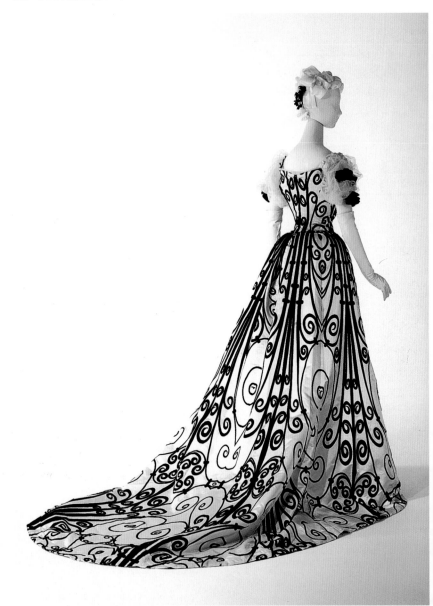

4 HOUSE OF WORTH, Paris, 1858–1956
Evening Gown
Silk satin and velvet; l. of bodice 17 in. (43 cm),
l. of skirt 42½ in. (107.5 cm)

Few garments better demonstrate the relation-
ship of haute couture to a major artistic
movement than does this Worth evening gown
(ca. 1898–1900). The dynamic linear motion as-
sociated with Art Nouveau is clearly evident in
the design of the fabric as well as in the cur-
vilinear volume of the silhouette. The luxury
of the gown, made of heavy white silk satin
voided with black velvet in an Art Nouveau
scroll design, exemplifies the elegance of the
late 1890s. The House of Worth was the first of
the great couture houses of Paris; under its
founder, Charles Frederick Worth (1825–1895),
it was known for the high quality of its design
and craftsmanship. These standards were
maintained by Worth's sons, Jean-Philippe
and Gaston, after the death of their father. *Gift*
of Eva Drexel Dahlgren, 1976, 1976.258.1ab

5 Woman's Costume: Blouse, Skirt, Apron, and Kerchief

Croatian, early 20th c.

Handwoven cotton, embroidered in silk and cotton floss and trimmed with lace; l. of blouse 25½ in. (64.8 cm), l. of skirt 28½ in. (72.4 cm), l. of apron 27½ in. (69.9 cm), kerchief 25½ × 16⅝ in. (64.8 × 42.2 cm)

This costume from Donja Kupčina is characteristic of those worn in the Panonian Plain region of northern Croatia. Unlike the clothing worn in urban areas, where fashions accent change, regional costumes reflect a preference for maintaining a traditional manner of dress that is unique to an ethnic group. As a result, these costumes reflect their geographical origin rather than the date they were made. The fact that this costume has a separate blouse and skirt—instead of the long one-piece chemise worn in most of the southern Balkan states— suggests that it is related to the central-eastern European group of costumes. Details such as the high collar, embroidered bib, deep sleeve cuffs, and system of pleating help to place this costume south of Zagreb in northern Croatia. Formerly a republic of Yugoslavia, Croatia had closer ties to Austria-Hungary than to the Ottoman Empire. Costumes from this region therefore have a distinct European flavor, while those from the lower republics show a strong Turkish influence. *Purchase, Irene Lewisohn Bequest, 1979, 1979.132.1a–c*

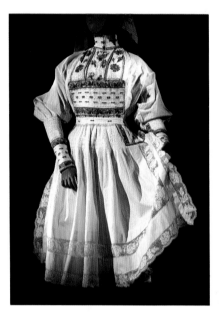

6 PACO RABANNE, French, b. 1934

Dress (left)

Vinyl and metal; l. at center back 28½ in. (74 cm)

WASTE BASKET BOUTIQUE, American, 1966

Dress (center)

Polyethylene; l. at center back 33½ in. (86 cm)

PIERRE CARDIN, French, b. 1922

Dress (right)

Silk; l. at center back 33½ in. (86 cm)

During the 1960s fashion designers sought technological innovation and self-consciously futuristic forms. Novelty and an emphasis on youth and the body resulted in garments of minimal form and experimental technique, including distinctly modern mail for a Space Age hero and disposable silver foil for a plain A-line dress. Historically speaking, the styles were akin to those of the 1920s, as in this Cardin dance dress, which recapitulates the fringe of the period, but designers clearly aspired toward a brave, new world rather than any preceding culture. *Left: Gift of Jane Holzer, 1974, 1974.384.33; center: Gift of Barbara Moore, 1986, 1986.91.1; right: Gift of Mrs. William Rand, 1975, 1975.145.7*

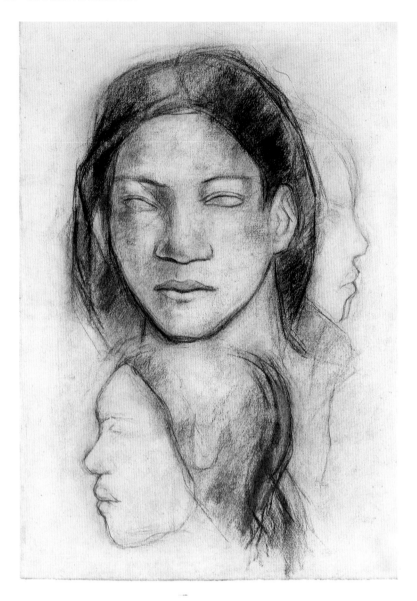

PAUL GAUGUIN, French, 1848–1903
Tahitians
Charcoal on laid paper; 16⅛ x 12¼ in. (41 x 31.1 cm)

Gauguin's almost worshipful appreciation of exotic peoples, whom he believed innocent of modern civilization's woes, is stirringly conveyed in this New World icon (ca. 1891–93). At its center is the face of a dark-haired young woman Gauguin painted on his first voyage to Tahiti. Two renderings of profiles (right and left) are conjoined with a full frontal view in a haunting totemic design. These masklike faces, devoid of any sign of emotion in their blank eyes and closed lips, appear timeless and remote, much as do the stone heads of ancient gods sculpted in Egypt or Asia long ago.

Arguably the finest of all Gauguin's surviving drawings, this charcoal study is a work of exceptional feeling and finesse. By smudging the sooty contour lines and shadows with his fingers (or perhaps a wad of soft bread), the artist defined facial features of the Maori people in a way that conveys both ethnographic accuracy and spirituality. For Gauguin, a young and beautiful Tahitian woman was a powerful symbol of life's forces. *Purchase, The Annenberg Foundation Gift, 1996, 1996.418*

DRAWINGS AND PRINTS

In 1880 Cornelius Vanderbilt presented to the Museum 670 drawings by or attributed to European Old Masters. The collection of drawings grew slowly through purchase, gift, and bequest until 1935, when the Museum purchased an album of fifty sheets by Goya, while more than one hundred works, mostly by Venetian artists of the eighteenth century, were acquired from the marquis de Biron in 1937. It was not until 1960 that the Department of Drawings was established as a separate division of the Museum, with Jacob Bean as its first curator. During the next thirty years, the department's holdings nearly doubled in size; the collection is especially known for its works by Italian and French artists of the fifteenth through the nineteenth century.

The Department of Prints was established in 1916 and rapidly developed into one of the world's most encyclopedic repositories of printed images, under the guidance of its first curators, William M. Ivins Jr. and his successor, A. Hyatt Mayor, both of whom attracted remarkable gifts and bequests to the Museum: Dürer prints from Junius Spencer Morgan; Gothic woodcuts and late Rembrandt etchings from Felix M. Warburg and his family; and Rembrandt, Van Dyck, Degas, and Cassatt prints from the H. O. Havemeyer Collection. The print collection is particularly rich in fifteenth-century German, eighteenth-century Italian, and nineteenth-century French images. Within the department's scope are also more than twelve thousand illustrated books and a comprehensive collection of designs for architecture and the decorative arts.

The Department of Drawings and Prints was created in October 1993, thus uniting the Museum's varied and extensive collections of graphic art. The department maintains a rotating exhibition of its holdings in the Robert Wood Johnson Jr. Gallery, and its Study Room is open to scholars by appointment.

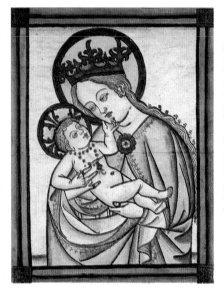

1 Virgin and Child
German, ca. 1430–50
Woodcut, hand-colored, heightened with silver and gold; 13 × 10 in. (33 × 25.4 cm)

The earliest known woodcuts on paper date from about the first quarter of the fifteenth century. Very few, if any, were consciously made as works of art; instead their function and tradition determined their forms. This exquisitely tender Virgin and Child marks one of the high points of folk art. It is typical of the earliest devotional woodcuts that worshipers purchased at local shrines or during pilgrimages. Since such prints were too cheap and common to preserve, very few of the thousands that were made have come down to us. This unique impression is an exception of arresting beauty and majesty. *Gift of Felix M. Warburg and his family, 1941, 41.1.40*

2 After ANDREA MANTEGNA, Italian, ca. 1430–1506
Bacchanal with a Wine Vat
Engraving; 11¾ × 17¼ in. (29.9 × 43.7 cm)

Andrea Mantegna was a quintessentially Renaissance artist, fusing in his intense expressive works the twin strivings of the time toward both naturalism and the revival of classical antiquity. He became intensely interested in the emerging medium of engraving, and some of his best-known compositions were designed for this medium, *Bacchanal with a Wine Vat* among them. It has been suggested that the compositions were originally destined for the decoration of a country palazzo, but they may well have been designed expressly as prints. *Bacchanal with a*

Wine Vat was inspired by an antique sarcophagus that Mantegna saw in Rome, and its friezelike form further recalls antique reliefs, but Mantegna has transformed his model into an intriguing composition that is uniquely his. This impression of the engraving, in a warm brown ink similar in color to that used for drawing, was taken shortly after the plate was engraved, while the fine lines—which flattened quickly and thus no longer printed in the later impressions that are most commonly seen—still provided subtle modeling of the figures. (See also European Paintings, no. 37.) *Rogers Fund and The Elisha Whittelsey Collection, The Elisha Whittelsey Fund, 1986, 1986.1159*

3 LEONARDO DA VINCI, Italian, 1452–1519
Studies for a Nativity
*Pen and brown ink, over preliminary sketches in
metalpoint on pink prepared paper; 7⅝ × 6½ in.
(19.4 × 16.4 cm)*

In these sketches of the Virgin kneeling before
the Christ Child, who lies on the ground,
Leonardo explored a theme that was to emerge
as the *Madonna of the Rocks,* where the Virgin
kneels facing the spectator, her right hand
raised in benediction over the seated Infant
Jesus. The sketches at the center and at the
lower left corner of the sheet, where the Virgin
raises both arms in devotional wonder, are re-
lated to a design by Leonardo that must have
been developed at least to the stage of a com-
plete cartoon, for several painted copies have
survived. The controversy about the dating of
Leonardo's two paintings of the *Madonna of the
Rocks* (Louvre, Paris; National Gallery, London)
makes it difficult to decide whether the drawing
is to be dated 1483 or considerably earlier, dur-
ing Leonardo's first Florentine period. *Rogers
Fund, 1917, 17.142.1*

4 ALBRECHT ALTDORFER, German, 1480–1538

Landscape with a Double Spruce
Etching; 4 ⅜ × 6 ⅜ in. (11.1 × 16.2 cm)

Altdorfer's scenic etchings are among the earliest works to present the subject of landscape unembellished by any reference to story or myth. Shaped by emotion and a certain amount of fantasy, they reflect the artist's deep appreciation of the majestic mountains, rough woodlands, and serenely winding paths and waterways of the Danube Valley, where he made his home. In their stirring response to the drama of nature these etchings helped to inaugurate a tradition later evident in the art of the German Romantics and Expressionists.

Nearly all of Altdorfer's paintings and drawings must be viewed in the great museums of northern Europe; so rare are impressions of his nine landscape etchings that only five are found in the United States, of which the Metropolitan's is the finest example. *Purchase, Gift of Halston, by exchange, The Elisha Whittelsey Collection, The Elisha Whittelsey Fund, and Pfeiffer Fund, 1993, 1993.1097*

5 ALBRECHT DÜRER, German, 1471–1528
Melencolia I, 1514
Engraving; 9 ½ × 7 ½ in. (24.1 × 19.1 cm)

More than five hundred impressions of prints by Dürer are in the Museum's collection. Virtually all of his printed oeuvre is represented: the early works of the 1490s, including several sets of the Apocalypse series, which spread his fame across Europe when it was published in 1498; the works he created for the Holy Roman Emperor Maximilian I in the second decade of the sixteenth century; and the books on geometry and proportion he worked on through much of his life, which were published in the 1520s. *Melencolia I* is one of three so-called master engravings Dürer produced when he was in his early forties; the other two are *Knight, Death, and the Devil* and *Saint Jerome.* The subject personifies both Melancholy, of the Four Humors the one associated with artistic genius, and Geometry, the one of the Seven Liberal Arts that Dürer yearned to understand profoundly, convinced that it was the key to the secrets of perfect form. *Fletcher Fund, 1919, 19.73.85*

6 MICHELANGELO BUONARROTI, Italian,
1475–1564
Studies for the Libyan Sibyl
Red chalk; 11⅜ × 8⅜ in. (28.9 × 21.3 cm)

This celebrated sheet bears on the recto a se-
ries of studies from a nude male model for the
figure of the Libyan Sibyl that appears on the
frescoed ceiling of the Sistine Chapel, commis-
sioned in 1508 and finally unveiled in 1512. In
the principal and highly finished drawing domi-
nating the sheet, Michelangelo has studied the
turn of the sibyl's body and the position of the
head and arms. The left hand of the figure is
studied again below, as are the left foot and
toes. A study of the sibyl's head, possibly the
first drawing made on the sheet, appears at the
lower left, and a rough sketch of the torso and
shoulders is immediately above it. *Purchase,
Joseph Pulitzer Bequest, 1924, 24.197.2*

7 CLAUDE LORRAIN, French, 1604/5?–1682
The Origin of Coral
*Pen and brown ink, brown, blue, and gray wash,
heightened with white; 9¾ × 15 in.
(24.7 × 38.2 cm)*

Signed and dated 1674, this large drawing may
be the final compositional study (*modello*) for, or
record (*ricordo*) of, a painting that Claude exe-
cuted in Rome for Cardinal Camillo Massimi;
the finished work is now in the collection of the
earl of Leicester at Holkham Hall, Norfolk. The
rather unusual subject is taken from Ovid's
Metamorphoses (4:740–752). After rescuing his
future bride, Andromeda, from the sea monster,
Perseus placed the severed head of the Gorgon
Medusa—the trophy of an earlier exploit—upon
a bed of seaweed, which instantly hardened into
coral. Of Claude's six known studies for *The Ori-
gin of Coral*, this one comes closest to the
painting. *Purchase, Mr. and Mrs. Arnold
Whitridge Gift, 1964, 64.253*

8 PETER PAUL RUBENS, Flemish, 1577–1640
Saint Catherine of Alexandria
*Counterproof of etching, first state of three, re-
worked in pen and ink by Rubens; 11⅝ × 7¾ in.
(29.5 × 19.7 cm)*

The swirling Baroque energy of this depiction of
Saint Catherine is typical of both Rubens and
his voluminous artistic output. Rubens presided
over a workshop of assistants—as well as a
large family—in his elegant house in Antwerp,
the preeminent port city of northern Europe
when Rubens was born, although it ceded that
place to Amsterdam during his lifetime. Among
many enterprises, Rubens closely oversaw the
translation of many of his painted compositions
into engravings. The *Saint Catherine*, however,
which is an etching, is the only plate thought to
have been personally worked on by Rubens.
This counterproof, made by running a blank
piece of paper through the press with a freshly
printed impression, was thus oriented in the
same direction as the plate, and the pen strokes
by Rubens indicate where changes were to be
made on the plate. The composition was origi-
nally created as part of the decoration of the
ceiling of the Jesuit church at Antwerp, a com-
mission Rubens worked on in the early 1620s
(the church was destroyed by fire in 1718).
Rogers Fund, 1922, 22.67.3

9 ANNIBALE CARRACCI, Italian, 1560–1609
Study of an Angel
Black chalk, heightened with white, on blue paper; 14 × 9⅝ in. (35.5 × 24.6 cm)

A native of Bologna, Annibale Carracci was instrumental in the revival of interest in life drawing that took place in Italy toward the end of the sixteenth century. This vigorous drawing of a partially draped youth was used for the figure of an angel in the foreground of a now-destroyed altarpiece representing Saint Gregory praying for the souls in Purgatory. Commissioned by Cardinal Antonio Maria Salviati for the church of San Gregorio Magno, Rome, the picture seems to have been finished by October 1603. In style and technique, the Museum's drawing closely resembles the many figure studies that Annibale made in connection with his most famous work, the frescoed decoration of the gallery of the Palazzo Farnese, Rome, which was carried out between 1597 and 1604. *Pfeiffer Fund, 1962, 62.120.1*

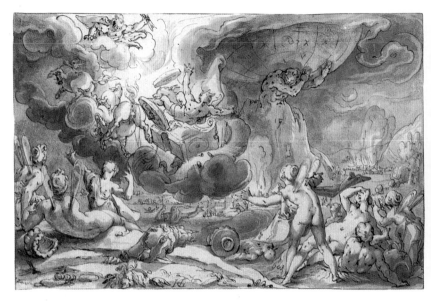

10 HENDRICK GOLTZIUS, Dutch, 1558–1617
The Fall of Phaeton
*Pen and brown ink, brown wash, heightened with
white, incised for transfer; 6½ × 10 in.
(16.5 × 25.3 cm)*

Between 1588 and 1590 the Haarlem Mannerist
Hendrick Goltzius produced designs for two se-
ries of twenty illustrations to Ovid's *Metamor-
phoses,* which were engraved anonymously; af-
ter 1615 he added twelve more. A complete set
is preserved in the Museum's collection of
prints. This splendid drawing is a full-scale
modello, in reverse of the print, for the second
series, published in 1590.

Phaeton persuaded his unwilling father, Ap-
ollo, the sun god, to allow him to drive his
chariot across the sky. The drama of Phaeton's
tragic demise unfolds in this cataclysmic pan-
orama that reveals Goltzius as the supreme
master of invention and elegant artifice. The
drawing is among only a handful of surviving
preparatory studies for this celebrated project.
Rogers Fund, 1992, 1992.376

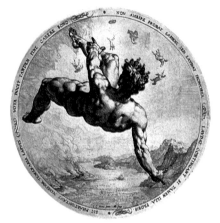

11 HENDRICK GOLTZIUS, Dutch 1558–1617,
after CORNELIS CORNELISZ. VAN HAARLEM,
Dutch, 1562–1638
Phaeton
*Engraving, first state of three; diam. 13 in. (33.2
cm)*

The brief collaboration in printmaking between
the Mannerist engraver Hendrick Goltzius and
the painter Cornelis Cornelisz. van Haarlem in
1588 resulted in some of the most striking prints
produced in the Netherlands during the six-
teenth and seventeenth centuries. Goltzius was
one of the great innovators in the technique of
engraving. He articulated figures with a fluid
network of cross-hatching, which accents their
musculature at every curve of the body. Gol-
tzius's virtuosity was a perfect complement to
Cornelisz. van Haarlem's unprecedented daring
in depicting the human figure. The body of
Phaeton, who had recklessly driven Apollo's
chariot, tumbles headfirst toward the viewer
with his hands and arms outstretched. The Latin
inscription that encircles the engraving echoes
the underlying moral of the entire *Four Dis-
gracers* series—that those with rash desires will
come to a bad end. *Harris Brisbane Dick Fund,
1953, 53.601.338(5)*

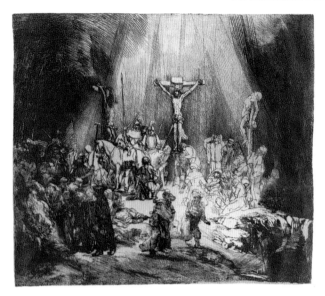

12 REMBRANDT, Dutch, 1606–1669
The Three Crosses
Drypoint and burin, second state of five, printed on vellum; 15 × 17¼ in. (38.1 × 43.8 cm)

One of the greatest painters, Rembrandt was also one of the greatest innovators in printmaking; he reforged and reworked the techniques of etching, engraving, and drypoint until he had not only completely altered their aspect but also shown how they could deal with things that previously lay beyond their scope. Whereas earlier intaglio prints were translucent and in general rather bodiless, Rembrandt's have a structure and richness of surface that approximate oil painting. Moreover, they are illumined by an expressive power that never fails to pierce to the heart of things, whether the subject be, as here, a momentous scene from Scripture or a simple local landscape. This drypoint is dated 1653. (See also European Paintings, nos. 79–81; and Robert Lehman Collection, nos. 16 and 36.) *Gift of Felix M. Warburg and his family, 1941, 41.1.31*

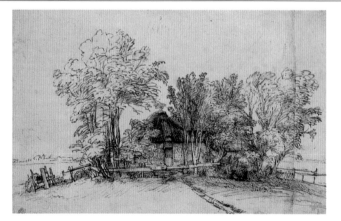

13 REMBRANDT, Dutch, 1606–1669
A Cottage Among Trees
Pen and brown ink, brown wash, on tan paper; 6¾ × 10⅞ in. (17.1 × 27.6 cm)

When Rembrandt turned to the landscape as a subject in the 1640s, he approached it with the same originality and probing intensity that characterize his portraits and his biblical scenes. With a fine quill pen he has transformed this solitary cottage, partially hidden by trees, into an image of pictorial richness and monumental grandeur. Alternating between broad and tightly rendered pen strokes, he captures the movement in the trees as the wind blows across the lowlands. The spectator is drawn to the firmly rooted dwelling as it recedes into the space of the composition; cast in shadow, it seems shrouded in mystery. This extraordinary drawing belongs to a series of landscape studies that Rembrandt executed about 1650–51 (the high point of his classical period), and it owes something of its technique and poetic mood to the sixteenth-century Venetian masters, whose landscape prints he collected. *H. O. Havemeyer Collection, Bequest of Mrs. H. O. Havemeyer, 1929, 29.100.939*

14 GIOVANNI BATTISTA TIEPOLO, Venetian, 1696–1770
The Discovery of the Tomb of Pulcinella
Etching; 9⅛ × 7⅛ in. (23.2 × 18.1 cm)

Tiepolo, who was perhaps the finest draftsman of his age, made the most of the etching medium by insisting that it keep pace with his pen. He translated his rapid sketches in an etching style of the purest quality, marked by brittle lines dancing in light and short hatches packed into shadows.

This work is one of his *Scherzi,* a series of twenty-three etchings in which he combined the pageantry of Venice's festivals, the drama of its street theater, and the sparkle of sunlit lagoons. Scholars continue to puzzle over the colorful array of youths, sages, and sibyls posed among the tombstones, skulls, and warriors' shields, but the fantastic tableaux were probably intended as diversions rather than lessons. (See also European Paintings, nos. 31 and 32.) *Purchase, The Elisha Whittelsey Collection, The Elisha Whittelsey Fund, Dodge and Pfeiffer Funds, and Joseph Pulitzer Bequest, and Gift of Bertina Suida Manning and Robert L. Manning, 1976, 1976.537.17*

15 GIOVANNI BATTISTA TIEPOLO, Venetian, 1696–1770
River God and Nymph
Pen and brown ink, brown wash, over a little black chalk; 9¼ × 12⅜ in. (23.5 × 31.4 cm)

This river god and his attendant nymph appear on the edge of a painted cornice at one end of the ceiling Tiepolo painted in fresco in the Palazzo Clerici, at Milan, in 1740. Some twelve years later Tiepolo used the same figures reclining on the edge of the frescoed ceiling of the Kaisersaal in the Würzburg Residenz (see European Paintings, no. 32). Only in his early years did Tiepolo produce drawings for sale; the drawings of his maturity seem to have been kept in his studio, where they served as a repertory of compositional motifs. *Rogers Fund, 1937, 37.165.32*

16 CHARLES MICHEL-ANGE CHALLE, French, 1718–1778
An Architectural Fantasy
Pen and brown ink drawing, with brown, gray, and black washes; 16⅞ × 26¼ in. (43 × 66.7 cm)

Trained in both architecture and painting, Challe in 1741 won the French Academy's Prix de Rome for painting. He went to Rome in 1742; he remained there, beyond the pensionnaire's usual three-year term, until 1749. In Rome his interests shifted from history painting to architecture and festival decoration. Challe and a number of his fellow pensionnaires were well acquainted with the work of Giovanni Battista Piranesi (1720–1778) and were admitted to his studio. Piranesi's architectural fantasies, which include a mixture of extraordinary and gran-diose ancient monuments disposed in ambiguous space, influenced the pensionnaires; the influence was mutual, and the young Frenchmen made their own contribution to the formation of Piranesi's style, especially his architectural fantasies.

After his return to France, Challe was in charge of designing theatrical productions for royal festivities. Under his direction architectural fantasies such as this one, which dates from 1746–47, were brought, if only temporarily, to realization. Through his work he participated in the radical change in direction of French architectural ideas at the end of the eighteenth century. *Edward Pearce Casey Fund, 1979, 1979.572*

17 Gerusalemme liberata
Printed by Albrizzi; illustrations by Giovanni Battista Piazzetta, Italian, 1682–1754; engraved by Martino Schedel and others; 17¾ × 12⅜ × 2⅝ in. (45.2 × 31.5 × 6.7 cm) (closed)

Gerusalemme liberata (1575), the masterpiece of the Italian poet Tasso, was the last major literary work of the Italian Renaissance. The epic poem, in twenty cantos, intertwines the deeds of historical figures, chiefly Godfrey of Boulogne, leader of the successful capture of Jerusalem from the Turks, the culmination of the First Crusade in 1099, with the story of the fictional Rinaldo, Armida, and others. Of the five illustrated editions of the epic in the Museum's collection, this is far and away the most lavish. Including a full-page engraved frontispiece, portraits of Tasso and of Maria Theresa of Austria—to whom this edition (1745) was dedicated—twenty-two initial letters, and sixty-one larger plates, all engraved after designs by Piazzetta, this is the pinnacle of Venetian eighteenth-century book production. The deep-red leather binding, elaborately gilt-tooled, also dates from the eighteenth century and is probably Italian. The book is shown open to canto nine. *Harris Brisbane Dick Fund, 1937, 37.36.1*

18 FRANCISCO GOYA, Spanish, 1746–1828
The Giant
Aquatint, first state of two; 11⅛ × 8⅛ in.
(28.3 × 20.6 cm)

Goya, the most bitter of satirists, often concealed his messages in disturbing and nightmarish images. His haunting *Giant* stands out as the most monumental and powerfully sculptured single figure among his shockingly dramatic etchings. More than any other print by Goya, it resembles the "black paintings" that the aging artist painted on the walls of his house near Madrid. This is one of only six known impressions of the print. *The Giant* announces not only nineteenth-century Impressionism, but also twentieth-century Surrealism and Expressionism. (See also European Paintings, nos. 54 and 55; and Robert Lehman Collection, no. 17.) *Harris Brisbane Dick Fund, 1935, 35.42*

19 FRANCISCO GOYA, Spanish, 1746–1828
Portrait of the Artist
Point of brush and gray wash; 6 × 3⅝ in.
(15.3 × 9.2 cm)

The artist, who wears on his lapel a locket inscribed with his name, stares at the spectator with an intensity that suggests the portrait is a mirror image. Goya reveals in this small and powerful work a technical virtuosity that was later to enable him to dash off an extraordinary series of miniatures on ivory. The drawing, the first page of an album of fifty Goya drawings dating from several periods of the artist's activity, was purchased by the Museum in 1935. (See also European Paintings, nos. 54 and 55, and Robert Lehman Collection, no. 17.) *Harris Brisbane Dick Fund, 1935, 35.103.1*

20 J. A. D. INGRES, French, 1780–1867
Study for the Figure of Stratonice
Graphite, black chalk, stumped, over incised contours, squared in graphite; 19 3/8 × 12 5/8 in. (49.2 × 32.1 cm)

This delicate, highly finished drawing is a study for the figure of Stratonice in a painting of Antiochus and Stratonice that was commissioned from Ingres by the duc d'Orléans in 1834 as a pendant to Paul Delaroche's *Death of the Duke of Guise*. Completed in 1840, the picture was ex-hibited at the Palais Royal in Paris later that same year and is now in the Musée Condé, Chantilly. The care with which Ingres elaborated the composition of the painting is reflected in the many preparatory drawings he executed be-fore beginning work on the canvas, including some twenty studies for Stratonice, either nude or, as here, elaborately draped in imitation of classical sculpture. *Pfeiffer Fund, 1963, 63.66*

21 GEORGES SEURAT, French, 1859–1891
Portrait of the Artist's Mother
Conté crayon; 12⅜ × 9½ in. (31.4 × 24.1 cm)

Using reserves of the white paper for his high-lights, Seurat has built up in graduated passages of velvety conté crayon a subtle but massive form that seems to shimmer in the light. Technically the drawing is simple but the results have a masterful plastic authority. The drawing was entered by Seurat in the Salon des Artistes Français of 1883 and is listed in the catalogue of the exhibition. At the last moment it was replaced by the much larger portrait of the painter Aman-Jean, a drawing also now in the Museum. (See also European Paintings, nos. 159 and 160.) *Purchase, Joseph Pulitzer Bequest, 1955, 55.21.1*

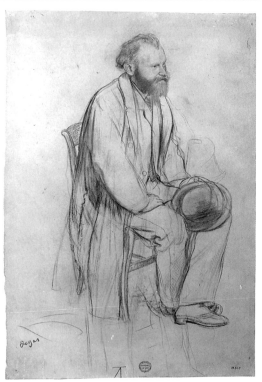

22 EDGAR DEGAS, French, 1834–1917
Portrait of Édouard Manet
Pencil and charcoal; 13 × 9⅛ in. (33 × 23.2 cm)

About 1864 Degas made two etched portraits of the painter Édouard Manet. In the first of these Manet is seated with his top hat in hand. The present drawing and another sketch in the Museum, both purchased at the sale of the contents of Degas's studio in 1918, are preparatory studies for this etching. Manet and Degas seem to have been good friends, in spite of the latter's rather irascible nature and a mutual professional suspicion. About the time these drawings were made, Degas painted Manet listening to Mme Manet playing the piano. Manet, to whom Degas presented the picture, was dissatisfied with his wife's likeness and cut her off the canvas—a mutilation that quite understandably enraged Degas. (See also European Paintings, nos. 141–43; European Sculpture and Decorative Arts, no. 27; and Robert Lehman Collection, no. 39.) *Rogers Fund, 1919, 19.51.7*

23 MARY CASSATT, American, 1845–1926
Woman Bathing
Drypoint and soft-ground etching printed in
color; 14¼ × 10⅜ in. (36.3 × 26.5 cm)

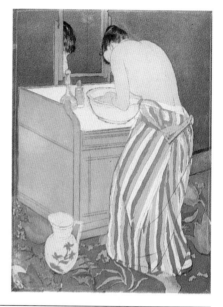

In 1877, three years after her arrival in Paris,
Cassatt was invited by Degas to exhibit with the
Impressionists. Like Degas, she concentrated on
the study of the human figure and in order to
improve her draftsmanship took up the exacting
technique of drypoint, drawing directly from
models.

After viewing a large exhibition of Japanese
prints at the École des Beaux-Arts in the spring
of 1890, Cassatt began work on a set of ten
color prints in conscious imitation of *ukiyo-e.*
Woman Bathing, which was executed in 1891,
was one of this series. Transporting Utamaro's
bathers and kimonos to French boudoirs, Cas-
satt converted the Japanese color woodcut
medium to the intaglio processes with which
she was familiar, and applied colors by hand to
prepared metal plates. (See also American
Paintings and Sculpture, no. 18.) *Gift of Paul J.
Sachs, 1916, 16.2.2*

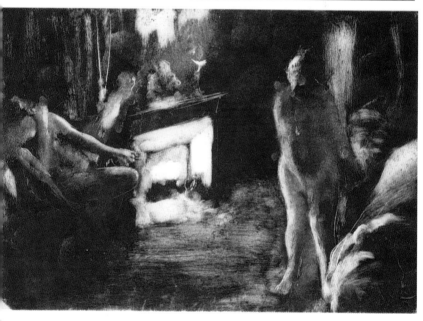

24 EDGAR DEGAS, French, 1834–1917
The Fireside
*Monotype in black ink; 16⅜ × 23⅛ in.
(41.5 × 58.6 cm)*

Between 1874 and 1893 Degas produced over
four hundred monotypes. These unique prints,
which the artist described as "greasy drawings
put through a press," exemplify Degas's fascina-
tion with technical experimentation and his
deep involvement in the representation of mod-
ern urban life. Treating the taboo subject of
prostitutes in brothels, Degas created a series of
monotypes showing nudes in dark hermetic in-
teriors, among which *The Fireside* (ca. 1877–80)
is the most monumental. Here, light blazing
from a single source harshly describes the face-
less women and furnishings of a *maison close.*
Degas blanketed the plate with ink and used
rags, brushes, and his fingers to extrapolate the
shadowy forms. (See also European Paintings,
nos. 141–43; and Robert Lehman Collection,
no. 39.) *Purchase, Harris Brisbane Dick Fund,
The Elisha Whittelsey Collection, The Elisha Whit-
telsey Fund, and Douglas Dillon Gift, 1968,
68.670*

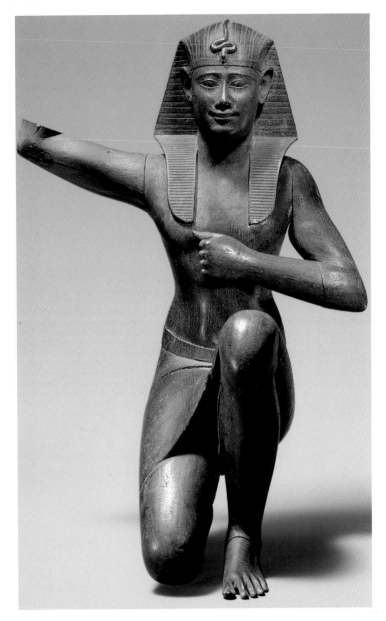

Royal Ritual Figure
Egyptian, Dynasty 30—possibly early Ptolemaic period, 4th–3rd century B.C.
Wood; h. 8¼ in. (21 cm)

Ancient Egyptian divine images resided in shrines deep inside the temple sanctuaries. Some shrines were surrounded by small figures in the hieratic pose seen in this masterpiece of Egyptian wood carving. The left fist strikes the chest, while the right is raised with the—now partly missing—arm angled at the elbow. In actual ritual performances the gesture would have alternated with a reversed position of arms and fists, and incantations would have accompanied this celebration of divine epiphany.

Among the figures in this pose some are depicted with the heads of jackals or falcons.

They represent the "souls" (ancestral spirits) of the two ancient cities of Buto (in the north) and Hierakonpolis (in the south). In some instances a human-headed figure such as the one seen here joins the animal-headed "souls." It wears the nemes headcloth of the Egyptian pharaoh. Scholars have different interpretations of this human-headed figure. Some see in it the representation of the ruling king (such as Nectanebo I or II); others understand it as a generic image of royalty.

The piece was created during a time when Egypt was first ruled by its last indigenous pharaohs (Dynasty 30, 380–343 B.C.) and then experienced the conquest by Alexander the Great (332 B.C.) and the beginning of the rule of the Ptolemies. *Purchase, Anne and John V. Hansen Egyptian Purchase Fund, and Magda Saleh and Jack Josephson Gift, 2003, 2003.154*

EGYPTIAN ART

In response to increasing public interest in ancient Egypt the Department of Egyptian Art was established in 1906 to oversee the Museum's Egyptian collection, which had been growing since 1874. At the same time the trustees, strongly encouraged by J. Pierpont Morgan, voted to begin an excavation program in Egypt that continued for thirty years and brought innumerable pieces of great artistic, historical, and cultural importance into the collection. Because of its work in Egypt, the Museum is particularly rich in both royal and private art of the Middle and early New Kingdoms and in funerary art of the Late Period. Through the generosity of donors such as Edward S. Harkness, Theodore M. Davis, Lila Acheson Wallace, and Norbert Schimmel, the acquisition of important pieces and private collections has supplemented the excavated material so that the collection is now one of the finest and most comprehensive outside Egypt.

The Egyptian galleries are arranged chronologically, beginning with the Predynastic Period (the time before the development of writing in about 3100 B.C.) and ending with late antiquity (8th century A.D.). The collection is most renowned for the Old Kingdom mastaba tomb of Perneb, the Meketra models, jewelry from the Middle and New Kingdoms, royal portrait sculpture of Dynasty 12, statuary from the temple of Queen Hatshepsut, and the Roman Period Temple of Dendur. Pieces of major interest are located in the main galleries, but many fascinating objects may be found in the smaller study galleries. Virtually all of the thirty-six thousand objects in the collection are on view.

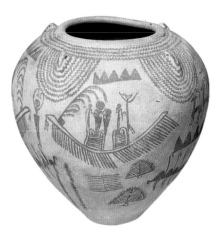

1 Vessel

Predynastic, Naqada II, ca. 3450–3300 B.C.
Painted pottery; h. 11¾ in. (30 cm)

The tendency to decorate utilitarian objects appeared very early in Egyptian culture. Among the oldest examples are the painted pots of various types that begin to appear in the Naqada Period, named after the site in Upper Egypt where the first examples were discovered. The scenes on this vessel are among the most elaborate that have survived and represent important social or religious events, the precise significance of which is not entirely understood. Certain fundamental characteristics of Egyptian art are already evident. Each scene depicts a single frozen event, and the more important participants are rendered in larger scale than the others. The scene illustrated here features a boat with two male and two large female figures, who may be goddesses or priestesses. *Rogers Fund, 1920, 20.2.10*

2 Comb

Predynastic, Naqada III, ca. 3300–3100 B.C.
Ivory; 2⅛ × 1½ in. (5.5 × 4 cm)

The finely carved ivory combs and knife handles produced toward the end of Egypt's prehistory demonstrate the high standards Egyptian artists had achieved, even before the Old Kingdom. This comb, whose teeth are now missing, is adorned with rows of wild animals carved in raised relief: elephants, wading birds, a giraffe, hyenas, cattle, and (possibly) boars. Similar arrangements of these creatures occur on other carved ivory implements, indicating that the pattern and choice of animals were not haphazard. The symbolic meaning of these representations is still being debated. *Theodore M. Davis Collection, Bequest of Theodore M. Davis, 1915, 30.8.224*

3 Cosmetic Palette

Predynastic, Naqada III, ca. 3300–3100 B.C.
Green schist; 7 × 2½ in. (17.8 × 6.3 cm)

The Predynastic palette was originally developed for the grinding of eye paint and other cosmetics and was ultimately interred in the grave of its deceased owner. Early examples often have the simplified outlines of animals. By the end of the Prehistoric Period, these objects had been adapted for votive or commemorative purposes and were elaborately decorated in relief on both sides. The motifs included heraldic or magical designs and scenes depicting events that may be historical or merely symbolic. The largest and most elaborate examples of these palettes were discovered in excavations of temples in which they were dedicated. This palette fragment shows part of the relief image of a bitch nursing her puppies. The back of the mother forms part of the exterior outline of the palette and is part of the frame for the interior design. *Gift of Henry G. Fischer, 1962, 62.230*

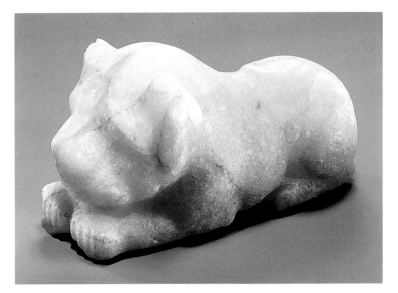

4 Lion

Gebelein(?), early Dynastic, ca. 3000–2700 B.C.
Quartz; l. 10 in. (25.2 cm)

This powerful figure, depicting a recumbent lion, belongs to the beginning of Egypt's historic period when the process of integrating Upper and Lower Egypt into one centralized state was under way. The simplified sculptural treatment, with the tail curled over the back, is typical of the time. This statuette may have been a votive offering for a temple, probably dedicated by one of the earliest Egyptian kings. *Purchase, Fletcher Fund and The Guide Foundation Inc. Gift, 1966, 66.99.2*

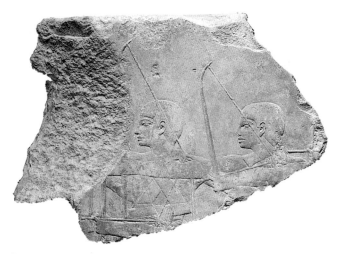

5 Archers

Lisht, Dynasty 4, ca. 2575–2465 B.C.
*Painted limestone; 14 1/2 × 9 7/8 in.
(37 × 25 cm)*

One of the most artistically interesting of the reused limestone blocks uncovered at Lisht in Lower Egypt (see no. 8) is this fragment from the core of the North Pyramid. Portions of five Egyptian archers are preserved. Such complexity in the overlapping of figures is rarely found in Egyptian reliefs at any period. The carving is of the highest quality, flat but with subtle modeling; only the ears stand out in a higher relief. The twisted bowstrings and arrow feathering are indicated with fine attention to detail. In style this work matches the best examples of Dynasty 4, although no exact iconographic parallels of such an early date are extant. This work is the earliest known battle scene in Egyptian art. Museum Excavation. *Rogers Fund and Edward S. Harkness Gift, 1922, 22.1.23*

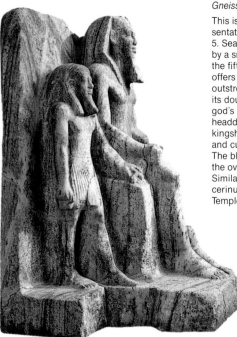

6 Sahura and a Deity
Dynasty 5, ca. 2458–2446 B.C.
Gneiss; h. 24¾ in. (62.9 cm)

This is the only known three-dimensional representation of Sahura, the second ruler of Dynasty 5. Seated on a throne, the king is accompanied by a smaller male figure personifying Koptos, the fifth nome (province) of Upper Egypt, who offers the king an ankh (symbol of life) with his outstretched left hand. The nome standard with its double falcon emblem is carved above the god's head. While Sahura wears the *nemes* headdress and square beard associated with kingship, the nome god wears an archaic wig and curled beard, which are divine attributes. The blocklike proportions of both figures echo the overall rectangular shape of the sculpture. Similar statue groups of King Menkaura (Mycerinus) of Dynasty 4 were found in his Valley Temple at Giza. *Rogers Fund, 1917, 18.2.4*

7 Memi and Sabu
Probably Giza, Dynasty 4, ca. 2575–2465 B.C.
Painted limestone; 24 ³⁄₈ in. (62 cm)

Pair statues, usually depicting a husband and wife, were frequently placed in a serdab, the hidden statue chamber often found in nonroyal tomb chapels of the Old Kingdom. The inscription identifies these individuals as the Royal Acquaintance Memi and Sabu, who was probably his wife, though the relationship is not stipulated. The statue can be linked stylistically with similar monuments that have recently been dated to Dynasty 4. This work is exceptional because Memi returns Sabu's embrace by draping his arm around her shoulders. The pose has only two known parallels, both found in the cemeteries surrounding the Great Pyramid of Khufu (Cheops) at Giza. *Rogers Fund, 1948, 48.111*

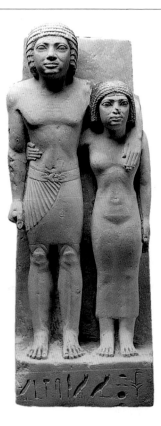

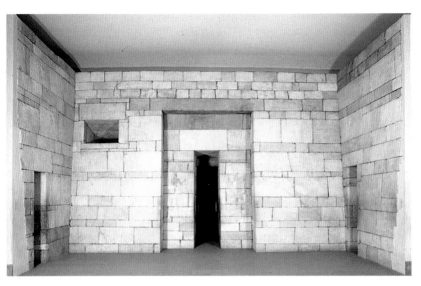

8 Tomb of Perneb

Saqqara, Dynasty 5, ca. 2450 B.C.
Partially painted limestone; h. of facade (recon-structed) 17 ft. (5.2 m)

Late in Dynasty 5 the palace administrator Per-neb built a tomb at Saqqara, twenty miles south of Giza. The tomb included an underground burial chamber and a limestone building (mas-taba) containing a decorated offering chapel and a statue chamber. The mastaba facade and chapel were purchased from the Egyptian gov-ernment in 1913 and, together with a replica of

the statue chamber, were reconstructed at the entrance to the Museum's Egyptian galleries.

Inside the chapel the painted reliefs depict Perneb seated before an offering table receiving food and other goods from relatives and re-tainers. Actual offerings were placed on the slab set before the false door, through which Per-neb's spirit could pass in order to receive sustenance. To understand the architectural ori-gin of the false door, one need only look at the central doorway of this mastaba. *Gift of Edward S. Harkness, 1913, 13.183.3*

9 False Door of Metjetji

Saqqara(?), late Dynasty 5–early Dynasty 6, ca. 2353–2255 B.C.
Limestone; 43 × 24 3/8 in. (109 × 66.5 cm)

The false-door stela, placed in the chapel of an Old Kingdom mastaba, served as a magic door through which the spirit of the deceased could pass to recieve nourishment in material or ritual form. This impressive stela bears ten inscrip-tions in the name of Metjetji, an overseer of the palace staff. The texts request offerings on Metjetji's behalf. Several of the inscriptions describe the deceased as "one revered before Unis," the last king of Dynasty 5, perhaps indi-cating that Metjetji's tomb was located near the king's pyramid at Saqqara. The fine quality of this stela is especially apparent in the sharp carving of the inscriptions and the eight images of the deceased which were sculpted in sunk relief. The elongated proportions and subtle modeling are typical of relief sculpture of Dynasty 6. *Gift of Mr. and Mrs. J. J. Klejman, 1964, 64.100*

10 Cosmetic Vessel of Ny-khasut-Merira
Dynasty 6, ca. 2259 B.C.
Egyptian alabaster (calcite); h. 5⅜ in. (13.7 cm)

Monkeys were kept as exotic pets by upper-class Egyptians and were frequently depicted in the decorative arts. The pose of this female monkey clutching its infant is attested first in Dynasty 6 and continues into later periods. The jar commemorates the first jubilee festival of Pepy I. Its style is quite distinct from a similar jar in the Museum that is dated to the next reign, demonstrating that a range of artistic individuality was accepted, especially in the decorative arts of ancient Egypt. *Purchase, Joseph Pulitzer Bequest, Fletcher Fund, and Lila Acheson Wallace, Russell and Judy Carson, William Kelly Simpson, and Vaughn Foundation Gifts, in honor of Henry George Fischer, 1992, 1992.338*

11 Relief of Nebhepetra Mentuhotep
Thebes, Dynasty 11, 2040–2010 B.C.
Painted limestone; h. 14⅛ in. (35.9 cm)

King Nebhepetra Mentuhotep was revered by the Egyptians as the ruler who reunited Egypt after a period of disunity, establishing what is now called the Middle Kingdom. He built his mortuary temple at Deir el-Bahri in western Thebes, where this relief was uncovered. The delicately modeled bas-relief and the finely painted details, especially of the architectural fa-cade (see no. 17) in the rectangular *serekh* enclosing the king's Horus name, demonstrate the high artistic standards that prevailed in the royal Theban workshops of this dynamic period in Egyptian history. The goddess at the right of the block, destroyed during the Amarna Period, was repaired in plaster in early Dynasty 19, indicating that the temple was still in use seven centuries after it was built. *Gift of Egypt Exploration Fund, 1907, 07.230.2*

12 Scarab of Wah
Thebes, early Dynasty 12, ca. 1990–1985 B.C.
Silver and gold; l. 1½ in. (3.8 cm)

The estate manager Wah was buried in a small tomb near that of his employer, Meketra. First seen in an X ray of Wah's mummy, this magnificent scarab is extraordinary for its superb craftsmanship and its material. Silver was not abundant in Egypt, and the metal's fragility caused most silver objects to disintegrate. This scarab is made of several sections soldered together and has a gold suspension tube running horizontally between the base and the back. On its back inlaid hieroglyphs of pale gold give the names and titles of Wah and Meketra. Museum Excavation. *Rogers Fund, 1920, 40.3.12*

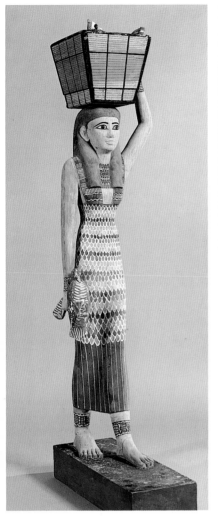

13 Offering Bearer

Thebes, early Dynasty 12, ca. 1990–1985 B.C.
Painted wood; h. 44 in. (111.8 cm)

The chancellor Meketra passed most of his life serving the kings of Dynasty 11 and died early in the reign of the first ruler of Dynasty 12. His tomb in western Thebes was plundered except for a small chamber filled with wooden models, common burial equipment in First Intermediate Period and early Middle Kingdom tombs. Meketra's models demonstrate the transition between the art of Dynasty 11, which was still predominantly Theban and Upper Egyptian in nature, and Dynasty 12, during which the capital was once more established near Memphis in the north. This graceful offering bearer, with her round, large-eyed face and her long, elegant limbs, seems to be the product of a northern workshop, influenced by an Old Kingdom tradition. This figure is not a servant but personifies an estate from which offerings are brought for the maintenance of the mortuary cult. Museum Excavation. *Rogers Fund and Edward S. Harkness Gift, 1920, 20.3.7*

14 Model of a Garden

Thebes, early Dynasty 12, ca. 1990–1985 B.C.
Gessoed and painted wood and copper; l. 33 in. (84 cm)

Tomb reliefs of the Old Kingdom present glimpses of rural life in ancient Egypt, but the painted wooden models from Middle Kingdom tombs offer even more insights into the lives of the ancient Egyptians. The Museum possesses thirteen of the models from the tomb of Meketra, which provide detailed views of food production, animal husbandry, and boats used for transportation, recreation, and ritual functions. This model shows an enclosed garden outside the portico of a house. In the center is a copper-lined pond surrounded by sycamore and fig trees. Museum Excavation. *Rogers Fund and Edward S. Harkness Gift, 1920, 20.3.13*

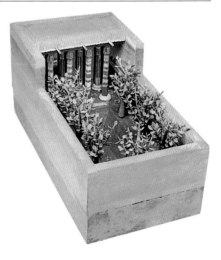

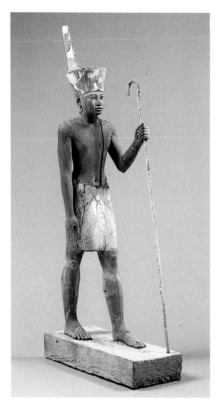

15 Ritual Figure

Lisht, Dynasty 12, ca. 1929–1878 B.C.
*Plaster and painted cedar; h. 22 ⅞ in.
(58.1 cm)*

This figure wears the red crown of Lower Egypt
and a divine kilt. The face is thought to reflect
the features of the reigning king, either
Amenemhat II or Senwosret II, but the combina-
tion of royal and divine attributes suggests that
the statuette was not merely a representation of
a living ruler. The surfaces of the crown and
kilt were bult up with a layer of plaster before
paint was applied. Traces of red, the traditional
skin color of male figures, can be seen on the
exposed flesh. The contours of the legs, the de-
tails of the hands and feet, and the delicate
modeling of the face set this sculpture apart as
one of the masterpieces of ancient Egyptian art.
Museum Excavation. *Rogers Fund and Edward S
Harkness Gift, 1914, 14.3.17*

16 Stela of Montuwoser

Dynasty 12, ca. 1954 B.C.
Painted limestone; 41 × 19 ⅝ in. (104 × 49.8 cm)

In the seventeenth year of his reign Senwosret I
dedicated this stela to Osiris, lord of Abydos,
on behalf of his steward Montuwoser. The text,
which describes the owner's good deeds, is
skillfully incised, while the offering scene is a
fine bas-relief in a style that recalls the early
Old Kingdom. A primary purpose of the stela is
explained in the final column of hieroglyphs (at
the left), where those who pause are asked to
repeat the offering text aloud, thus providing
sustenance in the form of "bread and beer, cat-
tle and fowl, offerings and food for the owner of
this stela." *Gift of Edward S. Harkness, 1912,
12.184*

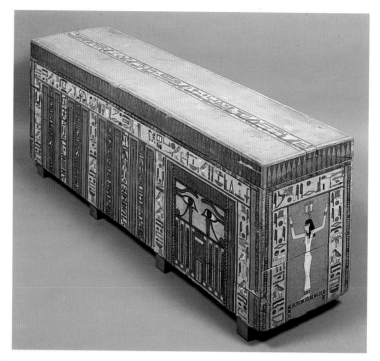

17 Coffin of Khnumnakht

Asyut(?), Dynasty 12, ca. 1900–1800 B.C.
Painted wood; l. 82 in. (208.3 cm)

The brilliantly painted exterior of the coffin of Khnumnakht, an individual unknown except for his name, displays the multiplicity of texts and decorative panels characteristic of coffin decoration in the second half of Dynasty 12. It has at least one feature—the figure of a goddess on the head end—that is rare before the late Middle Kingdom. Painted on the side is an architectural facade (shown here) with a doorway, the equivalent of the Old Kingdom false door (see no. 9). Above this, two eyes look forth into the land of the living. The face of the mummy would have been directly behind this panel. The rest of the exterior is inscribed with invocations to, and recitations by, various primeval deities, particularly those associated with death and rebirth, such as Osiris, foremost god of the dead, and Anubis, god of embalming. *Rogers Fund, 1915, 15.2.2*

18 Figurine of a Dwarf

Lisht, probably Dynasty 13, ca. 1783–after 1640 B.C.
Ivory; 2½ in. (6.5 cm)

The exquisite modeling and animated expression of this figure make it one of the finest pieces of small sculpture from the Middle Kingdom. It represents a dancing dwarf, clapping his hands to keep time. He was found with three figures, now in Cairo, who were attached to a board in such a way that they could be made to spin by manipulating strings. These statuettes hark back to Old Kingdom references to dwarfs of the divine dances who were brought from the "land of the horizon dwellers," far to the south of Egypt. They were found in front of the blocked entrance of an undisturbed tomb and may have been a magical offering to the deceased woman. Museum Excavation. *Rogers Fund, 1934, 34.1.130*

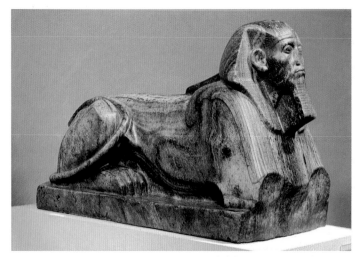

19 Sphinx of Senwosret III
Karnak, Dynasty 12, ca. 1878–?1841 B.C.
Gneiss; l. 28¾ in. (73 cm)

While the standing sphinx was viewed as a conqueror by the Egyptians, the crouching sphinx was a guardian of sacred places. Thus pairs of such images flanked avenues or entrances to important buildings. This magnificent sphinx of Senwosret III, one of Egypt's greatest soldiers and administrators, is carved from a single block of beautifully grained diorite gneiss from quarries in Nubia. The sculptor's attention has been focused on the deeply lined face of the pharaoh. The proud yet careworn features reflect the philosophy of kingship prevalent at this period, when the ruler was felt to be morally responsible for his governance of the land. *Gift of Edward S. Harkness, 1917, 17.9.2*

20 Cowrie Girdle
Lahun, Dynasty 12, ca. 1897–1797 B.C.
Gold, carnelian, and green feldspar; l. 33 in. (84 cm)

The personal jewelry and some other possessions of Princess Sithathoryunet—daughter of Senwosret II, sister of Senwosret III, and aunt of Amenemhat III—were found in the tomb of the princess, which was excavated within the pyramid complex of her father at Lahun (between Memphis and the Fayum). The Museum possesses all except four pieces of this treasure, the beauty and technical perfection of which have rarely been equaled in Egyptian art. This splendid girdle, which Sithathoryunet wore around her hips, is composed of eight large cowrie shells of hollow gold, one of which is split to form a sliding clasp. A double strand of small gold, carnelian, and green feldspar beads in the shape of acacia seeds separates the shells. Each of the seven whole cowries contains metal pellets, so that the girdle tinkled softly as the princess walked or danced. *Purchase, Rogers Fund and Henry Walters Gift, 1916, 16.1.5*

21 Cosmetic Vessel
Dynasty 12, ca. 1991–1783 B.C.
Egyptian alabaster (calcite); h. 5½ in. (11.4 cm)

The cat first appears in painting and relief at the end of the Old Kingdom, and this cosmetic jar is the earliest-known three-dimensional representation of the animal from Egypt. The sculptor demonstrates a keen understanding of the creature's physical traits, giving the animal the alertness and tension of a hunter rather than the elegant aloofness of later representations (see no. 51). The rock-crystal eyes, lined with copper, serve to enhance the impression of readiness. *Purchase, Lila Acheson Wallace Gift, 1990, 1990.59.1*

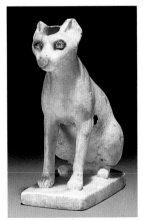

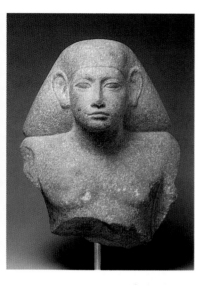

22 Anonymous Official

Dynasty 13, ca. 1783–1640 B.C.
Quartzite; h. 7 ¾ in. (19.5 cm)

This fragment is from a statuette of a man sitting cross-legged on the ground, wearing only a kilt and a full shoulder-length wig. The stone's grainy texture does not allow much detail, but the somewhat flabby torso is well presented. This piece cannot be dated precisely, but it has characteristics of Late Middle Kingdom sculpture: the curve of the almond-shaped eyes below a natural brow line, the straight nose with its downturned tip, the protruding mouth and narrow chin, and the solemn expression.
Purchase, Frederick P. Huntley Bequest, 1959, 59.26.2

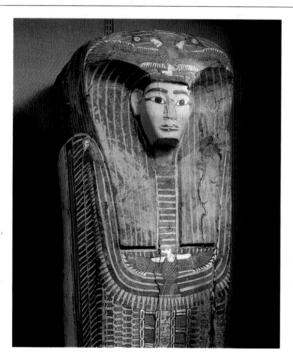

23 *Rishi* Coffin of Puhorsenbu

Thebes, Asasif, Dynasty 17, ca. 1640–1550 B.C.
Painted wood; l. 76 ¾ in. (195 cm)

The Arabic word *rishi*, meaning feathered, is used to describe a group of coffins made in the Theban area during Dynasty 17 and early Dynasty 18. The coffin, once considered a home for the spirit, later became a representation of the deceased. This coffin is a particularly fine example of the human-shaped type. The coffin is made of sycamore planks instead of a hollowed-out log, and special care has been taken with the modeling of the face, which has been painted a delicate pink. The feather pattern has become an abstract design, as has the broad collar, whose strands of beads echo the contour of the vulture pendant, making the bird's wings appear to engulf the mummy's shoulders. Museum Excavation. *Rogers Fund, 1930, 30.3.7*

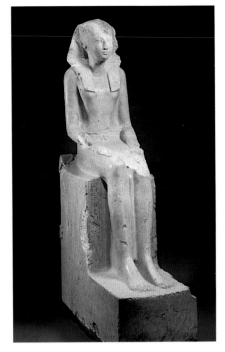

24 Statue of Hatshepsut

Thebes, Dynasty 18, ca. 1473–1458 B.C.
Indurated limestone; h. 76¾ in. (195 cm)

Hatshepsut, the best known of several female rulers of Egypt, declared herself king between years 2 and 7 of the reign of her stepson and nephew, Tuthmosis III. This lifesize statue shows her in the ceremonial attire of an Egyptian pharaoh, traditionally a man's role. In spite of the masculine dress, the statue has a distinctly feminine air, unlike most other representations of Hatshepsut as pharaoh. Even the kingly titles on the sides of the throne are feminized to read "Daughter of Ra" and "Lady of the Two Lands," a practice that was dropped later in her reign. Museum Excavation. *Rogers Fund, 1929, 29.3.2*

25 Head of Hatshepsut

Thebes, Dynasty 18, ca. 1473–1458 B.C.
Painted limestone; h. 42 in. (106.6 cm)

Soon after Hatshepsut took on the role of ruler, she began constructing a mortuary temple at Deir el-Bahri, beside the temple of her ancient predecessor Nebhepetra Mentuhotep (see no. 11). One of the most spectacular architectural achievements of the ancient world, the temple was decorated with numerous engaged colossal statues of Hatshepsut as Osiris. This head, wearing the double crown of Upper and Lower Egypt, was inside a shrine on the temple's upper terrace. Museum Excavation. *Rogers Fund, 1931, 31.3.164*

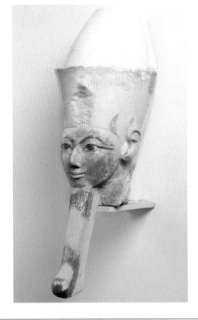

26 Ostracon of Senenmut

Thebes, Dynasty 18, ca. 1473–1458 B.C.
*Painted limestone; 8⅞ × 7¼ in.
(22.5 × 18.1 cm)*

Senenmut was one of Hatshepsut's most trusted officials (see nos. 24 and 25). He held many administrative positions but is best known as chief architect of her temple. Senenmut's depiction here is similar to others known of him. Chips of limestone and broken pottery, known as ostraca, were frequently used for sketches by Egyptian artists of all periods. This ostracon was found near Senenmut's tomb and may have been a guide for the decoration of one of his monuments. Museum Excavation. *Rogers Fund, 1936, 36.3.252*

27 Heart Scarab of Hatnofer
Thebes, Dynasty 18, ca. 1466 B.C.
Gold and green stone; 2 ⁵/₈ × 2 ¼ in. (6.7× 5.3 cm)

Hanofer was the mother of Senenmut (see no. 26). She was buried early in Hatshepsut's reign. Many of the goods in her tomb came from the royal storerooms, and it is possible that this heart scarab, with its gold setting and finely woven gold chain, was also provided by the queen. Heart scarabs, usually made of green-colored stone, were placed over the heart of the mummy. The heart was considered the home of the spirit and was left in the mummified body. Heart scarabs were inscribed with a spell from the Book of the Dead that exhorted the heart not to bear witness against the spirit during the judgment in the afterlife. Museum Excavation. *Rogers Fund, 1936, 36.3.2.*

28 Chair of Renyseneb
Middle Dynasty 18, ca. 1450 B.C.
Ebony with ivory; h. 35 in. (86.2 cm)

The back of this wooden chair, belonging to the scribe Renyseneb, is handsomely veneered with ivory and further embellished by incised decoration showing the owner seated on a chair of identical form. This is the earliest surviving chair with such a representation, and it is the only nonroyal example known of any date. The scene and accompanying text have funerary import and may have been added following Renyseneb's death to make the chair a more suitable funerary object. The high quality of its joinery and the harmony of its proportions testify to the skill of ancient Egyptian carpenters. The mesh seat has been restored according to ancient models. *Purchase, Patricia R. Lassalle Gift, 1968, 68.58*

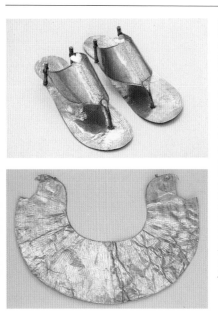

29 Sandals and Collar
Probably from Thebes, Dynasty 18, ca. 1479–1425 B.C.
Gold; l. of sandals 9⁷/₈ in. (25 cm), l. of collar 13½ in. (34.3 cm)

The fragility of this collar and pair of gold sandals would have prevented their being actually worn, even for ceremonial occasions. They were made as funerary objects for a woman of the royal family during the reign of Tuthmosis III. The sandals are replicas of leather ones commonly worn by Egyptian men and women. The collar, reminiscent of jewelry the woman would have worn during her lifetime, assures her the use of precious objects in the afterlife. Five rings of cylindrical beads are engraved in the thin sheet of gold, while the outer band has a flower-petal motif. The two falcon heads that terminate the collar at shoulder level had attached loops to accommodate the cords that secured the collar to the mummy wrappings. *Fletcher Fund, 1926, 26.8.147; Fletcher Fund, 1920, 26.8.101*

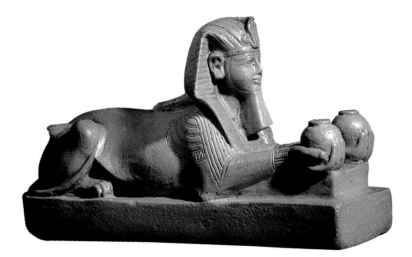

30 Sphinx of Amenhotep III
Dynasty 18, ca. 1391–1353 B.C.
Faience; l. 9 7/8 in. (25 cm)

The facial features of this faience sphinx would identify it as Amenhotep III even without the inscription. The graceful body of the lion transforms quite naturally into human forearms and hands, an innovation of Dynasty 18. In this form the sphinx combines the protective power of the lion with the royal function of offering to the gods. The even tone of the fine blue glaze and the almost flawless condition of this sculpture make it unique among ancient Egyptian faience statuettes. *Purchase, Lila Acheson Wallace Gift, 1972, 1972.125*

31 Fragmentary Head of a Queen
Dynasty 18, ca. 1353–1336 B.C.
Yellow jasper; h. 5½ in. (14.1 cm)

This extraordinary fragment, polished to a mirrorlike finish, is dated to the reign of Akhenaten on stylistic grounds. The complete head probably belonged to a composite statue in which only the exposed parts of the body were of jasper. In Egyptian artistic convention the color yellow usually indicates a woman, and the scale and superb quality of the work imply that this is a goddess or a queen. The head has variously been identified as Nefertiti, principal wife of Akhenaten, and as Tiye, his mother, who lived into his reign. However, the fragment could represent one of the other royal women of Amarna, such as Kiya or Meretaten. *Purchase, Edward S. Harkness Gift, 1926, 26.7.1396*

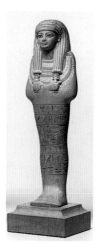

32 Shawabti of Yuya
Thebes, Dynasty 18, ca. 1391–1353 B.C.
Painted cedar; h. 10 5/8 in. (27 cm)

Yuya and Tuya, the parents of Queen Tiye (see no. 31), were granted burial in the Valley of the Kings. They were provided with funerary equipment from the finest royal workshops, like this superbly carved shawabti on which even the knees are subtly indicated. The text on such mummiform figurines states that the shawabti will substitute for the spirit in any obligatory tasks it is called upon to perform in the afterlife. *Theodore M. Davis Collection, Bequest of Theodore M. Davis, 1915, 30.8.57*

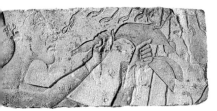

33 Sacrificing a Duck
Hermopolis(?), late Dynasty 18,
ca. 1345–1335 B.C.
*Painted limestone; l. 9⅝ × 21½ in.
(24.4 × 54.6 cm)*

In what many scholars have seen as an attempt
to limit the political, economic, and religious

power of the Amun clergy, Amenhotep IV, the
successor of Amenhotep III, severely curtailed
the worship of Amen-Ra, previously the chief
god of Egypt. Instead, he venerated exclusively
the Aten, the power embodied in the sun disk.
In about the sixth year of his reign, he changed
his name to Akhenaten and moved the religious
and administrative capital of Egypt from Thebes
to Tell el-Amarna in Middle Egypt, where he
founded the city of Akhetaten. This relief block,
originally from Akhetaten, is carved in the man-
ner and expressive style peculiar to Akhenaten's
reign. The king is shown making an offering of
a pintail duck to the Aten, whose rays, ending in
hands, stream down upon him. One of the
hands holds an ankh (the symbol of life) to the
king's nose. *Gift of Norbert Schimmel, 1985,
1985.328.2*

34 Prancing Horse
Dynasty 18, ca. 1390–1352 B.C.
Stained ivory and garnet; l. 6 in. (15 cm)

The horse was a relative latecomer in Egyptian
history. It was introduced during the Hyksos
domination (ca. 1667–1570 B.C.), when new ele-
ments of power, notably the horse and chariot,
were brought from the Near East. During the
New Kingdom this animal became a familiar
sight, and there were many portrayals of horses

in the art of the time, particularly during the
Amarna age. This small ivory handle of a light
whip or fly whisk is a sensitively carved pranc-
ing or running horse stained reddish brown with
a black mane. The eyes, one of which has
fallen out, were inlaid with garnet. The lively
carving of this piece, especially the gracefully
arched back, typifies the high quality of the
minor arts in the reign of Amenhotep III.
*Purchase, Edward S. Harkness Gift, 1926,
26.7.1293*

35 Statue of Horemhab
Late Dynasty 18, ca. 1325–1319 B.C.
Dark gray granite; h. 46 in. (116.8 cm)

Literacy was highly valued in Egypt, and im-
portant officials frequently had themselves
represented in the traditional pose of a scribe.
In this statue, the youthful face is belied by the
pot belly and folds of flesh beneath the breasts,
artistic conventions indicating that the subject
has reached the age of great wisdom. The
scribal pose exhibits the frontal orientation
common to all formal Egyptian statuary, but
the figure can also be appreciated in the round
since there is no back pillar. This magnificent
lifesize statue represents Horemhab, a powerful
general and royal scribe who served the last
pharaohs of Dynasty 18 and who became king
himself at the end of the dynasty. The style
retains some of the softness and naturalism of
the earlier Amarna Period, while looking forward
to later Ramesside art. *Gift of Mr. and Mrs. V.
Everit Macy, 1923, 23.10.1*

36 Protome

Qantir(?), late Dynasty 18–early Dynasty 19, ca. 1391–1280 B.C.

Egyptian blue (vitreous material), gold; l. 1 ¾ in. (4.3 cm)

This protome (representation of the head and neck of an animal) shows a lion, which symbolizes the pharaoh, subjugating a Nubian, a traditional Egyptian enemy. This image is frequent in early Ramesside art, especially during the reign of Ramesses II. Here both faces are modeled with superb naturalism, while the animal's mane and ears and the notches at the corners of its mouth are more stylized. The protome may have decorated a fly whisk or whip handle. *Gift of Norbert Schimmel Trust, 1989, 1989.291.92*

38 Ostracon

Thebes, Dynasty 19–20, ca. 1295–?1069 B.C.

Painted limestone; 5½ × 4¾ in. (14 × 12.5 cm)

In the lively hunting scene below, an unidentified Ramesside pharaoh is represented as slaying the enemies of Egypt in the form of a lion. The hieratic text reads: "The slaughter of every foreign land, the Pharaoh—may he live, prosper, and be healthy." The ostracon was found in the Valley of the Kings, but the scene is not used in royal tombs and, therefore, this was probably not a trial sketch made to facilitate an artist's work. The scene, although drawn by a skilled draftsman, has no grid lines and does not conform to the strict proportions of a formal rendering. *Purchase, Edward S. Harkness Gift, 1926, 26.7.1453*

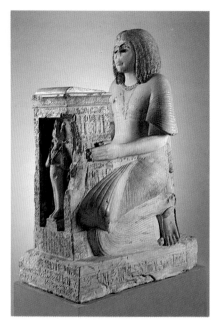

37 Statue of Yuni

Asyut, Dynasty 19, ca. 1294–1213 B.C.

Limestone; h. 50¾ in. (128.8 cm)

The kneeling statue of Yuni is representative of early Ramesside art. The inlaid eyes and eyebrows were removed by an ancient thief, but the finely modeled face and the intricately carved wig demonstrate the high standard of workmanship that prevailed. Yuni kneels, holding before him an elaborately carved shrine containing a small figure of Osiris. He wears the billowing robes and curled wig that were fashionable. His necklaces include the "gold of valor," a gift from the king for distinguished service, and a pendant of Bat, a goddess often associated with Hathor. Small standing nude figures of Yuni's wife, Renenutet, holding a *menit* necklace, also associated with Hathor, appear on the sides of the back pillar. *Rogers Fund, 1933, 33.2.1*

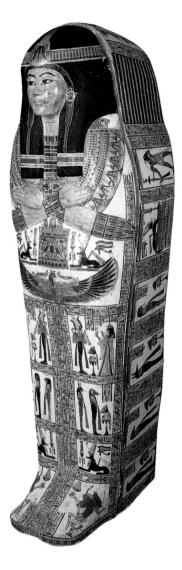

39 Outer Coffin of Henettawy
Thebes, Deir el-Bahri, Dynasty 21,
ca. 1040–991 B.C.
Plastered and painted wood; l. 79⅞ in. (203 cm)

At the beginning of the Third Intermediate Period, ruling power was divided between a dynasty resident in the delta city of Tanis and the high priests of Amun at Thebes. During this unsettled period the individual private tomb was abandoned in favor of family tombs (or caches) that could be more easily guarded from thieves; often tombs that had already been robbed were reused for this purpose. Henettawy, a mistress of the house and chantress of Amen-Ra, was buried in such a tomb. Since her tomb, like most others of the time, was undecorated, the paintings on her coffin, with their emphasis on elaborate religious symbolism and imagery, replaced the wall decorations of previous periods and reflect a style and iconography developed during the late New Kingdom. Henettawy wears a plain tripartite wig with two sidelocks and elaborate funerary jewelry typical of the period. *Rogers Fund, 1925, 25.3.182*

40 Papyrus of Nany
Thebes, Dynasty 21, ca. 1040–991 B.C.
*Painted papyrus; l. 205⅜ in. (521.5 cm),
h. 13¾ in. (35 cm)*

The spells written on funerary papyri, known by the Egyptians as the "Book of Coming Forth by Day," were meant to aid the spirit on its journey through the Underworld. In the spell called the "Declaration of Innocence," the spirit denied any wrongdoing before a tribunal of gods. One illustration that usually accompanied this spell shows the heart of the deceased being weighed against Maat, goddess of truth. Here, Isis accompanies the deceased woman, Nany, while Anubis balances the scale and Thoth, shown as a baboon (see no. 45), records the results. Museum Excavation. *Rogers Fund, 1930, 30.3.31*

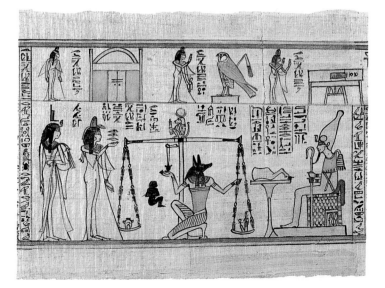

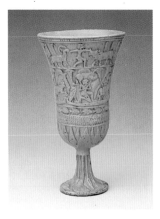

41 Lotiform Cup
Dynasty 22, ca. 945–715 B.C.
Faience; h. 5¾ in. (14.6 cm)

The fragrant blossom of the blue lotus is a common motif in all forms of Egyptian art. The opening of its petals to the sun each morning made it a symbol of creation and rebirth. This cup, made of brilliant blue faience, imitates the slender form of the flower and is decorated in relief with scenes depicting the plant's marshy habitat. Such cups were funerary offerings, made to be placed in tombs. *Purchase, Edward S. Harkness Gift, 1926, 26.7.971*

42 Funerary Stela of Aafenmut
Thebes, Khokha, Dynasty 22, ca. 924–909 B.C.
Painted wood; 9 × 7¼ in. (23 × 18.2 cm)

This small, exceptionally well-preserved wood stela was found in 1914–15 at Thebes by the Museum's Egyptian expedition during its clearance of a tomb containing the burial pit of Aafenmut, a scribe of the treasury. It was discovered along with some other small finds, which included a pair of leather tabs from a set of mummy braces bearing the name of Osorkon II, the second king of Dynasty 22. Solar worship is the theme of the stela's decoration: in the lunette the sun disk crosses the sky in its bark, while below, the falcon-headed Ra-Harakhty, the Lord of Heaven, receives food offerings and incense from Aafenmut. The same episodes appear in a virtually identical style on the brightly painted coffins of the period. *Rogers Fund, 1928, 28.3.35*

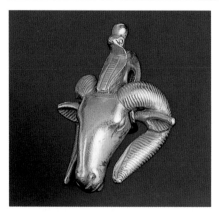

43 Ram's-Head Amulet
Dynasty 25, ca. 770–657 B.C.
Gold; 1⅝ × 1⅜ in. (4.2 × 3.6 cm)

This amulet was probably made for a necklace worn by one of the Kushite kings. Representations of these pharaohs show them wearing a ram's head amulet tied around the neck on a thick cord, the ends of which fall forward over the king's shoulders. Sometimes a smaller ram's head is attached to each end. Rams were associated with Amun, particularly in Nubia, where the god was especially revered. The Nubians were superb goldsmiths, as demonstrated by the workmanship of this amulet. *Gift of Norbert Schimmel Trust, 1989, 1989.281.98*

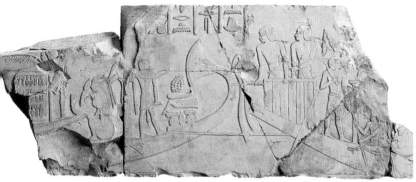

44 Funeral of Nespakashuty
Thebes, Deir el-Bahri, early Dynasty 26,
ca. 656–610 B.C.
Limestone; 13¾ × 22½ in. (35 × 57 cm)

The vizier Nespakashuty took over the terrace of
an old Middle Kingdom tomb tunneled into the
north cliff at Deir el-Bahri as the outer court of
his own sepulcher. Work on his tomb was never
finished, and many of the extant reliefs show
varying degrees of completion, ranging from
preliminary drawings in red ocher to finely
carved raised reliefs. Several of these intermedi-
ate stages are preserved in this relief fragment
depicting an episode from Nespakashuty's fu-
neral, in which the barge bearing his coffin and
the officiating mortuary priest clad in leopard
skin is towed across the river to the necropolis
on the west bank. There was a tendency during
this late period of Egyptian art to draw on ear-
lier styles and iconography. Theban tomb
paintings of the New Kingdom were the models
for this scene. *Rogers Fund, 1923, 23.3.468a*

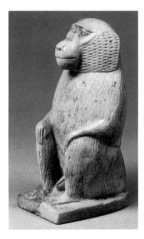

45 Baboon Statuette
Memphis(?) Dynasty 26, 664–525 B.C.
Faience; h. 3½ in. (8.8 cm)

The baboon with its arms upraised was thought
to worship the rising sun at dawn and was fre-
quently depicted in temple and tomb decoration
in connection with the solar cult. As repre-
sented here, with its intelligent, enigmatic gaze,
the animal was also associated with Thoth, god
of writing and mathematics. This statuette
demonstrates the consummate mastery of
faience achieved during Dynasty 26. *Purchase,
Edward S. Harkness Gift, 1926, 26.7.874*

**46 Face of a statue, possibly of King
Ptolemy II**
Heliopolis, 285–246 B.C.
Graywacke; h. 6¾ in. (17 cm)

The ancient city of Heliopolis, now suburb of
Cairo, was Egypt's primary place of solar worship.
An obelisk of Pharaoh Senwosret I (ca. 1961–
1917 B.C.) still graces the site. The British
archaeologist William Flinders Petrie discovered
this fragment near the obelisk. Its exquisite carv-
ing indicates its origin in a royal workshop. The
idealized features, serene smile, and soft fleshi-
ness point to a date in the early Ptolemaic era,
supported by its close resemblance to an
inscribed image of King Ptolemy II Philadelphos.
After Alexander the Great, Egypt was ruled by
Macedonian Greek kings. This sculpture, how-
ever, testifies to the undiminished skill with which
indigenous artists carved hard stone and to the
continuity of the age-old ideals of Egyptian art.
*Gift of the Egyptian Research Account and
British School of Archaeology in Egypt, 1912,
12.187.31*

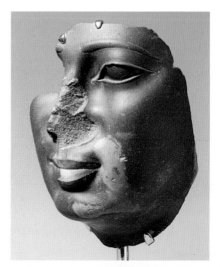

47 Statuette of a Woman
Dynasty 26, 664–525 B.C.
Silver; h. 9 ½ in. (24 cm)

This nude female figure, with her long, slender limbs, could be dated to Dynasty 26 even without the cartouches of Necho II embossed on her upper arms. She is cast in solid silver with the wig and jewelry made separately. Silver statuettes are extremely rare, and this figure was probably dedicated in a temple or placed in the tomb of a member of the royal family. *Theodore M. Davis Collection, Bequest of Theodore M. Davis, 1915, 30.8.93*

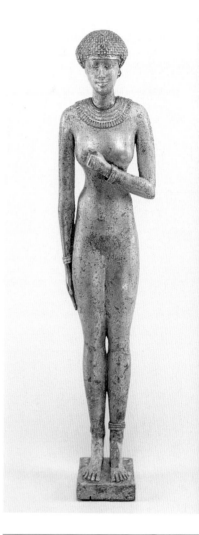

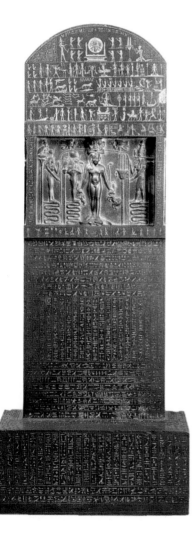

48 Magical Stela
Dynasty 30, 360–343 B.C.
Graywacke; 32 ⅞ × 10 ⅛ in. (83.5 × 35.7 cm)

This stela is dated to the reign of Nectanebo II, last king of Dynasty 30 and the last king of ethnic Egyptian origin. It is the most elaborate example of the magical stelae that originated in the late New Kingdom. The stela has been carved from extremely hard stone, and the artist's mastery is particularly evident in the sharp, cleanly cut lines of the inscription. Horus the child, standing on two crocodiles and often holding a scorpion in each hand, is the dominant feature of magical stelae, which were inscribed with spells to cure ailments and protect against dangerous animals. The texts could be recited aloud, or water could be poured over the stone and used for medicinal purposes, having taken on the magical quality of the words. The stela once belonged to the Austrian chancellor, Prince Metternich, and is often referred to by his name. *Fletcher Fund, 1950, 50.85*

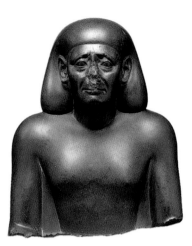

49 Anonymous Scribe
Memphis(?), 4th c. B.C.
Graywacke; h. 14⅛ in. (35.9 cm)

Even during the Old Kingdom seated scribal statues were distinguished by lively facial expressions that contrasted with summarily carved bodies. In this head and torso from a much later example of the type, the juxtaposition of the smooth contours of the bag wig and nearly featureless body and the vivid emotion of the face is particularly striking. The cheeks, chin, bags under the eyes, and bulge between the brows are fleshy in appearance and are balanced by incised brows, eyelids, frown lines, and crow's-feet. *Rogers Fund, 1925, 25.2.1*

51 Coffin for a Sacred Cat
Ptolemaic Period, ca. 305–30 B.C.
Bronze; h. 11 in. (28 cm)

The cat was long venerated as the sacred animal of Bastet, a goddess worshiped at the delta town of Bubastis. In 954 B.C. a family of Bubastite kings became the rulers of Egypt, and votive images of cats increased in popularity. In the fifth century B.C. the Greek historian Herodotus described the great annual festival of Bastet and her beautiful temple, near which mummified cats were interred in large cemeteries. This hollow figure served as a coffin for a mummified cat. The figure's smooth contours are complemented by a finely incised broad collar and a pectoral in the shape of a *wadjet* eye— the sacred eye of Horus. Holes for the attachment of earrings pierce the cat's ears. *Harris Brisbane Dick Fund, 1956, 56.16.1*

50 Taweret
Kena, Ptolemaic Period, ca. 332–30 B.C.
Glass; h. 4⅜ in. (11 cm)

This particularly fine depiction of Taweret, the patroness of women during pregnancy and childbirth, shows the hippopotamus goddess standing upright and steadying a *sa* amulet, the symbol of protection. The traditional tall, plumed crown would have been attached to the vertical projection on top of her head. The texture and composition of this opaque glass figure differ markedly from earlier Egyptian glass objects. Sculpture made of glass was rare at any period of Egyptian history, which makes it difficult to date any piece with confidence. Yet the statuette's turquoise color and the similarity of its sculptural technique to other late Egyptian mold-made figures suggest a date in the Ptolemaic Period. *Purchase, Edward S. Harkness Gift, 1926, 26.7.1193*

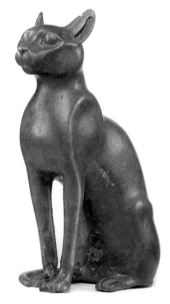

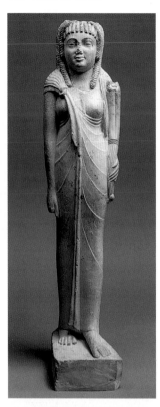

52 Arsinoe II

Ptolemaic Period, after 270 B.C.
*Limestone with traces of gilding and paint;
h. 15 in. (38.1 cm)*

Since the inscription on the back of this figure refers to Arsinoe II as a goddess, it was probably made after her death in 270 B.C., when her cult was established by her brother and husband, Ptolemy II. The queen stands in a traditional Egyptian pose, strictly frontal, with her left foot advanced and right arm, hand clenched, at her side. The statuette is a fine example of the tendency during the Ptolemaic Period to combine Egyptian artistic conventions with those of the classical world. The style of her wig and the cornucopia (a divine attribute) she holds are Greek elements, whereas her stylized features and garments and the back pillar are well-established Egyptian conventions of the period. *Rogers Fund, 1920, 20.2.21*

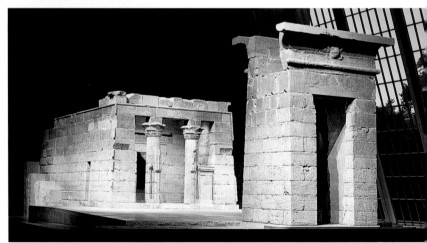

53 Temple of Dendur

Dendur, early Roman Period, ca. 15 B.C.
*Aeolian sandstone; l. of gateway and temple
82 ft. (25 m)*

The Temple of Dendur was erected by the Roman emperor Augustus during his occupation of Egypt and Lower Nubia, the area south of modern Aswan. It would have been submerged completely by Lake Nasser after the construction of the Aswan High Dam, but instead it came to the United States as a gift from Egypt in recognition of the American contribution to the international campaign to save the ancient Nubian monuments. The monument honors the goddess Isis and two sons of a Nubian chieftain, who were deified. The temple has been re-assembled behind its stone gate, which once served as an entrance through a mud-brick enclosure wall. The complex is a simplified version of the standard Egyptian cult temple, whose plan had remained fairly consistent for three thousand years. In the temple reliefs Augustus makes offerings to various Egyptian gods, the two brothers, and two Nubian gods. He is represented in the traditional manner of an Egyptian pharaoh, but in an artistic style that clearly dates the decoration to the Roman Period. *Given to the United States by Egypt in 1965, awarded to The Metropolitan Museum of Art in 1967, and installed in The Sackler Wing in 1978, 68.154*

54 Portrait of a Woman
Roman Period, ca. A.D. 160
Encaustic on wood; 15 × 7¼ in. (38.1 × 18.4 cm)

Paintings such as this are often called Fayum portraits, after the area in which the largest number have been found. The wooden panels initially may have been used as portraits in homes, but at the owner's death they were fitted into the wrapping over the face of a mummy, serving the function of the traditional mummy mask. Painted in the encaustic technique (pigment applied in melted wax), the artistic style of painting has more in common with the Hellenistic–Roman tradition, although the final use and much of the iconography is Egyptian. *Rogers Fund, 1909, 09.181.6*

55 Funerary Stela
Abydos, Roman Period, 3rd–4th c. A.D.
Limestone; h. 15 in. (38.1 cm)

By the third century A.D. many ancient Egyptian artistic conventions had given way to stylistic elements from the Mediterranean world of Greece and Rome. The carving on this stela is not typically Egyptian, but the figures of Anubis, at left, and Osiris, at right, the winged disk with uraeus cobras, and the two crouching canines in the lunette at the top reach back thousands of years into pharaonic Egypt. The inscription at the bottom is written in clumsy Greek, but the names of the four individuals to whom the stela was dedicated are Egyptian. The use of Greek, rather than Coptic or Demotic Egyptian, may reflect the preferential treatment accorded ethnic Greeks and speakers of Greek during the Roman domination of Egypt. *Rogers Fund, 1920, 20.2.44*

GIOVANNI DI SER GIOVANNI, called
SCHEGGIA, Florentine, 1407–1486
The Triumph of Fame
*Tempera, silver, and gold on wood; diam.
(painted surface) 24⅝ in. (62.5 cm)*

This imposing commemorative birth tray (*desco
da parto*) was commissioned to celebrate the
birth of Lorenzo de' Medici (1449–1492), the most
celebrated ruler of his day as well as an important
poet and patron of the arts; his name is synony-
mous with the Renaissance. It was painted by
the younger brother of Masaccio, and Lorenzo
kept it in his quarters in the Medici palace.

The auspicious imagery is taken from Boc-
caccio's *L'Amorosa visione* and Petrarch's
Trionfi. Knights extend their hands in allegiance
to an allegorical figure of Fame, who holds a
sword and a cupid (symbols of victory through
arms and love) and stands on a perforated globe
with winged trumpets. *Purchase in memory of
Sir John Pope-Hennessy: Rogers Fund, The
Annenberg Foundation, Drue Heinz Foundation,
Annette de la Renta, Mr. and Mrs. Frank E.
Richardson, and The Vincent Astor Foundation
Gifts, Wrightsman and Gwynne Andrews Funds,
special funds, and Gift of the children of Mrs.
Harry Payne Whitney, Gift of Mr. and Mrs.
Joshua Logan, and other gifts and bequests, by
exchange, 1995, 1995.7*

EUROPEAN PAINTINGS

The Museum's collection of Old Master and nineteenth-century European paintings numbers approximately three thousand works, dating from the twelfth through the nineteenth century. The Italian, Flemish, Dutch, and French schools are most strongly represented, but there are also fine works by Spanish and British masters.

The history of the collection is marked by extraordinary gifts and bequests. In 1901 the Museum received a bequest of almost seven million dollars from Jacob S. Rogers for the purchase of works of art in all fields. *The Fortune Teller* by La Tour and *Cypresses* by Van Gogh are only two examples from among many hundreds of works of art bought from this fund over the years. The bequest of Benjamin Altman in 1913 brought a number of major works to the Museum, including important paintings by Mantegna, Memling, and Rembrandt. In 1917 a bequest and funds for additional acquisitions were received from Isaac D. Fletcher. Velázquez's splendid portrait of Juan de Pareja was acquired in 1971 principally from the Fletcher Fund.

In 1929 the bequest of the H. O. Havemeyer Collection brought not only Old Masters but also unrivaled works by the French Impressionists. Among the works owned by Mr. and Mrs. Havemeyer were El Greco's *View of Toledo*, the portrait of Moltedo by Ingres, many paintings and pastels by Degas, and Monet's *Poplars*. Michael Friedsam's bequest in 1931 strengthened the department's holdings of early French and Flemish paintings. The collection formed by Jules Bache, which included superb French eighteenth-century paintings and notable works by Crivelli, Holbein, and Titian, was deposited in the Museum in 1949.

Over the last three decades Mr. and Mrs. Charles Wrightsman have presented many Old Master works of outstanding quality. And in recent years Walter H. and Leonore Annenberg have shared their collection of French Impressionists with the Museum. These are but two examples of the discerning generosity that has made the Museum what it is today.

1 BERLINGHIERO, Lucchese, act. by
1228–d. by 1236
Madonna and Child
*Tempera on wood, gold ground; painted surface
30 × 19½ in. (76.2 × 49.5 cm)*

The father of a family of painters in Lucca,
Berlinghiero was the most important Tuscan
artist of the early thirteenth century. He was ob-
viously familiar with Byzantine painting,
examples of which he could have seen in Lucca
and Pisa, as both cities traded extensively with
Constantinople. The composition of this picture,
in which the Christ Child sits on the left arm of
the Madonna and lifts his right hand in bless-
ing, conforms to the Byzantine type known as
the Hodegetria, the "Indicator of the Way." It is
one of only three certain works by Berlinghiero.
Typical of him are the impeccable technique,
the manner in which physiognomical details
create a lively network of patterns, and the ex-
pressive face of the Madonna. *Gift of Irma N.
Straus, 1960, 60.173*

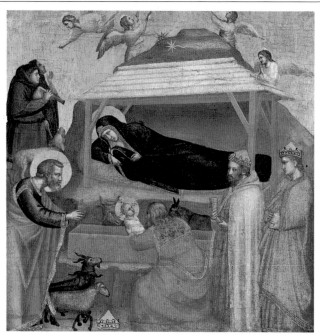

2 GIOTTO, Florentine, 1266/76–1337
The Epiphany
*Tempera on wood, gold ground; 17¾ × 17¼ in.
(45.1 × 43.8 cm)*

This picture, which shows the Adoration of the
Magi in the foreground and the Annunciation to
the Shepherds in the background, belongs to a
series of seven panels representing scenes
from the life of Christ. It seems to have been
painted about 1320, when Giotto was at the
height of his powers and enjoyed an unparalleled
reputation throughout Italy. The Museum's panel

is characterized by a clear organization of
space—the hill is divided into a series of
plateaus and the stable is viewed as though
seen from slightly to the right of center—and a
concern for simplified shapes that sets it apart
from the majority of works produced in the four-
teenth century. No less innovative is the manner
in which the eldest magus doffs his crown,
kneels down, and impetuously lifts the Christ
Child from the manger. *John Stewart Kennedy
Fund, 1911, 11.126.1*

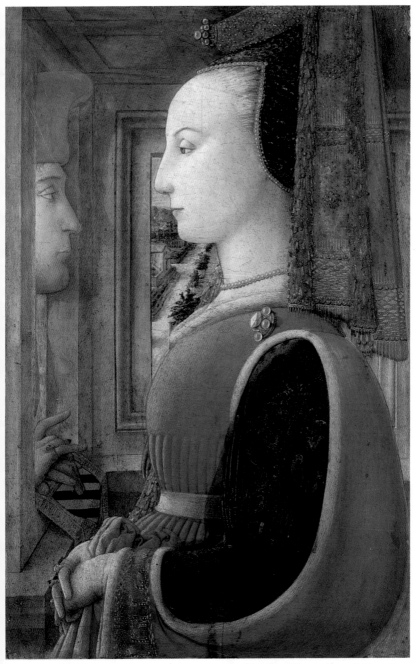

3 FRA FILIPPO LIPPI, Florentine,
ca. 1406–d. 1469
Portrait of a Man and Woman at a Casement
Tempera on wood; 25¼ × 16½ in.
(64.1 × 41.9 cm)

This painting, datable between 1435 and 1440,
is the earliest surviving double portrait and the
earliest Italian portrait in an interior setting; it
may have been painted to celebrate an engage-
ment or marriage. The lady is elaborately
dressed in the French style and wears a richly
embroidered headdress with scarlet lappets.
The word picked out in pearls on the sleeve
seems to read *leal[ta]* (fidelity). The young man
looking through the window rests his hands on
the coat of arms of the Scolari family, and the
sitters have been identified as Lorenzo di
Ranieri Scolari and Angiola di Bernardo Sapiti,
who were married in 1436. The landscape is
thought to have been inspired by Flemish mod-
els. *Marquand Collection, Gift of Henry G.
Marquand, 1889, 89.15.19*

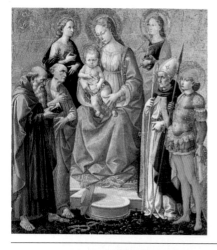

4 PESELLINO, Florentine, ca. 1422–d. 1457
Madonna and Child with Six Saints
*Tempera on wood, gold ground; 8⅞ × 8 in.
(22.5 × 20.3 cm)*

Although Pesellino's only documented work is a
large altarpiece in the National Gallery, London,
he specialized in delicately executed small-scale
paintings. This panel, painted in a miniature-like
technique, is one of his finest works. It should
be dated in the late 1440s and shows the influ-
ence of Fra Filippo Lippi in its figure types and
lighting. The saints are, from left to right, An-
thony Abbot, Jerome, Cecilia, Catherine of
Alexandria, Augustine, and George. *Bequest of
Mary Stillman Harkness, 1950, 50.145.30*

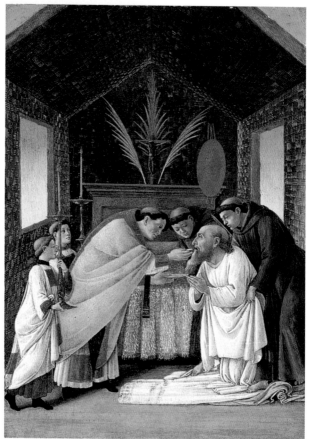

5 SANDRO BOTTICELLI, Florentine,
1444/45–1510
The Last Communion of Saint Jerome
Tempera on wood; 13½ × 10 in. (34.3 × 25.4 cm)

Here Saint Jerome is seen supported by his
brethren in his cell near Bethlehem. Above the
bed are two juniper branches, palms, a crucifix,
and Jerome's cardinal's hat. The picture, which
dates from the early 1490s, was painted for the
Florentine wool merchant Francesco del
Pugliese, who describes it in a will of 1503. Al-
though pictures of Saint Jerome in his study,
surrounded by ancient texts, were popular
among humanists, the choice of this devo-
tional subject, which is infrequently repre-
sented, may be related to the fact that Pugliese,
like Botticelli's brother, was a supporter of Sa-
vonarola, the Florentine reformer and preacher.
(See also Robert Lehman Collection, no. 8.) *Be-
quest of Benjamin Altman, 1913, 14.40.642*

DOMENICO GHIRLANDAIO, Florentine,
449–1494
Saint Christopher and the Infant Christ
fresco; 112 × 59 in. (284.5 × 149.9 cm)

This is a well-preserved example of the tech-
nique of applying pigments mixed in water onto
a fresh (or *fresco*) plaster wall. According to leg-
end, Saint Christopher uprooted a palm tree to
support himself when he carried the Christ
Child over the River Jordan. After the crossing,
the tree miraculously took root again and bore
fruit. Ghirlandaio, perhaps best known today as
the teacher of Michelangelo, devoted his life to
decorating large chapels with frescoes and to
painting remarkably lifelike portraits of his Flor-
entine contemporaries. *Gift of Cornelius
Vanderbilt, 1880, 80.3.674*

PIERO DI COSIMO, Florentine, 1462–?1521
A Hunting Scene
*tempera and oil on wood; 27³/₄ × 66³/₄ in.
(70.5 × 169.6 cm)*

Francesco del Pugliese, the owner of Botticelli's
Last Communion of Saint Jerome (no. 5), may
have commissioned this and at least two further
pictures by Piero di Cosimo illustrating the life
of primitive man. In the present picture fire

rages unchecked in the background, and men,
satyrs, and animals live a savage existence in a
dense forest. Another, less well-preserved panel
from the same series is also in the Museum; it
shows a higher state of civilization. Piero di
Cosimo was one of the most eccentric person-
alities of the early Renaissance, and this series
permitted his marvelously fertile imagination full
rein. *Gift of Robert Gordon, 1875, 75.7.2*

8 ANDREA DEL SARTO, Florentine, 1486–1530
The Holy Family with the Infant Saint John the Baptist
Oil on wood; 53½ × 39⅝ in. (135.9 × 100.6 cm)

Among Andrea del Sarto's most famous pictures is this Holy Family, which he painted about 1530 for the Florentine nobleman Giovanni Borgherini. Here John the Baptist, a patron saint of Florence, hands the globe to the infant Christ, possibly symbolizing the transfer of Florence's allegiance from Saint John to Christ himself. One of the masters of the High Renaissance, Andrea del Sarto was an exceptional draftsman and preferred the rich, varied palette that distinguishes this work. *Maria DeWitt Jesup Fund, 1922, 22.75*

BRONZINO, Florentine, 1503–1572
Portrait of a Young Man
Oil on wood; 37 ⅝ × 29 ½ in. (95.6 × 74.9 cm)

Bronzino is the foremost representative of the
sixteenth-century Mannerist style in Florence.
This is one of Bronzino's greatest portraits,
which probably shows a member of Bronzino's
close circle of literary friends. The bizarre orna-
ments on the furniture and the cold, abstract
forms of the architectural setting are fitting vi-
sual counterparts to the self-conscious literary
style popular at the time. The portrait seems to
have been painted about 1540. *H. O. Havemeyer
Collection, Bequest of Mrs. H. O. Havemeyer,
1929, 29.100.16*

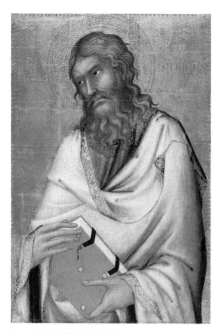

10 SIMONE MARTINI, Sienese, act. by 1315–d. 1344
Saint Andrew
Tempera on wood, gold ground; 22½ × 14⅞ in. (57.2 × 37.8 cm)

No Italian Gothic painter possessed a greater descriptive ability and a more refined technique than Simone Martini. Both of these qualities have been brought to bear in this picture of Saint Andrew, one of five panels of a folding altarpiece to which a Madonna and Child and a Saint Ansanus in the Robert Lehman Collection also belonged. Especially remarkable are the rich patterning of the folds, modeled in green, of the pink cloak and the marvelously drawn hands. The five panels may be identified with a portable altarpiece commissioned in 1326. *Gift of George Blumenthal, 1941, 41.100.23*

11 PAOLO DI GIOVANNI FEI, Sienese, act. by 1369–d. 1411
Madonna and Child
Tempera on wood, gold ground; overall, with engaged frame, 34¼ × 23¼ in. (87 × 59.1 cm)

Some of the most appealing images of the fourteenth century are based on the theme of the Virgin nursing her Child—the Madonna del Latte. Paolo di Giovanni Fei's remarkable painting, in which the solemn Virgin is portrayed frontally, while the head and the limbs of the lively Christ Child are aligned along a diagonal

12 SASSETTA, Sienese, act. by 1423–d. 1450
The Journey of the Magi
Tempera and gold on wood; 8½ × 11¾ in. (21.6 × 29.8 cm)

This panel, painted about 1435, was originally the upper part of a small *Adoration of the Magi;* the lower section, showing the magi presenting their gifts to the infant Christ, is in the Palazzo Chigi-Saraceni in Siena. Sassetta was one of the most enchanting narrative painters of the fifteenth century, and although the Museum's picture is only a fragment, the sprightly, fashionable procession of the magi, the sensitive feeling for light and atmosphere, and the stylized rendition of cranes flying across the sky have made this one of his most popular works. *Maitland F. Griggs Collection, Bequest of Maitland F. Griggs, 1943, 43.98.1*

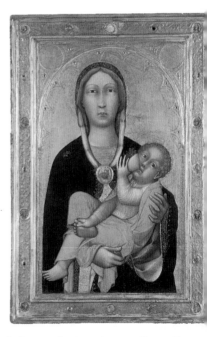

that crosses her torso, is among the most beautiful of these works. This picture is exceptional for both the tactility of the forms and the uncompromisingly regular brushwork with which they are described. No less exceptional are the almost perfect state of preservation and the original frame decorated with raised floral patterns, cabochon jewels, and glass medallions executed in a technique known as *verre églomisé.* The painting dates early in Fei's career, about 1380. *Bequest of George Blumenthal, 1941, 41.190.13*

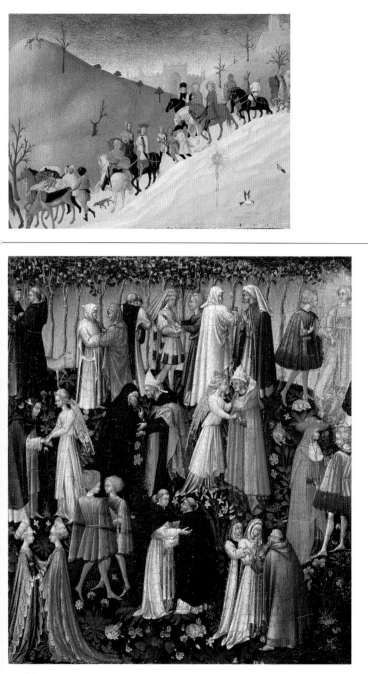

13 GIOVANNI DI PAOLO, Sienese, act. by
1417–d. 1482
Paradise
*Tempera and gold on canvas, transferred from
wood; painted surface 17½ × 15⅛ in.
(44.5 × 38.4 cm)*

In 1445 Giovanni di Paolo painted an elaborate
altarpiece for the church of San Domenico
in Siena, the main panels of which are now in
the Uffizi. There is reason to believe that both
this painting and the *Expulsion from Paradise*
in the Robert Lehman Collection (no. 6) come
from the predella of that altarpiece. Here a
company of saints—among them Augustine,
who embraces his aged mother, Monica, and
Dominic and Peter Martyr, who wear the black-
and-white Dominican habit—greet each other or
are welcomed by angels. In the upper right an
angel leads a young man into a golden light
that originally emanated from the city of Jerusa-
lem. Although the composition derives from Fra
Angelico, Giovanni di Paolo transforms Paradise
into a fairy-tale land of oversized flowers and
stylized trees silhouetted against a gold ground,
and he has endowed the figures with an inten-
sity all his own. *Rogers Fund, 1906, 06.1046*

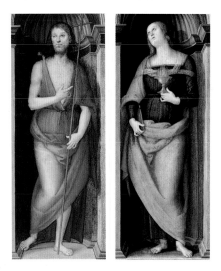

14 PIETRO PERUGINO, Umbrian, act. by 1469–d. 1523
Saint John the Baptist; Saint Lucy
Oil(?) on wood; each panel 63 × 26 ⅜ in. (160 × 67 cm)

In 1505 Perugino, at the peak of his career, received the prestigious commission to complete the monumental high altarpiece for the Servite church of Santissima Annunziata in Florence. The freestanding altarpiece was double-sided: the Deposition of Christ faced the nave and the Assumption of the Virgin faced the choir. Each scene was flanked by two saints; the present pair seems to have stood on either side of the Deposition. These saints are shown in shallow niches illuminated from the left, and in a fashion typical of Perugino they are conceived as mirror images. For their subdued coloring, subtle treatment of light, and refined conception these are among Perugino's most distinguished works. *Gift of The Jack and Belle Linsky Foundation, 1981, 1981.293.1,2*

15 LUCA SIGNORELLI, Umbrian, act. by 1470–d. 1523
Madonna and Child
Oil and gold on wood; 20 ¼ × 18 ¾ in. (51.4 × 47.6 cm)

A master of the nude, Signorelli was one of the most forceful draftsmen of the fifteenth century. He painted this picture about 1505, shortly after the completion of his famous fresco cycle in the cathedral of Orvieto. One of its most unusual features is the putti in athletic poses that are contained in the interlocked rings and acanthus borders of the gold background. The poses of some of the putti bear close comparison to figures at Orvieto. Adorning the upper corners are representations of Roman coins. *The Jules Bache Collection, 1949, 49.7.13*

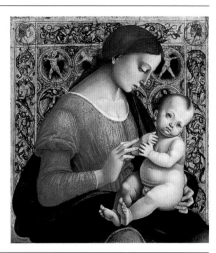

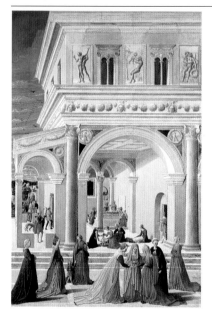

16 FRA CARNEVALE, Marchigian, act. by 1445–d. 1484
The Birth of the Virgin
Tempera and oil on wood; 57 × 37 ⅞ in. (144.8 × 96.2 cm)

This picture and a companion in the Museum of Fine Arts, Boston, showing the Presentation of the Virgin in the Temple, have been identified with an altarpiece commissioned in 1467 for the church of Santa Maria della Bella in Urbino. Their author, a Dominican friar, was trained in Florence under Filippo Lippi. The architectural setting and the carefully conceived perspective suggest that he knew the theorist and architect Leon Battista Alberti, a frequent visitor at the court of Federico da Montefeltro in Urbino (see European Sculpture and Decorative Arts, no. 50). The interpretation of the religious theme in terms of genre and the emphasis of the setting at the expense of the narrative are without precedent in Renaissance painting. The Santa Maria della Bella altarpiece was praised by Vasari, and in the seventeenth century it was removed from its church to the Barberini Palace in Rome, where it remained until this century. *Rogers and Gwynne Andrews Funds, 1935, 35.121*

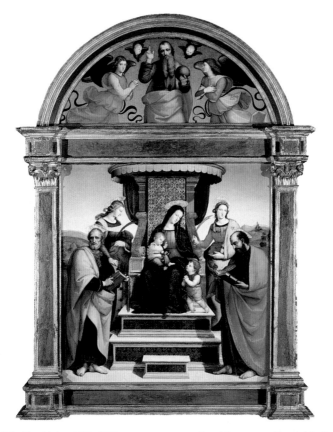

17 RAPHAEL, Marchigian, 1483–1520
Madonna and Child Enthroned with Saints
Tempera and gold on wood; main panel, painted surface 66¾ × 66½ in. (169.5 × 168.9 cm)

When Raphael began this celebrated altarpiece for the convent of Sant'Antonio at Perugia, he was barely twenty. He left for Florence in 1504 and probably completed it upon his return to Perugia the following year. His training under Perugino (no. 14) is evident in the emphatic symmetry of the composition, while the figures of Saints Peter and Paul possess a grandeur that may reflect Raphael's study of works by Fra Bartolomeo in Florence. The most remarkable portions of the altarpiece are the predella scenes (no. 18) and the lunette, where the angels and cherub heads are positioned in the space with unsurpassed precision. The frame is contemporary, though not the original one. *Gift of J. Pierpont Morgan, 1916, 16.30ab*

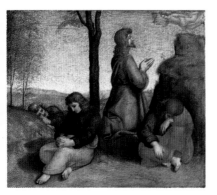

18 RAPHAEL, Marchigian, 1483–1520
The Agony in the Garden
Tempera on wood; 9½ × 11⅜ in. (24.1 × 29.9 cm)

Raphael's most engaging youthful works are his small narrative paintings. This one comes from the predella of the altarpiece for Sant'Antonio in Perugia (no. 17) and is executed with his characteristic delicacy. After the Last Supper Christ retired with the Apostles to the Mount of Olives, and here he is seen praying while Peter, James, and John are fast asleep. The pose of each figure has been conceived so as to clearly define the space, and a preparatory drawing in the Morgan Library, New York, establishes the care that Raphael lavished on every detail. In 1663 the nuns of Sant'Antonio separated the predella scenes from the altarpiece and sold them to Queen Christina of Sweden. *Funds from various donors, 1932, 32.130.1*

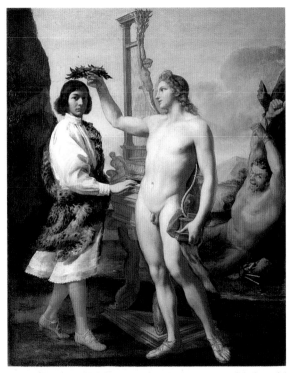

19 ANDREA SACCHI, Roman, 1599–1661
Marcantonio Pasqualini Crowned by Apollo
Oil on canvas; 96 × 76½ in. (243.8 × 194.3 cm)

Marcantonio Pasqualini (1614–1691) was per-
haps the leading male soprano (castrato) of his
day as well as a composer. He began his career
at the age of nine, and in 1630 he joined the
Sistine choir under the sponsorship of Cardinal
Antonio Barberini. Like Sacchi, Pasqualini was
a member of the Barberini household, and he
was a principal singer in the operas performed
in the Barberini palace. Here he wears the cos-
tume associated with pastoral roles and plays an
upright harpsichord. Apollo, the god of music,
holds a laurel wreath over his head to signify his
achievements, while at the right is the satyr Mar-
syas, who had unsuccessfully challenged Apollo
in a musical contest. The satyr's presence un-
derscores Pasqualini's triumph. Characteristic
of Sacchi, the leading classical painter in Rome
in the second quarter of the seventeenth cen-
tury, are the carefully balanced design of the
work and the intentional contrast between the
richly painted figure of Pasqualini and the
smooth, enamel-like treatment of Apollo. *Pur-
chase, Enid A. Haupt Gift and Gwynne Andrews
Fund, 1981, 1981.317*

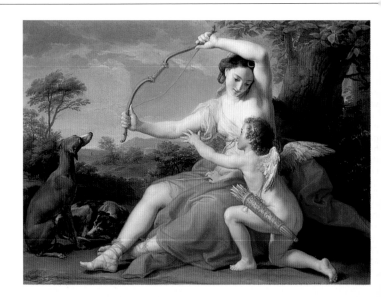

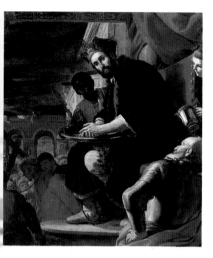

21 MATTIA PRETI, Neapolitan, 1613–1699
Pilate Washing His Hands
Oil on canvas; 81⅛ × 72¾ in. (206.1 × 184.8 cm)

Preti, who was born in the remote town of Ta-
verna, in Calabria, came to be one of the most
sought-after and innovative artists of the second
half of the seventeenth century. He painted this
picture in 1663, while he was decorating the
vault of the church of San Giovanni in Valetta
for the Knights of Malta. It illustrates the verses
in the Gospel of Matthew (27:11–24) that de-
scribe how Pilate, after hearing the accusations
brought against Jesus, washed his hands before
the multitude, saying, "I am innocent of the
blood of this righteous person." Executed with
Preti's accustomed bravura, this is a picture of
unusual psychological intensity. *Purchase, Gift
of J. Pierpont Morgan and Bequest of Helena W.
Charlton, by exchange, Gwynne Andrews, Mar-
quand, Rogers, Victor Wilbour Memorial and The
Alfred N. Punnett Endowment Funds, and funds
given or bequeathed by friends of the Museum,
1978, 1978.402*

22 SALVATOR ROSA, Neapolitan, 1615–1673
Self-portrait
Oil on canvas; 39 × 31¼ in. (99.1 × 79.4 cm)

A man of many talents, Rosa was a distin-
guished painter, engraver, playwright, poet, and
musician. During his residence in Florence,
where he worked for the Medici, he became a
close friend of Giovanni Battista Ricciardi, a
professor of philosophy at the University of Pisa
and a notable writer. The inscription on this
enigmatic portrait states that it was painted by
Rosa as a gift for Ricciardi. In the seventeenth
century it was described as depicting Ricciardi
dressed as a philosopher, but it has subse-
quently been shown to represent Rosa himself.
Rosa paints himself as a Stoic philosopher,
wearing a cypress wreath, a symbol of mourn-
ing, and is writing on the skull in Greek:
"Behold, whither, when." *Bequest of Mary L.
Harrison, 1921, 21.105*

20 POMPEO BATONI, Roman, 1708–1787
Diana and Cupid
Oil on canvas; 49 × 68 in. (124.5 × 172.7 cm)

Batoni was the most important Italian artist in
late-eighteenth-century Rome and was particu-
larly favored by English milords. This picture
was commissioned by Sir Humphry Morice,
who later had Batoni paint a pendant portrait
showing Sir Humphry reclining in the Roman
countryside with three hunting dogs and some
game. Diana was the goddess of the hunt and
here appears to reprove Cupid for his misuse of
the bow. Batoni was an avid student of ancient
sculpture, and the pose of Diana derives from
the so-called *Sleeping Ariadne* in the Vatican.
*Purchase, The Charles Engelhard Foundation,
Robert Lehman Foundation, Inc., Mrs. Haebler
Frantz, April R. Axton, L.H.P. Klotz, and David
Mortimer Gifts; and Gifts of Mr. and Mrs. Charles
Wrightsman, George Blumenthal, and J. Pierpont
Morgan, Bequests of Millie Bruhl Fredrick and
Mary Clark Thompson, and Rogers Fund, by ex-
change, 1982, 1982.438*

23 CARLO CRIVELLI, Venetian, act. 1457–93
Madonna and Child
*Tempera and gold on wood; painted surface
14 3/8 × 9 1/4 in. (36.5 × 23.5 cm)*

One of Crivelli's finest works, this small picture
is a virtual compendium of his art. The carefully
observed landscape reflects his knowledge of
Netherlandish painting, which he was able to
study as a youth in his native Venice, whereas
the various still-life details and trompe-l'oeil
devices—the swag of fruit, the jewel-encrusted
gold halos, and the signed piece of paper—
reveal the influence of the Paduan school of
painting. To complete this visual tour de force,
Crivelli has included a fly, depicted as though it
had just alighted on the painting. The picture
dates from the 1480s and was painted in the
Marches, where Crivelli spent most of his ca-
reer. *The Jules Bache Collection, 1949, 49.7.5*

24 MICHELE GIAMBONO, Venetian,
act. 1420–62
The Man of Sorrows
*Tempera on wood; painted surface 21 5/8 × 15 1/4 in.
(54.9 × 38.8 cm)*

Giambono was the outstanding Venetian propo-
nent of what has come to be known as the
International Gothic style. Influenced by both
Gentile da Fabriano and Pisanello, his works
combine rich surface patterns with delicately
rendered, naturalistic details. This small and

affective Man of Sorrows was painted as a pri-
vate devotional work, possibly for a Francis-
can friar. The crown of thorns and the blood
streaming from the wound is in relief in order
to focus the worshiper's attention on the suffer-
ing of Christ, whose delicate-limbed body was
originally set off against a richly patterned back-
ground heightened with gold leaf. Exceptionally,
the picture is in its original frame (the reverse is
painted to simulate porphyry). *Rogers Fund,
1906, 06.180.*

25 GIOVANNI BELLINI, Venetian, act. by 1459–
d. 1516
Madonna and Child
Oil on wood; 35 × 28 in. (88.9 × 71.1 cm)

In addition to the great altarpieces that Bellini
created for churches throughout the Veneto, he
also painted devotional images of the Madonna
and Child for domestic settings. Despite their
relatively modest dimensions and restrictive
theme, these pictures invariably exhibit a re-
markably fresh, inventive approach. In this
painting, which dates from the 1480s, the
Madonna is aligned with the vertical axis of the
picture, but the cloth of honor introduces an
asymmetry which at this date was extremely
daring. Bellini filled the resulting void with an
autumnal landscape of extraordinary beauty
that contrasts with the warm colors of the figure
group and at the same time contributes greatly
to the still, poignant mood of the picture. The
quince held by the Christ Child is a symbol of
the Resurrection. *Rogers Fund, 1908, 08.183.1*

26 VITTORE CARPACCIO, Venetian,
ca. 1455–1523/26
The Meditation on the Passion
*Oil and tempera on wood; 27 ¾ × 34⅛ in.
(70.5 × 86.7 cm)*

Although Carpaccio's most famous pictures are
the narrative cycles he painted for religious con-
fraternities in Venice, his altarpieces and devo-
tional paintings are no less distinguished. This
picture (ca. 1510) is a masterpiece from the sec-
ond group. To the right Job is seated on a
marble block inscribed with his words, "I know
that my redeemer liveth." According to Saint
Jerome, who is portrayed at the left as a hermit,
this passage refers to the Resurrection of
Christ. The figure of the dead Christ is displayed
on a broken marble throne, behind which a
small bird, a symbol of the Resurrection, flies
upward. The landscape—savage and barren on
the left, pastoral and lush on the right—also al-
ludes to death and life. In few other pictures by
Carpaccio is the rich technique of Venetian
painting employed to illustrate such a deeply se-
rious theme and meditative mood. *John Stewart
Kennedy Fund, 1911, 11.118*

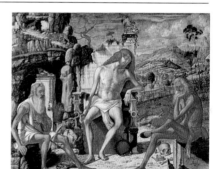

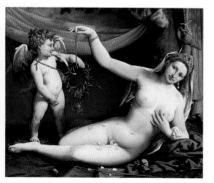

27 LORENZO LOTTO, Venetian, ca. 1480–
d. 1556
Venus and Cupid
*Oil on canvas; 36⅜ × 43⅞ in.
(92.4 × 111.4 cm)*

Possibly painted to celebrate a wedding, this
picture derives its unusual iconography from
classical marriage poetry (epithalamia). Cupid's
playful urination portends a fruitful union, while
the myrtle wreath and incense burner held by
Venus, who wears the crown, veil, and earring
of a bride, are symbols of marriage, as are the
red cloth and ivy. The snake may refer to jeal-
ousy. This is a most personal interpretation of
fecund sexuality, an enduring theme of Venetian
art. It appears to date from the 1520s and offers
an alternative to the idealizing style of Lotto's
contemporaries Giorgione and Titian. *Purchase,
Mrs. Charles Wrightsman Gift, in honor of
Marietta Tree, 1986, 1986.138*

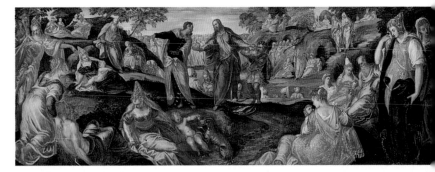

28 TINTORETTO, Venetian, 1518–1594
The Miracle of the Loaves and Fishes
Oil on canvas; 61 × 160½ in. (154.9 × 407.7 cm)

On two occasions Christ fed a multitude with a few loaves and fishes. This painting depicts the miracle as recounted in the Gospel of John 6:1–14) and shows Christ handing Saint Andrew one of the five loaves and two fishes to be distributed to the crowd. The picture should be dated about 1545–50, and judging from the point of view from which the figures in the foreground are painted, it was intended to be hung fairly high. As in other paintings of this date by Tintoretto, the figures are painted with great assurance in a dazzling array of colors. Especially notable is the vast, circular space, dotted with the arched openings of tombs and animated with clumps of trees, which he has created around the central figures of Christ and Saint Andrew. *Francis L. Leland Fund, 1913, 13.75*

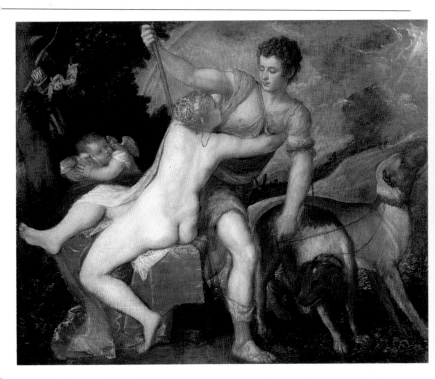

29 TITIAN, Venetian, ca. 1488–d. 1576
Venus and Adonis
Oil on canvas; 42 × 52½ in. (106.7 × 133.4 cm)

As often as not, Ovid's *Metamorphoses* provided the inspiration for Titian's mythological paintings, but in this case no precise literary source has been found. The pose of Venus seems to have been inspired by that of a similar figure on a Roman sarcophagus relief. She embraces her lover, the hunter Adonis, who is about to depart on his fatal boar chase. Cupid is seen behind a rock protectively holding a dove, as though forewarned of Adonis's imminent death. The beautiful landscape is lit by a golden ray of light emerging between the clouds, and a rainbow hangs over the lovers. Titian treated this subject a number of times, sometimes with the help of assistants, but the Museum's version appears to be completely autograph. It dates from the 1560s and exemplifies Titian's unsurpassed mastery and inspired interpretation of classical mythology. *The Jules Bache Collection, 1949, 49.7.16*

30 PAOLO VERONESE, Venetian, 1528–1588
Mars and Venus United by Love
Oil on canvas; 81 × 63⅜ in. (205.7 × 161 cm)

This work is one of five outstanding paintings by Veronese that were owned by Emperor Rudolf II in Prague. All illustrate abstruse allegories, and the exact meaning of the present picture has not been fully explained. It has been suggested that rather than being Venus, the woman symbolizes Chastity transformed by Love into Charity and that the horse held back by an armed cupid is an emblem of Passion Restrained. Regardless of its precise meaning, this is one of Veronese's masterpieces. When it was painted in the 1570s, Veronese was at the height of his powers, a marvelous colorist and the possessor of an unsurpassed representational technique. *John Stewart Kennedy Fund, 1910, 10.189*

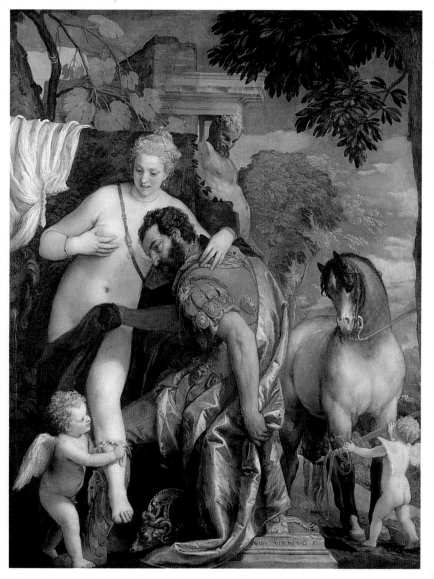

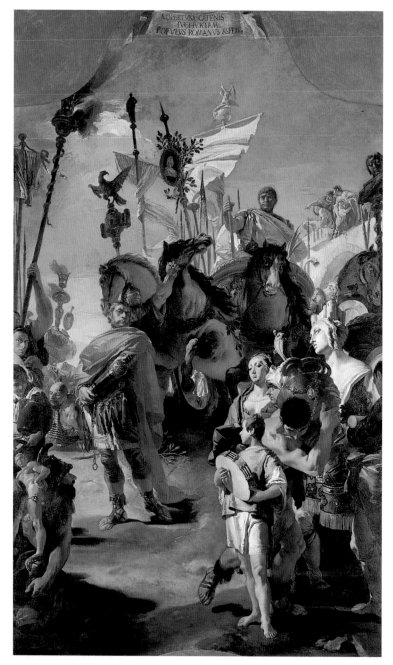

31 GIOVANNI BATTISTA TIEPOLO, Venetian, 1696–1770

The Triumph of Marius
Oil on canvas; 214¾ × 127¾ in. (545.5 × 324.5 cm)

In about 1725 G. B. Tiepolo was commissioned by Dionisio Dolfin, the patriarch of Aquileia, to undertake frescoes in the archepiscopal palace at Udine. Concurrently he decorated the salone of the Ca'Dolfin, the patriarch's Venetian palace, with a series of ten large paintings of classical subjects. These irregularly shaped canvases were set into the walls of the salone and surrounded with elaborate fictive frames. The paintings were removed in 1870, and three of them are now in the Museum. The present picture shows the Roman general Gaius Marius in the victor's chariot while the conquered African king Jugurtha walks before him, bound in chains. A young boy playing a tambourine leads a group of Romans who carry the spoils of victory. The Latin inscription on the cartouche at the top translates, "The Roman people behold Jugurtha laden with chains"; on an oval medallion the date 1729 is visible. The deep, resonant colors and masterly drawing are typical of the thirty-three-year-old Tiepolo, who is shown at left, in front of the torchbearer. *Rogers Fund, 1965, 65.183.1*

32 GIOVANNI BATTISTA TIEPOLO, Venetian, 1696–1770
Allegory of the Planets and Continents
Oil on canvas; 73 × 54⅞ in. (185.4 × 139.4 cm)

Tiepolo's greatest achievement was the decoration of the palace of Carl Philipp von Greiffenklau, prince-bishop of Würzburg, carried out between 1751 and 1753. The present picture is the model presented by Tiepolo on April 20, 1752, for the celebrated fresco over the staircase of the palace. It shows Apollo about to embark on his daily course across the sky. The deities around Apollo symbolize the planets, and the allegorical figures on the cornice represent the four continents of the world. Since the staircase measures over sixty by ninety feet, numerous changes were made between the model and the fresco. The model, however, shares with the completed ceiling the feeling for airy space, the beautiful colors, and the prodigious inventiveness that made Tiepolo the unexcelled decorator of the eighteenth century. (See also Drawings, no. 4.) *Gift of Mr. and Mrs. Charles Wrightsman, 1977, 1977.1.3*

33 GIOVANNI DOMENICO TIEPOLO, Venetian, 1727–1804
A Dance in the Country
Oil on canvas; 29¾ × 47¼ in. (75.6 × 120 cm)

The son and valued assistant of Giovanni Battista Tiepolo, Giovanni Domenico especially excelled as a recorder of contemporary life. This canvas, painted about 1756, depicts a dance in the garden of a villa. The young man dancing with an actress wears the scarlet suit and red cap with black feathers traditionally associated with the commedia dell'arte character Mezzetino, and another figure wears the long-nosed mask and tall hat of Punchinello. Of the countless conversation pieces produced in the mid-eighteenth century, this is one of the most effervescent and spontaneous, and it transmits an incomparably lively sense of the pleasures of aristocratic life in the Veneto. (See also Robert Lehman Collection, no. 38.) *Gift of Mr. and Mrs. Charles Wrightsman, 1980, 1980.67*

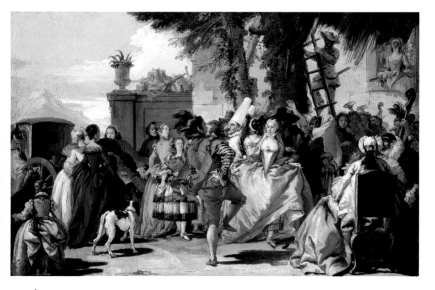

34 CANALETTO, Venetian, ca. 1697–1768
Piazza San Marco
Oil on canvas; 27 × 44 ¼ in. (68.6 × 112.4 cm)

Canaletto was preeminent among eighteenth-century topographical painters. The vast, arcaded Venetian piazza, unchanged to this day, opens onto a view of the Torre dell'Orologio (clock tower); the basilica of San Marco, patron saint of Venice; the campanile (bell tower); and the Palazzo Ducale, which until the Napoleonic era was the residence of the doges and the seat of government. The clear, blond light and sharp detail suggest a date for this canvas of about 1730. Despite the view's seeming verisimilitude, the artist has modified it in the interest of pictorial effect. The flagstaffs are taller than they are in fact, and the windows of the bell tower are fewer in number and more widely spaced. The sky is freely painted, and the white pigment used for the clouds projects slightly in relief. *Purchase, Mrs. Charles Wrightsman Gift, 1988, 1988.162*

35 FRANCESCO GUARDI, Venetian, 1712–1793
Fantastic Landscape
Oil on canvas; 61¼ × 74½ in. (155.6 × 189.2 cm)

This painting and its two companion works in the Museum come from the castle of Colloredo, near Udine, where they were installed in an eighteenth-century drawing room. They probably date from the 1760s and are among Guardi's finest imaginary landscapes. The light, airy touch with which they are painted and the feeling for a saturated atmosphere are characteristic of his best work. *Gift of Julia A. Berwind, 1953, 53.225.3*

36 MICHELINO DA BESOZZO, Lombard, act. 1388–1450
The Marriage of the Virgin
Tempera on wood, embossed and gilt halos and ornament; 25⅝ × 18¾ in. (65.1 × 47.6 cm)

Of the great painter-illuminators who dominated Lombard art in the early fifteenth century under the patronage of the Visconti, the most famous was Michelino da Besozzo. Little of his work survives, and only two panel paintings by him are known. This picture, which dates from about 1430, is laid out like an illumination, with the principal figures placed beneath the curves of the arch of the church, while the rejected suitors break their rods at the left. Typical of Michelino are the elaborate drapery and the suitors' comical expressions. *Maitland F. Griggs Collection, Bequest of Maitland F. Griggs, 1943, 43.98.7*

37 ANDREA MANTEGNA, Paduan, ca. 1430–d. 1506
The Adoration of the Shepherds
Tempera on canvas, transferred from wood; 15¾ × 21⅞ in. (40 × 55.6 cm)

Mantegna was one of the great prodigies of Italian painting, establishing his reputation when he was barely twenty years old with the frescoes in the church of the Eremitani in Padua. *The Ad-* oration of the Shepherds is among his earliest paintings, but already his highly individual style is evident. The hard, precise drawing, the astonishing clarity of even the smallest details in the distant landscape, and the refined, pure color are typical of his work, as are the intensely serious expressions of the figures. *Purchase, Anonymous Gift, 1932, 32.130.2*

38 COSIMO TURA, Ferrarese, act. by 1451–d. 1495
The Flight into Egypt
Tempera on wood; painted surface diam. 15¼ in. (38.7 cm)

This picture is one of three circular scenes illustrating the early life of Christ which have been supposed to belong to Tura's masterpiece, the Roverella altarpiece, painted about 1474 for the church of San Giorgio fuori le Mura in Ferrara. Tura was the greatest Ferrarese painter and one of the most individual artists of the fifteenth century. In this work the gnarled figures, the eerie, barren landscape, and the unearthly pink of the morning sky are typical of his wonderfully imaginative approach to painting. *The Jules Bache Collection, 1949, 49.7.17*

39 CORREGGIO, School of Parma, act. by
1514–d. 1534
**Saints Peter, Martha, Mary Magdalen, and
Leonard**
Oil on canvas; 87¼ × 63¾ in. (221.6 × 161.9 cm)

This altarpiece seems to have been commissioned about 1517 by Correggio's compatriot Melchiore Fassi, who had a special devotion for the four saints shown. It is a relatively early work, in which the delicate, feminine beauty of the figures, the subtle treatment of light, and the emphatic use of shadow presage the achievements of Correggio's maturity. Saints Peter, Mary Magdalen, and Leonard hold their traditional attributes: Peter the keys of the gates of Heaven, Mary Magdalen the jar of ointment, and Leonard the fetters of prisoners released through his intercession. Saint Martha, however, is shown with unusual attributes—an aspergillum and the dragon she tamed with holy water. *John Stewart Kennedy Fund, 1912, 12.211*

40 GIROLAMO ROMANINO, Brescian,
1484/87–1560
The Flagellation and (on the reverse) **The
Madonna of Mercy**
*Distemper and oil(?) on canvas; 70⅞ × 47½ in.
(180 × 120.7 cm)*

Although as a youth Romanino had studied the work of Titian in Venice, he also admired German prints, and his mature style has an expressive intensity rare in Italian art. This picture, which dates from about 1540, served as a processional standard for a Franciscan confraternity of flagellants. As this function required, it is painted on both sides (the reverse is badly damaged). The balletic pose of Christ, contrasting with the fury of his tormenters, may well have been inspired by a woodcut by Hans Baldung Grien. Romanino's composition appears, in turn, to have inspired an altarpiece of the same theme by Caravaggio, for whom Brescian painting was a major formative influence. *Purchase, Anonymous Bequest, by exchange, 1989, 1989.86*

41 MORETTO DA BRESCIA, Brescian,
ca. 1498–d. 1554
Portrait of a Man
Oil on canvas; 34½ × 32 in. (87 × 81.3 cm)

Although the sitter in this early portrait by Moretto was at one time thought to be a member of the Martinengo family of Brescia, this identification cannot be verified. It is one of his most striking portraits. Moretto was, of course, familiar with the work of Titian, but he took a more realistic approach to painting, and some of the most beautiful passages in this work are details like the Turkish carpet, the hourglass (a symbol of the passing of time), and the black watered satin of the sitter's robes. *Rogers Fund, 1928, 28.79*

42 GIOVANNI BATTISTA MORONI, Lombard,
ca. 1524–d. 1578
Abbess Lucrezia Agliardi Vertova
Oil on canvas; 36 × 27 in. (91.4 × 68.6 cm)

A pupil of Moretto da Brescia, Moroni was one of the most distinguished portraitists of the sixteenth century. The inscription on this portrait states that the sitter was the daughter of the nobleman Alessio Agliardi of Bergamo and the wife of Francesco Cataneo Vertova and that she founded the Carmelite convent of Sant'Anna in Albino, near Bergamo. In 1556 Lucrezia (b. ca. 1490) named the convent beneficiary in her will, and it is probable that the portrait was painted on this occasion. The inscribed date 1557 may be that of her death. The picture is one of Moroni's finest, notable especially for the severity of its design, the lack of idealization of the sitter's features, and the remarkable effect of the hands resting on the ledge. *Theodore M. Davis Collection, Bequest of Theodore M. Davis, 1915, 30.95.255*

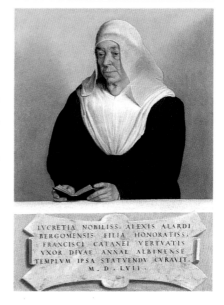

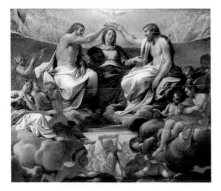

43 ANNIBALE CARRACCI, Bolognese, 1560–1609
The Coronation of the Virgin
Oil on canvas; 46³⁄₈ × 55⁵⁄₈ in. (117.8 × 141.3 cm)

Carracci painted this celebrated picture shortly after he arrived in Rome in 1595. It seems to have been commissioned by Cardinal Pietro Aldobrandini, a nephew of Pope Clement VIII, and was singled out by early sources as one of the most distinguished works in the cardinal's collection. Despite its relatively modest dimensions, this picture is an example of Carracci's work at its best; especially notable are the rich use of color and dramatic lighting, the idealized figures, and the carefully constructed empyrean. *Purchase, Bequest of Miss Adelaide Milton de Groot (1876–1967), by exchange, and Dr. and Mrs. Manuel Porter and Sons Gift, in honor of Mrs. Sarah Porter, 1971, 1971.155*

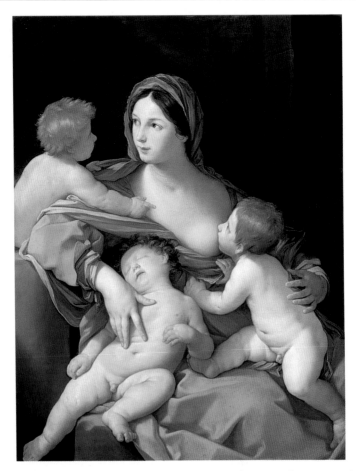

44 GUIDO RENI, Bolognese, 1575–1642
Charity
Oil on canvas; 54 × 41³⁄₄ in. (137.2 × 106 cm)

Guido Reni was one of the leading painters in Bologna in the second quarter of the seventeenth century. Here the virtue Charity is shown with three baby boys. The delicate and varied flesh tones, soft modeling, and gentle emotion are characteristic of Reni's late work at its best. The picture, which descended in the Liechtenstein family collection until the late nineteenth century, may have been purchased from the artist about 1630 by Prince Karl Eusebius von Liechtenstein. *Gift of Mr. and Mrs. Charles Wrightsman, 1974, 1974.348*

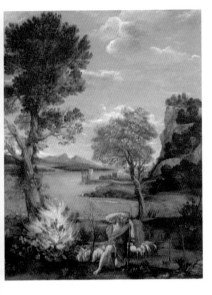

45 DOMENICHINO, Bolognese, 1581–1641
Landscape with Moses and the Burning Bush
Oil on copper; 17¾ × 13⅜ in. (45.1 × 34 cm)

Like his mentor Annibale Carracci (no. 43), Domenichino was known not only for his large narrative fresco cycles, but also for his idealized landscapes of the Roman countryside. This picture, painted about 1616, illustrates a passage in the book of Exodus (3:1–6) that tells how an angel of the Lord appeared to Moses in the guise of a burning bush. Idealized representations like this exquisite work established the vogue for classical landscapes and influenced Claude Lorrain (no. 113). *Gift of Mr. and Mrs. Charles Wrightsman, 1976, 1976.155.2*

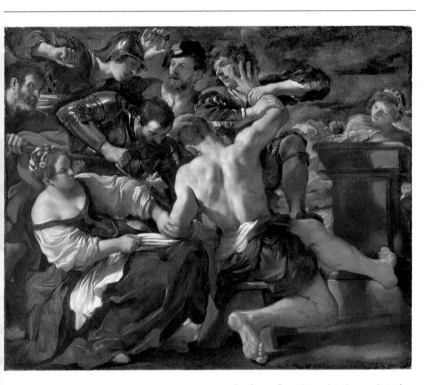

46 GUERCINO, Ferrarese, 1591–1666
Samson Captured by the Philistines
Oil on canvas; 75¼ × 93¼ in. (191.1 × 236.2 cm)

This picture was commissioned in 1619 by Cardinal Jacopo Serra, who in Rome had promoted the young Peter Paul Rubens. Upon his appointment as papal legate to Ferrara, the cardinal responded immediately to the brilliant Baroque style of the twenty-eight-year-old Guercino—an autodidact and the rising star of Northern Italian art. For Serra, Guercino painted a number of works, but none attains the dramatic intensity of this illustration of Samson, who, deprived of his strength-giving hair by the duplicitous Delilah, was bound and blinded by the Philistines. The idea of making Samson's back the vortex of the action was arrived at only after several preliminary studies. *Gift of Mr. and Mrs. Charles Wrightsman, 1984, 1984.459.2*

47 EL GRECO, Greek, 1541–1614
The Miracle of Christ Healing the Blind
Oil on canvas; 47 × 57½ in. (119.4 × 146.1 cm)

In the Gospels there are three accounts of
Christ healing blind men. This picture seems to
follow Mark 10:46–52, which tells that the blind
Bartimaeus cried out for Christ's mercy and was
healed. Blindness is an age-old symbol of un-
belief, and particularly in the context of the
Counter-Reformation, the gift of sight should
be interpreted as emblematic of the true faith.

El Greco, born Doménikos Theotokópoulos
in Crete, received his training in Venice, re-
portedly in the workshop of Titian. He was in
Rome in 1570 and settled in Spain by 1577.
The Miracle of Christ Healing the Blind was
probably painted shortly before his arrival in
Spain. A moving and highly individual picture,
it illustrates the artist's mastery of the vocabu-
lary of mid-sixteenth-century Venetian paint-
ing. *Gift of Mr. and Mrs. Charles Wrightsman,
1978, 1978.416*

48 EL GRECO, Greek, 1541–1614
**Portrait of a Cardinal, Probably Cardinal
Don Fernando Niño de Guevara**
Oil on canvas; 67¼ × 42½ in. (170.8 × 108 cm)

This portrait has long been thought to represent
Cardinal Don Fernando Niño de Guevara (1541–
1609), the grand inquisitor who lived in Toledo
from 1599 to 1601, when he was appointed
archbishop of Seville. More recently he has
been identified as Don Gáspar de Quiroga
(d. 1594) or Don Bernardo de Sandoval y Rojas
(d. 1618). Both were cardinal-archbishops of
Toledo. Whoever he may be, the sitter is por-
trayed as a man of power and uncompromising
religious fervor. This image should be inter-
preted as an ecclesiastical state portrait,
intended to express the authority not only of the
individual, but of his holy office. (See also Rob-
ert Lehman Collection, no. 15.) *H. O. Havemeyer
Collection, Bequest of Mrs. H. O. Havemeyer,
1929, 29.100.5*

49 EL GRECO, Greek, 1541–1614
View of Toledo
Oil on canvas; 47¾ × 42¾ in. (121.3 × 108.6 cm)

This view of Toledo, painted about 1597, is El
Greco's only true landscape. A city of great an-
tiquity, Toledo is the see of the primate arch-
bishop of Spain and until 1561 was the capital
of the Spanish empire. Although El Greco has
taken some liberties in the placement of the
buildings, the viewpoint is identifiable. The fore-
ground, irrigated by the Tagus flowing beneath
the Alcántara bridge, is fertile and green; the
distant landscape is barren and threatening.
The sharp white light evokes both the eerie
beauty of the place and the menace inherent in
nature. *H. O. Havemeyer Collection, Bequest of
Mrs. H. O. Havemeyer, 1929, 29.100.6*

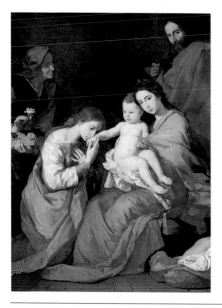

50 JUSEPE DE RIBERA, Spanish, 1591–1652
The Holy Family with Saints Anne and Catherine of Alexandria
Oil on canvas; 82½ × 60¾ in. (209.6 × 154.3 cm)

Ribera, who was born in Játiva, moved to Italy as a young man and remained there for the rest of his life. In 1616 he joined the Accademia di San Luca in Rome; shortly thereafter he settled in Naples, a Spanish possession, where he was patronized by a succession of Spanish viceroys. This picture, one of his most celebrated late works, depicts the mystic marriage of Saint Catherine. In it the realism of Ribera's early work, so strongly influenced by the example of Caravaggio, is tempered by his equally profound admiration of Raphael and Annibale Carracci. *Samuel D. Lee Fund, 1934, 34.73*

51 DIEGO VELÁZQUEZ, Spanish, 1599–1660
Juan de Pareja
Oil on canvas; 32 × 27½ in. (81.3 × 69.9 cm)

In 1648 Philip IV of Spain sent Velázquez to Italy to buy works of art for the Alcázar, the newly renovated royal palace in Madrid. While in Rome, then the center of the international art world, Velázquez painted two portraits which astounded his contemporaries: that of Pope Innocent X (Doria Pamphili Gallery, Rome) and that of his assistant, the painter Juan de Pareja (ca. 1610–1670), a Sevillian of Moorish descent. This picture was exhibited at the Pantheon on March 19, 1650, and one connoisseur who viewed it is said to have remarked that while all the rest was art, this alone was truth. *Purchase, Fletcher and Rogers Funds, and Bequest of Miss Adelaide Milton de Groot (1876–1967), by exchange, supplemented by gifts from friends of the Museum, 1971, 1971.86*

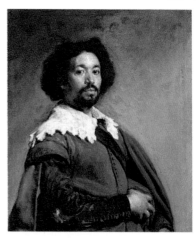

52 BARTOLOMÉ ESTEBAN MURILLO,
Spanish, 1617–1682
Virgin and Child
Oil on canvas; 65¼ × 43 in. (165.7 × 109.2 cm)

Murillo painted the Virgin and Child over and over again; his representations of the Virgin, supremely beautiful but always human, were sought after by Spanish ecclesiastics and pious families. This painting, which dates from the 1670s, hung in the private chapel of the Santiago family in Madrid until 1808. Palomino (*El Museo Pictórico*, 1715) described it as "enchanting for its sweetness and beauty." *Rogers Fund, 1943, 43.13*

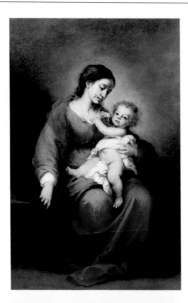

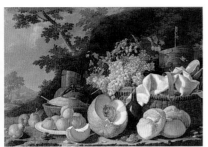

53 LUIS EGIDIO MELÉNDEZ, Spanish, 1716–1780
Still Life: The Afternoon Meal
Oil on canvas; 41 ¹/₂ × 60 ¹/₂ in.
(105.4 × 153.7 cm)

Luis Meléndez was trained in Madrid, where his father, Francisco, was employed as a miniaturist in the service of Philip V. Though the younger Meléndez was never awarded a post at court and died in poverty, he is now regarded as second only to Jean Siméon Chardin among eighteenth-century still-life painters.

Meléndez's still lifes are a uniquely Spanish type called bodegones, in which food, tableware, and kitchen utensils are represented. The format and the handling of space and light are typical of the artist, as is the meticulous rendering of textures and cubic volumes — here, of copper and pottery, the pitted flesh of pears, the rough skin of a melon, and the smooth, luminous skins of grapes. The copper pot, the basket with handle, and the large bowl were studio props that Meléndez used repeatedly, in different combinations. This painting is the largest and most elaborate of some eighty-five still lifes by Meléndez known today. *The Jack and Belle Linsky Collection, 1982, 1982.60.39*

54 FRANCISCO GOYA, Spanish, 1746–1828
Don Manuel Osorio Manrique de Zuñiga
Oil on canvas; 50 × 40 in. (127 × 101.6 cm)

Not long after Goya was appointed painter to Charles III of Spain in 1786, Count Altamira seems to have asked him to paint portraits of the members of his family, including his son, who was born in 1784. Goya depicts a fashionably dressed child holding a magpie on a string, a favorite pet since the Middle Ages. In the background three cats stare menacingly at the bird, traditionally a Christian symbol of the soul. In Renaissance art, the Christ Child is often depicted holding a bird tied to a string, and in the Baroque period, caged birds are symbolic of innocence. Goya apparently intended this portrait as an illustration of the frail boundaries that separate a child's world from the forces of evil. (See also Robert Lehman Collection, no. 17.) *The Jules Bache Collection, 1949, 49.7.41*

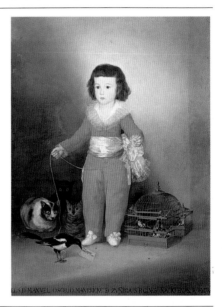

55 FRANCISCO GOYA, Spanish, 1746–1828
Don Sebastián Martínez y Pérez
Oil on canvas; 36 ⁵/₈ × 26 ⁵/₈ in. (93 × 67.6 cm)

Martínez (1747–1800) was a noted collector of books, prints, and paintings. Like Goya's other portraits of the intellectuals whom he met in the early 1790s, this painting is marked by an intensity of observation and immediacy of pose that represent a departure from the conventions of contemporaneous portraiture in Spain. He seems to have been strongly influenced by late-eighteenth-century French portraiture. This portrait was probably painted late in 1792, just before Goya contracted the illness that caused his deafness and affected him intermittently for the rest of his life. During his convalescence in 1793, he spent several months in Martínez's home. *Rogers Fund, 1906, 06.289*

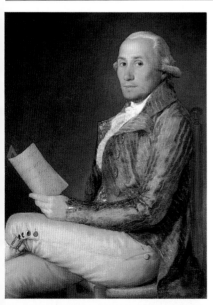

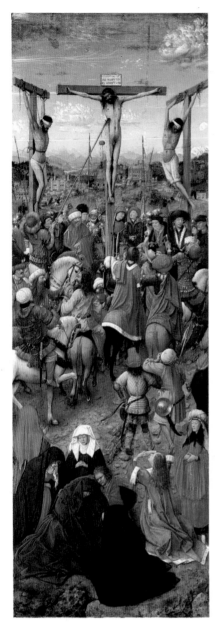

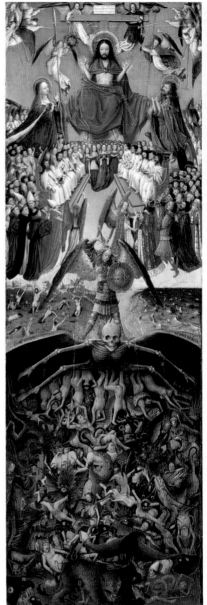

56 JAN VAN EYCK, Netherlandish, act. by 1422–d. 1441

The Crucifixion; The Last Judgment

Oil on canvas, transferred from wood; each 22¼ × 7¾ in. (56.5 × 19.7 cm)

These two paintings are among Jan van Eyck's earliest surviving works; they probably date from shortly before the Ghent altarpiece (completed 1432)—that is, between 1425 and 1430. They are closely related to a group of miniatures in the manuscript known as the Turin-Milan Hours, which are attributed to the young Jan van Eyck. It cannot be established whether *The*

Crucifixion and *The Last Judgment* were originally planned as a diptych or formed the wings of a triptych or tabernacle. Every detail here is observed freshly and with equal interest—the Alpine landscape, the slender body of Christ, the great variety of onlookers, mourners, monsters, and sinners. Perhaps more than any other works by van Eyck, these pictures show him as the forerunner of realism in the North and as one of the most inspired practitioners of the newly invented technique of oil painting. *Fletcher Fund, 1933, 33.92ab*

57 ROGIER VAN DER WEYDEN,
Netherlandish, 1399/1400–1464
Francesco d'Este
*Oil on wood; painted surface 11¾ × 8 in.
(29.8 × 20.3 cm)*

Francesco d'Este (ca. 1430–after 1475) was an illegitimate son of Leonello d'Este, duke of Ferrara. He was sent to the court of Brussels for his military training in 1444 and seems to have spent the remainder of his life in the service of the dukes of Burgundy. This portrait was probably made about 1460, when Francesco was close to thirty. The aristocratic aloofness and elegance of the sitter are characteristic of Rogier's portraiture, but the white background is exceptional. The hammer and ring may be emblems of office or may allude to a tournament victory. The Este coat of arms is painted on the reverse of the panel. *Bequest of Michael Friedsam, 1931. The Friedsam Collection, 32.100.43*

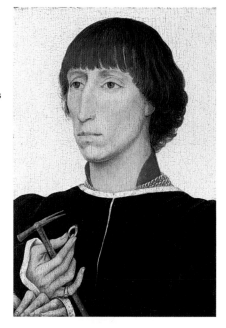

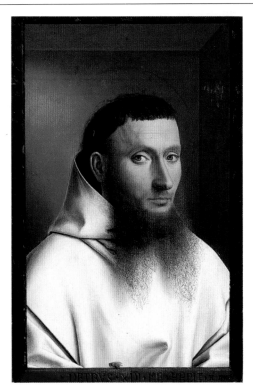

58 PETRUS CHRISTUS, Netherlandish, act. by 1444–d. 1475/76
Portrait of a Carthusian
*Oil on wood; painted surface 11½ × 7⅜ in.
(29.2 × 18.7 cm)*

In its effect of realism this picture owes much to the example of Jan van Eyck (no. 56). The sitter whose personality is so powerfully projected has been identified as a Carthusian lay brother. On the sill of the simulated frame with the date (1446) and his signature "carved" into it (*XPI* is an abbreviation of the Greek form of *Christus*), the artist has painted an astonishingly lifelike fly, perhaps as a reminder of the ever-present temptation of evil. (See also Robert Lehman Collection, no. 11.) *The Jules Bache Collection, 1949, 49.7.19*

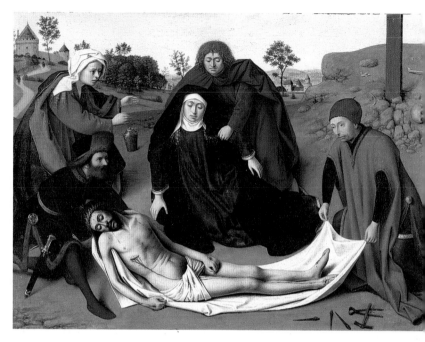

59 PETRUS CHRISTUS, Netherlandish, act. by 1444–d. 1475/76
The Lamentation
Oil on wood; painted surface 10 × 13¾ in. (25.4 × 34.9 cm)

The sweeping curves formed by the body of Christ with the Magdalen, Joseph of Arimathea, and Nicodemus, and by the Virgin and Saint John the Evangelist behind, make this one of Christus's most expressive compositions. Typically, the doll-like figures in their enveloping draperies are crisply drawn; the range of colors is restricted. The panel probably dates from the 1450s. A larger version of *The Lamentation* (Musées Royaux des Beaux-Arts, Brussels) was probably painted a few years earlier. *Marquand Collection, Gift of Henry G. Marquand, 1890, 91.26.12*

60 DIERIC BOUTS, Netherlandish, act. by 1457–d. 1475
Virgin and Child
Oil on wood; 8½ × 6½ in. (21.6 × 16.5 cm)

The motif of the Child placing his face affectionately against that of the Virgin derives from a Byzantine iconographic tradition, and it has been suggested that Bouts's painting reflects a much-venerated picture in the cathedral of Cambrai that was commonly believed to have been painted by Saint Luke. Bouts's composition was a popular one, but none of the surviving replicas (the finest is in the Bargello in Florence) achieves the tenderness and subtle description of light found in the Metropolitan's picture, an early work that may have been painted for an Italian patron. *Theodore M. Davis Collection, Bequest of Theodore M. Davis, 1915, 30.95.280*

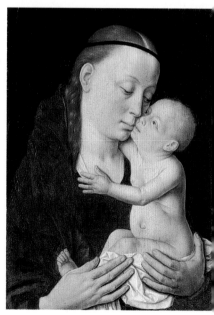

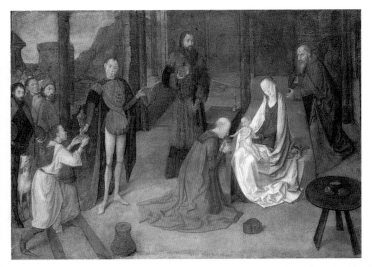

61 JUSTUS OF GHENT, Netherlandish, act. by 1460–d. ca. 1480
The Adoration of the Magi
Distemper on canvas; 43 × 63 in. (109.2 × 160 cm)

One of Justus of Ghent's most beautiful compositions, this painting on fine linen (which accounts for the muted effect of the color) was probably executed in Ghent about 1467. Like other early works attributed to him, it shows the influence of his friend Hugo van der Goes, as well as that of Dieric Bouts. Sometime after 1469 Justus left Ghent for Italy, where he entered the service of Federigo da Montefeltro, duke of Urbino; he remained there until the end of his life. *Bequest of George Blumenthal, 1941, 41.190.21*

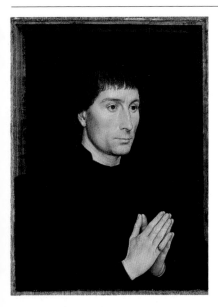

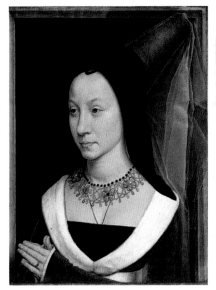

62 HANS MEMLING, Netherlandish, act. ca. 1465–d. 1494
Tommaso Portinari and His Wife
Oil on wood; left, painted surface 16⅝ × 12½ in. (42.2 × 31.8 cm); right, painted surface 16⅝ × 12⅝ in. (42.2 × 32.1 cm)

Tommaso Portinari was the Florentine representative of the Medici bank in Bruges. These portraits were probably commissioned after his marriage to Maria Baroncelli in 1470 and the birth of their first child the following year. They are the wings of a triptych that possibly showed the Virgin and Child in the center. Usually considered among Memling's finest portraits, they are a fitting testimony to Portinari's keen appreciation for Netherlandish art. His most famous commission was for the so-called Portinari altarpiece (Uffizi, Florence) by Hugo van der Goes. *Bequest of Benjamin Altman, 1913, 14.40.626,627*

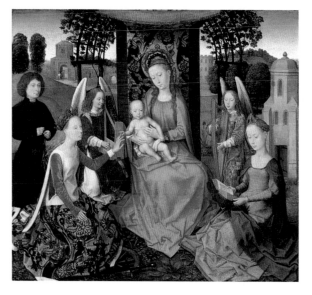

63 HANS MEMLING, Netherlandish, act. ca. 1465–d. 1494
Mystic Marriage of Saint Catherine
Oil on wood; painted surface 26⅜ × 28⅜ in. (67 × 72.1 cm)

Saint Catherine of Alexandria, kneeling on the sword and shield of her martyrdom, extends her hand to receive the ring with which she became the bride of Christ. On the right Saint Barbara stands in front of the tower her jealous father built to keep her from marrying. A male donor is seen at the left. The grape arbor that frames the Virgin and Christ Child and two angels is a eucharistic symbol that is rare in Netherlandish painting but not uncommon in German art. It is possible that this was a later addition, as it has been painted directly over the landscape and sky. (See also Robert Lehman Collection, no. 12.) *Bequest of Benjamin Altman, 1913, 14.40.634*

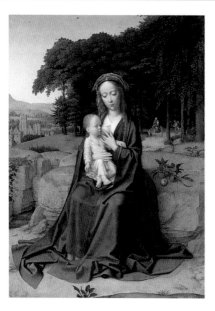

64 GERARD DAVID, Netherlandish, act. by 1484–d. 1523
The Rest on the Flight into Egypt
Oil on wood; 20 × 17 in. (50.8 × 43.2 cm)

This is one of Gerard David's most beautiful and tender compositions and one of his rare "inventions." He painted at least two other variants, and the composition inspired numerous followers well into the sixteenth century. The lively little scene in the background—Mary and the Christ Child riding on a donkey with Joseph running after them—and the extensive landscape setting are indications of David's pioneering role in the development of genre and landscape painting in the Netherlands. *The Jules Bache Collection, 1949, 49.7.21*

65 JOACHIM PATINIR, Netherlandish, act. by 1515–d. 1524
The Penitence of Saint Jerome
Oil on wood; central panel 46¼ × 32 in. (117.5 × 81.3 cm); each wing 47½ × 14 in. (120.7 × 35.6 cm)

The center panel of this triptych depicts the penitence of Saint Jerome; the baptism of Christ and the temptation of Saint Anthony are shown on the interior wings. On the exterior wings are painted Saint Anne with the Virgin and Child and Saint Sebald.

Patinir's emphasis on the natural setting over the narrative content of his paintings, as well as the probably true report that he furnished landscape backgrounds for other artists, has caused him to be regarded as the first landscape painter. In this panoramic view, so vast that we seem to see the curve of the earth, three saints are integrated in a setting that includes harbors, towns, a monastery, and a wilderness. *Fletcher Fund, 1936, 36.14a–c*

66 JUAN DE FLANDES, Netherlandish, act. in Spain by 1496–d. 1519
The Marriage Feast at Cana
Oil on wood; 8¼ × 6¼ in. (21 × 15.9 cm)

The marriage feast is set at a sparsely laid table in an open loggia. Christ blesses the water being poured by the wine steward from a pitcher into one of four large pots, thereby enacting the first of his miracles, the changing of the water into wine. Seated at the table with Christ are the Virgin and the groom and bride, who are attended by the master of the feast. The man outside the loggia looking directly at the viewer is thought to be a self-portrait. Remarkably well preserved, this small panel painting is one of the great treasures of the Linsky Collection. It is one of forty-seven panels that were commissioned about 1500 by Isabella the Catholic, queen of Castile and León. Presumably the panels were intended for a portable altarpiece for personal devotion. Paintings by Juan de Flandes (who trained in Flanders, probably in Bruges, but whose activity is not known outside Spain) are exceedingly rare. *The Jack and Belle Linsky Collection, 1982, 1982.60.20*

67 PIETER BRUEGEL THE ELDER,
Netherlandish, act. by 1551–d. 1569
The Harvesters
Oil on wood; 46½ × 63¼ in. (118.1 × 160.7 cm)

The casual truthfulness with which the peasants are painted, the convincing noonday heat and brilliant light, and the vast panoramic distance rendered with startling effectiveness are all characteristic of Bruegel. This is one of five remaining panels from a cycle devoted to the

months. The original number of paintings in the series was either six, with two months represented in each picture, or twelve. *The Harvesters,* dated 1565, probably represents either the month of August or the two months of July and August. The other surviving paintings are *Hunters in the Snow, Return of the Herd,* and *The Dark Day* (all in the Kunsthistorisches Museum, Vienna) and *Haymaking* (National Gallery, Prague). *Rogers Fund, 1919, 19.164*

68 PETER PAUL RUBENS, Flemish, 1577–1640
Portrait of a Man, Possibly an Architect or Geographer
Oil on copper; 8½ × 5¾ in. (21.6 × 14.6 cm)

This small portrait of 1597 is Rubens's earliest known dated work, and it is generally considered the best surviving example of Rubens's art from his early years in Antwerp.

The painting's style of execution derives from that of Rubens's teacher, Otto van Veen, while the composition recalls portraits by Anthonis Mor and his followers. In its strong modeling and spatial effect, however, the painting anticipates Rubens's development in Italy (1600–1608).

The sitter has been variously described, on the basis of the instruments he holds, as a geographer, an architect, an astronomer, a goldsmith, and a watchmaker. The watch in his hand, as in other sixteenth-century portraits, serves here as a *vanitas* symbol, that is, as a reminder of the brevity of life and of the relative unimportance of worldly affairs compared to spiritual being. Such a comment on the "vanity" of life was recognized at the time as especially appropriate to portraiture. (See also Drawings and Prints, no. 8.) *The Jack and Belle Linsky Collection, 1982, 1982.60.24*

69 PETER PAUL RUBENS, Flemish, 1577–1640
**Rubens, His Wife Helena Fourment, and Their
Son Peter Paul**
Oil on wood; 80¼ × 62¼ in. (203.8 × 158.1 cm)

This magnificent, very personal work, which
dates from about 1639, is a lifesize portrait of
the artist, his second wife, and their young son.
Rubens and Helena, the youngest daughter of
his old friend, the Antwerp merchant Daniel
Fourment, married in December 1630, when he
was fifty-three and she was sixteen. In this pic-
ture, as in the famous *Garden of Love* (Prado,
Madrid) to which it is closely related, Rubens
celebrates his love for Helena, although here he
presents her as both wife and mother.

The picture has passed directly through
three exceptionally distinguished collections.
According to tradition, the city of Brussels
presented the painting to the duke of Marl-
borough in 1704. It remained at Blenheim
Palace, the home of the Churchills, for nearly
two centuries. At the famous sale of 1884, it
was acquired by Baron Alphonse de Roth-
schild. The painting left the Rothschild
collection in 1975 and shortly thereafter en-
tered the collection of Mr. and Mrs. Charles
Wrightsman. (See also Drawings and Prints,
no. 8.) *Gift of Mr. and Mrs. Charles Wrightsman,
in honor of Sir John Pope-Hennessy, 1981,
1981.238*

70 PETER PAUL RUBENS, Flemish,
1577–1640
Venus and Adonis
Oil on canvas; 77¾ × 95⅝ in. (197.5 × 242.9 cm)

Here, as in many of the paintings from the glorious last decade of his career, Rubens has drawn his subject from the *Metamorphoses* of Ovid. Venus, assisted by Cupid, vainly tries to restrain her mortal lover Adonis from setting off for the hunt, fearing that he may be killed. The rich color, the superb technical ability, the vitality and human warmth of Rubens's best works are all united here.

When Rubens painted *Venus and Adonis,* he had in mind similar pictures by Titian (no. 29) and Veronese, but he designed it in a typically Baroque manner, with the large, twisting figures dominating the composition in a dramatic triangle. *Gift of Harry Payne Bingham, 1937, 37.162*

71 JACOB JORDAENS, Flemish, 1593–1678
The Holy Family with Shepherds
Oil on canvas, transferred from wood; 42 × 30 in. (106.7 × 76.2 cm)

This painting, inscribed J.JOR. . . . Fe . . . / 1616, is the earliest known dated work by Jacob Jordaens. He painted similar pictures of the Holy Family one or two years earlier. However, Saint Joseph is not included here; the old man offering milk to the Christ Child is certainly a shepherd. Radiographs reveal that an old shepherdess was originally placed in the now-ambiguous space beneath the pot of coals. The old woman, the boy, and the brazier derive from various works by Rubens, while the use of light and shade is one of Jordaens's earliest responses to Caravaggesque compositions by Rubens and Abraham Janssen. Unlike these Antwerp artists and, several years later, Van Dyck, Jordaens never went to Italy, which in part accounts for the slightly naive but touchingly intimate quality of this work. *Bequest of Miss Adelaide Milton de Groot (1876–1967), 1967, 67.187.76*

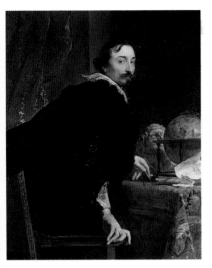

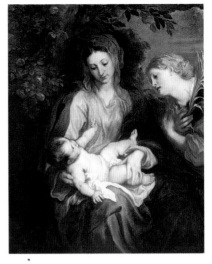

72 ANTHONY VAN DYCK, Flemish, 1599–1641
Lucas van Uffel
Oil on canvas; 49 × 39⅝ in. (124.5 × 100.6 cm)

This portrait belongs to a group of paintings executed by Van Dyck in Italy between 1621 and 1627. The objects on the table—a celestial globe, a recorder, a fragment of classical sculpture, and a red chalk drawing of a head—show that the sitter was a man of learning and an art collector. Van Dyck knew a number of wealthy Flemish merchants and connoisseurs in Italy. The identification of the sitter with Lucas van Uffel (1583?–1637), a Flemish merchant and collector living in Venice, is based upon an early handwritten note on an impression of Wallerand Vaillant's mezzotint after the painting. *Bequest of Benjamin Altman, 1913, 14.40.619*

73 ANTHONY VAN DYCK, Flemish, 1599–1641
Virgin and Child with Saint Catherine of Alexandria
Oil on canvas; 43 × 35¾ in. (109.2 × 90.8 cm)

Between 1621 and 1627 Van Dyck lived in Italy. Already an accomplished painter, he profited much from his study of Italian artists. He was chiefly interested in the Northern Italian painters, particularly Titian, whose example helped form the poetic and elegant style of the religious pictures, mythological scenes, and portraits Van Dyck painted later in Antwerp and in England. This painting was probably executed in Antwerp shortly after his return from Italy, and it reveals his study of Titian and also of Correggio and Parmigianino. *Bequest of Lillian S. Timken, 1959, 60.71.5*

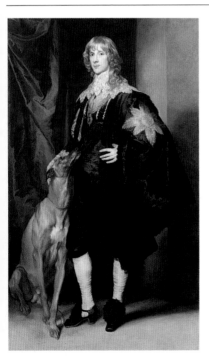

74 ANTHONY VAN DYCK, Flemish, 1599–1641
James Stuart, Duke of Richmond and Lennox
Oil on canvas; 85 × 50¼ in. (215.9 × 127.6 cm)

In 1632 Van Dyck entered the service of King Charles I of England; he was knighted the same year. Van Dyck's portraits of Charles I flatter a royal sitter who was actually not very imposing. Possibly the same was true of James Stuart (1612–1655), Charles's cousin and protégé, depicted here. Certainly Van Dyck has used all his skills to give the duke elegance and a commanding presence; the ratio of his head to his body is one to seven, as in a fashion plate, instead of one to six, the average in life. The tall greyhound leaning devotedly against its master also emphasizes the height and aristocratic bearing of the duke. *Marquand Collection, Gift of Henry G. Marquand, 1889, 89.15.16*

75 FRANS HALS, Dutch, after 1580–d. 1666
Portrait of a Man
Oil on canvas; 43½ × 34 in. (110.5 × 86.4 cm)

Hals was a prolific portraitist, so one can assume that he provided what his unpretentious bourgeois customers wanted: a good likeness, without many sittings, at a reasonable price. Probably few of them realized how much skill was needed to produce his deceptively simple pictures. The stable frontal pose of this portrait is characteristic of Hals's work of the early 1650s. The flesh tones and mauve and green ribbons play upon the gradations of black and white in the costume. Viewed closely, all the brushstrokes are visible. Yet, at a distance, everything falls into place, the spectator's eye unconsciously doing the work of making coherent forms out of slashes and dashes. This challenging technique impressed nineteenth-century painters, especially Manet and Sargent. *Marquand Collection, Gift of Henry G. Marquand, 1890, 91.26.9*

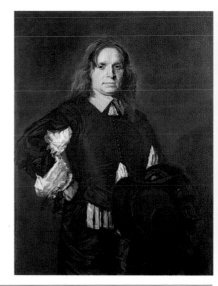

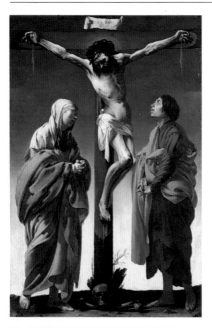

76 HENDRICK TER BRUGGHEN, Dutch, 1588–1629
The Crucifixion with the Virgin and Saint John
Oil on canvas; 61 × 40¼ in. (154.9 × 102.2 cm)

Ter Brugghen, who had studied in Rome, was influenced here not only by the realism of Caravaggio but also by the conventions of late Gothic devotional imagery. He probably used actual Dutch models for the Virgin and Saint John. The intensity of Saint John's anguish, expressed by his open mouth and twisted hands, is made even more poignant by his plain face and red nose. The compelling realism of the corpse, with its green-toned face and belly, is more disturbing than anything painted in Italy. The strange, starry sky and the low horizon heighten the impression of a supernatural event. *Funds from various donors, 1956, 56.228*

77 BARTHOLOMEUS BREENBERGH, Dutch, 1598–1657
The Preaching of Saint John the Baptist
Oil on wood; 21½ × 29⅝ in. (54.6 × 75.2 cm)

In 1619 Breenbergh traveled from Amsterdam to Rome, where he remained for over a decade. With Cornelis van Poelenburgh he established the taste for Italianate landscapes that flourished in Holland during the 1630s and continued with the works of younger painters such as Jan Asselijn, Nicolaes Berchem, Jan Both, Karel Dujardin, and Adam Pijnacker. Most of these artists were active in Utrecht but Breenbergh returned to Amsterdam where Rembrandt's teacher, Pieter Lastman, encouraged his eclectic approach. In this panel dated 1634, contrasts of light and shade and landscape motifs like the mountain beyond Saint John are employed to dramatic effect, while theatrical notions of ancient costume and ruins based on Breenbergh's own drawings of the Colosseum contribute to the exotic impression. Nonetheless, the subject meant much to Dutch Protestant viewers, who often compared the Baptist's preaching to their own clandestine sermons under Spanish rule. Rembrandt admired this painting, to judge from his slightly later treatment of the subject (Staatliche Museen, Berlin), and it has been in celebrated collections since at least the mid-eighteenth century. *Purchase, The Annenberg Foundation Gift, 1991, 1991.305*

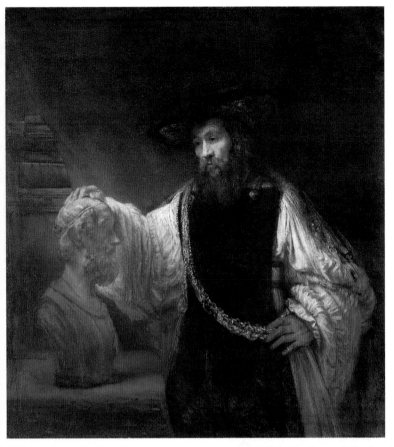

78 REMBRANDT, Dutch, 1606–1669
Aristotle with a Bust of Homer
Oil on canvas; 56½ × 53¾ in. (143.5 × 136.5 cm)

Rembrandt painted this picture for a Sicilian nobleman, Don Antonio Ruffo, his only foreign patron, who received it in 1654 and ten years later ordered from him two others, a Homer and an Alexander. In the *Aristotle,* dated 1653, three great men of antiquity are closely associated: Aristotle rests his hand on a bust of Homer and wears a gold chain with a medallion bearing the image of Alexander. The solemn stillness of the philosopher's study, the eloquence of the fingers laid on the head of the blind poet, and above all the brooding mystery in the face of Aristotle unite to communicate an image of great power. *Purchase, special contributions and funds given or bequeathed by friends of the Museum, 1961, 61.198*

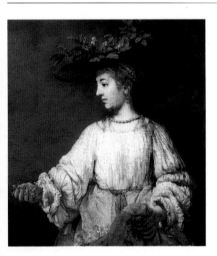

79 REMBRANDT, Dutch, 1606–1669
Flora
Oil on canvas; 39⅜ × 36⅛ in. (100 × 91.8 cm)

A collector in Amsterdam owned a painting of Flora by Titian that Rembrandt certainly remembered when he painted his own in the 1650s. The model wears a great black hat with shiny leaves and pink flowers, a yellow apron that looks as if it were filled with light as well as blossoms, and a full-sleeved blouse that falls into elaborate folds. One can almost feel the joy with which Rembrandt worked on these folds— painting them white, but full of touches of pink, blue, and green. The sitter is certainly no goddess, and she is very different from Titian's lush Venetian beauties; she seems a real person— modest, gentle, and good—and Rembrandt's common-law wife, Hendrickje, is thought to have been the model for the painting. *Gift of Archer M. Huntington, in memory of his father, Collis Potter Huntington, 1926, 26.101.10*

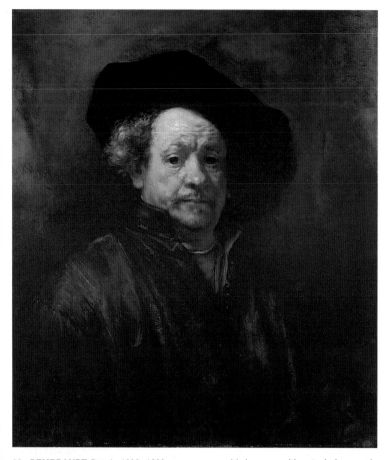

80 REMBRANDT, Dutch, 1606–1669
Self-portrait
Oil on canvas; 31⅝ × 26½ in. (80.3 × 67.3 cm)

Among Rembrandt's most memorable works are the dozen or more self-portraits that he painted in each decade of his career. Varying consider- ably in composition, technique, and expression, they constitute a visual autobiography. In this example of 1660 the broad application of paint conveys a candid record of the artist's aging features. *Bequest of Benjamin Altman, 1913, 14.40.618*

81 REMBRANDT, Dutch, 1606–1669
Woman with a Pink
Oil on canvas; 36¼ × 29⅜ in. (92.1 × 74.6 cm)

This portrait and its pendant, *Man with a Magnifying Glass* (also in the Museum), are datable between 1662 and 1665. The rich variety of reds and browns, the broad handling, and the thick impasto are familiar characteristics of Rembrandt's latest works. The sitter is clad in the exotic clothing common to a number of his later portraits of close friends and members of the artist's family. The special meaning of these garments may be personal and thus lost to us. X-ray analysis has revealed the head of a child near the left hand of the woman, which was apparently painted out by Rembrandt, perhaps after the child's death and before the completion of the portrait. The brightly lit carnation, which traditionally signifies love and constancy in marriage, may here allude to the briefness of life. None of the various identifications which have been proposed has proven to be very convincing. (See also Robert Lehman Collection, no. 16.) *Bequest of Benjamin Altman, 1913, 14.40.622*

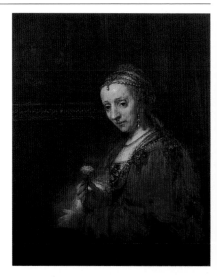

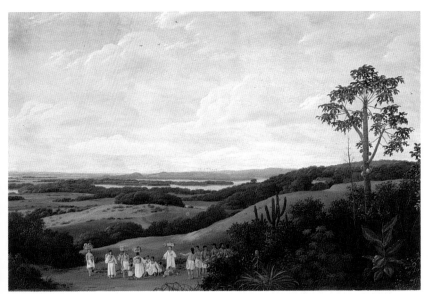

82 FRANS POST, Dutch, ca. 1612–d. 1680
A Brazilian Landscape
Oil on wood; 24 × 36 in. (61 × 91.4 cm)

The first landscapist of the New World, Post arrived in Brazil in 1637 as a member of the scientific staff of Prince Johan Maurice van Nassau. His best paintings date from the decade after his return to Haarlem in 1644. He painted this large, well-preserved picture in 1650. Post's almost exclusive devotion to Brazilian scenery reflects the cosmopolitan interests of Amsterdam and Haarlem. Exotic landscapes and still lifes were of scientific as well as aesthetic interest; both concerns are addressed by Post, who combines textbook detail with the landscape style established in Haarlem. The figures in this picture are unusually prominent and interesting, but the exotic plants and the iguana at the lower right are among his favorite motifs. *Purchase, Rogers Fund, special funds, James S. Deely Gift, and Gift of Edna H. Sachs and other gifts and bequests, by exchange, 1981, 1981.318*

83 GERARD TER BORCH, Dutch, 1617–1681
Curiosity
Oil on canvas; 30 × 24½ in. (76.2 × 62.2 cm)

Although Ter Borch worked in Deventer, outside the larger artistic centers of the United Provinces, he painted some of the most sophisticated genre pieces of his time. His paintings combine elegance and exquisite refinement of style with an extraordinary mastery of technique in the rendering of textures and light-touched surfaces. In his best work there is often, as here, an effect of seclusion and privacy and a very delicately implied wit. This picture is datable about 1660. *The Jules Bache Collection, 1949, 49.7.38*

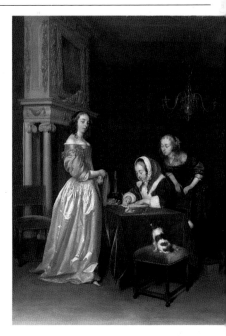

84 AELBERT CUYP, Dutch, 1620–1691
Starting for the Hunt
Oil on canvas; 43¼ × 61½ in. (109.9 × 156.2 cm)

The sitters, the brothers Michiel (1638–1653) and Cornelis Pompe van Meerdervoort (1639–1680), are shown with their tutor and coachman. One of very few datable works by Aelbert Cuyp, this picture must have been painted just before Michiel's death in 1653. The two boys were members of a wealthy family residing in the area around Dordrecht, where the terrain is similar to the landscape represented in the background. They wear exotic costumes, perhaps of Persian inspiration, which are often found in portraits of members of the upper classes during this period. Cuyp's bright palette and refined manner are appropriate to the subject; the soft, fluid handling of the landscape contrasts with the colorful and elegant apparel. *The Friedsam Collection, Bequest of Michael Friedsam, 1931, 32.100.20*

85 PHILIPS KONINCK, Dutch, 1619–1688
Wide River Landscape
Oil on canvas; 16¼ × 22⅞ in. (41.3 × 58.1 cm)

This panoramic view is a relatively early work. Koninck did not paint identifiable sites but constructed his flat landscapes from observations of nature. An exceptionally fine small painting, this picture was inspired by the somber color and moody drama of Rembrandt's landscapes. *Anonymous Gift, 1963, 63.43.2*

86 JAN STEEN, Dutch, 1626–1679
Merry Company on a Terrace
Oil on canvas; 55½ × 51¾ in. (141 × 131.4 cm)

Steen delighted in showing scenes of boisterous merrymaking. A prolific painter, he also owned a brewery and a tavern. The stout man sitting at the left, holding a jug, is a portrait

of Steen himself. His foremost quality has been described as a natural lightheartedness, but he has depicted this scene of good-humored gaiety and noise with the most refined palette and composition, centering on the tipsy fair-haired woman in the pale blue dress. *Fletcher Fund, 1958, 58.89*

87 JACOB VAN RUISDAEL, Dutch,
1628/29–1682
Wheatfields
Oil on canvas; 39⅜ × 51¼ in. (100 × 130.2 cm)

Better than any other Dutch painter, Ruisdael described in his landscapes—with their low horizons and wide vistas of sand and dunes— the look and feel of his country. In his paint

ings of the 1670s, such as *Wheatfields,* flat landscape subjects are characteristic, as are the converging lines of earth and sky and the alternation of shadow and sunlight. Ruisdael had numerous pupils and followers; Meindert Hobbema (no. 93) was his most famous disciple. *Bequest of Benjamin Altman, 1913, 14.40.623*

88 PIETER DE HOOCH, Dutch, 1629–1684
Paying the Hostess
Oil on canvas; 37¼ × 43¾ in.
(94.6 × 111.1 cm)

Like Vermeer (nos. 89–91), Pieter de Hooch is best known for his depictions of interiors, in which he explores the play of light as it illuminates space and reflects off various surfaces. Here a soldier pays the hostess of an inn. While the subject is often found in De Hooch's paintings of the 1650s, the complex organization of space, the use of multiple sources of light, and the exceptionally large size of the canvas suggest a date in his later years. The decorative flair of the soldier's garb may be due to the influence of French painting in Amsterdam, where De Hooch resided from 1670. This painting reflects a general trend in Dutch art of the 1660s and 1670s toward greater elegance and a more refined style. *Gift of Stuart Borchard and Evelyn B. Metzger, 1958, 58.144*

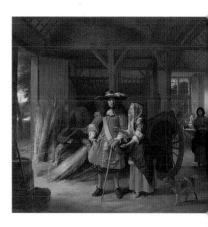

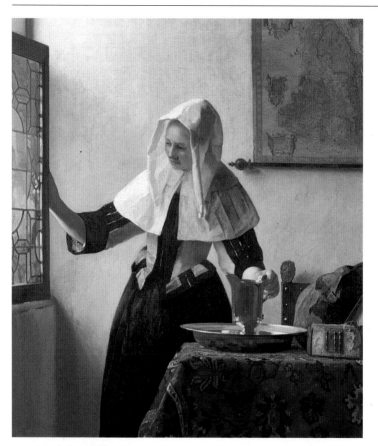

89 JOHANNES VERMEER, Dutch, 1632–1675
Young Woman with a Water Jug
Oil on canvas; 18 × 16 in. (45.7 × 40.6 cm)

The perfect balance of the composition, the cool clarity of the light, and the silvery tones of blue and gray combine to make this closely studied view of an interior a classic work by Vermeer. As Vermeer's paintings were few in number—fewer than thirty-five accepted works have survived—and as they were not widely known, he was forgotten soon after his death. Almost two hundred years passed before the French critic Théophile Thoré rediscovered Vermeer's work on a visit to Holland, and he is now one of the most esteemed Dutch painters. The *Young Woman with a Water Jug* is characteristic of his early maturity and dates from the beginning of the 1660s. *Marquand Collection, Gift of Henry G. Marquand, 1889, 89.15.21*

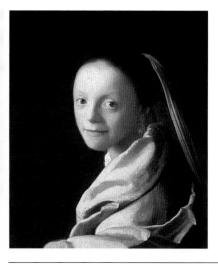

90 JOHANNES VERMEER, Dutch, 1632–1675
Portrait of a Young Woman
Oil on canvas; 17½ × 15¾ in. (44.5 × 40 cm)

The portrait is the rarest of all Vermeer's subjects. In technique and lighting, this painting is closely related to Vermeer's most celebrated work, the *Portrait of a Girl* (Mauritshuis, The Hague), and seems to have been painted in the late 1660s. It is a subtle and delicate picture in which the artist explores the ambiguity of human expression with rare sensitivity. The work is remarkable for its simple yet highly sophisticated structure, subtlety of coloring, and intimate mood. The painting reminded the French critic Thoré of that most enigmatic of all female portraits, Leonardo da Vinci's *Mona Lisa*. *Gift of Mr. and Mrs. Charles Wrightsman, in memory of Theodore Rousseau Jr., 1979, 1979.396.1*

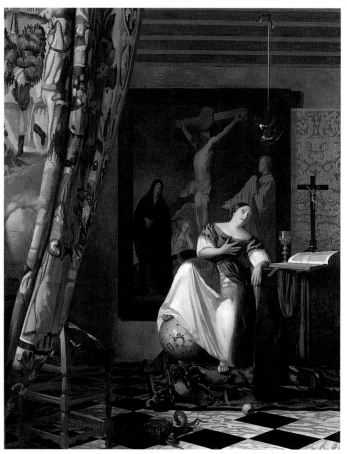

91 JOHANNES VERMEER, Dutch, 1632–1675
Allegory of the Faith
Oil on canvas; 45 × 35 in. (114.3 × 88.9 cm)

This is one of two pictures by Vermeer with explicit allegorical content. The woman is a personification of Faith and matches a description of Faith in Cesare Ripa's *Iconologia* (1593), in which the chalice, book, and globe are mentioned along with other attributes. Here Vermeer remains concerned with the depiction of objects, space, and light. The simplification and hardening of the light in this painting are characteristic of the artist's late style. The Museum's collection of five paintings by Vermeer is one of the most important in the world. *The Friedsam Collection, Bequest of Michael Friedsam, 1931, 32.100.18*

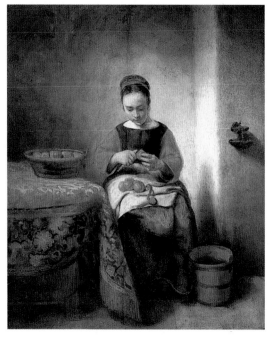

92 NICOLAES MAES, Dutch, 1634–1693
Young Girl Peeling Apples
Oil on wood; 21½ × 18 in. (54.6 × 45.7 cm)

This picture is one of a number of quiet scenes of women performing domestic tasks painted by Maes in the mid-1650s. In the distribution of light and shade, these paintings still show the influence of his teacher, Rembrandt. Maes's sensitive variations on the theme of domestic virtue probably influenced both De Hooch and Vermeer. *Bequest of Benjamin Altman, 1913, 14.40.612*

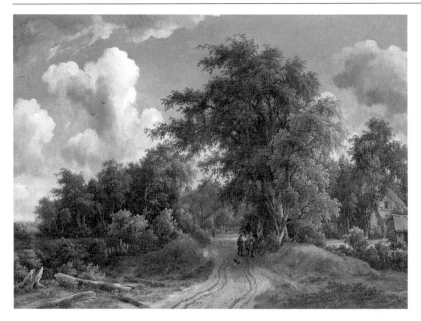

93 MEINDERT HOBBEMA, Dutch, 1638–1709
Woodland Road
Oil on canvas; 37¼ × 51 in. (94.6 × 129.5 cm)

The luxuriant foliage, the lively play of light and shadow, and the figures that animate this country scene give it greater immediacy than that found in many Dutch landscapes of about this date, which is probably close to 1670. Nonetheless, Hobbema's descriptive abilities, adapted from his teacher Jacob van Ruisdael, are here complemented by sophisticated pictorial effects, such as the rhythmic massing of forms and deliberate diversity of textures and colors. *Bequest of Mary Stillman Harkness, 1950, 50.145.22*

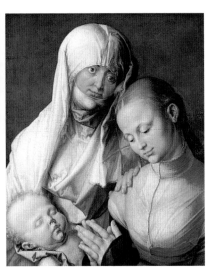

94 ALBRECHT DÜRER, German, 1471–1528
Virgin and Child with Saint Anne
Oil on wood; 23⅝ × 19⅝ in. (60 × 49.8 cm)

Saint Anne, who was particularly venerated in
Germany, is often represented with her daugh-
ter, the Virgin Mary, and the Christ Child. This
picture was painted in 1519, the year that Dürer
became an ardent follower of Martin Luther, and
the emotional intensity of the image may be a
reflection of his conversion. The motif of the Vir-
gin adoring the sleeping Christ Child was
probably inspired by the Venetian painter Gio-
vanni Bellini (no. 25), whose art Dürer admired
on his two trips to Italy. The monumental
masses of the figures and the balanced com-
position attest to the impact that Italian art
made on Dürer's native northern Gothic style.
(See also Robert Lehman Collection, no. 34,
and Drawings and Prints, no. 5.) *Bequest of Ben-
jamin Altman, 1913, 14.40.633*

95 LUCAS CRANACH THE ELDER, German,
1472–1553
The Judgment of Paris
Oil on wood; 40⅛ × 28 in. (101.9 × 71.1 cm)

This painting shows Paris awarding a golden
apple (here transformed into a glass orb) to
Venus, whom he judged more beautiful than
Juno or Minerva. This myth was a favorite with
Cranach and his large, prolific workshop.
Painted about 1528, the sprightly narrative
and decorative scene, if contrasted with Dü-
rer's *Virgin and Child with Saint Anne* above
of a few years earlier, shows how oblivious
Cranach was to the lofty monumental con-
cepts of the southern Renaissance. *Rogers
Fund, 1928, 28.221*

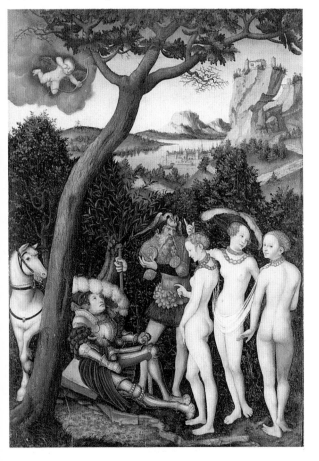

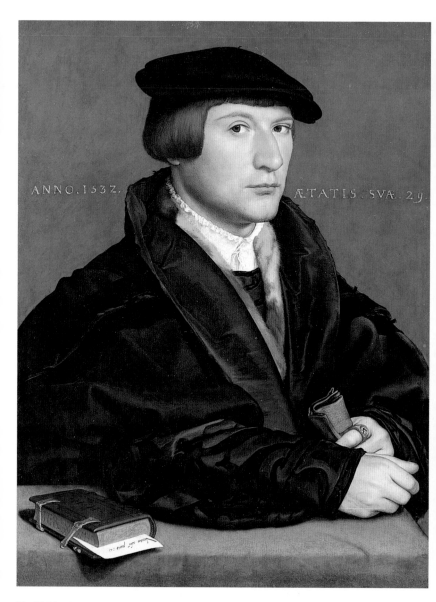

96 HANS HOLBEIN THE YOUNGER, German, 1497/98–1543

Portrait of a Member of the Wedigh Family
Tempera and oil on wood; 16 5/8 × 12 3/4 in. (42.2 × 32.4 cm)

During Holbein's second stay in England, he found many clients among the colony of German merchants in London. The arms on the ring worn by the sitter and the lettering on his book indicate that he is a member of a Cologne trading family named Wedigh; presumably he was their representative in England. He has sometimes been identified as Hermann Wedigh III (d. 1560), a merchant and a member of the Hanseatic trading company. This painting, dated 1532, demonstrates why Holbein is regarded as one of the world's greatest portraitists. The clarity of color, the precision of drawing, and the crisp, explicit characterization constitute a compelling expression of human personality. *Bequest of Edward S. Harkness, 1940, 50.135.4*

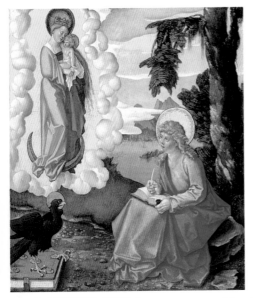

97 HANS BALDUNG GRIEN, German,
1484/85–1545
Saint John on Patmos
*Oil on wood; painted surface 34 ⅜ × 29 ¾ in.
(87.3 × 75.6 cm)*

This picture exemplifies the qualities of Baldung
both as a religious artist and as a landscape
painter. The young Saint John, seated on the
right, gazes tenderly at a vision of the Virgin,
who stands on a crescent moon with the Christ
Child in her arms. Behind Saint John stretches
a romantic landscape, and at the lower left an
eagle, the symbol of the Evangelist, is perched
on top of a closed book. This animal's imposing
outline, the foreshortened book, and the power-
ful contrasts of black, turquoise, and gold
make this one of the most arresting areas of
the composition. The painting is almost per-
fectly preserved, and the highlights that are so
important a feature of Baldung's pictorial lan-
guage are intact. *Purchase, Rogers and
Fletcher Funds, The Vincent Astor Foundation,
The Dillon Fund, The Charles Engelhard Foun-
dation, Lawrence A. Fleischman, Mrs. Henry J.
Heinz II, The Willard T. C. Johnson Foundation
Inc., Reliance Group Holdings Inc., Baron H.
H. Thyssen-Bornemisza, and Mr. and Mrs.
Charles Wrightsman Gifts; Joseph Pulitzer Be-
quest; special funds and other gifts and
bequests, by exchange, 1983, 1983.451*

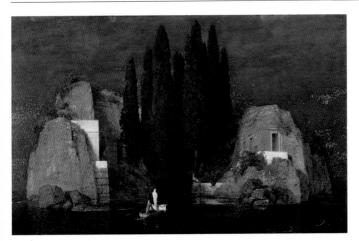

98 ARNOLD BÖCKLIN, Swiss, 1827–1901
Island of the Dead
Oil on wood; 29 × 48 in. (73.7 × 121.9 cm)

Böcklin painted five versions of *Island of the
Dead* between 1880 and 1886. This painting,
the first to be completed, resulted from a re-
quest made by the recently widowed Marie
Berna. In Florence in 1880 she asked Böcklin
to paint a picture on the theme of her bereave-
ment. In a letter dated April 29, 1880, Böcklin
wrote to her: "You will be able to dream your-
self into the world of dark shadows until you
believe you can feel the soft and gentle breeze
that ripples the sea so that you shy from inter-
rupting the stillness with any audible sound."
Reisinger Fund, 1926, 26.90

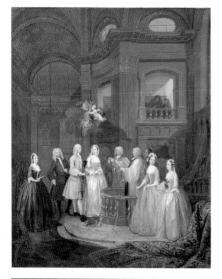

99 WILLIAM HOGARTH, British, 1697–1764
The Wedding of Stephen Beckingham and Mary Cox
Oil on canvas; 50½ × 40½ in. (128.3 × 102.9 cm)

Hogarth, who is perhaps best known for his satirical prints, was also a gifted portraitist and observer of the English scene. Here he represents the marriage of Stephen Beckingham (d. 1756) and Mary Cox (d. 1738), which took place on June 9, 1729. The Beckingham family were members of the landed gentry, and Stephen Beckingham, like his father, was a barrister at Lincoln's Inn. The putti with the cornucopia, symbolizing plenty, and the portrait of Rev. Thomas Cooke, which borders on caricature, are rather surprising additions to this picture, which otherwise documents the occasion with due solemnity. *Marquand Fund, 1936, 36.111*

100 SIR JOSHUA REYNOLDS, British, 1723–1792
Colonel George K. H. Coussmaker, Grenadier Guards
Oil on canvas; 93¾ × 57¼ in. (238.1 × 145.4 cm)

Reynolds was the first president of the Royal Academy and the author of fourteen discourses on painting, which are classics of the theory of art. As a young man he spent two years in Rome studying the antique and the works of the High Renaissance masters, especially Michelangelo. These studies had a formative influence on his own style.

In this portrait of 1782, Reynolds presents Colonel Coussmaker (1759–1801) in a pose of casual but studied negligence, the line of his body reversed in the curving neck of his horse. The summer before he painted the picture, Reynolds traveled to the Low Countries and profited by his observation of Rubens's works, especially in the creation of a free and painterly surface treatment. *Bequest of William K. Vanderbilt, 1920, 20.155.3*

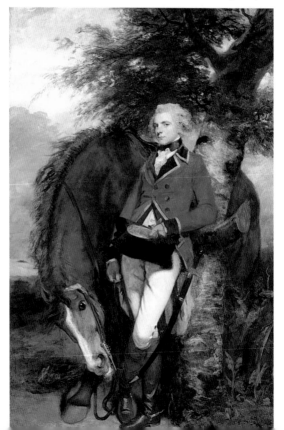

101 GEORGE STUBBS, British, 1724–1806
**A Favorite Hunter of John Frederick Sackville,
Later Third Duke of Dorset**
Oil on canvas; 40 × 49¾ in. (101.6 × 126.4 cm)

Stubbs was largely self-taught, and except for a trip to Rome in 1746, he spent his early years in the north of England. For two decades from about 1759, when he settled in London, he commanded the field as an animal painter with his coolly detached and meticulously accurate and individual portraits of dogs and horses, often with their owners, riders, or stablemen. Despite the popularity of his paintings, Stubbs attracted little critical notice in his lifetime. He did, however, transform sporting art, and he is now regarded as one of the most innovative painters of his age. This picture, which dates from 1768, shows a favorite hunter of John Frederick Sackville, and it may be supposed that the canvas was painted at Knole, the Sackville family seat.
Bequest of Mrs. Paul Moore, 1980, 1980.468

102 THOMAS GAINSBOROUGH, British, 1727–1788
Mrs. Grace Dalrymple Elliott
Oil on canvas; 92¼ × 60½ in. (234.3 × 153.7 cm)

This portrait was probably painted not long before 1778, when Gainsborough sent it to be exhibited at the Royal Academy, of which he was a founding member. It is an excellent example of his fashionable portrait style, which he built upon his awareness of English likenesses by Van Dyck (no. 74), modifying their monumental quality with the grace and elegance of Watteau (no. 114).

When very young, Mrs. Elliott (1754?–d. 1823) made a good marriage, which was followed by a slightly lurid romantic career in Paris and London. The marquess of Cholmondeley (who commissioned this picture) and the Prince of Wales, later George IV, were among her admirers. *Bequest of William K. Vanderbilt, 1920, 20.155.1*

103 SIR THOMAS LAWRENCE, British,
1769–1830
Elizabeth Farren, Later Countess of Derby
Oil on canvas; 94 × 57½ in. (238.8 × 146.1 cm)

The verve and freshness that make this portrait
so appealing are congruous with the youthful-
ness of Lawrence when he painted it in 1790.
The composition, the construction of the figure,
and the virtuosity and variety of the brushwork
are, however, extraordinary in an artist of rela-
tively limited experience. Lawrence had been
admitted as a student at the Royal Academy
School in 1787, only three years before this
portrait was exhibited there.

Miss Farren (ca. 1759–d. 1829), a hugely ad-
mired actress, retired from the stage in 1797.
She became the second wife of the twelfth
earl of Derby, who had commissioned this por-
trait. *Bequest of Edward S. Harkness, 1940,
50.135.5*

104 SIR THOMAS LAWRENCE, British,
1769–1830
The Calmady Children
Oil on canvas; 30⅞ × 30⅛ in. (78.4 × 76.5 cm)

The children in this portrait, painted in 1823–24,
are Emily (1818–1906) and Laura Anne (1820–
1894), the daughters of Mr. and Mrs. Charles
Biggs Calmady of Langdon Hall, Devon. In com-
position this work shows the influence of
sixteenth- and seventeenth-century Italian paint-
ings of the Infant Christ and Saint John the
Baptist; its circular form recalls the *Madonna
della Sedia,* Raphael's celebrated tondo. Exhi-
bited at the Royal Academy in 1824 and later
engraved under the title *Nature,* this portrait be-
came one of Lawrence's most popular paintings.
The artist himself declared: "This is my best pic-
ture. I have no hesitation in saying so—my best
picture of the kind, quite—one of the few I
should wish hereafter to be known by." *Bequest
of Collis P. Huntington, 1900, 25.110.1*

105 J. M. W. TURNER, British, 1775–1851
The Grand Canal, Venice
Oil on canvas; 36 × 48⅛ in. (91.4 × 122.2 cm)

Venice, more than any of the other cities that he visited on his constant travels, provided Turner with congenial subject matter. This view is taken from the middle of the Grand Canal near the church of Santa Maria della Salute, which can be seen at the right, looking toward the doge's palace and the exit to the sea. Painted in or shortly before 1835, when Turner was at the height of his powers, it is a splendid expression of his ability to render solid architectural forms bathed in shimmering light and pearly atmospheric glow. When this painting was exhibited at the Royal Academy in 1835, it was well received as one of his "most agreeable works," though one critic cautioned Turner not to think "that in order to be poetical it is necessary to be almost unintelligible." *Bequest of Cornelius Vanderbilt, 1899, 99.31*

106 JOHN CONSTABLE, British, 1776–1837
Salisbury Cathedral from the Bishop's Grounds
Oil on canvas; 34⅝ × 44 in. (87.9 × 111.8 cm)

Constable, in his day the preeminent painter of the English landscape, was a friend of Dr. John Fisher, bishop of Salisbury. Between 1820 and 1830 he repeatedly recorded the aspect of the great Gothic cathedral that presented itself to an observer standing in the bishop's grounds. Besides three sketches there are three finished paintings in various museums. All are very similar in composition. It seems likely that this one is the full-scale sketch for the third and final version of the picture, which is dated 1826 and is now in the Frick Collection, New York. *Bequest of Mary Stillman Harkness, 1950, 50.145.8*

107 JEAN CLOUET, French, act. by
1516–d. 1541
Guillaume Budé
Oil on wood; 15⅝ × 13½ in. (39.7 × 34.3 cm)

Budé (1467–1540) was an outstanding human-
ist, the founder of the Collège de France, the
first keeper of the royal library, an ambassador,
and chief city magistrate of Paris. Jean Clouet,
who was probably from the Netherlands,
worked at the French court from 1516 and even-
tually became chief painter to King Francis I.
This much damaged portrait, which is men-
tioned in Budé's manuscript notes, is datable
about 1536 and is Clouet's only documented
work. *Maria DeWitt Jesup Fund, 1946, 46.68*

108 GEORGES DE LA TOUR, French,
1593–1652
The Fortune Teller
Oil on canvas; 40⅛ × 48⅝ in. (101.9 × 123.5 cm)

Georges de La Tour, who was born in the inde-
pendent duchy of Lorraine, established himself
by 1620 as a master at Lunéville, where he re-
mained for most of his career. Nothing is known
of his training or travels, but his patrons in-
cluded Henri II, duke of Lorraine, Richelieu, and
Louis XIII. Forgotten for two centuries, La Tour
is now recognized as an artist of great brilliance
and originality.

This picture, probably executed between 1632
and 1635, is one of his rare daylight scenes and
depicts a fashionably dressed young innocent
who is drawn into the snare of deceitful gypsies.
The subject of trickery, a common theme in
early-seventeenth-century paintings, was popu-
larized by Caravaggio and his followers. La Tour
may have known their work, and he may also
have been influenced by theatrical perfor-
mances of his day. *The Fortune Teller* serves as
an object lesson, warning the unsuspecting of
the dangerous ways of the world. *Rogers Fund,
1960, 60.30*

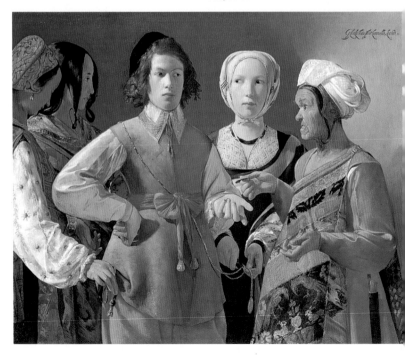

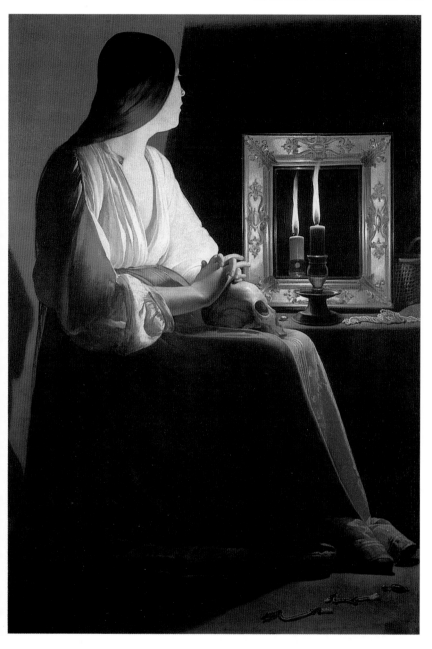

109 GEORGES DE LA TOUR, French,
1593–1652
The Penitent Magdalen
Oil on canvas; 52½ × 40¼ in. (133.4 × 102.2 cm)

Georges de La Tour's candlelit scenes, star-
tlingly eloquent and austere, are among his
best-known works. This picture, probably
painted between 1638 and 1643, is one of four
representations that La Tour did of the penitent
Magdalen, and it is unique in depicting her at
the dramatic moment of her conversion. The
elaborate silver mirror symbolizes luxury,
while the self-consuming candle reflected in it
suggests the frailty of human life. The skull
upon which her clasped hands rest may stand
for peaceful acceptance of death. La Tour's
extraordinary control of light—from near total
darkness to the bright flame—contributes to
the profoundly moving effect of this picture.
The still atmosphere has a warm cast that re-
lates to the paintings of northern followers of
Caravaggio. *Gift of Mr. and Mrs. Charles
Wrightsman, 1978, 1978.517*

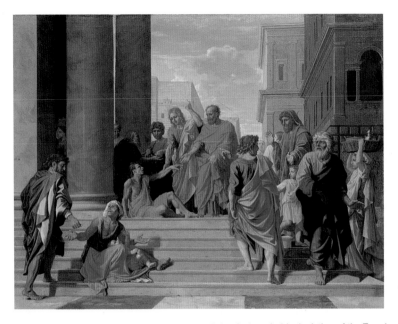

110 NICOLAS POUSSIN, French, 1594–1665
Saints Peter and John Healing the Lame Man
Oil on canvas; 49½ × 65 in. (125.7 × 165.1 cm)

Based on the text of Acts 3, this picture is a key work of Poussin's late career. The brilliant colors reflect his ideas about ancient painting, while the emphatic use of gesture to convey the meaning of the story is bound up with precepts of classical art. In his depiction of the Temple of Jerusalem and the poses of some of the figures, Poussin reveals his indebtedness to the work of Raphael, who was viewed as the founder of academic practice. Painted in 1655 for the treasurer of the city of Lyons, the picture was subsequently owned by Prince Eugene of Savoy and the princes of Liechtenstein. *Marquand Fund, 1924, 24.45.2*

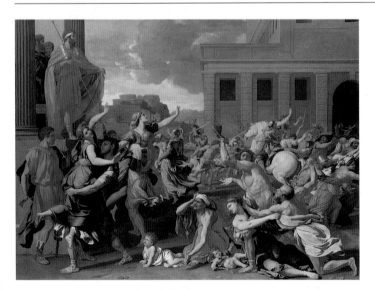

111 NICOLAS POUSSIN, French, 1594–1665
The Rape of the Sabine Women
Oil on canvas; 60⅞ × 82⅝ in. (154.6 × 209.9 cm)

Although French by birth and training, Poussin spent almost the whole of his career in Rome, where his work came to exemplify the ideals of classical painting. Here he re-creates a famous episode of ancient history. Romulus, the ruler of the newly founded city of Rome, raises his cloak as a signal to his men to carry off unmarried Sabine women as their wives (the Sabines had been tricked into coming to what they thought would be a religious festival). Poussin has drawn on his unparalleled knowledge of ancient art as well as a command of gesture and expression to invest this scene with intense dramatic power. *Harris Brisbane Dick Fund, 1946, 46.160*

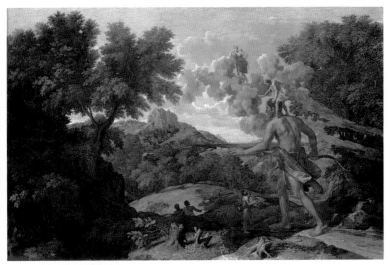

112 NICOLAS POUSSIN, French, 1594–1665
Blind Orion Searching for the Rising Sun
Oil on canvas; 46⅞ × 72 in. (119.1 × 182.9 cm)

According to classical mythology, the king of Chios blinded the huge hunter Orion, who had attempted to ravish his daughter. Told by an oracle that the rays of the rising sun would restore his sight, Orion walked eastward. Here Cedalion, Orion's guide, stands on his shoulder; at his feet Hephaestus, god of fire, points out where the sun will rise; and from the clouds Diana, goddess of the hunt, looks on. Poussin interpreted the story as an allegory of the formation of clouds.

Late in his career Poussin turned to landscape painting, and this powerful and haunting vision of Orion's story, executed in 1658, is one of his greatest achievements. *Fletcher Fund, 1924, 24.45.1*

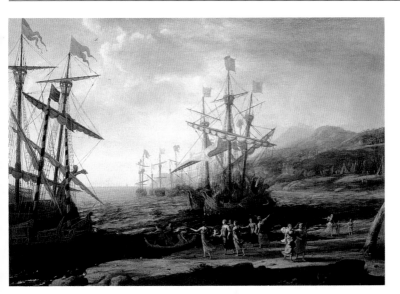

113 CLAUDE LORRAIN, French, 1604/5?–1682
The Trojan Women Setting Fire to Their Fleet
Oil on canvas; 41⅜ × 59⅞ in. (105.1 × 152.1 cm)

Like his compatriot Poussin, Claude Lorrain settled in Rome, where he became the greatest painter of idealized landscapes. Claude based a number of his paintings on the poems of Virgil, who tells the story of the Trojan women in the fifth book of the *Aeneid*. Defeated by the Greeks in the Trojan War, a band of Trojans, led by Aeneas, set out to found a new city in Latium in Italy. These legendary ancestors of the Roman people met with many adventures. In Sicily the women, exhausted by seven years of wandering, were inspired by Juno and Iris to burn their "beautifully painted" ships, so that the exiles would be forced to settle where they had landed. Aeneas, however, prayed to Jupiter, who put out the fires with a rainstorm. Claude's landscapes, in which he enhanced effects of sunlight and atmosphere, transform Italian scenery into a vision of the world of antiquity. (See also Drawings and Prints, no. 7.) *Fletcher Fund, 1955, 55.119*

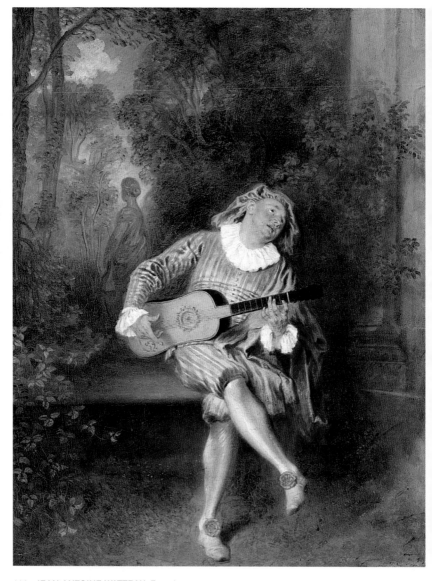

114 JEAN ANTOINE WATTEAU, French,
1684–1721
Mezzetin
Oil on canvas; 21¾ × 17 in. (55.2 × 43.2 cm)

Mezzetin, whose name means "half measure,"
was a stock character of the commedia dell'arte,
a form of improvisational theater of Italian ori-
gin; he was an amorous and sentimental valet
frequently engaged in the troublesome pursuit
of unrequited love. He is shown singing before
an overgrown garden in which stands a marble
statue of a woman with her back turned—an al-
lusion to the insensible lover who turns a deaf
ear to his romantic entreaties. Watteau made
many paintings of actors and friends in theatri-
cal costumes, but the sitter here has not been
identified. The picture was painted between
1717 and 1719, near the end of Watteau's short
life. *Munsey Fund, 1934, 34.138*

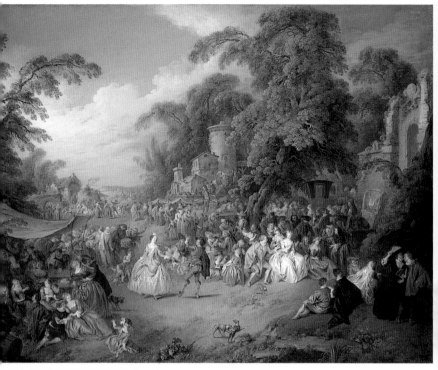

115 JEAN BAPTISTE PATER, French,
1695–1736
The Fair at Bezons
Oil on canvas; 42 × 56 in. (106.7 × 142.2 cm)

The annual fair at Bezons, a village near Versailles, was the subject of several paintings by Watteau's followers, of whom Pater was among the most gifted. Here in the midst of some two hundred skillfully drawn figures, an actor and an actress, flanked by comics and clowns, dance in a burst of sunlight. The picturesque landscape only vaguely suggests the village of Bezons. This canvas, Pater's masterpiece, probably dates to about 1733. *The Jules Bache Collection, 1949, 49.7.52*

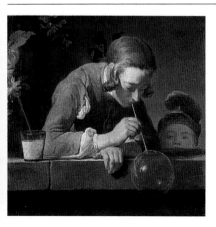

116 JEAN SIMÉON CHARDIN, French,
1699–1779
Soap Bubbles
Oil on canvas; 24 × 24⅞ in. (61 × 63.2 cm)

Chardin, who was inspired by seventeenth-century Dutch and Flemish genre painters, based this picture on a familiar metaphor— human life is as brief as that of a soap bubble. The balanced composition and the restricted color scheme contribute to the effect of stillness and solemnity. Chardin has recorded this moment as if it were eternal. *Wentworth Fund, 1949, 49.24*

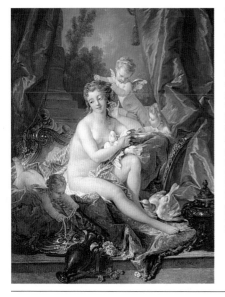

117 FRANÇOIS BOUCHER, French, 1703–1770
The Toilet of Venus
Oil on canvas; 42⅝ × 33½ in. (108.3 × 85.1 cm)

Boucher's career is inextricably linked with that of his patroness, the marquise de Pompadour, mistress of Louis XV, and this picture, signed and dated 1751, is thought to have been commissioned as part of the decoration for Bellevue, her château near Paris. This painting and its companion piece, *Bath of Venus* (National Gallery, Washington), were installed there in her *salle de bain.* The winged putti and the doves are among the attributes of Venus as goddess of love, while the flowers allude to her role as patroness of gardeners, and the pearls to her birth from the sea. As a painter of nudes Boucher ranks with Rubens in the seventeenth century and Renoir in the nineteenth; among his contemporaries he had no equal. *Bequest of William K. Vanderbilt, 1920, 20.155.9*

118 JEAN BAPTISTE GREUZE, French, 1725–1805
Broken Eggs
Oil on canvas; 28¾ × 37 in. (73 × 94 cm)

Greuze was much influenced by Dutch genre painting and chose themes that allowed him to explore conflicting human emotions. This picture was one of four canvases, painted in Rome and representing figures in Italian costume, which Greuze sent to the Paris Salon of 1757. *Broken Eggs* and *The Neapolitan Gesture* (Worcester Art Museum, Massachusetts) were exhibited as a pair. The young woman of easy virtue seen here was contrasted with the chaste girl in the pendant, who gazes longingly at her suitor but remains separated from the object of her desire. *Bequest of William K. Vanderbilt, 1920, 20.155.8*

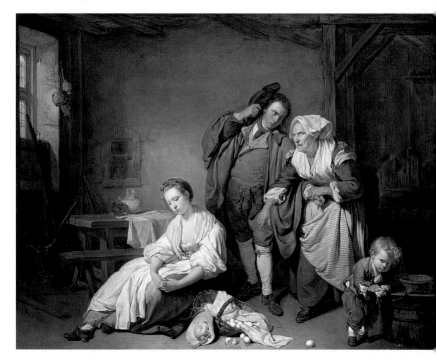

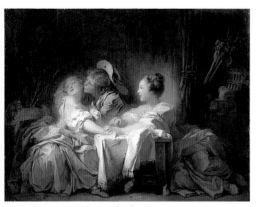

119 JEAN HONORÉ FRAGONARD, French, 1732–1806
The Stolen Kiss
Oil on canvas; 19 × 25 in. (48.3 × 63.5 cm)

Fragonard, who in 1752 won first prize at the Paris Academy, went to the French Academy in Rome in 1756 and remained in Italy, traveling widely there until 1761. While he was in Italy, he painted this picture, which was evidently commissioned by the *bailli* de Breteuil, ambassador of the Order of Malta in Rome. It shows the influence of Fragonard's teachers, Boucher and Chardin (nos. 117 and 116). The smooth surface distinguishes this early picture from his later works, in which the technique is freer and more spontaneous. *Gift of Jessie Woolworth Donahue, 1956, 56.100.1*

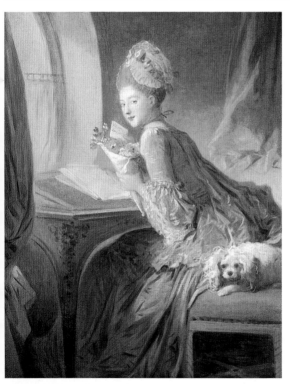

120 JEAN HONORÉ FRAGONARD, French, 1732–1806
The Love Letter
Oil on canvas; 32¾ × 26⅜ in. (83.2 × 67 cm)

This picture exemplifies Fragonard's feeling for color, his sensitive handling of effects of light, and his extraordinary technical facility. The elegant blue dress, lace cap, and coiffure of the woman seated at her writing desk would have been the height of fashion in the 1770s. The inscription on the letter she holds has given rise to two different interpretations. It may simply refer to her cavalier, but if it should be read "Cuvillere," then the sitter would be François Boucher's daughter Marie Émilie (1740–1784), who married, in 1773, her father's friend, the architect Charles Étienne Gabriel Cuvillier. *The Jules Bache Collection, 1949, 49.7.49*

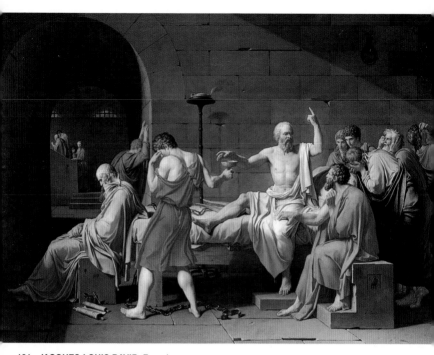

121 JACQUES-LOUIS DAVID, French,
1748–1825
The Death of Socrates
Oil on canvas; 51 × 77¼ in. (129.5 × 196.2 cm)

The philosopher Socrates had been bitterly critical of Athenian society and its institutions. Accused by the Athenian government of denying the gods and corrupting the young through his teachings, he chose to die by his own hand rather than renounce his beliefs. David has portrayed him calmly reaching for the cup of poisonous hemlock while he discourses on the immortality of the soul. This picture was first exhibited at the Salon of 1787, on the eve of the Revolution. A tribute to the social criticism and stoical self-sacrifice of Socrates, it was full of political implication and was regarded as a protest against the injustices of the ancien régime. *The Death of Socrates* became a symbol of republican virtue and a manifesto of the Neoclassical style. *Catharine Lorillard Wolfe Collection, Wolfe Fund, 1931, 31.45*

122 JACQUES-LOUIS DAVID, French, ▶
1748–1825
Antoine-Laurent Lavoisier and His Wife
Oil on canvas; 102¼ × 76⅝ in. (259.7 × 194.6 cm)

The great David portraits are always richly informative about their sitters. Lavoisier (1743–1794), a celebrated scientist and chemist, is represented with a number of scientific instruments, including two relating to his experiments with gun-powder and oxygen. The manuscript on which he is engaged may be that of the *Traité élémentaire de chimie,* which was published in 1789, the year after this picture was painted. The book was illustrated by his wife, Marie-Anne-Pierrette Paulze (1758–1836), who is said to have been a pupil of David; a portfolio of her drawings rests on an armchair at the left. One of David's greatest paintings, this is a key work in the development of eighteenth-century portraiture. *Purchase, Mr. and Mrs. Charles Wrightsman Gift, in honor of Everett Fahy, 1977, 1977.10*

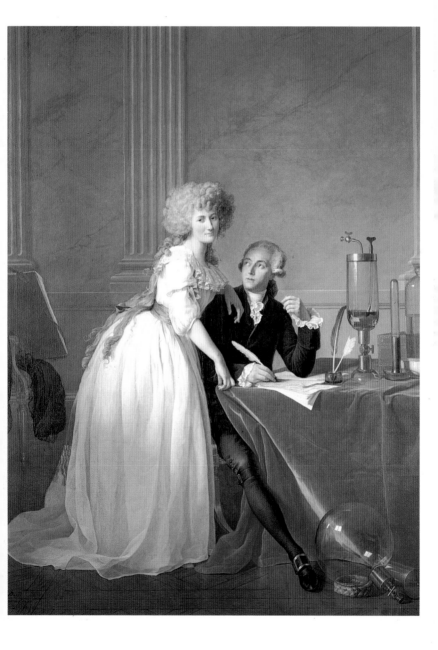

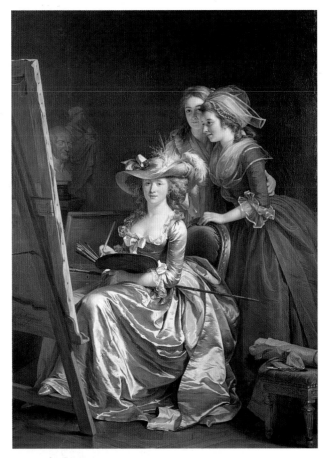

123 ADÉLAÏDE LABILLE-GUIARD, French, 1749–1803
Self-portrait with Two Pupils
Oil on canvas; 83 × 59½ in. (210.8 × 151.1 cm)

Labille-Guiard was first apprenticed to a minia-
ture painter and later studied the art of pastel
with Maurice Quentin de La Tour. The rich pal-
ette and fine detail in this picture, which is
dated 1785, reflect her earlier training. In 1783,
when Labille-Guiard and Vigée Le Brun (no.
124) were admitted to the French Royal Acad-
emy, the number of women artists eligible for
membership was limited to four, and this paint-
ing has been interpreted as a propaganda
piece, arguing for the place of women in the
academy. The artist's pupils are Mlle Capet
(1761–1818), who exhibited in Paris from 1781
until her death, and Mlle Carreaux de Rose-
mond (d. 1788), who exhibited in 1783–84.
Labille-Guiard sympathized with the Revolution,
and unlike Vigée Le Brun she remained in
France throughout her life. *Gift of Julia A.
Berwind, 1953, 53.225.5*

125 J. A. D. INGRES, French, 1780–1867
Joseph-Antoine Moltedo
Oil on canvas; 29⅝ × 22⅞ in. (75.2 × 58.1 cm)

Ingres arrived in Rome in 1806 as a fellow of the French Academy and remained there for fourteen years. He benefited from the patronage of a number of Napoleon's official representatives and painted many other members of the French colony in Rome, as well as prominent English visitors on the Grand Tour. The sitter here has been convincingly identified as Joseph-Antoine Moltedo (b. 1775), a French industrialist who, like Napoleon, was born in Corsica. Moltedo served as director of the Roman post office from 1803 to 1814. He appears to have been in his thirties at the time this portrait was painted. The Colosseum and the Appian Way are visible in the background. Ingres has captured the sitter's confident attitude; the technique is characteristically impeccable. (See also Drawings and Prints, no. 20, and Robert Lehman Collection, no. 18.) *H. O. Havemeyer Collection, Bequest of Mrs. H. O. Havemeyer, 1929, 29.100.23*

124 ÉLISABETH LOUISE VIGÉE LE BRUN, French, 1755–1842
Comtesse de la Châtre
Oil on canvas; 45 × 34½ in. (114.3 × 87.6 cm)

In 1779 Marie Antoinette began to show a strong interest in Vigée Le Brun's work, and during the next ten years the artist was much patronized by the court. The sitter for this portrait painted in 1789 was the daughter of Louis XV's *premier valet de chambre* and the wife of the comte de la Châtre. (She later married the marquis de Jaucourt.) In her memoirs Vigée Le Brun writes that she favored the kind of white muslin dress worn here by the comtesse. The artist wore such dresses herself, often persuaded her sitters to wear them, and apparently admired them for their classic simplicity. *Gift of Jessie Woolworth Donahue, 1954, 54.182*

126 CAMILLE COROT, French, 1796–1875
The Letter
Oil on wood; 21½ × 14¼ in. (54.6 × 36.2 cm)

In the 1850s and 1860s Corot often painted
models in his studio. He posed them against a
dark background suggestive of contemporary
interiors. In this painting, which is thought to
date from about 1865, a simply dressed woman,
her white chemise open to expose her shoul-
ders, sits holding a letter. The motif and
handling reflect an awareness of seventeenth-
century Dutch painters, particularly Vermeer
and De Hooch. Corot undoubtedly became ac-
quainted with the work of both artists during a
trip to Holland in 1854, and in the 1860s he
must have been aware of the revival of interest
in Vermeer's art. (See also Robert Lehman
Collection, no. 19.) *H. O. Havemeyer Collection,
Gift of Horace Havemeyer, 1929, 29.160.33*

127 EUGÈNE DELACROIX, French,
1798–1863
The Abduction of Rebecca
Oil on canvas; 39½ × 32¼ in. (100.3 × 81.9 cm)

From the beginning of his career, Delacroix was
inspired by the novels of Sir Walter Scott, a fa-
vorite author of the French Romantics. This
painting, dated 1846, depicts a scene from
Ivanhoe: Rebecca, who had been confined in
the castle of Front de Boeuf, is being carried off
by two Saracen slaves at the command of the
Christian knight Bois-Guilbert, who has long
coveted her. The contorted poses and the
compacted space, which shifts abruptly from
a high foreground across a deep valley to the
fortress behind, create a sense of intense
drama. Critics censured its Romantic qualities
when the painting was shown in the Salon of
1846; nevertheless, it inspired Baudelaire to
write: "Delacroix's painting is like nature; it
has a horror of emptiness." *Catharine Lorillard
Wolfe Collection, Wolfe Fund, 1903, 03.30*

128 HONORÉ DAUMIER, French, 1808–1879
The Third-Class Carriage
Oil on canvas; 25¾ × 35½ in. (65.4 × 90.2 cm)

In 1839 Daumier began to depict groups of people in public conveyances and waiting rooms, and for more than two decades he treated this subject in lithographs, watercolors, and oil paintings. His characterizations of travelers document the period in the mid-nineteenth century when life in France was undergoing the im-

mense changes brought about by industrialization. Many of Daumier's canvases seem to have been executed between 1860 and 1863, when he stopped producing lithographs for the satirical newspaper *Le Charivari* to devote himself to painting. *The Third-Class Carriage* is believed to have been painted at that time.
H. O. Havemeyer Collection, Bequest of Mrs. H. O. Havemeyer, 1929, 29.100.129

129 THÉODORE ROUSSEAU, French, 1812–1867
The Forest in Winter at Sunset
Oil on canvas; 64 × 102⅜ in. (162.6 × 260 cm)

Rousseau was a leading member of the Barbizon school, a group of French landscape painters who worked mainly in the forest of Fontainebleau near the village of Barbizon. Rousseau began this ambitious canvas in the winter of 1845–46 and worked on it intermittently

for the next twenty years. He considered it his most important painting and refused to sell it during his lifetime. The ancient oaks towering above the tiny figures of the peasant women bent beneath their bundles of wood symbolize the grandeur of nature. Rousseau wished to create an imposing vision of the life of growing things, indestructible in their chaotic vitality and majestically dwarfing humanity.
Gift of P. A. B. Widener, 1911, 11.4

130 JEAN-FRANÇOIS MILLET, French, 1814–1875
Haystacks: Autumn
Oil on canvas; 33½ × 43⅜ in. (85.1 × 110.2 cm)

This picture is from a series depicting the four seasons that the industrialist Frederick Hartmann commissioned in 1868. Millet, a member of the Barbizon school, worked on the group intermittently during the next seven years. He completed *Spring* (Louvre, Paris) in 1873; by spring 1874 he reported that *Summer: Buckwheat Harvest* (Museum of Fine Arts, Boston) and *Haystacks: Autumn* were almost finished. *Winter: The Woodgatherers* (National Museum of Wales, Cardiff) was incomplete when he died.

Series of paintings depicting the seasons had long been created by European artists, but during the nineteenth century the subject grew increasingly rare. *Bequest of Lillian S. Timken, 1959, 60.71.12*

131 GUSTAVE COURBET, French, 1819–1877
Young Women from the Village
Oil on canvas; 76¾ × 102¾ in. (194.9 × 261 cm)

Here Courbet shows his sisters walking in the Communal, a valley near his native Ornans. One young woman offers either food or money to a poor cowherd. This picture was painted during the winter of 1851–52. When it was shown in the Salon of 1852, Courbet was sure the critics, who had treated him harshly in the past, would like the painting. It was, however, attacked for its "ugliness," and the critics were disturbed by the young women's common features and countrified costumes, the "ridiculous" dog and cattle, and the lack of unity and traditional perspective and scale. The effects Courbet worked hardest to achieve were those that were most strongly attacked. *Gift of Harry Payne Bingham, 1940, 40.175*

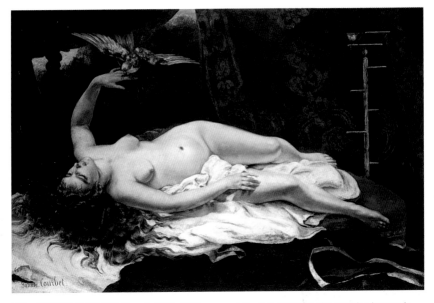

132 GUSTAVE COURBET, French, 1819–1877
Woman with a Parrot
Oil on canvas; 51 × 77 in. (129.5 × 195.6 cm)

Painted in 1865–66, *Woman with a Parrot* was one of two works that Courbet showed in the Salon of 1866. It is the best known of the series of nudes that he painted in the 1860s. The model's sensuality is emphasized by the exotic richness of details like the bird's bright plumage and the landscape and tapestry backgrounds. Critics censured Courbet's "lack of taste," as well as his model's "ungainly pose" and "disheveled hair." Their comments made clear that Courbet's woman was perceived as provocative. In 1866 Manet began his version of the subject, *Woman with a Parrot* (no. 139). *H. O. Havemeyer Collection, Bequest of Mrs. H. O. Havemeyer, 1929, 29.100.57*

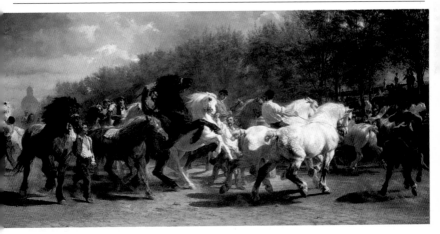

133 ROSA BONHEUR, French, 1822–1899
The Horse Fair
Oil on canvas; 96¼ × 199½ in. (244.5 × 506.7 cm)

The horse market of Paris was held on the tree-lined boulevard de l'Hôpital, near the asylum of Salpêtrière, which is visible in the left background. Bonheur began this painting in 1852. Twice a week for a year and a half she went to the market to make sketches, dressed as a man so as not to attract attention. *The Horse Fair* was shown in the Salon of 1853. It is signed and dated, but the date is followed by the numeral 5, apparently because Bonheur retouched the painting in 1855. The repainted passages were the ground, the trees, and the sky—the passages that were criticized for their summary execution at the time of the Salon. *Gift of Cornelius Vanderbilt, 1887, 87.25*

134 GUSTAVE MOREAU, French, 1826–1898
Oedipus and the Sphinx
Oil on canvas; 81¼ × 41¼ in. (206.4 × 104.8 cm)

Moreau's interpretation of the Greek myth draws heavily on Ingres's *Oedipus and the Sphinx* (1808; Louvre, Paris). Both painters chose to represent the moment when Oedipus confronted the winged monster in a rocky pass outside the city of Thebes. Unlike her other victims, he could answer her riddle and thus saved himself and the besieged Thebans. This painting was extremely successful at the Salon of 1864; it won a medal and established Moreau's reputation. Critics offered a variety of interpretations of the theme: Oedipus was thought to symbolize contemporary man, and the confrontation between the Sphinx and Oedipus was believed to symbolize the opposition of female and male principles, or possibly the triumph of life over death. *Bequest of William H. Herriman, 1921, 21.134.1*

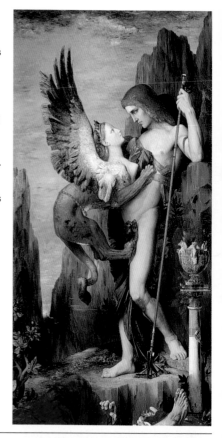

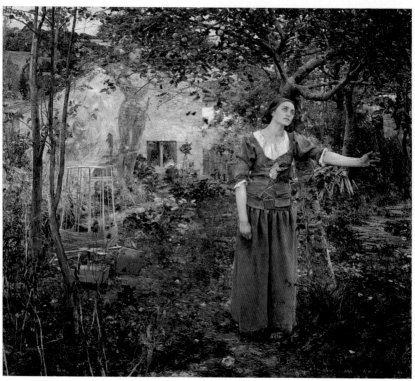

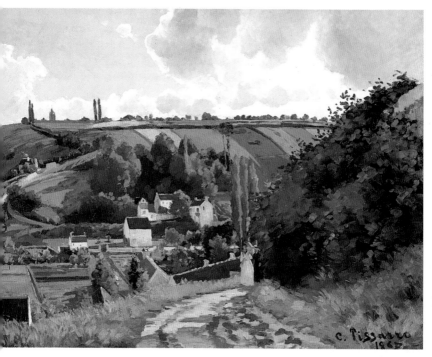

136 CAMILLE PISSARRO, French, 1830–1903
Jallais Hill, Pontoise
Oil on canvas; 34¼ × 45¼ in. (87 × 114.9 cm)

In 1866 Pissarro moved to Pontoise, northwest of Paris, where he lived until 1868. The lanes, farm buildings, hillsides, and plowed and planted fields of this hilly village on the Oise provided the subject matter for a group of firmly structured works. Their strong brushstrokes and broad, flat areas of color owe much to the example of Courbet and Corot, whose work was on view in large, much discussed exhibitions in Paris.

This picture, dated 1867, was shown in the Salon of 1868. Émile Zola praised it, stating: "There is the modern countryside. One feels that man has passed, turning and cutting the earth. . . . And this valley, this hillside embody a simplicity and heroic freedom. Nothing could be so banal were it not so great. From ordinary reality the painter's temperament has produced a rare poem of life and strength." *Bequest of William Church Osborn, 1951, 51.30.2*

135 JULES BASTIEN-LEPAGE, French, 1848–1884
Joan of Arc
Oil on canvas; 100 × 110 in. (254 × 279.4 cm)

After the province of Lorraine was lost to Germany following the Franco-Prussian War, the French saw in Joan of Arc a new and powerful symbol. In the fifteenth century this national heroine had heard heavenly voices that urged her to support the dauphin Charles in his battle against the English invaders. In this picture, which dates from 1879, Bastien-Lepage, a native of Lorraine, shows Joan receiving her revelation in the garden of her parents. Behind her, floating in supernatural light, are Saints Michael, Margaret, and Catherine. The artist deliberately rendered the scene with as little archaeological detail as possible, so that it would seem to be taking place in Lorraine in his own time. As contemporary critics noted, his work is a combination of the solid drawing of academic art and the emphasis on light effects introduced by the plein air (open air) painters. *Gift of Erwin Davis, 1889, 89.21.1*

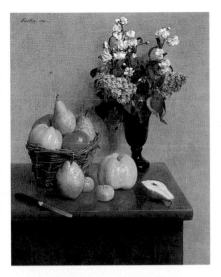

137 HENRI FANTIN-LATOUR, French, 1836–1904
Still Life with Flowers and Fruit
Oil on canvas; 28¾ × 23⅝ in. (73 × 60 cm)

In the early years of his career, Fantin-Latour painted various subjects, including allegory, still life, and portraiture, but he always worked in an unmistakably contemporary idiom. He was particularly successful with still-life and flower subjects, which occupied him throughout his life. Inspired by Chardin and Courbet, his approach was direct and naturalistic. Several paintings of flowers and fruit of 1865–66, including this example, are his first major still lifes. The special character of his work was described by Jacques-Émile Blanche, a painter of the next generation: "Fantin studied each flower, each petal, its grain, its tissue, as if it were a human face. In Fantin's flowers, the drawing is large and beautiful, and it is always sure and incisive." *Purchase, Mr. and Mrs. Richard J. Bernhard Gift, by exchange, 1980, 1980.3*

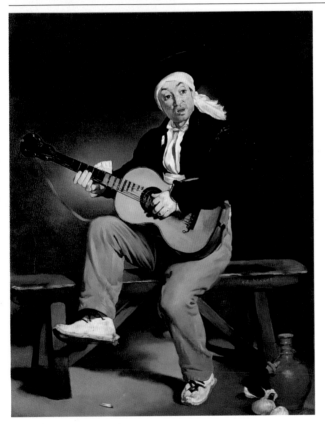

138 ÉDOUARD MANET, French, 1832–1883
The Spanish Singer
Oil on canvas; 58 × 45 in. (147.3 × 114.3 cm)

Manet made his public debut at the Salon of 1861 with a portrait of his parents (Musée d'Orsay, Paris) and *The Spanish Singer.* The paintings were well received, and the noted critic Théophile Gautier praised him as a gifted realist in the tradition of Spanish painters from Velázquez to Goya. As Gautier's own essays on Spanish culture had stimulated French printmakers to flood the market with illustrations of Spanish types, the theme of this picture was hardly novel. Yet, as Gautier observed, most of the illustrators romanticized their subjects, whereas Manet did not. Here the artist treats every detail with extraordinary finesse: the red shoulder strap, the rumpled trousers, the spent cigarette, and the soulful expression, captured in just two hours' work. *Gift of William Church Osborn, 1949, 49.58.2*

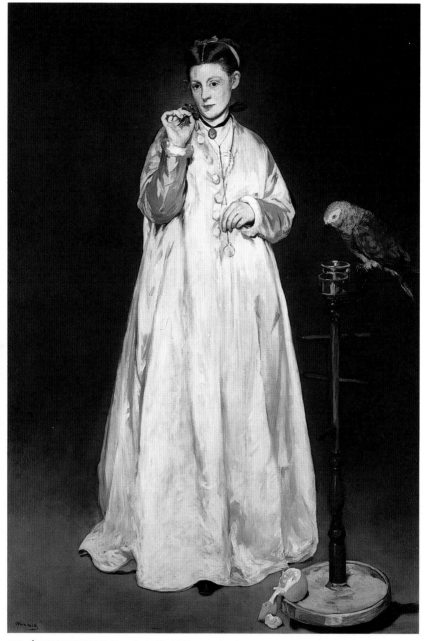

139 ÉDOUARD MANET, French, 1832–1883
Woman with a Parrot
Oil on canvas; 72⅞ × 50⅝ in. (185.1 × 128.6 cm)

Given his inclination to allude to the works of other painters, it is probable that Manet conceived this picture in response to the controversial nude exhibited by his rival Courbet at the Salon of 1866 (no. 132). While Courbet's picture is explicitly sexual, Manet's is discreet and spare. It has been suggested that this picture is an allegory of the five senses: smell (the violets), touch and sight (the monocle), hearing (the talking bird), and taste (the orange). The model is Victorine Meurent, who also posed for Manet's celebrated *Olympia* and *Le Déjeuner sur l'herbe* (both 1863; Musée d'Orsay, Paris). *Gift of Erwin Davis, 1889, 89.21.3*

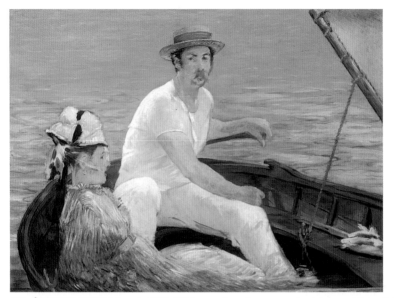

140 ÉDOUARD MANET, French, 1832–1883
Boating
Oil on canvas; 38¼ × 51¼ in.
(97.2 × 130.2 cm)

Boating was painted during the summer of 1874, when Manet was working with Renoir and Monet at Argenteuil, a village on the Seine northwest of Paris. The high-keyed palette, the elevated viewpoint from which the water's sur- face rises up as a backdrop, and the artist's decision to celebrate the everyday pleasures of the middle class are in keeping with the Im- pressionist style recently developed by his younger colleagues. The cutting of forms at the edges of the picture reflects Manet's inter- est in Japanese prints. *H. O. Havemeyer Collection, Bequest of Mrs. H. O. Havemeyer, 1929, 29.100.115*

141 EDGAR DEGAS, French, 1834–1917
A Woman Seated Beside a Vase of Flowers
Oil on canvas; 29 × 36½ in. (73.7 × 92.7 cm)

In a departure from tradition, most portraits by Degas were not formally posed. He wanted to depict his subjects in familiar and typical positions, often observing them in private, unguarded moments. The sitter for this por- trait of 1865 is possibly Mme Paul Valpinçon, wife of Degas's childhood friend. The bouquet is composed largely of asters. (See also Draw- ings and Prints, no. 22.) *H. O. Havemeyer Collection, Bequest of Mrs. H. O. Havemeyer, 1929, 29.100.128*

142 EDGAR DEGAS, French, 1834–1917
James-Jacques-Joseph Tissot
Oil on canvas; 59⅝ × 44 in. (151.4 × 111.8 cm)

Tissot (1836–1902) was a friend of Degas's and a fellow artist, who fled France after having played an active role in the Paris Commune in 1871. He spent ten years in England, where he was known as James Tissot, and achieved great success as a painter of fashionable women. In Degas's portrait, which dates from 1866–68, Tissot seems to have been interrupted while in the middle of a casual discourse on painting. On the wall of the studio are improvisations on works that Degas knew well: Old Masters, contemporary paintings, and oriental works. Their presence underscores Degas's, and presumably Tissot's, eclectic sensibility and willingness to consider the art of all periods in order to create a style anchored in tradition and appropriate to subjects taken from modern life. *Rogers Fund, 1939, 39.161*

143 EDGAR DEGAS, French, 1834–1917
Dancers Practicing at the Bar
Mixed media on canvas; 29¾ × 32 in. (75.6 × 81.3 cm)

Although this picture has a casually realistic appearance, Degas's fascination with form and structure is reflected in the analogy between the watering can (used to lay the dust on the studio floor) and the dancer at the right. The handle on the side imitates her left arm, the handle at the top mimics her head, and the spout approximates her right arm and raised leg. Composi-

tional devices such as this bear out the artist's famous remark: "I assure you that no art was ever less spontaneous than mine. What I do is the result of reflection and study of the great masters; of inspiration, spontaneity, temperament . . . I know nothing." (See also Drawings and Prints, no. 24; European Sculpture and Decorative Arts, no. 28; and Robert Lehman Collection, no. 39.) *H. O. Havemeyer Collection, Bequest of Mrs. H. O. Havemeyer, 1929, 29.100.34*

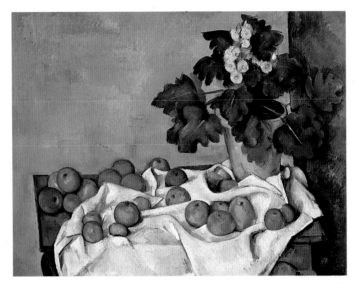

144 PAUL CÉZANNE, French, 1839–1906
Still Life with Apples and a Pot of Primroses
Oil on canvas; 28¾ × 36⅜ in. (73 × 92.4 cm)

This painting, once owned by Monet, is thought to date from the early 1890s. Controversy about the date results in part from its quiet, almost static quality. The pattern of leaves against the background is unusual in Cézanne's work, as is the highly finished surface. But, with the exception of the primroses, the objects in the picture appear frequently in the artist's still lifes: the scalloped table, the cloth pinched up in sculptural folds, and the apples nestled in isolated groups. When Cézanne visited Monet at Giverny in 1894, he met the critic Gustave Geffroy, to whom he explained in reference to his still lifes that he wanted to astonish Paris with an apple. He never did so during his lifetime, for his works were always considered unacceptable by Salon juries. *Bequest of Sam A. Lewisohn, 1951, 51.112.1*

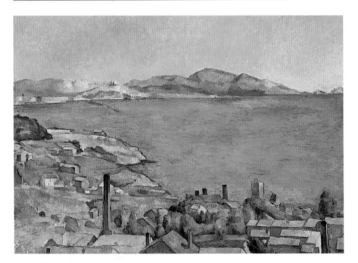

145 PAUL CÉZANNE, French, 1839–1906
The Gulf of Marseilles Seen from L'Estaque
Oil on canvas; 28¾ × 39½ in. (73 × 100.3 cm)

In the 1880s Cézanne executed more than a dozen closely related pictures of the panoramic view from the Provençal town of L'Estaque toward a low range of mountains across the Gulf of Marseilles. Pissarro and Monet independently adopted similar working methods. Their primary purpose, however, was to record transient effects of light, whereas Cézanne was interested in the variations in composition that resulted when he changed his vantage point or slightly shifted his angle of vision. Here Cézanne contrasted the closely packed geometric forms of buildings in the foreground with the more scattered and irregularly shaped mountains. The composition is intriguing, for from the elevated position scale is distorted, and the nearby buildings seem comparable in size to the mountains in size. *H. O. Havemeyer Collection, Bequest of Mrs. H. O. Havemeyer, 1929, 29.100.67*

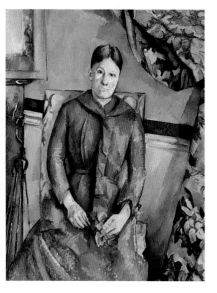

146 PAUL CÉZANNE, French, 1839–1906
Madame Cézanne in a Red Dress
Oil on canvas; 45⅞ × 35¼ in. (116.5 × 89.5 cm)

This picture, which dates from about 1890, is one of twenty-seven portraits that Cézanne painted of his wife, Hortense Fiquet (1850–1922). These paintings are compositional studies based on the figure rather than portraits in the conventional sense. Here she does not sit comfortably in her chair but tilts to the right, echoing the axis of the fire tongs on the left and the curtain on the right. The flower that she holds seems neither more nor less real than those in the curtain at the right side of the painting. The reflection of a similar curtain is visible in the rectangular shape on the wall that we might not otherwise recognize as a mirror. The displaced image in the mirror is in keeping with the spatial dislocations evident in the artist's interpretation of the scene as a whole. *The Mr. and Mrs. Henry Ittleson Jr. Purchase Fund, 1962, 62.45*

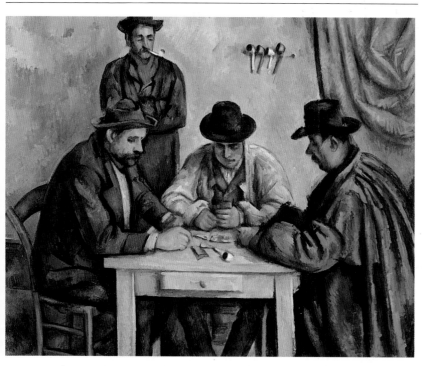

147 PAUL CÉZANNE, French, 1839–1906
The Card Players
Oil on canvas; 25¾ × 32¼ in. (65.4 × 81.9 cm)

The majority of Cézanne's works are landscapes, still lifes, or portraits. In 1890, however, he undertook this ambitious genre scene of peasants playing cards, possibly in emulation of Mathieu Le Nain (1607–1677), whose painting of the same subject was on view in the museum at Aix-les-Bains. The subject continued to interest Cézanne, and during the next years he painted five versions of the scene. In each of these he emphasizes the somber concentration of the participants. Expression and even personality have been suppressed by their interest in cards. *Bequest of Stephen C. Clark, 1960, 61.101.1*

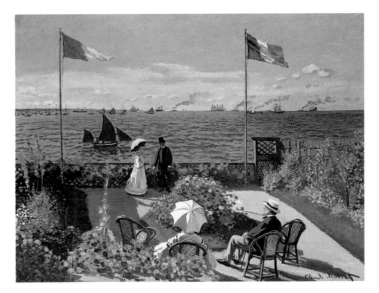

148 CLAUDE MONET, French, 1840–1926
Garden at Sainte-Adresse
Oil on canvas; 38⅝ × 51⅛ in. (98.1 × 129.9 cm)

A prime mover among the artists who came to be known as Impressionists, Monet spent the summer of 1867 at the resort town of Sainte-Adresse on the English Channel. It was there that he painted this picture, which combines smooth, traditionally rendered areas with sparkling passages of rapid, separate brushwork and spots of pure color. The elevated vantage point and relatively even sizes of the horizontal areas emphasize the two-dimensionality of the painting. The three horizontal zones of the composition seem to rise parallel to the picture plane instead of receding clearly into space. The subtle tension resulting from the combination of illusionism and the two-dimensionality of the surface remained an important characteristic of Monet's style. *Purchase, special contributions and funds given or bequeathed by friends of the Museum, 1967, 67.241*

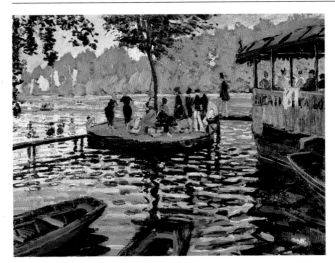

149 CLAUDE MONET, French, 1840–1926
La Grenouillère
Oil on canvas; 29⅜ × 39¼ in. (74.6 × 99.7 cm)

In 1869, when this picture was painted, Monet and Renoir were living near one another in Saint-Michel, a few miles west of Paris. They often visited La Grenouillère, a swimming spot with a boat rental and a café on the Seine, and each artist painted three views of the area. This example and the one by Renoir in the National-museum, Stockholm, are nearly identical in composition; they were undoubtedly painted side by side. Pursuing interests earlier defined in *Garden at Sainte-Adresse* (no. 148), Monet concentrated on repetitive elements—the ripples on the water, the foliage, the boats, and the human figure—to weave a fabric of brushstrokes which, although emphatically brushstrokes, retain a strong descriptive quality. (See also Robert Lehman Collection, no. 20.) *H. O. Havemeyer Collection, Bequest of Mrs. H. O. Havemeyer, 1929, 29.100.112*

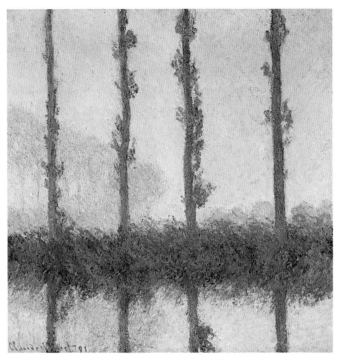

150 CLAUDE MONET, French, 1840–1926
Poplars
Oil on canvas; 32¼ × 32⅛ in. (81.9 × 81.6 cm)

During the summer and fall of 1891 Monet painted a series of works depicting the poplars along the Epte River, about a mile from his house in Giverny. Some of these were painted from the banks of the river; others, such as this example, were painted from a boat. Lila Cabot Perry, an American who spent the summers of 1889–1901 in Giverny, wrote, "The Poplars series . . . were painted from a broad-bottomed boat fitted up with grooves to hold a number of canvases. [Monet] told me that in one of his Poplars the effect lasted only seven minutes, or until the sunlight left a certain leaf, when he took out the next canvas and worked on that." When fifteen paintings from this series were shown in Paris in 1892, some critics praised them for their naturalism, while others admired their abstract and decorative qualities. *H. O. Havemeyer Collection, Bequest of Mrs. H. O. Havemeyer, 1929, 29.100.110*

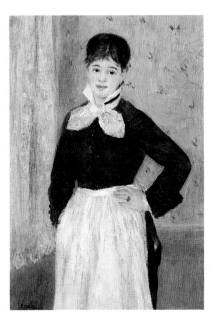

151 PIERRE-AUGUSTE RENOIR, French, 1841–1919
A Waitress at Duval's Restaurant
Oil on canvas; 39½ × 28⅛ in. (100.3 × 71.4 cm)

In 1879 Edmond Renoir wrote that his brother was committed to art rooted in actual experience rather than contrived with the assistance of professional models wearing costumes. For this picture, painted about 1875, Renoir depicted a waitress whom he had met in a Parisian restaurant. Evidently he asked her to come to his studio to pose in her uniform, just as she looked while working. As he explained in a different context, "I like painting best when it looks eternal without boasting about it: an everyday eternity, revealed on the street corner: a servant-girl pausing a moment as she scours a saucepan, and becoming a Juno on Olympus." (See also Robert Lehman Collection, no. 21.) *Bequest of Stephen C. Clark, 1960, 61.101.14*

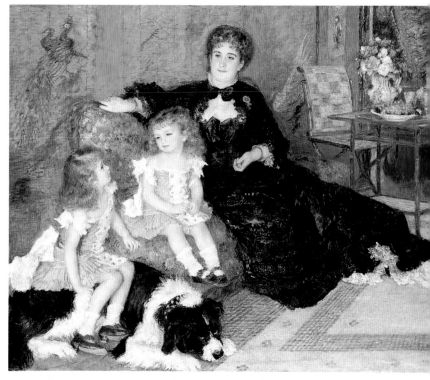

152 PIERRE-AUGUSTE RENOIR, French, 1841–1919

Madame Georges Charpentier and Her Children, Georgette and Paul

Oil on canvas; 60½ × 74⅞ in. (153.7 × 190.2 cm)

The well-to-do publisher Georges Charpentier and his wife entertained political, literary, and artistic notables on Friday evenings, and they welcomed Renoir to these gatherings. He was paid handsomely to paint this stunning group portrait, which is dated 1878. Though Renoir conveys the opulent ease of his subjects' lives, he made no attempt to capture their personalities. Consequently, his portrait of this stylish family is closer in spirit to works by Rubens and Fragonard that he admired than to the more penetrating portraits of his colleague Degas (no. 142). The picture was well received at the Salon of 1879. *Catharine Lorillard Wolfe Collection, Wolfe Fund, 1907, 07.122*

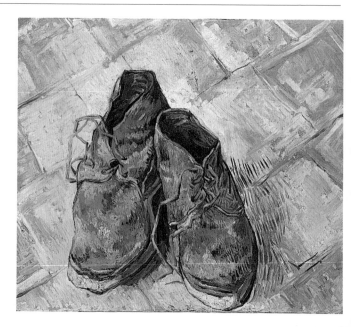

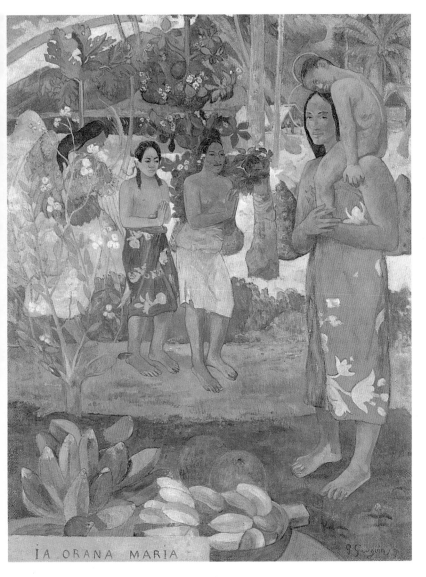

IA ORANA MARIA

153 VINCENT VAN GOGH, Dutch, 1853–1890
Shoes
Oil on canvas; 17⅜ × 20⅞ in. (44.1 × 53 cm)

In 1894 Paul Gauguin wrote: "In my yellow
room there was a small still life. . . . Two enor-
mous shoes, worn, misshapen. The shoes of
Vincent. Those that, when new, he put on one
nice morning to embark on a journey by foot
from Holland to Belgium." This recollection
informs us that Van Gogh valued the still life
highly enough to place it in the room in his
house in Arles that Gauguin occupied in late
1888. Van Gogh had made five paintings of
shoes while he was in Paris in 1887, but this is
the only one he made in Arles, probably in
August 1888. The image's rich strength has
prompted numerous studies exploring its mean-
ing and significance in the artist's work.
*Purchase, The Annenberg Foundation, 1993,
1993.132*

154 PAUL GAUGUIN, French, 1848–1903
Ia Orana Maria (Hail Mary)
Oil on canvas; 44¾ × 34½ in. (113.7 × 87.6 cm)

This is the most important picture that Gauguin
painted during his first trip to Tahiti (1891–93).
The title is native dialect that translates, "I hail
thee, Mary," the angel Gabriel's first words to
the Virgin Mary at the Annunciation. In a letter
written in the spring of 1892, Gauguin described
the painting: "An angel with yellow wings who
points out to two Tahitian women the figures of
Mary and Jesus, also Tahitians. Nudes dressed
in pareus, a kind of flowered cotton which is
wrapped as one likes around the waist. . . . I am
rather pleased with it." The only elements that
he has taken from traditional representations of
the Annunciation are the angel, the salutation,
and the halos. Everything else is rendered in Ta-
hitian idiom except the composition, which
Gauguin adapted from a photograph of a bas-
relief in the Javanese temple of Borobudur.
Bequest of Sam A. Lewisohn, 1951, 51.112.2

155 VINCENT VAN GOGH, Dutch, 1853–1890
Self-portrait with a Straw Hat
Oil on canvas; 16 × 12½ in. (40.6 × 31.8 cm)

This picture was probably painted toward the end of Van Gogh's two-year stay in Paris, from March 1886 to February 1888, not long before he departed to live and work in the Provençal city of Arles. The palette and directional brush-strokes are evidence of the influence of Divisionism, especially as represented by the work of Seurat (nos. 159 and 160) and Signac. Van Gogh has clearly mastered the Neo-Impressionist current in his painting. This self-portrait reflects the bold temperament of the individual who in December 1885 wrote to his brother: "I prefer painting people's eyes to cathedrals, for there is something in the eyes that is not in the cathedral, however solemn and imposing the latter may be—a human soul, be it that of a poor streetwalker, is more interesting to me." *Bequest of Miss Adelaide Milton de Groot (1876–1967), 1967, 67.187.70a*

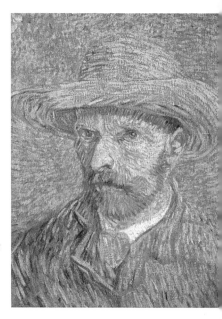

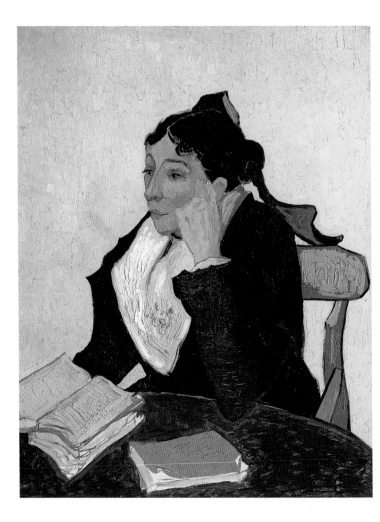

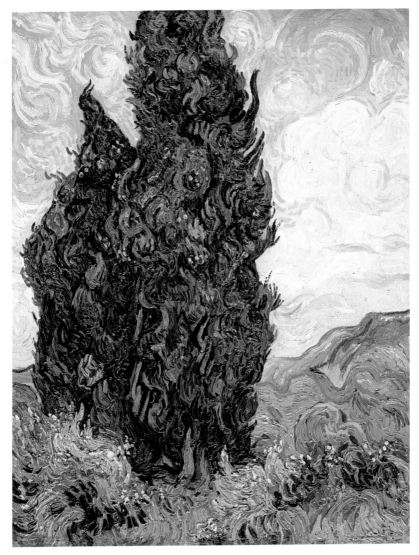

156 VINCENT VAN GOGH, Dutch, 1853–1890
L'Arlésienne: Madame Joseph-Michel Ginoux
Oil on canvas; 36 × 29 in. (91.4 × 73.7 cm)

Van Gogh stayed at Arles from February 1888 to
May 1889. While there, he painted two very simi-
lar portraits of Mme Ginoux, the proprietress of
the Café de la Gare. The first version, which he
described in a letter of November 1888 as "an
Arlésienne . . . started on in an hour," must be
the more thinly and summarily executed portrait
in the Musée d'Orsay, Paris. It dates to the two-
month period that Gauguin spent with Van
Gogh in Arles. The two artists reportedly cajoled
the reluctant *patronne* of the café into posing by
inviting her to have coffee with them. The large
areas of single colors and the bold contours of
the figure reflect the influence of Japanese
prints and medieval cloisonné enamels. Van
Gogh's highly abstract use of line and color was
undoubtedly approved of by Gauguin, who, with
their friend and fellow artist Émile Bernard, ad-
vocated such syntheses of form and color, in
contrast to the empiricism of Impressionism.
Bequest of Sam A. Lewisohn, 1951, 51.112.3

157 VINCENT VAN GOGH, Dutch, 1853–1890
Cypresses
Oil on canvas; 36¾ × 29⅛ in. (93.4 × 74 cm)

Van Gogh painted *Cypresses* in June 1889,
not long after the beginning of his year-long
voluntary confinement at the asylum of Saint-
Paul-de-Mausoie in Saint-Rémy. The cypress
represented a kind of perfect natural architec-
ture in Van Gogh's canon of pantheism: "It is as
beautiful of line and proportion as an Egyptian
obelisk." The loaded brushstrokes and the swirl-
ing, undulating forms are typical of his work in
Saint-Rémy. The subject posed an extraordinary
technical problem for the artist, especially with
regard to realizing the deep, rich green of the
trees. On June 25, 1889, he wrote to his brother,
"It is a splash of *black* in a sunny landscape, but
it is one of the most interesting black notes, and
the most difficult to hit off that I can imagine."
Rogers Fund, 1949, 49.30

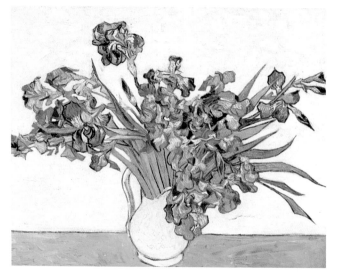

158 VINCENT VAN GOGH, Dutch, 1853–1890
Irises
Oil on canvas; 29 × 36¼ in. (73.7 × 92.1 cm)

In May 1890 Van Gogh was released from the asylum in Saint-Rémy. His last month there was a period of relative calm and productivity, and he wrote to his brother: "All goes well. I am doing . . . two canvases representing big bunches of violet irises, one lot against a pink background in which the effect is soft and harmonious . . . the other . . . stands out against a startling citron background [with] an effect of

tremendously disparate complementaries, which strengthen each other by their juxtaposition." The first picture is illustrated here (the background has faded considerably); the second is *Still Life: Vase with Irises Against a Yellow Background* (Rijksmuseum Vincent van Gogh, Amsterdam). The entirely different effects achieved through alterations in his palette emphasize Van Gogh's interest in the symbolic meaning as well as the formal value of color. *Gift of Adele R. Levy, 1958, 58.187*

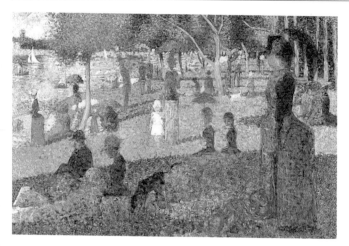

159 GEORGES SEURAT, French, 1859–1891
Study for "A Sunday on La Grande Jatte"
Oil on canvas; 27¾ × 41 in. (70.5 × 104.1 cm)

This painting, which dates from 1884, is Seurat's final sketch for his masterpiece depicting Parisians enjoying their day off on an island in the Seine (Art Institute of Chicago). As in the final work, the sketch juxtaposes contrasting pigments and depends on optical mixture—the phenomenon that causes two tones seen at a distance to form a single hue—to create the desired effect. Although there are only minor

differences in compositional detail between this study and the final work, the pictures represent distinct stages in the development of Seurat's color theory. For the study he applied layers of saturated colors in hatched strokes, whereas in the larger version he applied his paints in the small, discrete dabs characteristic of his Pointillist technique. About 1885 Seurat restretched this canvas and added its painted border. (See also Drawings and Prints, no. 21.) *Bequest of Sam A. Lewisohn, 1951, 51.112.6*

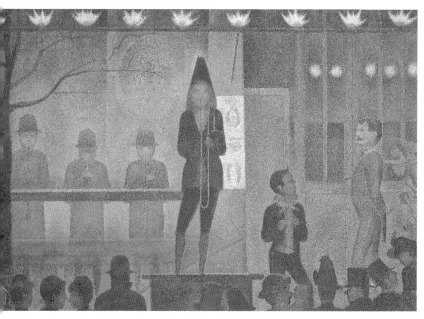

160 GEORGES SEURAT, French, 1859–1891
Circus Sideshow
Oil on canvas; 39¼ × 59 in. (99.7 × 149.9 cm)

This picture, painted in 1887–88, represents the *parade* of the Corvi Circus in the Place de la Nation in Paris. A *parade* is a sample entertainment performed on the street to entice passersby to purchase tickets. Using a fine brush, Seurat covered the canvas with precise, interspersed orange, yellow, and blue touches. Though his research in optics and perceptual psychology was highly scientific, the luminous shadows endow objectively observed forms with mystery. His contemporaries used the term *féerique* (enchanted) to describe pictures like this one, in which light imbues the commonplace with poetry. *Bequest of Stephen C. Clark, 1960, 61.101.17*

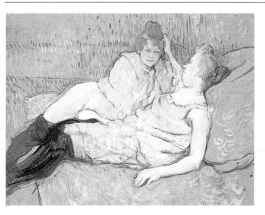

161 HENRI DE TOULOUSE-LAUTREC,
French, 1864–1901
The Sofa
Oil on cardboard; 24¾ × 31⅞ in. (62.9 × 81 cm)

Intrigued by erotic Japanese prints, as well as by Degas's small monotypes of brothel scenes (which were not intended for public exhibition), Lautrec set out to document the lives of prostitutes in a series of pictures executed between 1892 and 1896. Himself a social outcast because of his physical deformities, Toulouse-Lautrec was accepted by the prostitutes and keenly apprehended the dreary sadness of their lives.

Since they were accustomed to being observed, these women made unaffected models, never compromising Toulouse-Lautrec's commitment to utter candor. At first he made sketches in the brothels; hampered by the insufficient lighting, however, he eventually had his models pose in his studio on a large divan.

The prostitutes often fell in love with one another, and Toulouse-Lautrec was sympathetic to lesbianism. Although the sexual attraction between the women is evident in this picture, their attentive affection is equally striking. *Rogers Fund, 1951, 51.33.2*

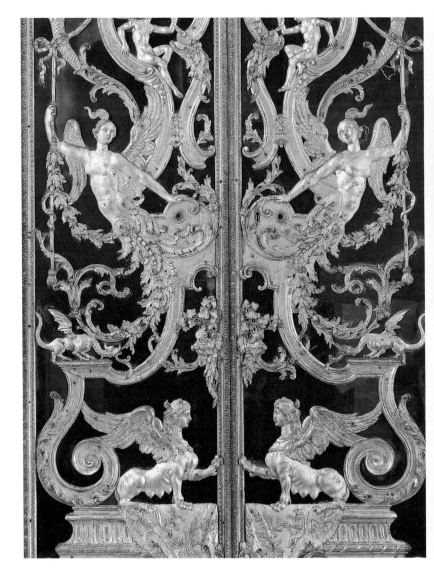

LORENZO DE' FERRARI (designer), Italian (Genoa), 1680–1744
Pair of Double Doors
Gilded linden wood, mirror glass, pine, the backs paneled in walnut; h. 109 in. (277 cm)

The central portion of this pair of doors illustrates an extraordinary mingling of styles: Baroque solidity in the lower section rising to sinuous Rococo extravagance above. The pair is part of a set of four double doors (ca. 1743–44)

provided for the Golden Gallery in the Palazzo Carrega Cataldi, now the Chamber of Commerce, Genoa. The ceiling and wall paintings for this large, sumptuous room were by the relatively unknown Genoese artist Lorenzo de' Ferrari, who also designed the plasterwork, woodwork, and furniture. All the doors were purchased and brought to New York in the late 1890s by the American architect Stanford White. *Rogers Fund, 1991, 1991.307a,b*

EUROPEAN SCULPTURE AND DECORATIVE ARTS

The Department of European Sculpture and Decorative Arts was established in 1907 as part of the reorganization of the Museum under the presidency of J. Pierpont Morgan. Conceived as a mere repository of decorative arts, the department, one of the Museum's largest, is at present responsible for a comprehensive and important historical collection reflecting the development of art in the major Western European countries. The holdings, comprising some sixty thousand works of art, include many masterpieces and cover the following areas: sculpture, woodwork and furniture, ceramics and glass, metalwork and jewelry, horological and mathematical instruments, and tapestries and textiles. The department has distinguished works of Italian Renaissance sculpture, notably bronze statuettes, and French sculpture of the eighteenth century. Other major areas of strength are French and English furniture and silver, Italian maiolica, and French and German porcelain. Important also are the architectural settings and period rooms, among them the sixteenth-century patio from Vélez Blanco, Spain, several salons from eighteenth-century French mansions, and two English Neoclassical rooms.

In recent years the department has focused its energies on a series of new gallery installations, which, when completed, will present the rich collections in a panoramic way. Starting with the fifteenth-century intarsia *studiolo* from the ducal palace in Gubbio and nearby Renaissance galleries flanking the Medieval Sculpture Hall, the galleries will continue with the rise of the Italian, French, and English national schools and the display of eighteenth-century Central European art, concluding in the Kravis Wing with a presentation of Italian and French sculpture from the seventeenth to the twentieth century and a synthesis of the decorative arts throughout Europe during the eighteenth and nineteenth centuries.

1 Winged Infant: A Fountain Figure
Florentine, mid-15th c.
Gilt bronze; h. 24½ in. (61.5 cm)

The sculptor of this sturdy figure, with its commanding forms, was clearly an astute observer of Donatello's angels for the font of the Siena Baptistery (1429). The winged ankles suggest that the subject is a young Mercury, but the figure is also equipped with winged shoulders and a fleecy tail, which indicate a more complex meaning. The composition had considerable influence on later Florentine sculptors, raising the possibility that this was a commission from a member of the Medici family. *Purchase, Mrs. Samuel Reed Gift, Gifts of Thomas Emery and Mrs. Lionel F. Straus, in memory of her husband, by exchange, and Louis V. Bell Fund, 1983, 1983.356*

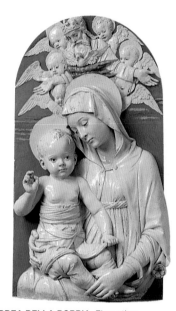

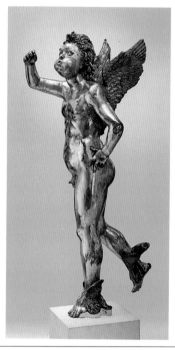

2 ANDREA DELLA ROBBIA, Florentine, 1435–1525
Madonna and Child
Glazed terracotta; 37⅜ × 21⅝ in. (95 × 55 cm)

Andrea was the nephew and disciple of Luca della Robbia, developer of the blue-and-white glazes for terracotta sculpture with which the name della Robbia is associated. By the time he made the Lehman Madonna (ca. 1470–75), Andrea had for some years been chiefly responsible for the output of the family shop in the Via Guelfa in Florence. Though he was a faithful follower of his uncle's style, his own personality emerged distinctly in works such as this, with its exceptionally high relief, in which he achieved monumental forms without sacrificing any of that sweetness and harmony of expression for which Luca is so admired. *Gift of Edith and Herbert Lehman Foundation, 1969, 69.113*

3 ANTONIO ROSSELLINO, Florentine, 1427–1479
Madonna and Child with Angels
Marble, with gilt details; 28¾ × 20¼ in. (73 × 51.4 cm)

Antonio Rossellino was trained in Florence in the workshop of his older brother, Bernardo. This Madonna and Child seems to have been carved about 1455–60, before the start of Antonio's first major independent work, the tomb of the cardinal of Portugal in the church of San Miniato, Florence, which he began in 1461. The relief has a certain naïveté in the densely packed surface decoration, which was to be eliminated by subtle changes in his later works. The exacting description of surfaces is extraordinary in sculpture at this or any other time: the halos and the Virgin's hem are picked out in gold, working in conjunction with the carved details, to make the piece wonderfully varied. *Bequest of Benjamin Altman, 1913, 14.40.675*

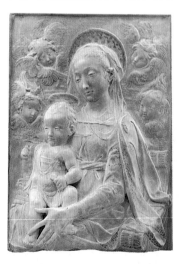

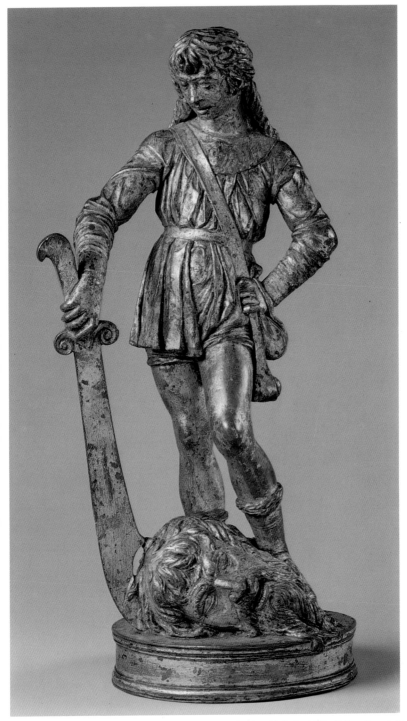

4 BARTOLOMEO BELLANO, Paduan, ca. 1440–1496/97
David with the Head of Goliath
Bronze, partly gilt; h. 11¼ in. (28.6 cm)

Bellano, the son of a Paduan goldsmith, is recorded working with Donatello in Florence in 1456, and a clear point of reference for the swaggering pose of this statuette is Donatello's bronze nude *David* in the Bargello, Florence, probably made in the 1440s. Bellano has clothed his figure and has probably remembered Donatello's from some distance, long after his return to Padua, for the closest parallels to the statuette in Bellano's works are to be found in his highly picturesque bronze reliefs (1484–88) in the choir of Sant'Antonio in Padua. *Gift of C. Ruxton Love Jr., 1964, 64.304.1*

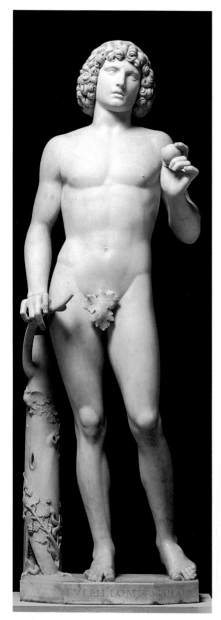

6 ANTONELLO GAGINI, Sicilian, 1478–1536 ▶
Spinario
Bronze; h. 34¼ in. (87 cm)

The *Spinario* (*Boy Removing a Thorn*), datable about 1505, is an early work by Gagini, the leading Sicilian sculptor of his day, who virtually overnight created the Sicilian High Renaissance in sculpture. The original *Spinario*, a famous Hellenistic bronze in the Palazzo dei Conservatori in Rome, was one of the most frequently studied of all antiquities. Copies in many media exist, but no one this early has the size and independent character of Gagini's, which has mellower, more rounded forms than the original and clipped curls instead of a pageboy haircut. *Gift of George and Florence Blumenthal, 1932, 32.121*

7 ANTICO, Mantuan, ca. 1460–d. 1528
Paris
Bronze, partly gilt and silvered; h. 14⅝ in. (37.2 cm)

Pier Jacopo Alari-Bonacolsi received the nickname Antico in acknowledgment of his reverent attitude toward classical antiquity. Most of his statuettes are small-scale replicas of ancient sculptures, but the prototype for his *Paris* has yet to be identified. The youth, holding a ring and an apple, looks as if he is about to choose the goddess Venus over Juno and Minerva, in the scene long familiar as the Judgment of Paris. The elegantly chased small details, smooth brown lacquer, and touches of both gilding (hair, apple) and silvering (eyes) are good indications of why Antico's bronzes are among the most sought-after of all early Renaissance statuettes. *Edith Perry Chapman Fund, 1955, 55.93*

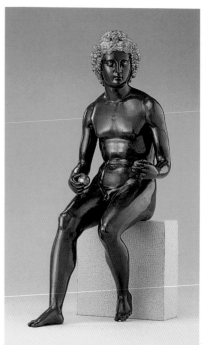

5 TULLIO LOMBARDO, Venetian, ca. 1455–d. 1532
Adam
Marble; h. 75 in. (190.5 cm)

This figure belonged to the most lavish funerary monument of Renaissance Venice, that of Doge Andrea Vendramin, in the church of SS. Giovanni e Paolo. Lombardo is generally credited with the scheme of the monument as a whole (ca. 1490–95). Adam's pose is based on a combination of antique figures of Antinous and Bacchus, interpreted with an almost Attic simplicity. But the meaningful glance, the elegant hands, and the tree trunk are refinements on the antique. Remarkable for the purity of its marble and the smoothness of its carving, *Adam* was the first monumental classical nude to be carved since antiquity. *Fletcher Fund, 1936, 36.163*

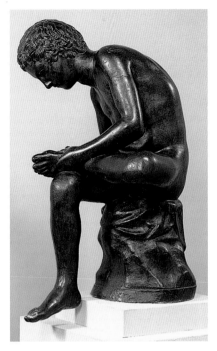

8 ANDREA RICCIO, Paduan, ca. 1470–d. 1532
Satyr
Bronze; h. 14⅛ in. (35.7 cm)

This striding satyr, with its curvilinear contours and masterly control of chasing, was executed about 1507, at the height of Riccio's powers. He had probably just completed his pair of Old Testament bronze reliefs for Sant'Antonio in Padua and had embarked on the model for what was to be his greatest work, the bronze *Paschal Candlestick* in the same church. The candlestick includes satyrs among the many nearly freestanding statuettes in its elaborate decoration. *Rogers, Pfeiffer, Harris Brisbane Dick and Fletcher Funds, 1982, 1982.45*

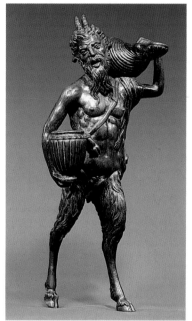

9 SIMONE MOSCA, Florentine (Settignano), 1492–1553
Wall Fountain, 1527–34
Gray sandstone; h. 16 ft. 3 in. (4.95 m)

Conceived in the monumental terms of a triumphal arch, this wall fountain is a richly harmonized balance of mass and ornament in the spirit of the High Renaissance. It comes from Palazzo Fossombroni in Arezzo, which still houses a chimneypiece that Simone Mosca also made for it. A native of Settignano, near Florence, Mosca was involved in several important Central Italian campaigns of decorative stone carving, in the course of which he proved himself adept at picking up the architectural forms and ornamental vocabulary of Antonio da Sangallo the Younger and Michelangelo, notably the latter's work for the Medici Chapel in San Lorenzo, Florence. *Harris Brisbane Dick Fund, 1971, 1971.158*

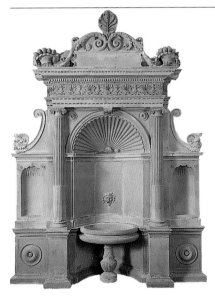

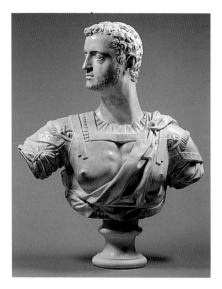

10 BACCIO BANDINELLI, Florentine,
1493–1560
Cosimo I de' Medici (1519–1574), **Duke of
Florence**
Marble; h. 32¼ in. (81.9 cm)

This remarkable bust was carved about 1539–
40, soon after Cosimo's election as head of the
Florentine government and his assumption of
the title of duke. The young ruler's subtly ideal-
ized features are carefully observed, as are his
helmet of dense curls and his sparse, youthful
beard. The portrait's power lies not in its pleas-
ing verisimilitude, however, but in its personifi-
cation of rulership. The powerful torso emerg-
ing from a framework of antique armor might
overwhelm this portrait were it not for the dra-
matic nature of Cosimo's pose. The thrusting
turn of the neck shows a leader ever on the
alert, while the vivid suggestion of arms akimbo
conveys a sense of masterful force. Aggressive
energy cloaked in the trappings of classicism,
which typifies this pugnacious sculptor's style,
illustrates the empathy between the artist and
his newly minted ruler. *Wrightsman Fund, 1987,
1987.280*

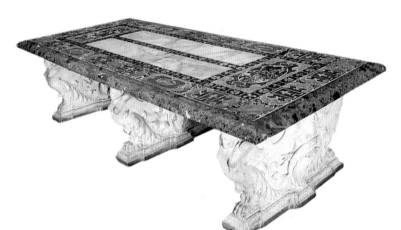

11 The Farnese Table
Roman, ca. 1565–73
*Marble, alabaster, and semiprecious stones;
150 × 66¼ × 37¾ in. (381 × 165.3 × 95.9 cm)*

This monumental and sumptuous table, after a
design by Jacopo Barozzi da Vignola (1507–
1573), proclaims the majesty of the Roman High
Renaissance. Vignola was connected with the
Palazzo Farnese in Rome as both an architect
and a designer; his principal original contribu-
tion was designing the fittings of the rooms of
the state apartment, for which this table was
made. The top of the table is an inlay of various
marbles and semiprecious stones. The two
"windows" in the center are of oriental alabas-
ter, and the piers are of carved marble. The lilies
(fleurs-de-lis) in the decoration of the top are
emblems of the Farnese family; the arms on the
piers are those of Cardinal Alessandro Farnese.
Harris Brisbane Dick Fund, 1957, 58.57

12 GIOVANNI BOLOGNA, Florentine, ▶
1529–1608
Triton
Bronze; h. 36 in. (91.5 cm)

The *Triton* served originally as a fountain figure.
With its supple modeling in bold triangulations
and its brisk, vigorous chasing, especially to be
admired in the hair, this bronze is the earliest
example of the composition to survive and
should be dated to the artist's early maturity in
the 1560s. One example, presumably fairly large
like this one, was cast and sent to France, along
with a cast of Giovanni Bologna's celebrated
Mercury. Known reductions of the *Triton* com-
position show the streamlined simplifications
that mark the majority of the output of bronzes
after Giovanni Bologna's models as they in-
creased in popularity in the course of the
seventeenth century. *Bequest of Benjamin Alt-
man, 1913, 14.40.689*

13 Rearing Horse

Probably Milanese, late 16th–early 17th c.
Bronze; h. 9⅛ in. (23.1 cm)

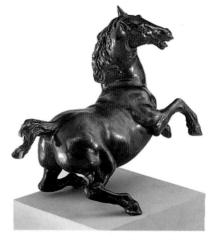

This statuette is thought to be after a model by
Leonardo da Vinci (1452–1519). Leonardo's
longtime experimentations with equestrian
movement included two planned sculptural
monuments in Milan and the *Battle of Anghiari*
fresco in Florence, none of which survives, so
that our knowledge of his intentions is provided
chiefly by his drawings. We know from his
notes, however, that small models were also
part of his preparation. The Milanese sculptor
Leone Leoni (1500–1590), who possessed many
of Leonardo's drawings, also owned a "horse in
sculptural relief" said to be by Leonardo. Leoni
may be the author of the bronze statuette of a
horse and rider in Budapest which is based on
Leonardo; the horse is nearly identical in pose
to the Museum's statuette. The Budapest work
is fractionally larger and has greater force than
the present bronze. The Museum's statuette
may also have been cast in Milan but at a
slightly later date. *Rogers Fund, 1925, 25.74*

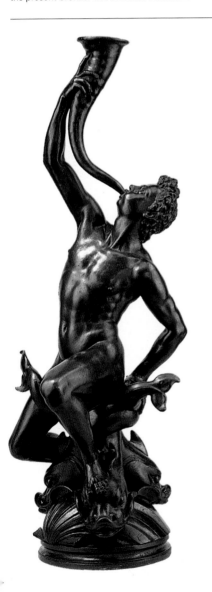

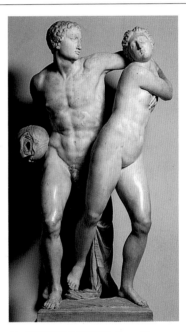

14 BATTISTA LORENZI, Florentine, 1527/28–1594

Alpheus and Arethusa

Marble; h. 58½ in. (148.6 cm)

This work, Battista Lorenzi's masterpiece, illus-
trates a tale from Ovid. The wood nymph
Arethusa, pursued by the river god Alpheus, im-
plored the goddess Diana to save her. Hearing
her chaste plea, Diana quickly hid her in a cloud
of mist and later transformed her into a foun-
tain. Lorenzi's group (carved in Florence about
1570–80) shows Arethusa being overtaken by
the river god. It was erected in a grotto at the
Villa Il Paradiso, belonging to Alamanno Ban-
dini, sometime before 1584, when Raffaello
Borghini mentioned it in his *Il Riposo*. The
grotto combined water, statuary, and a theatrical
setting in a lively manner that anticipated the
Baroque. *Fletcher Fund, 1940, 40.33*

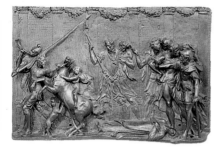

15 TIZIANO ASPETTI, Venetian, 1565–1608
**Saint Daniel Being Dragged Before the
Governor of Padua**
Bronze; 19 × 29¼ in. (48.3 × 74.3 cm)

The Counter-Reformation in Italy saw an
increase in the literal depictions of the martyr-
doms of saints. Here the spectacle of Saint
Daniel being dragged by a horse is presented
with the full repertory of classical and Renais-
sance poses and gestures. This relief is one of a
pair that originally adorned the altar of the saint,
commissioned in 1592, in the cathedral of
Padua. *Edith Perry Chapman and Fletcher Funds,
1970, 1970.264.1*

16 GIAN LORENZO BERNINI, Roman,
1598–1680
Bacchanal: A Faun Teased by Children
Marble; h. 52 in. (132.1 cm)

A prodigy of astonishing facility, the young Ber-
nini was trained in the workshop of his father,
Pietro, an important pre-Baroque sculptor. Dur-
ing this apprenticeship he executed a number
of marble sculptures, which were recorded in
his father's name. The present group is the most
ambitious of these works and provides insights
into the crucial shift in style that took place dur-
ing the early seventeenth century. The subject is
a somewhat mysterious one, having its origins,
but no precise analogue, in the Bacchic revels
of classical and Renaissance iconography. In his
portrayal of the faun, Bernini revealed what
would become a lifelong interest in the render-
ing of emotional and spiritual exaltation.
*Purchase, The Annenberg Fund, Inc. Gift,
Fletcher, Rogers, and Louis V. Bell Funds, and
Gift of J. Pierpont Morgan, by exchange, 1976,
1976.92*

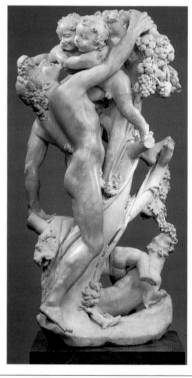

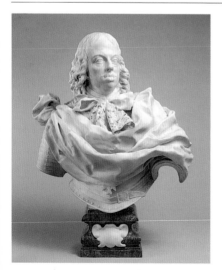

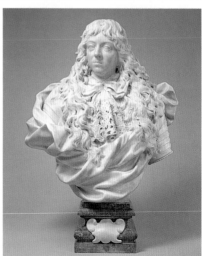

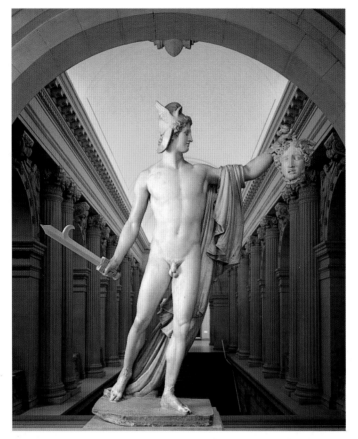

17 ANTONIO CANOVA, Roman, 1757–1822
Perseus with the Head of Medusa
Marble; h. 86 ⅝ in. (220 cm)

Among the art treasures removed from Italy to
France by Napoleon's army was the antique Vat-
ican *Apollo Belvedere*. Between 1790 and 1800
Canova executed the first version of his *Perseus,*
based on the *Apollo*. Perseus is shown carrying
the head of Medusa, whom he has slain with
the help of the goddess Athena. When the
sculpture was exhibited in Canova's studio, it
was acclaimed as the last word in the continu-
ing purification of the Neoclassical style, and it
was bought by Pius VII to replace the *Apollo
Belvedere*. In 1804 a Polish countess commis-
sioned another *Perseus,* the one shown here.
This work, with refinements that perfect the first
version, was completed about 1808. *Fletcher
Fund, 1967, 67.110*

18 GIOVANNI BATTISTA FOGGINI,
Florentine, 1652–1725
Grand Duke Cosimo III de' Medici
Grand Prince Ferdinando de' Medici
Marble; each: h. including base 39 in. (99.1 cm)

Owing to a period of training in Rome, Foggini
was influenced by Bernini's ruler portraits (Fran-
cesco d'Este, 1650–51, and Louis XIV, 1665),
but in this pair he achieved sensations of flesh
and blood and of a rippling, opulent materiality
that are all his own. With their vibrant contrasts
of compositional and psychological elements,
these sculptures constitute his finest moment in
portraiture. They may have had the dynastic
purpose of promoting marriage, as Foggini
made them in about 1683 to 1685, when
Cosimo III (1642–1723) was pressing his son
Ferdinando (1663–1713) to take a wife. He did
so in 1689, marrying Princess Violante of
Bavaria, but the union did not produce an heir,
and Ferdinando predeceased his father by ten
years. *Purchase, The Annenberg Foundation
Gift, 1993, 1993.332.1, 2*

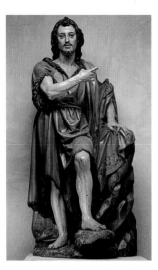

19 JUAN MARTÍNEZ MONTAÑÉS, Spanish, 1568–1649
Saint John the Baptist
Gilt and polychromed wood; h. 61 in. (155 cm)

Montañés was a native of Seville, where he was known as *El Dios de la Madera* for his many retables which populate the churches with magnificently polychromed wood figures. This figure, which dates from about 1625–35, came from the convent of Nuestra Señora de la Concepción. It has for its compositional precedent Montañés's own *Baptist* of the main altar in San Isidoro del Campo at Santiponce, made between 1609 and 1613. The Museum's *Baptist* is, however, a fuller and more emotionally charged figure. In fact, it has been called Montañés's most beautiful single figure. Its austere expression, solid corporeality, and sharp colors give a disquietingly urgent impression of actuality and conviction. *Purchase, Joseph Pulitzer Bequest, 1963, 63.40*

20 PIERRE ÉTIENNE MONNOT, French, 1657–1733
Andromeda and the Sea Monster
Marble; h. 61 in. (154.9 cm)

When John Cecil, fifth earl of Exeter, commissioned this sculpture in Rome, he chose not an Italian but one of the French artists who dominated the field of Roman monumental sculpture at the time. Monnot shows Andromeda chained to a rock, lifting an imploring gaze heavenward, with the monster emerging from the waves. This coolly poised work of 1700, with its brilliant carving and psychological dissolution of spatial bounds, is a vivid example of the late Baroque in Rome. *Purchase, Josephine Bay Paul and C. Michael Paul Foundation Inc. and Charles Ulrick and Josephine Bay Foundation Inc. Gifts, 1967, 67.34*

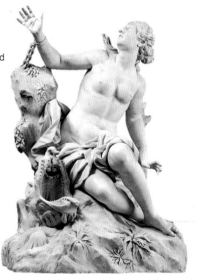

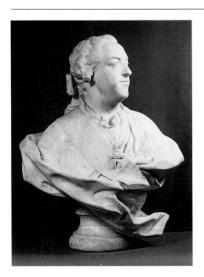

21 JEAN BAPTISTE LEMOYNE, French, 1704–1778
Bust of Louis XV
Marble; h. including socle 34¼ in. (87 cm)

Lemoyne was the favorite sculptor of Louis XV, and for forty years he held a virtual monopoly on recording the benign royal features. He made a number of portrait busts of the king; many were destroyed during the French Revolution, as were Lemoyne's equestrian statues of the king in Bordeaux and Rennes. The Museum's bust is dated 1757, when Louis XV was forty-seven years old. *Gift of George Blumenthal, 1941, 41.100.244*

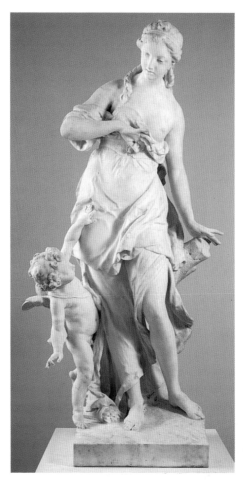

22 JEAN LOUIS LEMOYNE, French,
1665–1755
Fear of Cupid's Darts
Marble; h. 72 in. (182.9 cm)

In this lightly erotic group, a nymph reacts with
a startled, self-protective gesture to the sudden
appearance of Cupid, who is about to cast an
arrow into her breast. The technique, in which the
marble seems touched with flickering light, and
the delicately off-balance pose are typically
Rococo. Commissioned for Louis XV, this group
was completed in 1739–40. *Purchase, Josephine
Bay Paul and C. Michael Paul Foundation Inc.
and Charles Ulrick and Josephine Bay Founda-
tion Inc. Gifts, 1967, 67.197*

23 JEAN ANTOINE HOUDON, French,
1741–1828
Bust of Diderot
Marble; h. including socle 20 ½ in. (52 cm)

Houdon made over 150 portrait busts of the
great men and women of his age. He combined
psychological perception with analytical realism
to bring out the individual character of each sit-
ter. Houdon executed a number of busts of the
much-admired Denis Diderot—this one of 1773
was made for a Russian count—and of other
leading Encyclopedists, such as d'Alembert,
Rousseau, and Voltaire, which are masterpieces
of portrait sculpture. *Gift of Mr. and Mrs. Charles
Wrightsman, 1974, 1974.291*

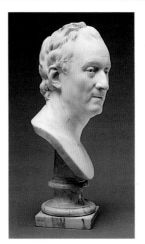

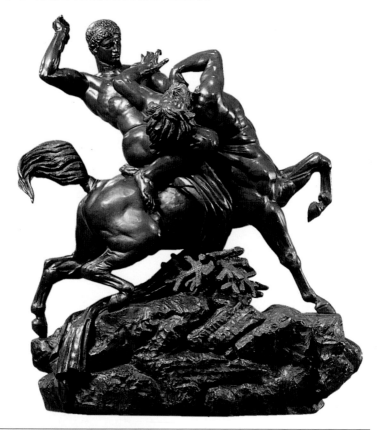

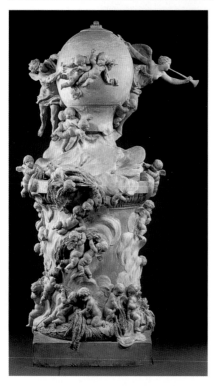

25 CLAUDE MICHEL (called CLODION),
French, 1738–1814
Balloon Monument
Terracotta; h. 43½ in. (11.5 cm)

This whimsical model for a monument that was never built celebrates the 1783 invention of the lighter-than-air balloon, a triumph over gravity not easily demonstrated in the earthbound art of sculpture. Clodion evoked the insubstantial by juxtaposing allegory and the real: above, Aeolus, puffy-cheeked god of wind, guides the flight of the ascending balloon while Fame trumpets the great advance; below, hordes of putti haul sheaves of brittle straw, feeding the creamy clouds of smoke that swirl the balloon aloft (the Montgolfier brothers' actual hot-air technique). Clodion had achieved great popularity producing intimate terracotta evocations of rollicksome arcadian life. While it is difficult to imagine a stone monument that could have captured the charm of this version, which exploits the contrasting tones and textures of malleable clay, it is precisely the sculptor's mastery of the sketchy medium that makes his model a fully achieved work of art. *Rogers Fund and Rear Admiral Frederic R. Harris Gift, 1944, 44.21ab*

24 ANTOINE-LOUIS BARYE, French, 1796–1875
Theseus Fighting the Centaur Bianor
Bronze; h. 50 in. (127 cm)

While better known for his animal sculpture, Barye based a number of his works on classical subjects. The subject of this one is an episode from the battle between the Lapiths and Centaurs described in Book XII of Ovid's *Metamorphoses*. This bronze is reminiscent of antique sculptural representations of the Lapiths and Centaurs, for the sculptor must have known the metopes from the Parthenon, at least in reproduction. But the *Theseus,* first modeled in 1849, also reflects the underlying Romanticism of Barye's vision. Like many Romantic artists who were his contemporaries, Barye was fascinated by the primal energy of the animal world, the violence of combat, and the elemental struggle for survival, here embodied in the death struggle of the half-animal, half-human centaur with the Greek hero Theseus. *Gift of Samuel P. Avery, 1885, 85.3*

26 JEAN-BAPTISTE CARPEAUX, French, 1827–1875
Ugolino and His Sons
Marble; h. 77 in. (195.6 cm)

The subject of this intensely Romantic work is derived from canto XXXIII of Dante's *Inferno,* which describes how the Pisan traitor Count Ugolino della Gherardesca, his sons, and his grandsons were imprisoned in 1288 and died of starvation. Carpeaux's visionary statue, executed in 1865–67, reflects his passionate reverence for Michelangelo, specifically for the *Last Judgment* of the Sistine Chapel in Rome,as well as his own painstaking concern with anatomical realism. *Purchase, Josephine Bay Paul and C. Michael Paul Foundation Inc. and Charles Ulrick and Josephine Bay Foundation Inc. Gifts, 1967, 67.250*

27 EDGAR DEGAS, French, 1834–1917
Little Fourteen-Year-Old Dancer
Bronze and muslin; h. 39 in. (99.1 cm)

In the taut adolescent body of the little dancer, Degas has captured the mannered but still slightly awkward stance of the aspiring ballerina. The original work was modeled in wax about 1880–81; its realism was heightened by the addition of ballet shoes, a bodice overlaid with a thin layer of wax, a tutu of muslin, and a horsehair wig tied behind with silk ribbon. The Museum's bronze was cast in 1921; the tinted bodice and slippers, augmented by a muslin skirt and silk hair ribbon, skillfully evoke the materials of the original sculpture. (See also Drawings and Prints, no. 22; European Paintings, nos. 141–43; and Robert Lehman Collection, no. 39.) *H. O. Havemeyer Collection, Bequest of Mrs. H. O. Havemeyer, 1929, 29.100.370*

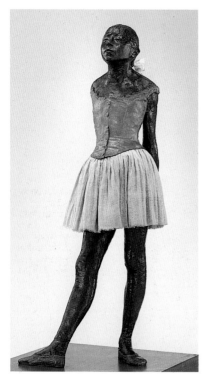

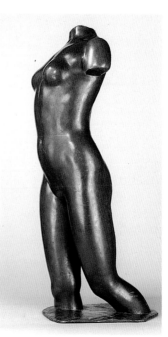

28 ARISTIDE MAILLOL, French, 1861–1944
Torso of Île-de-France
Bronze; h. 42⅜ in. (107.5 cm)

Maillol was primarily interested in representing the formal structure of the human figure, but he never ventured into the avant-garde world of abstraction. While influenced by Greek sculpture of the early fifth century B.C., Maillol's female nudes are often recognizable as modern French women. Three versions of this torso were made between 1910 and 1921; this one is believed to be the second. *Edith Perry Chapman Fund, 1951; Acquired from The Museum of Modern Art, Gift of A. Conger Goodyear, 53.140.9*

29 AUGUSTE RODIN, French, 1840–1917
Adam
Bronze; h. 76¼ in. (193.7 cm)

Adam shows the first man being roused to life slowly and with difficulty. Like Carpeaux (no. 26), Rodin drew upon Michelangelo's Sistine Chapel frescoes as a direct source of inspiration. In his *Adam* he combined elements from the *Creation of Man* in the Sistine Chapel and from the Christ of Michelangelo's *Pietà* in the Duomo in Florence. *Adam* was modeled originally in 1880, and for a time Rodin intended to incorporate the figure into his design for *The Gates of Hell*, the portal planned for a building in Paris that was never constructed. In 1910 the Museum commissioned this bronze from Rodin. *Gift of Thomas F. Ryan, 1910, 11.173.1*

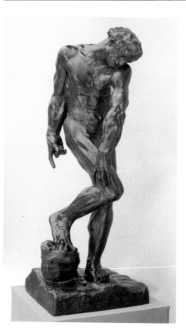

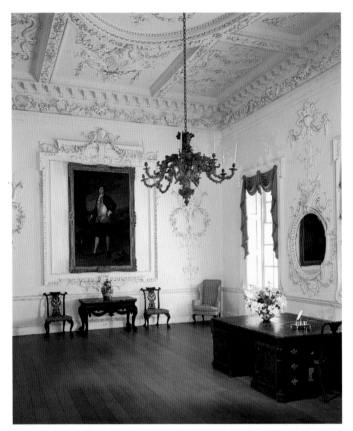

30 Room from Kirtlington Park
English, 1742–48
Wood, plaster, and marble; h. 20 ft. (6.09 m), l. 36 ft. (10.97 m), w. 24 ft. (7.32 m)

Kirtlington Park, near Oxford, was built for Sir James Dashwood between 1742 and 1746 by William Smith and John Sanderson; the park was laid out by Lancelot ("Capability") Brown. This room, originally used for dining, has its original overmantel painting by John Wooton, dated 1748. The spirited plaster decoration was designed by Sanderson and executed by an Oxford stucco-worker; the central panels at the four sides of the ceiling depict the seasons. The richly carved chimneypiece is of marble, the mahogany doors and shutters are equipped with their original gilt-bronze hardware, and the oak floor is also original. *Fletcher Fund, 1931, 32.53.1*

31 WILLIAM VILE, British, d. 1767
Coin Cabinet
Mahogany; 79 × 27 × 17¼ in. (200.7 × 68.6 × 43.8 cm)

William Vile and his partner, John Cobb, created some of the finest pieces of English court furniture in the eighteenth century. Commissioned in 1758 by the Prince of Wales (later George III), this cabinet was completed in 1761. In all likelihood it was an end section of a tripartite piece of furniture. The other end section is in the Victoria and Albert Museum, London; the middle section, if it exists, has not been identified. There are 135 shallow drawers for coins and medals, allowing space for over six thousand items from the king's collection. The top door is carved with the star of the Order of the Garter, to which the Prince of Wales was elected in 1750. *Fletcher Fund, 1964, 64.79*

32 Tapestry Room from Croome Court
English, 1760–71
Wood, plaster, and tapestry; h. 13 ft. 10¾ in. (4.23 m), l. 27 ft. 1 in. (8.27 m), w. 22 ft. 8 in. (6.9 m)

Robert Adam designed the Tapestry Room and other interior architecture after he replaced Lancelot ("Capability") Brown as architect to the sixth earl of Coventry, whose country seat was Croome Court, near Worcester. Designed in 1763, the ceiling of this room, with its orna-mented wheel molding and garlanded trophies, is an example of Adam's vigorous early style.

The tapestries on the walls and on the seat furniture were woven at the Royal Gobelins Manufactory, Paris, in the workshop of Jacques Neilson. The medallions after designs by François Boucher portray scenes from classical myths symbolizing the elements. The borders were designed by Maurice Jacques. Commissioned in 1763, these tapestries were installed in 1771. (See also no. 62.) *Gift of Samuel H. Kress Foundation, 1958, 58.75.1a*

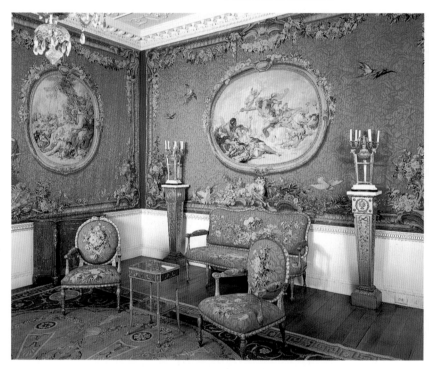

33 Commode
English, ca. 1770–80
Satinwood, tulipwood, and other marquetry woods on oak with inlay of ivory; 37 × 59⅞ × 25⅜ in. (94 × 152 × 64.4 cm)

The ornamental chests of drawers known as commodes originated in France in the late seventeenth century. In this piece each of the three doors opens upon a bank of four drawers, and the frieze is fitted with three drawers. The classical urns depicted in the marquetry on the sides and the floral garlands on the front resemble motifs that appear on a commode attributed to Thomas Chippendale, dated 1770, at Nostell Priory, Yorkshire. *Purchase, Morris Loeb Bequest, 1955, 55.114*

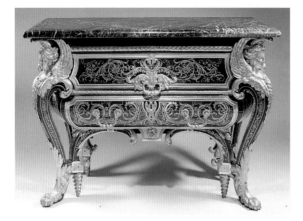

34 ANDRÉ CHARLES BOULLE, French, 1642–1732
Commode
Walnut veneered with ebony and marquetry of engraved brass, inlaid on a tortoiseshell ground; gilt-bronze mounts; verd antique marble top; h. 34½ in. (87.6 cm)

In 1708 André Charles Boulle, the most celebrated cabinetmaker of Louis XIV's reign, executed two "bureaux," or commodes, for the bedroom of Louis XIV at the Palais de Trianon (known today as the Grand Trianon). A new invention in the history of furniture, the Trianon bureaus were a combination of the table and the newly emerging commode, with two drawers fitted under the top in a shape influenced by the Roman sarcophagus and by Jean Berain's engraved designs for bureaus. The drawers in Boulle's model required four extra tapered scroll legs for support. The commode became one of the most frequently repeated pieces of French eighteenth-century furniture. This example appears to be an early version (ca. 1710–32) made in Boulle's workshop. *The Jack and Belle Linsky Collection, 1982, 1982.60.82*

35 Dining Room from Lansdowne House
English, 1765–68
Wood, plaster, and stone; h. 17 ft. 11 in. (5.46 m), l. 47 ft. (14.31 m), w. 24 ft. 6 in. (7.47 m)

Robert Adam's refined style is seen in this room from Lansdowne House, the London residence of Lord Shelburne (later the marquess of Lansdowne). The feathery arabesques of griffins and putti, vases and trophies of arms, leaf garlands, sprays, rosettes, Vitruvian scrolls, and fan-shaped motifs are cast in plaster and constitute one of the glories of this room. The niches originally contained antique sculptures from Lord Lansdowne's collection, one of which, *Tyche,* still remains; the eight other niches hold plaster casts of Roman statues. The oak floor of the room is original. *Rogers Fund, 1931, 32.12*

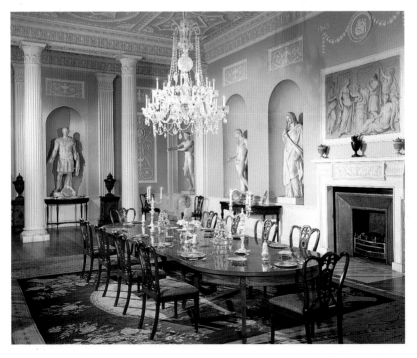

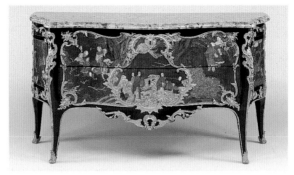

36 BERNARD VANRISAMBURGH II, French, act. ca. 1730–64
Commode
Coromandel lacquer and ebony on oak; marble top; 34 × 63 × 25¼ in. (86.4 × 160 × 64.1 cm)

Vanrisamburgh was one of the great masters of the fully developed Louis XV style in furniture. In this commode, which was made about 1745, he skillfully veneered the curving front and sides with colorful panels from an incised Coromandel lacquer screen. This type of lacquer derived its name from the Coromandel coast in southeast India. In the late seventeenth and eighteenth centuries merchant ships stopped at ports along this coast to pick up goods exported from China (such as the screen used in this commode). The front panel of the commode has scattered groups of oriental figures. Typically for the period, they are arranged without regard to perspective. The side panels represent fantastic animals and are, like the front, set within gilt-bronze Rococo mounts of exceptional vitality and inventiveness. *The Lesley and Emma Sheafer Collection, Bequest of Emma A. Sheafer, 1973, 1974.356.189*

37 Armoire
French, Paris, 1867
Oak veneered with cedar, ivory, and marquetry woods; silvered-bronze mounts; 93¾ × 59½ × 23⅝ in. (238 × 151 × 60 cm)

Evoking a legendary past, this impressive "Merovingian" armoire was the result of a collaborative effort by the industrial designer Jean Brandely, the cabinetmaker Charles-Guillaume Diehl, and the sculptor Emmanuel Frémiet. The central plaque depicts the victory of the troops of King Merovech over the forces of Attila the Hun in 451. The silver relief and the mounts were created by Frémiet, who was known for his vivid representations of animals. The prototype, a medal cabinet made for the Paris Exposition Universelle of 1867, is in the Musée d'Orsay, Paris. *Purchase, Mr. and Mrs. Frank E. Richardson Gift, 1989, 1989.197*

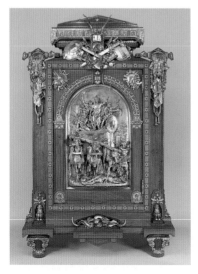

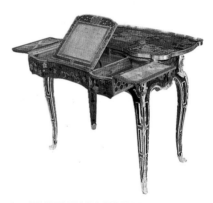

38 JEAN FRANÇOIS OEBEN, French, ca. 1721–1763
Writing Table
Oak veneered with mahogany, kingwood, tulipwood, and marquetry woods; gilt-bronze mounts; h. 27½ in. (69.8 cm)

Long recognized as one of Jean François Oeben's masterpieces, this table (ca. 1761–63) was made for his frequent and most important client, Mme de Pompadour (the main charge of her coat of arms, a tower, appears at the top of the gilt-bronze mount at each corner). The marquetry of the top—one of the finest panels in all of Oeben's furniture—was designed to reflect her interest in the arts and depicts a vase of flowers as well as trophies emblematic of architecture, painting, music, and gardening. The table demonstrates Oeben's talents not only as a creator of beautiful furniture, but also as a mechanic, since an elaborate mechanism allows the top to slide back at the same time as the large drawer moves forward, thereby doubling the surface area. *The Jack and Belle Linsky Collection, 1982, 1982.60.61*

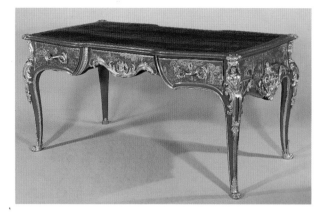

39 GILLES JOUBERT,
French, ca. 1689–d. 1775
Writing Table
Oak with red japanning, gilt bronze; 31½ × 69¼ × 36 in. (80.7 × 175.9 × 91.4 cm)

This piece is documented by the number 2131, which is painted on its underside. It is identified under that number in the *Journal du Garde-Meuble,* the royal furniture registry, as the desk delivered by Joubert on December 29, 1759, for use by Louis XV in the *cabinet intérieur,* his favorite study at Versailles. Louis XV was surely consulted about the design and execution of this splendid red japanned writing table, which can thus be understood as an expression of the king's personal taste. *Gift of Mr. and Mrs. Charles Wrightsman, 1973, 1973.315.1*

40 Grand Salon from the Hôtel de Tessé
French, 1768–72
Carved, painted, and gilded oak; h. 16 ft. (4.88 m), l. 33 ft. 7½ in. (10.25 m), w. 29 ft. 6½ in. (9 m)

The noble grace of the Louis XVI style is exemplified by the *grand salon* from the Hôtel de Tessé (the building still stands at no. 1, Quai Voltaire, Paris). The mansion was built in 1765–68 for Marie Charlotte de Béthune-Charost, comtesse de Tessé; the plans are attributed to the architect Pierre Noël Rousset. The interior decoration was probably completed in 1772, when final payment was made to the architect and contractor Louis Letellier.

Each of the four double doors is surmounted by a stucco relief of a pair of children holding a medallion of a dancing maiden. The four arched mirror surrounds contribute to the serenely Neoclassical effect of the room. *Gift of Mrs. Herbert N. Straus, 1942, 42.203.1*

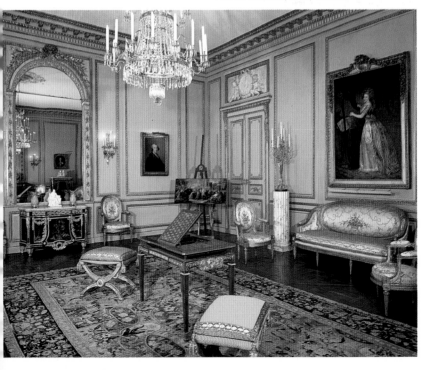

41 Shopfront from No. 3, Quai Bourbon, Paris
French, ca. 1775
Carved oak; 13 ft. 1 in. × 20 ft. 4 in. (3.99 × 6.24 m)

This Parisian shopfront, from the north bank of the Île Saint-Louis, stood on a site favorable to commerce, close to the junction of the Quai Bourbon and the Pont Marie, an early-seventeenth-century bridge over the Seine. It was superimposed on the masonry of an existing seventeenth-century building, the modest outlines of which can still be seen. Chroniclers of late-nineteenth- and early-twentieth-century Paris drew attention to the charm and rarity of this isolated little shopfront, which was thought to be the only surviving eighteenth-century example in the city. By the time it was dismantled in World War I, the original painted surface had weathered to the bare oak and the woodwork had suffered some losses. When the shopfront was restored at the Museum, the natural tone of the wood was retained. The missing elements were supplied in accordance with a measured drawing of the shopfront published in 1870. *Gift of J. P. Morgan, 1920, 20.154*

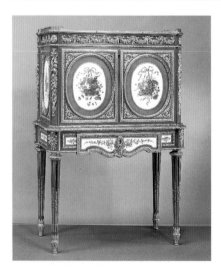

42 MARTIN CARLIN, French, act. 1766–85
Upright Secretary
Oak veneered with tulipwood and purplewood; porcelain plaques; white marble top; 47 × 31¾ × 14¾ in. (119.4 × 80.6 × 37.5 cm)

This upright secretary with a fall front (*secrétaire à abattant*), signed by Carlin, is decorated with ten plaques of Sèvres porcelain. The veneered and marquetried wood surfaces of such pieces of furniture have faded over the years, but the porcelain plaques have retained their original brilliant coloration. These plaques have apple-green borders, and their white reserves are painted with naturalistic floral subjects, including baskets heaped with blooms and suspended from blue and violet ribbons. The plaques bear the date letter for 1773 and the designations of three flower painters (Xhrouet, Bulidon, and Noël). The chasing and gilding of the bronze mounts are of very high quality, contributing to the effect of rich ornamentation. *Gift of Samuel H. Kress Foundation, 1958, 58.75.44*

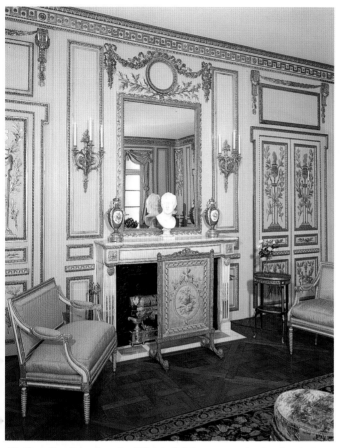

43 Reception Room from the Hôtel de Cabris
French, 1775–78
Carved, painted, and gilded oak; h. 11 ft.
8½ in. (3.57 m), l. 25 ft. 6 in. (7.77 m),
w. 13 ft. 11 in. (4.24 m)

The Hôtel de Cabris in Grasse, from which this room was taken, is now the Musée Fragonard. It was built between 1771 and 1774 for Jean Paul de Clapiers, marquis de Cabris, after designs by a little-known Milanese architect, Giovanni Orello.

The paneling, dating from 1775–78, was carved, painted, and gilded in Paris and was installed in a small reception room on the main floor. The four pairs of double doors are remarkable for the carved motifs of smoking incense burners, interlaced laurel sprays, and torches; this decoration exemplifies the sobriety of the Neoclassical style. The white marble chimney-piece, contemporary with the room, comes from the Hôtel de Greffulhe in Paris. *Purchase, Mr. and Mrs. Charles Wrightsman Gift, 1972, 1972.276.1,2*

44 GEORGES JACOB, French, 1739–1814
Armchair
Gilded walnut and embroidered satin;
40¼ × 29½ × 30⅝ in. (102.2 × 74.9 × 77.8 cm)

The Museum has a set of two armchairs (*fauteuils à la reine*) and two side chairs (*chaises courantes*) that were made about 1780 by Jacob; one of the armchairs is illustrated here. The carved and gilded frames show the extreme finesse of the woodcarver's technique. The pieces are upholstered in white silk satin embroidered with colored silks; the design is in the style of Philippe de la Salle, the most prominent designer of woven silk fabrics of the period. *Gift of Samuel H. Kress Foundation, 1958, 58.75.26*

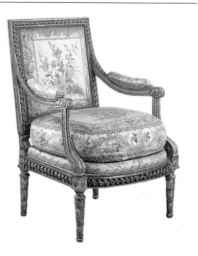

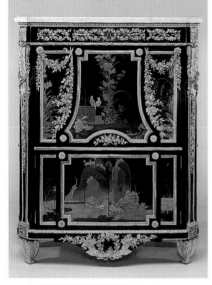

45 JEAN HENRI RIESENER, French,
1734–1806
Upright Secretary
*Japanese black-and-gold lacquer and ebony,
veneered on oak; white marble top; gilt-bronze
mounts; 57 × 43 × 16 in. (144.8 × 109.2 ×
40.5 cm)*

This secretary and its companion commode,
also in the Museum, stood in Marie Antoinette's
private apartment at the Château de Saint-
Cloud; her initials appear three times in the gilt-
bronze frieze under the marble top. The opulent
refinement of this secretary, made in 1783–87, is
a direct response of the maker, Riesener, to the
taste of his royal client. Cascading down the
front are exquisitely chased gilt-bronze flowers,
while fruits, wheat, flowers, and symbols of
princely glory spill from the cornucopia mounts
along the lower edge. The black-and-gold
panels of Japanese lacquer reflect the queen's
fondness for this material. *Bequest of William K.
Vanderbilt, 1920, 20.155.11*

46 Coin Cabinet
French, ca. 1805
*Mahogany with silver inlay and silver mounts;
35½ × 19¾ × 14¾ in. (90.2 × 50.2 × 37.5 cm)*

This cabinet is part of a set of furniture deco-
rated with Egyptian figures, including a bed and
a pair of armchairs, commissioned by Domi-
nique Vivant Denon (1747–1825). The Parisian
cabinetmaker Jacob-Desmalter executed the
cabinet after a design by Charles Percier (1764–
1838), probably suggested by Denon, and incor-
porated mounts by Martin Guillaume Biennais
(1764–1843), whose workshop produced much
of the best Empire silver and gilt bronze. The
upper part of the cabinet is derived from the
pylon at Apollonopolis (Ghoos) in Upper Egypt,
which Denon saw while accompanying Napo-
leon's Egyptian campaign of 1798–99 and which
is illustrated in his *Voyage dans la Basse et la
Haute Égypte* (Paris, 1802). *Bequest of Collis P.
Huntington, 1925, 26.168.77*

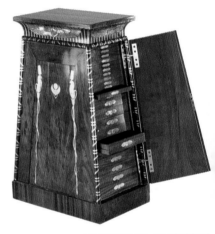

47 Corner Settee
German, 1766
*Carved, painted, and gilded pine;
43 × 54½ × 25¼ in. (109.2 × 138.4 × 63.7 cm)*

The Rococo style in Germany was based on
French prototypes and enriched by the native
Baroque traditions. Fantasy seems to play over
this extraordinary piece, made in Würzburg in
1766. It is part of a set of four side chairs, two
armchairs, and two settees made by the cabi-
netmaker Johann Köhler for Seehof Castle, near
Bamberg. *The Lesley and Emma Sheafer Collec-
tion, Bequest of Emma A. Sheafer, 1973,
1974.356.121*

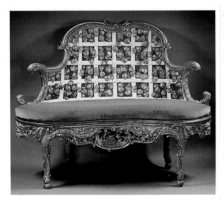

48 DAVID ROENTGEN, German, 1743–1807
Commode
Oak and pine veneered with tulipwood, syc-
amore, boxwood, purplewood, pearwood,
harewood, and other woods; drawer linings of
mahogany; gilt-bronze mounts; red brocatelle
marble top; h. 35¼ in. (89.5 cm)

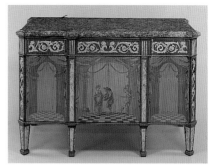

Branded twice on the back with the mark of the
Château de Versailles (a double V beneath a
crown), this commode is recorded in a 1792 in-
ventory as standing in Louis XVI's private
apartments. Roentgen, who became the most
successful cabinetmaker of the eighteenth cen-
tury, also supplied large quantities of furniture
for Catherine the Great and had workshops in
Vienna and Naples as well as in Paris and
Neuwied—home of his first shop. His exquisite
pictorial marquetry and intricate mechanical de-
vices, such as elaborate locks and concealed
buttons to open doors and drawers, appealed to
collectors who could afford his high prices.
Roentgen's flourishing career, however, was ef-
fectively ended by the Revolution, when his
Neuwied workshop was destroyed.

The three marquetry scenes on the front of
this fine example of Roentgen's work depict the-
atrical stages: those on the side are empty; that
in the center is occupied by three figures from
the commedia dell'arte—Pantaloon, his daugh-
ter Isabella, and Harlequin. *The Jack and Belle
Linsky Collection, 1982, 1982.60.81*

49 Patio from Vélez Blanco
Spanish, 1506–15
Marble; h. 63 ft. (19.5 m), l. 44 ft. (13.41 m),
w. 33 ft. (10.59 m)

The richly carved Renaissance patio from the
castle at Vélez Blanco, near Almería, is a jewel
of Spanish and Italian architecture of the early
sixteenth century. Its fundamental structure re-
flects the strongly Spanish, conservative taste of
its architect in the asymmetrical layout, the use
of Gothic gargoyles, the flat-timbered ceilings of
the galleries, and the low, segmental arches. Yet
the decorative details of the carved ornament
are composed of Italian Renaissance motifs and
were executed by carvers from northern Italy. A
sumptuous array of fanciful flora and fauna ap-
pears on the spandrels and intrados of the
arches, on the piers of the balustrade, and espe-
cially around the doors and windows. For all
their elaboration, the motifs preserve the con-
trolled clarity of form and organization, the vivid
naturalism, and the bold three-dimensional
quality characteristic of the early Italian Renais-
sance style. *Bequest of George Blumenthal,
1941, 41.190.482*

50 Studiolo from the Palace of Duke Federico da Montefeltro at Gubbio

Italian, ca. 1477–83

Intarsia of walnut, beech, rosewood, oak, and fruitwoods on walnut base; h. 15 ft. 11 in. (4.85 m), l. 17 ft. (5.18 m), w. 12 ft. 7 in. (3.84 m)

This is a detail from a small room (studiolo) intended for meditation and study, which was commissioned by the powerful condottiere Duke Federico da Montefeltro (1422–1482) for his palace at Gubbio. The studiolo's panels are dazzling examples of an inlay technique known as intarsia. Here thousands of pieces of different varieties of wood were used to create extraordinarily realistic depictions of objects associated with Duke Federico. Armor and insignia allude to his prowess as a warrior and a wise ruler, and musical and scientific instruments and books attest to his love of learning. The great interest in linear perspective at that time is evident throughout. The studiolo is a glorious Renaissance interior, rivaled only by a slightly earlier room of the same type commissioned by the duke for his palace at Urbino, where it remains. *Rogers Fund, 1939, 39.153*

51 FRA DAMIANO DA BERGAMO,
Bolognese, ca. 1480–d. 1549
The Last Supper
Walnut, inlaid with various woods; 60³/₄ x 40⁷/₈ in. (154.3 x 103.7 cm)

This altarpiece (1547–48) was signed by Fra Damiano da Bergamo, whose workshop was at the convent of San Domenico in Bologna; it was designed by Jacopo Barozzi da Vignola (1507–1573). The heavy proportions of the architectural elements and the effects of depth, mass, and "surprise" are paralleled in the facade of a palazzo in Bologna that Vignola designed in 1545 for the humanist Achille Bocchi. This altarpiece was commissioned by Claude d'Urfé, the French ambassador to the Council of Trent. It was installed in the chapel of La Bastie d'Urfé, his château near Lyons. *Gift of the children of Mrs. Harry Payne Whitney, 1942, 42.57.4.108*

52 Cabinet
Florentine, ca. 1615–23
Various exotic hardwoods, veneered on oak, with ebony moldings; plaques of marble, slate, and hardstones; pietra dura *work of colored marbles, rock crystal, and various hardstones; 23 ¹/₄ × 38 ¹/₈ × 14 ¹/₈ in. (59 × 96.8 × 35.7cm)*

In the late sixteenth and early seventeenth centuries the chief center for Florentine, or *pietra dura* (hand stone), mosaic was the court workshop of the grand dukes of Tuscany. Tabletops and plaques for mounting in cabinets, made of marbles and hardstones cut, polished, and inlaid in various designs, were a specialty of the workshop. The most admired products, however, were landscapes and scenes with figures, such as those found on this cabinet, in which the court artists exploited colors and patterns in the stone to create naturalistic effects. The largest panel on the front of this cabinet depicts Orpheus; six of the other panels are taken from woodcuts in Francesco Tuppo's edition of Aesop's *Fables* (Naples, 1485). The cabinet was probably made for Maffeo Barberini (1568–1644), later Pope Urban VIII, in the years immediately preceding his elevation to the papacy in 1623, as the coat of arms on the pediment of the door on the front of the cabinet suggests. *Wrightsman Fund, 1988, 1988.19*

53 Bedroom from the Palazzo Sagredo
Venetian, ca. 1718
Wood, stucco, marble, glass; h. 13 ft. (3.96 m)

In design and workmanship this bedroom, consisting of an antechamber with a bed alcove, is one of the finest of its period in existence. The decoration is partly in stucco, partly in carved wood. In the antechamber fluted Corinthian pilasters support an entablature out of which *amorini* fly, bearing garlands of flowers. Other *amorini* bear the gilded frame of a painting by Gasparo Diziani, which depicts Dawn triumphant over Night. Above the entry to the alcove seven *amorini* frolic. Around the room runs a paneled wood dado with a red-and-white marble base. The unornamented portions of the walls are covered with seventeenth-century brocatelle. The bed alcove has its original marquetry floor. The stucco work was probably done by Carpoforo Mazetti and Abondio Statio. The *amorini* are beautifully modeled, and the arabesques of the doors are exquisitely executed. Everything unites to form a buoyant and joyful ensemble. *Rogers Fund, 1906, 06.1335.1a–d*

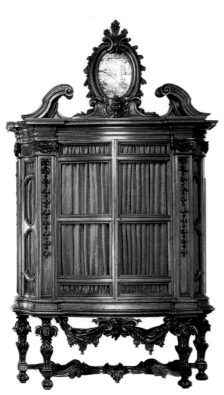

55 Table

German (Berlin, Royal Porcelain Manufactory), 1834
Hard-paste porcelain and gilt bronze; h. 35⅜ in. (89.9 cm)

By about 1832 new production methods and a broad range of new colors enabled Berlin's porcelain factory to create objects of exceptional size and brilliance. Even so, tables made entirely of porcelain are rare, and this is the only Berlin example known to survive. The monochromatic pedestal, its refined gilding simulating metalwork, is composed of porcelain sections slipped over a thin metal rod and provides stately support for the dazzling polychromy of the top. Within a central medallion Apollo drives his chariot amid the constellations, a scene framed by signs of the zodiac. Encircling this are two luxuriant wreaths, the inner of fruits and vegetables and the outer of glossy leaves alive with darting insects. The entire table may have been designed by Karl Friedrich Schinkel (1781–1841), the versatile architect who created both furniture and porcelain for the Berlin factory.

The impetus for such virtuoso pieces came from the Prussian king Frederick William III (1770–1840), whose patronage of the royal manufactory was extensive. We are not certain that he commissioned this table, but on June 1, 1835, it was recorded as a gift from him to Grand Duchess Helena Pavlovna of Russia (1807–1873). *Wrightsman Fund, 2000, 2000.189*

54 Bookcase

Roman, ca. 1715
Walnut and poplar; 157 x 94 x 24 in. (398.8 x 238.8 x 61 cm)

The stand and crest of this bookcase, one of a pair at the Museum, offered scope for an unknown sculptor to execute marvelously ebullient Baroque woodcarvings. The pair formerly stood in a wing added to the Palazzo Rospigliosi in Rome, where they were recorded in a 1722 inventory shortly after the wing was built. It is thought that the architect responsible for the new building, Nicola Michetti (d. 1759), may have supplied the design for the bookcases. *Gift of Madame Lilliana Teruzzi, 1969, 69.292.1*

56 The Bridal Chamber of Herse ▶

Flemish, Brussels, ca. 1550
Wool, silk, and metal threads; 172 x 204 in. (436.9 x 520.7 cm)

This tapestry is one of a set of eight that tell the story of the love affair between the god Mercury and Herse, daughter of Cecrops, king of Athens. Here Mercury enters her bedroom so eagerly that his winged sandals fall from his feet. Several cupids attend him; one removes his hat and another takes off Herse's sandal. The splendid room is gorgeously furnished, with rich fabrics covering the walls and bed; Mercury has laid his golden staff, the caduceus, on an elaborately carved table. The figures in the borders represent Virtues and have no connection with the main scene; they were originally designed to frame tapestries after Raphael's cartoons of the Acts of the Apostles. Silver and silver-gilt threads are lavishly used throughout. In the lower borders, in gilt thread, are the letters BB for Brabant-Brussels and the weaver's mark of Willem de Pennemaker (fl. 1541–78). Another panel of the set is in the Museum and two are in the Prado. *Bequest of George Blumenthal, 1941, 41.190.135*

57 Birth of the Virgin

Florentine, third quarter of 15th c.
Silk and metallic threads on canvas;
12 ¾ x 19 ½ in. (32.4 x 49.5 cm)

In the Middle Ages and the Renaissance, embroidery intended for use in a church was often extremely elaborate and sumptuous. Altar frontals and vestments were embellished not only with decorative patterns or heraldic and symbolic motifs but also with figural compositions. Among the latter the most popular subjects were those that allowed for a sequence of events, such as the lives of Christ, Saint John the Baptist, and the Virgin Mary. This panel may have been part of an altar frontal which included other scenes from the life of the Virgin. The designer's talent and the embroiderer's skill are equally matched in this representation of the Virgin's birth. The believable interior space, which gives way to a glimpse of landscape through the doorway, is enlivened by patterned bedhangings, ceiling, and floor. The embroidery techniques include finely executed *or nué,* in which metallic threads are laid down and then worked over in silk, and split stitch, especially visible in the clothing and hair of the figures. Although the identity of the designer is not certain, Benozzo Gozzoli (1420–1497) has been suggested. *Gift of Irwin Untermyer, 1964, 64.101.1381*

58 Savonnerie Carpet

French, 1680
Knotted and cut wool pile; 29 ft. 9¾ in. × 10 ft. 4 in. (9.09 × 3.15 m)

This carpet is one of a series of ninety-two made for the *grande galerie* of the Louvre after designs by Charles Le Brun (1619–1690), *premier peintre* of Louis XIV. In 1663 he was appointed to supervise the Savonnerie man-ufactory, a carpet-weaving works near Paris. He started the designs for the Louvre in 1665, and the first carpets were put on the looms in 1668. These carpets, among the most extraordinary ever made in Europe, have about ninety Ghiordes knots per square inch. The carpet illustrated here, one of the finest of the more than fifty known to have survived from the series, was delivered in 1680. *Gift of Mr. and Mrs. Charles Wrightsman, 1976, 1976.155.14*

59 The Drowning of Britomartis

French, probably Paris, 1547–59
Wool and silk; 183 × 114 in. (465 × 290 cm)

This panel, from a set of eight tapestries depicting the story of the goddess Diana, illustrates the little-known myth of the nymph Britomartis. At the upper left King Minos of Crete relentlessly pursues Britomartis, who chooses, however, to fling herself into the sea. The virgin huntress Diana, pictured with her hound and attendants, invents the net and gives one to fishermen, so they may retrieve the nymph's body and bring it to a holy place. Probably designed by Jean Cousin the Elder (ca. 1490–1560/61), the tapestries were made for Diane de Poitiers (1499–1566), mistress of Henri II (r. 1547–59), perhaps for her Château d'Anet. Personal references to Diane de Poitiers include the Greek deltas and the monograms HD that decorate the hem of the goddess's gown. The shields and arms in the top corners, as well as the linked GS in the side borders, refer to the Grillo family of Genoa, subsequent owners of the tapestries. *Gift of the children of Mrs. Harry Payne Whitney, 1942, 42.57.1*

60 Bookbinding with Representations of King David

English, 17th c.
Silk, silver, and silver-gilt metal threads on canvas; medallions embroidered in silk and metal threads on silk satin; 7 × 4½ in. (17.8 × 11.4 cm)

The medallion on each cover of this bookbinding depicts King David: on the front he is shown playing his harp, while on the back he is seen with the instrument at his side. These representations have their source in printed-book illustrations. Surrounding each medallion is an ornate frame; the remaining spaces of each cover are filled with birds, fruits, and flowers. ▶ Five large embroidered flowers decorate the spine. While the design of the medallions is not uncommon, the workmanship of the embroidery is of exceedingly fine quality, and the cover is in excellent condition. The binding encloses three books: *The New Testament* (London, 1633), *The Booke of Common Prayer* (London, 1633), and *The Whole Book of Psalmes* (London, 1636). Later inscriptions attribute ownership of the book to William Laud, archbishop of Canterbury (executed 1643). *Gift of Irwin Untermyer, 1964, 64.101.1294*

61 Air

French, Paris, ca. 1683

Silk, wool, and metal thread on canvas;
168 × 108 in. (427 × 274 cm)

Probably made at the convent of Saint-Joseph-de-la-Providence for the marquise de Montespan (1641–1707), this large embroidered hanging is from a set of eight depicting the elements and seasons, four of which are in the Museum's collection. Louis XIV, his mistress the marquise de Montespan, and six of their children are each depicted as a central character in one of the hangings. Here, as the personification of Air, Louis XIV appears as the god Jupiter, sitting atop an eagle while holding a bolt of lightning in one hand and a shield decorated with a Medusa head in the other. He is surrounded by birds and butterflies, as well as by musical instruments that require the passage of air to make their sounds. The elaborate designs must have come from the workshop of Charles Le Brun and were executed in colored silks and wools in tent stitch on canvas, with an intricately worked background of silver and silver-gilt threads couched in herringbone and spiral patterns. *Rogers Fund, 1946, 46.43.4*

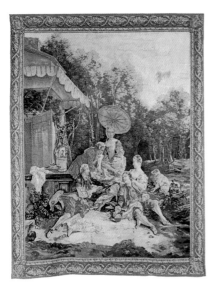

62 La Collation

French, Beauvais, 1762
Wool and silk; 130 × 102 in. (330.2 × 259.1 cm)

This tapestry is from the first series (eight pieces) designed by François Boucher (1703–1770) for the Beauvais manufactory. The contemporary name for the series was *Fêtes italiennes,* and the first four designs, woven from 1736 on, do indeed show peasants, statues, and ruins like those Boucher might have seen in Italy; by the time the second four designs, including this convivial picnic, were first produced in the 1740s, however, the actors have become ladies and gentlemen enjoying themselves in the French countryside. The young men and women wear bright colors, and the parasol is a brilliant pink against the blue-green trees. The set to which this tapestry belongs is in the Museum; it is made up of six of the original designs with two other narrow pieces added long after Boucher had ceased to work for Beauvais. The original purchaser and the entire history of the set are known; it is apparently the only one that has remained together. (See also no. 32 and European Paintings, no. 117.) *Gift of Ann Payne Robertson, 1964, 64.145.3*

63 Greenery

English, Merton Abbey, 1905
Wool and silk; 73½ × 185 in. (187 × 470 cm)

Reflecting the influence of earlier verdure tapestries, *Greenery* presents a dense screen of trees, foliage, flowers, and animals. The scrolls, similar to those found in Gothic and early Renaissance tapestries, are inscribed with a text by William Morris (1834–1896). Each banderole identifies the tree beneath it and explains in poetic terms the use of its wood in art and industry: pearwood for printing blocks, chestnut for rafters, and oak for ships. Designed in 1892 by John Henry Dearle (1860–1932), only two tapestries of *Greenery* were ever woven; the first, in that year, for Clouds, the home of the Honorable Percy Wyndham; the second, this example, thirteen years later. *Purchase, Edward C. Moore Jr. Gift, 1923, 23.200*

64 Pendent Jewel: Prudence

Probably French, Paris, mid-16th c.
Gold, chalcedony, enamel, emeralds, rubies, a diamond, and a pendent pearl; 3½ × 2 in. (8.9 × 5 cm)

The mirror and snake identify the subject of this jewel as Prudence, one of the Seven Virtues. Her image—white chalcedony carved in relief, combined with raised and tooled gold—is attached to a ground of enameled gold. The technique, a rare one, is a variety of *commesso*. In medium and style this Prudence is characteristic of a group of jewels traced to the court of the French king Henri II (r. 1547–59). *Gift of J. Pierpont Morgan, 1917, 17.190.907*

65 JEAN FRÉMIN, French, master 1738– d. 1786

Snuffbox
Gold; 3⅜ × 2¾ × 1⅝ in. (8.6 × 7 × 4 cm)

In the eighteenth century snuff constituted the most important part of the tobacco trade. In France snuff taking was enhanced among the nobility and gentry by the glitter and elegance of gold snuffboxes. By about 1740 the making of these *tabatières* became a specialized profession. This example was made in Paris by Jean Frémin in 1756–57, and its ample shape and uninterrupted decoration of enameled flowers are characteristic of the 1750s. The surface is worked in an extravagantly twisting trellis pattern, and the enamel is applied *en plein*, directly on the metal. *Gift of Mr. and Mrs. Charles Wrightsman, 1976, 1976.155.14*

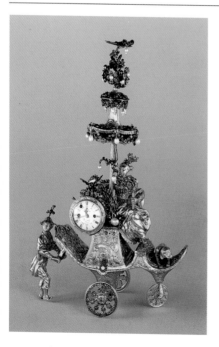

66 JAMES COX, English, act. ca. 1749–83, d. 1791

Automaton in the Form of a Chariot Pushed by a Chinese Attendant and Set with a Clock
Gold, brilliants, and paste jewels; h. 10 in. (25.4 cm)

A pair of automata, of which this is the surviving half, was commissioned from James Cox by the East India Company for presentation to the Ch'ien-lung emperor in 1766. Almost nothing is known of Cox before this date, but it is clear that he must have acquired a reputation for this genre, with which his name is regularly associated. From 1766 until 1772 Cox was preeminent in the vigorous but short-lived industry of manufacturing clocks and automata for the Chinese market, which he continued to supply at least until 1783.

This automaton is set in motion by levers that activate the whirligig held in the woman's left hand and the wings of the bird perched above the dial of the clock. A bell hidden beneath the lower tier of the parasol sounds the hours, and the entire mechanism is propelled by a spring and fusee device housed above the two central wheels. *The Jack and Belle Linsky Collection, 1982, 1982.60.137*

67 Processional Cross
Florentine, probably ca. 1460–80
*Silver gilt, nielloed silver, and copper with traces
of gilding; 21¾ × 12¾ in. (55.2 × 32.4 cm)*

An inscription on the base states that this cross
was made for the convent of Santa Chiara in
Florence. It is an extraordinary example of Flor-
entine Renaissance metalwork incorporating
within its silver-gilt frame a series of twenty sil-
ver plaques with nielloed scenes depicting the
Passion of Christ and various saints. *Gift of
J. Pierpont Morgan, 1917, 17.190.499*

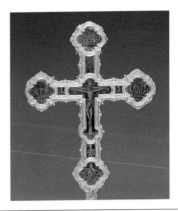

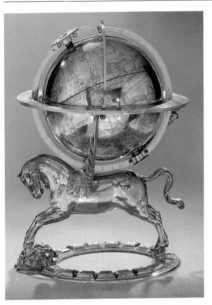

68 Celestial Globe with Clockwork
Austrian, Vienna, 1579
*Case: silver, partly gilded, and brass; movement:
brass and steel; 10¾ × 8 × 7½ in.
(27.3 × 20.3 × 19 cm)*

Described in an early-seventeenth-century in-
ventory of the Prague Kunstkammer of the Holy
Roman Emperor Rudolf II (1552–1612), this
globe houses a movement made by Gerhard
Emmoser, imperial clockmaker from 1566 until
his death in 1584, who signed and dated the
globe's meridian ring. The movement, which
has been extensively rebuilt in the course of its
existence, rotated the celestial sphere and drove
a small image of the sun along the path of the
ecliptic. The hour was indicated on a dial
mounted at the top of the globe's axis, and the
day of the year on a calendar rotating in the in-
strument's horizon ring. The silver globe, with
its exquisitely engraved constellations and its
Pegasus support, is the work of an anonymous
goldsmith who was probably employed in the
imperial workshops in Vienna or possibly in
Prague. *Gift of J. Pierpont Morgan, 1917,
17.190.636*

69 FRANÇOIS THOMAS GERMAIN, French,
1726–1791
Coffeepot
Silver; h. 11⅝ in. (29.5 cm)

This coffeepot, made in Paris and dated 1757,
was part of a service for the Portuguese court.
Delightfully designed, with spiral flutes giving
variety and movement to its surface, the cof-
feepot follows a familiar eighteenth-century
style, but with rare distinction. The leaves and
berries of the coffee plant decorate the finial,
spout, and handle support. *Purchase, Joseph
Pulitzer Bequest, 1933, 33.165.1*

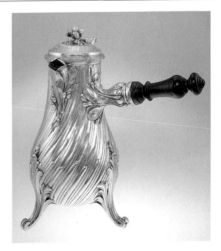

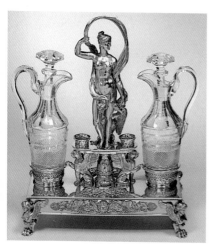

70 JEAN BAPTISTE CLAUDE ODIOT, French, 1763–1850
Cruet
Silver gilt and glass; h. 15 in. (38.2 cm)

This cruet, one of a pair in the Museum, was made in Paris about 1817. It exemplifies Odiot's move away from the current flat decorative style to one that was boldly sculptural. Here the central figure is the focus of the design, as commanding by itself as it is a dramatic element in the overall composition. *Gift of Audrey Love, in memory of C. Ruxton Love Jr., 1978, 1978.524.1*

71 Clock
French, Paris, 1881
Silver, gold, semiprecious stones, enamel, amethysts, and diamonds; h. 17¾ in. (45 cm)

Both a clock and an intricate jewel, this piece was designed by Lucien Falize (1838–1897) for an English patron, Alfred Morrison (1821–1897), and executed by the firm of Bapst and Falize. It is in the form of a late Gothic tower enriched with gold sculptures by Léon Chedeville (d. 1883) and enameled plaques, all of allegorical imagery. Richly colorful and highly programmatic in its decoration, the clock is a virtuoso example of nineteenth-century historicism. *Purchase, Mrs. Charles Wrightsman Gift, 1991, 1991.113a–f*

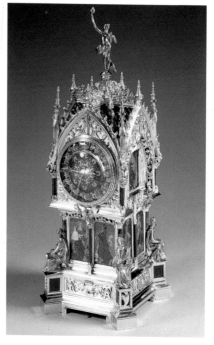

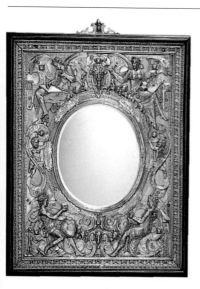

72 WENZEL JAMNITZER, German, 1508–1585
Relief with Allegorical Figures, Mounted as a Mirror Frame
Silver gilt; 11⅝ × 9⅛ in. (29.5 × 23.2 cm)

Wenzel Jamnitzer was probably the greatest German Mannerist goldsmith, as well as an engraver, medalist, and maker of plaquettes and mathematical instruments. Born in Vienna, he became a master goldsmith in 1534 in Nuremberg, where his workshop included his brother Albrecht, his nephew Barthel, and his sons Wenzel II, Abraham, and Hans II. The design of this relief, with figures of Arithmetic, Geometry, Perspective, and Architecture, was adapted from the title page of the *Perspectiva Corporum Regularium*, Jamnitzer's second book on perspective, published in Nuremberg in 1568. The relief's use as a mirror frame seems to be of relatively recent date. *Gift of J. Pierpont Morgan, 1917, 17.190.620*

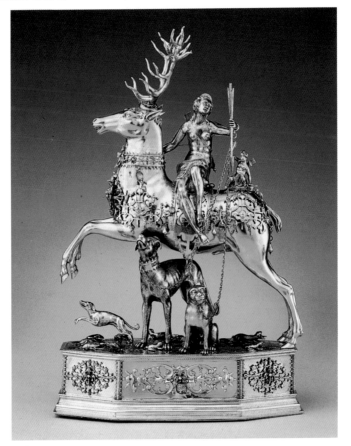

73 JOACHIM FRIES, German, ca. 1579–1620
Automaton: Diana on a Stag
*Silver, partially gilt, encasing a movement of
iron and wood; 14¾ × 9½ in. (37.5 × 24.1 cm)*

This automaton was used during luxurious
drinking bouts, and some twenty other surviv-
ing examples of this composition attest to its pop-
ularity. When the stag's head is removed, the
body serves as a drinking vessel. A mechanism
in the base causes the automaton to roll about a
tabletop in a pentagonal pattern and then stop;
the person before whom it stopped had to drain
the contents. Diana's bow, quiver, and arrow are
of a later date. *Gift of J. Pierpont Morgan, 1917,
17.190.746*

74 LÉONARD LIMOSIN, French, ca. 1505–
1575/77
Henri d'Albret, King of Navarre
Limoges, dated 1556
*Enamel, painted on copper and partly gilded;
7½ × 5⅝ in. (19 × 14 cm)*

Léonard Limosin was the greatest of the enamel
painters who worked in the style evolved by a
group of Italian Mannerists and native French
artists active at the French royal court from
about 1530 to 1570, known collectively as the
school of Fontainebleau. Limosin's enameled
portraits are numerous, and he has been ranked
with Jean Clouet (1486–1540) and Corneille de
Lyon (before 1500–1574) as the best of the por-
trait painters of the French Renaissance. This
plaque, one of at least six that are based on a
drawing attributed to Limosin in the Biblio-
thèque Nationale in Paris, portrays the brother-
in-law of the French king, François I (1497–
1547), who ruled the tiny, independent kingdom
of Navarre from 1518 until 1555. *The Jules
Bache Collection, 1949, 49.7.108*

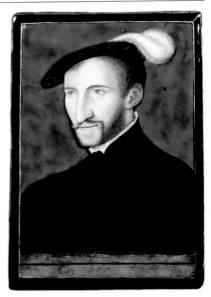

75 SIMON PANTIN, British, d. 1731
Teakettle, Lamp, and Table
Silver; h. 40¾ in. (103.5 cm)

Simon Pantin, a very successful London silver-
smith of Huguenot origin, made this extra-
ordinary set in 1724. Probably a special order
for the wedding of George Bowes to the heiress
Eleanor Verney, it is distinguished by its superb
unity of design and its authority of execution,
especially in the crisply engraved arms of its
original owners. The tripod stand adopts the
form of contemporary mahogany furniture. The
plain faceted kettle is a late example of the
Queen Anne style—the high point of English sil-
ver styles. *Gift of Irwin Untermyer, 1968,
68.141.81*

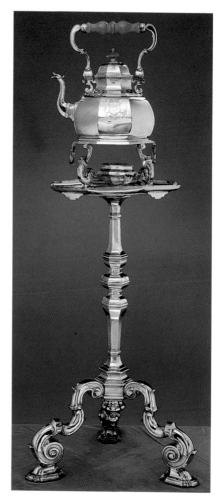

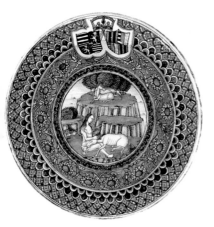

76 Dish
Italian, Faenza or Pesaro, ca. 1490–1500
*Maiolica; h. 4⅛ in. (10.5 cm), diam. 18⅞ in.
(47.9 cm)*

This dish is decorated with the arms of Matthias
Corvinus (1440–1490), king of Hungary from

1458 to 1490, and Beatrix of Aragon, whom he
married in 1476. It is one of a very small number
of pieces surviving from a service of Italian
maiolica sent to Queen Beatrix by her sister
Eleanora. Painted in Faenza or Pesaro, this
large plate documents the very best that could
be done at that moment technically and artis-
tically in the medium of maiolica. The palette is
still limited to blues, browns, greens, and
aubergine, which are harmoniously juxtaposed
and combined in the four bands of ornament
surrounding the central scene—a lady combing
the mane of a very subdued unicorn. The dish
demonstrates the receptivity to the Italian Re-
naissance shown by the Hungarian court under
the leadership of King Matthias. He brought
Hungary fully into the sphere of the Renais-
sance by his knowledge and encouragement of
all that was forward-looking in science, art, and
literature. During his lifetime Hungary was one
of those lands in the forefront of European cul-
tural and intellectual life. *Fletcher Fund, 1946,
46.85.30*

77 NICOLA PELLIPARIO, Italian, 1475–ca. 1545
Dish with the Death of Achilles
*Tin-glazed earthenware (faience); diam. 10⅜ in.
(26.3 cm)*

Tin-glazed earthenware, a Near Eastern invention, is characterized by its opaque white glaze. Introduced into Italy by the early thirteenth century, it was produced in many Italian towns. The technique reached its highest development in north-central Italy during the sixteenth century, when a full range of colors had been developed for decorating the white surface.

Nicola Pellipario was the central figure of the school of maiolica painting in Castel Durante, specializing in narrative subjects. Here his depiction of the death of Achilles, carried out with great delicacy of line and coloring, is based on a woodcut in an edition of Ovid's *Metamorphoses* (Venice, 1497). Polyxena, daughter of Priam, king of Troy, has lured Achilles to the temple of Apollo in Thymbra, where Paris is about to shoot him in the heel, his only vulnerable point. Of particular note is the temple interior, a display of Renaissance architecture with precisely calculated perspective. This dish dates from about 1520. *Purchase, 1884, 84.3.2*

78 ANTOINE SIGALON, French, ca. 1524–1590
Pilgrim Flask
*Tin-glazed earthenware (faience); h. with stopper
15 in. (42.6 cm)*

A "pilgrim" flask was slung from shoulder or saddle by a strap which passed through the slots on its sides. The flattened shape was more practical for travelers than a rounded one. The form is of great antiquity, but by the sixteenth century such bottles were also made in silver or fine pottery, clearly not intended for rough use on a journey.

The heraldic decoration on this flask is that of Count John Casimir of Bavaria. On each side of the coat of arms appear grotesques, ridiculing practices of the Roman Catholic Church, adapted from an engraving by Étienne Delaune (ca. 1518–d. 1583 or 1595). Sigalon was an ardent Huguenot, and this flask was undoubtedly made to commemorate the convocation of Protestant churches that met in Nîmes in February 1581. Sigalon's atelier in Nîmes was one of the first to make fine tin-glazed earthenware in France. *Samuel D. Lee Fund, 1941, 41.49.9ab*

79 JOSEPH-THÉODORE DECK,
French, 1823–1891
Dish
Earthenware; diam. 16 in. (40.6 cm)
Signed and dated 1866 by Joseph-Théodore Deck, this dish offers an unusually early and well-developed glimpse of the Japonisme that would sweep French taste later in the nineteenth century. Deck was widely influential for his revival of Islamic style and his innovative ceramic techniques. He was also, as is evident here, a brilliant colorist. *Purchase, Friends of European Sculpture and Decorative Arts and Robert L. Isaacson Gifts, 1992, 1992.275*

80 Ewer

French, Saint-Porchaire, ca. 1550
White earthenware with inlaid clay decoration under a lead glaze; h. 10¼ in. (26.1 cm)

Little is known about the small manufactory at Saint-Porchaire that produced highly elaborate pottery between 1524 and 1560. The products of the early, best period required much careful hand preparation after the basic shapes had been achieved by throwing on a wheel. This ewer, for example, has some sculptural decorations that were made in molds and then applied—the spout and handle, the festoons, the arcade of saints, and the lion masks. Other ornaments, which lie level with the surface, were made by pressing metal dies into the body and then filling the cavities with brown clay. Surviving examples of Saint-Porchaire ware, often with the devices or armorial bearings of royalty and members of the French nobility, demonstrate the clientele for this kind of domestic luxury ceramic. *Gift of J. Pierpont Morgan, 1917, 17.190.1740*

81 Ewer

Florentine, 1575–87
Soft-paste porcelain; h. 8 in. (20.3 cm)

Inspired by imported blue-and-white Chinese porcelain, the grand duke Francesco de' Medici (1541–1587) established a factory which produced the first surviving porcelain to have been made in Europe. The models and designs were borrowed from Near Eastern and Western as well as Chinese sources. This ewer is one of four examples of the so-called Medici porcelain in the Museum. *Gift of J. Pierpont Morgan, 1917, 17.190.2045*

82 Corpus from a Crucifix

Italian, Doccia, ca. 1745–50
Hard-paste porcelain; h. 26⅜ in. (67 cm)

The early productions of the Doccia factory, founded outside Florence in 1737 by Carlo Ginori (1702–1757), reflected Ginori's personal tastes and experimental turn of mind. A collector of bronze sculptures of the late Baroque period, Ginori set himself the task of reproducing them in porcelain, often casting them from molds and models in his possession. The origin of this figure is a sculpture by Massimiliano Soldani Benzi (1656–1740). Although slightly simplified by the Doccia modeler—probably Gaspero Bruschi (ca. 1701–1780)—all the somber grace and crisp detail of Soldani's figure have been successfully re-created in Ginori's porcelain. *Purchase, Lila Acheson Wallace Gift, 1992, 1992.134*

83 Shou Lao
French, Chantilly, ca. 1735–40
*Tin-glazed soft-paste porcelain; h. 10 ¼ in.
(26 cm)*

The early French porcelain factories were lo-
cated in or around Paris. Among them was
Chantilly, founded in 1730 by Louis Henri Au-
guste, seventh prince de Condé. The prince had
an extensive collection of oriental art, and his
predilection for the Japanese kakiemon style is
reflected in the productions of the factory
which, during his lifetime (1693–1740), were
made almost exclusively in that idiom. This fig-
ure of Shou Lao, the Taoist god of longevity, is
identified principally by his very long head,
which, like his hands, has been dramatically
painted brown. Although the inspiration for the
model was Chinese, the robe is patterned and
colored in the prevailing Japanese manner.
*The Jack and Belle Linsky Collection, 1982,
1982.60.371*

84 Persian Couple
French, Mennecy, ca. 1760
Soft-paste porcelain; h. 9⅝ in. (24.4 cm)

Porcelain was first made by the Chinese, and no
comparable hard-paste porcelain was produced
in Europe until the eighteenth century, although
artificial, or "soft-paste," porcelain—the material
of which this charming piece is made—was in-
troduced somewhat earlier. The Mennecy
factory where it was created began not in the
town of that name but nearby at Villeroy in
1737. In 1748 the factory was relocated at Men-
necy, but in 1773 it was again transferred, to
Bourg-la-Reine, where it remained until it closed
in 1806. Two variant models of this delightful
figure—neither in oriental costume, however—
have been recorded at auction. *The Jack and
Belle Linsky Collection, 1982, 1982.60.367*

85 Potpourri Vase
French, Sèvres, 1757
Soft-paste porcelain; h. 17½ in. (44.4 cm)

This Sèvres vase (*vase vaisseau à mât*), in the
soft pink known as *rose Pompadour*, is date-
marked 1757. Its imaginative shape may be an
allusion to the single-masted vessel in the an-
cient coat of arms of the city of Paris. Along the
shoulder is a series of "porthole" apertures, and
at either end is a triton head. The intricately
pierced cover suggests a mast; it is enclosed by
four gilded rope ladders, and about its upper
portion is the blue-and-gold pennant of France.
The model is attributed to Jean Claude Du-
plessis (d. 1774), and the figure painting is in the
manner of Charles Nicolas Dodin. *Gift of Samuel
H. Kress Foundation, 1958, 58.75.89ab*

86 Vase
French, Sèvres, 1832 (manufacture) and 1844
(decoration)
Hard-paste porcelain; h. 13¾ in. (34.9 cm)

The vase is one of a pair in which Gothic and
Renaissance Revival styles have been deftly
merged. The shape was designed by Alexandre-
Évariste Fragonard (1783–1850); in the decora-
tion by Jacob Meyer-Heine (1805–1879) figure
groups are enclosed in an elaborate but deli-
cate framework of tracery and foliage. The
figures depict scientist-inventors of the early Re-
naissance, and Meyer-Heine chose to execute
his decoration in a grisaille technique imitative
of sixteenth-century Limoges enamels. *Wrights-
man Fund, 1992, 1992.23.1*

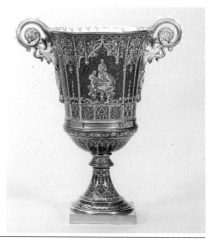

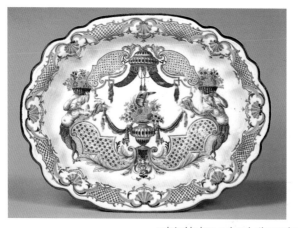

87 Dish
Austrian, Vienna, ca. 1730–40
Hard-paste porcelain; 7 × 9⅛ in. (17.8 × 23.2 cm)

This dish was made at the factory in Vienna di-
rected by Claudius du Paquier (d. 1751). The
motif that distinguishes his finest productions of
the 1730s is the leaf-and-strapwork pattern,
often interspersed with flowers and fruits,
painted in iron red and other colors. Originating
as a border ornament, strapwork emerges in its
mature form as an entirely independent motif,
and perfect harmony is achieved between the
form of the piece and its painted decoration,
each enhancing the other. *Gift of R. Thornton
Wilson, in memory of Florence Ellsworth Wilson,
1950, 50.211.9*

88 Chinese Musicians
English, Chelsea, ca. 1755
Soft-paste porcelain; h. 14½ in. (36.8 cm)

The technical difficulties of firing so large a
soft-paste group were considerable, and this
work is therefore among the most remarkable
creations of Chelsea's Red Anchor period
(1753–57). The modeler, Joseph Willems (ca.
1715–d. 1766), succeeded in harmonizing his
exotic figures with Rococo ideals of beauty. Of-
fering satisfying views from all sides, his group
is ideally suited as a table centerpiece. It is ap-
parently mentioned in the Chelsea sale
catalogue of April 8, 1758: "A most magnificent
LUSTRE in the Chinese taste, beautifully orna-
mented with flowers, and a large group of
Chinese figures playing music." This description
indicates that the model was also available for
use as a candelabrum. *Gift of Irwin Untermyer,
1964, 64.101.474*

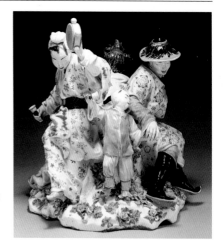

89 Augustus the Strong
German, Meissen, ca. 1713
Böttger stoneware; h. 4⅝ in. (11.6 cm)

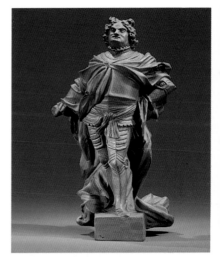

Meissen, the first of the European hard-paste porcelain factories, was formally established in 1710 after five years of experimentation directed toward the rediscovery of porcelain. Sculpture was produced at Meissen from the beginning, but it was both experimental and somewhat tentative; it was not until the appointment in 1733 of Johann Joachim Kändler (1706–1775) as chief modeler that the factory turned to the production of a wide repertoire of vividly modeled small sculptures. This small but powerful portrait of the founder of the Meissen factory reflects the early interest in sculpture at Meissen generated by such artists as Balthasar Permoser and Benjamin Thomae. This model, which has been attributed to Johann Joachim Kretzschmar (1677–1740) on stylistic grounds, was intended as a chess piece. *The Jack and Belle Linsky Collection, 1982, 1982.60.318*

90 Goat and Suckling Kid
German, Meissen, ca. 1732
Hard-paste porcelain; 19⅜ × 25½ in. (49.2 × 64.8 cm)

In 1732 Johann Joachim Kändler completed the model for an Angora-goat group to be "left in the white" (glazed but unpainted). Depicting a nanny goat suckling her kid, the group is charged with energy and tenderness, and Kändler has invested familiar barnyard animals with aspects of nobility. Large composi-

tions such as this group far exceed the normal capacity of the porcelain medium, as can be seen from the large fissures that developed in the first firing. But in his bold and simple manipulation of the surface, Kändler seems to have anticipated the inevitable firecracks, for they blend with the deep and wavy furrows in the shaggy coat of the nanny goat. A great modeler, he was the first to exploit porcelain fully as a medium for sculpture. *Gift of Mrs. Jean Mauzé, 1962, 62.245*

92 An Artist and a Scholar Being Presented to the Chinese Emperor

German, Höchst, 1766
Hard-paste porcelain; h. 15⅞ in. (40.3 cm)

This group was modeled by Johann Peter Melchior (1742–1825) at the Höchst factory in 1766. The exact source of the subject is unknown, but the piece was probably inspired by a French engraving, possibly Boucher's *Audience of the Emperor of China* or Watteau's *Chinese Emperor.* The emperor is backed by a Rococo structure surmounted by a canopy hung with bells. A court official presents an artist wearing a laurel chaplet and a scholar holding an open scroll. The group, an ambitious blending of chinoiserie with elements of the Rococo, was part of a table centerpiece and would have been surrounded by attendant figures. *Gift of R. Thornton Wilson, in memory of Florence Ellsworth Wilson, 1950, 50.211.217*

91 Lalage

German, Nymphenburg, ca. 1758
Hard-paste porcelain; h. 8 in. (20.3 cm)

Franz Anton Bustelli (1723–1763), the modeler of this figure, is best known for his representations of the characters of the commedia dell'arte. In addition to Harlequin and Columbine, Pantaloon and the Doctor, he also conceived models for characters whose names are known only from a single eighteenth-century German engraving. Lalage is one of these and has the dancing grace of pose and manner that characterizes all Bustelli's models. Portrayed here wearing a lozenge-patterned bodice, she represents a variant on the role of Columbine. *The Lesley and Emma Sheafer Collection, Bequest of Emma A. Sheafer, 1973, 1974.356.524*

93 Kazan Tartar Woman

Russian, ca. 1780
Hard-paste porcelain; h. 9 in. (22.9 cm)

Only two porcelain factories were in operation in Russia during the eighteenth century, the Imperial Porcelain Manufactory in Saint Petersburg and the Gardner factory at Verbilki, outside Moscow. About 1780 the imperial factory began the production of a large series of figures depicting Russian national types, of which fourteen are represented in the Linsky Collection. Like most of the figures, this elegant woman from Kazan is modeled from engravings published by Johann Gottlieb Georghi in his *Description of All the Peoples Inhabiting the Russian State* (1774). The authorship of the models themselves is not established, but some may be attributable to Jean Dominique Rachette (1744–1809), chief modeler at the factory from 1779 to 1804. Production of the series is believed to have continued until the end of the century. *The Jack and Belle Linsky Collection, 1982, 1982.60.146*

94 Armorial Jardinière
Chinese, English market, ca. 1692–97
Hard-paste porcelain; diam. 13 in. (33 cm)

In perfecting blue-and-white porcelain in the fourteenth century, the Chinese developed one of the most basic techniques of ceramic decoration: that of painting the designs "underglaze," or directly on the porcelain surface. The cobalt oxide pigment, which is used for the design, matures to a rich blue during the same firing that fuses the ingredients of the ware itself. Underglaze decoration has an agreeable directness and permanence that surface enameling, however colorful, lacks. The first Chinese porcelain to reach Europe was blue-and-white, and it enjoyed instant and lasting favor. Its novelty, economy, and dependability made it by far the largest group of Chinese export wares made for the West.

This large bowl belongs to the earliest known set of armorial wares made for an English patron. In a panel on one side are the arms of Sir Henry Johnson, of Aldborough and Blackwall; on the other sides are peonies and plants growing by rocks. *Gift of Mr. and Mrs. Rafi Y. Mottahedeh, 1976, 1976.112*

95 Goblet
Venetian, ca. 1475
Enameled and gilt glass; h. 8½ in. (21.6 cm)

This goblet is probably from the workshop established in Murano by the Venetian glass-painter Angelo Barovieri (act. 1424–d. 1461). The decoration illustrates a popular Italian story. Virgil, the renowned poet, fell in love with Febilla, the daughter of the emperor of Rome. Enraged when she spurned him, Virgil magically caused all the fires in Rome to go out. The emperor had to agree to the remedy—Febilla was exposed in the marketplace until all the women of Rome had rekindled their fires with tapers lighted from a live coal magically placed in her body.

The decoration is one of the earliest surviving examples of work on a minute scale for enameling and gilding on glass. The composition was probably taken from a contemporary illuminated manuscript of the Venetian school. *Gift of J. Pierpont Morgan, 1917, 17.190.730*

96 CARL VON SCHEIDT, German,
act. early 19th c.
Beaker
Enameled and gilt glass; h. 3⅞ in. (9.8 cm)

This beaker painted with a view of the Brandenburg Gate, which closes the famous Unter den Linden allée in Berlin, is an example of the new medium of translucent enamels developed by a porcelain painter, Samuel Daniel Mohn (1762–1815) about 1805. He worked in Dresden, with a workshop of painters he had trained in the technique. Among his followers, who carried the art to Berlin and Vienna, were Gottlob Samuel Mohn, his son; Carl von Scheidt, who signed and dated this beaker; and Anton Kothgasser. It was a cool, delicate medium, especially suitable for topographical views on small objects. However, Gottlob Samuel Mohn also executed stained-glass windows in the technique at the Imperial Palace at Laxenburg for Emperor Francis II of Austria. *Munsey Fund, 1927, 27.185.116*

97 Monteith

English, 1700
*English flint glass; h. 6⅝ in. (16.8 cm),
diam. 12¼ in. (31.1 cm)*

Monteiths, filled with ice water, were used to cool wineglasses—the glasses were suspended in the water by their feet, which were held in the notches of the rim. At the time this piece was made, monteiths were normally made in silver, and this is an unusually large object to be found in glass. It is engraved with the names and arms of William Gibbs and his wife, Mary Nelthorpe, and with inscriptions expressing moral sentiments in Italian, Hebrew, Slavonic, Dutch, French, and Greek. In the main decoration Cupid holds a bride by the hand and sings from a songbook while musicians assembled around a table play the lute, viola, and recorder. The piece was presumably made to mark the betrothal of William Gibbs and Mary Nelthorpe. It is the Museum's earliest example of English flint glass, which was perfected late in the seventeenth century and immediately became a strong competitor to both Venetian and German clear glass since it had equal strength but greater inner "fire," or luminosity. *Bequest of Florence Ellsworth Wilson, 1943, 43.77.2*

98 The Virgin Annunciate

French, Paris, 1552
Colored, stained, and painted glass; h. 64 in. (162.6 cm)

This stained-glass panel with the kneeling Virgin disturbed at prayer is a fragment of a window from the north aisle of the church of Sainte-Foy in the village of Conches in Normandy. The whole window depicted the Annunciation taking place in a lofty pillared hall. This window and another opposite it in the south aisle of the church were given in 1552 by a native of Conches, Jean Le Teillier, lord of Evreux (of which Conches was a dependency). Glass-making centers in Normandy contributed the rest of the glass in the aisle and choir. Because Jean Le Teillier was a member of the court of Henry II, overseer of the regional chancelleries and treasurer to the queen, he ordered his windows from a Parisian workshop, which used a design supplied by an artist working in the style of the School of Fontainebleau. *Rogers Fund, 1907, 07.287.12*

99 Ewer
Bohemian, Prague, ca. 1680; probably mounted in London, ca. 1810–19
Smoky crystal with enameled gold mounts set with diamonds; h. 9⅞ in. (25 cm)

The Napoleonic Wars resulted in an enormous displacement of art of all kinds, and after the defeat of Napoleon in 1810, English collectors rushed to take advantage of the Continental markets from which they had long been excluded. Among them was the wealthy eccentric William Beckford, who bought this ewer (as a work by Cellini) to adorn his celebrated—and treasure-filled—neo-Gothic Fonthill Abbey. Made of a variety of crystallized quartz sometimes, and incorrectly, called smoky topaz, the ewer can be attributed to the Prague workshop of Ferdinand Miseroni and can be dated about 1680. The Renaissance-style mounts of enameled gold set with diamonds, however, are both different in style and far more elaborate than others made in Prague during this period. In fact, they are in all probability the early-nineteenth-century product of a still unidentified London goldsmith whose neo-Renaissance design must have drawn heavily on the same sources that inspired the chinoiseries of the Royal Pavilion at Brighton. *The Jack and Belle Linsky Collection, 1982, 1982.60.138*

101 *Reja* from the Cathedral of Valladolid
Spanish, 1763
Wrought iron, partially gilt, and limestone;
52 × 42 ft. (15.86 × 12.81 m)

This *reja* (choir screen) from the cathedral of Valladolid, attributed to the Amezúa family of Elorrio, was erected in 1763 and painted and gilded in 1764. The decorative motifs—the *piedras y gallones* (which imitate precious gems) in the uppermost frieze, the small twisted columns among the bars, and the markedly Rococo ornamentation—are characteristic of the work of Rafael and Gaspar Amezúa. There is great formal clarity in the crestwork of the Valladolid screen, and even the capricious Rococo scrollwork is clearly silhouetted in space. *Gift of The William Randolph Hearst Foundation, 1956, 56.234.1*

100 WILLIAM GLASBY, English, 1863–1941
Night
Colored, stained, painted, ground, and etched glass; h. 20 in. (50.8 cm)

The small stained-glass panel *Night,* designed by William Glasby in 1897, was probably also executed by him at the Henry Holiday studio in Hampstead, London, where Glasby was foreman and chief glass painter. The panel displays the personification of Night as a woman carrying a lamp and draped in a dark cloak overlaid with a multitude of stars. The figure stands against a background and within a frame of night symbols, owls on the wing, and flaming torches. Techniques adopted from the high traditions of the Middle Ages—painting and staining on clear glass, with areas of colored glass and details wrought by grinding the surface of two-layered glass—are augmented here by a sculptural treatment of the drapery, where the folds are literally carved in the glass with acid. *Purchase, Gift of J. Pierpont Morgan, by exchange, 1987, 1987.172.2*

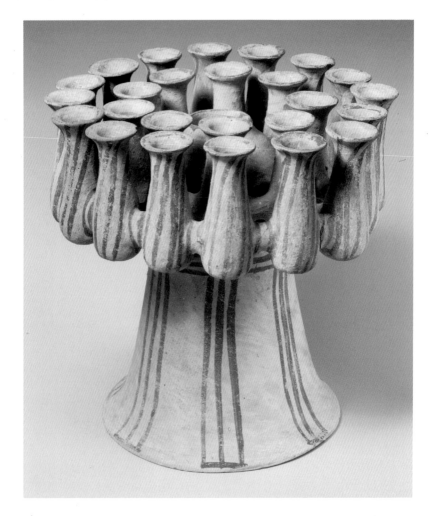

Kernos
Cycladic, Early Cycladic III–Middle Cycladic I,
ca. 2300–2200 B.C.
Terracotta; h. 13⅝ in. (34.5 cm)

Used for multiple offerings, the kernos is an
ancient terracotta vessel from the Mediterranean
and Near Eastern regions. During the late third
millennium B.C., this shape was produced with
some frequency on the Cycladic island of Melos.
Remarkable for its complexity and excellent
preservation, the Museum's example shows

twenty-five receptacles in two rings cantilevered
over the base. The offerings would have con-
sisted of grains, fruit, flowers, and perhaps fibers
such as wool.

This kernos was found, together with a jar
and a jug, in 1829 in a tomb on Melos by Cap-
tain Copeland, a British naval officer. In 1857 his
widow gave the objects to Eton College, where
they remained until they were purchased by the
Museum in 2004. *Purchase, The Annenberg
Foundation Gift, 2004, 2004.363.1*

GREEK AND ROMAN ART

The Greek and Roman collections comprise the art of many civilizations and several millennia. The areas represented are Greece and Italy, but not as limited by modern political frontiers: much of Asia Minor on the periphery of Greece was settled by Greeks; Cyprus became increasingly Hellenized in the course of its long history; and Greek colonies sprang up all over the Mediterranean basin and on the shores of the Black Sea. In Roman art the geographical limits coincide with the political expansion of Rome. In addition, the collections illustrate the pre-Greek art of Greece and the pre-Roman art of Italy. The later chronological limits are imposed by a religious event, the conversion of the emperor Constantine to Christianity in A.D. 337, which did not coincide with the fall of the Roman Empire and which did not bring about an immediate or complete change in art.

Although the Department of Greek and Roman Art was formally established only in 1909, the very first accessioned object in the Museum was a Roman sarcophagus from Tarsus, donated in 1870. Today the strengths of the vast collection include Cypriot sculpture, painted Greek vases, Roman portrait busts, and Roman wall paintings. The department's holdings in glass, gold, and silver are among the finest in the world, and the collection of archaic Attic sculpture is second only to that in Athens.

The department is engaged in a complete reinstallation of its galleries. In 1996 the display of prehistoric and early Greek art was inaugurated. In 1999 seven rooms of Greek art from about 700 B.C. to about 300 B.C. were opened, followed in 2000 by four galleries of works from Cyprus. To come are new spaces for Hellenistic, Roman, and Etruscan art as well as extensive open study storage for pieces not in the primary display areas.

1 Seated Harp Player
Cycladic, 3rd millennium B.C.
Marble; h. 11½ in. (29.2 cm)

Little is known of the culture that flourished in
the islands of the Aegean Sea known as the
Cyclades. Artists of the twentieth century, how-
ever, have drawn our admiring attention to these
prehistoric masters. Although most Cycladic
sculptures are of women, there are also some of
men, and in a few cases the sculptor has aban-
doned the traditional pose to show musicians.
This seated harp player is executed in astonish-
ing detail despite the primitive tools at the
sculptor's disposal. *Rogers Fund, 1947, 47.100.1*

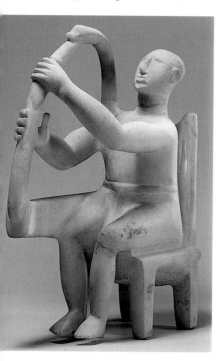

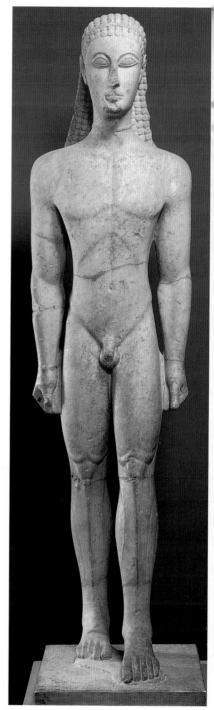

2 Kouros (Statue of a Youth)
Attic, end of 7th c. B.C.
*Marble; h. without plinth 76 in. (193 cm),
h. of head 12 in. (30.5 cm)*

This kouros is the earliest monumental Greek
marble statue in the Museum. It probably stood
on the tomb of a young man but could also
have been dedicated in a sanctuary. Contact
with Egypt provided an impetus for Greek art-
ists to create monumental sculptures such as
this one. Its blocklike form, frontal pose,
advanced left foot, and clenched hands can be
matched in Egyptian sculpture, but departures
from Egyptian style are equally evident: the
space between the elbows and waist is cut
away, and there is no supporting back pillar. An-
atomical details are still schematized. Later,
however, the body is rendered increasingly real-
istically until classic perfection was achieved in
the second half of the fifth century B.C.
Fletcher Fund, 1932, 32.11.1

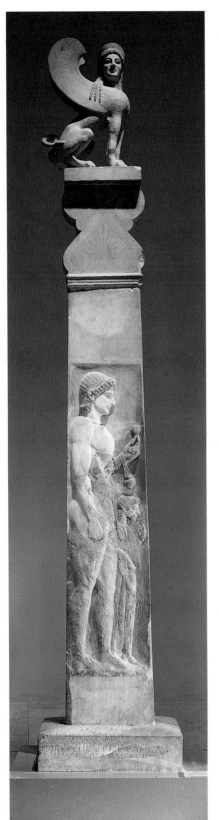

3 Grave Stele: Youth and Girl
Attic, ca. 540 B.C.
Marble; h. 13 ft. 11 in. (4.23 m)

The Museum is rich in archaic grave reliefs made in Attica during the sixth century B.C. The most sumptuous (and most complete) is this stele of a youth and a girl, surmounted by a sphinx as guardian of the tomb. As is customary in archaic reliefs, the figures are shown in profile with the eyes frontal. The carving is relatively flat, but here, and on other stelai in the collection, the background is concave, so that the sculpture looks more rounded. The sphinx, worked separately, is carved in the round. Much of the original color is preserved under incrustation; Greek stone sculpture was never left the dead white favored by classicizing imitators. Paint was used to differentiate hair, nails, eyes, lips, drapery, armor, and other accessories. *Frederick C. Hewitt Fund, 1911; Rogers Fund, 1921; Munsey Fund, 1936, 1938; Anonymous Gift, 1951, 11.185a–g*

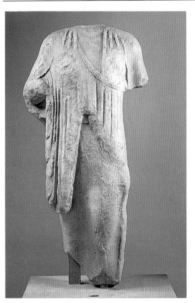

4 Kore (Statue of a Girl)
Attic, late 6th c. B.C. (from Paros)
Marble; h. 41½ in. (105.4 cm)

This statue of a maiden ("kore," in Greek) was found on the island of Paros in the Cyclades sometime before 1860. It was presumably a votive offering like the many korai found on the Acropolis in Athens. The right forearm was worked separately and is lost. The left leg is slightly forward, and the drapery is pulled tight across the thigh by the right hand which, together with most of the arm, is broken off and missing.

Many of the earliest Greek marble statues were made on the islands, and the island schools of Greek sculpture owed much to the excellent quality of the marble that was quarried there from prehistoric times. In style and execution this kore resembles one found on the Acropolis in Athens, which has also been attributed to Cycladic workmanship. *Gift of John Marshall, 1907, 07.306*

5 Head from a Herm
Greek (Attic), mid-5th c. B.C.
Marble; h. 6½ in. (16.4 cm)

A herm is a quadrangular shaft, typically of stone, surmounted by the bearded head of the god Hermes. Herms served as boundary markers and as guardians of thoroughfares and entrances. This work beautifully exemplifies the gravity and nobility of classical Greek sculpture. It is, moreover, of considerable artistic importance because it reflects a melding of the imagery of Zeus, Dionysos, and Hermes. *Purchase, Lila Acheson Wallace Gift, 1992, 1992.11.61*

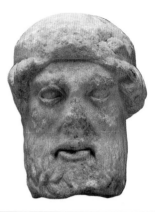

7 Wounded Amazon
Roman copy of a Greek original of ca. 430 B.C.
Marble; h. including plinth 80¼ in. (203.8 cm)

The Roman writer Pliny tells the story of the four sculptors (Polykleitos, Phidias, Kresilas, and Phradmon) who in a competition made statues of Amazons for the temple of Artemis at Ephesus. In the vote for the best, each artist put himself first, but Phidias, Kresilas, and Phradmon gave second place to Polykleitos, who thus won the prize. Although this anecdote may be apocryphal, Roman copies of three different types of Amazons are known, all after Greek originals. This statue is a copy after the one thought to be by Kresilas. The Amazon is wounded in her right breast where blood flows from a gash, yet her pose and expression reveal neither pain nor suffering. She embodies the classic ideal and represents an evolution of almost two hundred years from the earliest archaic marbles. *Gift of John D. Rockefeller Jr. 1932, 32.11.4*

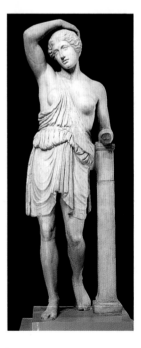

6 Wounded Warrior Falling (*Volneratus Deficiens*)
Roman copy of a Greek bronze original of 440–430 B.C. by Kresilas
Marble; total h. 87 in. (221 cm), h. without plinth 77½ in. (196.9 cm)

This over-life-size warrior is shown with his right hand raised. A short mantle covers his left shoulder; his left arm is bent and must have carried a shield. His Corinthian helmet is pushed back on his head and his gaze is directed downward.

When first acquired, the statue was identified as Protesilaos, the first Greek to die at Troy. It was later remarked, however, that his right arm is not raised in an attitude of attack and that he is, in fact, wounded under his right armpit and supports himself on a spear. These observations bear out an identification of the statue with the *Volneratus Deficiens* by the renowned Greek sculptor Kresilas. *Frederick C. Hewitt Fund, 1925, 25.116*

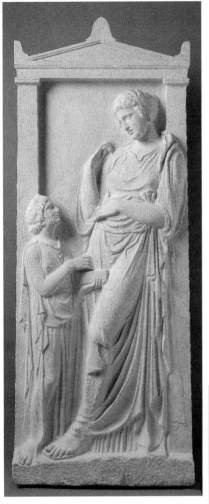

8 Grave Stele: Woman and Attendant
Attic, about 400 B.C.
Marble; h. as preserved 70⅛ in. (178.1 cm), h. as restored 74 in. (188 cm), w. 29⅞ in. (75.9 cm)

The dead woman is portrayed leaning against the pilaster of the architectural frame. With her right hand she fingers her mantle. A girl, perhaps a servant, approaches with a casket, perhaps her jewelry box. As often on Greek grave reliefs, the gazes of the two women do not meet, and the dead person is shown in a somewhat larger scale. The upper left corner of the relief is missing, but as the right acroterion is preserved, the restoration is certain. *Fletcher Fund, 1936, 36.11.1*

9 Old Market Woman
Greek, perhaps an original of 2nd c. B.C.
Pentelic marble, restorations in plaster on face and breast; h. including base 49⅝ in. (126 cm)

The Hellenistic period spanned the three centuries between the death of Alexander the Great (323 B.C.) and the Battle of Actium (31 B.C.), which marked the beginning of the Roman Empire. In art the most creative centers were no longer on the Greek mainland but abroad, in Pergamon and Alexandria and on the island of Rhodes. Hellenistic art did not, of course, break with the past, but the conquest of the East brought with it a widening of horizons. Artists looked for new subjects and discovered *genre*, an excellent example of which is this realistic study of an old, tired woman going to market with her basket of fruits and vegetables and chickens. *Rogers Fund, 1909, 09.39*

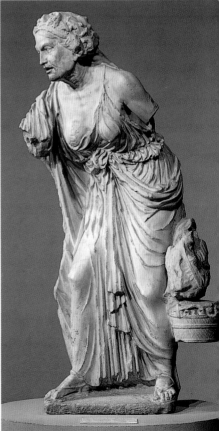

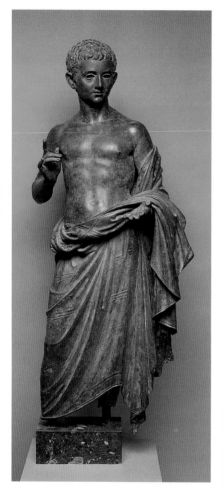

10 Portrait Statue of a Roman Prince, probably Lucius Caesar

Roman, late 1st c. B.C. (said to be from Rhodes)
Bronze; h. 48½ in. (123.2 cm)

The mixed nature of adolescence is neatly presented in this portrait: the subject has the body of a boy and the demeanor of a self-possessed young man. His hands are empty but probably once held objects connected with a religious ceremony. The richly decorated pallium he wears is a mark of wealth, and his features strongly suggest that he is a relative of the emperor Augustus. The most likely candidate is Lucius Caesar (17 B.C.–A.D. 2), the younger of the emperor's grandsons.

Augustan portraiture in general tempers the stark realism favored in preceding decades with graceful, classicizing modeling but, as this portrait attests, not at the expense of vivid characterization. *Rogers Fund, 1914, 14.130.1*

11 The Hope Dionysos

Roman, late 1st c. A.D., with 18th-c. restorations by Vincenzo Pacetti
Marble; h. 82¼ in. (210.2 cm)

The Hope Dionysos is one of the finest and best preserved Roman replicas of a Greek sculptural type that originated in the second quarter of the fourth century B.C. It has been known since 1796, when the English collector and antiquarian Henry Philip Hope acquired it in Rome from the sculptor and restorer Vincenzo Pacetti. After over a century of renown in the Hope Collection, the sculpture was bought in 1917 by Francis Howard, a collector-agent who was a grandson of Benjamin Franklin. *Gift of The Frederick W. Richmond Foundation, Judy and Michael Steinhardt, and Mr. and Mrs. A. Alfred Taubman, 1990, 1990.247*

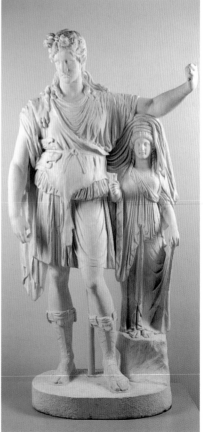

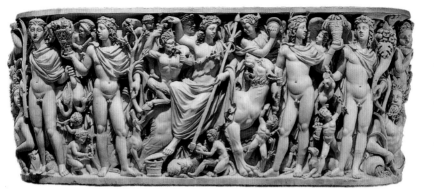

12 The Badminton Sarcophagus

Roman, A.D. 260–65
Greek marble; greatest h. 35 in. (88.9 cm),
greatest l. 87¾ in. (222.9 cm)

Sarcophagi, literally "flesh eaters," were used for burial throughout antiquity. This one, in the shape of a tub, shows Dionysos and his followers. The young god is seated on a panther; around him are satyrs and maenads and the horned god Pan. Four winged youths, in the front plane and in a larger scale, represent the seasons. They remind the viewer that time no longer touches the heroized dead, who now participate in the eternal feast, symbolized here by the Dionysiac festival. The relief uses classical tradition in many details, but the indications of space and scale and the relationships among the figures do not attempt to reflect reality. In this respect, the sarcophagus documents the beginning of a stylistic transition toward the Middle Ages.

The sarcophagus was brought from Italy to the collection of the duke of Beaufort at Badminton House in Gloucestershire in 1728. *Purchase, Joseph Pulitzer Bequest, 1955, 55.11.5*

13 Support for a Basin

Roman, 2nd c. A.D.
Porphyry; w. 58½ in. (148.6 cm)

Quarried in the eastern desert of Egypt, porphyry became an imperial monopoly under the Romans. Its sumptuous effect stems from its vibrant purple color and extreme hardness, which produces bold, clear forms and can be polished to a high luster. This support is one of a pair for an oval trough or water basin. At each end the decoration consists of a composite lion's head and paw, linked by foliate scrollwork. *Harris Brisbane Dick Fund, 1992, 1992.11.70*

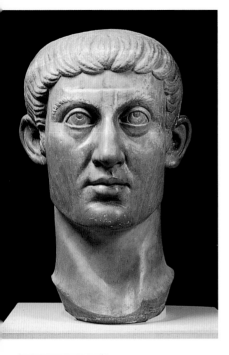

14 Colossal Head of Constantine
Roman, ca. A.D. 325
Marble; h. 37½ in. (95.3 cm)

During the late third century A.D., Roman portrait sculpture tended to become less naturalistic and more geometric or blocklike in structure. In this head of Constantine the development is evident in the lines of the jaw, chin, and forehead and in the regular and symmetrical crown of hair. The upward gaze of the eyes with their transcendental seriousness is also characteristic of Roman portraiture of the third and fourth centuries A.D.

The head, which was once part of a colossal statue, probably showing the emperor seated, was known as early as the seventeenth century, when it was in the Giustiniani collection in Rome. The nose, lips, and chin and parts of the ears are restored. *Bequest of Mary Clark Thompson, 1923, 26.229*

15 Sarcophagus with Lid
Greek, Cypriot, 5th c. B.C. (from Amathus)
Limestone; l. 93⅛ in. (236.5 cm)

From earliest times the art of Cyprus has reflected the island's position as a crossroads between East and West. This sarcophagus is Greek in form, in architectural ornament, and in details like the sphinxes at each end of the lid. Oriental are the "Bes" and "Astarte" figures decorating the short sides, the parasols in the chariot procession, and the horses' harnesses and other trappings. Made of the typical local limestone, the sarcophagus preserves an unusually large amount of added color. *The Cesnola Collection, Purchased by subscription, 1874–1876, 74.51.2453*

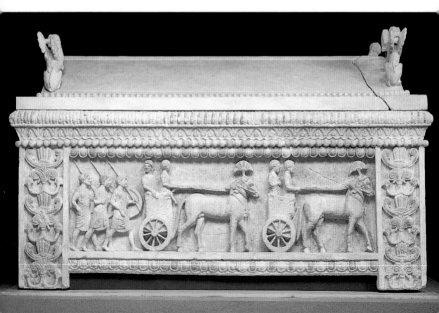

16 Centauromachy, perhaps Herakles and Nessos

Greek, 8th c. B.C. (said to be from Olympia)
Bronze; h. of man 4½ in. (11.4 cm), h. of centaur 3⅞ in. (9.9 cm)

In this small bronze group, cast in one piece, a man confronts a centaur. Their feet are close together and they stand bolt upright; the action is limited to the arms that are locked in a wrestling pose. Clearly the man is a hero; he may be Herakles, but the absence of attributes makes a precise identification hazardous. The workmanship is Peloponnesian, and the group is said to have been found at Olympia, the great Greek sanctuary that has yielded so many bronze votive offerings. *Gift of J. Pierpont Morgan, 1917, 17.190.2072*

17 Head of a Griffin

Greek, mid-7th c. B.C. (found at Olympia)
Bronze; h. 10⅛ in. (25.8 cm)

A feature characteristic of utilitarian objects made by the Greeks, whether in metal or clay, is the high quality of the workmanship and the often masterful decoration. This head of a griffin probably served originally as one of several attachments on a deep cauldron. It was cast in the lost-wax technique and would have been attached to a hammered—rather than cast—neck; the eyes would have been inlaid. Like the sphinx and other hybrid creatures, the griffin came to Greece from the East. It was particularly popular during the seventh and sixth centuries B.C., and as a protome it is one of the most typical types of vessel attachment. In its size, design, and execution, however, this example is exceptional. *Bequest of Walter C. Baker, 1971, 1972.118.54*

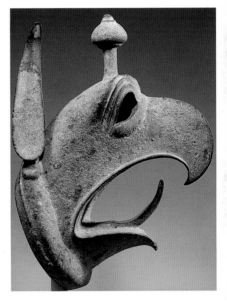

18 Herakles

Greek, late 6th c. B.C. (said to have been found in Arcadia)
Bronze; h. 5 in. (12.6 cm)

The very sturdy Herakles is shown brandishing a short club. He stands with legs far apart, and the entire body is dominated by his well-developed muscles. As is usual in Greek art, Herakles wears his hair short. Herakles was worshiped as a god, and many statuettes of him were dedicated as votive offerings. *Fletcher Fund, 1928, 28.77*

19 Athena Flying Her Owl
Greek, ca. 460 B.C.
Bronze; h. with owl 5⅞ in. (14.9 cm)

Athena, the patron goddess of Athens, could be considered present rather than remote, human rather than perfect and immortal. The combination of dignity and informality gives this small bronze its particular character. The goddess wears only a peplos that reveals the body beneath; her helmet has been pushed back in a moment of ease; she held a spear in her left hand, but with her right she is about to let fly an owlet, the bird sacred to her. While possibly influenced by a monumental statue, the artist has achieved great freshness and great sympathy for the patroness of the city and of craftsmen. *Harris Brisbane Dick Fund, 1950, 50.11.1*

20 Mirror Supported by a Woman Holding a Bird
Greek, 5th c. B.C.
Bronze; h. 15⅞ in. (40.3 cm)

Greek artists incorporated the human form into utilitarian objects of all kinds. This mirror is an example of exceptional quality. Made for the toilette of a person of means, it shows a woman draped softly in a peplos, holding a pet bird. She serves as the support and handle for the mirror. *Bequest of Walter C. Baker, 1971, 1972.118.78*

21 Hermes
Late Hellenistic—early Roman,
1st c. B.C.—1st c. A.D.
Bronze; h. 11½ in. (29.2 cm)

By the end of the fourth century B.C. Greek statues had attained the stance and proportions that we call classic, and the idealized renderings of gods and goddesses, athletes and heroes, continued to be admired and copied for many centuries. The perfect proportions of this Hermes are echoed in other portrayals of the god. Especially well preserved, this large statuette counts among the finest of its period. *Rogers Fund, 1971, 1971.11.11*

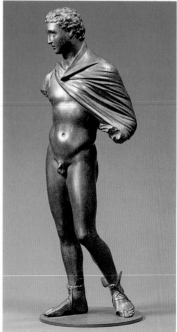

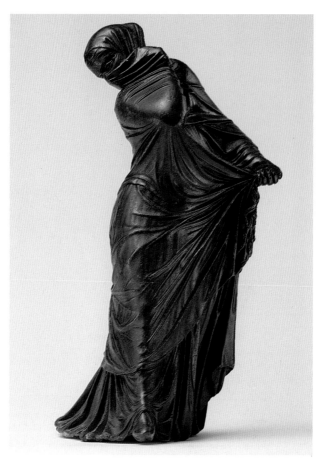

22 Veiled and Masked Dancer
Greek, 3rd c. B.C.
Bronze; h. 8⅛ in. (20.4 cm)

An innovation of Greek art in the fourth and third centuries B.C. was the characterization of specific subjects, which led to the development of such genres as portraiture and caricature. This bronze is remarkable in that its effect depends not on physical features of the figure but exclusively on the pose and on the treatment of the drapery. While the type of a long-robed dancer became established during the fourth century B.C., especially in terracottas, no surviving example can match the way folds are composed and articulated over the body of this figure, which is known as the "Baker dancer." *Bequest of Walter C. Baker, 1971, 1972.118.95*

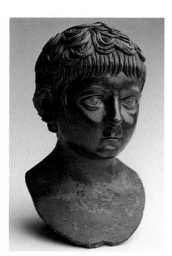

23 Portrait Bust of a Child
Roman, first half of 1st c. A.D.
Bronze; h. 11½ in. (29.2 cm)

Likenesses of children were not uncommon in the Roman imperial period, but they are usually made of marble or of less expensive materials. A portrait of one so young as this boy in a material so costly as bronze is highly unusual and indicates that he was especially wellborn. It has been argued that the sitter is Nero as a boy of five or six. The bust resembles other images of the future emperor at an early age, and the style of the work accords well with portraits from the 40s A.D. It is nonetheless difficult to identify portraits of children, particularly when there are so many who share the family traits of the Julio-Claudian house.

The bust was originally mounted on a hermlike base, probably of marble. *Funds from various donors, 1966, 66.11.5*

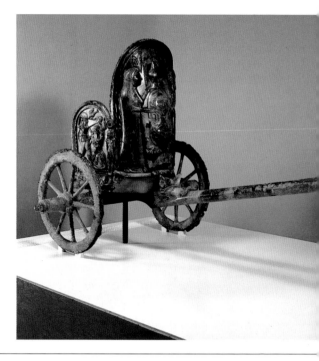

26 Stirrup Jar

Mycenaean, 12th c. B.C.
Terracotta; h. 10¼ in. (26 cm)

At the end of the Bronze Age, during the so-called Mycenaean period (ca. 1600–1100 B.C.), Greek influence in the Mediterranean extended from the Levant to Italy. The chief vehicle of this influence was trade, as ships sailed along the coast or from island to island bartering their products. One of the most characteristic types of Mycenaean vase, probably used for transporting and storing liquids like wine or oil, was the stirrup jar, named after the form of the handle at top. The marine decoration on this jar, featuring an octopus, is both typical and significant, for the sea was the ancient Greeks' chief source of livelihood. *Purchase, Louisa Eldridge McBurney Gift, 1953, 53.11.6*

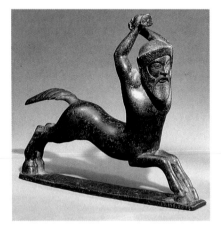

25 Centaur

Etruscan or Campanian, 6th or 5th c. B.C.
Bronze; l. 5⅝ in. (14.3 cm), h. 4½ in. (11.3 cm)

In its raised arms this galloping centaur wielded an uprooted tree (now broken off and lost). As it is cast with a curving plinth, the statuette must have been soldered to the rim or shoulder of a bronze cauldron, probably accompanied by other centaurs in similar poses. The elongated face and the treatment of the body (both the equine and the human parts) are typical of Etruscan sculptural tradition. *Gift of J. Pierpont Morgan, 1917, 17.190.2070*

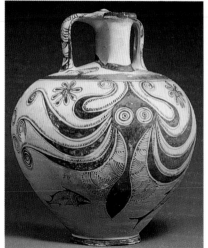

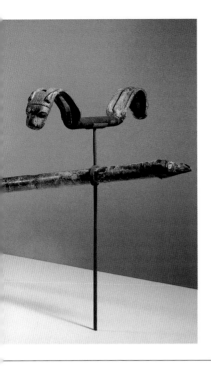

24 Chariot
Etruscan, late 6th c. B.C.
Bronze; h. 51½ in. (130.8 cm)

Though familiar to us from representations of all kinds in ancient art, very few actual chariots survive because by the sixth century B.C. they were no longer used in warfare; the scenes in which they appear refer to an earlier, mythological period. This chariot, found in a tomb in Monteleone, Italy, probably saw little actual use before it was buried with the owner. The richness and quality of the decoration, however, are exceptional. The pole issues from the head of a boar and ends in the head of a beaked bird. The principal subjects on the three parts of the chariot box refer to the life of a hero, probably Achilles. In the center he receives armor from his mother, Thetis; on one side he engages in combat with another hero, possibly Memnon; on the other side he appears in a chariot drawn by winged horses. While the style and subject depend on Greek sources, the interpretation is thoroughly Etruscan. *Rogers Fund, 1903, 03.23.1*

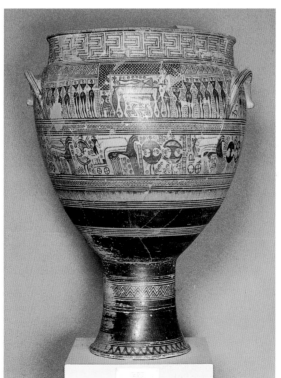

27 Sepulchral Vase
Attic, second half of 8th c. B.C.
Terracotta; h. 42 5/8 in. (108.3 cm)

This impressive vase was a funerary monument, the construction of the interior allowing for offerings to be poured to the deceased. The primary scene shows the deceased flanked by his household and mourners. The zone below, with warriors and chariots, suggests the dead man's chief pursuits in his lifetime. Because of the schematic rendering of the figures and the character of the ornament, this style of early Greek painting is called "geometric." *Rogers Fund, 1914, 14.130.14*

29 Trefoil Oinochoe (Wine Jug)

Corinthian, ca. 625 B.C.
Terracotta; h. 10¼ in. (26 cm)

Some of the finest vases in the seventh century B.C. were made and painted in Corinth. The black-figure technique, which was invented there, enlivened the black silhouettes of figures by incised lines and added colors. This oinochoe is remarkably articulated. The animals and monsters are confined to a narrow zone in the middle of the vase. The sloping shoulder is given over to a scale pattern, and rosettes are painted in white on the neck and the mouth. The painter was obviously concerned with the overall appearance of the vase and the proper balance of dark and light areas. *Bequest of Walter C. Baker, 1971, 1972.118.138*

28 Black-Figured Amphora: Combat Between Herakles and the Centaur Nessos

Attic, second quarter of 7th c. B.C.
Terracotta; h. 42¾ in. (108.6 cm)

The chief picture on this very large funerary vase depicts the combat between Herakles and the centaur Nessos. Herakles has seized the centaur by his hair and holds his sword at the ready. The centaur has let go of his weapon, a tree trunk, and sinks to his knees, pleading for mercy. The chariot of Herakles stands by. On the shoulder two horses graze peacefully, and on the neck a panther attacks a deer. As often in early archaic art, ornaments fill the background. They also frame the narrative frieze above and below and come into their own on the back of the vase, which is devoid of figures. *Rogers Fund, 1911, 11.210.1*

30 Kylix (Wine Cup)

Laconian, ca. 550 B.C. (found at Sardis)
Terracotta; h. 5 in. (12.7 cm), diam. 7⅜ in. (18.8 cm)

Laconian pottery was at its prime in the sixth century B.C. and was widely exported. This drinking cup was found in a tomb at Sardis, the capital of Lydia, together with Attic and Lydian vases; it is attributed to the manner of the Arkesilas Painter. The offset rim of the vase is decorated both on the inside and on the outside with ornaments, as are the outside of the bowl and the upper part of the stem. The figured decoration is limited to the tondo that displays a majestic sphinx. *Gift of the Subscribers to the Fund for Excavations at Sardis, 1914, 14.30.26*

31 Vase

Greek, late 6th–early 5th c. B.C.
Faience; h. 2⅛ in. (5.4 cm)

During the sixth century B.C., several Greek centers produced small vases in the form of human figures, animals, or mythological creatures. This extraordinary example, which may have contained cosmetics or medicinal preparations, consists of two pairs of heads conjoined, those of a young woman and a howling demon, those of a lion and a Negroid youth. The piece may have been made in Rhodes, where craftsmen were exposed to the Egyptian technique of faience, as well as Near Eastern iconography. *Classical Purchase Fund, 1992, 1992.11.59*

32 NIKIAS (potter), Attic, mid-6th c. B.C.
Black-Figured Panathenaic Prize Amphora: Athena Polias

Terracotta; h. as restored (the foot is modern) 24⅜ in. (61.9 cm)

The composition on the obverse (illustrated here) is traditional in that it shows the statue of Athena Polias; the reverse shows three men sprinting. The amphora is inscribed: FROM THE PRIZES AT ATHENS and STADION RACE OF MEN. (The stadion was a race of nearly two hundred yards.)

Panathenaic vases were first created in the second quarter of the sixth century B.C. and continued well into Roman times. This amphora is among the earliest of those dated between 566 and 550 B.C., a period of some experimentation. The ornaments on neck and shoulder and the placement of the official prize inscription did not become established until the last quarter of the sixth century; in the early group no two amphorae are alike in these details. The prize vases were filled with oil from the sacred olive grove; each amphora holds one metretes (39.312 liters), which dictated a fairly uniform height. The presence of a potter's signature is rare, but not unique, though the potter Nikias is not known from any other vase. *Classical Purchase Fund, 1978, 1978.11.13*

33 LYDOS (painter), Attic, ca. 550 B.C.
Black-Figured Krater: The Return of Hephaistos

Terracotta; h. 22 in. (55.9 cm)

This mixing bowl of impressive proportions offered the artist a broad surface to depict Hephaistos being escorted to Mount Olympus by Dionysos and his retinue of satyrs and maenads. Lydos conveys the exuberance of the procession so vividly that one can almost hear it.

The black-figure technique of vase painting, invented in Corinth, was perfected in Attica, and by the mid-sixth century B.C. Attic vases began to eclipse those made in other centers. Distinct styles emerged, and the development of individual artists can be observed. Some names of vase painters are known from their signatures; others remain anonymous and have been given names of convenience. Among the painters of Attic black-figured vases of the sixth century, Kleitias, Lydos, the Amasis Painter, and Exekias can be singled out as leaders, and all four are represented in the Museum. *Fletcher Fund, 1931, 31.11.11*

34 Lekythos (Oil Jug)
Attic, ca. 550 B.C. (said to be from Vari)
Terracotta; h. 6¾ in. (17.1 cm)

Lekythoi were used for oil and are often found
in tombs. This lekythos is attributed to the
Amasis Painter. It may have been the property
of a woman, as it shows several women and
girls working wool—from spinning and carding
to weaving and folding the finished cloth. On the
shoulder girls dance on either side of a seated
woman or goddess flanked by two standing
youths.

Another lekythos by the Amasis Painter was
acquired by the Museum in 1956. It is not only
very close in shape, size, style, period, and
scheme of decoration but also shares with this
one the dancing girls on the shoulder. There the
chief subject is a wedding procession, and it is
tempting to think that the two vases were made
for the same lady. *Fletcher Fund, 1931, 31.11.10*

35 EXEKIAS (painter), Attic, ca. 540 B.C.
**Black-Figured Neck-amphora with Lid: On
Each Side, Wedding Procession in a Chariot**
Terracotta; h. 18½ in. (47 cm)

Exekias is one of the greatest Attic black-figure
vase-painters, and this neck-amphora, or stor-
age jar for wine or oil, is one of his finest works.
A wedded pair in a chariot is greeted by a woman
(or a goddess), while a youth, perhaps Apollo,
plays the kithara: the procession is about to
start, led by the boy in front of the horses.
The subject on the reverse is similar but with-
out the boy; the kithara player is replaced by
an old man or king. *Rogers Fund, 1917,
17.230.14ab, and Gift of J. D. Beazley, 1927,
27.16*

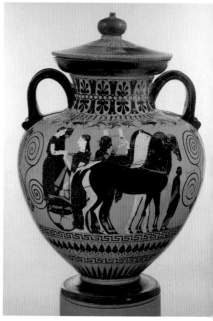

36 ANDOKIDES PAINTER, Attic, ca. 530 B.C.
**Red-Figured Amphora: Herakles and Apollo
in the Struggle over the Delphic Tripod**
Terracotta; h. 22⅝ in. (57.5 cm)

Shortly after 530 B.C. the black silhouettes of
the black-figured technique are replaced by
figures left the color of the clay, which on firing
turns orange-red. These figures are set against
a black background. Details are painted in glaze
lines, and the added opaque colors, white and
purple, are used only sparingly. The new tech-
nique appears first on vases by an anonymous
painter called the Andokides Painter, since some
of his works, like this amphora, are signed by
Andokides as potter.

The struggle for the Delphic tripod also oc-
curs on the pediment of the Siphnian treasury
at Delphi with which many of the vases by the
Andokides Painter are connected stylistically.
As the dates of the Siphnian treasury are known
approximately (ca. 530–525 B.C.), we thus have
a reasonably accurate date for the beginning of
Attic red-figure. *Purchase, Joseph Pulitzer
Bequest, 1963, 63.11.6*

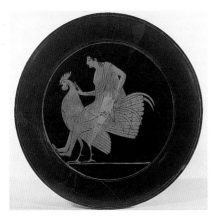

37 EPIKTETOS (painter), Attic,
act. ca. 520–510 B.C.
Red-Figured Plate: Boy on a Rooster
Terracotta; diam. 7 3/8 in. (18.7 cm)

This plate, signed by Epiktetos as painter, shows the rare subject of a boy perched on a rooster, his toes braced against the framing line, reserved in red, of the tondo border. It was found in Vulci on the property of Lucien Bonaparte, prince of Canino, in 1828, and twenty years later passed into the collection of the second marquess of Northampton at Castle Ashby, where it remained until 1980. The plates by Epiktetos are all by the same potter and differ from other contemporary plates in that they are not equipped with two holes on the rim for suspension. Nine complete plates by Epiktetos are known (of which two are now lost), as are fragments of three others. *Purchase, Classical Purchase Fund, and Schimmel Foundation Inc. and Christos G. Bastis Gifts, 1981, 1981.11.10*

38 EUPHRONIOS (painter),
EUXITHEOS (potter), Attic, ca. 515 B.C.
Red-Figured Calyx-krater: Sleep and Death Lifting the Body of Sarpedon
Terracotta; h. 18 in. (45.7 cm)

If the amphora by the Andokides Painter (no. 36) may count as the earliest vase in the red-figure technique, this krater signed by Euxitheos as potter and by Euphronios as painter demonstrates how in less than half a generation the new technique had been explored and mastered. Diluting the black glaze introduces new subtleties: the hair of Sarpedon is reddish-brown, lighter than the hair and beard of Sleep (on the left). Muscles and tendons can now be faithfully rendered, and foreshortenings pave the way to an understanding of corporeal perspective. This krater is a masterpiece of composition, in full harmony with the requirements of the shape, in its movement of heads, arms, and legs, framed by the two guards that flank the scene. The alternation of black and red is carefully balanced and extends even to the pattern work on the rim and to the area below the picture frieze. All the figures are inscribed, their names painted in added red, as are the artists' signatures. *Purchase, Bequest of Joseph H. Durkee, Gift of Darius Ogden Mills and Gift of C. Ruxton Love, by exchange, 1972, 1972.11.10*

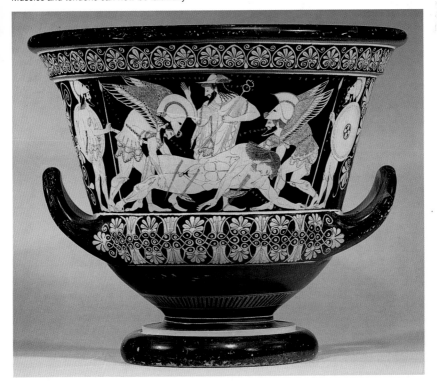

39 EUTHYMIDES (potter), Attic, ca. 510 B.C.
Red-Figured Oinochoe (Wine Jug): The Judgment of Paris
Terracotta; h. as preserved 6⅜ in. (16.2 cm)

Here, as often in archaic art, Paris is shown running away in an effort to avoid judging which of three goddesses—Hera, Athena, and Aphrodite—is the most beautiful. Hermes restrains the Trojan prince by seizing his lyre and is followed by the three goddesses. Behind them Iris approaches, together with a seventh figure, Peitho, who rushes up. Though there are many gaps (only the heads of Athena, Aphrodite, and Iris are fully preserved), the drawing is extremely skillful, with great emphasis on the rich garments and on subtle variations in stance and gesture. Euthymides, whose name appears as the incised potter's signature on the foot, is otherwise known only as the friendly rival of Euphronios (no. 38). *Purchase, Leon Levy Gift and Classical Purchase Fund, 1981, 1981.11.9*

40 BERLIN PAINTER, Attic, ca. 490 B.C.
Red-Figured Amphora: Youth Singing and Playing the Kithara
Terracotta; h. 16⅜ in. (41.6 cm)

In the days of Euphronios (no. 38), it was discovered that single figures gain much by not being framed but by letting the black background merge with the black of the body of the vase itself. This youthful citharoedus thus appears spotlighted against a darkened stage formed by the entire vase. The swaying figure of a young performer is the most impressive picture of ancient music that has come down to us and makes us regret the more that Greek music, like Greek painting, has been almost completely lost. *Fletcher Fund, 1956, 56.171.38*

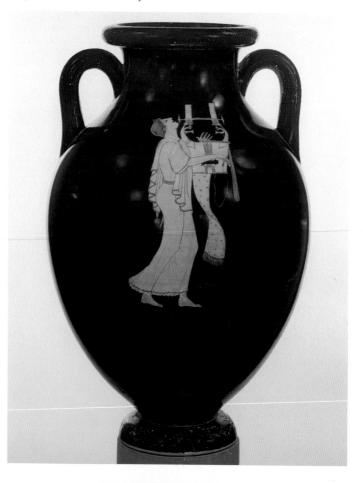

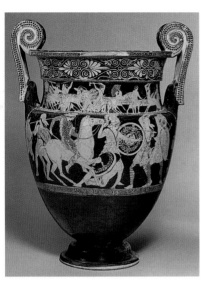

41 Volute-krater (Bowl for Mixing Wine and Water)
Attic, ca. 450 B.C.
Terracotta; h. 25 in. (63.5 cm)

The principal scenes on this volute-krater are the battle of Greeks and Centaurs at the wedding of Perithous (on the neck of the obverse) and the battle of Athenians and Amazons (on the body). Both subjects appear to reflect the great artistic creations of the middle of the fifth century: the sculptures of the west pediment of the temple of Zeus at Olympia and the wall paintings by Mikon in the Theseion and in the Painted Porch at Athens. The wall paintings are totally lost, but a score of contemporary Attic vases, unusually ambitious in their compositions if not always exceptionally well drawn, help us to visualize Mikon's great paintings. This volute-krater is attributed to the Painter of the Woolly Satyrs. *Rogers Fund, 1907, 07.286.84*

42 PENTHESILEA PAINTER, Attic, ca. 465–460 B.C.
Pyxis (Cosmetic Box) with Lid: The Judgment of Paris
Terracotta; h. with cover 6¾ in. (17.1 cm)

The drawing on this pyxis is contemporary with the beginning of mural painting in Athens. Covering part of the vase with a white slip had been an Attic innovation half a century earlier, but polychromy (within the range of the ceramic colors) had not previously been attempted. Thus most conventional vase paintings resemble colored drawings, and it is almost impossible to speak of brushwork. Here, however, in such details as the rock on which Paris sits, outline drawing gives way to an imaginative rendering done exclusively with the brush. Some time-honored conventions are retained, such as the common groundline and the avoidance of overlap in the composition. *Rogers Fund, 1907, 07.286.36*

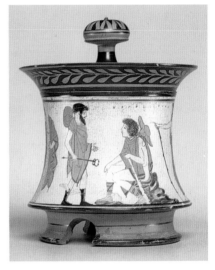

43 Column-krater (Bowl for Mixing Wine and Water): The Painting of a Marble Statue
Early Apulian, first quarter of 4th c. B.C.
Terracotta; h. 20¼ in. (51.5 cm)

That Greek marble statues were not left as white as plaster casts but were tinted or painted is well known from ancient authors and from surviving sculptures, chiefly of the archaic period. This South Italian vase is unique in that it illustrates exactly how the paint was applied in what is called the encaustic technique. A statue of Herakles is about to be painted, and we observe the artist applying his emulsion of pigment and wax to the surface of the lion skin. After application, the painted surface was gone over with a red-hot iron so that the molten paint penetrated the stone. To the left of the statue an assistant or slave is heating several such rods in a charcoal brazier. Unbeknown to the artist who applies the finishing touches, Herakles himself approaches with an expression of critical curiosity. Zeus and Nike, seated above, complete the scene. *Rogers Fund, 1950, 50.11.4*

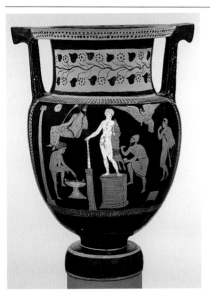

44 Scaraboid Gem: Archer Crouching, Testing His Arrow
Greek, late archaic period, ca. 500 B.C.
Chalcedony; 21/32 × 9/16 × 9/32 in.
(1.6 × 1.4 × 0.7 cm)

This gem shows in masterly fashion the accomplishment of late archaic Greek art. The anatomy is fully understood and rendered correctly in spite of the difficult foreshortening. On the evidence offered by another chalcedony scaraboid in Boston, signed by Epimenes, this archer gem has been attributed to the same master, who was an Ionian, as the letter forms and the trappings on the horse of the Boston gem indicate. *Fletcher Fund, 1931, 31.11.5*

45 Head of a Sphinx
Corinthian, ca. 500 B.C.
Terracotta; h. 8⅛ in. (20.6 cm)

Most terracotta sculptures of the archaic and classic periods that are known today are either architectural adjuncts or small votive figurines found in sanctuaries and graves. That the Greeks, however, were equally good at making freestanding life-size terracotta statues has only recently become known thanks to excavations, especially in Corinth and at Olympia. This very fine female head is a Corinthian work as can be ascertained by the clay. It is slightly under life-size, but not out of scale when we think of it as a head of a sphinx that was shown seated. This would also explain the very pronounced angle at which the hair falls in back in a compact mass, without indication of locks or tresses. *Rogers Fund, 1947, 47.100.3*

46 The Ganymede Jewelry
Greek, late 4th c. B.C. (said to have been found in a tomb near Salonica)
Four gold fibulae: h. 1⅝ in. (4.1 cm); pair of gold earrings: h. 2⅛ in. (5.4 cm); pair of rock-crystal bracelets with gold ram's-head finials: h. 3 in. (7.6 cm); gold ring with emerald: h. ⅞ in. (2.2 cm); gold necklace: l. 13 in. (33 cm)

This very rich parure, presumably that of a woman, was found together in Macedonia sometime before 1913. These objects are among the finest pieces of Macedonian jewelry known. The pair of gold earrings belongs to a very small class of superbly crafted examples that have sculptural pendants. Although both show Zeus, in the guise of an eagle, carrying off Ganymede, the earrings are not identical. In one the head of Ganymede is turned to the left; in the other it is turned to the right. The upper part of each earring, hiding the loop, is decorated with acanthus palmettes. Equally rare is the pair of rock-crystal bracelets, which terminate with gold finials of ram's heads with much detailed ornamentation on the cuffs. The rock crystal is grooved spirally, with a fine gold wire running along the groove. *Harris Brisbane Dick Fund, 1937, 37.11.8–17*

47 Phiale (Libation Bowl)

Greek, 4th c. B.C.

Gold; diam. 9¹⁄₄ in. (23.5 cm), h. 1³⁄₈ in. (3.6 cm)

Libations were one of the most common religious rituals, and many contemporary representations of these ceremonies are preserved (on painted vases, for example). The offering was poured from a phiale, a special type of shallow bowl that fits comfortably into the palm of the hand and has a hollow in the center for the fingers. Such bowls are known mainly from examples in clay, bronze, and silver, and this is one of only five Greek phialai of gold. It is decorated with three concentric rows of acorns and one of beechnuts; in the interstices appear bees and highly stylized filling motifs. It is of Greek workmanship but, interestingly, has incised on the underside a weight inscription in Carthaginian letters. One can imagine its being the prized possession of a Carthaginian living in or trading with a Greek community. *Rogers Fund, 1962, 62.11.1*

48 Silver Treasure

Hellenistic, first quarter of 4th c. B.C.

Two deep bowls, three drinking cups with emblemata, a skyphos, a hemispherical bowl, an oinochoe, a phiale, a ladle, a small portable altar, a pyxis, an emblema, and two horns (perhaps from a helmet)

This rich treasure, acquired in two lots, should on the analogy of the famous Rothschild treasure be attributed to a Tarentine workshop of the early Hellenistic period. There is much gilding, and the stylistic unity of the objects is proved by the various figural adjuncts. The three theatrical masks that serve as feet of the two deep bowls (probably wine coolers) are echoed in the mask below the handle of the small oinochoe, and the ornaments of the drinking cups recur on the small altar. Perhaps the finest object in this hoard is the parcel gilt relief of the sea monster Scylla, who raises her arms to throw an enormous boulder at an unsuspecting seafarer. Of her three canine adjuncts that leap from her hips, two are feeding on an octopus and a fish, while the third is eyeing a dolphin. The altar, which bears a dedication "to the eight gods," is equipped with interchangeable containers for incense and other offerings. *Purchase, Rogers Fund, Classical Purchase Fund, Harris Brisbane Dick Fund and Anonymous, Mrs. Vincent Astor, Mr. and Mrs. Walter Bareiss, Mr. and Mrs. Howard J. Barnet, Christos G. Bastis, Mr. and Mrs. Martin Fried, Jerome Levy Foundation, Norbert Schimmel, and Mr. and Mrs. Thomas A. Spears Gifts, 1981–82*

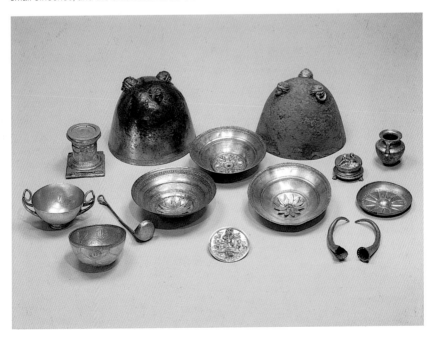

detail

49 Woman Playing the Kithara
Roman, Boscoreale, 40–30 B.C.
Wall painting; 73½ × 73½ in.
(186.7 × 186.7 cm)

This painted panel, together with those exhibited beside it, comes from a villa near the town of Boscoreale. The figures painted on this section of the wall are a woman seated on a throne and a little girl standing beside her. The identities of these figures and those on the other panels from the villa's largest room have long been the subject of debate. They may be associated with Aphrodite and Adonis but are more likely members of the Macedonian royal family from the third century B.C. (See also no. 50.) *Rogers Fund, 1903, 03.14.5*

50 Cubiculum from Boscoreale
Roman, 40–30 B.C.

The Museum possesses the greatest assembly of Roman paintings to be seen outside Italy. One set includes most of the paintings from a villa at Boscoreale, about a mile north of Pompeii. Like Pompeii, the villa was buried by the eruption of Mount Vesuvius in A.D. 79, and it is for this reason that the paintings survived relatively intact. Among the paintings from Boscoreale is this complete bedroom decorated with rustic scenes and with complex architectural vistas that recall stage settings. (See also no. 49.) *Rogers Fund, 1903, 03.14.13*

51 Polyphemus and Galatea
Mid-Augustan, ca. 11 B.C.
Wall painting; 73¾ × 47 in. (188 × 119 cm)

The villa at Boscotrecase from which this wall
panel comes belonged to the immediate family
of the emperor Augustus and was decorated by
the foremost artists of the day. The mythological
pictures, of which two are preserved, are partic-
ularly evocative because they depict Greek
myths in the same landscape of vegetation,
rocks, sea, and sky that existed around the Bay
of Naples. *Rogers Fund, 1920, 20.192.17*

Animal Rug
Turkish, 14th century
*Wool pile on wool foundation; 60¼ x 49½ in.
(153 x 125.7 cm)*

No group of Oriental carpets has aroused as much interest as the early animal rugs of Anatolia. Popular in Europe in the fourteenth and fifteenth centuries, numerous versions were depicted in fourteenth- and fifteenth-century paintings, especially Italian ones. The style, however, seems to have fallen out of fashion by the end of the fifteenth century.

This animal rug, with its bold coloring and highly stylized design, conforms to the general characteristics of this small group. Four stylized quadrupeds—forelegs raised, jaws agape, and antenna-like tails projecting upward—confront each other in pairs. Each one contains a smaller animal. They have little striped collars and colored toes. Snapping at the air, they perform a lively dance, the symmetry of which is pleasingly disturbed by the different ground color within the beast at the upper right. *Purchase, Harris Brisbane Dick Fund, Joseph Pulitzer Bequest, Louis V. Bell Fund and Fletcher, Pfeiffer, and Rogers Funds, 1990, 1990.61*

ISLAMIC ART

Islam, the religion founded by Muhammad in A.D. 622, spread in succeeding generations from Mecca in Arabia to Spain in the west and to India and Central Asia in the east. The Museum's collection of Islamic art, which dates primarily from the seventh to the nineteenth century, reflects the diversity and range of Islamic culture. In 1891 the Museum received its first major group of Islamic objects, a bequest of Edward C. Moore. Since then the collection has grown through gifts, bequests, and purchases; it has also received important artifacts from the Museum-sponsored excavations at Nishapur, Iran, in 1935–39 and 1947. The Museum now offers perhaps the most comprehensive exhibition of Islamic art on permanent view anywhere in the world. Outstanding holdings include ceramics and textiles from all parts of the classical Islamic world, as well as glass and metalwork from Egypt, Syria, Mesopotamia, and Persia, royal miniatures from the courts of Persia and Mughal India, and classical carpets from the sixteenth and seventeenth centuries. An early-eighteenth-century room from Syria completes the complex of galleries and study areas. Small temporary exhibitions are presented in The Hagop Kevorkian Fund Special Exhibitions Gallery.

1 Ewer

Iranian, 7th c.
Bronze, originally inlaid; greatest h. 19⅛ in. (48.5 cm)

Early Islamic metalwork developed under the influence of the pre-Islamic traditions of the ancient Near East and those of the late classical eastern Mediterranean world. This ewer's shape, graceful elongated feline handle, and decoration were inherited from the art of the pre-Islamic Sasanian dynasty of Iran and that of the preceding Parthian period. The repetitive rhythm of its decoration, probably based on stylized landscape and plant motifs, reflects an Islamic approach to design. Although the ewer is made of bronze, its size and elegant form suggest that it is an object of luxury. *Fletcher Fund, 1947, 47.100.90*

2 Bowl

Iraqi, Abbasid period, 9th c.
Earthenware, glazed and luster-painted; diam. 7¾ in. (19.7 cm)

The technique of luster painting on pottery was one of the greatest contributions of Islamic ceramists to pottery decoration. In this extremely difficult process, silver and copper oxides, each mixed with a medium, were used to paint designs on a vessel already covered with an opaque glaze and fired. During a second firing in a reducing kiln, oxygen was drawn out of the metallic oxides, leaving the metal suspended on the surface to refract light and create a lustrous appearance. Shades of green were obtained from silver and those of brown from copper.

Originating as a means of decorating glass, luster painting was first employed on pottery in ninth-century Iraq. This innovation had a permanent influence on the pottery industry in general, passing from Iraq to Egypt, North Africa, Syria, Iran, and Spain, and from the Islamic world to Italy, England, and America. On this bowl, which exhibits the polychrome scheme found only in the ninth century, the influence of Roman and contemporary Samarra millefiori glass is evident in the gridlike decoration as well as in several of the motifs. *Rogers Fund, 1952, 52.114*

3 Koran Leaf

Egyptian, 9th c.
Ink, colors, and gold on parchment; l. 13⅛ in. (33.3 cm)

Despite its great variety, Arabic calligraphy can be reduced to two basic categories: the angular scripts, usually called Kufic (after the town of Kufa in Iraq, where such scripts may have first been put to official use), and the cursive scripts.

A handsome example of Kufic from the ninth century—one of Arabic calligraphy's very finest periods—is this Koran page, which typifies the imposing grandeur and reverence for the written word that calligraphers succeeded in giving the text. The style's horizontality, austerity, and formality are emphasized by monumental scale: not untypically, the whole top line is formed by a single compound word. Other examples of the period have as few as three lines on the page.

The text is written on parchment, which was supplanted in the East by paper in the tenth century. The vowel marks are red, yellow, and green dots; some diacritics are in the form of red diagonals, and the tenth-verse marker in the margin is a triangle of six gold dots. *Gift of Professor R. M. Riefstahl, 1930, 30.45*

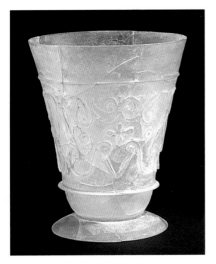

4 Beaker

Iranian or Iraqi, 9th c.
Glass, free-blown(?) and relief-cut; h. 5⅜ in. (13.6 cm), diam. at lip 5⅝ in. (14.2 cm)

In many respects the glass produced by medieval Muslim craftsmen has never been surpassed. These artists continued pre-Islamic glass traditions as well as developing totally new departures for the medium. One such new technique was used to produce this beaker, whose ornament was created by cutting away the entire outer surface except for the design, which is then in relief. The technique and the design (palmettes, half-palmettes, and floral motifs on two scrolls between two horizontal ridges) bear a close resemblance to early Islamic carved rock crystal. In size, preservation, and fineness, this piece has few parallels in Islamic relief-cut glass. *Purchase, Rogers Fund and Jack A. Josephson, Dr. and Mrs. Lewis Balamuth, Mr. and Mrs. Alvin W. Pearson Gifts, 1974, 1974.45*

5 Bowl

Iranian or Transoxianan, Nishapur or Samarkand, 10th c.
Earthenware, slip-painted and glazed; diam. 18 in. (45.7 cm)

Because of the sacred aspect of the Arabic language and the design potential of its various scripts, the use of calligraphy as a decorative element is prominent in all periods of Islamic art and in all media—on both secular and religious objects and buildings.

Perhaps the most outstanding examples of the use of calligraphy on pottery are to be found among wares from Nishapur and Samarkand. Now a small town, in the tenth century Nishapur was one of the great centers of Islamic art (it was totally destroyed by Mongol invaders in the early thirteenth century). The finest Nishapur ceramics were the slip-painted wares on which elegantly painted Arabic inscriptions are the main and frequently the only decoration. This bowl (the largest and among the finest in the collection) bears an inscription in Kufic script stating: "Planning before work protects you from regret; prosperity and peace." *Rogers Fund, 1965, 65.106.2*

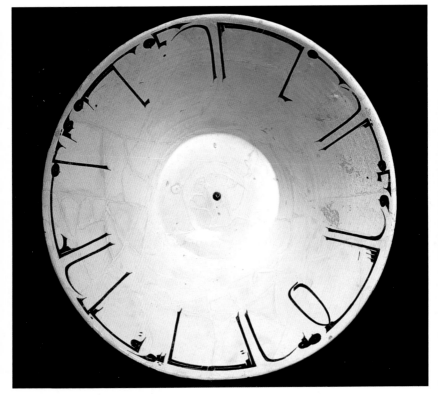

6 Textile Fragment Probably from a Shawl
Yemeni, 10th c.
*Cotton with gilded inscription; 23 × 16 in.
(58.4 × 40.6 cm)*

In the early and medieval periods textile production in Islamic lands was largely in the hands of factories controlled by the caliph. Textiles and garments manufactured for use or wear at court or for presentation by the ruler bore the mark of sovereignty, an inscription giving the sovereign's name. Such inscribed textiles are known as tiraz, from the Persian word for embroidery. This textile fragment, probably from a shawl, is typical of a type of tiraz produced in Yemen in the tenth century. The pattern results from the ikat technique, in which bundles of warp threads are resist-dyed before weaving and then arranged on the loom to form the pattern of arrowheads and diamonds. A gilded inscription, stylized with plaiting and floriation nearly to the point of illegibility, was painted on the woven fabric. *Gift of George D. Pratt, 1929, 29.179.9*

7 Pendant
Egyptian, Fatimid period, 12th c.
Gold, enamel, and turquoise; h. 1¾ in. (4.4 cm)

The school of art centered in Egypt during the reign of the Fatimids from Cairo (969–1171) is noted for a surprising increase in the use of human and animal motifs and for a high level of craftsmanship. The goldwork is especially fine, with elaborate designs constructed in filigree on a gold grid. The use of crescent-shaped ornaments was borrowed by the Fatimids from Byzantine art, as was the technique of cloisonné enamel (employed here for the birds in the center). This pendant would have been framed by strands of pearls or beads of precious or semiprecious stones, laced through the gold hoops around the edge. *Theodore M. Davis Collection, Bequest of Theodore M. Davis, 1915, 30.95.37*

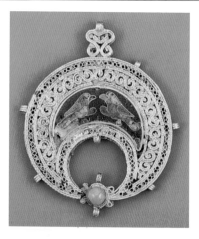

8 Gold Bead
Greater Syrian, 11th c.
Gold; l. 2 in. (5.2 cm), greatest diam. ⅝ in. (2 cm)

The history of Islamic jewelry is a long and illustrious one. The goldwork of the Fatimid period in Syria during the eleventh and twelfth centuries is the most accomplished and decoratively complex group within this history. This biconical bead is one of only two such beads known. Made of filigree on a strip-support, with the paired twisted wires surmounted by grains of more than one size, the bead is covered with beautifully executed leaf scrolls, which unroll themselves along each of the bead's five sections. *Purchase, Sheikh Nasser Sabah al-Ahmed al-Sabah Gift, in memory of Richard Ettinghausen, 1980, 1980.456*

9 Plaque
Spanish, early 11th c.
Ivory; 8 × 4¼ in. (20.3 × 10.8 cm)

This plaque belongs to a group of eleventh-century ivories made in Spain during the reign of the Umayyad caliphs. Among the dynasty's most outstanding extant artistic achievements, most of these ivories were created for the royal family or its entourage, and many were made in the capital, Cordoba, or in Madinat az-Zahra, the royal residence. Because of the Umayyads'

Syrian roots, it is not surprising that many of the motifs found on these ivories can be traced to that area. The leaf arabesques on this plaque are a stylized version of the vine-and-acanthus scroll so popular in late antique ornament. The prototypes for the animated figures can be found on early Islamic textiles from Syria or Egypt in which birds, animals, and human beings of similar character are also paired on either side of stylized trees.
John Stewart Kennedy Fund, 1913, 13.141

10 Incense Burner
Iranian, 1181/82
Bronze, pierced and incised; l. 33½ in. (85.1 cm), h. 31½ in. (80 cm)

This unusually large and noble metal animal sculpture in the form of a lion belongs to a small group of incense burners with similar forms and shapes. The head is removable so that the in-

cense can be placed inside, and the arabesque interlace on the body and neck is pierced to allow the aroma to escape. The Arabic inscriptions in Kufic script on the various parts of the animal as well as on three bosses provide the name of the emir who commissioned the work, its artist, and the date. *Rogers Fund, 1951, 51.56*

11 Armlet

Iranian, first half of 11th c.
Gold sheet with applied twisted gold wire and granulation, originally set with stones; greatest diam. 4⅛ in. (10.5 cm), h. at clasp 2 in. (5.1 cm)

The pivotal pieces for the study of early medieval jewelry in Iran are this armlet and its mate in the Freer Gallery of Art, Washington. Here each of the four hemispheres flanking the clasp bears at its base a flat disk of thin gold that was decorated by pouncing it over a coin bearing the name of the Abbasid caliph al-Qadir

Billah (991–1031). There are a large number of extant bracelets in both gold and silver that are analogous to this pair, although none is as fine or as elaborate.

Pre-Islamic jewelry forms can be seen in these bracelets, indicating continued conservatism and traditionalism in the art. Examples of coins and imitation coins on jewelry are quite numerous in the Byzantine period. The twisted effect of the shank must ultimately derive from Greek bracelets with similar shanks.
Harris Brisbane Dick Fund, 1957, 57.88a–c

12 Ewer

Iranian, Khorasan, early 13th c.
Bronze, silver, and gold; h. 15½ in. (39.4 cm)

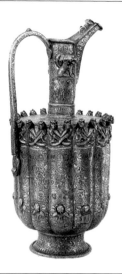

This outstanding example of bronze inlaid with gold and silver from the Seljuq period in Iran (1037/38–1258) epitomizes the fine metal workmanship characteristic of that time. The body of the ewer, which is covered with an elaborate interlace design with animal-headed terminals, is divided into twelve lobes, each topped by a pair of crowned harpies. Near the center of each lobe is a medallion enclosing a sign of the zodiac, generally shown with its ruling planet; the other motifs seem to reflect and support the astrological theme.

Several inscriptions on the shoulder and neck—all but one executed in Naskh (cursive) letters whose elongated ends are in the shape of human heads—express good wishes to the owner, a common theme of the epigraphic decoration on Islamic metalwork in all periods.
Rogers Fund, 1944, 44.15

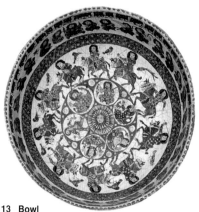

13 Bowl

Iranian, 12th–13th c.
Composite body, stain- and overglaze-painted and gilded; diam. 7⅜ in. (18.7 cm)

In an attempt to increase the number of colors in their palettes, twelfth-century Iranian potters developed a technique now known as *mina'i* (enameled), in which stable colors were stain-painted in a lead glaze opacified with tin and, after a first firing, less stable colors were applied and the object was refired at a lower temperature. This technique enabled the artist to paint in a greater variety of colors with complete control, lending a miniature-like quality to the designs not found on other pottery types. Whether for practical or aesthetic reasons, this method was relatively short-lived.

In this brightly painted ceramic bowl, an enthroned ruler and his retinue of attendants, musicians, and mounted falconers surround the central astrological design, which augurs good fortune for its owner. *Gift of the Schiff Foundation and Rogers Fund, 1957, 57.36.4*

14 Bowl

Iranian, Rayy, late 12th–early 13th c.
Composite body, glazed and luster-painted; diam. 8 in. (20.3 cm)

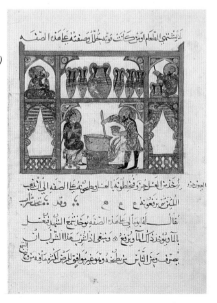

Starting from around the time of the collapse of the Fatimid dynasty in 1171, luster-painted ware appeared in Iran as well as in Spain and Syria. While it seems quite certain that migrating Egyptian potters were responsible for bringing the technique to the latter two countries, their role in the appearance of luster-painted ware in Iran is less clear. Among the reasons given to support a connection between Egyptian and Iranian luster, particularly that from Rayy, are certain features characteristic of both wares, such as a central design reserved on a lustered ground, seen on this bowl from Iran, dated to the late twelfth to early thirteenth century. This feature, in addition to the monumental quality of the design and the clear distinction between foreground and background, is typical of pot-tery attributed to Rayy prior to its destruction by the Mongols in the 1220s. *Rogers Fund, 1916, 16.87*

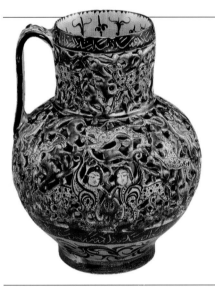

15 Ewer

Iranian, Kashan, 1215/16
Composite body, painted and glazed; h. 8 in. (20.3 cm)

In the early medieval period faience was re-discovered in an attempt to imitate the appearance of Sung porcelain. Once re-discovered, the white composite body was soon being used by Islamic ceramists as a ground for painted designs that exhibited greater linear and tonal variety than could have been achieved before.

Surely one of the most beautiful examples of underglaze-painted ware made by Muslim ceramists is this double-walled ewer. The design includes pairs of winged sphinxes and harpies, together with deer, dogs, and hares, on a ground of carved and pierced arabesques. Persian inscriptions surround the neck and lower body above a border of willow reeds. *Fletcher Fund, 1932, 32.52.1*

16 The Preparation of Medicine from Honey

Late Abbasid period, Baghdad, page from a manuscript dated A.H. 621/A.D. 1224
Ink, colors, and gold on paper; page 13 × 9⅝ in. (33 × 24.1 cm), painting 5¼ × 6⅞ in. (13.3 × 17.5 cm)

This miniature painting illustrates a pharmacist preparing a medicine whose main ingredient is honey. The interior space is indicated by red frames, arches, and is seen front-ally as on a stage. A seated youth watches over the preparation of the medicine while, on the second floor, a man drinks some drug and an-other stirs the liquid in a jar. The illustration, although influenced by Byzantine manuscripts, is a genre scene in the best tradition of Arab painting. This page comes from a dispersed manuscript, an Arabic translation of a Greek treatise commonly known as *De Materia Medica* by the first-century A.D. botanist Dioscorides. *Cora Timken Burnett Collection of Persian Miniatures and Other Art Objects, Bequest of Cora Timken Burnett, 1957, 57.51.21*

17 Jug

Syrian, probably Raqqa, Ayyubid period,
late 12th–early 13th c.
*Composite body, painted and glazed; h. 7 ⅜ in.
(18.7 cm)*

This jug is decorated in cobalt blue and brown
luster painting over a white slip, which has been
successively coated with a transparent glaze.
The tall foot on which it stands is left white,
while the main decoration on the body consists
of four medallions filled with a geometric pat-
tern and separated by large pseudo-vegetal
patterns, all set on a background of minute spi-
rals in reserve in luster over the white slip. An
inscription in cobalt blue in cursive script
(Naskh) runs around the neck; it conveys good
wishes. The contrast of brown luster and cobalt
blue over the white color is typical of the pottery
production of the late twelfth to early thirteenth
century in northern Syria. These objects are
usually attributed to the town of Raqqa, al-
though other nearby centers were active at the
time. The pseudo-vegetal pattern and the spiral
background recall similar compositions in luster
found on Persian pottery of the early thirteenth
century. The Persian and the Syrian productions
have much in common, but the use of cobalt
blue did not enter the Persian repertoire until
later in the thirteenth century. *H.O. Havemeyer
Collection, Bequest of Horace Havemeyer, 1948,
48.113.16*

19 Pair of Doors

Egyptian, Cairo, probably second half of 14th c.
*Wood, inlaid with carved ivory panels;
65 × 30 ½ in. (165.1 × 77.5 cm)*

These doors of wood inlaid with carved ivory,
probably from a minbar (pulpit) in an Egyptian
mosque or madrasah, are outstanding examples
of the high achievement of the Mamluk crafts-
men. "Infinite" geometric design, prominent in
Islamic art from the beginning of its history,
reached its height during the Mamluk period in
Egypt (1250–1517). No other artistic tradition
has approached in number, sophistication, and
complexity the geometric motifs of Islamic art,
nor does any other tradition rival the Islamic in
the importance given to such motifs. The Is-
lamic designer exercised greater freedom and
imagination in his use of geometric structure
than any of his predecessors, and it is this fact,
more than any other, that explains the abun-
dance and diversity of patterns in Islamic art.
*Edward C. Moore Collection, Bequest of Edward
C. Moore, 1891, 91.1.2064*

18 Mosque Lamp

Syrian, Mamluk period, late 13th c.
*Free-blown glass, tooled, applied foot, enameled,
and gilded; h. 10 ½ in. (26.7 cm)*

In the Koran, God's light is likened to "a niche
in which is a lamp, the lamp is in a glass, and
the glass is as it were a brightly shining star."
Because of the vivid simile, this verse was often
placed on the richly enameled mosque lamps of
the Mamluk period. This example bears an in-
scription stating that it was made for the
mausoleum of a Syrian official (d. 1285) who
had served as bowman to the ruler (which ex-
plains the blazon in the roundels). *Gift of J.
Pierpont Morgan, 1917, 17.190.985*

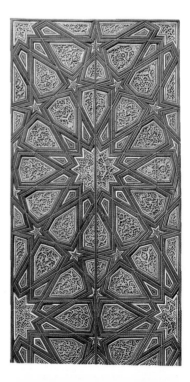

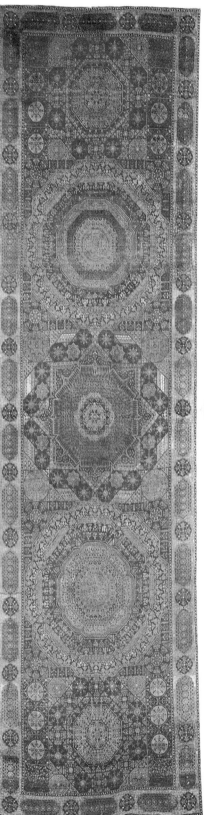

20 Carpet

Egyptian, Cairo, last quarter of 15th c.
Wool (about 100 Senneh knots per sq. in.);
29 ft. 7 in. × 7 ft. 10 in. (9 × 2.4 m)

In fineness, size, and preservation, this carpet is one of the most renowned of its type. Its design is seldom matched in carpets, and its complementary color balance is both subtle and harmonious.

This carpet belongs to a type now recognized not only as Egyptian but also as made in Cairo in the late fifteenth and early sixteenth centuries. The style combines motifs and compositions long out of usage (such as the papyrus plants with umbrella-shaped leaves) with contemporaneous designs. This particular carpet is unique among Mamluk rugs in having five major units. *Fletcher Fund, 1970, 1970.105*

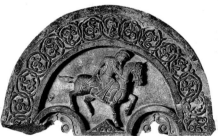

21 Tympanum

Caucasian, probably Kubachi in Daghestan area, first half of 14th c.
Carved stone; 51 × 28¾ in. (129.5 × 73 cm)

This monumental stone tympanum from the Caucasus shows the treatment of the human figure by Iranian artists in the early fourteenth century. The boldness of the relief carving, the naturalness of movement (the horse in mid-stride, the warrior using his whip), and the realism of the warrior's accoutrements are effectively set off by the decorative approach to details and surface patterns. The artist's skill is also apparent in the way the horse and warrior fit into the space: the figures are carved to the correct scale but are not at all cramped by the semicircular shape of the tympanum. *Rogers Fund, 1938, 38.96*

22 Koran Leaf

Iraqi, Baghdad, Mongol period, 1307–8
*Ink, colors, and gold on paper; 14½ × 20³/₁₆ in.
(36.8 × 51.3 cm)*

Ahmad ibn al-Suhrawardi al-Bakri was one of
the six outstanding disciples of Yaqut al-Musta
'ṣimi (d. 1298), who gave the Arabic cursive
scripts their last refinement by cutting the pen
nib obliquely. This style of writing is known as
muhaqqaq. The border text (in Kufic) reads: "It
is written: Baghdad, may God protect her, in the
months of the lunar year 707 [1307–8 A.D.]." The
muhaqqaq text reads:

> Ahmad ibn al-Suhrawardi al-Bakri,
> praising God and blessing His Prophet
> Muhammad and his family and his
> companions, and submitting [himself to God].

The illuminator was Muhammad ibn Aybak.
Rogers Fund, 1955, 55.44

23 Yazdigird I and the Water Horse That Killed Him

Ilkhanid period, early 14th c.
*Leaf from a manuscript; ink, colors, and gold on
paper; 5 × 6¼ in. (12.7 × 15.9 cm)*

The legendary death of the Sasanian king
Yazdigird I—who was said to have been kicked
by a horse that magically emerged from a
spring—is charmingly depicted in this leaf from
a dispersed manuscript of the *Shānāmā* (Book
of the Kings) of Firdawsi. The decoratively curv-
ing tree and the grassy verge of the groundline,
which rings the water, are traditional; the
funguslike growths are derived from Chinese art
and the costumes are Mongol. The gestures of
the figures at the left register astonishment and
dismay. *Cora Timken Burnett Collection of Per-
sian Miniatures and Other Art Objects, Bequest of
Cora Timken Burnett, 1957, 57.51.33*

24 Jonah and the Whale

Iranian, late 14th–early 15th c.
Painting; 12⅝ × 19 in. (32 × 48.1 cm)

One of the most popular prophets in Muslim
tradition was Jonah, and the story of his encoun-
ter with a whale was referred to in the Koran.
This story was retold in Muslim world histories
and was no doubt familiar to the general pop-
ulace. Here the whale, actually a carp, delivers
Jonah to the shore, where a gourd vine, custom-
arily depicted in Western medieval illustrations
of the subject, curves out and over his head.
The waves, made of neatly overlapping arcs,
are, like the fish, based on Chinese prototypes.
The painting, however, is characteristically
Persian, with its bright colors, strong outlines,
striking patterning of the angel's wings, and
decorative arrangement of the flowering plants.
Jonah modestly reaching for the clothes proffered

by the angel reinforces in a tangible manner
the Muslim belief in human dependence on the
will of God in every aspect of life. *Purchase,
Joseph Pulitzer Bequest, 1933, 33.113*

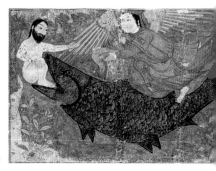

25 Mihrab

Iranian, Isfahan, ca. 1354
Mosaic tile, composite body, painted and glazed, restored; h. 11 ft. 3 in. (3.43 m)

The most important element in any Muslim house of worship is the mihrab, or niche, which indicates the direction of Mecca. Because it is the focal point in the mosque, a great deal of attention has been devoted to its decoration throughout the Islamic world. This superb example, from the Madrasah Imami (theological school) in Isfahan (founded in 1354), is composed of small pieces of ceramic, each fired at a temperature that would bring out the brilliance of the glaze. The pieces were then fitted together to form geometric and floral patterns and inscriptions.

There is a long history of glazed-ceramic architectural decoration in the Near and Middle East. Such decoration was first used in Islamic Iran in the twelfth century, when small, monochrome glazed tiles were set into walls of buildings in a very tentative manner. By the time this mihrab was made, whole walls were being covered with mosaics totally executed in small pieces. This highly exacting phase soon gave way to whole designs painted on larger tiles—a much quicker, easier way to cover large surfaces with patterned glazed ceramics. *Harris Brisbane Dick Fund, 1939, 39.20*

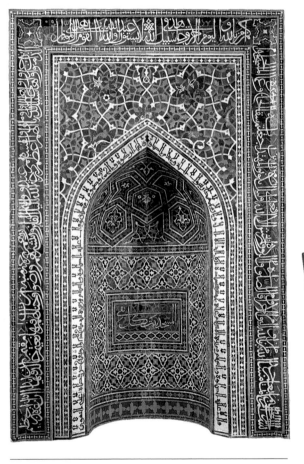

26 Koran Stand

West Turkestan, 1360
Carved wood; h. 51¼ in. (130.2 cm)

The word of God as revealed to his prophet Muhammad is recorded in the Koran, the Muslim holy book. Very large, sumptuous Korans were too difficult to hold, and special stands were built for them. This stand was made by Hasan ibn Sulaymān of Isfahan for a madrasah (theological school), the name of which is partly obliterated in the inscription and the location of which is unknown. The stand's form is derived from a folding chair, and the decoration of the lower section, depicting a mihrab (no. 25), is exquisitely carved on three levels. *Rogers Fund, 1910, 10.218*

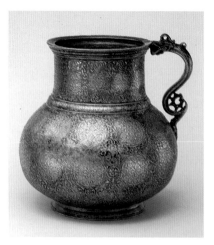

27 Ewer

Iranian, probably Herat, Safavid period, early 16th c.
Brass, inlaid with gold and silver; h. 5½ in. (14 cm)

The arabesque is the most distinctively Islamic of all forms of decoration. Invented and developed in the first centuries of Islam, it was used in a rich variety of forms and patterns in all areas of the Muslim world. Basically, it consists of vegetal ornament inorganically treated—tendrils terminating in bilateral leaves with more tendrils springing from their tips, in an infinite diversity of rhythmic repetitions.

In this Persian jug balanced arabesque designs in medallions punctuate a ground filled with arabesques. These are all inlaid in silver, with gold at the center of the medallions, the inlay shimmering against a brass ground darkened with bitumen. This dense design, with its counterplay of form and ornament, of movement and stability, of glittering and matte surfaces on a pleasing shape, shows the Islamic artist at his most successful. *Edward C. Moore Collection, Bequest of Edward C. Moore, 1891, 91.1.607*

28 Cross Guard

Iranian, Timurid period, 15th c.
Nephrite jade; l. 4⅛ in. (10.5 cm)

Several jade objects of the Timurid period have terminals or handles with dragons' heads. The deep green of the nephrite of this cross guard, a color favored by the Timurids, accentuates the stylized fierceness of the mythical beast. The prototype for this object is found in metalwork of the period. The Timurids were partial to jade objects, and the Mughal rulers of India emulated their Timurid ancestors and made many objects in this hard stone. *Gift of Heber R. Bishop, The Heber R. Bishop Collection, 1902, 02.18.765*

29 Bahram Gur with the Indian Princess in Her Black Pavilion

Iranian, Herat, Timurid period, ca. 1426
Leaf from a manuscript; ink, colors, and gold on paper; 8⅝ × 4⅝ in. (21.9 × 11.7 cm)

This painting illustrates an episode from the story of the Sasanian king Bahram Gur, the great hunter in the romantic epic *Haft Paykar* by the twelfth-century Persian poet Nizami. This miniature exemplifies the classic style of Persian painting, which reached full development in Herat under the patronage of the Timurid prince Bāysunghur. The Timurid school excelled in purity and harmony of colors, delicacy of drawing, fine rendering of pattern and detail, and subtle balance of composition. Here the Persian artist characteristically shows every element in its most easily understood aspect. The pool and the bed are seen from a bird's-eye view, the human figures from a three-quarter view. Throughout there is an exquisite use of patterning. *Gift of Alexander Smith Cochran, 1913, 13.228.13, folio 23b*

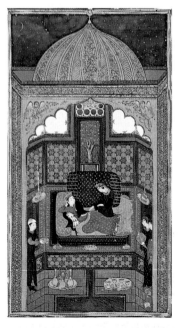

30 The Feast of Sadah

Iranian, Tabriz, Safavid period, ca. 1520–22
Ink, colors, and gold on paper; painting
9¹/₁₆ × 9½ in. (23 × 24.1 cm)

This miniature, from the great *Shānāmā* (Book of the Kings) made for Shah Tahmasp (1514–1576), was painted by Sultan Muhammad, the first of several artists in charge of work on the manuscript. The Feast of Sadah celebrates the discovery of fire by one of the early kings, Hushang. The miniature is in the exuberant style inherited from the Tabriz studio of the White Sheep Turkoman rulers of the late fifteenth century. A number of delightful beasts prowl or rest among the rocks, which in some places take the form of animal and human heads. Tree branches and stumps twist and bend; the picture pulsates with the stirrings of an awakening world. Hushang, with his jeweled wine cup, and his courtiers would appear to be sophisticated Safavids enjoying a picnic, were it not for the leopard- and tiger-skin coats that some of them wear— thus placing them in a time when only animal skins were available as clothing. *Gift of Arthur A. Houghton Jr., 1970, 1970.301.2*

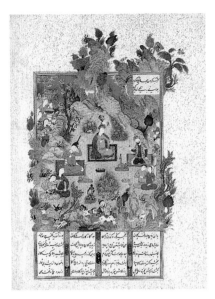

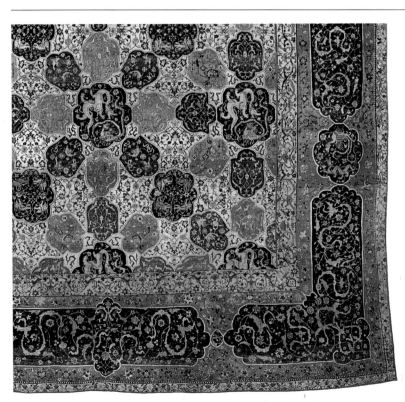

31 Compartment Carpet

Iranian, Tabriz, Safavid period, early 16th c.
Silk and wool (about 550 Senneh knots per sq. in.); 16 ft. 4 in. × 11 ft. 2 in. (4.9 × 3.4 m)

The carpets woven in Safavid Iran have a greater affinity with miniature painting and manuscript illumination than with the angular, textile-like patterns of earlier rugs from this country. In fact, their designs are so close to the art of the book that it seems quite probable that painters were commissioned to execute the patterns for the weavers to follow. This rug was probably made during the period of Shah Isma'il (1502–1524) in the northwestern region of the country. The magnificent jewel-colored carpet, with its elegant, curvilinear "compartments" based on a geometric star pattern, is filled with creatures borrowed from Chinese art, such as the dragon and phoenix, and transformed into the Islamic idiom. While the overall pattern is a continuous repeat, the motifs in one half of the rug form a mirror image of those in the other, so the design is effective when viewed from either end.
Frederick C. Hewitt Fund, 1910, 10.61.3

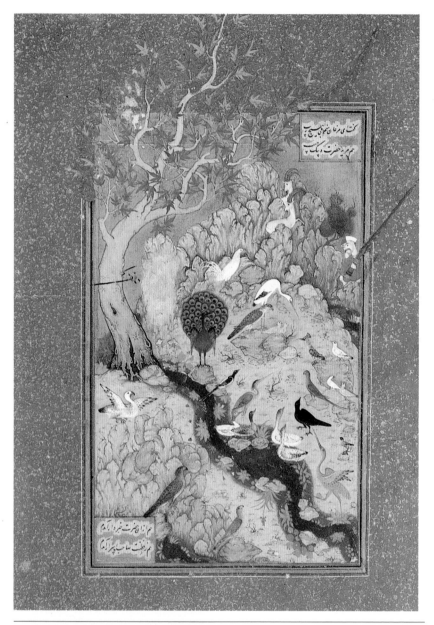

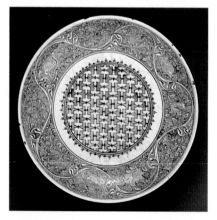

33 Dish

Turkish, Iznik, Ottoman period, ca. 1535–45
Composite body, slip- and stain-painted; diam.
15½ in. (39.4 cm)

The elements found in this unique piece of
blue-and-white Iznik ware were inspired by both
Chinese blue-and-white porcelain and celadon.
The shape, a rimless dish with curved sides,
and the patterns, particularly the interior square
grid and the exterior leaf scroll, have been com-
pared to Chinese models. The square grid,
however, is an Islamic geometric pattern first
found in an eleventh-century tomb tower in Iran
and later all over the Islamic world. The color
scheme, the technical composition of the body,
and the clear white ground and brilliant glaze
show the skills of the Iznik potters. *Bequest of
Benjamin Altman, 1913, 14.10.727*

◄ 32 The Concourse of the Birds

Iranian, ca. 1600
*Ink, colors, and gold on paper; 9¾ × 5½ in.
(24.8 × 14 cm)*

The painters of the School of Bihzad at Herat at
the end of the fifteenth century were unsur-
passed in delicacy of drawing, pureness of
color, and attention to detail. They incorporated
the conventions of Persian painting developed
in the fifteenth century (see no. 29). The innova-
tions of this school were primarily a new
interest in the everyday world coupled with a
keener observation of both man and nature.
When the manuscript of the *Mantiq at-Tayr* (The
Language of the Birds) by the twelfth-century
poet Farid al-din Attar came into the possession
of Shah Abbas the Great (1557–1628), it had
four miniatures from the time the manuscript
was completed in 1486 in Herat and four blank
spaces for other miniatures. Since the shah
wished to present the manuscript to his family
shrine, in about 1600 he had his own artists
paint four miniatures to complete the book.
Habib Allah, who painted *The Concourse of the
Birds,* did his best to paint a miniature in a style
that would be in harmony with the fifteenth-
century illustrations of the manuscript. The
birds that set out on a journey to seek a spir-
itual leader symbolize mankind in search of
God. The crested bird perched on a rock on the
right, to which the other birds are listening, is a
hoopoe (known in Iran as the *tajidar,* or "crown
wearer"), which is said to have a special rela-
tionship with the supernatural world. The
Prophet Muhammad is said to have forbidden
killing it. *Fletcher Fund, 1963, 63.210.11 recto*

34 Tile Panel

Turkish, Iznik, Ottoman period, second half of
16th c.
*Composite body, painted and glazed;
47¾ × 47½ in. (121.3 × 120.7 cm)*

One of the outstanding artistic achievements of
the Ottoman period was the development of the
tile industry centered in Iznik (ancient Nicea).
Tiles came to be widely used in both religious
and secular buildings and can still be seen to-
day in all their richness in situ in Istanbul,
Bursa, and other Ottoman cities. The colors in
this tile panel, a cobalt blue, emerald green, and
the celebrated "sealing-wax" red—a color
added to the palette only in the mid-sixteenth
century and applied in low relief—were painted
on a composite white body under a flawless
transparent glaze. The layout of floral es-
cutcheons in offset rows surrounded by floral
sprays is one also found in textiles of the pe-
riod, and indeed this very dense pattern has the
quality of textile. The flowers are those typically
favored on Ottoman ceramics: tulips, carna-
tions, cherry or plum blossoms, and hyacinths.
The repeat pattern is here cut off by a border in
the form of a crenellated frieze of alternating
outlines, a familiar device on Ottoman tiles. *Gift
of J. Pierpont Morgan, 1917, 17.190.2083*

35 Tughra of Sulaymān the Magnificent
(r. 1520–66)

Turkish, Ottoman period, reign of Sulaymān,
ca. 1550–60
*Ink, colors, and gold on paper; 25⅜ × 20½ in.
(64.5 × 52.1 cm)*

There is no agreement among scholars con-
cerning the underlying inspiration for the form
of the Ottoman tughra (calligraphic emblem),
which became largely standardized in general
appearance at least as early as the fifteenth cen-
tury and which preceded all imperial edicts. The
characteristic scrolls, arabesques, and flowering
plants are both sumptuous and refined. Almost
all of the orthographically functional lines of
this tughra are concentrated in the area of
dense activity at the lower right, which gives the
name and patronymic of the sultan as well as
the formula "ever victorious." The exaggerated
verticals with their descending, swaying appen-
dages, as well as the elaborate sweeping curves
that form the large loops to the left and their ex-
tensions to the right, are essentially decorative.
Rogers Fund, 1938, 38.149.1

36 Prayer Rug

Turkish, probably Bursa, Ottoman period, late 16th c.

Wool, silk, and cotton (about 288 Senneh knots per sq. in.); 66 × 50 in. (167.6 × 127 cm)

This outstanding prayer rug, probably the most famous in existence, is one of four types surviving among the Ottoman court prayer rugs, which share the technical features of silk warps and wefts with Senneh knots in colored wool and white (and sometimes light blue) cotton, producing an especially light and supple rug. This rug displays patterned columns supporting three arches with a mosque lamp hanging in the center. The favorite Turkish flowers, tulips and carnations, are visible between the carefully rendered column bases. Split palmette leaves and small blossoms pattern the spandrels. In the horizontal panel above the spandrels, four domed buildings and varied flora appear between the curved crenellations.

The use of several delicate color tones (light blue in particular) characterizes these court rugs; the clarity of the drawing and the balance of motifs, especially in the main border, reveal the heights attained by the Ottoman court designers and weavers. *Gift of James F. Ballard, 1922, 22.100.51*

37 Textile Fragment

Turkish, Istanbul or Bursa, Ottoman period, second half of 16th c.

Silk and metallic threads; l. 48 in. (121.9 cm)

In the sixteenth century Turkish imperial power reached its height in Asia and Europe. A correlation between this political eminence and the character of Turkish art may well be established by pointing to this boldly colored, monumental piece of silk, probably manufactured in Istanbul in the mid-sixteenth century. Its inner dynamics are established by the strong movements and countermovements of the large leaves and flowers and by the grandiose, sweeping verticals to which they are attached. The individual units combine the special qualities of several flowers (such as lotuses and tulips) and are further enriched by superimposed floral sprays. Highly decorative as this design is, it nevertheless evokes a natural setting. The parallel chevron lines within the wavy verticals are an age-old symbol of water; hence the image of a garden with watercourses is readily evoked. *Purchase, Joseph Pulitzer Bequest, 1952, 52.20.21*

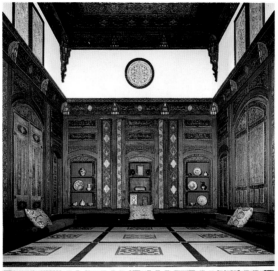

38 Nur ad-Din Room
Syrian, Damascus, Ottoman period, 1707
Marble floors, wood paneling, stained-glass windows; h. 22 ft. ½ in. (6.71 m), l. from inside front entrance to back wall 26 ft. 4 ¾ in. (8.04 m), w. 16 ft. 8½ in. (5.09 m)

This room, built in 1707, from the Nur ad-Din house in Damascus, is typical of traditional Syrian homes of the Ottoman period. The courtyard contains a fountain and flooring executed in richly colored marble. A high arch and a step lead to the raised reception area, where the master of the house welcomed guests. The wooden panels in both areas are lavishly painted, with raised designs, poetic Arabic inscriptions, and architectural vignettes. The warm colors are heightened with gilding. The open niches were used for books and other objects; the closed ones covered windows or served as closets or doors. The high stained-glass windows set in stucco permitted tinted light to enter, while fresh air came through the lower grilled windows. Both ceilings are sumptuously ornamented, with decorated beams in the courtyard and a complex design in the reception area. *Gift of The Hagop Kevorkian Fund, 1970, 1970.170*

39 Pair of Jālīs (Pierced Screens)
Indian, Mughal period, reign of Akbar (1556–1605), second half of 16th c.
Sandstone; 73 ¾ × 51 ⅛ × 3 ½ in. (186 × 130 × 9 cm)

Pierced screens, called *jālīs*, were a fundamental component of Mughal architecture and were used in a variety of ways (windows, room dividers, railings, and the like). Here the arch suggests use as a window, and the slight weathering on one side indicates its position in an outside wall. These two screens are the same size and have the same crenelated border design, arch shape with a finial, and spandrel design. They probably belonged to a larger set, each with a different interior geometric design. The design here shows ten-pointed stars within decagons in offset rows; in its pair eight-pointed stars appear within octagons in even rows. Following wooden prototypes, red sandstone had become the dominant building material under Akbar the Great; it was later supplanted by white marble. *Rogers Fund, 1993, 1993.67.1*

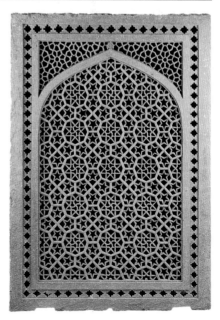

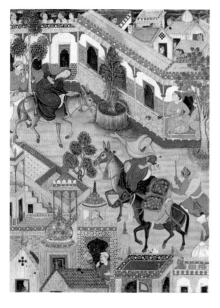

40 Zanbur the Spy

Indian, Mughal period, reign of Akbar (1556–1605), ca. 1561–76

Ink, colors, and gold on cotton mounted on paper; 29 ⅛ × 22 ½ in. (74 × 57.2 cm)

The first major work of the Mughal school — an illustrated copy of the *Dastan-i Amir Hamzeh* (The Story of Amir Hamzeh) — narrated the exploits of the Prophet Muhammad's uncle Hamzeh (and another hero of the same name whose adventures were interwoven into this text). This manuscript consists of fourteen huge volumes (about thirty by twenty-three inches). Each contains one hundred full-page paintings on cotton; many are scenes of violence and horror, but there are also quieter paintings, in which the artist portrayed his subject realistically in a peaceful setting. He did so in this picture, which shows the spy Zanbur bringing the maiden Mahiyya to town on a donkey. The houses and pavilions are more truthfully rendered than in contemporary Iranian miniatures. The high viewpoint and decorative quality stem from Persian models, but the increased realism indicates a new and different attitude. *Rogers Fund, 1923, 23.264.1*

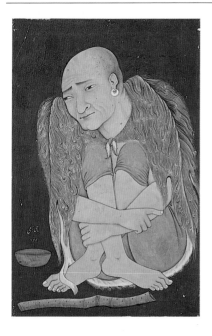

41 Portrait of a Sufi

Indian, Deccan, probably Bijapur, ca. 1620–30

Ink, colors, and gold on paper; painting 8 ⅞ × 5 ⅞ in. (22.6 × 14.9 cm), page 15 ⅛ × 9 ¾ in. (38.4 × 24.8 cm)

Here a sufi is hunched over his crossed legs. His arms hug them close to his body, a physical containment perhaps alluding to the discipline essential to achieving spiritual unity. The artist uses abstract forms and simplified lines. The picture is dominated by the sufi's head with its bony, shaved skull, strong features, and intense gaze. His humanity is somewhat diminished by the stylized patterning of the wool (*suf*) cloak, from which the word sufi is derived. The figure has a staff and a begging bowl, above which is written a prayer that can be translated: "O Prophet [Muhammad], descendant of Hashim, from thee is our help." The dark background and thick paint application are characteristic of Bijapur painting, as are the cool skin tones. *Cora Timken Burnett Collection of Persian Miniatures and Other Art Objects, Bequest of Cora Timken Burnett, 1957, 57.51.30*

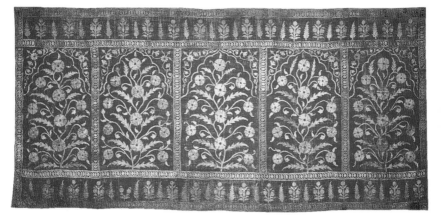

42 Tent Hanging

Indian, Mughal period, reign of Shah Jahan
(1628–58), ca. 1635
*Red silk velvet and gold leaf; 18 ft. × 8 ft. 5 in.
(5.48 × 2.56 m)*

In the lavish temporary encampments used by
Mughal emperors when traveling for reasons of
state or pleasure, the tents were lined with
beautiful textiles. This panel from the interior of
a tent complex, which was made about 1635,
probably for Raja Jai Singh I of Amber (Jaipur),
indicates the colorful ambience of such tent
cities. The velvet ground is intensified by glitter-
ing gold leaf. The panel has five compartments,
each containing a poppy plant under an arch,
with floral and leaf scrolls in the spandrels (a
typical pattern in Indian art). A floral-and-leaf
motif fills the narrow borders, and the large
main border shows poppy plants alternating
with miniature "trees" or stylized leaves. The
gold decoration was made by covering parts of
the design with an adhesive substance, then
placing gold leaf on top, rubbing and beating it
into the surface—the gold leaf remaining only
on the treated areas—and then burnishing the
surface. *Purchase, Bequest of Helen W. D.
Mileham, by exchange, Wendy Findlay Gift, and
funds from various donors, 1981, 1981.321*

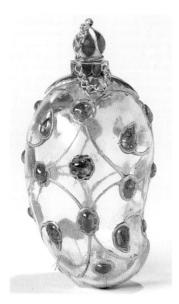

43 Flask in the Shape of a Mango

Indian, Mughal period, mid-17th c.
*Rock crystal with gold, enamel, rubies, and
emeralds; h. 2 ½ in. (6.5 cm)*

Effectively combining the Mughal love of pre-
cious materials and penchant for natural forms,
this exquisite flask probably held perfume for its
Indian or European owner. It has been seduc-
tively inlaid with gold wire that forms a network
of scrolling vines embellished with blossoms of
rubies and emeralds set in gold mounts. The
rock-crystal body of the flask was made in two
halves, held together in part by the gold-wire
network. A delicate gold chain connects the
enameled stopper and collar. *Purchase, Mrs.
Charles Wrightsman Gift, 1993, 1993.18*

ROBERT LEHMAN COLLECTION

The Robert Lehman Wing, which opened to the public in 1975, houses the extraordinary collection assembled by Mr. Lehman and his parents. Rich in Italian paintings of the fourteenth and fifteenth centuries, the collection also includes important works by early northern masters, including Petrus Christus, Hans Memling, and the Master of Moulins (Jean Hey). Among other strengths are Dutch and Spanish paintings, notably those by Rembrandt, El Greco, and Goya. French masterworks of the nineteenth and twentieth centuries include paintings by Ingres, Renoir, and the most important Post-Impressionists and Fauves.

This department is also known for its collection of drawings, among which are rare early Italian works, important sheets by Dürer, Rembrandt, and Flemish masters, a large group of French works, and close to two hundred eighteenth-century Venetian drawings.

Renaissance maiolica, Venetian glass, bronzes, furniture, enamels, and textiles form the core of an outstanding group of decorative arts. These works, like a large part of the Robert Lehman Collection, are exhibited in galleries designed to reflect the ambience of the Lehman house in New York.

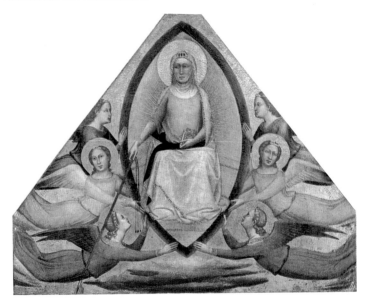

1 BERNARDO DADDI, Florentine,
act. by 1327–d. 1348
The Assumption of the Virgin
Tempera on panel; 42¹/₂ × 53⁷/₈ in.
(108 × 136.8 cm)

Bernardo Daddi was the most successful and
influential painter of the generation that fol-
lowed Giotto in Florence. Among his more
important commissions was an altarpiece for
the chapel of the Sacro Cingolo in the cathedral
of Prato (1337), where a highly venerated relic of
the Virgin's girdle is preserved. This panel is

believed to be a fragment of that altarpiece, the
upper half of its central section. It shows the Vir-
gin being carried to heaven by six angels and
lowering her girdle to Saint Thomas, whose out-
stretched hands are just visible at the bottom
edge of the panel. In addition to the rest of the
figure of Saint Thomas, the lower half of the al-
tarpiece, which has been lost, probably
included the remaining Apostles standing
around the tomb or the deathbed of the Virgin.
Robert Lehman Collection, 1975, 1975.1.58

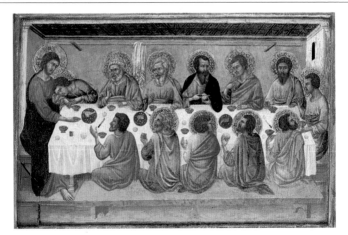

2 UGOLINO DA SIENA, Sienese, act. ca.
1315–40
The Last Supper
Tempera on panel; 13¹/₂ × 20³/₄ in.
(34.3 × 52.7 cm)

Ugolino di Nerio, also known as Ugolino da Si-
ena, was the principal exponent of Duccio's
style in Siena in the 1320s and 1330s. He was
called to Florence, probably about 1325–30, to
paint the high altarpiece of Santa Croce, the
most important Franciscan church in Tuscany,

whose chapels were then being decorated by
Giotto and his pupils. *The Last Supper* is one of
seven predella panels from that altarpiece, each
of which shows a scene from the Passion of
Christ. This early attempt at rendering space in
perspective and portraying the details of a do-
mestic interior, such as the coffered ceiling, the
table settings, and the carved feet of the bench
in the foreground, would prove influential for
later Renaissance painters. *Robert Lehman Col-
lection, 1975, 1975.1.7*

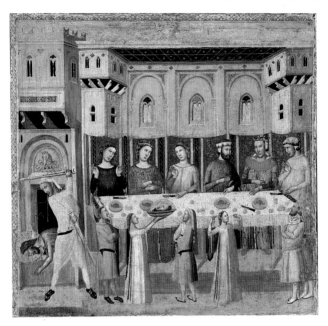

3 MASTER OF THE LIFE OF SAINT JOHN THE BAPTIST, Riminese, act. first half of 14th c.
The Feast of Herod and the Beheading of the Baptist
Tempera on panel; 18 × 19½ in. (45.6 × 49.7 cm)

This anonymous follower of Giotto, who was active in Rimini, on Italy's Adriatic coast, in the early part of the fourteenth century, is named after a famous series of eight panels showing scenes from the life of Saint John the Baptist, of which this is the largest and among the best preserved. It shows at the right Salome dancing before King Herod, who, excited by her beauty, grants her any wish she might have. Salome asks for the head of Saint John the Baptist, who is shown at the left being decapitated at his prison window. At the center of the picture Salome is shown a second time, presenting the head of the Baptist on a salver to Herod and her mother, Herodias, both of whom are seated behind the table recoiling from the sight. *Robert Lehman Collection, 1975, 1975.1.103*

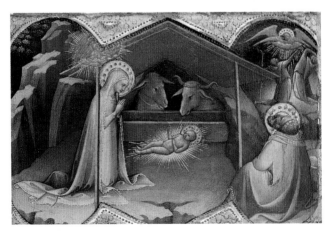

4 LORENZO MONACO, Florentine, ca. 1370–1423
The Nativity
Tempera on panel; 8¾ × 12¼ in. (21.4 × 31.2 cm)

The premier Florentine painter of the first two decades of the fifteenth century, Don Lorenzo was a monk of the Camaldolese order, although he was permitted to live and operate a workshop outside his monastery of Santa Maria degli Angeli. This *Nativity,* part of the predella to an altarpiece painted in 1409, shows his distinctly rich, bright palette, his calligraphic drawing style, and his brilliant compositional solutions to filling the irregular shapes of his picture fields—all derived from his experience as a manuscript illuminator. As a night scene, the painting also displays the artist's skill at representing light through changes of color, especially in the small scene of the Annunciation to the Shepherds at the upper right. *Robert Lehman Collection, 1975, 1975.1.66*

5 THE OSSERVANZA MASTER, Sienese, act. second quarter of 15th c.
Saint Anthony in the Wilderness
Tempera on panel; 18⅜ × 13¼ in. (46.8 × 33.6 cm)

Sassetta's most gifted pupil and one of the most engaging Sienese painters of the early fifteenth century, the Osservanza Master is best known for a series of eight panels of about 1435 illustrating the life of Saint Anthony Abbot. In this scene the saint, commonly regarded as the founder of Western monasticism, is tempted to stray from the narrow, stony path of righteousness by the apparition of a plate of gold (which has been scratched away and painted over in the left foreground). The gnarled trees in a barren, hilly landscape, the rabbits and grazing deer, the shells dotting the shore of a distant lake, and above all the rosy sunset, curving horizon, and fantastic cloud formations make this a masterpiece of early Renaissance naturalism blended with the distinctly Sienese penchant for poetic invention. *Robert Lehman Collection, 1975, 1975.1.27*

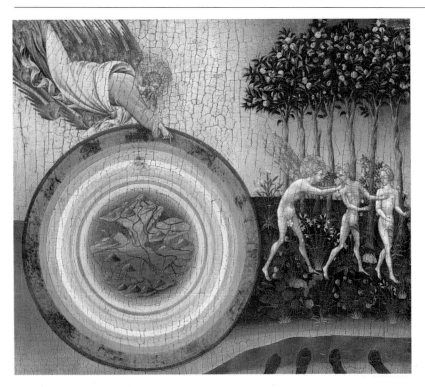

6 GIOVANNI DI PAOLO, Sienese, ca. 1400–1482
The Creation of the World and the Expulsion from Paradise
Tempera on panel; 18½ × 20½ in. (46.5 × 52 cm)

Painted in 1445 as part of the predella to an altarpiece for the Guelfi chapel in San Domenico, Siena, this panel actually portrays two different episodes in the story of the Creation. Borne on a cloud of cherubim at the left, God points to the newly created heavens and earth: the mountains and rivers of the globe are surrounded by the green of the encompassing seas and ocean and by rings of air, fire, the sun and the movable planets, and the fixed stars (symbolized by the signs of the zodiac). At the right Adam and Eve are expelled by an angel from the garden of the earthly paradise, represented by the artist as a meadow of lilies, carnations, and roses, with a row of golden fruit trees. Another fragment from the same predella, showing the Paradise of the Last Judgment, is in the Department of European Paintings. (See also European Paintings no. 6.) *Robert Lehman Collection, 1975, 1975.1.31*

7 GIOVANNI DI PAOLO, Sienese,
ca. 1400–1482
The Coronation of the Virgin
Tempera on panel; 70 ⅝ × 51⅝ in.
(179.9 × 131.3 cm) ·

This splendid panel of about 1455 is richly dec-
orated with painted brocades and velvets, a
faux-marble pavement, mosaic inlays on the
arms of the marble throne, and elaborate tool-
ing and engraving in the gold halos of the
heavenly chorus and the Virgin's crown. The
panel is one of two full-size altarpieces by Gio-
vanni di Paolo in the collections of the
Metropolitan Museum, which owns the largest
selection of the artist's works outside his native
Siena. Giovanni di Paolo's somewhat eccentric,
highly expressive figure style and remarkable
sensitivity to pattern and color made him a
great favorite with American collectors; Robert
Lehman owned as many as eleven of his paint-
ings. *Robert Lehman Collection, 1975, 1975.1.38*

8 SANDRO BOTTICELLI, Florentine,
1445–1510
The Annunciation
Tempera on panel; 7½ × 12⅜ in. (19.1 × 31.4 cm)

Perhaps the best-loved master of the Florentine
Renaissance, Botticelli is most admired today
for the stately grace of his figures and the lyrical
fantasy of his settings, but he was also es-
teemed by his contemporaries for his
complicated intellectual themes and composi-
tions. In this jewel-like panel the artist has
created the illusion of deeply receding space

through the projections of a mathematically pre-
cise linear perspective. The painted architecture
is severe and monumental at the left, lending a
sense of majesty to the elegant, adolescent an-
gel, and softened in the Virgin's bedchamber at
the right by the addition of hanging draperies,
carved furniture, and intimate domestic objects.
The entire scene is animated by a stream of di-
vine light, which enters with the angelic
messenger through the doorway opposite the
Virgin, who kneels humbly in its path. *Robert
Lehman Collection, 1975, 1975.1.74*

9 FRANCESCO DI MARCO MARMITTA DA PARMA, Emilian, 1457–1505
The Adoration of the Shepherds
Tempera(?) on parchment; 9⅝ × 5⅞ in. (24.5 × 15 cm)

Once in the collection of Pope Clement VII de' Medici (r. 1523–34) and given in 1591 by Pope Gregory XIV to Christina of Lorraine, grand duchess of Tuscany, this splendid miniature seems to have been painted not as a book illumination but as an independent object for private devotions. Set in a luminous nighttime landscape, the Virgin, Saint Joseph, three angels, and three shepherds adore the Christ Child, who lies on the ground, supported by a bundle of hay. Behind them the manger is built into the ruins of a classical temple. In the middle distance the Magi can be seen wandering along the banks of a river as they follow the star and the angelic chorus that hovers above the infant Savior. *Robert Lehman Collection, 1975, 1975.1.2491*

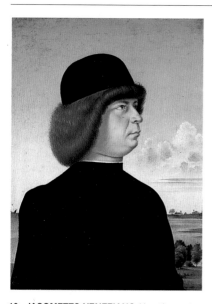

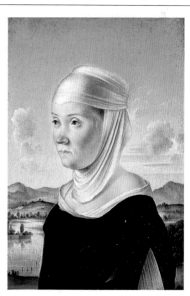

10 JACOMETTO VENEZIANO, Venetian, act. ca. 1472–ca. 1497
Portrait of Alvise Contarini(?);
Portrait of a Lady
Contarini: oil on panel; 4⅛ × 3 in. (10.5 × 7.7 cm)
Lady: oil on panel; 3¾ × 2⅝ in. (9.6 × 6.5 cm)

The most celebrated miniaturist and small-scale portrait painter in Venice in the late fifteenth century, Jacometto is today a mysterious personality whose few surviving works have all been identified on the basis of their resemblance to these two well-known panels. Admired as early as 1543 in one of the first guidebooks to masterpieces of art in Venice, where they are described as "most perfect," these portraits are remarkable for their meticulous rendering of lifelike detail and, despite their small size, the panoramic breadth of their landscape backgrounds. *Robert Lehman Collection, 1975, 1975.1.86,85*

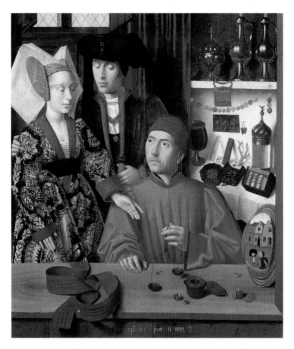

11 PETRUS CHRISTUS, Netherlandish, act. by 1444–d. 1475/76
Saint Eligius
Oil on panel; 39 × 33½ in. (99 × 85 cm)

Petrus Christus was profoundly influenced by the innovations of Jan van Eyck. This *Saint Eligius,* signed and inscribed with the date 1449, ranks among his most celebrated works. Saint Eligius was the patron saint of goldsmiths, and the painting is believed to have been executed for the chapel of the gold- and silversmith's meetinghouse in Bruges. The Netherlandish penchant for descriptive naturalism is evident in the carefully rendered objects: the convex mirror, the rich brocade of the woman's gown, and the assorted coins, jewels, and vessels— wares of the goldsmiths' trade—displayed on the shelves. A link with the viewer is established through the monumental scale of the figures and their proximity to the surface plane, as well as through such illusionistic devices as the mirror reflecting two bystanders outside the picture and the sash extending in front of the ledge.
Robert Lehman Collection, 1975, 1975.1.110

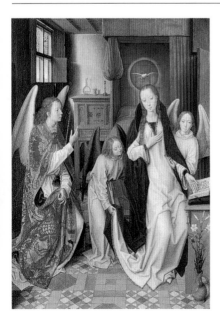

12 HANS MEMLING, Netherlandish, act. ca. 1465–d. 1494
Annunciation
Oil on panel; 31 × 21⅝ in. (78.8 × 55 cm)

Active in the late fifteenth century, Hans Memling was one of the leading artistic personalities in the Flemish city of Bruges. Like other painters of his generation active in the wake of Jan van Eyck, he cloaked his religious subjects in the language of everyday life with close attention to realistic detail. This scene of the Annunciation, when the archangel Gabriel appears to the Virgin Mary and informs her she will bear the Son of God, appears to take place in a wealthy bourgeois bedchamber, although many of the domestic furnishings—the carafe of water and the candlestick on the chest beside the bed and the vase of lilies at the lower right— carry symbolic meaning and allude to the Virgin's purity. The *Annunciation,* especially notable for the soft, glowing light that suffuses the figures, is one of Memling's most important works.
Robert Lehman Collection, 1975, 1975.1.113

13 JEAN FOUQUET, French, 1415/20–1481
**The Right Hand of God Protecting the Faithful
Against the Demons**
Parchment; 7¾ × 5¾ in. (19.7 × 14.6 cm)

A page from one of the most lavish illuminated books painted in France in the fifteenth century, this unusual scene illustrates the evening prayer for the Hours of the Holy Spirit. It shows in the foreground a congregation of the faithful looking up toward the hand of God, which appears in the center of the sky, with crowds of demons fleeing to the left and right. In the background is a meticulously accurate view of medieval Paris, perhaps the earliest ever painted. Jean Fouquet painted forty-seven full-page illuminations in this Book of Hours, which was commissioned from him in 1452 by Étienne Chevalier, the treasurer of France. *Robert Lehman Collection, 1975, 1975.1.2490*

14 JEAN HEY, French, ca. 1450–after 1503
Portrait of Margaret of Austria
*Oil on wood; 13½ × 9½ in.
(34.3 × 24.1 cm)*

Originally part of a diptych (the missing right-hand panel would have shown the Virgin and Child), this intimate portrait of Margaret of Austria, daughter of Emperor Maximilian I, was painted in 1490, when the ten-year-old princess, betrothed at the age of three to the infant Charles VIII, had been unofficially the queen of France for seven years. The sitter's velvet dress with ermine cuffs and the cloth-of-gold headdress denote her exalted rank, while the rich fleur-de-lis pendant at her throat signifies her pending marriage into the royal house of France (although she was repudiated by Charles VIII the year after this portrait was painted).

The artist was until recently known only as the Master of Moulins, but he can now be identified as Jean Hey, court painter of Duke Pierre II of Bourbon and one of the most famous painters in France during his lifetime. *Robert Lehman Collection, 1975, 1975.1.130*

15 EL GRECO, Greek, 1541–1614
Saint Jerome as a Scholar
Oil on canvas; 42 ½ × 35 ⅛ in. (108 × 89 cm)

Saint Jerome, a Doctor of the Church, is here
identified by his attributes of the red robes of a
cardinal and an open book (Saint Jerome made
the first translation of the Bible from Greek to
Latin). Images of the saint as a scholar were
extremely popular in the fifteenth century, but in
the sixteenth it became more common to por-
tray him as a penitent ascetic, an aspect of his
spirituality suggested by El Greco in the gaunt,
haggard look of the cardinal's face. This subject
was treated by El Greco on at least five occa-
sions, and the present version is a masterpiece
of the artist's late career. *Robert Lehman
Collection, 1975, 1975.1.146*

16 REMBRANDT, Dutch, 1606–1669
Portrait of Gerard de Lairesse
Oil on canvas; 44¼ × 34½ in. (112.4 × 87.6 cm)

Gerard de Lairesse (1641–1711) was in his day a
well-known painter and etcher. He suffered from
congenital syphilis, which caused him to go
blind about 1690, after which time he focused
his energies on art theory. By the time Rem-
brandt painted this portrait in 1665, the ravaging
effects of the disease were already visible in the
sitter's swollen features and bulbous nose. Re-
cording his unfortunate appearance with an
uncompromising directness, Rembrandt none-
theless invested his subject with an air of quiet
dignity, producing a sympathetic portrayal of
the younger artist whose theories about paint-
ing were antithetical to his own style. *Robert
Lehman Collection, 1975, 1975.1.140*

LA EX. S. D. MARIA YGNACIA ALVAREZ D TOLEDO MARQUESA D ASTORGA CONDSA D ATAMIRA
Y LA S. D. MARIA AGVSTINA OSORIO ALVAREZ D TOLEDO SV HIJA NACIO EN 21 D FEBRERO D 1787

17 FRANCISCO GOYA, Spanish, 1746–1828
Countess of Altamira and Her Daughter,
Maria Agustina
Oil on canvas; 77 ¼ × 45½ in. (195 × 115 cm)

This double portrait is the third of four portraits
Goya painted of Count Altamira and his family
(see also European Paintings, no. 54), a com-
mission that led to his appointment as First
Painter to the King in 1789. The rigid formality
of the composition is softened by the freshness
and intimacy of such painted details as the em-
broidery of the countess's dress, by the glowing
warmth of Goya's light, and by his loose, rapid
brushstrokes, as in the gauzy transparency of
the child's gown. The freedom of Goya's tech-
nique and his penetrating insights into human
nature were to prove highly influential for later
generations of painters, especially the French
Impressionists. *Robert Lehman Collection, 1975,
1975.1.148*

18 J. A. D. INGRES, French, 1780–1867
The Princesse de Broglie
Oil on canvas; 47¾ × 35¾ in. (121.3 × 90.8 cm)

Although portraiture was a genre he disliked, Ingres painted many of the leading personalities of his day. His portrait of the Princesse de Broglie, a member of the most cultivated circles of the Second Empire, amply attests to his gifts at transcribing not only the material quality of the objects he painted—the rich satin and lace of the sitter's gown, the brocade chair, the elegant jewels—but also the character of his subject, whose aristocratic bearing and shy reserve are compellingly captured. The Princesse de Broglie died prematurely at the age of thirty-five, and her bereaved husband kept this portrait behind draperies as a tribute to her memory. It was acquired by Robert Lehman in 1957 from the family's direct descendants, in whose possession the jewels represented in the painting still remain. *Robert Lehman Collection, 1975, 1975.1.186*

19 CAMILLE COROT, French, 1796–1875
Diana and Actaeon
Oil on canvas; 61⅝ × 44⅜ in. (156 × 112.7 cm)

Founder of the Barbizon school, a group of artists whose favorite subject was the tranquil forest of Fontainebleau outside Paris, Corot produced numerous paintings of the French and Italian landscape over the course of his long career. *Diana and Actaeon* is one of his earliest depictions of a theme from ancient mythology. In representing a classical subject in a landscape setting, Corot was responding in this work to the example of Poussin. The landscape at the upper left, executed in the loose brushwork of Corot's late style, was repainted by the artist in 1874, a year before his death, at the request of the painting's new owner. *Robert Lehman Collection, 1975, 1975.1.162*

20 CLAUDE MONET, French, 1840–1926
Landscape near Zaandam
Oil on canvas; 17⅜ × 26⅜ in. (44 × 67 cm)

Monet left Paris in 1870 during the Franco-Prussian war. He went briefly to London and then, on the advice of the painter Charles François Daubigny, to Zaandam in the Netherlands, where this painting was executed. Employing a limited palette in which muted shades of green predominate, the artist brilliantly captured the hazy, damp atmosphere and light-dappled water of this picturesque Dutch port. Monet's Dutch landscapes were widely admired by contemporary artists, particularly Daubigny. *Robert Lehman Collection, 1975, 1975.1.196*

21 PIERRE-AUGUSTE RENOIR, French, 1841–1919
Two Young Girls at the Piano
Oil on canvas; 45¾ × 35⅜ in. (116.2 × 90 cm)

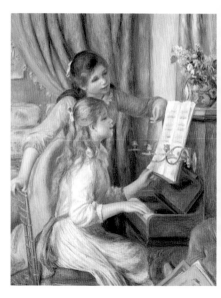

In late 1891 or early 1892 Renoir was asked by the director of the École des Beaux-Arts to make a painting for a new museum in Paris, the Musée du Luxembourg, which was devoted to the work of living artists. He chose as his subject two girls at the piano. Aware of the intense scrutiny his painting would elicit, the artist lavished extraordinary care on this project, developing and refining the composition in a series of five canvases. The painting in the Lehman Collection, which once belonged to the nineteenth-century art dealer Durand-Ruel, and the nearly identical version formerly in the collection of Renoir's fellow Impressionist Gustave Caillebotte have long been regarded as the most accomplished variants of this intimate and engaging scene of bourgeois domestic life. *Robert Lehman Collection, 1975, 1975.1.201*

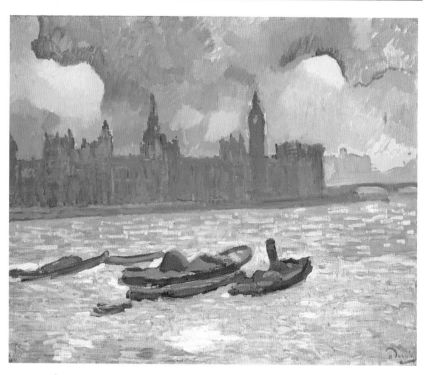

22 ANDRÉ DERAIN, French, 1880–1954
The Houses of Parliament at Night
Oil on canvas; 31 × 39 in. (81 × 100 cm)

Together with Henri Matisse and Maurice de Vlaminck, André Derain was a leading representative of the group of French painters known as the Fauves. In 1905 and again in the following year, he traveled to London at the suggestion of the art dealer Ambroise Vollard, for whom he made a number of views of the city, including *The Houses of Parliament at Night*. As the artist himself later recalled, these canvases were inspired by the views of London painted a few years earlier (about 1900–1903) by Claude Monet, which had "made a very strong impression on Paris in the preceding years." The long, broken brushstrokes of Derain's painting and the bright, bold colors reflect the influence of the Neo-Impressionists Paul Signac and Henri-Edmond Cross as well as of the contemporary works of Matisse, with whom Derain spent the summer of 1905 in the south of France (see no. 23). *Robert Lehman Collection, 1975, 1975.1.168*

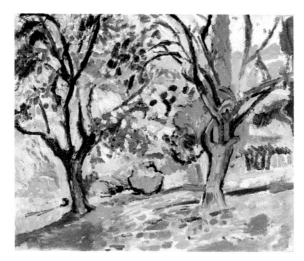

23 HENRI MATISSE, French, 1869–1954
Promenade Among the Olive Trees
Oil on canvas; 7½ × 21¾ in. (44.5 × 55.2 cm)

Painted in Collioure, a scenic town on the Mediterranean coast that attracted many painters of the day, *Promenade Among the Olive Trees* is one of Matisse's earliest and most distinguished Fauve canvases. Inspired by the works of his older contemporaries Paul Signac and Henri-Edmond Cross, both of whom also lived in the south of France at the time, Matisse here adopted the vibrant, unnatural colors favored by the Fauves. The artist found great inspiration in the sun-drenched landscape of Collioure and wrote to a friend, the painter Manguin, that it was full of "charming sights." Shortly after it was completed, this painting was acquired by Gertrude and Leo Stein. *Robert Lehman Collection, 1975, 1975.1.194*

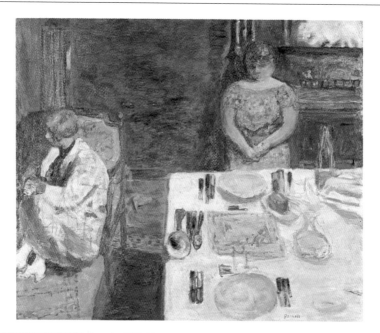

24 PIERRE BONNARD, French, 1867–1947
Before Dinner
Oil on canvas; 35½ × 42 in. (90.2 × 106.7 cm)

Like his friend and contemporary Édouard Vuillard, Bonnard frequently painted intimate domestic interiors. In this work the artist emphasizes the large dinner table covered with a white cloth and laid with flatware, plates, and carafes. The primary focus of the composition is this tableau of inanimate objects treated as an independent still life, rather than the two detached and psychologically remote figures. Typical of Bonnard is the absence of perspective and the flattening of forms, as well as an evident fondness for decorative surface patterns. *Before Dinner* is one of three paintings by the artist in the Lehman Collection. *Robert Lehman Collection, 1975, 1975.1.156*

25 BALTHUS (Balthasar Klossowski),
French, b. 1908
Figure in Front of a Mantel
Oil on canvas; 75 × 64½ in. (190.5 × 163.8 cm)

Balthus is regarded as one of the preeminent figure painters of the twentieth century. Largely self-taught, he trained by copying the Old Masters in the Louvre, especially Poussin. His work reveals a deep admiration for the art of Piero della Francesca, whose famous True Cross cycle he studied during a trip to Arezzo in 1926.

Balthus has painted landscapes, portraits, and interiors, but the female sitter in various states—daydreaming, reclining, and sleeping, often nude or partly clothed and invested with an erotic undercurrent—is the most frequently depicted subject in his art. Particularly striking in the *Figure in Front of a Mantel* is the sculptural monumentality of the model, who seems to be carved from marble, and the soft, silvery light that bathes the figure and fills the room. *Robert Lehman Collection, 1975, 1975.1.155*

26 Aquamanile: Aristotle Ridden by Phyllis ▶
South Netherlands or eastern France, ca. 1400
Bronze; h. 13¼ in. (33.5 cm)

An aquamanile is a vessel for pouring water used in the ritual washing of hands in both religious and secular contexts—by the priest before Mass and in households before a meal. This celebrated example has as its subject the moralizing legend of Aristotle and Phyllis, which achieved widespread popularity in the later Middle Ages. Aristotle, the Greek philosopher and tutor of Alexander the Great, allowed himself to

27 GIOVANNI MARIA VASARO, Italian (Castel Durante)
Bowl, 1508
Maiolica; diam. 12¾ in. (32.5 cm)

Variously described as "one of the most beautiful pieces of maiolica ever made," as "a triumph of the art," and as painted by "the most talented artist who ever worked in a maiolica workshop," this remarkable bowl is signed on the back by the otherwise unknown Giovanni Maria Vasaro and is dated September 12, 1508. Commissioned either as a gift to Pope Julius II Della Rovere from his loyal supporter Melchiorre di Giorgio Manzoli of Bologna or, more likely, as a gift from the pope to his Bolognese servitor, it is richly decorated with classical symbols of triumph, symbols of papal authority, and personal references to Julius II and his family. *Robert Lehman Collection, 1975, 1975.1.1015*

28 NICOLO DA URBINO, Italian (Castel Durante or Urbino), 16th c.
Plate, ca. 1520–25 (or 1519?)
Maiolica; diam. 10⅞ in. (27.5 cm)

This plate is one of twenty-one surviving pieces of perhaps the best-known and most elaborate maiolica service of the Renaissance. The dishes in this service were all painted by Nicolo da Urbino, the most distinguished maiolica painter of his generation, for Isabella d'Este, marchioness of Mantua (1474–1539), a preeminent patron of the arts. This dish is filled in the center with Isabella d'Este's coat of arms, surrounded by three of her personal emblems: a scroll of music, a candelabrum with one lighted candle, and a bundle of lottery tickets. On the rim the artist has portrayed the musical contest of Apollo and Pan with King Midas as judge, set in an expansive landscape painted with great subtlety of color and delicacy of execution. *Robert Lehman Collection, 1975, 1975.1.1019*

be humiliated by the seductive Phyllis as a lesson to the young ruler, who had succumbed to her wiles and neglected the affairs of state. Allowing Alexander to witness this folly, Aristotle explained that if he, an old man, could be so easily fooled, the consequences for a young man were even more dangerous. The ribald subject indicates that this aquamanile was made for a domestic setting, where it would have doubled as an object of entertainment for guests at the table. *Robert Lehman Collection, 1975, 1975.1.1416*

29 Goblet

Probably southern Netherlands, 17th c.
Glass; h. 11⅛ in. (28.1 cm)

Wineglasses with fantastic "dragon" stems, sometimes known as serpent glasses, were first made in Venice in the late sixteenth century, and they became popular in the Netherlands and elsewhere in northern Europe by the middle of the seventeenth. The stem is formed by heating a clear glass rod with colored threads, stretching and twisting it, and then quickly bending it into a knotted shape. The wings, jaws, and fins are added bits of hot blue glass shaped with a pincers. Although requiring great skill to make, serpent glasses were once fairly common; owing to their excessive fragility, however, early examples such as this one are rare. *Robert Lehman Collection, 1975, 1975.1.1206*

30 Hat Ornament

French or Netherlandish, ca. 1520
Gold, gold filigree, and enamel; diam. 2¼ in. (5.7 cm)

Hat badges were fashionable ornaments in sixteenth-century Europe. This particularly fine and elaborate example illustrates a satirical theme, the old lover deceived by a young woman, which enjoyed widespread popularity in that period. A well-dressed lady holds the hand of a young man, while she shamelessly allows an older, lecherous gentleman to fondle her. Thus distracted, he is unaware that she reaches for his purse, presumably intending to share its contents with her young suitor. The inscription, AMOR FAIT MOVLT ARGENT FAIT TOVT (Love does much [but] money does everything), makes her sentiments perfectly clear. *Robert Lehman Collection, 1975, 1975.1.1524*

31 ANTONIO POLLAIUOLO, Florentine, 1431/32–1498

Study for an Equestrian Monument
Pen and brown ink, light and dark brown wash; 11⅛ × 10 in. (28.1 × 25.4 cm)

Equally admired by his contemporaries as a painter, sculptor, engraver, and goldsmith, Antonio Pollaiuolo was one of the most influential artists in Florence in the second half of the fifteenth century. This celebrated drawing, which once belonged to the painter and historian Giorgio Vasari and was fully described in his *Lives of the Artists* (1568), was prepared for Duke Ludovico Sforza of Milan as a model for a monumental bronze statue of his father, Francesco Sforza. Leonardo da Vinci is also known to have prepared several studies for a monument to Francesco Sforza, but neither his projects nor Pollaiuolo's were ever realized. *Robert Lehman Collection, 1975, 1975.1.410*

32 BERNAERT VAN ORLEY, Flemish, ca. 1491–1541/42
The Last Supper, ca. 1520–30
Wool, silk, and silver-gilt thread; 11 ft. 11 in. × 11 ft. 6 in. (363 × 351 m)

Bernaert van Orley was the court painter of Margaret of Austria, daughter of the emperor and the leading tapestry designer in Brussels in the first half of the sixteenth century. This splendid *Last Supper* is part of a series of four tapestries illustrating the Passion of Christ designed by van Orley about 1520 and probably woven by Pieter de Pannemaker (fl. 1517–35). The overall composition and the poses and gestures of some of the figures are closely based on a 1510 woodcut of this subject by Albrecht Dürer. Italian influence is evident in the architectural background and in the dramatic intensity of the scene, which derives from Leonardo da Vinci's famous mural of this subject and from Raphael's *Acts of the Apostles* tapestry cartoons. Who commissioned the Passion tapestries is unknown, but the exceptionally high quality of the series, the elaborate and intricate borders, and the use of silver thread all point to a wealthy, aristocratic patron. *Robert Lehman Collection, 1975, 1975.1.1915*

33 Tabernacle Mirror Frame
Florentine, ca. 1510
Walnut and poplar; 29 3/4 × 14 1/2 in. (75.6 × 36.8 cm)

Florentine mirrors in the sixteenth century commonly employed a sliding shutter to cover the glass when not in use. Both the shutter and the glass have been lost from this unusually fine frame, which was probably carved about 1510 in the Del Tasso family workshop, but a slot in the right side through which the shutter was meant to pass betrays its original function. So, too, does the moralizing inscription carved in the cartouche at its base: NON FORMA SED VERITAS MIRANDA EST (Truth, not appearances, is to be admired). *Robert Lehman Collection, 1975, 1975.1.1638*

34 ALBRECHT DÜRER, German, 1471–1528
Self-portrait
Pen and ink; 14³⁄₈ × 18³⁄₄ in. (36.5 × 47.5 cm)

This penetrating self-portrait by Dürer shows the artist at about the age of twenty-two. The drawing is closely related to a painted self-portrait of 1493 in the Louvre, for which it evidently served as the model. Dürer's keen powers of observation, captured in his scrutinizing gaze, are evident in the foreshortened fingers and cast shadows of the carefully rendered hand and in the crumpled folds of the cushion. Similar studies of a cushion occur on the verso. Although Dürer inscribed many of his drawings with a monogram, the *A d* at the top of the sheet is by a later hand. *Robert Lehman Collection, 1975, 1975.1.794*

35 TADDEO ZUCCARO, Marchigian, 1529–1566
The Martyrdom of Saint Paul
Pen and brown and gray ink, brown wash, over black chalk sketch, heightened with white (oxidized) on buff paper; 19¹⁄₄ × 14⁷⁄₈ in. (48.8 × 37.7 cm)

Taddeo Zuccaro was a highly successful entrepreneur as well as a great artist who oversaw numerous campaigns of fresco decoration in palaces and churches throughout Rome and elsewhere in the Papal States before his premature death at the age of thirty-seven. This drawing, which shows the beheading of Saint Paul outside the walls of ancient Rome, is a highly finished model for a fresco on the ceiling of the Frangipani chapel in the church of San Marcello al Corso. Prepared between 1556 and 1559, the drawing shows the young artist, not yet thirty years old, at the height of his powers as a draftsman and designer. *Robert Lehman Collection, 1975, 1975.1.553*

36 REMBRANDT, Dutch, 1606–1669
The Last Supper, after Leonardo da Vinci
Red chalk on paper; 14³/₈ × 18⁵/₈ in.
(36.4 × 47.3 cm)

This monumental drawing reveals the young Rembrandt, at the age of twenty-eight, exploring the dramatic and expressive potential of one of the most revered works of art of the Renaissance, Leonardo da Vinci's mural of the Last Supper in Milan. Ostensibly a copy, the drawing creates a more psychologically intimate and at the same time emotionally charged scene through subtle changes in the setting, the lighting, and the positions and attitudes of Christ and his disciples, each wondering who will fulfill the master's word and betray him. This is a remarkable tribute by arguably the greatest painter of the seventeenth century to one of the preeminent masters of the fifteenth. *Robert Lehman Collection, 1975, 1975.1.794*

37 CANALETTO, Venetian, 1697–1768
Warwick Castle, the East Front
Pen and brown ink, gray wash; 12¹/₂ × 22¹/₈ in.
(31.6 × 56.2 cm)

Best known as a painter of highly detailed views of the city of Venice, Giovanni Antonio Canal, called Canaletto, spent ten years in London, from 1746 to 1756, painting monuments of the city and of the English countryside for his British patrons. For Francis Greville, Lord Brooke, later earl of Warwick, he painted five views of Warwick Castle, including two of the east front. This airy, light-filled drawing, also made for Lord Brooke, was used as a preparatory design for the painting now hanging in the City Museum and Art Gallery, Birmingham. *Robert Lehman Collection, 1975, 1975.1.297*

38 GIOVANNI DOMENICO TIEPOLO, Venetian, 1727–1804
The Burial of Punchinello
Pen and brown ink, brown and yellow wash, over black chalk; 13⅞ × 18⅝ in. (35.3 × 47.3 cm)

The son, assistant, and eventual successor of Giovanni Battista Tiepolo as the premier painter of monumental narrative frescoes and altarpieces in Venice in the eighteenth century, Domenico Tiepolo is best remembered today for a series of 104 drawings chronicling the birth, life, and death of the Venetian comic hero Punchinello. Among the last works Domenico executed at the end of a long and distinguished career, this drawing is number 103 of the series. A haunting image, it was followed on the last page of the album from which it came by a scene of Punchinello's skeleton crawling from its grave. *Robert Lehman Collection, 1975, 1975.1.473*

39 EDGAR DEGAS, French, 1834–1917
Dancing Peasant Girls
Pastel on tracing paper; 24¾ × 25½ in. (62.9 × 64.7 cm)

In the last two decades of his life, Degas executed a number of pastels and drawings of Russian dancers. He may have first been inspired to turn to this subject after seeing a Russian dance troupe perform in Paris at the Folies Bergère. This richly colored example is believed to be one of his earliest treatments of the theme and is probably one of the works referred to by Manet's niece in her journal. Visiting Degas in his studio on July 1, 1899, she recalled his words as he offered "to show you the orgy of color I am making at the moment" and proceeded to bring out three pastels of women in Russian costume. Her description of the "pearl necklaces, white blouses, skirts in lively hues, and red boots, dancing in an imaginary landscape . . . the movements [that] are astonishingly drawn, and the costumes of very beautiful colors" is suggestively evocative of this image. *Robert Lehman Collection, 1975, 1975.1.166*

40 MAURICE PRENDERGAST,
American (b. Newfoundland), 1858–1924
The Huntington Avenue Streetcar (Page from the Large Boston Public Garden Sketchbook)
Watercolor over pencil; 14⅛ × 11⅛ in. (35.9 × 28.3 cm)

This charming depiction of a woman stepping off a streetcar is one of fifty-eight sheets from Prendergast's Large Boston Public Garden Sketchbook, so-called because a number of the scenes—including the Huntington Avenue streetcar represented here—are recognizable sites in the Public Garden. Begun shortly after the artist's return to Boston from Paris, the drawings and watercolors of this now dismantled sketchbook have as their primary subject the cheerful activity of elegantly attired women, who are seen riding bicycles, pushing prams, strolling with parasols, and resting on park benches. As a number of the images are rough ideas for advertisements, it seems likely that Prendergast used this sketchbook to promote his talents to publishers and other clients. This volume is one of eighty-eight surviving sketchbooks by the artist. *Robert Lehman Collection, 1975, 1975.1.924–67*

41 ODILON REDON, French, 1840–1916
Pegasus and Bellerophon
Charcoal on paper; 20⅛ × 14⅛ in. (51 × 36 cm)

In his charcoal drawings Odilon Redon evolved a highly personal vision of myth and symbol redolent with obscure philosophical undertones. The dramatic contrast of light and dark made possible by this medium was ideally suited to his enigmatic subject matter. Praising its expressive range of tonal effects, Redon observed that "black is the most essential color. . . . It is the agent of the spirit." This drawing of about 1890 takes its subject from Greek myth. The mortal Bellerophon captured the winged horse Pegasus and with him defeated the monster Chimaera. Bellerophon later tried to fly with Pegasus to heaven but was cast down by Zeus's thunderbolt. *Robert Lehman Collection, 1975, 1975.1.686*

Saint Margaret
French (Toulouse), ca. 1475
Alabaster with traces of gilding; h. 15⅛ in. (39 cm)

Margaret, the Early Christian saint also known as Marina, experienced many painful ordeals before her decapitation at Antioch of Pisidia in central Asia Minor during the reign of Emperor Diocletian (284–305). Having been swallowed by the devil in the guise of a dragon, the saint burst unharmed from its body after making the sign of the cross. Known for her innocence and faith, the saint emerges like an opening flower.

This Late Gothic work is an outstanding example of the late-fifteenth-century Languedoc style, centered in Toulouse. A masterpiece in spite of its damaged state, this sculpture is remarkable for the contrast between the freshness and delicacy of the figure and the scaly and coarse textures of the lizard-turned-dragon at the bottom of the composition. *Gift of Anthony and Lois Blumka, in memory of Ruth and Victoria Blumka, 2000, 2000.641*

MEDIEVAL ART

MAIN BUILDING

The Middle Ages, the period between ancient and modern times in Western civilization, extends from the fourth to the sixteenth century—that is, roughly from the Fall of Rome to the beginning of the Renaissance. The Museum's collections cover the art of this long and complex period in all its many phases, including Early Christian, Byzantine, Migration, Romanesque, and Gothic. The Department of Medieval Art and The Cloisters oversees both the collection in the Museum's main building on Fifth Avenue and that of The Cloisters in northern Manhattan (see pp. 393–411).

A gift from the financier and collector J. Pierpont Morgan in 1917 forms the core of the more than four thousand medieval works of art now housed in the Museum's main building. The collection has grown through purchases as well as through gifts and bequests, most notably those from George Blumenthal, George and Frederic Pratt, and Irwin Untermyer. Among the strengths of the collection are Early Christian and Byzantine silver, enamels, glass, and ivories; Migration jewelry; Romanesque and Gothic metalwork, stained glass, sculpture, enamels, and ivories; and Gothic tapestries.

1 Frieze from a Sarcophagus
Early Christian carved early 300s, in Rome,
restoration 1906–7
Marble, 26 x 84 x 22⅞ in. (66 x 213.4 x 58 cm)

Carved when Christianity was first being recog-
nized as an official religion of the Roman
Empire, this sarcophagus is one of the earliest
works indicating the importance of Saint Peter to
Rome. The two scenes on the left end of the sar-
cophagus show Peter being arrested in Rome
and Peter miraculously causing a spring to flow
in his prison cell. The dramatic thrusting poses
of these images are typical of the style of early
fourth-century Roman art. The scenes from the
life of Christ to the right are original below the
knees; the restoration above is indicated in part
by the subdued poses of the figures carved in
low relief. *Gift of Josef and Marsy Mittlemann,
1991, 1991.366*

2 Portrait Medallion of Gennadios
Roman, Alexandria, second half of 3rd c.
Gold glass; diam. 1⅝ in. (4.2 cm)

Perhaps made for use as a pendant, this bust
portrait of a young man is drawn with a fine
point on gold leaf applied to the surface of a
deep sapphire-blue glass and sealed with a
clear glass overlay; the rim is beveled for framing.
The subject is identified by the inscription as
"Gennadios, the most accomplished in musical
art." The grammatical variants in the inscription
correspond to the Alexandrian dialect of Greek,
and the technique of making portrait medallions
of this type is also generally identified with that
city. *Fletcher Fund, 1926, 26.258*

3 The Vermand Treasure
Provincial Roman, second half of 4th c.
*Silver gilt and niello; left: l. 3¾ in. (9.5 cm); cen-
ter: l. 4⅞ in. (12.4 cm); right: h. 1⅜ in.
(3.5 cm), diam. ⅞ in. (2.2 cm)*

A group of richly decorated silver mounts was
among the objects unearthed from a military
tomb in Vermand, near Saint-Quentin in north-
ern France. The tomb must have been that of a
chieftain of high rank, perhaps a Roman military
officer or a barbarian in Roman service. Three
of the pieces are illustrated here: the ring and
two plaques for the spear shaft. They are decor-
ated with vines and floral arabesques, cicadas,
and fantastic animals.

The patterns belong to the repertory of Late
Antique art, but the technique was a new method
developed in the frontier regions along the
Rhine and the Danube and used chiefly for the
decoration of such military trappings. It is called
chip-carving because the patterns, although not
carved, are made up of wedge-shaped troughs
like those left by the chips cut in woodcarving.
The contrasts in the design are made more
vivid by niello—a silver sulfide alloy set into the
incised gilded silver. The Vermand find is the
most distinguished example of chip-carving in
existence. *Gift of J. Pierpont Morgan, 1917,
17.190.143–145*

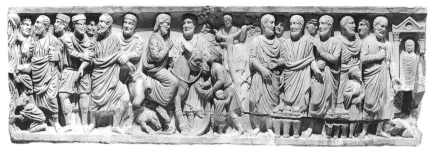

4 Tomb Relief with the *Traditio Legis*
Early Christian, Rome, fourth quarter of 4th c.
Marble; 19 1/8 × 52 1/2 × 5 3/4 in. (48.6 × 133.4 × 14.6 cm)

The very popular Early Christian image of the *Traditio Legis* (Christ giving the law to Peter) is depicted on this handsome relief which was probably made to face a tomb. In the right central niche Christ (his face missing) raises his right hand in proclamation and unfurls the scroll of the law toward Peter on his left. Paul is on Christ's right. The bottom half of the relief is

missing. Traces of arcades at the edges of the relief indicate that it had at least six, but most likely seven, niches with Christ in the center.

The relief is a finely carved example of Roman work produced under Eastern influence in the late fourth century. The figural style is strong and subtly molded, with well-rounded bodies set against delicate and intricate architectural decoration. *Gift of Ernest and Beata Brummer, in memory of Joseph Brummer, 1948, 48.76.2*

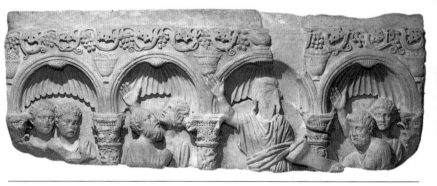

5 Bust of a Lady of Rank
Early Byzantine, Constantinople, late 5th–early 6th c.
Marble; h. 20 7/8 in. (53 cm)

This bust, from the region of Constantinople, shows a young woman who wears an elegantly draped mantle over a tunic; her hair is covered by a snoodlike bonnet of the imperial type. The subtle and delicate modeling of her face still retains a feeling of naturalism in spite of the fixed gaze. The person represented probably enjoyed a high rank in the Byzantine court in the late fifth or early sixth century. *The Cloisters Collection, 1966, 66.25*

6 Bow Fibula

Gepidic, 5th c.
Gold over silver core with almandine, mother-of-pearl, or enamel; l. 6¾ in. (17.1 cm)

Bow fibulae were worn in pairs to secure a cloak. This type of fibula, with head and foot plates joined by an arched bow and a heavily gilded silver core decorated with rounded stones, has been discovered mainly in Hungary and southern Russia. The closest parallels to this fibula are those from the Second Szilagy-Somlyo Treasure (Transylvania), from which this example may also come. *Fletcher Fund, 1947, 47.100.19*

7 Steelyard Weight and Hook

Early Byzantine, first half of 5th c.
Weight: bronze filled with lead; hook: brass; 9⅛ × 4¼ in. (23.5 × 11 cm); 5.04 lb. (2.29 kg or 7 Byzantine litrae)

The weight is cast in the form of the bust of an empress. She is elaborately coiffed. The richness of her jeweled diadem, from which hang strands of pearls, is echoed in her four-tiered gem- and pearl-studded necklace. The bust is set on a plinth bordered with pearls and decorated with a guilloche pattern. Although governed by the hieratic style customary for Early Byzantine weights, the face, hair, jewelry, and clothing are sensitively and carefully modeled. When the weight was suspended by its hook, it could be moved along a ruled steelyard to establish the weight of the commodity hung from the opposite side. *Purchase, Rogers Fund, Bequest of Theodore M. Davis, by exchange and Gifts of George Blumenthal, J. Pierpont Morgan, Mrs. Lucy W. Drexel and Mrs. Robert J. Levy, by exchange, 1980, 1980.416a,b*

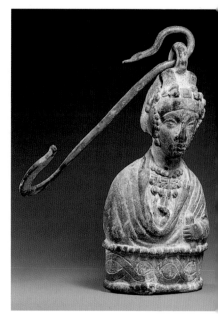

8 The "Antioch Chalice"

Early Byzantine, Syria, 6th c.
Silver gilt; h. 7½ in. (19.1 cm)

The plain silver cup that is the core of this vessel is encased in an elaborate openwork container of silver gilt. Recent research has identified the vessel as part of a large horde of Early Christian liturgical silver probably from the village of Kaper Koraon in Syria. It has been suggested that it was never a chalice, but a standing oil lamp. In its densely inhabited grapevine Christ appears twice—seated with a scroll and seated by a lamb above an eagle with outspread wings. The other seated figures acclaim Christ perhaps in reference to "I am the light." Early in this century, the inner cup was incorrectly identified as the Holy Grail. *The Cloisters Collection, 1950, 50.4*

▶

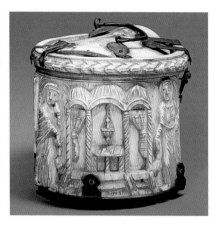

10 Diptych of the Consul Justinian
Early Byzantine, Constantinople, 521
Ivory; each leaf 13¾ × 5¾ in. (35 × 14.5 cm)

Justinian was appointed consul for the East in 521, six years before he became emperor, and had this diptych and others made for presentation to members of the senate to celebrate his consulship. In the center of each leaf is a medallion framing a running inscription addressed to the senator. Elegant in its simplicity, the medallion is composed of a simple pearl motif and a complex cyma carved with great care and precision. At the four corners of each leaf are lion's heads emerging from the center of lush acanthus leaves. The soft, plastic quality of the acanthus contrasts strongly with the abstract, geometric cyma. *Gift of J. Pierpont Morgan, 1917, 17.190.52,53*

9 Pyxis with the Holy Women at the Tomb of Christ
Early Byzantine, Syria-Palestine(?), 6th c.
Ivory; h. 4 in. (10.2 cm), diam. 5 in. (12.7 cm)

The subject of this pyxis is the visit of the Holy Women to the tomb of Christ; however, the two Marys, carrying censers, approach not a tomb but an altar. By substituting an altar for the actual tomb, the artist illustrated the popular belief that the altar symbolized the Holy Sepulcher. This association grew out of the belief in the presence of the crucified Christ on the altar during the celebration of the Eucharist. This scene is well suited for a pyxis which was probably used as a container for the bread consecrated during the Mass. *Gift of J. Pierpont Morgan, 1917, 17.190.57*

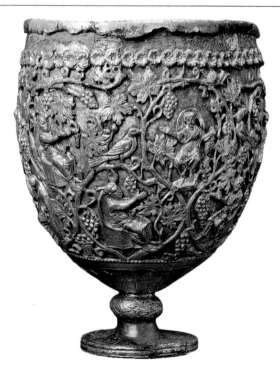

11 Pectoral

Early Byzantine, Constantinople(?), mid-6th c.
Gold and niello; h. including neck-ring 9 ⅜ in. (23.8 cm)

This pectoral is part of a treasure said to have been found either at Antinöe or in Tomei, near Assiût. It is composed of a plain neck-ring attached to a frame set with a large central medallion flanked by coins and two decorative disks. The two ribbed rings at the bottom originally held a medallion. The coins represent emperors of the fourth to sixth centuries, portrayed for the most part in military dress. The latest coins date from the reign of Justinian. The central medallion shows on the obverse an emperor in military attire and on the reverse the figure of Constantinopolis, seated on a throne and wearing a helmet and tunic. She holds a *globus cruciger* and a scepter, and her left foot rests on the prow of a ship. This image reflects the passing of political primacy from Rome to Constantinople. *Gift of J. Pierpont Morgan, 1917, 17.190.1664*

12 Dove

Early Byzantine, Attarouthi, Syria, 6th–7th c.
Silver; l. 5 ¾ in. (14.6 cm)

Worked from a single sheet of silver, the dove is shown in flight with its legs tucked under its body. Originally carrying a cross in its beak, it is probably intended as a symbol of the Holy Spirit appearing as a dove over the head of Christ at his baptism by John the Baptist (Matthew 3:16). Many texts refer to such doves over altars and tombs, but no other example is known from the Early Christian or Byzantine periods. It is part of the Attarouthi Treasure, a large hoard of liturgical silver named for the north Syrian town where it was found. This trove testifies to the wealth and prestige of Christian Syria in the early Byzantine era. *Purchase, Rogers Fund and Henry J. and Drue E. Heinz Foundation, Norbert Schimmel and Lila Acheson Wallace Gifts, 1986, 1986.3.15*

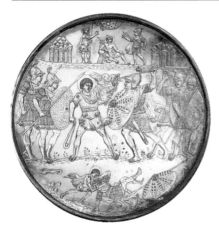

13 Plate with David and Goliath

Byzantine, Constantinople, 628–630
Silver; diam. 19 ½ in. (49.5 cm)

Ten silver plates of various sizes from the so-called Cyprus Treasure form a cycle showing scenes from the life of David. Six of these plates are in the Museum and four in the Cyprus Museum, Nicosia. They were made in Constantinople during the reign of Heraclius (610–641) and were perhaps intended as an imperial gift. The set was probably made for display. Its largest dish, which is illustrated here and which shows David fighting and slaying Goliath, may have been placed in the center, flanked or surrounded by the others of diminishing size. The series of images, as well as the classical style, may be based on earlier models; they appear to represent a conscious effort to keep alive the Hellenistic forms of antiquity. *Gift of J. Pierpont Morgan, 1917, 17.190.396*

14 Bow Fibula

Langobardic, first half of 7th c.
Silver gilt and niello; 6¼ × 3¾ in. (15.9 × 9.5 cm)

This large bow fibula represents the work of the Langobards in Italy, which they occupied from 568 to 774. Unlike Frankish artists, who worked chiefly in bronze, the Langobards often produced jewelry in gold and silver. The design of the body of the bow fibula is composed of chip-carved zoomorphic forms. Two bird's heads project from each side of the body. Like the work of other barbarian tribes who gradually settled in western Europe in the so-called Migration period (fourth–seventh centuries), the art of the Langobards was dedicated to the ornamentation of weapons and other portable articles. Jewelry and weapons revealed the status of the barbarian warrior in a military society and were buried with him in his tomb. *Purchase, Joseph Pulitzer Bequest, 1955, 55.56*

15 Reliquary of the True Cross

Byzantine, Constantinople(?), late 8th– early 9th c.
Silver gilt, cloisonné enamel, niello; 4 × 2⅞ in. (10.2 × 7.35 cm)

This reliquary's top and sides are decorated with enamels of the Crucifixion and busts of twenty-seven saints, including the twelve apostles. Scenes of the Annunciation, Nativity, Crucifixion, and Anastasis (Descent into Limbo) are worked in niello on the underside of the lid. Inside the reliquary is a cross-shaped compartment that once held a particle of the True Cross and perhaps other relics as well. On the lid Christ is shown alive on the cross, wearing a long tunic (colobium) of Eastern origin; he is mourned by his mother and Saint John. The extensive program of enameling stands at the beginning of the rich history of this technique in Byzantine and Western art. *Gift of J. Pierpont Morgan, 1917, 17.190.715*

16 Christ Enthroned with Saints and Emperor Otto I

Ottonian, Court School, 962–968
Ivory; 5 × 4½ in. (12.7 × 11.4 cm)

This dedication plaque shows Christ enthroned, accepting a model of the church of Saint Mauritius in Magdeburg from Otto I (r. 962–973). It is one of a series of nineteen known as the Magdeburg ivories. All of identical size and all having an unusual cutout geometric or floral background, these ivories depict various New Testament and symbolic scenes with a severe monumentality like that of Ottonian wall painting. Now dispersed in European and American collections, they once were part of a much larger ensemble, conservatively estimated at forty-four scenes, at the church of Saint Mauritius (founded by Otto between 955 and 973). The whole was probably a didactic embellishment for an ambo (pulpit) or a chancel door. *Gift of George Blumenthal, 1941, 41.100.157*

17 Plaque with the Crucifixion and the Stabbing of Hades

Byzantine, 10th c.
Ivory; 5 × 3½ in. (12.7 × 8.9 cm)

This plaque's iconography is unusual among surviving Byzantine representations of the Crucifixion. While the Virgin, Saint John, the two angels, and the three soldiers dividing Christ's garment are frequent witnesses to Christ's death, the bearded reclining man who is stabbed by the cross is a most uncommon feature. He is Hades, ruler of the underworld.

After the devastations of the Iconoclastic Controversy (ca. 725–842), artists and scholars searched for earlier pictorial and literary sources to re-create a corpus of Christian imagery. The theme of Hades pierced by the cross, illustrating the victory of Christ over death and the forces of evil, was inspired by literary sources, particularly the *Hymn on the Triumph of the Cross* by Romanos the Melodist (d. 556), which was sung on Good Friday in the Byzantine church. *Gift of J. Pierpont Morgan, 1917, 17.190.44*

18 Enthroned Christ from a Pectoral Cross

Anglo-Saxon, early 11th c.
Walrus ivory and copper gilt; 5⅞ × 2½ in. (14.9 × 6.4 cm)

This fragment of a pectoral cross shows Christ on one face and the Lamb of God and two Evangelist symbols on the other. It dates from the early eleventh century, but it is difficult to determine whether it was made in northern France or in England. The figure's posture and facial type—oval eyes (once inlaid with dark beads), drooping mustache, and divided beard—have parallels in English manuscripts and ivories. However, there are also clear stylistic affinities with some Saint-Bertin manuscripts created under English, or more specifically Winchester, influence. The French monasteries of Saint-Bertin and Saint-Vaast were closely connected to similar foundations in England, and the Winchester style not only dominated the ateliers of England but also had wide-ranging effects on the Continent, particularly in the area directly across the Channel. It may be that the cross was made at Saint-Bertin by an English artist or a Continental artist trained in England. *Gift of J. Pierpont Morgan, 1917, 17.190.217*

19 Plaque with the Journey to Emmaus and the Noli Me Tangere

North Spanish, probably León, ca. 1115–20
Ivory; 10⅝ × 5⅜ in. (27 × 13.7 cm)

Two appearances of the risen Christ are represented on this plaque. The Gospel of Luke tells of the risen Christ traveling with two disciples on the road from Jerusalem to Emmaus. The Gospel of John describes the risen Christ's appearance to Mary Magdalen as she stood weeping at his tomb. Warning her, "Noli me

tangere (Do not touch me)," he then told ▶ her to carry the news of his resurrection to his disciples.

A companion plaque with the Descent from the Cross and the Holy Women at the Tomb is divided between a private collection in Oviedo and the Hermitage, St. Petersburg. The animated carving of this ivory is characteristic of a number of Spanish Romanesque works of art. *Gift of J. Pierpont Morgan, 1917, 17.190.47*

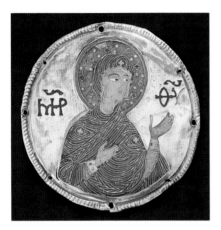

20 Roundel of the Virgin
Byzantine, Constantinople, early 12th c.
*Cloisonné enamel on gold; diam. 3¼ in.
(8.25 cm)*

This is one of nine medallions in the Museum
that came from an eleventh-century silver icon
of the archangel Gabriel (now destroyed) from
the Djumati monastery in Georgia (formerly part
of the U.S.S.R.). The medallions present an ex-
tended Deesis—the Virgin's and the saints'
intercession with Christ for the salvation of
humankind—a subject drawn from the Byzan-
tine liturgy. Technically and stylistically accom-
plished, they are fine examples of Byzantine
cloisonné enameling. In this technique, strips,
or *cloisons,* are soldered onto the base to form
a system of cells that contains the glass flux
and prevents the various colors from running
into one another. Cloisonné enamels thus com-
bine the luminosity of colored glass with the
shimmer of gold. *Gift of J. Pierpont Morgan,
1917, 17.190.675*

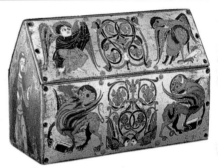

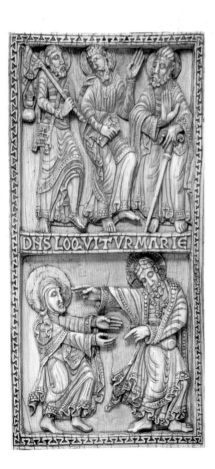

21 Reliquary Casket
Central French (Limousin) or North Spanish
(Castile), ca. 1150–75
*Copper gilt and champlevé enamel; 4⅞ × 8 ×
3-⅜ in. (12.4 × 20.3 × 8.6 cm)*

On the front plaques of this reliquary are the
symbols of the four Evangelists—the angel of
Matthew, the eagle of John, the lion of Mark, and
the ox of Luke. The other side represents Christ
between the Virgin Mary and Saint Martial (a
third-century bishop of Limoges) and the hand
of God flanked by two censer-bearing angels;
the narrow ends show Saints Peter and Paul.
Saint Martial had a special cult in Limoges, and
the reliquary is known to have been in the
nearby town of Champagnat in the nineteenth
century. Stylistic elements such as the floral or-
nament, however, relate to the decoration on
enamels created for the monastery at Silos. *Gift
of J. Pierpont Morgan, 1917, 17.190.685–
687,695,710,711*

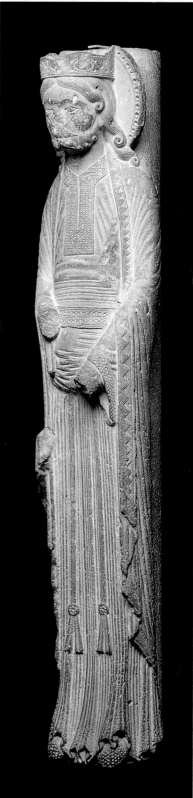

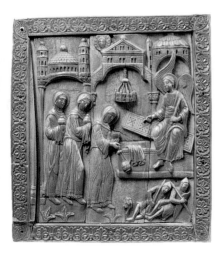

22 Plaque with the Three Marys at the Tomb of Christ
Rhenish, Cologne, ca. 1135
Walrus ivory; 8³/₈ × 7³/₄ in. (21.3 × 19.7 cm)

This plaque, its companion piece in the Museum (the Doubting of Thomas), and three others in the Victoria and Albert Museum, London, probably come from the same ensemble, possibly an ambo (pulpit) decorated with scenes of the Infancy and Passion of Christ. All are carved in walrus ivory, often used in lieu of elephant ivory in northern Romanesque art. The relatively small size of walrus tusks necessitated the use of three plaques for the central composition. The pricked drapery is a hallmark of the Cologne style, and the composition is close to that of an ivory plaque in the Schnütgen Museum in Cologne. Though stylized, the buildings in the background suggest contemporary Romanesque architecture. *Gift of George Blumenthal, 1941, 41.100.201*

23 Column Figure of an Old Testament King
French, Paris, ca. 1150–60
Limestone; 45¼ × 9¼ in. (115 × 23.5 cm)

This column statue is from the old cloister of the abbey of Saint-Denis outside Paris. A vast program of construction and architectural decoration was carried out at Saint-Denis under the direction of the extraordinary churchman Suger, who was abbot from 1122 to 1151. This king is the only complete column figure known to have survived from that period. Like the head of King David from Notre-Dame (no. 26), it has been identified from early engravings. With the other sculpture from the cloister, this Old Testament king may have represented the royal genealogy of Christ. *Purchase, Joseph Pulitzer Bequest, 1920, 20.157*

24 Reliquary Crucifix
North Spanish, Asturias, ca. 1150–70
Silver and niello repoussé over a wood core, carved gems, jewels; 23¼ × 19 in. (59.1 × 48.3 cm)

The repoussé figure of Christ flanked by the Virgin and Saint John dominates the front of this reliquary crucifix. Above him is a censing angel, while at the bottom Adam rises from his tomb, symbolizing the redemption of humankind. The large crystal over the figure of Christ once contained a relic. The reverse shows the Lamb of God, surrounded by the symbols of the four Evangelists. The reverse also bears a Latin inscription which translates, "Sanccia Guidisalvi made me in honor of the Holy Savior." Sanccia is a woman's name; while she may have been the donor, contemporary records do refer to women artists working in Spain.

The cross comes from the church of San Salvador de Fuentes in the province of Oviedo and can be compared stylistically to other works from that region. Details such as the filigree can be compared to the silver-gilt bookcovers from the cathedral of Jaca which are also exhibited in the Medieval Treasury. *Gift of J. Pierpont Morgan, 1917, 17.190.1406*

25 Virgin and Child
French, Auvergne, second half of 12th c.
Walnut with linen, gesso, polychromy; h. 31 in. (78.7 cm)

This type of image of the Virgin and Child enthroned was very popular in the Auvergne region where this work was made. Mary, as the mother of God, also represents the Throne of Divine Wisdom. The missing scroll or book once held by the Child symbolized the imparting of knowledge through the Word of God. To convey these abstract ideas the statues had to be formal and symmetrical, with a rigid frontality and stylized forms and drapery. (See also Medieval Art—The Cloisters, no. 2.) *Gift of J. Pierpont Morgan, 1916, 16.32.194*

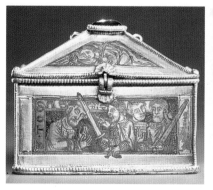

26 Head of King David
French, Paris, ca. 1150
Limestone; h. 11¼ in. (28.6 cm)

This is the only extant head from the jamb sculptures of the Saint Anne portal of the cathedral of Notre-Dame in Paris. It has been identified on the basis of engravings made of the portal before the destruction of its sculpture during the French Revolution. Carved in fine-grained limestone, the head has a polish that makes it look like marble. The deeply incised pupils of the large round eyes were originally inlaid with lead. The somewhat soft and fleshy cheeks contrast with the strong cheekbones and the intense eyes. This magnificent head is carved in the transitional style between Romanesque and Gothic and was possibly first intended for the basilica of Saint-Étienne, which was being reconstructed after 1124 and before 1150 on the site of the cathedral. *Harris Brisbane Dick Fund, 1938, 38.180*

27 Panel with Censing Angels
French, Troyes, ca. 1170–80
Pot-metal glass; 18½ × 17⅜ in. (47 × 44 cm)

Stained glass produced in Troyes during the later twelfth century represents a major transition from the Romanesque to the Gothic style. This panel with censing angels, perhaps from the church of Saint-Étienne, is from a window of connected semicircles whose overall subject was the Dormition (Death) of the Virgin. (Also in the collection is the head of the Virgin from this window.)

The panel is painted with exceptional precision against a ground decorated with fine rinceaux. Stylistic links with Mosan enamelwork and illuminations from Champagne demonstrate that the Troyes artist had assimilated techniques, color relationships, and figure types not characteristic of other twelfth-century stained-glass painting. *Gift of Ella Brummer, in memory of her husband, Ernest Brummer, 1977, 1977.346.1*

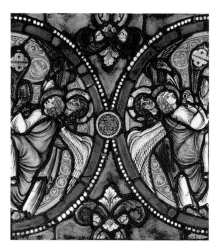

◀ **28 Reliquary of Saint Thomas Becket**
English, 1175–80
Silver gilt, niello, glass; 2¹/₄ × 2³/₄ × 1³/₄ in.
(5.7 × 7 × 4.4 cm)

The oblong front and back plaques show the
murder and burial of Saint Thomas Becket, the
archbishop of Canterbury who was killed in
1170 by four knights from the court of Henry II.
The front and back roof plaques contain half-
figures of angels, and the angel above the
martyrdom scene holds a child symbolizing
Becket's soul. The end plaques are filled with
foliate ornament, as are the roof plaques above
them. The reliquary's magnificent craftsman-
ship is evident in the beaded bands, hinges,
and floral decoration; the figures are delicately
drawn, and the bodies are modeled by sharply
drawn drapery folds. One of the earliest Becket
reliquaries, it is attributed to an English work-
shop active in the 1170s. *Gift of J. Pierpont
Morgan, 1917, 17.190.520*

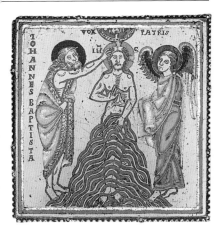

29 Plaque with the Baptism of Christ
Mosan, 1150–75
Champlevé enamel on copper gilt; 4 × 4 in.
(10.2 × 10.2 cm)

Traditionally renowned for their production of
outstandingly beautiful works in champlevé
enamel, artists of the Meuse valley (in modern-
day France and Belgium) created this plaque.
Here Saint John the Baptist anoints Christ, who
stands in the rippling waters of the River Jor-
dan. An angel on the opposite bank attends
him, while the voice of God descends from the
heavens above. A rich and varied spectrum of
colors further enlivens the delicate, animated
style of engraving. This work was part of an ex-
tensive series of plaques that once decorated a
single large object, perhaps an altarpiece or
pulpit. *Gift of J. Pierpont Morgan, 1917,
17.190.430*

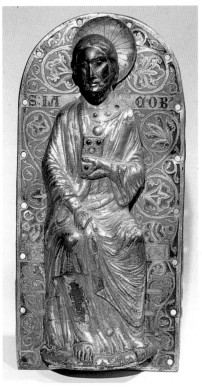

**30 Plaque with Applied Figure of
Saint James the Greater**
French, Limoges, ca. 1225–30
Champlevé enamel on copper gilt; 11³/₈ × 5¹/₂ in.
(29 × 14 cm)

This plaque is one of six (the others are in
Paris, Saint Petersburg, and Florence) which
are thought to have come from the altar of the
abbey of Grandmont in the Limousin region of
France. The ateliers of Limoges were known for
works of this type, in which gilded figures and
decorative elements were attached by rivets to
an enamel ground. The Grandmont plaques
are exceptional among these pieces for their
classicistic drapery and monumentality. Each
figure was cast and then finished by chiseling.
The eyes are formed by dots of dark blue
glass, and small stones enhance details of
the robes. *Gift of J. Pierpont Morgan, 1917,
17.190.123*

31 Panel with Saint Vincent in Chains

French, Paris, ca. 1244–47
*Pot-metal glass with vitreous paint; 147 × 43½ in.
(373.4 × 109.2 cm)*

This stained-glass panel is one of a series depicting episodes from the life of the deacon Vincent, the most celebrated of Spanish martyrs, who was executed in 304 at Valencia in the persecution under Diocletian. The series formed a window in the Lady Chapel of the Benedictine abbey church of Saint-Germain-des-Prés in Paris, where the relics of Saint Vincent had long been venerated. The abbey was rich in stained glass, notably the windows of the thirteenth-century Lady Chapel; much of this glass was destroyed after the French Revolution. Other panels from this series are now in the Walters Art Gallery, Baltimore, in London's Victoria and Albert Museum, and at Wilton Parish Church. These panels are masterworks in the Gothic style. The bodies are elongated; the heads are expressive, drawn with great freedom and variety; the gestures are eloquent and emphatic.
Gift of George D. Pratt, 1924, 24.167

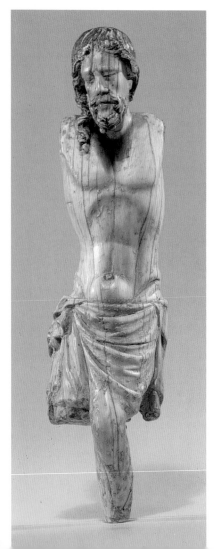

32 Corpus of Christ

French, Paris, third quarter of 13th c.
Ivory; h. 6½ in. (16.5 cm)

The suffering Christ on the cross was a central theme in Gothic art. Carved in the round and intended for an altar cross, this masterpiece, probably from Paris, conveys the pathos and agony of Christ. In spite of the loss of arms and legs, the figure reveals a profound sensitivity to form and expression. The polychromy on the hair and on the facial features and body enhances the naturalism of the image. The powerful anatomical structure is remarkable for crucifixes of the Gothic period. The strict verticality of the corpus in Romanesque versions of the Crucifixion has been replaced by a subtly twisted posture. This magnificent corpus anticipates the more refined style of the court of the mid-thirteenth century, while retaining the main features of the Gothic classicism of the early part of the century.
Gift of Mr. and Mrs. Maxime L. Hermanos, 1978, 1978.521.3

33 GIOVANNI PISANO, Italian, ca. 1245/50– ▶
after 1314

Lectern

Carrara marble; 28 × 23 in. (71.1 × 58.4 cm)

This lectern in the shape of an eagle grasping an open book in its claws, with a polygonal bookrest, is believed to have come from the pulpit of the church of Sant'Andrea in Pistoia. The pulpit is by Giovanni Pisano and was completed in 1301. There is an aggressive bravura in the rendering of the feathers with strong, sweeping strokes of the chisel, almost horizontal in the legs, conveying a feeling of air and movement which is shared by the eagles carved by Giovanni Pisano in Siena and Perugia. *Rogers Fund, 1918, 18.70.28*

34 Aquamanile

German, Lower Saxony, second half of 13th c.
Bronze; h. 12¼ in. (31.1 cm)

This aquamanile in the form of a knight on horse-back was made in Saxony in northern Germany. Aquamanilia were used by laymen to wash their hands at meals and by celebrants to wash their hands during the Mass. This example was surely intended for domestic use. The figure symbolizes the ideals of knighthood depicted in the popular medieval *romans courtois* (chivalric tales).
Gift of Irwin Untermyer, 1964, 64.101.1492

35 The Visitation

German, Constance, ca. 1310
Walnut, polychromed and gilded; 23¼ × 12 in. (59.1 × 30.5 cm)

Soon after the Annunciation, when she learned of her miraculous conception of Jesus, the Virgin Mary visited her kinswoman Elizabeth, who was also expecting a child (John the Baptist). This representation of their joyous meeting comes from the Dominican monastery of Katharinenthal, in the Lake Constance region of present-day Switzerland. With the groups of Saint John and Christ in Antwerp and Berlin, the Metropolitan Visitation has been attributed to the circle of Master Heinrich of Constance. The crystal-covered cavities probably contained representations of the Christ Child and Saint John, a common German iconographic motif at that time. *Gift of J. Pierpont Morgan, 1917, 17.190.724*

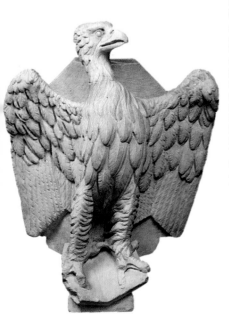

36 Casket with Scenes from Romances

French, Paris, ca. 1320–40
Ivory; 4⅜ × 10 × 6⅛ in. (11.1 × 25.4 × 15.5 cm)

This casket is exceptionally rich in carvings depicting chivalric scenes from medieval romances. Knights assault the castle of love and joust for their ladies' favors. Gawain and Galahad rescue maidens imprisoned in castles. Lancelot, in order to rescue Guinevere, crosses a raging torrent, using the blade of his sword for a bridge. Tristan and Isolde are spied upon from a tree by King Mark, but the king's reflection in a fountain reveals his presence to the lovers. Other popular themes—the unicorn captured by the lady; the hairy wild men of the forest—also are depicted. The front panel shows Phyllis and Aristotle and scenes from the tragedy of Pyramus and Thisbe. Front panel: *The Cloisters Collection, 1988, 1988.16;* rest of casket: *Gift of J. Pierpont Morgan, 1917, 17.190.173*

37 Virgin and Child

French, probably Vexin, 1300–1325
Limestone with polychromy; h. 62½ in. (158.8 cm)

In this unusually large and imposing devotional statue, the Virgin holds the Child as if elevating him before the faithful. Her body forms a gentle curve, which is repeated in the parallel folds of her skirt. The subject of this sculpture was a frequent one in fourteenth-century French, German, and Netherlandish regions, and its widespread popularity as a votive image developed out of the intensity of belief in the cult of the Virgin at that time. Very few of these sculptures are preserved in the locations for which they were originally made, whether a parish church, a great cathedral, an aristocratic oratory, or a monastic chapel. Isolated examples intended for veneration in the open air, as at remote crossroad shrines, at town gateways, or on the exteriors of houses, have virtually vanished. Therefore, the preponderance of preserved examples—including this work—are without any historical clues as to their provenance, those responsible for commissioning them, and their original settings. On the basis of stylistic comparisons, the Vexin region, between Normandy and the Île-de-France, has been suggested as the most probable origin for this work. *Bequest of George Blumenthal, 1941, 41.190.279*

38 Monstrance Reliquary

Monstrance: Italian (probably Florence), late 15th c.; disk: Italian (possibly Tuscany), 1375–1400
Silver gilt, rock crystal, verre églomisé; *h. 22 in. (55.9 cm)*

This monstrance reliquary bears an inscription indicating that the relic, a tooth, is of Saint Mary Magdalen. The relic is encased in an almond-shaped crystal container, fixed in an openwork turreted shrine which is set on a chalicelike base. From the shrine's crown rises a glass disk, which is a superb example of reverse painting on glass (*verre églomisé*). The Crucifixion is shown on one side of the dish and the Nativity on the other. This form of reliquary is similar to that used for a monstrance of the Host. *Gift of J. Pierpont Morgan, 1917, 17.190.504*

39 Morse with Saint Francis of Assisi

Italian, Tuscany, ca. 1350
Copper gilt and translucent and opaque enamel; diam. 4¼ in. (10.8 cm)

In this morse, or clasp for a cope, Saint Francis is shown receiving the stigmata, the wounds corresponding to those suffered by Christ. The closest iconographic parallels to this representation are the frescoes of the upper church of the basilica of Assisi. The morse departs from its prototypes, however, by presenting a nocturnal scene. The enamel technique differs completely from that seen in most other Italian and south European works of the fourteenth century. The artist was perhaps a Tuscan from Florence, who was drawn to Assisi when the basilica was being decorated. This octalobular morse could have been made for the ceremonial cope of one of the abbots. *Gift of Georges and Edna Seligmann, in memory of his father, Simon Seligmann, the collector of Medieval art, and of his brother René, 1979, 1979.498.2*

40 Basin with Horseman Spearing a Serpent

Spanish, Valencia(?), 1390–1400
Lustered earthenware; diam. 17¼ in. (43.8 cm)

The earliest example of medieval lusterware in the collection, this basin displays both Islamic glazing technique and Gothic decoration. This combination is an expression of the meeting of the Christian and Islamic cultures that resulted from the gradual Christian reconquest of Muslim Spain. The figure in the middle—a horseman spearing a serpent—is perhaps inspired by representations of the legend of Saint George and the Dragon. Details are delineated by sgraffito (surface scratching). Although the shields around the rim are not identifiable coats of arms, they also appear on a contemporary piece in the Instituto de Valencia de Don Juan in Madrid. The representation of a large figure rather than the more usual floral or geometric decoration and the coloring of the Museum's basin make it exceptional. *Gift of George Blumenthal, 1941, 41.100.173*

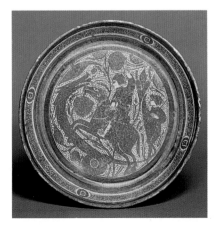

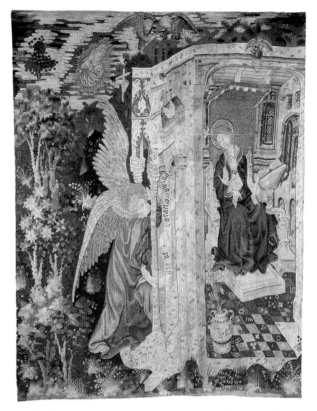

41 The Annunciation Tapestry

South Netherlandish, 1400–1430
Wool and metal foil on silk; 11 ft. 4 in. × 9 ft. 6 in.
(3.4 × 2.9 m)

Seated on the right under an open edicule,
Mary looks away from her book on the lectern
to listen to the archangel Gabriel. He is holding
a banner with the words "*Ave gracia plena* (Hail
[Mary], full of grace)." In the sky, God the Father
sends the infant Jesus bearing a cross down
toward the Virgin; Jesus is preceded by the
dove of the Holy Spirit. Two angels hold a coat
of arms, which may be that of the patron. The
cartoonist for the Annunciation clearly belonged
to the Gothic International school. This work was
probably woven in Arras, the most important
center of tapestry weaving in the first half of the
fifteenth century. The tapestry, however, was
found in Spain, and the coat of arms has been
called Spanish; whether the cartoon reflects a
Flemish or a north Spanish design is still an
open question. *Gift of Harriet Barnes Pratt,*
1949, in memory of her husband, Harold Irving
Pratt (born February 1, 1877, died May 21,
1939), 1945, 45.76

42 Saint Catherine of Alexandria

French, Paris, ca. 1400–1410
Gold, ronde-bosse enamel, jewels:
h. 3¾ in. (9.5 cm)

Saint Catherine of Alexandria was said to have
been a Christian princess executed by the
Roman emperor Maxentius in the fourth
century. She was one of the most popular saints
in the medieval Church, and her relics were
renowned for their miraculous powers. This
statuette may have come from a reliquary where
it and figures of other saints would have been
integrated into an architectural ensemble. The
artistry of this piece is extremely fine, and the
delicate modeling of the face approaches that
of the enameled-gold Madonna of Toledo that
was made for Jean, duc de Berry, before 1402.
This statuette of Saint Catherine is said to come
from a convent in Clermont-Ferrand. *Gift of*
J. Pierpont Morgan, 1917, 17.190.905

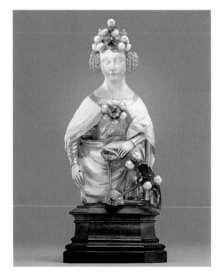

43 Mourner from the Tomb of the Duc de Berry

French, Burgundy, ca. 1453
Alabaster; h. 15⅛ in. (38.4 cm)

The tomb at Bourges of Jean, duc de Berry (1340–1416), was begun by Jean de Cambrai and completed by Étienne Bobillet and Paul de Mosselman. A naturalistic life-size effigy of the duke was placed on top of the sarcophagus, while on the sides were figures of mourners rendered in high relief under a series of arcades. These statuettes can be identified as relatives and allies of the deceased. The tomb was vandalized during the Revolution, and the mourner figures were destroyed or dispersed. Of the forty statuettes, twenty-five survive, including this one and two others in the Museum's collection.

The duc de Berry was a great patron, and the Museum has several works from his collection (see Medieval Art—The Cloisters, no. 27). *Gift of J. Pierpont Morgan, 1917, 17.190.389*

44 Courtiers in a Rose Garden

French or South Netherlandish, 1450–55
*Wool, silk, metallic foil on silk;
10 ft. 2 in. × 8 ft. 3 in. (3.1 × 2.5 m)*

This work is part of a set known as the Rose Tapestries. They were perhaps made for the French king Charles VII, whose colors were white, red, and green, and one of whose emblems was the rose tree. A royal connection is likely, for the tapestries are sumptuous, with metal threads not only in the clothes and jewelry but also, most unusually, in the leaves, buds, and open rose hearts. Woven in Arras or Tournai, the tapestries probably date from about 1450, since such details as the dark locks on the women's foreheads do not seem much in evidence before that time. *Rogers Fund, 1909, 09.137.1*

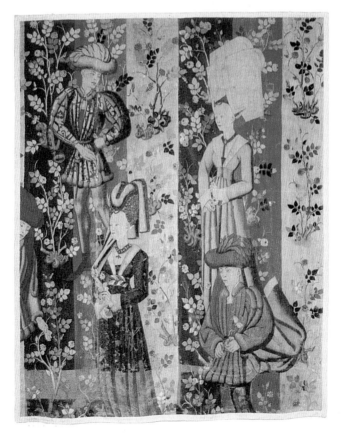

45 ATTRIBUTED TO CLAUX DE WERVE,
Netherlandish, act. 1396–d. 1439
Virgin and Child
Limestone with polychromy and gilding;
53¼ × 41½ in. (135.3 × 105.4 cm)

This monumental portrayal of the Virgin and
Child from the convent of the Poor Clares in
Poligny is distinguished by its convincing natu-
ralism. Characteristic of sculptors working in
the circle of Claus Sluter, this emphasis on
monumentality influenced French Burgundian
sculpture for generations. The relationship de-
picted between mother and child conveys a
tender intimacy as the chubby infant playfully
interrupts the Virgin as she reads. Despite this
domesticity, the inscription on the bench rein-
forces Christ's fulfillment of biblical prophecy:
"From the beginning and before the ages was I
created" (Ecclesiasticus 24:14). *Rogers Fund,*
1933, 33.23

46 Crib of the Infant Jesus ▶
South Netherlandish, Brabant, 15th c.
Wood, polychromed and gilt, lead, silver gilt,
painted parchment, and silk embroidered with
seed pearls, gold thread, tinsel, and translucent
enamels; 12½ × 11 × 7⅛ in. (35 × 28 × 18.1 cm)

This extraordinary piece from Brabant is an ex-
ample of a reliquary crib known as a *repos de*
Jésus. Such cribs seem to have been popular
devotional objects during the fifteenth and early
sixteenth centuries. They were venerated during
Christmas festivities and may have been given
as presents to nuns taking their vows. The Child
(now missing) lay beneath the silk coverlet dec-
orated with the Tree of Jesse, his head resting
on the Lamb of God embroidered on the pillow.
Inside the bed is the case for the relic. *Gift of*
Ruth Blumka as a memorial to her late husband's
ideals, 1974, 1974.121

47 Chair
North Italian, 15th c.
Oak; 32 × 28 × 17 in. (81.3 × 71.1 × 43.2 cm)

This chair, decorated with Gothic tracery, is thought to come from the Piedmont region of north Italy. It is one of the earliest medieval chairs in the Museum's collection. Similar examples are preserved in the Collegiata di San Orso in Aosta. Chairs such as this may also have been intended for secular use. An illegible inscription in Gothic characters can be seen on the left stile. *Gift of George Blumenthal, 1941, 41.100.124*

48 ATTRIBUTED TO NICLAUS WECKMANN, South German, act. 1481–1528
The Holy Family
Lindenwood with traces of polychromy and gilding; h. 31½ in. (80 cm)

This engaging group of the Virgin and Child with Saint Joseph was once the center of a large altarpiece in the Cistercian convent in Gutteneel bei Biberach. The Virgin and Child face in the same direction, and the Child raises his right hand in blessing. Their posture suggests they may have been part of a Holy Kinship group with Saint Anne or of an Adoration of the Magi scene. The orb in Christ's left hand symbolizes his role as spiritual ruler of the world. Formerly attributed to various other Ulm masters, this relief has only recently been attributed to Niclaus Weckmann. *Gift of Alastair B. Martin, 1948, 48.154.1*

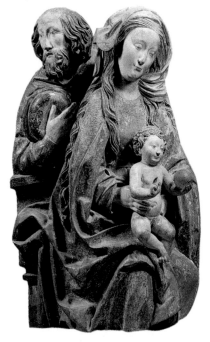

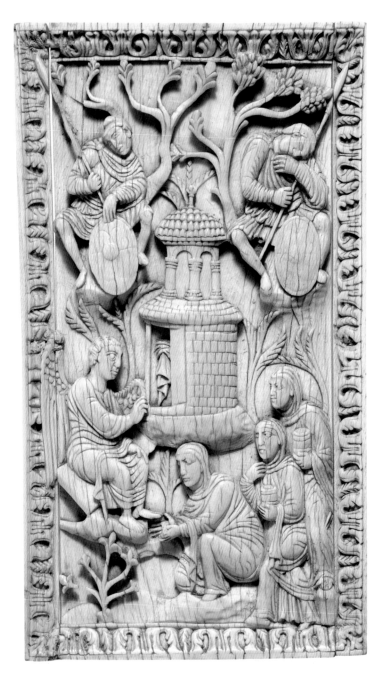

Three Marys at the Holy Sepulcher
North Italian (Milan?), early 10th century
Ivory; h. 7½ in. (19 cm)

This noble ivory almost certainly once decorated the cover of a late Carolingian liturgical manuscript such as a sacramentary or gospel book. The theme of the Three Marys at the Holy Sepulcher is essential to Christian art, since it shows Christ's empty tomb after he has risen from the dead. Following the gospels of Matthew and Mark, the story is depicted in compelling visual terms. The guards, frightened by the angel, are seen above and behind the tomb while the three Marys approaching the tomb with their ointment jars recoil in surprise at the angel atop a slab. In the center is the Holy Sepulcher, a cylindrical structure with an arcaded and domed tower, the empty shroud visible within.

The story is told with a boldness that makes clear the symbolic significance of the scene. Here the vitality of the composition causes the scene to burst out of the traditionally confining frame. *Purchase, The Cloisters Collection and Lila Acheson Wallace Gift, 1993, 1993.19*

MEDIEVAL ART

THE CLOISTERS

The Museum's collection of medieval art is housed not only in the main building on Fifth Avenue (pp. 371–391) but also at The Cloisters. Located in Fort Tryon Park in northern Manhattan, a magnificent setting that overlooks the Hudson River, The Cloisters was opened in 1938. It incorporates elements of five medieval cloisters from Saint-Michel-de-Cuxa, Saint-Guilhem-le-Désert, Bonnefont-en-Comminges, Trie-en-Bigorre, and Froville, and from other monastic sites located in southern France. Much of the sculpture was acquired by George Grey Barnard (1863–1938), who was a prominent sculptor and an avid collector of medieval art. Barnard opened his museum on Fort Washington Avenue to the public in 1914; through the generosity of John D. Rockefeller Jr., most of its collection was acquired in 1925. A new museum was built in medieval architectural style, incorporating elements from Barnard's museum as well as works from Rockefeller's own collection. The Cloisters continues to grow, thanks to Rockefeller's endowment and other significant gifts.

Known particularly for its Romanesque and Gothic architectural sculpture, The Cloisters collection also includes illuminated manuscripts, stained glass, metalwork, enamels, ivories, and paintings. Among its tapestries is the renowned Unicorn series.

HOW TO REACH THE CLOISTERS

Subway: IND Eighth Avenue A train to 190th Street—Overlook Terrace. Exit by elevator, then take number 4 bus or walk through Fort Tryon Park to the Museum.

Bus: Madison Avenue bus number 4, "Fort Tryon Park—The Cloisters," stops at the door of the Museum.

Car: From Manhattan: Henry Hudson Parkway north to the first exit after the George Washington Bridge.

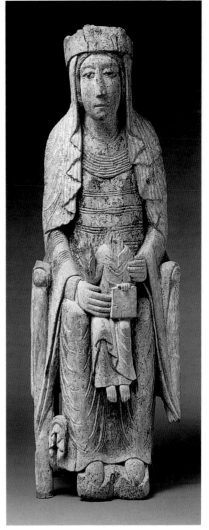

1 Plaque with Seated Saint John the Evangelist
Carolingian (court school), early 9th c.
Ivory; 7½ × 3⅝ in. (18.3 × 9.5 cm)

The four Evangelists were among the most frequently represented images in Carolingian art. In this plaque John, accompanied by his symbol, the eagle, displays the opening text of his Gospel. The inscription along the top edge is from the writings of the early Christian poet Sedulius and translates: "Calling out, like an eagle, the word of John reaches the heavens." While inscribed in a later hand, it probably replaces an earlier original. This splendid plaque may have decorated the wing of a triptych. With the other Evangelists and their symbols, it would have framed a central image of Christ. The style—with deep layering of folds repeated across the surface—and the iconography closely link this ivory to manuscripts and ivories of Charlemagne's court school. *The Cloisters Collection, 1977, 1977.421*

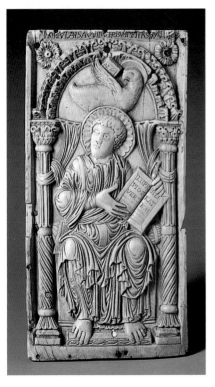

2 Enthroned Virgin and Child
French, Burgundy, first half of 12th c.
Birch with polychromy; h. 40½ in. (102.9 cm)

This sculpture comes from Autun in Burgundy; it is a moving example of the Throne of Wisdom type. Another example, from the Auvergne, is illustrated in this guide (Medieval Art—Main Building, no. 25). This Virgin is not quite so rigid and frontal as the one from the Auvergne: her head is slightly turned, and the linear treatment of the drapery at the "flying fold" near her right ankle suggests movement. The repetition and variation of linear rhythms throughout serve to heighten the intensity of the image.

Traces of color can still be seen on the Virgin, and one of the original blue glass inlays for the eyes is still in place. *The Cloisters Collection, 1947, 47.101.15*

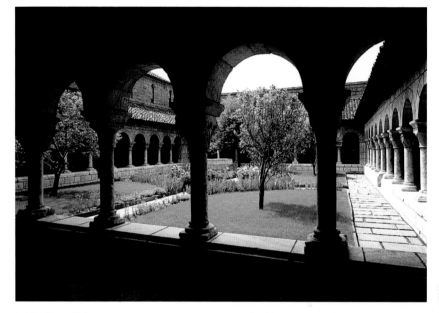

3 The Cuxa Cloister
Pyrenees, Roussillon, ca. 1130–40
Marble

The Benedictine monastery of Saint-Michel-de-Cuxa, located at the foot of Mount Canigou in the Pyrenees, was founded in 878. Its cloister, seen here in part, was built in the twelfth century. In 1791, when France decreed the Civilian Constitution of the Clergy, Cuxa's monks departed; the monastery's stonework was subsequently dispersed. Since not all the capitals are at The Cloisters, the reconstruction is only a little over half the original size.

The boldly cut marble capitals show great variety of design. Some are fashioned in the simplest of block forms; others are intricately carved with scrolling leaves, pinecones, animals with two bodies and a common head (a special breed for the corners of capitals), lions devouring people or their own forelegs, lions restrained by apes, a leaping man blowing a horn, and a mermaid holding her tail. Some of the capitals suggest influences from Near Eastern textile designs with animal compositions. Others appear to derive from fables or the imaginative lore preserved in bestiaries. Many of the motifs represent Christian versions of the struggle between the forces of good and evil, but for the Cuxa artists, conveying the old meanings seemed to be less important than creating striking compositions.

The cloister garden is traversed by walks, which provided rapid access from one part of the monastery to another. As in most monasteries, a source of water occupies the center of the garden—here, an eight-sided fountain from a neighboring monastery, Saint-Genis-des-Fontaines. *The Cloisters Collection, 1925, 25.120.398, 399, 452, 547–589, 591–607, 609–638, 640–666, 835–837, 872c,d, 948, 953, 954*

4 Portion of a Crosier Shaft
Northern Spanish, late 12th c.
Ivory; h. 11¼ in. (28.6 cm), diam. 1⅜ in. (3.5 cm)

A masterpiece of Romanesque art, this delicately carved cylinder formed part of a crosier shaft. It is divided into four bands depicting two principal realms—one celestial, the other terrestrial—each heralded by angels. At the top is Christ enthroned within a mandorla, and on the other side are the Virgin and Child in another mandorla. The two central registers are filled with angels dressed as deacons. The bottom register shows the installation of a bishop.

The figural style and technical virtuosity of the carving are almost without parallel in twelfth-century ivories. The entire surface is densely filled with richly animated figures. The chief characteristic of the style is the turbulence of the abundant drapery. *The Cloisters Collection, 1981, 1981.1*

5 The Cloisters Cross

English, attributed to Bury Saint Edmunds,
ca. 1150–60?
Walrus ivory with traces of polychromy;
22⅝ × 14¼ in. (57.5 × 36.2 cm)

Carved on both sides, this cross has on it more
than a hundred small figures and some sixty
inscriptions in Latin and Greek. Despite the
complexity of the religious content—eight scenes
from the Old Testament and the New, the allegory
of the Lamb of God,
likenesses of twenty-one
prophets, and symbols of
the Evangelists—the over-
all effect is one of
simplicity and strength.
The cross is attributed to
the abbey of Bury Saint Edmunds, Suffolk,
England, a thriving monastic center in the
twelfth century. *The Cloisters Collection, 1963, 63.12*

6 CIRCLE OF MASTER BIDUINUS, ▶

Italian, ca. 1180
Lintel of a Doorway
Marble; entire doorway 158 × 76 in.
(401.3 × 193 cm)

This lintel is part of a Romanesque doorway
from the church of San Leonardo al Frigido
near Massa-Carrara in Tuscany. Christ is repre-
sented entering Jerusalem, accompanied by
the apostles and by Saint Leonard of Aquitaine.
As in several works by the well-known Tuscan
sculptor Master Biduinus, with whom this
carving is associated, this scene follows
representations of Early Christian sarcophagi,
reflecting the revival of interest in Late Antique
and Early Christian art that occurred in Tuscany
during the twelfth century. *The Cloisters*
Collection, 1962, 62.189

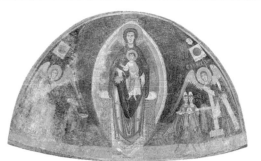

7 Apse

Spanish, Fuentidueña, ca. 1175–1200
Limestone; h. 10½ ft. (3.06 m)

The apse, or rounded end of a church that
usually faces east, is the church's most sacred
space, being the site where the Mass is
performed. This apse comes from the church
of San Martin in the Spanish village of
Fuentidueña, about seventy-five miles north of
Madrid. Constructed of some three thousand
massive blocks of golden limestone, the apse is
composed of a graceful arch and semicircular

barrel vault surmounted by a half dome. This
architectural system is ultimately of Roman ori-
gin, and by virtue of this derivation, the style it
exemplifies is now referred to as Romanesque.
The great expanse of wall space in churches of
this period was often decorated with fresco
paintings such as the representation here of the
Virgin and Child Enthroned in Majesty, origi-
nally from a smaller apse in the church of San
Juan de Tredós in the Catalonian Pyrenees.
1958, Exchange Loan from the Government of
Spain, L. 58.86

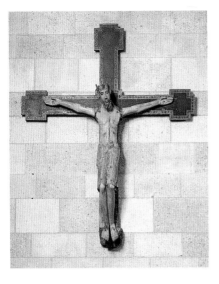

8 Crucifix

Spanish, Palencia, second half of 12th c.
Cross: red pine; Christ: white oak and poly-chromy; 102¹/₂ × 81³/₄ in. (260.4 × 207.6 cm)

According to tradition, this crucifix hung in the convent of Santa Clara near Palencia. It is one of the finest surviving examples of the Romanesque type. Wearing the golden crown of the King of Heaven and triumphant over death, this Christ contrasts sharply with crucifixes of later dates, in which Christ, wearing the crown of thorns, is shown in the full agony of his suffering. The almost horizontal arms, stylized anatomy, and flattened drapery folds give the sculpture an impressive dignity. The figure, carved of white oak, and the pine cross retain much of their original paint. The gesso base over which the paint was applied is thick, and at some points it is molded to produce finer details than could be achieved by carving. *The Cloisters Collection, 1935, 35.36a,b*

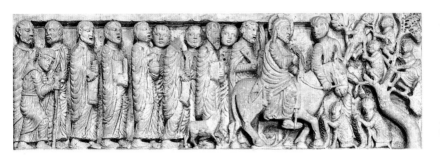

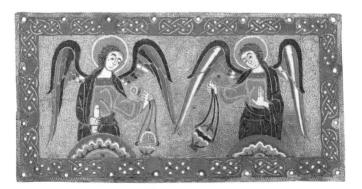

9 Plaque with Censing Angels

French (Limoges), ca. 1170–80
Champlevé enamel and gilded copper; 4³/₈ x 8⁵/₈ in. (11 x 21.1 cm)

This image of two angels originally crowned the top of a cross. With chalk white faces and furrowed brows, the angels mournfully bear witness to the Crucifixion. Symbolically and ceremonially, they proclaim the death of Jesus by swinging censers, since fragrant incense was used in funerals and at the altar during Mass, which is a reenactment of Christ's sacrifice. Set against a crowd that is exquisitely engraved and shimmering with gold, the angels, in their lapis-colored robes, appear to hover in the heavens. Such enamels, produced in Limoges in central France, were renowned throughout Europe in the twelfth and thirteenth centuries. *The Cloisters Collection, 2001, 2001.634*

10 Scene from the Life of Saint Nicholas

French, Soissons, 1200–1210
Pot-metal glass with vitreous paint; 21½ × 15½ in. (54.6 × 39.3 cm)

This panel, which has been traced to the early thirteenth-century glazing program at Soissons Cathedral, illustrates a scene from the life of Saint Nicholas. A fourth-century bishop, Nicholas was a popular saint in western Europe, particularly in northern France, in the twelfth and thirteenth centuries, and a chapel was dedicated to him at Soissons in 1200. The rich, brilliant color of the glass and the small, tubular, molded folds of drapery are characteristic of this period, while the rectangular panels set in arcades are an innovation that would become the standard by the mid-thirteenth century. *The Cloisters Collection, 1980, 1980.263.3*

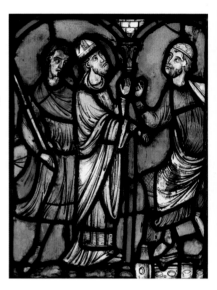

11 Panel with a Lion

Spanish, San Pedro de Arlanza, ca. 1220
Fresco mounted on canvas; 89 × 132 in. (226.1 × 335.3 cm)

According to medieval bestiaries, lions sleep with their eyes open, and therefore they represent paragons of Christian watchfulness. This lion was one of a pair from the monastery of San Pedro de Arlanza. Growling fiercely, it stands between an arcade and a flowering tree and is the image of invincible power. Beneath the lion is a border of decorative fish. In its freedom of line the fresco is reminiscent of the calligraphy of manuscript illumination. *The Cloisters Collection, 1931, 31.38.1a*

12 Chalice

North European, 1222
Silver gilt; 7¼ × 3⅝ in. (18.4 × 9.2 cm)

This sacramental cup, distinguished by its spare ornamentation, bears an inscription around its foot stating that it was made by Brother Bertinus in 1222. As Bertinus has not been identified, the place of origin is unknown. The tight interlacing of animals and foliage indicates a knowledge of Mosan art of the early thirteenth century. *The Cloisters Collection, 1947, 47.101.30*

14 Clasp
Mosan, ca. 1210
Gilt bronze; 2 × 3 in. (5 × 7.5 cm)

On the right half of this clasp a crowned male figure sits on a bench, his feet resting on a lion. A kneeling male attendant places a hand on the king's shoulder. On the left half is a seated woman; she rests her feet on a basilisk with the head of a monkey and the body of a dragon. She too has an attendant seated at her side. This piece may be a partial illustration of Psalm 91:13—"Thou shalt tread upon the adder and the basilisk and trample under foot the lion and the dragon"—a passage traditionally interpreted as the triumph of Christ and by Augustine as the triumph of the Church.

Many stylistic features, such as the drapery drawn across the knees and the ornamental motifs, point to the art of Nicholas of Verdun and his school and to a date of about 1210.
The Cloisters Collection, 1947, 47.101.48

13 Virgin
Alsatian, Strasbourg, 1248–51
Sandstone, polychromed and gilded; h. 58½ in. (148.6 cm)

This polychromed sculpture of the Virgin, the most important in the collection, was originally set on the choir screen of Strasbourg Cathedral. Though the screen was destroyed in 1682, a drawing of about 1660 records the position of the Cloisters sculpture among others on the face of the screen. The Virgin was once accompanied by the Christ Child, who was supported by a rose(?) bush. The figure retains much of its original polychromy. The breaking folds of the drapery are indicative of the contemporary development of the court style in Paris. *The Cloisters Collection, 1947, 47.101.11*

15 Diptych with the Coronation of the Virgin and the Last Judgment
French, Paris, ca. 1260–70
Ivory; h. 4⅞ in. (12.4 cm)

This diptych is exceptional not only for the depth and refinement of its carving but also for its juxtaposition of scenes. While the Coronation of the Virgin and the Last Judgment often appear together on Gothic portal sculpture, they rarely do so in ivory carvings. Of further iconographic interest is the representation of a friar—members of mendicant orders played an active role in the religious life at court—guided to heaven by an angel and followed by a king and a pope. On the basis of comparisons to Parisian metalwork and monumental sculpture, this ivory has been dated to just after the mid-thirteenth century. *The Cloisters Collection, 1970, 1970.324.7a,b*

16 Aquamanile
German, 13th c.
Brass; h. 8¾ in. (22.2 cm)

Aquamanilia were made in imaginative, often playful forms. They held water for the washing of priests' hands during the celebration of the Mass, and they were also used in households for the washing of hands at meals. This two-legged dragon, or wyvern, swallowing a man curves its tail over its winged body to form the handle. The water issues from a hole beneath the man's head. *The Cloisters Collection, 1947, 47.101.51*

17 Doorway
French, Burgundy, ca. 1250
Limestone with traces of polychromy;
15 ft. 4 in. × 12 ft. 5¾ in. (4.7 × 3.8 m)

This doorway from the Burgundian monastery of Moutiers-Saint-Jean originally served as an entrance from the main cloister to the sanctuary of the abbey church. It was built during a prosperous period in the abbey's history and shows the union of architecture and sculpture popular during the Gothic period. The tympanum surmounting the entryway illustrates a celestial court of angels attending Christ and the Virgin as she is crowned Queen of Heaven. The theme of heavenly kingship is transposed to the earthly realm through the large column figures of kings under canopied niches that flank the entrance. It has been suggested that they represent Clovis, the first Christian ruler of France, and his son, Chlothar. Medieval tradition held that the newly converted Clovis granted the monastery a charter exempting it in perpetuity from royal and ecclesiastic jurisdiction, a privilege later confirmed by Chlothar. *The Cloisters Collection, 1932, 32.147*

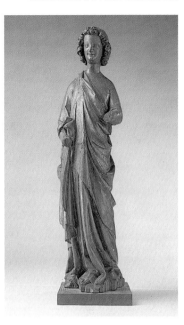

18 Pair of Altar Angels
French, Artois, 1275–1300
Oak with traces of polychromy; h. 29 in.
(73.7 cm)

These angels combine the monumentality of stone figures on cathedral portals of the thirteenth century with the delicacy and elegance of ivory carvings. Their mantles form deep, full folds, some resting along one hip.

They are believed to have come from the region around Pas-de-Calais in Artois. These two angels were originally polychromed and gilded and had wings. Angels of this type, holding candlesticks or carrying the instruments of Christ's Passion, were usually made in groups of four or six and were placed on top of columns around the altars of churches. *The Cloisters Collection, 1952, 52.33.1,2*

19 Tomb of Ermengol VII
Spanish, Lérida; effigy: 1320–40; sarcophagus and celebrants relief: mid-14th c.; assembled in 18th c.
Limestone with traces of polychromy; greatest overall measurements 89 × 79½ × 35½ in. (226.1 × 201.9 × 90.2 cm)

One double and three single engaged tombs in the Gothic Chapel belonged to members of the Urgel family of Catalonia and are among the finest surviving examples of sepulchral art of the Léridan school. Though the Urgels were patrons of the monastery of Bellpuig de la Avellanas, near Lérida, with which all but the effigy of a youth have long been associated, the figures have never been positively identified. They are thought to date from Ermengol X's rebuilding of the chapel in the early fourteenth century.

The effigy of the largest single-tomb ensemble —that of Ermengol VII (d. 1194), according to a tradition dating from the eighteenth century— is stylistically related to the other tombs but is more elaborate and refined. Ermengol is shown lying on the lid of the sarcophagus. Behind his effigy and carved from the same block of stone are rows of mourners. Above them, in separate and not so finely carved panels, clerics perform the funeral rite of absolution. The sarcophagus,

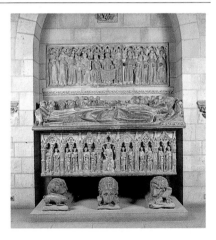

somewhat later in date than the effigy, is ornamented with carved reliefs of Christ in Majesty and of the apostles. The tomb is not mentioned in monastic records until the mid-eighteenth century and may have been assembled at that time from parts of other tombs, accounting for the mixture of styles that characterizes its present arrangement. *The Cloisters Collection, 1928, 28.95*

20 Virgin and Child
English, Westminster or London, 1290–1300
Ivory; h. 10¾ in. (27.3 cm)

Ivory statuettes such as this, appearing at the height of the popularity of the cult of the Virgin, were devotional in nature and must have been intended for chapels and small oratories. In a complete change from the rigid frontality of Romanesque sculptures, these statuettes tended to emphasize an intimate and reciprocal tenderness between the Virgin and the Child. This is the finest of the very few extant English examples of the subject, even though the Christ Child, who at one time climbed up over the Virgin's left knee, is missing. It is a masterpiece for its unified clarity of vision, intense refinement, which is both pervasive and detailed, and impression of monumentality. The face of the Virgin is so exquisitely modeled and courtly that it may be regarded as one of the most beautiful images in all Gothic art. The Virgin's highly polished surfaces have taken on over the centuries an appealing dark reddish-brown patina. *The Cloisters Collection, 1979, 1979.402*

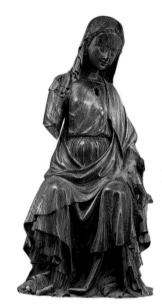

21 JEAN PUCELLE, French, act. ca. 1320– ca. 1350
Book of Hours of Jeanne d'Evreux
Grisaille, tempera, gold leaf, ink on vellum; 3½ × 2½ in. (8.9 × 6.4 cm)

This tiny book of hours, almost certainly made for Jeanne d'Evreux, queen of France, was illuminated between 1325 and 1328 by Jean Pucelle, whose style influenced Parisian manuscript illumination for nearly a full century. The only work entirely by Pucelle's hand, it contains twenty-five full-page miniatures, a calendar illustrating the signs of the zodiac, and numerous marginal drolleries, all painted in grisaille with touches of color. The two cycles of images illustrate the Infancy and Passion of Christ and the life of Saint Louis. Iconographic details of the Crucifixion scene (above left; folio 68v) point to the influence of Italy, and particularly the Sienese master Duccio. Pucelle's mastery is evident in the tightness of the drawing, the freedom in handling forms, and the degree of concentration and depth of expression in illustrations so restricted in dimension and color. *The Cloisters Collection, 1954, 54.1.2*

22 Virgin and Child
French, Île-de-France, Paris(?), first half of 14th c.
Limestone, polychromed and gilded; h. 68 in. (172.7 cm)

Made in the Île-de-France, the region around Paris, this Virgin and Child is extraordinarily well preserved: the paint and gilding are almost intact, and most of the stones remain in the crown and borders of the garments. The Virgin is interpreted as the Queen of Heaven, regal, gracious, and serene, but more relaxed than earlier models. The figure swings in a graceful S-curve and the draperies are soft and pliant, characteristics of the style of the mid-fourteenth century. *The Cloisters Collection, 1937, 37.159*

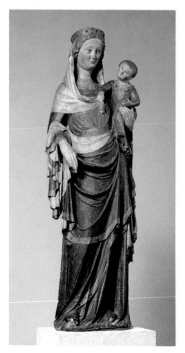

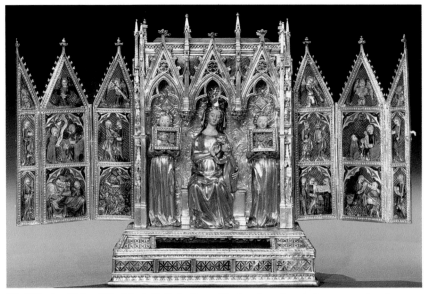

23 Reliquary Shrine ("The Elizabeth Shrine")
French, Paris, 1320–40
Silver gilt and translucent enamel; h. 10 in.
(25.4 cm), w. (open) 16 in. (40.6 cm)

This reliquary shrine of the Virgin and Child, in the form of a miniature altarpiece with hinged wings, was made in Paris about 1320–40. It is believed to have been purchased on the order of Queen Elizabeth of Hungary and to have been bequeathed by her to the convent of the Poor Clares in Budapest, which she founded in 1334.

The translucent enamel scenes on the wings, front and back, are of a jewel-like brilliance. The architectural details are reminiscent of Gothic churches, notably the trefoil arches and the ribbed vaulting above the seated Virgin and Child and her attendant angels. Since most of the scenes on the wings have to do with the Infancy of Christ, it may be that the angels once displayed relics associated with the Nativity in their small windowed boxes. *The Cloisters Collection, 1962, 62.96*

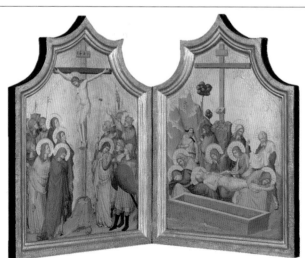

24 MASTER OF THE CODEX OF SAINT GEORGE, Italian, Florence, act. after 1310–1340s
The Crucifixion; The Lamentation
Tempera on wood, tooled gold ground; each panel 15 5/8 × 10 5/8 in. (39.7 × 27 cm)

This small diptych is a late work (ca. 1340–45) by an Italian panel painter and illuminator known as the Master of the Codex of Saint George. His mature style is characterized by restraint and depth of emotion, harmony of mass and space, and elegant and refined use of color and detail.

The Lamentation is not mentioned in the Gospels; here the artist follows closely the description in the *Meditations on the Life of Christ,* a work by a thirteenth-century Franciscan known as Pseudo-Bonaventura: "Our Lady supports the head and shoulders [of Christ] in her lap, the Magdalen the feet at which she had formerly found so much grace. The others stand about making a great bewailing over him . . . as for a firstborn son." *The Cloisters Collection, 1961, 61.200.1,2*

25 Emperor Henry II

Austrian, Lavanthal, 1340–50
Pot-metal glass with vitreous paint; 39 × 17¾ in.
(99.1 × 45.1 cm)

The three center windows in the apse of the
Gothic Chapel contain glass from the church of
Saint Leonhard in Lavanthal, built about 1340.
The two complete windows, one with its original
tracery lights, and parts from three others at
The Cloisters illustrate scenes from the life of
Christ and the Virgin and standing figures of
saints. Together they constitute the most exten-
sive collection of Austrian stained glass from a
single church in a foreign country. Illustrated
here is the Holy Roman Emperor Henry II; he
and his wife, Kunigunde, were the patron saints
of the windows' donors. (The panels showing
the donors are still preserved at Lavanthal.) *The
Cloisters Collection, 1965, 65.96.3*

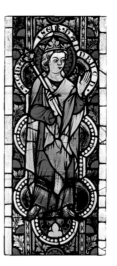

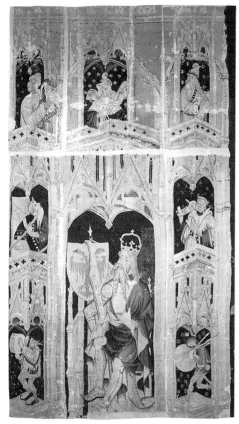

26 The Nine Heroes Tapestries: Julius Caesar

South Netherlandish or French, ca. 1385–1410
Wool; 160½ × 91¾ in. (407.7 × 233 cm)

Among the earliest Gothic tapestries to survive,
the Nine Heroes Tapestries were woven either in
the workshop of Nicolas Bataille in Paris or by a
master in the South Netherlands. The theme of
the heroes was popularized in a French poem
of about 1312 in which three pagan, three
Hebrew, and three Christian heroes were
described. Illustrated here is Julius Caesar,
identified by a double-headed eagle, his
customary medieval coat of arms. Medieval
artists typically portrayed the ancients in
contemporary dress, and the Nine Heroes are
sumptuously clad and accoutered in the style
of about 1380. The tapestries suggest the
wealth and power of the French aristocracy;
the small figures surrounding the heroes
represent the members of a medieval court:
bishops, cardinals, knights, ladies, musicians,
spearmen, and archers. The arms displayed
on most of the banners are those of Jean, duc
de Berry; the prominence of his arms indi-
cates that the tapestries were commissioned
either by him or for him. *Gift of John D.
Rockefeller Jr. 1947, 47.101.3*

27 POL, JEAN, AND HERMAN DE LIMBOURG, act. ca. 1400–1416
The Belles Heures of Jean, Duc de Berry
French, Paris, 1406–8 or 1409
*Tempera and gold leaf on parchment;
9³⁄₈ × 6⁵⁄₈ in. (23.8 × 16.8 cm)*

The exquisite paintings in this book of hours, in tempera and gold, were the first commission undertaken by Pol de Limbourg and his brothers for Jean, duc de Berry, one of the greatest art patrons and bibliophiles of the Middle Ages. (He also owned the Hours of Jeanne d'Evreux [no. 21] and the Heroes Tapestries [no. 26] in The Cloisters Collection.) Recorded in the duke's inventory of 1413 as a "belles heures," the book has ninety-four full-page miniatures, such as the duc de Berry on a journey (fol. 223v) reproduced here, and many smaller ones, as well as calendar vignettes and border illuminations. The Limbourgs' style is characterized by meticulous detail, exquisite color, a degree of realism previously unknown in France, and a treatment of form and space that indicates a strong awareness of Italian painting traditions. (See also Medieval Art—Main Building, no. 43.) *The Cloisters Collection, 1954, 54.1.1*

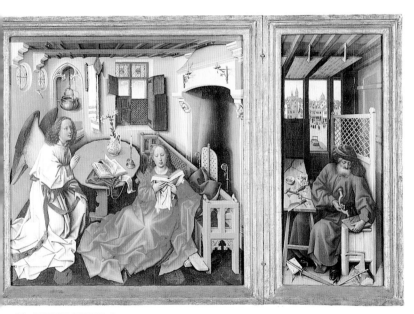

28 ROBERT CAMPIN, South Netherlandish, ca. 1373–1444
Triptych with the Annunciation
Oil on wood; central panel 25¹⁄₄ × 24⁷⁄₈ in. (64.1 × 63.2 cm), each wing 25³⁄₈ × 10³⁄₄ in. (64.5 × 27.3 cm)

The central panel of this small triptych shows the Annunciation (the archangel Gabriel's announcement to the Virgin Mary that she would miraculously conceive Jesus Christ). Joseph, Mary's spouse, is seen in his workshop in the right panel; the donor, presumably Ingelbrecht of Mechelen whose coat of arms appears in the left window of the central panel, and his wife are shown kneeling in the left panel. This work (also called the Mérode Altarpiece) dates from about 1425 and is in the then-new Flemish technique of oil colors on wood panels. It is also innovative in showing the Annunciation occurring not in a portico or an ecclesiastical setting but in a middle-class room of the patron's own time. In all this Campin's art anticipates future developments in Flemish painting.

Although Campin clearly rejoices in his ability to paint real objects with beauty of form and texture, he is also guided by the symbolic needs of his subject. The laver and the Madonna lily in the vase are symbols of Mary's purity. The candle is a symbol of Christ; the candlestick represents the Virgin who bore him. *The Cloisters Collection, 1956, 56.70*

29 Windows with Saints

Rhenish, 1440–46

Pot-metal glass with vitreous paint; h. of entire panel 12 ft. 3½ in. (3.77 m), w. of each window 28¼ in. (71.8 cm)

In the Boppard Room are six panels of stained glass from the nave of the Carmelite church of Saint Severinus at Boppard-on-Rhine. These six lancets, placed three over three, originally constituted a single tall window, made and installed between 1440 and 1446. Following the secularization of the monasteries in the wake of the Napoleonic invasion of the Rhineland, all the stained glass was removed and dispersed. The Cloisters panels are the only series from the extensive cycle at Boppard to have survived intact and the only extant works by one of the two Boppard masters. His figure style and wide use of white glass suggest that he was probably trained in Cologne.

The three lower lancets are shown here. The saints standing in elaborate canopied niches are, from left to right: Saint Catherine of Alexandria with the wheel and sword of her martyrdom; Saint Dorothy receiving from the Christ Child a basket of roses from the celestial garden; and Saint Barbara carrying her attribute, a tower. In the lancets above, Saint Servatius, bishop of Tongres, and Saint Lambert flank the central figure of the Virgin, around whom the iconographic program of the north nave was devised. The panels represent the most brilliant ensemble of late Gothic glass in the United States. *The Cloisters Collection, 1937, 37.52.4–6*

30 Ape Beaker

Franco-Netherlandish, ca. 1430–40

Painted enamel on silver and silver gilt; h. 7⅞ in. (20 cm), diam. 4⅝ in. (11.7 cm)

This rare and beautiful beaker, the work of Netherlandish or Franco-Netherlandish artists, was probably made for the Burgundian court. It is decorated with "painted" enamel, so called because the material was applied freely over the silver, without the grooves that separate the colors in champlevé enameling or the incised patterns that provide guidelines for the application of translucent enamels. Inside the beaker two apes, with their hounds, pursue two stags. One ape has a hunting horn, the other a bow and arrow. The chase occurs against a stylized forest with a cloud band at the top. The exterior presents a favorite northern theme: apes rob a sleeping peddler of his wares and his clothing and frolic with their prizes in the beaker's elegant foliage scrolls. *The Cloisters Collection, 1952, 52.50*

31 GIL DE SILOE, Spanish, act. 1475–?1505
Saint James the Greater
Alabaster with traces of polychromy and gilding;
h. 18⅛ in. (46 cm)

In 1486 Isabel of Castile commissioned an
elaborate alabaster tomb for her parents, Juan II
of Castile and Isabel of Portugal. This star-shaped
tomb, still standing in the middle of the church
of the Carthusian monastery of Miraflores in
Burgos, was executed between 1489 and 1493.
The sculptor, Gil de Siloe, employed assistants
who were responsible for many of the monu-
ment's figures, but this statuette of the patron
saint of Spain must surely have been by him
alone. The carving of the entire piece, espe-
cially the fine details of the hands and face, is
masterful. Portrayed as a pilgrim, the saint has
a pilgrim's gourd hanging from his staff and
wears a hat adorned with the cockleshell and
the crossed staffs worn by the pilgrims to Santi-
ago de Compostela. Traces of gold and poly-
chromy remain on the figure's surface. *The
Cloisters Collection, 1969, 69.88*

32 Caspar, One of the Three Magi
German, Swabian, before 1489
*Poplar, polychromed and gilded; h. 61½ in.
(156.2 cm)*

In the Middle Ages, particularly in the Nether-
lands and Germany, the kings who brought the
Christ Child gifts of gold, frankincense, and
myrrh were thought to have descended from the
three sons of Noah and thus to represent the
three races of humankind. Here the Moorish
king opens a lidded cup, which resembles
German metalwork of the late fifteenth century.
This statue and similar ones of the two other
Magi were once part of the high altarpiece, with
painted wings, in the convent of Lichtenthal near
Baden-Baden. The kings are especially
appealing in the elegance and vivacity of their
poses and the exceptional quality of their
polychromy. *The Cloisters Collection, 1952,
52.83.2*

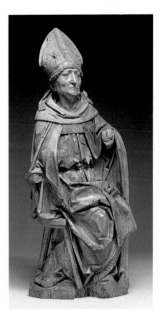

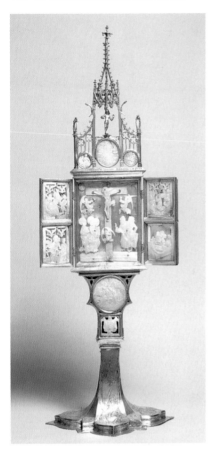

33 Tabernacle with Folding Wings
Austrian, Salzburg, 1494
*Silver, parcel-gilt, mother-of-pearl, and enamel;
h. 27 ⅜ in. (69.2 cm), w. (open) 9 ⅞ in.
(25.1 cm)*

This tabernacle is exceptional in its high artistic quality and its full documentation. According to the archives of the Benedictine monastery of Saint Peter of Salzburg, it was made in 1494 for Rupert Keutzl, abbot of the monastery, by the master goldsmith Perchtold. On the molding above the Last Supper is a Latin inscription which translates, "I stand by order of Abbot Rupert." On the base are shields with the arms of the monastery and of Abbot Rupert and the date 1494. The mother-of-pearl carvings are typically Austrian, but few examples are as successful as these, in which the polished silver background brings out the lively silhouettes. The scene of the Last Supper on the back is taken from an engraving by the Master J. A. M. Zwolle, whereas the Flagellation and the Taking of Christ are free copies of Schongauer engravings. *Gift of Ruth and Leopold Blumka (in commemoration of the Centennial of The Metropolitan Museum of Art), 1969, 69.226*

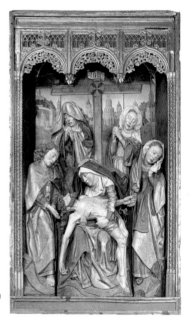

34 The Lamentation
Central Spanish, ca. 1480
*Walnut with polychromy and gilding;
83 × 48½ × 13½ in. (210.8 × 123.2 × 34.3 cm)*

Originally the center of a large retable with painted wings, this polychromed Lamentation is an interesting example of Spanish workshop production at the end of the fifteenth century. The hands of several artists can be detected; different sculptors carved the frame and the figures, and different paints were used for the figures and the landscape. The debt to northern painting is evident in such figures as Saint John and the Magdalen wiping her eye, both of which are derived from Rogier van der Weyden (see European Paintings, no. 57). The gilded framework and brocaded sidewalls are, however, characteristically Spanish. *The Cloisters Collection, 1955, 55.85*

◄ 35 TILMAN RIEMENSCHNEIDER,
German, Franconia, 1460?–1531
Seated Bishop
Limewood; h. 35⅞ in. (91 cm)

Between 1475 and 1525 a school of limewood sculptors, known especially for their elaborate altarpieces, flourished in southern Germany. Riemenschneider, who also produced notable works in stone, was one of the first limewood masters; he had a large workshop in Würzburg from 1485 into the 1520s. Until the end of the fifteenth century it was usual for limewood sculptures to be painted; many still were, long after 1500. As early as 1490, however, Riemenschneider produced works that were not polychromed but were finished with a brown glaze. This sculpture, which dates from 1495–1500, is one of the artist's few extant works in wood from the 1490s; it may have belonged to a monochrome retable. The figure may represent Saint Kilian or Saint Erasmus or perhaps one of the four Latin Fathers of the Church. The eyes—large, downturned, with the lower lid sharply marked—are characteristic of Riemenschneider's work, as are the handling of the drapery and the stance of the figure. *The Cloisters Collection, 1970, 1970.137.1*

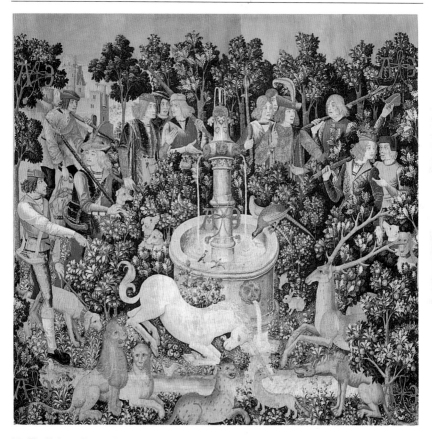

36 The Unicorn Tapestries: The Unicorn at the Fountain
Design: Parisian; weaving: South Netherlandish, Brabant, Brussels, ca. 1500
Wool, silk, metallic thread; 12 ft. 1 in. × 12 ft. 5 in. (3.68 × 3.78 m)

This tapestry showing a unicorn surrounded by hunters at a fountain is the second in a series of seven representing the Hunt of the Unicorn. The first pictures the beginning of the hunt. The unicorn attempts to escape in the third, and in the fourth he defends himself. Only a small fragment of the fifth remains, illustrating the best-known part of the legend, which tells that the beast was captured when he rested his head in the lap of a virgin. The sixth tapestry shows the slain unicorn brought back to the castle, and in the seventh he is resurrected, enclosed in a garden under a pomegranate tree.

The legend of the unicorn was a popular parallel to the Passion of Christ: as the unicorn gave up his fierceness and was tamed by a maid, so Christ surrendered his divine nature and became human through the Virgin. The kneeling unicorn, dipping his horn into the water, alluded to the popular belief that the horn of the unicorn had the gift of purifying.

In view of their style and technique, these tapestries must have been woven in Brussels from a design by an artist familiar with French art. The mingling of Christian symbolism with flora and fauna associated with profane love and fertility suggests that the tapestries may have been designed to celebrate a marriage. However, the person who commissioned this superb ensemble and the occasion for which it was produced are unfortunately not known. *Gift of John D. Rockefeller Jr., 1937, 37.80.2*

37 Playing at Quintain

French, Paris(?), ca. 1500
White glass, silver stain, two shades of vitreous paint, back painting; diam. 8–9½ in. (20.3–23.7 cm)

Silver-stained roundels were widely used for the decoration of secular buildings in northern Europe at the end of the Middle Ages. In guild-halls they often depicted the guilds' crafts or patron saints. In private residences they usually illustrated scenes from the Bible or saintly legends; they were set in diamond-pane windows of clear glass, evidence of the new prosperity of the middle class.

This roundel is unusual in that it depicts a game known as quintain, in which the standing player attempts to topple his seated opponent. Developed from a tilting exercise for knights, the sport became a courting game in the fifteenth century and a common subject in late-medieval secular art. *The Cloisters Collection, 1980, 1980.223.6*

38 The Death of the Virgin

German, Cologne, end of 15th c.
Oak; 69 × 79½ in. (175.3 × 201.9 cm)

The Death of the Virgin was a popular subject in fifteenth-century art. Sculptural compositions were often indebted to Netherlandish paintings for composition and iconography, and this relief parallels several examples, including one by the Master of the Amsterdam Death of the Virgin in the Rijksmuseum, Amsterdam, and one by Petrus Christus in the Timken Gallery, Putnam Foundation, San Diego. The apostles are assembled at the Virgin's bed, as Saint Peter conducts the sacrament of extreme unction. The canopied bed and linenfold bench denote a fifteenth-century interior, while the censer held by one apostle resembles contemporary metalwork. In the doorway at the right the Legend of the Girdle is represented. Saint Thomas, who had not been at the deathbed, became convinced of the Virgin's Assumption only when her belt fell from the sky into his hands.

Originally the central scene of a polychromed altarpiece with two wings, this relief has been attributed to the Cologne workshop of Tilman van der Burch. *The Cloisters Collection, 1973, 1973.348*

39 Ewer with Wild Man Finial

German, probably Nuremberg, late 15th c.
Silver, silver gilt, enamel; h. 25 in.
(63.5 cm)

This ewer with a wild man heraldic finial, one of a pair in the Museum, is thought to have been made in Nuremberg for Hartmann von Stockheim, German master of the Order of Teutonic Knights from 1499 to 1510. With the traditional attributes of cudgel and armorial shield (now missing), the wild man announced the ewer's ownership and his protection of it.

The wild man was a literary and artistic invention of the medieval imagination. Thought to live in remote forested regions, he was frequently represented in German-speaking lands. The wild man was originally regarded as brutish and irrational, but he was transformed by Renaissance humanism. Perceived as the embodiment of legendary Germanic strength and endurance, he became the standard by which man must test his own mettle. *The Cloisters Collection, 1953, 53.20.2*

40 Eagle Lectern

South Netherlandish, Limburg, Maastricht, ca. 1500
Brass; 79½ × 15½ in. (201.9 × 39.4 cm)

Assembled from separately cast pieces, this monumental work was made about 1500 in Maastricht, possibly by the metal-caster Aert van Tricht the Elder. The lectern rests upon couchant lions and is topped by an eagle holding in its claws a vanquished dragon. The eagle's wings support a large bookrack; a smaller rack, possibly for the use of choirboys, is attached below. Statuettes of Christ, saints, prophets, the Three Kings, and the Virgin and Child appear in the setting of mingled architecture and knotty branches. Similar in type to lecterns still in parish churches at Venraai and Vreren, this lectern is believed to have come from the north side of the high altar of the collegiate church of Saint Peter in Louvain. *The Cloisters Collection, 1968, 68.8*

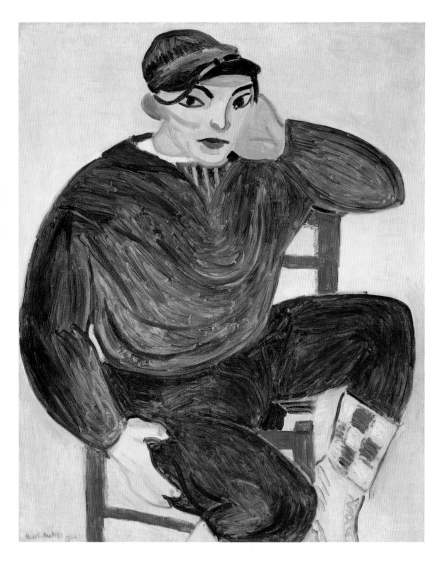

HENRI MATISSE, French, 1869–1954
The Young Sailor II
Oil on canvas; 40 x 32¾ in. (101.5 x 83 cm)

The Young Sailor II (1906) is an icon of Fauve portraiture. Together with *The Young Sailor I* (also 1906; private collection), it forms the artist's earliest pair of paintings in which the first version is more naturalistic and the second more abstract.

Here contours are emphasized, forms are well defined, and colors consist of large, mostly flat areas of bright green, blue, and pink. Matisse used this decorative style and palette from that point on. The subject, the eighteen-year-old Germain Augustin Barthélémy Montargès, was not a sailor; he does, however, wear the typical French fisherman's garb of the time. *Jacques and Natasha Gelman Collection, 1999, 1999.363.41*

MODERN ART

LILA ACHESON
WALLACE WING

The Department of Modern Art surveys paintings, works on paper, sculpture, design, and architecture from 1900 to the present. Since its inception the Museum has had continuous contact with contemporary art. In 1906 George A. Hearn, a trustee of the Museum, established a fund in his name for the purchase of art by living American artists; a second fund, in the name of his son Arthur Hoppock Hearn, was established five years later. These funds continue to be a main source of income. The collection has also grown through gifts and bequests, notably Georgia O'Keeffe's gift from the estate of Alfred Stieglitz in 1949, the bequest of Scofield Thayer in 1982, Heinz Berggruen's gift of ninety works by Paul Klee in 1984, the bequest of Lydia Winston Malbin in 1989, and the bequest of the Jacques and Natasha Gelman Collection in 1998, as well as the bequest of Florene M. Schoenborn in 1995 and gifts from the Mr. and Mrs. Klaus G. Perls Collection in 1997.

This department was formally established in 1967. Such European artists as Bonnard, Matisse, Picasso, Boccioni, and Balthus are represented by important works, and the collection is particularly strong in paintings of the School of Paris. The American holdings, which are equally strong, include paintings by the Eight, the Modernist works of the Stieglitz circle, and Abstract Expressionist paintings and works on paper. Major works by postwar European and American artists, among them Anselm Kiefer and Jasper Johns, are also included. The design and architecture collection includes furniture, metalwork, glass, ceramics, textiles, and design drawings from major twentieth-century movements, as well as masterpieces of French Art Deco furniture.

The Lila Acheson Wallace Wing, opened in 1987, provides permanent exhibition space for modern art. Installations change frequently, and special exhibitions are shown in the wing. The Blanche and A. L. Levine Court on the mezzanine opened in 1993. Sculpture is primarily displayed in The Iris and B. Gerald Cantor Roof Garden, which also offers dramatic views of the city's skyline.

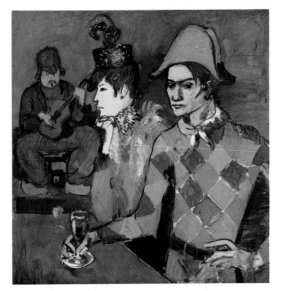

1 PABLO PICASSO, Spanish, 1881–1973
Au Lapin Agile
Oil on canvas; 39 x 39½ in. (99.1 x 100.3 cm)

Picasso gave this 1905 painting to Frédé, the bearded guitar-playing owner of the Montmartre cabaret Au Lapin Agile. In addition to Frédé, at the far left, it shows Picasso in the guise of his alter ego, Harlequin, and Germaine Pichot, his sometime lover, over whom his friend Carles Casagemas committed suicide in 1901. Gertrude Stein recalled Pichot as "quiet and serious and spanish [sic], she had the square shoulders and unseeing fixed eyes of a Spanish woman." Picasso's companion Françoise Gilot recalled the artist giving money to a toothless and elderly Pichot, explaining "when she was young she was very pretty and she made a painter friend of mine suffer so much that he committed suicide . . . now look at her." *The Walter H. and Leonore Annenberg Collection, Gift of Walter H. and Leonore Annenberg, 1992, Bequest of Walter H. Annenberg, 2002, 1992.391*

2 PABLO PICASSO, Spanish, 1881–1973
La Coiffure
Oil on canvas; 68⅞ × 39¼ in. (174.9 × 99.7 cm)

Beginning in 1905 Picasso frequently used as his models the saltimbanques, or itinerant circus people, whose world appeared in nearly every aspect of his work. In painting, his palette shifted from blue to rose, although the works were not entirely happy. This painting of a mother having her hair dressed while her son plays at her feet was made in 1906, toward the end of the Rose period, when Picasso developed a more classical, sculptural approach to depicting figures. The ambiguity of his circus pictures is still present, however, for the three figures seem unrelated to each other, formally united by the composition but psychologically isolated. *Catharine Lorillard Wolfe Collection, Wolfe Fund, 1951; acquired from The Museum of Modern Art, Anonymous Gift, 53.140.3*

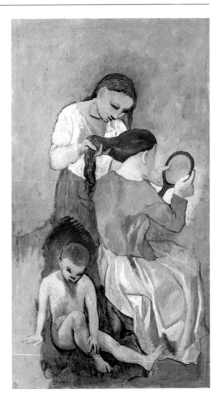

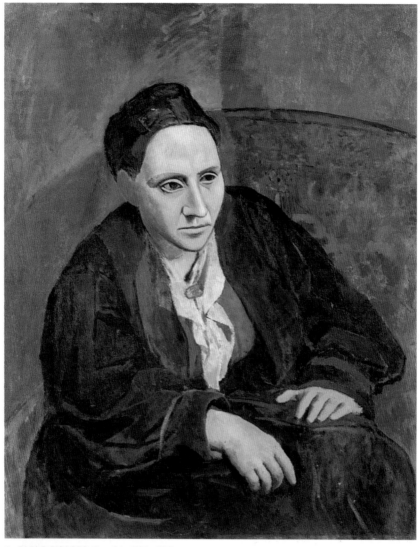

3 PABLO PICASSO, Spanish, 1881–1973
Gertrude Stein
Oil on canvas; 39⅜ × 32 in. (100 × 81.3 cm)

This portrait of the American writer Gertrude
Stein was begun during the winter of 1905–6.
Pablo Picasso was twenty-four years old and
had been working in Paris for five years. Stein
posed for Picasso on some eighty occasions,
but he had great difficulty with the head. After a
trip to Spain in the fall of 1906, he painted in a
new head. The masklike face with its heavy-
lidded eyes reflects Picasso's recent encounter
with African, Roman, and Iberian sculpture. The
massive quality of the figure (which accurately
reflects Stein's body) shows the artist's transi-
tion from the ethereal slender figures of the
previous five years (the so-called Blue and Rose
periods) to the sturdy cubistic forms that imme-
diately preceded the formal breakthrough of the
Demoiselles d'Avignon. It is said that in response
to the observation that Stein, who was then
thirty-two years old, bore little resemblance to
the portrait, Picasso replied simply, "She will."
Bequest of Gertrude Stein, 1946, 47.106

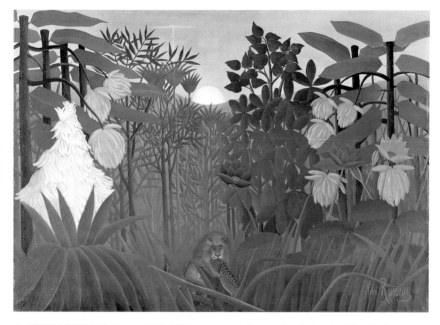

4 HENRI ROUSSEAU, French, 1844–1910
The Repast of the Lion
Oil on canvas; 44¾ × 63 in. (113.7 × 160 cm)

Rousseau had begun to paint imaginary scenes set in the jungle by 1891. This picture, which shows a lion devouring a jaguar, was probably first exhibited at the Salon d'Automne of 1907. The vegetation in Rousseau's jungle paintings is evidently based upon exotic plants that the artist had studied at the botanical garden in Paris, but disregarding their actual sizes, he invented forests that dwarf his figures of natives and animals. Reminiscent of Delacroix's studies of fighting lions, Rousseau's animals are often closely based upon photographs in a children's book that his daughter owned. Here the full moon partly visible beyond a hill intensifies the dreamlike character of the scene. *Bequest of Sam A. Lewisohn, 1951, 51.112.5*

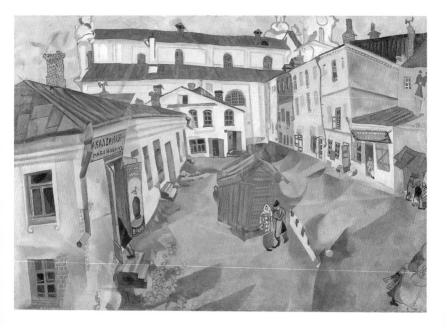

6 AMEDEO MODIGLIANI, Italian, 1884–1920
Reclining Nude
Oil on canvas; 23⅞ x 36½ in. (60.6 x 92.7 cm)

The paintings by which Modigliani is best known were done between 1915 and 1919. In the great series of nudes he began in 1917, the women are always seen close-up and usually from above; their stylized bodies span the entire width of the composition; the dark bed covering accen-tuates the glow of skin; and their feet and hands always remain outside the picture frame. One or two of the women seem to be asleep, but usually, as here, they face the viewer. In these works Modigliani continues the tradition of depicting the nude Venus, which extends from the Renaissance through the nineteenth century. *The Mr. and Mrs. Klaus G. Perls Collection, 1997, 1997.149.9*

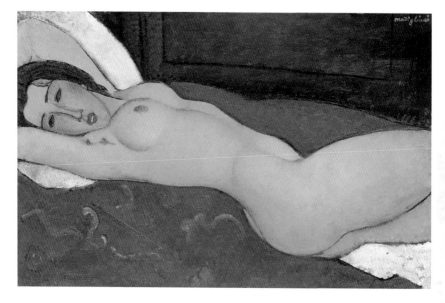

5 MARC CHAGALL, French, born Russia, 1887–1985
The Marketplace, Vitebsk
Oil on canvas; 26⅛ x 38¼ in. (66.4 x 97.2 cm)

Chagall was born in a suburb of Vitesbk, a small Russian town near the Polish border. Through-out his life his memories of the peasants and animals in Vitebsk's Jewish ghetto were con-stant themes in his paintings. Jewish folklore, Old Testament tales, and the circus would become his preferred subjects. He left Russia for Paris in 1910, returning in 1914 to marry his child-hood sweetheart Bella Rosenfeld. During the summer of 1917, while still in Russia, Chagall painted this view of Vitebsk's sleepy market-place from an upper-storey window. The shifting, unstable composition, as well as the faceted planes, may owe something to Chagall's expo-sure to Cubism while in Paris. The meticulously rendered shop signs evoke Chagall's early train-ing as a sign painter. *Bequest of Scofield Thayer, 1982, 1984.433.6*

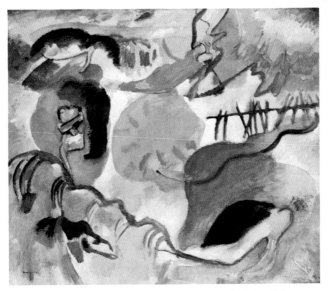

7 WASSILY KANDINSKY, Russian, 1866–1944
The Garden of Love (Improvisation Number 27)
Oil on canvas; 47 3/8 × 55 1/4 in. (120.3 × 140.3 cm)

The first abstract pictures were painted shortly after 1910 by Wassily Kandinsky, a Russian who had moved in 1896 to Munich, and Frantisek Kupka, a Czech living in France. Both artists, working independently, evolved a new pictorial language, spiritual in intent, emotional in expression, and abstract in effect. The specific source for the imagery in *The Garden of Love* (1912) is most likely the biblical story of Paradise and the Garden of Eden. Several animals, figures, and landscape motifs are placed around a large yellow sun. The broadly painted landscape reflects Kandinsky's mastery of watercolor technique, here adapted to oil painting. The idyllic scene is not without a threatening tone, as indicated by the presence of ominous black spots of paint and the slithering snake at center right. *Alfred Stieglitz Collection, 1949, 49.70.1*

8 JUAN GRIS, Spanish, 1887–1927
Still Life with a Guitar
Oil on canvas; 26 x 39 1/2 in. (66 x 100.5 cm)

At Céret in the French Pyrenees in late summer 1913, Juan Gris made a breakthrough in Cubism. Adopting the collage compositions that Picasso and Braque had used in 1912—with broad planes placed in a linear armature—Gris added strong, saturated color. To what had been a stringent and hermetic style, Gris brought the warmth and vibrancy of color. This work, one of the most accomplished of the period, shows how carefully Gris analyzed his forms and planned his pictures, unlike Picasso and Braque who took a spontaneous approach. *Jacques and Natasha Gelman Collection, 1998, 1999.363.28*

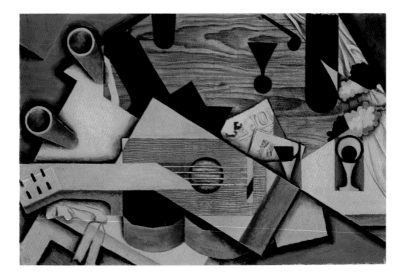

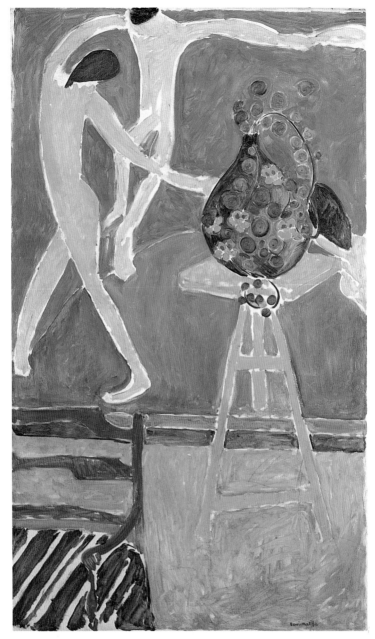

9 HENRI MATISSE, French, 1869–1954
Nasturtiums with "Dance, I"
Oil on canvas; 75½ × 45⅜ in. (191.8 × 115.3 cm)

In late spring of 1912 Henri Matisse returned to Issy-les-Moulineaux, southwest of Paris, after an extended stay in Morocco. He immediately began work on two six-foot-high canvases that were variations on the same subject—a view of the artist's studio showing a portion of his painting *Dance, I* (1909) in the background (the other version is in the Pushkin Museum, Moscow). This device of incorporating his own work into other compositions was one of Matisse's favorites. In both versions of this subject a wooden armchair is in the left foreground, and a vase of flowering nasturtiums set on a tripod

table is at the center right; what distinguishes them are the different color schemes and treatment of space. Space is boldly flattened in the Museum's painting, and objects are rendered without volumetric modeling. The images are highly simplified, and everything but the vase of nasturtiums is cut off by the edge of the canvas. The paint here is thinly applied and broadly brushed, allowing the unpainted canvas to outline the forms and show through the colored areas with luminous results. A celebration of color and light, *Nasturtiums with "Dance, I"* was one of thirteen paintings that Matisse exhibited at the Armory Show in New York in 1913.
Bequest of Scofield Thayer, 1982, 1984.433.16

10 FERNAND LÉGER, French, 1881–1955
Woman with a Cat
Oil on canvas; 51³/₈ x 35¹/₄ in. (130.5 x 89.5 cm)

This powerful nude woman, painted in grisaille, is composed of spheres, cones, and tubes. The stark simplicity of the composition is matched by the reduced palette of red, yellow, black, and white. *Woman with a Cat* (1921) belongs to a group of works of monumental female figures— some reading, others drinking cups of tea—that are emblematic of the artist's grand figure style of his "mechanical" period of 1918–23. *Anonymous Gift, 1994, 1994.486*

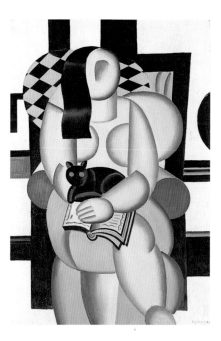

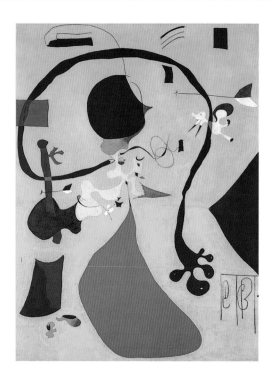

11 JOAN MIRÓ, Spanish, 1893–1983
Dutch Interior
Oil on canvas; 51¹/₈ x 38¹/₈ in. (129.9 x 96.8 cm)

During a two-week trip to the Netherlands in the spring of 1928, Miró became fascinated with Dutch genre and still-life painting. He was especially captivated by the Dutch painters' depiction of minute details of plants and insects. Upon his return to Spain, he emulated these elements in a series of three Dutch Interiors in his characteristic biomorphic Surrealist style. The first two works can be traced to specific works by Hendrick Sorgh and Jan Steen, respectively, but here, in his third *Dutch Interior* (1928), Miró appears to have combined elements from various sources. *Bequest of Florene M. Schoenborn, 1995, 1996.403.8*

12 MARSDEN HARTLEY, American, 1877–1943
Portrait of a German Officer
Oil on canvas; 68¼ × 41⅜ in. (173.4 × 105.1 cm)

Hartley painted his most startlingly advanced and integrated abstractions during the first years of World War I while living in Berlin (March 1914–December 1915). War Motifs, his German military series, are intensely powerful canvases in an Expressionist vein; they reflect not only his revulsion at the wartime destruction but also his fascination with the energy and pageantry that accompanied the carnage. *Portrait of a German Officer,* painted in November 1914, shows Hartley's assimilation of both Cubism (the collagelike juxtaposition of visual fragments and the hieratic structuring of geometric shapes) and German Expressionism (the coarse brushwork and dramatic color). The condensed mass of images (badges, flags, medals) evokes a collective psychological and physical portrait of the officer. There are also specific references to Hartley's close friend Karl von Freyburg, a young cavalry officer who had recently been killed in action: KvF are his initials, 4 was his regiment number, and 24 his age. *Alfred Stieglitz Collection, 1949, 49.70.42*

13 GEORGES BRAQUE, French, 1882–1963
Le Guéridon
Oil with sand on canvas; 75 × 27 ¾ in.
(190.5 × 70.5 cm)

The period 1919–22 was a transitional one in Braque's career. Approaching the age of forty, he had resumed painting after serving in the army during World War I. Braque's work began to show the reemergence of naturalistic elements, while retaining many of the formal innovations of Cubism. This still-life composition, *Le Guéridon* (The Small Round Table) of 1921–22, is typical of this period. Braque retains the Cubist palette of greens, beiges, and whites with a prominent use of black. The pictorial space is compressed to the front of the picture plane, and the tabletop is tilted to display the still-life arrangement of fruits, pipes, newspapers, and musical instruments. The fragmented geometric forms and flat patterned shapes are related to the collage technique first explored by Braque and Picasso some ten years earlier. Braque did no fewer than fifteen *Guéridons* between 1921 and 1930. This painting is probably the earliest of the series and was exhibited at the Salon d'Automne in November 1922. *Partial Gift of Mrs. Bertram Smith, in honor of William S. Lieberman, 1979, 1979.481*

14 PIERRE BONNARD, French, 1867–1947
The Terrace at Vernon
Oil on canvas; 57 ¾ × 76½ in. (146.7 × 194.3 cm)

As a young artist, Bonnard came under the influence of Gauguin's ideas about representing things symbolically in strong patterns and color. Bonnard and his friend Édouard Vuillard also adapted the lyrical elements of a Renoiresque Impressionism and Pointillism to their quiet everyday scenes, which have come to be termed "Intimist." These influences remain evident in

The Terrace at Vernon, which he began in 1920 and reworked in 1939. This painting of his house in the Seine Valley reveals an intricate spatial organization. Bonnard differentiates the foreground space from the background by the dramatic vertical of the huge tree trunk. On the right he frames pockets of space around the figures. Thus the viewer can isolate areas of the composition and discern an orderly progression through this heroically proportioned work. (See also Robert Lehman Collection, no. 24.) *Gift of Mrs. Frank Jay Gould, 1968, 68.1*

15 BALTHUS (Balthasar Klossowski), French,
b. 1908
The Mountain
Oil on canvas; 98 × 144 in. (248.9 × 365.8 cm)

The Mountain was completed in 1937, three years after Balthus had his first one-man exhibition at the age of twenty-six. The ambition and accomplishment of this composition demonstrate his precocity. His strong simplified forms show the influence of Piero della Francesca and Georges Seurat, and the cultivated awkwardness of his figures indicates his debt to Gustave Courbet. *The Mountain* has been considered Balthus's answer to Courbet's *Young Women*

from the Village, painted almost a century before (see European Paintings, no. 131). Like Courbet, Balthus depicts a landscape that he has known since childhood. The forms of the indolent adolescent girls find corresponding echoes in the mountains behind them. This work is the masterpiece of Balthus's early period. (See also Robert Lehman Collection, no. 25.) *Purchase, Gifts of Mr. and Mrs. Nate B. Spingold and Nathan Cummings, Rogers Fund and The Alfred N. Punnett Endowment Fund, by exchange, and Harris Brisbane Dick Fund, 1982, 1982.530*

16 OTTO DIX, German, 1891–1969
The Businessman Max Roesberg
Oil on canvas; 37 × 25 in. (94 × 63.5 cm)

Dix was the best-known painter of the move-ment toward a deadpan, matter-of-fact realism that became known in Germany in the 1920s as Neue Sachlichkeit (New Objectivity). His clinical, often merciless realism, however, set him apart from his contemporaries. Using just a few poi-gnant details, Dix successfully captured the individuality of his sitters, who included promi-nent lawyers, businessmen, and art dealers, as well as poets, prostitutes, and dancers. The dia-bolical candor that infuses Dix's later work is absent in this early commissioned portrait of 1922. Roesberg (1885–1965), a manufacturer of industrial tools, collected the works of young Dresden artists, Dix among them. Fastidiously dressed in a taupe jacket, gray vest, blue pat-terned tie, and starched white collar, Roesberg exhibits a keen intelligence. Picturesque details anchor the sitter firmly in his business activities: the wall clock, the daily tear-off calendar, the mail-order catalogue of machine parts, and the registered letter addressed to Otto Dix on his desk blotter. The sleek black-and-silver tele-phone lends a cosmopolitan flair to this small-town office, which is rendered in the sober colors of commerce and money, mainly greens and browns highlighted with black and white.
Purchase, Lila Acheson Wallace Gift, 1992, 1992.146

17 FLORINE STETTHEIMER, American, 1871–1944
The Cathedrals of Art
Oil on canvas; 60¼ x 50¼ in. (153 x 127.6 cm)

In her series of four Cathedral canvases (exe-cuted 1929–42), Stettheimer, a socially promi-nent New Yorker, created a fantastical portrait of the city's economic, social, and cultural institu-tions, using her insider's wit and unique style of naive painting. In this 1942 work she presents the directors and collections of three major museums—the Museum of Modern Art (top left), The Metropolitan Museum of Art (top center), and the Whitney Museum of American Art (top right)—who preside over a coterie of other art-world figures (critics, dealers, and photogra-phers of the day, as well as the artist herself, lower right). *Gift of Ettie Stettheimer, 1953, 53.24.1*

18 CHARLES DEMUTH, American, 1883–1935
The Figure 5 in Gold
Oil on composition board; 35½ × 30 in.
(90.2 × 76.2 cm)

Charles Demuth was among the group of Modernists who exhibited regularly at Alfred Stieglitz's gallery 291. Although Demuth was influenced by Cubism and Futurism, his choice of urban and industrial subjects, his sense of scale, and his directness of expression were American. In the 1920s Demuth produced a series of poster-portraits honoring his contemporaries, inspired by Gertrude Stein's word-portraits. *The Figure 5 in Gold* (1928) is the most accomplished of the group. It was dedicated to the artist's friend William Carlos Williams, the American poet whose "The Great Figure" inspired the painting's title and imagery. Demuth's painting, however, is not a representational illustration of the poem but rather an abstract impression of the No. 5 fire engine clanging through the lamp-lit streets of the darkened, rainy city. Scattered words and initials refer to the artist and the poet. *Alfred Stieglitz Collection, 1949, 49.59.1*

19 GEORGIA O'KEEFFE, American, 1887–1986
Red, White, and Blue
Oil on canvas; 39⅞ × 35⅞ in. (101.3 × 91.1 cm)

Georgia O'Keeffe was the only woman among the early American Modernists to be avidly promoted by Alfred Stieglitz in his New York galleries. For nearly seven decades she produced highly original paintings, almost exclusively of landscape and floral and skeletal motifs. The theme of animal bones and skulls appeared in her work in 1930, at first alone and later in landscape settings. Although the bones were collected on her trips to New Mexico, they were often used in paintings that she created in New York. *Red, White, and Blue,* one of her most fa-mous works, was probably painted at Lake George, New York, during the fall of 1931. She saw in the jagged edges, worn surfaces, and pale colors of the cow's skull the essence of the desert, a timeless beauty. This picture is both an eloquent abstraction of form and line and a richly symbolic icon. Its crucifix configuration, created by the extended horns and the vertical post, elevates this straightforward study to the level of a sacred relic. The title of the painting and the tricolor palette were meant to be a satirical comment on America's obsession in the 1920s and 1930s with nationalistic identity. *Alfred Stieglitz Collection, 1952, 52.203*

20 GIORGIO DE CHIRICO, Italian, 1888–1978
The Jewish Angel
Oil on canvas; 26⅝ x 17¼ in. (67.5 x 44 cm)

De Chirico is acclaimed for the melancholic, magical Italian cityscapes which he painted between 1911 to 1917 and which inspired the Surrealists ten years later. This still life, with its painted wood elements, stacked above what might be kilometer markers, is exceptional in the artist's oeuvre. The pink-dotted French curve, the blue-and-white meter stick, and the wooden right-angles are drafting and measuring devices which might be used in construction. In contrast to these carefully rendered components is the oversized eye crudely drawn on a large piece of paper, its corner folded like that of a calling card. De Chirico's father was employed as an engineer by a railroad company, and it has been suggested that this scaffold-like structure and its eye might be an abstract portrait of him.
Jacques and Natasha Gelman Collection, 1998, 1999.363.15

21 GRANT WOOD, American, 1892–1942
The Midnight Ride of Paul Revere
Oil on Masonite; 30 x 40 in. (76.2 x 101.6 cm)

Grant Wood was the most self-consciously prim-
itive artist of his generation. Strongly influenced
by the Neue Sachlichkeit (New Objectivity) in
Germany, he adopted a similar realist style in
reaction to modernism and abstraction. A lead-
ing Regionalist painter during the 1930s and

1940s (with Thomas Hart Benton and John
Steuart Curry), Wood celebrated the American
landscape, country life, and American history.
This 1931 canvas gives a bird's-eye view of a
New England town on the historic night of April
18, 1775. The small figure of Paul Revere on his
horse can be seen (lower left) riding out to warn
the colonists of the approach of the British.
Arthur Hoppock Hearn Fund, 1950, 50.117

22 MAX BECKMANN, German, 1884–1955
Beginning
*Oil on canvas; triptych, center panel 69 × 59 in.
(175.3 × 149.9 cm); side panels each 65 × 33¼ in.
(165.1 × 84.5 cm)*

Beginning, the eighth of the artist's ten triptychs,
was begun in 1946 in Amsterdam and com-
pleted in 1949 in America, where Beckmann
had immigrated in 1947. The work's theme of
childhood memories may be linked to Beck-
mann's feeling of uprootedness at the time. The
right panel depicts the forces that curb a child's
fantasy and the left those that liberate it, while
in the center a child's imagination is given free
rein. In the classroom scene on the right, a
stern teacher towers over his students, and for
the crowned boy in the left panel the celestial
music played by the blind organ grinder con-
jures up a choir of angels. The central panel
depicts noisy games in the attic. The Puss-in-
Boots, hanging with his head downward, evokes
the shameful end of many dictators, while a tai-
lor's dummy blows three large colorful soap
bubbles, perhaps alluding to the evanescence
of childhood. *Bequest of Miss Adelaide Milton
de Groot (1876–1967), 1967, 67.187.53a–c*

23 EDWARD HOPPER, American, 1882–1967
The Lighthouse at Two Lights
Oil on canvas; 29½ × 43¼ in. (74.9 × 109.9 cm)

This painting shows a lighthouse and coast-guard station on the rocky point of Cape Elizabeth, Maine. During his long career, the scene painter Edward Hopper alternated between such quintessential views of rural America, especially New England, and scenes of the streets, skyscrapers, restaurants, and theaters of urban America. His compositions invariably evoke feelings of isolation, be it of the human condition or the circumstance of locale. Hopper, who worked for many years as an illustrator, studied first with Robert Henri, leader of the Eight, a group that celebrated the chaos of daily life in turn-of-the-century American cities. Hopper renders his scenes in stronger, more simplified forms that betray a powerful, underlying geometric impulse. The morning light in this painting (1929) strikes the front facade of the building complex, providing a stark contrast to the angles cast in shadow. While other artists might choose this subject for its dramatic potential, Hopper has viewed the buildings without reference to the ocean, and the scene is relatively tranquil. *Hugo Kastor Fund, 1962, 62.95*

24 STUART DAVIS, American, 1892–1964
Report from Rockport
Oil on canvas; 24 × 30 in. (61 × 76.2 cm)

After an extended apprenticeship to the Cubism of Braque and Picasso and the techniques of American advertising, Stuart Davis evolved his signature style, which featured a palette of brilliant color. By the 1940s he had developed an entire vocabulary of signs, symbols, and words that give his art a unique quality. Like many of the paintings Davis executed during the last two decades of his life, *Report from Rockport* (1940) is based on an earlier composition, in this case *Town Square* (1925–26) in the Newark Museum.

The white kiosk on the left and the black gasoline pump on the right stand like heralds guiding us into the composition. The yellow road leads to the garage at the center of the picture, an inward movement reinforced by the diagonal edges of the two planes on each side. Any sense of depth, however, is countered by Davis's use of fully saturated color and curved lines and shapes that create an allover feeling of flatness. This scene conveys the vitality, disjunction, and speed of modern American life at mid-century, which held such an attraction for the artist. *Edith and Milton Lowenthal Collection, Bequest of Edith Abrahamson Lowenthal, 1991, 1992.24.1*

25 ARSHILE GORKY, American (b. Armenia),
1904–1948
Water of the Flowery Mill
Oil on canvas; 42¼ × 48¾ in. (107.3 × 123.8 cm)

Gorky's biomorphic abstractions, produced in
New York in the 1940s, reflect the liberating in-
fluence of Surrealist automatism and anticipate
the gestural calligraphy of Abstract Expression-
ism. His work, however, remained tied to the
traditional values of Western painting—relatively
moderate-size easel paintings, based on care-
fully planned and presketched compositions.
Gorky's vocabulary reached mature refinement
in the mid-1940s and is exemplified by his mas-
terpiece, *Water of the Flowery Mill* (1944), a
landscape of exquisite color, poetic brushwork,
and compositional complexity. Although not
easily deciphered, the painting's images are
based on those observed in nature and depict a
specific setting, the remains of an old sawmill
on the Housatonic River in Connecticut. After
Gorky visited there in 1942, the Connecticut ter-
rain became, in his late paintings, a surrogate
for his native Armenia, whose presence per-
vaded his early work. *George A. Hearn Fund,
1956, 56.205.1*

26 ROMARE BEARDEN, American,
1911–1988
The Block
*Cut and pasted printed, colored and metallic
papers, photostats, pencil, ink marker, gouache,
watercolor, and pen and ink on Masonite; overall
48 x 216 in. (121.9 x 548.6 cm); six panels, each
48 x 36 in. (121.9 x 91.4 cm)*

This mural-size tableau (1971) is a tribute to
Bearden's Harlem neighborhood in New York
City. The architectural elements are based on
those in his sketches of Lenox Avenue (between
132nd and 133rd streets), to which he added
real and imagined people at rest, play, and work.
Within the larger framework of the block, sepa-
rate vignettes offer poignant and often humorous
observations about human relations, social ritu-
als, and the spirit of survival. Here collage, the
medium which Bearden used for his best-known
works, becomes a visual equivalent for the over-
lapping sounds of music, traffic, and conversa-
tion on the street. *Gift of Mr. and Mrs. Samuel
Shore, 1978, 1978.61.1-6*

27 WILLEM DE KOONING, American
(b. The Netherlands), 1904–1997
Attic
*Oil, enamel, and newspaper transfer on canvas;
61⁷/₈ × 81 in. (157.2 × 205.7 cm)*

The gestural dynamism and allover imagery of
Attic (1949), de Kooning's early masterwork,
exemplify the radically new visual language es-
poused by the Abstract Expressionist painters in
New York during the late 1940s and 1950s. The
painting culminates a series of complex black-
and-white abstractions, begun in 1946, that ex-
plore the positive-negative relationships of form
and space. The web of white shapes is so dense
that the black background on which they are
situated virtually disappears. De Kooning's al-
most exclusive use of black and white was
determined in part by the availability of inexpen-
sive commercial enamel paint. Although his
palette is severely restricted, de Kooning dis-
plays virtuosity in his sensuous and expressive
handling of paint, surface, and line. In the works
that immediately followed *Attic*, de Kooning re-
sumed his use of full color. *The MURIEL KALLIS
STEINBERG NEWMAN Collection, jointly owned
by The Metropolitan Museum of Art and Muriel
Kallis Newman, in honor of her son Glenn David
Steinberg, 1982, 1982.16.3*

28 JACKSON POLLOCK, American, 1912–1956
Autumn Rhythm
Oil on canvas; 105 × 207 in. (266.7 × 525.8 cm)

Pollock, a leading Abstract Expressionist and
member of the New York School, is best known
for his "drip" paintings, which continue to
evoke strong reactions more than forty years
after the first one was painted. Along with
his colleagues Willem de Kooning, Barnett
Newman, and Mark Rothko, Pollock rejected the
subjects and techniques of traditional easel
painting as insufficient to express the truths he
needed to convey in his art. In his early work,
Pollock sought truth in the archaic myths of
many cultures, but as he sought new subject
matter, he also worked toward a new technique
that would be as direct and fundamental as the
content he wished to express. By the late 1940s
he had rejected representation and specific sub-
ject matter, concentrating on the process of
painting itself. *Autumn Rhythm* (1950) is a prime
example of this new painting. *George A. Hearn
Fund, 1957, 57.92*

29 CLYFFORD STILL, American, 1904–1980
Untitled (PH-114)
Oil on canvas; 91¾ × 70¾ in. (233 × 179.7 cm)

Still, who was born in North Dakota and educated in the northwestern United States, came to New York City in the mid-1940s and soon began to exhibit paintings characterized by amorphous, jagged forms applied exclusively with a palette knife. As in *Untitled (PH-114)* of 1947–48, different areas of color abut one another like the interlocking pieces of a puzzle.

The colors are deep and rich, and small swatches of contrasting color frequently appear at the edges or in the middle of larger areas. Although Still avoided assigning any associative meaning to his work, scholars have often remarked on the allusions to landscape in his compositions, particularly the rugged terrain of the American West. Indeed, the ominous presence of the black area dominating this composition suggests a cavern or a ravine. *Gift of Mrs. Clyfford Still, 1986, 1986.441.3*

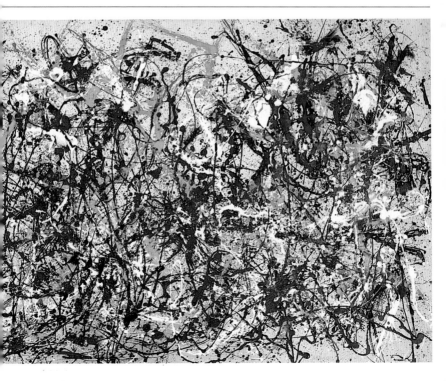

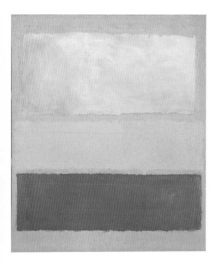

30 MARK ROTHKO, American, b. Russia, 1903–1970
No. 13 (White, Red on Yellow)
Oil and acrylic with powdered pigments on canvas; 95³/₈ x 81³/₈ in. (242.3 x 206.7 cm)

Mark Rothko developed a unique compositional format in which two or three horizontal bands divide a large, usually vertical canvas. He used this highly structured, reductive approach in a sustained manner from 1950 until his death in 1970. As *No. 13 (White, Red on Yellow)* (1958) exemplifies, these forms are reduced, but they are not geometric. The edges of the red and white shapes are soft and frayed. The boundaries between colors merge imperceptibly as one hue changes into another. The paint was so diluted that it saturated and stained the canvas fibers. Rothko used color and shape to replace traditional narrative and figurative imagery. The simplification of structure is designed to convey powerful emotion and revelation. *Gift of The Mark Rothko Foundation Inc., 1985, 1985.63.5*

31 ANDY WARHOL, American, 1930–1987
Self-Portrait
Acrylic and silk screen on canvas; 80 x 80 in. (203.2 x 203.2 cm)

Andy Warhol, pioneer of Pop Art, emerged on the international scene in the early 1960s. He embraced American popular culture and, like other Pop artists, borrowed images from newspapers and advertisements. He aimed to demystify art, and his subject matter included everyday consumer products (Brillo scouring pads, Campbell's soup cans, and Coca-Cola bottles), celebrated personalities (Marilyn Monroe and Mao Zedong), and scenes of death and disaster (car crashes and executions).

As famous for his carefully crafted public persona as his artistic production, Warhol created this unsettling self-portrait in 1986, just a few months before his death in February 1987. *Purchase, Mrs. Vera G. List Gift, 1987, 1987.88*

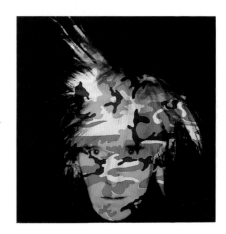

33 CY TWOMBLY, American, b. 1928 ▶
Untitled
Oil and crayon on canvas; 61¹/₂ x 75 in. (156.2 x 190.5 cm)

The phrase "drawing into painting," which has been used to explain Jackson Pollock's mature work, exactly describes this large, untitled abstraction of 1970 by Twombly. In his personal style, Twombly transfers the media and techniques of drawing, in this case colored crayon used in a calligraphic manner, to a painted canvas surface. Unlike Pollock, Twombly maintains control over the creative process by applying pigment directly onto the surface in an action akin to writing. His expressive gesture is highly disciplined, although it seems to produce scribbling. The gradation of sizes and hues in the parallel bands of loosely coiled lines creates a sense of movement and suggests depth. This is an exceptionally fine example of Twombly's later work. *Purchase, The Bernhill Fund Gift, 1984, 1984.70*

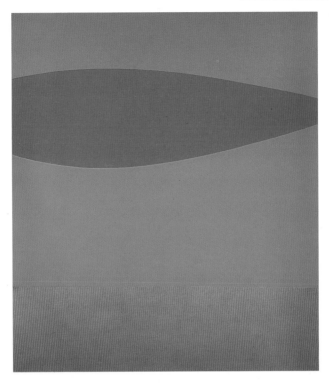

32 ELLSWORTH KELLY, American, b. 1923
Blue Green Red
Oil on canvas; 91 x 82 in. (231.1 x 208.3 cm)

Kelly's precisely rendered paintings utilize a few flatly painted abstract forms of intense, bold color. His six-year stay in Paris (1948–54) directed his art toward the biomorphic abstractions of Jean Arp and the late paper cutouts of Matisse, rather than to the gesturalism of Abstract Expressionism. Kelly's close-up scale and oversize canvases, however, expressed contemporary concern with flattening the picture space to focus attention on the formal elements of color and shape. *Blue Green Red* (1962–63) creates a tense ground–space relationship between the incomplete, irregular ellipse and the rectangular field it bisects. The rectangle can be viewed as a flat plane or as a slightly receded background. Kelly explores the same visual vocabulary and concerns in his sculpture.
Arthur Hoppock Hearn Fund, 1963, 63.73

34 JAMES ROSENQUIST, American, b. 1933
House of Fire
Oil on canvas; 78 x 198 in. (198.1 x 502.9 cm)

Painted twenty years after Rosenquist's first Pop Art canvases, *House of Fire* (1981) exudes the same dynamism that characterizes his best work of the 1960s. The elimination of visible brushwork and the use of commercial materials exemplify American Pop Art. Images are dis-

quietingly juxtaposed and realistically rendered. The exact meaning of this allegorical triptych is elusive. In the central panel a bucket of molten steel, supernatural in its radiance, descends through a partly open window. Intruding from the right are fiery red and orange lipsticks aligned like a battery of guns. At the left a brown paper bag overflowing with groceries is unexpectedly turned upside down. Allusions to

35 ROY LICHTENSTEIN, American, 1923–1997
Stepping Out
Oil and magna on canvas; 86 x 70 in. (218.4 x 177.8 cm)

Since his Pop Art canvases of the 1960s Roy Lichtenstein has recycled imagery from everyday culture, often rendering it in the ben-day dots of the comic strips. More recently, subjects are borrowed from the masterpieces of art history. In *Stepping Out* (1978), the dapper young man, wearing a straw hat and high-collared shirt, relates directly to figures in Fernand Léger's 1944 painting *Three Musicians* (Museum of Modern Art, New York). The blond woman at the left is a synthesis of Surrealist imagery, such as that used by Picasso in the 1930s. Although these characters are presented in a witty manner, Lichtenstein's attention to composition is studied and structured. The painting exemplifies his individual style: color is bright and limited to the three primaries plus black and white; paint is applied in a flat, hard-edged manner; and forms are thickly outlined in black. *Purchase, Lila Acheson Wallace Gift, Arthur Hoppock Hearn Fund, Arthur Lejwa Fund in honor of Jean Arp, The Bernhill Fund, Joseph H. Hazen Foundation Inc., Samuel I. Newhouse Foundation Inc., Walter Bareiss, Marie Bannon McHenry, Louise Smith and Stephen C. Swid Gifts, 1980, 1980.420*

war, sex, violence, industry, and domesticity may be drawn from the images. The painting can also be interpreted as a metaphor for modern American society, a society filled with contradictions. *Purchase, Arthur Hoppock Hearn Fund, George A. Hearn Fund, and Lila Acheson Wallace Gift, 1982, 1982.90.1a–c*

36 CHUCK CLOSE, American, b. 1940
Lucas

Oil and pencil on canvas; 100 x 84 in. (254 x 213.4 cm)

Chuck Close's gigantic portrait of his artist friend Lucas Samaras is based on a Polaroid photograph divided into grid segments for enlargement into this painted image of 1986–87. Close first showed his large, picture-perfect portraits in the early 1970s, but during the last few years he has experimented with ways of challenging our notions of verisimilitude. A close examination of the surface of the painting reveals that the artist has retained the grid used to enlarge the original image and subdivided it further into thousands of small squares. Within each square he has painted a distinct pattern consisting of combinations of circles, squares, and lozenges in various colors. The image received is thus made up of myriad atomized elements, which the eye organizes into a coherent image, not unlike the chromatic system used by the Post-Impressionists Seurat and Signac. This technique allows Close to combine decorative elements with depiction, precision with painterliness, abstraction with realism. *Purchase, Lila Acheson Wallace Gift and Gift of Arnold and Milly Glimcher, 1987, 1987.282*

37 DAVID HOCKNEY, British, b. 1937
Large Interior, Los Angeles
Oil, ink on cut and pasted paper, on canvas;
72¼ x 120¼ in. (183.5 x 305.4 cm)

In David Hockney's deft hands the elements of collage, drawing, and painting unite to achieve artistic statements that are without equal in the art world of today. This rambunctious interior space, painted in 1988, is an arena in which Hockney's various obsessions over the last twenty or so years have converged with California life-styles, still lifes and interiors, and modern art history, specifically the dominating presence of Picasso. While Hockney's interior scenes from the 1970s embrace formalist precepts in their explorations of repeated patterns and spatial frontality, works from the 1980s such as this one engage space and detail in a voracious manner. The painting is a compositional tour de force, vividly demonstrating how the artist's involvement in stage design has revitalized the genre of interior scenes within his oeuvre. *Purchase, Natasha Gelman Gift, in honor of William S. Lieberman, 1989, 1989.279*

38 PHILIP GUSTON, American, born Canada, 1913–1980
The Street
Oil on canvas; 69 x 110¾ in. (175.3 x 281.3 cm)

This monumental painting brings together many of the raw and visceral themes that characterize Guston's return to figurative subject matter in the late 1960s. The poignant narrative of confrontation, struggle, and uncertainty is as ambiguous as it is compelling and has precedents in the social commentaries Guston painted in the 1930s and 1940s.

The Street (1977) is a serious investigation into states of disorder and confusion presented in the vernacular language of cartoon figures and naive drawing. As Guston wrote in 1974, his late paintings depict a "sort of Dante Inferno land." The unsettling color scheme of red, bright pink, and gunmetal gray and the crude style of paint application add to the sense of urgent turmoil and despair that the work conveys. *Purchase, Lila Acheson Wallace and Mr. and Mrs. Andrew Saul Gifts, Gift of George A. Hearn, by exchange, and Arthur Hoppock Hearn Fund, 1983, 1983.457*

39 LUCIAN FREUD, British, b. 1922
Naked Man, Back View
Oil on canvas; 72¼ x 54⅛ in. (183.5 x 137.5 cm)

For almost half a century Lucian Freud has concentrated on depicting the human figure and face. This astonishing picture of 1991–92, among Freud's largest, portrays a subject frankly not beautiful. An enormous man, a broken giant, is posed in the artist's attic studio. Head shaved, he is nude and seen from the back as he sits on a covered stool that has been placed on a model's red-carpeted stand. The model is Leigh Bowery, a theatrical personality in London. With stark truthfulness, Freud records Bowery's physical appearance. The manipulation of paint to describe different textures is virtuosic, and the rendition of a landscape of flesh, here beaten by time and abuse, is extraordinary. In essence this is not a portrait but rather a still life of skin. *Purchase, Lila Acheson Wallace Gift, 1993, 1993.71*

40 GEORG BASELITZ, German, b. 1938
Man of Faith
Oil on canvas; 97½ x 78 in. (247.7 x 198.1 cm)

Since 1969 Georg Baselitz, who lived in East Germany until 1957, has painted and drawn his subjects upside down. This way of painting, according to the artist, allows him to reduce the narrative content of his images and prevents unwelcome literary interpretation. In short, he wants to create paintings that hover between abstraction and figuration. In *Man of Faith* (1983) Baselitz represents a simple, disturbing image on a large scale (the picture is over eight feet tall). A man in a dark robe, bent over in prayer, comes hurtling down the canvas, as if in flight. The sensation of rapid descent is heightened by the jagged halo of white, yellow, pink, and mauve paint that surrounds the figure. It seems only natural that he should pray, caught in such a predicament. *Gift of Barbara and Eugene Schwartz, in memory of Alice Schwartz, 1985, 1985.450.1*

42 ALBERTO GIACOMETTI, Swiss, 1901–1966
Tall Figure
Bronze; h. 83 in. (210.8 cm)

In 1945 Giacometti abandoned one- or two-inch-tall figures in favor of larger ones. By 1947, the date of *Tall Figure,* he had adopted what was to become his characteristic style, creating extremely attenuated sculptures. There were three main forms: the walking man, the bust or head, and the standing nude woman. The nude woman here is nearly seven feet tall. Almost without mass, she appears weightless and remote, her eerie otherworldliness accentuated by the matte beige paint that Giacometti applied over the bronze. The sculpture looks as if it has withstood centuries of rough weather which has left its surface crusty and eroded. *The Pierre and Maria-Gaetana Matisse Collection, 2002, 2002.456.111*

41 UMBERTO BOCCIONI, Italian, 1882–1916
Antigraceful
Bronze; 23 x 20½ x 20 in. (58.4 x 52.1 x 50.8 cm)

Boccioni was the foremost exponent of Italian Futurism, a short-lived movement (ca. 1909–15) concerned with abstracting the speed and dynamism of the modern city.

His book on Futurist painting and sculpture, published in 1914, announced the group's rejection of traditional artistic values: "We must smash, demolish, and destroy our traditional harmony, which makes us fall into a 'gracefulness.' . . . We disown the past because we want to forget, and in art to forget means to be renewed."

Borrowing from Cubist distortion and fragmentation, Boccioni attempted to undermine the accepted concepts of proportion, harmony, and beauty. *Antigraceful,* one of his four extant sculptures, was posthumously cast in bronze in 1950–51 from a carved plaster of 1913. The image, based on his mother's likeness, is at the same time a formal analysis of faceted planes and three-dimensional masses. By attaching architectural elements to the top of her head, Boccioni epitomizes the Futurist union of figure and space. *Bequest of Lydia Winston Malbin, 1989, 1990.38.1*

43 GASTON LACHAISE, American (b. France),
1882–1935
Standing Woman
Bronze; h. 72⅞ in. (185.1 cm)

Gaston Lachaise, who began his career as a
sculptor in Paris during the early years of the
twentieth century, found his lifelong muse in
Isabel Dutaud Nagle, an American woman
whom he married in 1917. In 1906 Lachaise
had followed her to America, where he
remained until his death in 1935, becoming one
of this country's foremost sculptors of the
human figure. *Standing Woman* was his first
full-size sculpture, begun shortly after his arrival
in New York in 1912. He made numerous revi-
sions before exhibiting it as a painted plaster in
1918, but it was not until 1927 that the piece
was cast in bronze. Several casts exist, this one
made specifically for the collection of Scofield
Thayer, copublisher of *The Dial*, a literary art
magazine that frequently featured Lachaise's
work. The anatomical features of *Standing
Woman* are undoubtedly based on Isabel's
body. The fully rounded torso with its broad, flat
back and buttocks and wide, full breasts con-
trasts with the slender hands and tapered legs
and feet on which the entire weight of the figure
is gracefully supported. For Lachaise *Standing
Woman* represented the archetypal ideal
woman. *Bequest of Scofield Thayer, 1982,
1984.433.34*

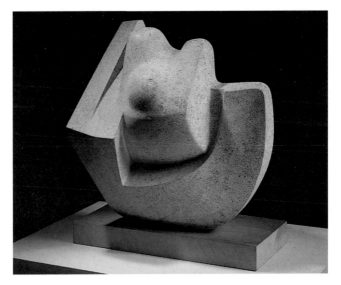

44 HENRY MOORE, British, 1898–1986
Untitled
Hoptonwood stone; h. 18¼ in. (46.4 cm)

Although Henry Moore's later work is large in size and cast as editions in bronze, his earlier works from the 1920s and 1930s were executed as single pieces, on a more intimate scale, in wood or stone. As the artist has explained, "I am by nature a stone-carving sculptor, not a modelling sculptor. I like chopping and cutting things, rather than building up. I like the resistance of hard material." In this untitled work of 1937, as in most of his stone carvings, Moore's physical confrontation with his materials is not evident in the smoothly finished surface. The compact, blocklike forms are highly abstract, their shapes and configurations suggesting human anatomy, without being completely identifiable. *Bequest of Lydia Winston Malbin, 1989, 1990.38.41*

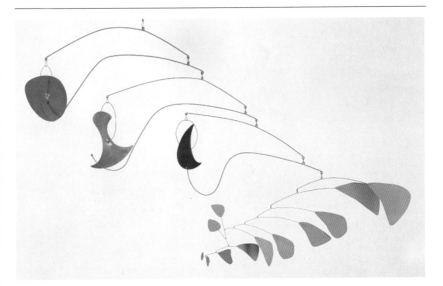

45 ALEXANDER CALDER, American, 1898–1976
Red Gongs
Painted aluminum, brass, steel rod, and wire; 60 x 144 in. (152.4 x 365.8 cm)

Calder's first works were witty, sophisticated toys; he began making moving sculpture—or mobiles, as his works were named by the artist Marcel Duchamp—in 1932. *Red Gongs*, completed in 1950, demonstrates how, with a minimum of detail, Calder was able to create lyrical, rich works. As Klee and Matisse did in their painting, so Calder has here described volume with line alone. This sense of volume is increased as the sculpture moves, describing literal volume in space. Even when static, the piece is marked by a sense of movement, as each element increases in scale and breadth, from the cluster of small forms at one end to the large solitary ones at the other, to form a rising visual crescendo. *Fletcher Fund, 1955, 55.181.1a–f*

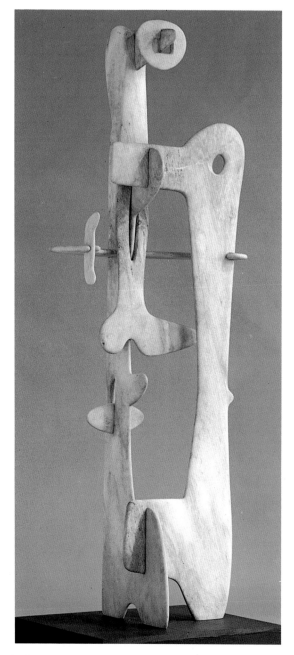

46 ISAMU NOGUCHI, American, 1904–1988
Kouros
Marble; h. 117 in. (297.2 cm)

After the Metropolitan bought Noguchi's *Kouros* (1944–45), the sculptor wrote to the Museum: "The image of man as Kouros goes back to student memories of your archaic plaster casts and the pink Kouros you acquired [see Greek and Roman Art, no. 2] — the admiration of youth. My Kouros is a stone construction. The weight of the stone holds it aloft — a balance of forces as precise and precarious as life." Soon after

Noguchi, a Japanese-American, was released from an internment camp in Arizona where he had been held during World War II, he made this figure using pieces of marble that he had found at construction sites in New York City. In describing this period in his autobiography, the artist again wrote about the *Kouros*: "It's like life — you can lose it at any moment." *Fletcher Fund, 1953, 53.87a–i*

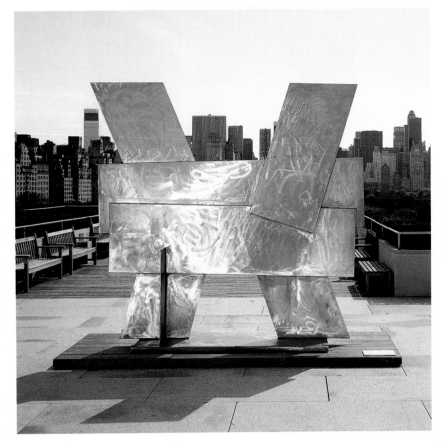

47 DAVID SMITH, American, 1906–1965
Becca
Stainless steel; 9 ft. 5¼ in. x 10 ft. 3 in. x 30½ in.
(287.3 x 312.4 x 77.5 cm)

This century's most influential American sculptor, Smith was a master of the welded-metal technique. He was trained as a painter (1927–32), and his subsequent sculptural work was paradoxically frontal in its orientation, almost two-dimensional, and often calligraphic, paralleling concerns of postwar American painting. His early constructions of the 1930s were influenced by the works of Julio González and by Picasso's iron sculptures. Smith's landscape-inspired works of the 1940s and 1950s were open "drawings in metal." The art of the last fifteen years of his life was characterized by monumental pieces utilizing overlapping rectangular plates of highly polished steel. *Becca* (1965), named after one of Smith's two daughters, exemplifies the bold simplicity and remarkable grace of these forms. The surface is covered with elaborate scribblings that resemble brushstrokes. *Bequest of Miss Adelaide Milton de Groot (1876–1967), by exchange, 1972, 1972.127*

48 LOUISE BOURGEOIS, American ▶
(b. France), b. 1911
Eyes
Marble; h. 74¾ in. (189.9 cm)

The eye, a recurring motif in Surrealism, served as both a symbol for the act of perception—which the Surrealists sought to subvert—and as an allusion to other anatomical elements of a more overtly sexual nature. Bourgeois's artistic career has been marked by a highly personal vocabulary, which encompasses variations of totemic elements and Surrealist iconography, as well as a biomorphism charged with an intense sexuality. Her forms can often be perceived as portraits abstracted from descriptive or anecdotal matter. *Eyes* is a monumental work carved in marble, one of the artist's preferred materials, and reflects her preoccupation with sleep. The combination of architectural form and human anatomy is a motif that reflects Bourgeois's paintings of the 1940s. Her approach to image-making conveys the freshness of a child's elementary perception, a primal examination of the complexities of life through formal means. *Anonymous Gift, 1986, 1986.397*

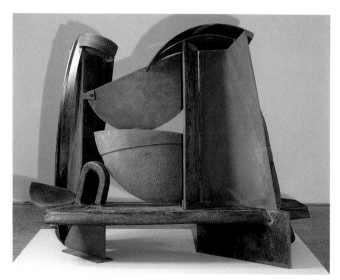

49 ANTHONY CARO, British, b. 1924
Odalisque
Steel; h. 77 in. (195.6 cm)

The British sculptor Sir Anthony Caro was apprenticed to his renowned countryman Henry Moore and, during the 1950s, his work was influenced by Moore's version of abstracted figuration. Caro's encounter with the work of the American David Smith in 1959 precipitated a revolution in his art that eventually established his reputation as a major figure in twentieth-century welded sculpture. In *Odalisque* (1984) Caro has achieved a dialogue between vertical and horizontal movements, curved and straight lines, convex and concave forms. The fabricated cut-steel forms work in tandem with the buoys and chains, which have been cut apart and rejoined to the assembled whole. Unlike Caro's early work, which tended to emphasize frontality, this piece is meant to be viewed from both front and back. Over the years Caro has favored a horizontal orientation in his sculpture, one that conveys a sense of the body at rest. In this context, the motif of the reclining woman of the harem, the odalisque, seems to be an appropriate thematic association. *Purchase, Stephen and Nan Swid Gift, 1984, 1984.328a–d*

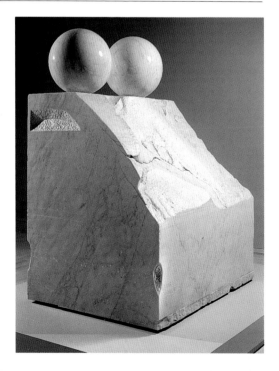

50 PABLO PICASSO, Spanish, 1881–1973
Standing Female Nude
Charcoal on paper; 19 x 12³/₈ in. (48.3 x 31.4 cm)

51 PABLO PICASSO, Spanish, 1881–1973
Ambroise Vollard (1867–1939)
Pencil on paper; 18³/₈ x 12⁵/₈ in. (46.7 x 32.1 cm)

These two drawings epitomize the artist's achievements in two very different styles. The standing nude is one of the purest and most beautiful of Picasso's Cubist drawings, while the portrait of Vollard, his sometime art dealer, is the most masterful expression of Picasso's Ingriste manner. *no. 50: Alfred Stieglitz Collection, 1949, 49.70.34; no. 51: The Elisha Whittelsey Collection, The Elisha Whittelsey Fund, 1947, 47.14*

52 GINO SEVERINI, Italian, 1883–1966
The Train in the City
Charcoal on paper; 19⁵/₈ x 25¹/₂ in. (49.8 x 64.8 cm)

This charcoal drawing epitomizes the Italian Futurists' preoccupation with movement and velocity as expressed in images of war and modes of rapid transportation. The drawing is a kaleidoscopic aerial view of angled rooftops and spindly trees intersected dramatically by a speeding train that spews out billowing clouds of smoke across the landscape. The drawing belongs to a series that occupied Severini's attention late in 1915 when he watched troops and artillery move past his house in the French countryside and below his apartment window in Paris. *Alfred Stieglitz Collection, 1949, 49.70.23*

53 EGON SCHIELE, Austrian, 1890–1918
Self-Portrait
*Watercolor, gouache, and pencil on paper;
20¼ x 13¾ in. (51.4 x 35 cm)*

Schiele was amazingly productive during his short, intense career. Before dying from influenza in 1918 at the age of twenty-eight, he created more than three hundred oil paintings and several thousand works on paper. The human figure, rendered with powerful energy, was the subject of most of his paintings and drawings. The large number of self-portraits he created between 1910 and 1918 are searing explorations of his psychic state. Assuming a pose suggestive of the crucified Christ in this self-portrait of 1911, he stares out wildly, his shock of hair standing on end. *Bequest of Scofield Thayer, 1982, 1984.433.298*

54 HENRI MATISSE, French, 1869–1954
Sergei Ivanovich Shchukin
Charcoal on paper; 19½ x 12 in. (49.5 x 30.5 cm)

A member of a rich Russian merchant family, Sergei Ivanovich Shchukin (1854–1936) was a successful textile trader. He was also a bold and passionate collector of French art, acquiring works from Impressionism to Postimpressionism to Matisse and Picasso. Matisse drew the fifty-eight-year-old Shchukin in July 1912, during one of the Russian's trips to Paris to purchase paintings. This work was a study for a planned portrait in oil which was not executed. This oddly disembodied head is roughly drawn in thick charcoal lines; smudged areas accentuate Shchukin's prominent cheekbones, bushy eyebrows, and wispy mustache and beard. *The Pierre and Maria-Gaetana Matisse Collection, 2002, 2002.456.38*

55 PAUL KLEE, German, 1879–1940
Angel Applicant
Gouache, ink, and pencil on paper; 19¼ x 13⅜ in. (48.9 x 34 cm)

In 1939 Klee composed twenty-nine works featuring angels, not the celestial kind but hybrid creatures riddled with human foibles. Suffering from an incurable illness, Klee possibly felt a kinship with these outsiders. In this work he covered a sheet of newspaper with black gouache, over which he drew the figure and the moon with pencil, filling in the forms with a thin white wash. The black ground showing through the white gives this creature a ghostly shimmer. *The Berggruen Klee Collection, 1984, 1984.315.60*

56 RENÉ JULES LALIQUE, French,
1860–1945
Necklace
*Gold, enamel, Australian opals, Siberian
amethysts; diam. 9½ in. (24.1 cm)*

Art Nouveau flourished in France and Belgium in
the years around the turn of the twentieth cen-
tury. Though purportedly antihistoricist, its ele-
gant organic forms and asymmetrical curves
often evoke the Rococo style of mid-eighteenth
century France. One of the most admired
designers in this idiom, Lalique avoided using
the precious stones and conservative classical
settings favored by other leading jewelers of the
time, preferring to offset semiprecious stones
with materials such as enamel, horn, ivory, coral,
and rock crystal. He designed this necklace
about 1900 for his second wife, Augustine-Alice
Ledru. The repeats of the main motif—an attenu-
ated female nude with stylized hair and arms
that extend down to enclose a pair of enamel-
and-gold swans (probably an allusion to marital
fidelity) and an oval cabochon amethyst—are
separated by pendants set with fire opals
mounted in swirling gold tendrils. *Gift of Lillian
Nassau, 1985, 1985.114*

57 PIERO FORNASETTI, Italian, 1913–1988,
and **GIO PONTI,** Italian, 1891–1979
"Architettura"Trumeau
*Screen-printed wood fiberboard, mahogany,
brass, wire, electric light; h. 86 in. (218.4 cm)*

Design in Italy underwent radical changes after
World War II. In an effort to revive the depressed
postwar economy, Italian designers made a self-
conscious effort to establish themselves as lead-
ers in the lucrative international market for
domestic design (millions of recently demobi-
lized war veterans and their families needed
new homes and furnishings throughout war-
devastated Europe). Historical precedent pro-
vides both formal and decorative inspiration for
this drop-front writing cabinet (1952), a collabo-
rative effort between the architect Gio Ponti, who
designed the pared-down yet still traditional
form, and the designer Piero Fornasetti, who
was responsible for the exuberant, illusionistic
decoration. Fornasetti's depictions of architec-
tural fantasies, in the style of sixteenth-century
Italian Mannerist compositions, are screen-
printed onto fiberboard panels applied to the
framework of the cabinet and varnished. *John C.
Waddell Collection, Gift of John C. Waddell,
1997, 1997.460.2ab*

58 JOE COLOMBO, Italian, 1930–1971
"Tube" Chair
Manufacturer: Flexform; PVC plastic (polyvinyl chloride), tubular steel, rubber, polyurethane foam, synthetic knit upholstery; w. 25¼ in. (64.1 cm)

Postwar designers often embraced new materials and technologies to produce innovative and inexpensive designs that rejected historical precedent and expressed a newfound wit and optimism. Drastic changes in housing conditions and lifestyles—living quarters became smaller, less formal and required increased adaptability (living-dining rooms, for example)—served as a challenge to Colombo, who strove to create low-cost, mass-producible multiuse furniture. This chair (1969–70) is made of four hollow cast-plastic cylinders wrapped in polyurethane foam covered with upholstery fabric. The tubes can be hooked together with metal and rubber clips in a variety of configurations to make a chair, stool, chaise longue—whatever form is desired. Nested within each other for storage, the cylinders could be compactly packaged inside a drawstring canvas tote bag and affordably sold off the shelf. *Purchase, Theodore R. Gamble Jr., in honor of his mother, Mrs. Theodore Robert Gamble, 1987, 1987.98.1a–d*

59 DOMINICK LABINO, American, 1910–1987
Emergence in Polychrome
Glass; h. 8½ in. (21.6 cm)

In 1965 Dominick Labino retired from a successful career as an engineer-inventor in the glass industry to devote full time to his own creative endeavors in glassblowing. He devised a formula that allowed glass to melt at low temperatures in small furnaces suitable for the needs of individual glassblowers, and thus the international studio glass movement was begun. *Emergence in Polychrome* (1977), a hot-worked glass sculpture, is one of a series of flame-shaped pieces that Labino made during the 1970s. The colorless glass encases interior veils of "dichroic" color, causing the hues to change as light strikes the piece from different angles. The graceful, fluid form of Labino's sculpture complements the special nature of the material, but it is his extraordinary sense of color and his ability to create color relationships through technical expertise that make him a master of twentieth-century glassmaking. *Gift of Mr. and Mrs. Dominick Labino, 1977, 1977.473*

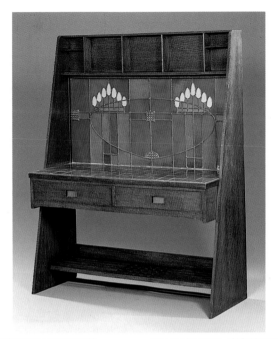

60 CHARLES RENNIE MACKINTOSH,
Scottish, 1868–1928
Washstand, 1904
Oak, ceramic tile, leaded colored glass, and mirror glass; h. 63¼ in. (160.5 cm)

Mackintosh designed this washstand as part of the furnishings for the Blue Bedroom in Hous'hill, a house he remodeled for Miss Cranston and her husband. She was the pro- prietress of a group of highly successful tea- rooms in Glasgow, many of which Mackintosh designed for her, and she was one of his most important clients. With its uncompromising shape and brilliant abstract panel of glass, this washstand shows the architect/designer at the height of his powers. *Purchase, Lila Acheson Wallace Gift, 1994, 1994.*

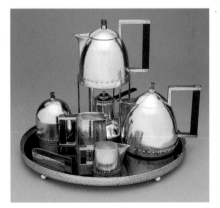

61 JOSEF HOFFMANN, Austrian, 1870–1956
Manufacturer: Wiener Werkstätte
Tea Service, ca. 1910
Silver, amethyst, carnelian, and ebony; w. (of tray) 13⅞ in. (35.2 cm)

In 1903 a number of Viennese avant-garde designers whose work was characterized by a strict yet vigorous geometry formed the Wiener Werkstätte (Vienna Workshops). Under the direction of the architect/designer Josef Hoff- mann, this designers' cooperative followed the principles of the Arts and Crafts movement— that is, it strove to provide a wide range of well-designed, often handmade products for a sophisticated audience. This tea service—a composition of cylinders, cones, and hemi- spheres made from rich materials—is both luxu- rious and austere, qualities typical of the Weiner Werkstätte. *Cynthia Hazen Polsky and Leon B. Polsky Fund, 2000 2000.278.1-9*

62 ÉMILE JACQUES RUHLMANN, French, 1879–1933
Cabinet, 1926
Macassar ebony, amaranth, and ivory; h. 50¼ in. (127.6 cm)

The Art Deco style reached its height in the designs exhibited at the 1925 Paris Exposition Internationale des Arts Décoratifs et Industriels. Émile Jacques Ruhlmann was the leading furniture maker of this period in France, and this cabinet, made of exotic wood and precious ivory, was commissioned by the Metropolitan Museum in 1925 after the first model was purchased by the French government. The central motif, a flower-filled basket, fashioned in marquetry, is a tour de force of craftsmanship and design, and the cabinet epitomizes the kind of deluxe objects produced by Ruhlmann at this time. *Purchase, Edward C. Moore Jr. Gift, 1925, 25.231.1*

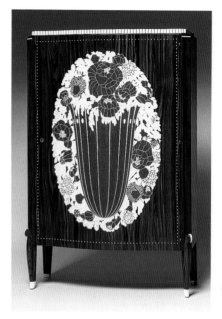

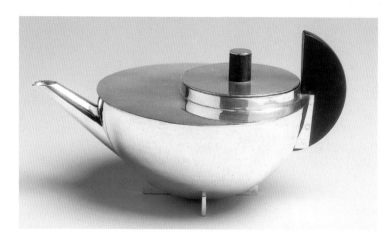

63 MARIANNE BRANDT, German, 1893–1983
Tea Infuser and Strainer, ca. 1924
Silver, ebony; h. 2⅞ in. (7.3 cm)

During its brief existence (1919–33) the German Bauhaus produced a group of architects and designers whose work profoundly influenced the visual environment of the twentieth century. They believed that everyday objects, stripped of ornament, could achieve beauty simply through form and color. While incorporating all the usual elements of a teapot (body, lid, handle, spout),

Brandt has here reinvented them as a series of abstract geometric forms; indeed, the only deviation from geometric purity is the tapered spout, which is slightly curved downward to prevent drips. Although the pot is carefully resolved functionally, its visual impact lies in the uncompromisingly sculptural statement it makes. Its diminutive size results from its function: it is intended to distill a concentrated extract which, when combined with hot water in the cup, can produce tea of any desired strength. *The Beatrice G. Warren and Leila W. Redstone Fund, 2000, 2000.63a–c*

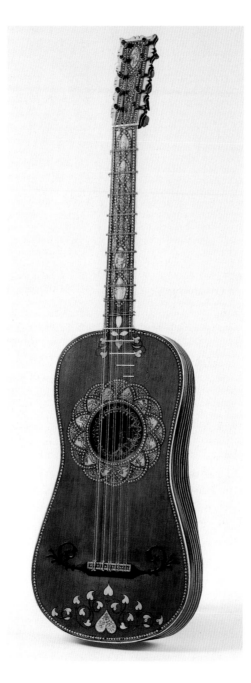

MATTEO SELLAS, German, b. ca. 1580, active in Venice, mid-17th century
Baroque Guitar
Wood, ivory, and various other materials; l. 38 in. (96.5 cm)

Guitars were among the most popular Baroque musical instruments for both solo playing and accompaniment and were especially prominent in theatrical music. Many costly, finely decorated examples survive. Some of the most exquisite were fashioned in Italy by luthiers, including Antonio Stradivari. But many—perhaps the majority—of the lesser-known guitar makers in northern Italy before about 1650 were of south German origin; most altered their names to Italian forms. Among the highest regarded of these German-Italian craftsmen was Matteo Sellas (Matthäus Seelos). The present design from about 1640 incorporates engraved bone plaques showing hares and dogs, borders of small triangular bone inlays set in a black ground, and a checkerboard pattern on the back of the neck. It is typical of Italo-German work of the period.
Purchase, Clara Mertens Bequest, in memory of André Mertens, 1990, 1990.103

MUSICAL INSTRUMENTS

The Department of Musical Instruments, founded in 1942, preserves more than four thousand works from six continents, dating from prehistory to the present. A large part of the department's holdings came to the Museum in 1889, when Mrs. John Crosby Brown donated The Crosby Brown Collection of Musical Instruments.

The works in the Museum's collection, selected for technical and social importance as well as for tonal and visual beauty, illustrate the history of music and performance. Of particular note are European courtly instruments from the Renaissance, the oldest extant piano, rare violins and harpsichords, instruments made from precious materials, and a fully equipped traditional violin-maker's workshop. The galleries, opened in 1971, display a representative selection of some eight hundred European, American, and non-Western works. Audio equipment enables visitors to hear music performed on these instruments, which are also used in gallery concerts and lecture-demonstrations.

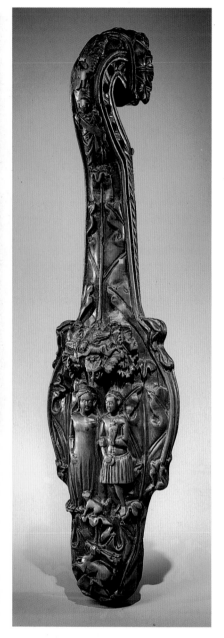

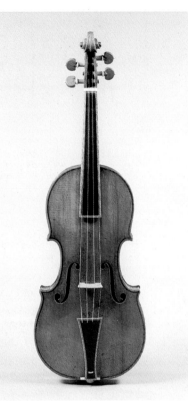

2 ANTONIO STRADIVARI, Italian, 1644–1737
Violin
*Maple, spruce, various other materials;
l. 23⅝ in. (60.1 cm)*

During the Baroque era (roughly 1600–1750), instrumentalists strove for clarity rather than for dynamic nuance. The supreme Italian luthiers valued warmth of tone above all, and their durable masterworks retain this quality after three centuries.

This Stradivarius is the finest of all Baroque violins. Made in Cremona in 1691, it is unique in having been restored to its original appearance and tone. All other violins by this great master show later modifications aimed at exaggerating their loudness and brilliance, qualities remote from the maker's intent. This violin is robust but not shrill, its gut strings producing a sound ideal for chamber music. *Gift of George Gould, 1955, 55.86*

1 Late-Medieval Stringed Instrument
North Italian, ca. 1420
Boxwood and rosewood; l. 14⅛ in. (36 cm)

This appealing little cousin of the guitar was probably meant as a gift for the enjoyment and edification of a young woman. Its five strings would have passed over a low flat bridge, and the player would have used a plectrum to strum a chord or pick out a melody on one string at a time. This instrument may have been made to commemorate a betrothal. In Renaissance and earlier folklore, plucked instruments were frequently associated with Venus, with love and well-being, with springtime and vernal pursuits. The modestly garbed young couple on the back of this instrument, formally posed beneath a Tree of Life in which a naked Cupid draws his bow, seems to have nuptial implications. A number of familiar emblems drawn from sculpture, illumination, bestiaries, and other sources contribute to the imagery of courtship and betrothal. *Gift of Irwin Untermyer, 1964, 64.101.1409*

3 JOHANN WILHELM HAAS, Nuremberg,
1648–1723
Trumpet (left)
*Silver; mouthpiece and cord not original; l. 28 in.
(71.2 cm)*
CHARLES JOSEPH SAX, Belgian, 1791–1865
Clarinet (right)
Ivory and metal; l. 26¾ in. (68 cm)

Flute (bottom)
Saxon, 1760–90
Porcelain and metal; l. 24⅝ in. (62.6 cm)

Unlike keyboard and stringed instruments, wood-
winds and brasses offer little area for decoration.
These examples are unusual in combining rare
materials with elegant ornament.

The silver trumpet with gold-washed mounts
dates from about 1700 and bears the engraved
arms of the king of Saxony in whose service it
probably sounded. Emblems of nobility, trum-
pets were played by an elite guild of musicians.

The ivory clarinet, made in Brussels in 1830,
has gilt lion-head keys and carries the arms
and motto of the princes of Orange.

The porcelain flute is embellished with a
colorful band of flowers that spirals between the
finger and embouchure holes, interrupted only
by gold-plated ferrules that connect the sepa-
rate sections of tubing. Three center sections of
slightly different lengths can be interchanged to
adjust the pitch.

Trumpet: *Purchase, Funds from Various
Donors, 1954, 54.32.1;* clarinet: *Funds from Vari-
ous Donors, 1953, 53.223;* flute: *Gift of R.
Thornton Wilson, in memory of Florence E.
Wilson, 1943, 43.34*

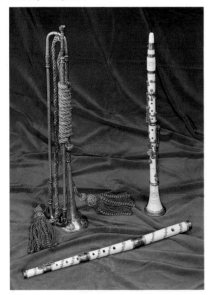

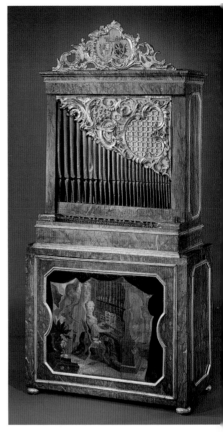

4 Chamber Organ
German, 18th c.
*Wood, metal, various other materials; h. 85½ in.
(217 cm)*

Small pipe organs once served the same domes-
tic functions as electric organs do today, fur-
nishing popular musical entertainment and
accompanying private devotional services. This
colorful Baroque chamber organ reportedly
came from Castle Stein in Taunus, a region near
Frankfurt am Main. Its marbleized case has two
components: a cubical base containing the bel-
lows and wind reservoir, fronted by a naive
painting of Saint Cecilia by Franz Caspar Hofer,
dated 1758, and an upper section holding the
keyboard, windchest, and pipes. Above the
cornice a carved gilded frame encloses two
unidentified coats of arms and the date 1700.
Another carved frame shades the tops of the
front rank of metal pipes. Two more ranks
within complete the tonal apparatus, which is
controlled by iron stop levers at the right of the
forty-five-note keyboard. The organist had to
play standing up, with another person inflating
the bellows by pulling a strap at the right side.
*The Crosby Brown Collection of Musical Instru-
ments, 1889, 89.4.3516*

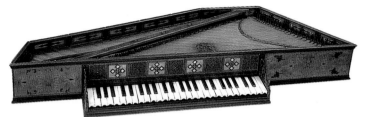

5 Pentagonal Spinet
Venetian, 1540
Wood, various other materials; w. 54⅜ in.
(138 cm)

In Renaissance Italy delicate spinets were the favored keyboard instruments of the aristocracy. Intended for amateur use, they were often richly decorated to charm the eye as well as the ear. One of the finest surviving spinets, this instrument was commissioned by the duchess of Urbino and was built by an unknown Venetian master. Over the keyboard is inscribed a humanistic appeal: "I'm rich in gold and rich in tone; if you lack goodness, leave me alone." ("Goodness" here means both personal virtue and musical skill.) Emblematic carvings bracket the arcaded keyboard, and intricate intarsia and pierced ornaments cover the front and the interior.

One of the oldest playable keyboard instruments, this spinet has been used in the Museum for concerts and recordings. Its brass strings are plucked by crow quills, and its lutelike tone especially suits the popular repertoire of its period, chiefly dances and variations on sacred and secular tunes. *Purchase, Joseph Pulitzer Bequest Fund, 1953, 53.6*

6 HANS RUCKERS THE ELDER, Flemish. ca. 1545–d. 1598
Double Virginal
Wood, various other materials; w. 74¾ in.
(190 cm)

This sumptuously painted virginal, made in Antwerp in 1581, is the oldest extant work by Hans Ruckers the Elder, head of a renowned family of Flemish harpsichord builders. Brought to Peru, it was discovered about 1915 in a hacienda chapel near Cuzco. Philip II of Spain and his wife Anne appear on gilt medallions over the right keyboard. When the high-pitched "child" at the left is placed above its "mother," both can be played by one person. The panel below the keyboards bears a Latin motto, which may be translated, "Sweet music is a balm for toil." *Gift of B. H. Homan, 1929, 29.90*

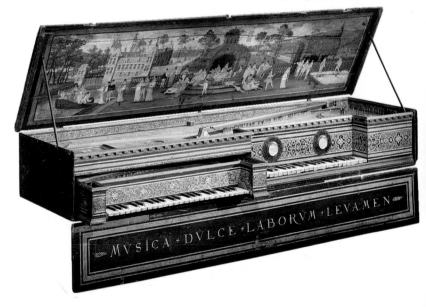

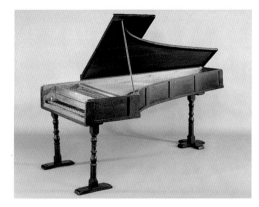

7 BARTOLOMMEO CRISTOFORI, Italian, 1655–1731
Piano
Wood, various other materials; l. 90 in. (228.6 cm)

This, the oldest piano in existence, is one of three that survive from the workshop of Bartolommeo Cristofori, who invented the piano at the Medici court in Florence about 1700. The Museum's example is dated 1720 and remains in playable condition, thanks to successive restorations that began in the eighteenth century. Outwardly plain, this piano is nevertheless a marvel of technology and tone. Its complex mechanism prefigures the modern piano's, but its keyboard is shorter and no pedals exist to provide tonal contrast. Instead, the compass comprises three distinct registers: a warm, rich bass; more assertive middle octaves; and a bright, short-sustaining treble. Intended chiefly for accompanimental use, Cristofori's invention was called *gravicembalo col piano e forte* (harpsichord with soft and loud), referring to its novel dynamic flexibility. Lodovico Giustini exploited its expressive qualities in composing the first published piano music (Florence, 1732), which was inspired by Cristofori's ingenious instruments. *The Crosby Brown Collection of Musical Instruments, 1889, 89.4.1219*

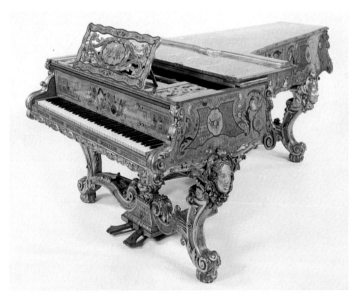

8 ERARD & COMPANY, London, ca. 1840
Piano
Wood, metal, various other materials; l. 97¼ in. (247 cm)

The London branch of the famous Parisian firm of harp and piano makers built this magnificent piano for the wife of the third baron Foley. The keys and pedals seem scarcely to have been touched, so we can surmise that this fine instrument was kept merely as an emblem of culture and status. No other piano so richly decorated is known from this period. The marquetry of dyed and natural woods, engraved ivory, mother-of-pearl, abalone, and wire illustrates many musical scenes and trophies as well as animals, grotesque figures, floral motifs, dancers, Greek gods, and the Foley arms. This decor was executed by one George Henry Blake, of whom nothing is known. The mechanism, patented by Erard, is the direct ancestor of the modern grand "action," which allows great power and rapidity in technique; hence, Erard's pianos were favored by virtuosi such as Franz Liszt. *Gift of Mrs. Henry McSweeney, 1959, 59.76*

9 Bowl Drum
Ghanaian, 20th c.
Polychromed wood; l. 21 in. (53.4 cm)

Many African tribesmen still make and play drums according to centuries-old methods, which are governed by complex rules and taboos. The carved decoration of the variously shaped wood bodies symbolizes their ritual functions. Drums may "reside" in huts where, representing deities or enclosing powerful fetishes, they receive offerings of food. A significant Ghanaian example is this polychromed bowl drum supported on the shoulders of two seated women. The depiction of writing and the drum's good state of preservation indicate a fairly recent origin for this evocative sculpture, symbolic of maternity. Presumably this cult drum was once an important furnishing of an Ashanti shrine; it must have lost its efficacy before leaving the cult's possession. *Gift of Raymond E. Britt Sr., 1977, 1977.454.17*

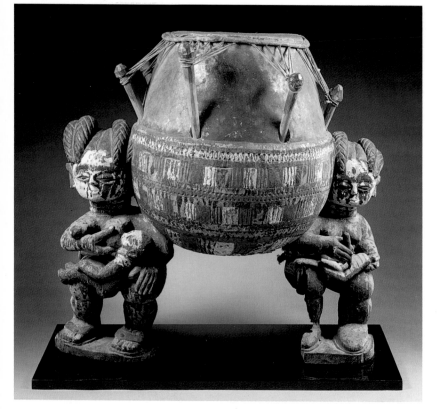

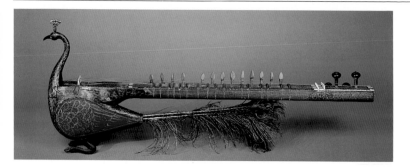

10 Mayuri
Indian, 19th c.
Wood, feathers, various other materials; l. 44⅛ in. (112 cm)

A type of bowed sitar, the mayuri is one of many Indian instruments incorporating animal forms. Its Sanskrit name means "peacock." When it is played, the bird's feet stand on the ground, and the pegbox rests over the player's shoulder. Adjustable frets and wire strings lie along the fingerboard, above a tail of vivid feathers. Other kinds of sitars also employ avian materials, including eggshells, in their construction. *The Crosby Brown Collection of Musical Instruments, 1889, 89.4.3516*

11 Pi-pa

Chinese, Ming dynasty, 17th c.
Wood, ivory, various other materials; I. 37 in.
(94 cm)

The term "pi-pa," originally a generic name
for Chinese lutes, describes the back-and-forth
motion of the player's right hand across the
strings. Lutes of various shapes and sizes
were mentioned as early as the Han dynasty
(206 B.C.–A.D. 220). The modern type shown
here, probably introduced by Central Asian
invaders by the sixth century A.D., reached
its zenith during the T'ang dynasty (618–907)
but is still heard in ensembles, accompanying
dramatic narrations and ballads, and in virtuo-
sic solo pieces with programmatic titles. The
extraordinary carved decoration of this example
includes 120 ivory plaques depicting animals,
flowers, people, and Buddhist emblems all sym-
bolizing good luck, longevity, and immortality.
A bat, conventional symbol of good fortune,
appears at the end of the neck. Instruments of
such rare beauty were made as gifts for foreign
rulers and for use at court. The player of this
pi-pa certainly enjoyed high status as a musician.
Bequest of Mary Stillman Harkness, 1950,
50.145.74

12 Sesando

Indonesian, Timor, late 19th c.
Palm leaf, bamboo, wire; h. 22½ in. (57 cm)

In Indonesia, sections of palm leaf (*Borassus
flabellifera*) are commonly sewn together to
make buckets for collecting sap. Here a similar
palm-leaf "bucket" forms the sound reflector for
a tubular bamboo zither with twenty wire strings
raised on short bridges. The elegant design is
practical and musically efficient: the fragile re-
flector can be cheaply replaced if damaged,
and the instrument is both lightweight and
resonant. The sesando is held vertically in front
of the player's chest, its opening toward his
body. The top is suspended from a strap around
the player's neck, and the bottom rests on his
lap. Fingers of both hands pluck the strings.
Tube zithers like this are also found in Mada-
gascar, where they were brought across the
Indian Ocean by sailors from the East. These
instruments play in ensembles accompanying
singing and dancing. Sesandos are seldom
seen in the West, where winter dryness cracks
their tropical materials. *The Crosby Brown Col-
lection of Musical Instruments, 1889, 89.4.1489*

13 Shaman Rattle

Tsimshian Indian, around Queen Charlotte Is-
lands, British Columbia, 19th c.
Wood; I. 14 in. (35.5 cm)

Chordophones, or stringed instruments, were
unknown in the Western Hemisphere before its
conquest by Europeans. Instead, over tens of
thousands of years Native Americans devel-
oped an astonishing variety of idiophones, drums,
and winds. Crisp-sounding rattles and non-
pitched single-head drums accompanied dance,
song, and ritual. Vivid bird-form rattles, such as
this one, are characteristic carvings from the
northwest coast of North America. These instru-
ments embody totemic emblems and depict
animals conveying magical power to the sha-
man through their tongues. Particular colors
from natural pigments are essential to the rattles'
efficacy. *The Crosby Brown Collection of Musi-
cal Instruments, 1889, 89.4.615*

JULIA MARGARET CAMERON, British,
1815–1879
Philip Stanhope Worsley
*Albumen silver print from glass negative;
11⅞ x 9¾ in. (30.4 x 25 cm)*

Philip Stanhope Worsley (1835–1866) was an
Oxford-educated poet who translated the
Odyssey and part of the *Iliad* into Spenserian
stanzas. Tubercular from childhood, he died at
the age of thirty at Freshwater, Isle of Wight,
where Julia Margaret Cameron also lived. The
intensity of Worsley's intellectual life and some-
thing of its tragedy are vividly conveyed in
Cameron's portrait (1864–65). Isolating his face
against an indistinct background, she placed his
raised and baleful gaze at the very center of the
picture. To her subject's hypnotic gravity she
added intimations of sacrifice, swathing the body
and engulfing the great head, rendered nearly
lifesize, in dramatic darkness. In powerful por-
traits such as this one, Cameron's ability to evoke
an inner struggle presaged the next generation's
morbid cult of subjectivity, with in Walter Pater's
words, "each mind keeping as a solitary prisoner
its own dream of a world." *Gilman Collection,
Purchase, The Horace W. Goldsmith Foundation
Gift, 2005, 2005.100.27*

PHOTOGRAPHS

Although established as an independent curatorial department as recently as January 1992, the Department of Photographs houses a collection of more than twenty thousand images acquired by the Museum over sixty-six years. Individual photographic treasures entered the collection as early as 1928, thanks to the all-encompassing view of the graphic arts held by the first two curators of prints, William Ivins Jr. and A. Hyatt Mayor.

Providing the cornerstones of the department's holdings, however, are two individual collections that together cover the half-century between 1895 and 1945: the Alfred Stieglitz Collection and the Ford Motor Company Collection. Stieglitz, a passionate advocate of photography as art and editor of the influential journal *Camera Work,* made gifts of more than five hundred photographs to the Museum in 1928, 1933, and in a bequest following his death in 1946. The Ford Motor Company Collection, five hundred works collected by John C. Waddell and donated to the Museum in 1987 as a gift of Ford Motor Company and Mr. Waddell, represents avant-garde European and American photography between the two world wars.

Photographs and photographically illustrated books and albums can be seen by appointment from Tuesday through Friday in the Study Room for Prints and Photographs.

1 WILLIAM HENRY FOX TALBOT, British,
1800–1877
Wrack, 1839
Salted paper print; 8⅝ × 6⅞ in. (22 × 17.5 cm)

This evanescent trace of a botanical specimen,
among the rarest of photographs, was made by
William Henry Fox Talbot just months after he
first presented his invention—photography, or
"photogenic drawing," as he called it—to the
public. Talbot's earliest images were made with-
out a camera; here a piece of slightly trans-
lucent seaweed was laid directly on a sheet of
photosensitized paper, blocking the rays of
the sun from the portions it covered and leaving
a light impression of its form.

Plants were often the subject of Talbot's early
photographs, for he was a serious amateur bot-
anist and envisioned the accurate recording of
specimens as an important application of his in-
vention. The *Album di disegni fotogenici,* in
which this print appears, contains thirty-six im-
ages sent by Talbot to the Italian botanist
Antonio Bertoloni in 1839–40. It was the first im-
portant photographic work purchased by the
Metropolitan Museum. *Harris Brisbane Dick
Fund, 1936, 36.37*

2 ROGER FENTON, British, 1819–1869
Reclining Odalisque
*Salted paper print from glass negative; 11¼ x
15⅜ in. (28.5 x 39 cm)*

Fenton wanted to elevate the status of photogra-
phy by tackling themes more frequently treated
in painting. This image (1858) is modeled on
the harem scenes and odalisques of Eugène
Delacroix and J.-A.-D. Ingres which he had seen
in Paris. It is among the quietest in his series

of some fifty Orientalist pictures. There are no
cowering slaves or leering sultans, no music or
dancing, few props, and no narrative. The odal-
isque, floating in darkness, is an embodiment of
the Victorian fascination with the exotic and the
erotic. *The Rubel Collection, Purchase, Lila
Acheson Wallace, Anonymous, Joyce and
Robert Menschel, Jennifer and Joseph Duke,
and Ann Tenenbaum and Thomas H. Lee Gifts,
1997, 1997.382.34*

3 ÉDOUARD BALDUS, French (b. Prussia),
1813–1889
Pont en Royans, 1854–59
Salted paper print from paper negative;
17 × 13⅜ in. (43.2 × 33.9 cm)

Édouard Baldus is acclaimed for his photo-
graphs of the grand architectural projects and
expanding railroads of Second Empire France,
for his views of historic monuments, and for his
dramatic landscapes. Here, in a picturesque
corner of eastern France, Baldus treated the
power of nature and the ingenuity of man's
claim upon it.

This extraordinarily rich and well-preserved
print of 1854–59 demonstrates Baldus's innova-
tive aesthetic command of the medium. Artists
in other media had visited and depicted Pont en
Royans, but none before Baldus had dared to
push the town's bridge and cliff-bound houses
to the very top of the picture and to banish the
horizon altogether. Our attention is focused on
the rough rock surfaces of the ravine, rendered
with a brute realism more akin to the paintings
of Courbet than to anything hitherto produced
in photography. *Louis V. Bell Fund, 1992,*
1992.5003

**4 ALBERT SANDS SOUTHWORTH and
JOSIAH JOHNSON HAWES,** American,
1811–1894; 1808–1901
**Lemuel Shaw, Chief Justice of the
Massachusetts Supreme Court,** 1850s
Daguerreotype; 8½ × 6½ in. (21.6 × 16.5 cm)

The Boston partnership of Southworth and
Hawes produced the finest portrait daguerre-
otypes in America for a clientele that included
leading political, intellectual, and artistic figures.
This photographic process was invented by
Louis Daguerre (1787–1851) and spread rapidly
around the world after its public presentation in
Paris in 1839. Exposed in a modified camera
obscura and developed in mercury vapors, each
highly polished silvered copper plate is a unique
photograph that, viewed in proper light, exhibits
extraordinary detail and three-dimensionality.
Lemuel Shaw's imposing presence, sculpted in
a deluge of sunlight through the daguerreo-
typists' daring vision, is a startling departure
from the studio accoutrements and indirect
lighting of conventional portraits in the 1850s.
*Gift of Edward S. Hawes, Alice Mary Hawes and
Marion Augusta Hawes, 1937, 38.34*

5 CARLETON WATKINS, American, 1829–1916
Cape Horn near Celilo
Albumen silver print from glass negative; 15¾ x 20⅝ in. (40 x 52.4 cm)

Watkins, one of the finest landscape artists in any medium, took this photograph in 1867. The site is one hundred miles up the Columbia River from Portland, the farthest point reached by a photographic survey commissioned by the Oregon Steam Navigation Company. Watkins achieved an artful balance between nature and human incursion into it—between the valley carved out by the river and the railroad laid down alongside the shore. For him, the natural world was a providential place of aesthetic and moral harmony whose state of grace could be expressed pictorially. *Gilman Collection, Purchase, The Horace W. Goldsmith Foundation Gift, 2005, 2005.100.109*

6 THOMAS EAKINS, American, 1844–1916
Two Pupils in Greek Dress, ca. 1883
Platinum print; 14½ × 10½ in. (36.8 × 26.6 cm)

Famed for the incisive realism of his paintings, Thomas Eakins took up photography as an aid in his naturalistic studies and in his teaching. As director of the Pennsylvania Academy of Fine Arts in the 1880s, he encouraged students to work immediately and directly from the model. He also photographed the models to build a collection of images from life for his students' future reference. This photograph of two pupils in Greek dress illustrates Eakins's ability to capture in an offhand moment an exquisitely transient poise—that liveliness we confusingly call "classic" in an ancient Greek sculpture, but which is forever modern. *David Hunter McAlpin Fund, 1943, 43.87.17*

7 EDWARD STEICHEN, American
(b. Luxembourg), 1879–1973
The Flatiron, 1904
Gum bichromate over platinum print;
18¼ × 15⅛ in. (47.8 × 38.4 cm)

The imposing height and dynamic shape of the Flatiron Building, constructed in 1902 on Madison Square, made it a favorite subject for photographers at the turn of the century. Edward Steichen's three large prints of *The Flatiron* (1904, printed 1909) in this collection, each a different color, together form the quintessential chromatic study of twilight in a modern urban setting. The moody, painterly effects of this photograph were achieved by adding to a platinum print layers of pigment suspended in a light-sensitive solution of gum arabic and potassium bichromate. Clearly indebted in its flattened composition to the Japanese woodcuts then in vogue and in its coloristic effect to the Nocturnes of Whistler, this picture is a prime example of the efforts of photographers in the circle of Alfred Stieglitz to represent their experience of the world in ways that melded photography's verisimilitude with current artistic visions. *Alfred Stieglitz Collection, 1933, 33.43.39*

8 PAUL STRAND, American, 1890–1976
Blind, 1916
Platinum print; 13¼ × 10⅛ in. (33.7 × 25.6 cm)

After studying photography in high school with the social reformer Lewis Hine, Paul Strand absorbed the lessons of recent European art through Alfred Stieglitz's exhibitions of the works of Picasso, Brancusi, and others at his gallery in 1914–15. In 1916 Strand made a series of portraits of New Yorkers, in which he fused the objectivity of social documentation with the boldly simplified forms of modernism. Unflinching in its candor and graphically insistent, *Blind* succeeds in being at once poignant and trenchant. The image immediately became an icon of the new American photography through its reproduction in Stieglitz's magazine *Camera Work. Alfred Stieglitz Collection, 1933, 33.43.334*

9 MAN RAY, American, 1890–1976
Rayograph
Gelatin silver print; 19⅜ x 15¾ in. (49 x 39.8 cm)

No technique was better suited to Man Ray's interest in chance than the photogram, a camera-less process in which objects are placed directly upon sensitized paper and exposed to light. Called "rayographs" by Man Ray's friend Tristan Tzara, photograms are unique and unrepeatable and, to a degree, uncontrollable. This rayograph (1923–28) is one of Man Ray's largest. In it white incandescent shapes float against a murky background "painted" by liquid chemicals, in what is probably a metaphor of creation. The Surrealist poet Robert Desnos wrote that Man Ray "succeeded in creating landscapes which are foreign to our planet, revealing a chaos that is more stupefying than that foreseen by any Bible." *Gilman Collection, Purchase, The Horace W. Goldsmith Foundation Gift, 2005, 2005.100.140*

10 UMBO (Otto Umbehr), German, 1902–1980
Mystery of the Street, 1928
Gelatin silver print; 11⅜ × 9¼ in. (29 × 23.5 cm)

This photograph does not describe what Otto Umbehr saw when he looked out his window in Berlin, but what he discovered when he turned his overhead view of the street upside-down. His simple inversion (indicated by the signature "Umbo" in the lower right corner) posits an unsettling world where the insubstantial dominates substance, effect overshadows cause, and imagination intercepts cognition. *Ford Motor Company Collection, Gift of Ford Motor Company and John C. Waddell, 1987, 1987.1100.49*

11 WALKER EVANS, American, 1903–1975
Kitchen Corner, Tenant Farmhouse, Hale County, Alabama, 1936
Gelatin silver print; 7⅝ × 6⅜ in. (19.5 × 16.1 cm)

In the summer of 1936 Walker Evans collaborated with writer James Agee on an unpublished article about cotton farmers in the American South, which eventually became the seminal book *Let Us Now Praise Famous Men* (1941). For four weeks in July, Evans made photographs of three sharecropper families and their environment—intimate, respectful portraits of the farmers, as well as their homes, furniture, clothing, and rented land. This study of a clean-swept corner is the twelfth plate in the book; it recalls Agee's observations on the significance of "bareness and space" in these homes: "general odds and ends are set very plainly and squarely discrete from one another . . . [giving] each object a full strength it would not otherwise have." *Purchase, The Horace W. Goldsmith Foundation Gift, 1988, 1988.1030*

12 DIANE ARBUS, American, 1923–1971
Child with a Toy Hand Grenade in Central Park, N.Y.C.
Gelatin silver print; 15½ x 15¹/₁₆ in. (39.4 x 38.3 cm)

Arbus, one of the most influential artists of the last half century, forever altered our expectations of portraiture with a series of lacerating, matter-of-fact photographs of the normal and the marginal in American society. In 1962, on a bucolic day in Central Park, the photographer and a young boy engage each other like foot soldiers, face-to-face. Armed with searing gazes but relatively benign weapons (a plastic toy hand grenade and a camera), they attain a momentary, if unbearably intense, draw. With exquisite prescience, Arbus was able to grasp that explosive potential and translate it into an indelible picture about childhood tomfoolery, war, and the role of the photographer in society. *Purchase, Jennifer and Joseph Duke Gift, 2001, 2001.474*

13 THOMAS STRUTH, German, born 1954
San Zaccaria, Venice
Chromogenic print; 71⁵/₈ x 90¾ in. (181.9 x 230.5 cm)

In the center of Struth's photograph (1995) is Giovanni Bellini's luminous San Zaccaria altarpiece (1505), which reigns over the adjacent paintings and all the surrounding space. Through his mastery of light and perspective, Bellini created the illusion that the space within the painting exists beyond the wall. Struth, however, used photography's trompe l'oeil effect to bring the marble niche forward, as if floating on the photograph's surface. Everything in the photograph seems to exist in the same sensuous, orderly world—as if Bellini's and Struth's monumental images of sacred spaces washed in translucent Venetian light were actually of the same moment. *Purchase, The Howard Gilman Foundation Gift, 1996, 1996.297*

ACKNOWLEDGMENTS

We extend our thanks to everyone on the Museum's staff who cooperated so willingly in revising this guide. These include especially H. Barbara Weinberg, Joan Aruz, Kim Benzel, Stuart W. Pyhrr, Richard Martin, William Griswold, Colta Ives, Catherine Roehrig, Everett Fahy, Katharine Baetjer, Keith Christiansen, Walter Liedtke, James David Draper, Jessie McNab, William Rieder, Judith Smith, Carlos Picón, Joan R. Mertens, Daniel Walker, Laurence Kanter, Linda Wolk-Simon, Mary Shepard, Julie Jones, William S. Lieberman, Lisa Messinger, Lowery S. Sims, Sabine Rewald, J. Stewart Johnson, Jane Adlin, Barbara Bridgers, and Deanna Cross.

INDEX